HISTORICAL DICTIONARIES OF LITERATURE AND THE ARTS
Jon Woronoff, Series Editor

Historical Dictionary of German Theater

William Grange

Historical Dictionaries of
Literature and the Arts, No. 11

The Scarecrow Press, Inc.
Lanham, Maryland • Toronto • Oxford
2006

SCARECROW PRESS, INC.

Published in the United States of America
by Scarecrow Press, Inc.
A wholly owned subsidiary of
The Rowman & Littlefield Publishing Group, Inc.
4501 Forbes Boulevard, Suite 200, Lanham, Maryland 20706
www.scarecrowpress.com

PO Box 317
Oxford
OX2 9RU, UK

British Library Cataloguing in Publication Information Available

Library of Congress Cataloging-in-Publication Data

Grange, William, 1947–
 Historical dictionary of German theater / William Grange.
 p. cm. — (Historical dictionaries of literature and the arts ; no. 11)
 Includes bibliographical references.
 ISBN-13: 978-0-8108-5315-7 (hardcover : alk. paper)
 ISBN-10: 0-8108-5315-9 (hardcover : alk. paper)
 1. Theater—Germany—Biography—Dictionaries. 2. Theater—Germany—
Dictionaries. 3. Dramatists, Germany—Biography—Dictionaries. I. Title. II. Series.

PN2657.G73 2006
792.0973'03—dc22 2006008124

⊗™ The paper used in this publication meets the minimum requirements of
American National Standard for Information Sciences—Permanence of Paper
for Printed Library Materials, ANSI/NISO Z39.48-1992.
Manufactured in the United States of America.

For Georgie

Contents

Acknowledgments

The completion of this book has given rise to numerous debts of gratitude, none of which any author could ever fully repay. The endeavor to complete this book was obviously an international affair, with research conducted both here in the United States and in Germany. Substantial thanks are due first of all to Jon Woronoff in France, editor of the Scarecrow series of which this volume is a part; his astonishing ability to read entries with a keen eye for accuracy and concision was particularly helpful. The Lied Foundation of the Hixson-Lied College of Fine and Performing Arts here at the University of Nebraska was generous and supportive as the book neared completion. My colleagues within the Johnny Carson School of Theatre and Film have been extremely patient with me throughout the writing process, as have been my students there.

Individuals who have provided insight, support, and help in putting this book together include Dr. Marvin Carlson of the City University of New York; Dr. Carlson is one of the academic world's premiere theater scholars, and I was extremely fortunate to have received his singular wisdom and guidance. To Dr. Elmar Buck, director of the Theater Research Collection at the University of Cologne, I offer my sincere appreciation; to his colleague Dr. Hedwig Müller, also of the University of Cologne, I extend heartfelt gratitude for research assistance, sage advice, and a healthy sense of humor. My Nebraska colleagues Dr. Tice Miller and Prof. Harris Smith provided unlimited professional reinforcement in helping me to complete research on this project. Dr. Leigh Woods at the University of Michigan gave several points of direction, as did Dr. Jürgen Ohlhoff and Frau Ulrike Münkel-Ohlhoff in Berlin.

To my wife Willa, with tender sincere apologies for my somewhat erratic behavior during the completion of the book, but she seems to have forgiven me already. She is a woman with few peers anywhere, not only because of her forgiving nature; she remains my most discerning and appreciated audience.

Editor's Foreword

For centuries, theater has represented a significant concern in the German-speaking world, a world that includes Germany, Austria, and part of Switzerland today. In previous centuries, it was a world that encompassed a far larger community. The German theater, as elsewhere, has provided relaxation and entertainment—but it has also been an instrument for loftier goals. At various times in history, those goals have entailed education, cultural uplift, or affirmation of the "nation" in one form or another. This does not mean that the German theater, like its counterparts elsewhere, eschewed the banal or that all Germans everywhere cherished theater as a peculiar kind of birthright. But the German theater can indeed boast an impressive array of outstanding playwrights, directors, actors, and designers who have achieved not only national but also international fame. One need think only of Goethe and Schiller, Hauptmann and Brecht, Reinhardt and Piscator, the Devrients and Gründgens. Most exceptional were the plays—plays that created new trends and plays that became part of universal theater, such as *Faust* or *The Threepenny Opera*.

This makes the first book in the subseries on theater particularly welcome. The *Historical Dictionary of German Theater* covers the whole field very broadly. In the chronology, readers can trace its evolution from the earliest to the most recent times. The introduction describes and explains major developments, including not only artistic aspects but also commercial imperatives. But the dictionary section imparts most of the information, with hundreds of entries on outstanding playwrights, directors, actors, designers, and others, along with the more memorable plays. There are also entries on major styles and trends as well as some of the most prominent theaters and the cities best known for their theatrical traditions. While this book is a good starting point, it can be no

more than that; thus a substantial bibliography pointing toward other reading serves as a precious addition.

This book was written by William Grange, who is, among other things, a professor of theater and performance at the Johnny Carson School of Theatre and Film of the University of Nebraska, with a specialization in European and especially German theater. There, he has won awards as a top-ranked scholar and teacher; he has also received numerous citations and prizes, from the Fulbright Commission in Berlin, the Council for the International Exchange of Scholars in New York, the German Academic Exchange Service, the Harry Ransom Center at the University of Texas, and several others. But scholarship is just part of his range of interests, since he has also worked as an actor and director and even translated plays by Bertolt Brecht and Georg Büchner, which he then directed on college campuses. Dr. Grange has lectured and written extensively on German theater, including three books, *Partnership in the German Theatre*, *Comedy in the Weimar Republic*, and *Hitler Laughing: Comedy in the Third Reich*. This has provided a strong foundation for compiling the present reference work, one which his students and many other fans of German theater will be pleased to have available.

Jon Woronoff
Series Editor

Chronology

970–980 Roswitha of Gandersheim writes six comedies in Latin at the Brunshausen Cloister, near Braunschweig.

1185–1240 Neidhart von Reuental's poems presumably become the basis for several *Neidhartspiele*, comic interludes in Middle High German featuring conflicts between peasant and knight.

1220 Religious plays begin to appear in Middle High German, the earliest of which was probably *The Easter Play of Mary*.

1300–1400 *Vasnachtspile*, or Shrovetide plays, emerge in Early New High German and Germanic dialects from native practices in or around Lübeck, Hessia near the Rhine, Sterzing in Tyrol (present-day Italy), Swabia, and Eger (present-day Czech Republic).

1430–1460 Hans Rosenplüt is among the first Shrovetide playwrights in Nuremberg.

1455 Evidence of touring troupes staging passion plays and secular folk plays in Tyrol.

1493 Passion play in Frankfurt am Main established.

1501 Konrad Celtis publishes works of Roswitha and stages plays by Terence, Plautus, and Seneca with students at University of Vienna.

1514 Passion play in Heidelberg established.

1517 Protestant Reformation begins in Wittenberg; amateurs write and produce scores of plays attacking Roman Catholic Church practices, among them Martin Luther's student Paul Rebhun.

1550 Hans Sachs creates first German theater building—St. Martha's Church in Nuremberg, an expropriated Catholic church—and presents dozens of his Shrovetide plays there.

1551 Jesuits arrive in Vienna; they establish a school there in 1553 and employ staging of plays in the curriculum.

1568 Italian *commedia* troupe under the direction of Orlando di Lassi arrives in Munich; several other commedia troupes follow them to Munich in subsequent years.

1570–1588 Jesuit schools in Graz, Munich, and other southern locales present interludes in vernacular.

1576 Death of Sachs in Nuremberg; he claimed to have written more than 200 plays.

1583 Passion play of Lucerne established.

1586 Arrival of English Comedians on German soil by way of Denmark; they establish professional standards which German performers attempt to emulate.

1592 Duke Heinrich Julius of Braunschweig invites English actors to perform at his court in Wolfenbüttel. Robert Browne takes a London troupe to Frankfurt am Main and tours Hessia.

1606 Count Moritz in Kassel builds a theater for English troupes, with John Greene and his troupe in residence.

1608 Greene's troupe travels to Graz and other southern cities.

1618–1648 Thirty Years' War devastates most of German-speaking Europe. Touring nearly stops, but Jesuit and Protestant school productions continue and some courts mount amateur theatricals.

1634 Passion play at Oberammergau established.

1650–1658 Andreas Gryphius writes tragedies and comedies, which, though unperformed, serve as the first literary models of drama.

1660–1700 Several touring troupes attempt to establish themselves in cities and courts; their amateurish productions of *Haupt- und Staatsaktion* plays are ridiculed, as are the plays themselves. Character of "Hanswurst" emerges as a Teutonic Arlecchino who improvises during interludes of Haupt- und Staatsaktion plays.

1662–1677 Johannes Velthen joins Carl Andreas Paulsen's troupe of actors and tours northern Germany.

1678 Velthen assumes leadership of Paulsen troupe, renaming it the "Elector of Saxony's Players"; their repertoire exceeds 90 plays, many based on English models, and they reside in Dresden.

1683 Turks lay siege to Vienna.

1699 Josef Anton Stranitzky originates Viennese version of Hanswurst, touring southern German and Austrian provinces.

1700 Theater im Marstall in Berlin becomes a facility for touring troupes.

1705 Stranitzky arrives in Vienna with his German Players troupe.

1711 Stranitzky's troupe awarded lease of Kärntnertor Theater in Vienna, the first permanent private theater in German-speaking Europe.

1725 Gottfried Prehauser arrives in Vienna as a member of Stranitzky's troupe; he develops the Salzburg version of Hanswurst.

1725–1730 Johann Christoph Gottsched in Leipzig publishes articles, essays, and books calling for reform of German-language theater.

1727 Friederike Caroline Weisenborn Neuber and her husband Johann Neuber are named court players in Saxony and establish residency in Leipzig.

1728 Heinrich Gottfried Koch joins Neuber troupe.

1730 Johann Friedrich Schönemann joins Neuber troupe.

1732 Neuber troupe performs Gottsched's *The Dying Cato* as part of reform movement to upgrade German aesthetic standards for spoken drama based on French precedents; Carl Theophil Döbbelin plays title role.

1737 Neuber and Gottsched hold a ceremony in Leipzig to ban Hanswurst from the German stage.

1740 King Frederick the Great of Prussia initiates First Silesian War and defeats Austria, making Silesia a Prussian territory.

1741 Koch and Schönemann form their own troupes and emulate Neuber's attempts to improve status of the German actor; Koch awarded Neuber's license to perform in Prussia. Habsburg empress

Maria Theresa leases reception hall adjacent to her royal palace to Karl Josef Selliers for the purpose of presenting plays to her court, and the hall comes to be known as the Burgtheater.

1743 Prussian court awards Schönemann troupe a general license to perform in all Prussian provinces.

1748 Neuber's troupe premieres Gotthold Ephraim Lessing's *The Young Scholar*; Schönemann publishes the plays in his company's repertoire.

1751 Schönemann's troupe named court players for the Duke of Schwerin, allowing them to concentrate on touring mostly in northern Germany.

1753 Prussian court awards Konrad Ernst Ackermann a concession to build his own theater building in Königsberg.

1755 Ackermann premieres Lessing's *Miss Sara Sampson* in Potsdam.

1756 Döbbelin establishes troupe in Erfurt. Frederick the Great initiates Seven Years' War and captures Saxony. Russian army defeats Prussians near Königsberg, forcing Ackermann troupe to abandon its theater there.

1757 Prussian army defeats French at Rossbach and Austrians at Leuthen. Russian troops take 13-year-old Friedrich Ludwig Schröder into custody.

1758 Koch assumes leadership of Schönemann's troupe. Prussian army defeats Russians at Zorndorf.

1759 Lessing publishes *Letters Concerning Recent Literature* to refute Gottsched's Francophilia. Russian army captures and occupies Berlin.

1764 Konrad Ekhof joins Ackermann's troupe in Hannover.

1765 Ackermann builds Komödienhaus in Hamburg.

1766 Koch builds Leipzig's first permanent theater building. Johann Friedrich Löwen publishes first history of German theater. Christoph Martin Wieland completes 20 translations of Shakespeare's plays into German prose and one (*A Midsummer Night's Dream*) into verse.

1767 Ackermann leases Komödienhaus to Löwen, who names it Hamburg National Theater. Löwen hires Lessing as dramaturg along with many actors from Ackermann's troupe, Ekhof the most important among them. Sonnenfels publishes attacks on Viennese popular theater tradition, calling for reform similar to Gottsched and Neuber's. Lessing's *Minna von Barnhelm* premieres at Hamburg National Theater.

1769 Lessing publishes his *Hamburg Dramaturgy*, based on his observations of the Hamburg National Theater project, which soon disbands. Döbbelin buys Berlin's Theater am Monjoubiplatz.

1771 Koch buys Theater in der Behrenstrasse in Berlin. Schröder assumes leadership of Ackermann's troupe in Hamburg.

1772 Döbbelin's troupe premieres Lessing's *Emilia Galotti* in Braunschweig.

1774 Ekhof with Abel Seyler establish the first permanent German-language subsidized court theater in Gotha. Schröder premieres Johann Wolfgang Goethe's *Clavigo* in Hamburg. Koch premieres Goethe's *Götz von Berlichingen* in Berlin.

1775 Döbbelin buys Theater in der Behrenstrasse in Berlin from Koch. Johann Joachim Eschenburg publishes translations of Shakespeare's plays into German prose.

1776 French court troupes perform in Berlin's French Comedy Theater. Schröder premieres Friedrich Klinger's *The Twins* in Hamburg. Habsburg emperor Joseph II decrees Burgtheater to be the "Teutsches Nationaltheater" (German National Theater).

1777 Klinger's *Sturm und Drang* (*Storm and Stress*) premieres in Dresden, ushering in a new movement; Schröder premieres Storm and Stress plays by Klinger, Jakob Lenz, and Heinrich Leopold Wagner in Hamburg. Ekhof hires August Wilhelm Iffland in Gotha.

1778 Prussian court names Döbbelin's troupe National Prussian Players and installs them in Berlin's French Comedy Theater until 1786.

1779 Wolfgang Heribert von Dalberg hires Iffland in Mannheim; Gotha court theater disbanded.

1781 Schröder joins Burgtheater. Karl Marinelli builds Leopoldstädter Theater in Vienna.

1782 Dalberg premieres Friedrich Schiller's *The Robbers* in Mannheim.

1783 Döbbelin premieres Lessing's *Nathan the Wise* in Berlin. Dalberg appoints Schiller resident dramatist in Mannheim.

1784 Dalberg premieres Schiller's *Intrigue and Love* and *Fiesko* in Mannheim with Iffland as central character in both.

1786 Schröder returns to Hamburg. Iffland engages Ferdinand Fleck in Mannheim. King Friedrich Wilhelm II of Prussia buys inventory of Theater in der Behrenstrasse from Döbbelin.

1787 Schröder premieres Schiller's *Don Carlos* in Hamburg. Friedrich Wilhelm II installs Döbbelin's troupe in Berlin Royal Opera House and creates Prussian Royal National Theater.

1788 Goethe returns to Weimar from two-year sojourn in Italy. Karl Meyer builds Josephstädter Theater in Vienna.

1789 Schiller appointed adjunct professor at University of Jena. Joseph II appoints Johann Franz Brockmann the Burgtheater's director. August von Kotzebue's *Misanthropy and Repentance* premieres in Reval.

1791 Joseph Bellomo's troupe premieres Goethe's *Egmont* in Weimar.

1792 Goethe appointed director of Weimar Court Theater.

1794 Burgtheater in Vienna receives official name: "Royal and Imperial Court Theater Adjacent the Burg."

1796 Iffland appointed director of Prussian Royal National Theater in Berlin.

1797 August Wilhelm Schlegel begins translations of Shakespeare.

1799 Schiller takes up residence in Weimar; Goethe premieres Schiller's "Wallenstein Trilogy" (*Wallenstein's Camp*, a prelude; *The Piccolominis*; and *Wallenstein's Death*) in Weimar. Iffland stages Schlegel's translation of *Hamlet* in Berlin.

1800 Goethe premieres Schiller's *Maria Stuart* and Schiller's translation of *Macbeth* in Weimar. Napoleon's troops defeat Austrians in the Battle of Marengo; French troops occupy Munich.

1801 Schiller's *The Maid of Orleans* premieres in Leipzig. Emanuel Schikaneder opens Theater an der Wien in Vienna. Austria capitulates to Napoleon; Austria and Prussia cede left bank of the Rhine River to France.

1802 Goethe premieres Schiller's adaptation of his *Iphegenie auf Tauris* in Weimar.

1803 Goethe premieres Schiller's *The Bride of Messina* in Weimar. Napoleon occupies Vienna.

1804 Goethe premieres Schiller's *William Tell* in Weimar.

1805 Schiller dies in Weimar. Austria cedes Bavaria and parts of Austria itself to Napoleon; duchies of Württemberg and Baden are declared kingdoms.

1806 Napoleon defeats Prussians in the Battle of Jena near Weimar, then captures and occupies Berlin; he establishes Confederation of the Rhine, eventually consisting of all German-speaking states except Austria, Prussia, Braunschweig, and Hessen.

1807 Goethe's *Torquato Tasso* premieres in Weimar. Treaty of Tilsit obliges Prussia to cede half its territory to Napoleon. French acting troupe occupies Berlin Royal Theater. French troops arrest Heinrich von Kleist.

1808 François-Joseph Talma makes sojourn to Weimar in Napoleon's retinue; he and Théâtre Français troupe perform at Weimar Court Theater. Kleist meets with Ludwig Tieck in Dresden. Goethe premieres *The Broken Jug* in Weimar.

1809 French troops depart Berlin. Goethe stages Schlegel's translation of *Hamlet* in Weimar with Pius Alexander Wolff in title role.

1811 Prussian court issues new theater regulations, officially declaring troupes private businesses under jurisdiction of local law enforcement authorities.

1813 French armies defeat combined Austrian, Prussian, and Russian forces at Battle of Dresden in August. In October, Napoleon loses Battle of Leipzig and retreats across the Rhine, freeing German-speaking territories.

1814 Iffland engages Ludwig Devrient as leading actor at Berlin Royal Theater. Joseph Schreyvogel assumes leadership of Vienna Burgtheater.

1815 King Frederick William III of Prussia promises a constitution; he reorganizes Prussian bureaucracy and forms customs union.

1816 Goethe resigns as director of Weimar Court Theater.

1818 German Confederation (comprised of 39 German-speaking states and four free cities) declared at Congress of Vienna; Frankfurt am Main chosen as its capital.

1819 German Confederation adopts Carlsbad Decrees, requiring local police to approve any play and supervise rehearsals and performances. Kotzebue murdered; soon thereafter thousands of productions of his plays proliferate.

1820 Karl Friedrich Schinkel–designed Königliches Schauspielhaus (Royal Theater) in Berlin completed.

1821 Tieck publishes plays by Kleist; *Prince Friedrich of Homburg* premieres at Burgtheater.

1824 Friedrich Cerf builds Königstädtisches Theater am Alexanderplatz in Berlin and begins staging Louis Angely's comedies there.

1826 Carl leases Theater an der Wien in Vienna.

1827 Carl leases Theater in der Josephstadt and hires both Johann Nepomuk Nestroy and Wenzel Scholz.

1828 Charlotte Birch-Pfeiffer's first play, *Herma*, premieres in Vienna.

1829 August Ernst Klingemann stages first performance of complete version of Goethe's *Faust, Part 1* in Braunschweig.

1837 Birch-Pfeiffer begins her management of Zurich City Theater.

1838 Carl buys Theater in der Josephstadt.

1842 Carl premieres Nestroy's *Out on a Lark*. The Great Fire of Hamburg destroys most of the city's theaters.

1843 Tieck presents *A Midsummer Night's Dream* on a platform stage in Potsdam with music by Felix Mendelssohn. Carl premieres Nestroy's *Love Affairs and Wedding Bells*.

1846 Deutscher Bühnen Verein (German Theater League), an association of theater owners and managers, formed. Bogumil Dawison gets first professional German-language engagement, in Breslau. Friedrich Hebbel's *Maria Magdalena* premieres in Leipzig.

1847 Carl levels Theater in der Josephstadt and builds the Carl Theater in its place.

1848 March revolutions in Berlin and Vienna. Prussian cabinet issues decree that would end theater censorship. Friedrich-Wilhelm Deichmann gets license to establish a "casino" on Schumann Strasse in Berlin; it later becomes an important theater.

1849 Heinrich Laube assumes directorship of the Burgtheater; Dawison emerges as star of the company.

1851 Berlin police chief Karl Friedrich von Hinckeldey issues decree that police must supervise theater rehearsals and report on "anything that looks suspicious." Franz Dingelstedt becomes intendant at Munich Court Theater.

1852 Hebbel's *Agnes Bernauer* premieres at Burgtheater.

1854 Carl dies; Nestroy takes over Carl Theater. First complete performance of Goethe's *Faust, Part 2*, in Hamburg.

1855 Roderich Benedix becomes director of the Frankfurt am Main City Theater. Franz Wallner leases Theater in der Blumenstrasse in Berlin, later renaming it after himself.

1861 Hebbel's *The Nibelungs* premieres in Weimar.

1864 Ludwig Barnay begins his career at the Burgtheater.

1865 Wallner builds splendid new theater in Berlin, again naming it after himself.

1867 Friedrich Mitterwurzer debuts at Burgtheater.

1869 Prussian Royal Cabinet enacts the Business Freedom Act, removing all restrictions except censorship on theater practice.

1871 German Empire formed, with Prussian king Wilhelm I as emperor. Dingelstedt named director of Burgtheater. Ludwig Chronegk appointed director of the Meiningen Theater.

1872 Laube premieres Franz Grillparzer's *Fraternal Guile within the House of Habsburg* at Vienna City Theater.

1873 Theodor Lebrun premieres *Mein Leopold* by Adolph L'Arronge at Wallner Theater.

1874 First tours of the Meininger troupe to Berlin and other major German cities.

1875 In Weimar, Otto Devrient stages first complete performance of both parts of *Faust*.

1876 Richard Wagner's Festival Playhouse opens in Bayreuth.

1878 Ernst Possart becomes director of Munich Court Theater.

1881 Adolf Wilbrandt appointed director of the Burgtheater.

1882 Agnes Sorma makes Berlin debut, at Deutsches Theater.

1883 L'Arronge buys Friedrich-Wilhelmstädtisches Theater, renaming it Deutsches Theater; he hires Josef Kainz as his leading performer.

1885 Franz and Paul von Schönthan's *The Rape of the Sabine Women* premieres, eventually to become the German theater's most frequently performed comedy.

1886 Georg II, Duke of Saxony-Meiningen, premieres Henrik Ibsen's *Ghosts* in Meiningen.

1887 Andre Antoine's Théâtre Libre performs in Berlin.

1888 Oskar Blumenthal builds the Lessing Theater in Berlin and presents first unabridged version of Ibsen's *A Doll's House* there.

1889 Otto Brahm stages Ibsen's *Ghosts* in Berlin under the auspices of the Freie Bühne.

1890 Max Burckhard assumes directorship of Burgtheater. *The Schöller Boardinghouse* premieres in Berlin.

1893 Gerhart Hauptmann's *The Beaver Coat* premieres in Berlin. *Charley's Aunt* premieres in Berlin with Guido Thielscher in title role.

1894 Brahm begins 10-year lease of Deutsches Theater from L'Arronge and premieres Hauptmann's *The Weavers*; Kaiser Wilhelm II publicly denounces the play, forbids all German military officers from attending any performances, and dismisses the judge who granted permission for play's public performance.

1895 First premiere of any Georg Büchner play (*Leonce and Lena*, in Berlin). Paul Lindau becomes intendant of Meiningen Theater. Arthur Schnitzler's *Loving* premieres at Burgtheater.

1896 Karl Lautenschläger installs first German stage revolve, based on 18th-century Japanese models.

1898 Blumenthal premieres his *White Horse Inn* at his Lessing Theater. Otto Gebühr makes debut at Dresden Court Theater. Paul Schlenther appointed director of Burgtheater.

1899 Kleist's *Amphytrion* premieres at Neues Theater am Schiffbauerdamm, Berlin. Kainz joins Burgtheater company.

1900 Julius Bab begins career as theater critic in Berlin. Deutsches Schauspielhaus completed in Hamburg.

1901 Siegfried Jacobsohn begins career as critic in Berlin. Max Reinhardt forms "Noise and Smoke" cabaret.

1902 Reinhardt premieres Frank Wedekind's *Earth Spirit*, with Gertrud Eysoldt as Lulu, at Kleines Theater, Berlin.

1903 Berlin's underground and surface rail transportation system completed, allowing a substantial increase in audience accessibility to theaters. Alexander Moissi makes Berlin debut, at Neues Theater under Reinhardt's direction.

1904 Tilla Durieux makes Berlin debut. Louise Dumont founds Düsseldorf Schauspielhaus with Lindemann.

1905 Monty Jacobs begins career as critic in Berlin.

1906 Reinhardt premieres Wedekind's *Spring's Awakening*. Reinhardt buys Deutsches Theater from L'Arronge.

1907 Ferdinand Bonn debuts the first of his Sherlock Holmes adaptations in Berlin. Georg Fuchs opens Munich Artists' Theater.

1909 Alfred Kerr begins career as critic in Berlin. Hermann Bahr's *The Concert* premieres in Berlin.

1910 Curt Goetz makes Berlin debut. Emil Jannings makes acting debut at a dinner theater in Bohemia. Fritz Kortner debuts in Mannheim.

1911 Carl Sternheim's *The Underpants* premieres in Frankfurt am Main. Paul Fechter becomes lead theater critic for the Berlin *Vossische Zeitung*. Kleist Prize Foundation established in Berlin.

1912 Hauptmann awarded Nobel Prize for literature. Munich Kammerspiele established.

1913 Werner Krauss makes Berlin acting debut under Reinhardt at Deutsches Theater. Viktor Barnowsky leases Lessing Theater. Reinhardt premieres Sternheim's *Citizen Schippel*. Otto Falckenberg begins directing career in Munich. Büchner's *Woyzeck* premieres at Munich Court Theater.

1914 German Empire embarks on invasion of France, and World War I begins. Berlin Volksbühne opens. Ernst Deutsch debuts at Vienna Volksbühne. Gustav Hartung named principal director at Frankfurt City Theaters.

1915 Falckenberg stages premiere of Strindberg's *The Ghost Sonata* in Munich. Agnes Straub makes Berlin debut.

1916 Sternheim awarded Fontane Prize. Erich Ziegel establishes Hamburg Kammerspiele.

1917 Falckenberg stages premiere of Georg Kaiser's *From Morn to Midnight* in Munich. Reinhardt premieres Reinhard Johannes Sorge's *The Beggar* in Berlin. Heinrich George debuts in Frankfurt. Walter Hasenclever awarded Kleist Prize.

1918 Reichstag passes Act of Parliamentary Rule, denying Kaiser Wilhelm II authority to act without its permission; Wilhelm II abdicates, and a republic is declared from the window of the Reich Chancellery. Revolution breaks out in Berlin streets. Baden and Bavaria become "people's republics."

1919 "Spartacus Uprising" begins as Communists occupy several Berlin newspaper offices and attempt to monopolize information flow out of the city. Leopold Jessner appointed intendant of newly renamed Berlin State Theater. Hermine Körner becomes director of Munich Schauspielhaus. Reinhardt, Hugo von Hofmannsthal, and others establish Salzburg Festival. Heinz Hilpert and Kortner make Berlin acting debuts in Ernst Toller's *The Transformation*. Reinhardt buys Busch Circus in Berlin and transforms it into the Grosses Schauspielhaus. Saladin Schmitt becomes director of Bochum Schauspielhaus. Toller sentenced to five years in prison for revolutionary activities.

1920 Berlin incorporates surrounding towns and villages to become "Greater Berlin," covering the largest land surface of any city in the world (214,977 acres). Gustaf Gründgens makes professional debut in Halberstadt. Rudolf Forster begins Berlin career with both Reinhardt and Jessner. Hartung stages his last Expressionist premiere in Frankfurt, *Platz* by Fritz von Unruh. Erwin Piscator opens his Proletarian Theater in Berlin. Toni Impekoven and Carl Mathern's *The Tart* opens in Frankfurt.

1921 Franz Arnold and Ernst Bach's *The Reluctant Playboy* becomes the first of a string of hits that earn them the nickname of "the firm of Arnold and Bach"; their plays are performed more often than any others through the 1920s. Goetz's *Ingeborg* premieres at Theater am Kurfürstendamm and Toller's *Masse Mensch* at Volksbühne.

1922 Jessner hires Jürgen Fehling as principal director at Berlin State Theater. Falckenberg stages premiere of Bertolt Brecht's *Drums in the Night* in Munich. Elisabeth Bergner makes Berlin debut. Brecht awarded Kleist Prize. Ferdinand Bruckner leases Renaissance Theater in Berlin. Arnolt Bronnen's *Patricide* premieres at Deutsches Theater.

1923 Devastating monetary inflation severely reduces operations in most German theaters; Reinhardt begins his first American tour to avoid bankruptcy. Emil Pirchan designs Jessner's *William Tell* at Berlin State Theater with "Jessner steps," as he had earlier with *Richard III*.

Berthold Viertel founds an informal group called "The Troupe" and premieres plays by Robert Musil, Paul Gurk, and Kaiser.

1924 German economy begins recovery with issuance of new currency. Carl Zuckmayer and Brecht begin working for Reinhardt as dramaturgs. Friedrich Kayssler hires Piscator to direct at Berlin Volksbühne. Reinhardt hires Oskar Strnad as principal designer at Deutsches Theater. Bergner plays title role in German premiere of Shaw's *St. Joan*. Adolf Hitler sentenced to brief prison term and later released.

1925 Zuckmayer's *The Merry Vineyard* premieres, igniting protests against the play in more than 60 cities. Zuckmayer awarded Kleist Prize. President Friedrich Ebert dies, and Gen. Paul von Hindenburg is elected to replace him. Governmental and judicial attacks on the theater begin a marked increase. Germany regains rank as second in world iron and steel production.

1926 "Smut and Filthy Literature Law" goes into effect nationwide. Brecht's *A Man's a Man* premieres in Darmstadt. Bruckner's *Illness of Youth* premieres at Renaissance Theater. Hitler appoints Joseph Goebbels propaganda director for the National Socialists in Berlin. Helene Weigel makes Berlin debut in Hebbel's *Herod and Miriam*. Premiere of Marieluise Fleisser's *Purgatory in Ingolstadt*. Marlene Dietrich gets her first critical notices in premiere of *Duell am Lido* at State Theater under Jessner's direction. Ernst Barlach's *The Blue Boll* premieres in Stuttgart. Krauss stars in Hilpert's sensational production of the military epic *Gneisenau* at Deutsches Theater. Zuckmayer is tried for blasphemy in Munich.

1927 Ernst Busch makes Berlin debut at Volksbühne. Piscator leases Theater am Nollendorfplatz. Hasenclever's *Ein besserer Herr* premieres in Frankfurt am Main, and Kaiser's comedy *The Paper Mill* premieres in Dresden. Piscator premieres Toller's *Hurrah, We're Alive!* at Theater am Nollendorfplatz. President Hindenburg declares that World War I was, for the Germans, a "means of self-determination in a world surrounded by enemies."

1928 Ernst Josef Aufricht leases Theater am Schiffbauerdamm and premieres Brecht and Kurt Weill's *The Threepenny Opera* there. Piscator stages *The Adventures of the Good Soldier Schweik*. Hilpert premieres Bruckner's *The Criminals*, giving Gründgens his first starring

role in Berlin. Jessner removed as intendant of the State Theater. Max Reinhardt Seminar, a theater school for acting and directing, opens its doors to students.

1929 Aufricht premieres Brecht and Weill's *Happy End* at Theater am Schiffbauerdamm and also produces Fleisser's *Pioneers in Ingolstadt*. German banking system collapses in the wake of the Wall Street crash. Goetz's *The Liar and the Nun* premieres in Hamburg.

1930 National Socialists capture a majority in Thuringian elections, their first conquest of a state legislature. Six Berlin theaters file for bankruptcy, while many provincial theaters (e.g., Breslau, Essen, Magdeburg, and Wiesbaden) do likewise. *Sturm im Wasserglas* by Bruno Frank premieres in Dresden. Agnes Straub plays title role in premiere of Bruckner's *Elizabeth of England*. Jannings makes first Berlin theater appearance since winning an Academy Award for best actor in Hollywood films.

1931 Hilpert stages premiere of Zuckmayer's *The Captain of Köpenick* and Ödön von Horváth's *Tales of the Vienna Woods* at Deutsches Theater Berlin; Horváth's *Italian Night* premieres at Theater am Schiffbauerdamm Berlin. Thuringian minister for internal affairs Wilhelm Frick publishes the "State Proclamation against Negro Culture." Frank's *Nina* premieres in Dresden. Piscator emigrates to Moscow, where he hopes to make films. Communist and National Socialist militias battle openly in the streets of many cities.

1932 Reinhardt relinquishes control of all three of his Berlin theaters, keeping only the Deutsches. Hilpert appointed director of Berlin Volksbühne. National Socialists win big in several state and local elections and become the largest party in the Reichstag. Gründgens plays Mephisto for the first time in Berlin. Goetz's *Job Pretorius, M.D.* premieres in Stuttgart and Horváth's *Kasimir and Karoline* in Leipzig. Traugott Müller begins work at State Theater; he would later become the most accomplished stage designer in the Third Reich. Straub receives Louise Dumont Award.

1933 Hindenburg names Hitler chancellor on 30 January. Premiere of Hanns Johst's *Schlageter* in honor of Hitler's birthday (20 April); several plays by pro-Nazi playwrights (e.g., Billinger, Bethge, Möller, Rehberg, Blunck, and others) also premiere. Hundreds of theater artists

emigrate to Austria and Switzerland. Ministry of Propaganda created. Elisabeth Flickenschildt makes Berlin debut. August Hinrichs's *When the Rooster Crows* premieres in Oldenburg.

1934 Reinhardt bequeaths Deutsches Theater to the "German Nation." Gründgens appointed intendant of Berlin State Theater, Eugen Klöpfer of Volksbühne, and Hilpert of Deutsches. Cultural Chamber Law goes into effect, implementing goals set forth by Goebbels's Ministry for Propaganda and Popular Enlightenment, which assumes authority for all theater activity in Germany; Hitler publicly pledges to "cleanse" the German theater of its "lethargy." Hans Schweikart becomes principal director at Bavarian State Theater. Klöpfer is declared state actor and Emmy Sonnemann state actress.

1935 Viktor DeKowa joins Gründgens's company at State Theater. Premiere of Heinrich Zerkaulen's *Out of the Ordinary*. Maximilian Böttcher's *Uproar in the Inner Courtyard* premieres in Eisenach. Körner is declared state actress. Zuckmayer's *Der Schelm von Bergen* premieres in Zurich and Jochen Huth's *The Four Associates* in Berlin.

1936 Goebbels bans theater criticism in newspapers, demanding "cultural reporting" in its place; he commissions Eberhard Wolfgang Möller to write an outdoor spectacle (termed *Thingspiel*) titled *The Frankenburg Dice Game* to premiere at Berlin Olympics. Paula Wessely plays title role in Schiller's *The Maid of Orleans* at Olympics. Leo Lenz's *Honeymoon without a Husband* premieres in Berlin, Richard Billinger's *The Witch of Passau* in Augsburg, and Hauptmann's *Hamlet in Wittenberg* in Leipzig.

1937 Hitler names Jannings, Gebühr, George, Paulsen, Paul Otto, and Matthias Wiemann state actors and Lucie Höflich state actress. Brecht's *Frau Carrar's Rifles* premieres in Paris and Horváth's *A Village without Men* in Prague. Fehling's production of *Richard III* at the Berlin State Theater creates one of the few theater sensations in the Third Reich.

1938 Oskar Wälterlin becomes director of Zurich Volkstheater am Pfauen, which is soon rechristened the Schauspielhaus. Nazi regime awards Hans Blunck its Goethe Medallion. Horváth's *Figaro Gets a Divorce* premieres in Prague and Zuckmayer's *Bellmann* in Zurich; Reinhardt premieres Thornton Wilder's *The Merchant of New York*, based on Nestroy's *Out on a Lark*, in New York City. Austria joins "Greater Ger-

many," accepting Hitler as head of government; Goebbels assumes authority over Austrian theaters.

1939 Fehling stages *Richard II* in Müller's design (with Gründgens in title role) at Berlin State Theater. Reich Theater Festival held in Heidelberg. German troops invade Poland on 1 September, and World War II begins. Hitler declares Hans Albers, René Deltgen, Albert Florath, and Alexander Golling state actors and Wessely and Käthe Haack state actresses. Theater attendance reaches unprecedentedly high levels throughout Germany and Austria.

1940 More than 350 new plays and operettas premiere. Several theaters in Poland and France are confiscated and turned over to German producers. Gründgens premieres Mussolini's *Cavour* at State Theater.

1941 Brecht's *Mother Courage* (with Therese Giehse in title role) premieres in Zurich. Germany invades Soviet Union in June; "front theaters" are set up in Ukraine for benefit of soldiers. Hinrichs's *The Model Farmer* premieres in Oldenburg.

1942 Fehling stages *The Beaver Coat* in Berlin on the occasion of Hauptmann's 80th birthday, with Flickenschildt miscast as Mother Wolff. Propaganda Ministry decrees closure of private theaters.

1943 Bombing raids on German cities intensify; theater performances are frequently interrupted. Brecht's *Good Person of Setzuan* premieres in Zurich. Lessing Theater, Opera House, Theater am Kurfürstendamm, and Komödie Theater are among several Berlin venues destroyed in bombing raids.

1944 Assassination attempt of 20 July on Hitler nearly succeeds. Goebbels closes all theaters in the Reich on 1 August.

1945 Soviet army occupies Berlin; Hitler commits suicide on 30 April. *The Rape of the Sabine Women* opens on 27 May at Renaissance Theater in Berlin, the first production after German capitulation. DeKowa and other actors perform one-acts at Berlin Tribüne Theater. Soviet authorities appoint Gustav von Wangenheim intendant of Deutsches Theater in August; Erich Ponto becomes intendant of Dresden State Theater. Erich Engel is appointed director of Munich Kammerspiele. Brecht and Weill's *Threepenny Opera* opens in Berlin's Hebbel Theater.

1946 Hilpert stages premiere of Zuckmayer's *The Devil's General* in Zurich. Gründgens is released from Soviet custody and begins work with Busch at Deutsches Theater. Frisch's *Now They Sing Again* premieres in Zurich and German-language version of Tennessee Williams's *The Glass Menagerie* in Basel. Klaus Kinski debuts at Berlin Schlosspark Theater.

1947 Gründgens becomes intendant of Düsseldorf City Theaters. Borchert's *The Outsider* premieres in Hamburg. Schweikart assumes directorship of Munich Kammerspiele and Körner becomes director at Stuttgart State Theater. Otto Falckenberg School founded in Munich.

1948 Brecht stages his adaptation of *Oedipus* in Chur, Switzerland, with Weigel and premieres his *Mr. Puntila and His Servant Matti* in Zurich; Langhoff's stages Brecht's *Fear and Misery in the Third Reich* at Berlin Deutsches Theater. Viertel returns to work as director at Vienna Burgtheater. Josef Stalin attempts to seal off West Berlin, and Americans and British begin Berlin Airlift in response. At Burgtheater, Käthe Gold plays both Laura Wingfield in Williams's *The Glass Menagerie* and Blanche Dubois in his *A Streetcar Named Desire*. Jean Giraudoux's *Madwoman of Chaillot* premieres in Hamburg.

1949 Brecht establishes the Berliner Ensemble, housed at Berlin Deutsches Theater, and stages his *Mother Courage* starring Weigel. Friedrich Dürrenmatt's *Romulus the Great* and Max Frisch's *When the War Was Over* both premiere in Zurich; Hilpert stages premiere of Zuckmayer's *Barbara Blomberg* in Constance. Kortner returns to Munich as a director with Kammerspiele. Separate German republics are declared—the Federal Republic of Germany (FRG) and the German Democratic Republic (GDR)—with separate currencies and governments.

1950 Brecht stages his adaptation of Jakob Lenz's *The Tutor* with Berliner Ensemble. Kortner stages *Don Carlos* in Munich with Kinski. Hilpert becomes intendant of newly renamed Deutsches Theater in Göttingen and stages premiere of Zuckmayer's *Song in the Fiery Furnace*. Körner plays title role in *Madwoman of Chaillot* in Stuttgart. Reconstructed Bremen City Theater opens.

1951 Boleslaw Barlog becomes intendant of Berlin Schiller Theater. Harry Buckwitz is named director of the Frankfurt City Theaters. Frisch's

Count Oederland premieres in Zurich. Piscator returns to work as freelance director in West Germany.

1952 Hilpert stages premiere of Zuckmayer's *Ulla Winblad* in Göttingen, and Benno Besson premieres Brecht's *The Trial of Joan of Arc in Rouen* in Berlin. Grete Mosheim returns to Berlin in premiere of John van Druten's *I Am a Camera* at Schlosspark Theater. Zuckmayer awarded Goethe Prize.

1953 Street demonstrations erupt in Berlin as workers protest policies of East German government; Brecht supports use of Soviet force against them. Caspar Neher, Curt Bois, and other Brecht colleagues leave East Berlin. Käthe Dorsch awarded Art Prize of the City of Berlin. Hilpert stages German-language premiere of Federico García Lorca's *Yerma* in Göttingen. Kurt Horowitz named intendant of Bavarian State Theaters. Reconstructed Kiel City Theater opens.

1954 Brecht's *Mother Courage* wins first prize at Theater of the Nations festival in Paris; East Germany awards Brecht a permanent home for Berliner Ensemble at Theater am Schiffbauerdamm, where Brecht and Engel stage Brecht's *The Caucasian Chalk Circle*. Karl von Appen is appointed Berliner Ensemble's principal designer. Kortner stages Samuel Beckett's *Waiting for Godot* with Heinz Rühmann in Munich.

1955 Brecht awarded Stalin Prize in Moscow; his production of *The Caucasian Chalk Circle* wins first prize at Theater of the Nations festival in Paris. Besson premieres Brecht's *Trumpets and Drums* for Berliner Ensemble. Gründgens becomes intendant of Hamburg Deutsches Schauspielhaus and premieres Zuckmayer's *The Cold Light* there.

1956 Dürrenmatt's *The Visit* premieres in Zurich. Mosheim plays Mary Tyrone in Berlin premiere of Eugene O'Neill's *Long Day's Journey into Night*. German premiere of James Hilton's *Good-bye, Mr. Chips* and Giraudoux's *Siegfried* in Göttingen.

1957 Engel stages premiere of Brecht's *The Life of Galileo* at Berliner Ensemble. Hilpert premieres Osborne's *The Entertainer* in Hamburg, with Gründgens in title role.

1958 Premiere of Frisch's *Biedermann and the Arsonists* in Zurich, Günter Grass's *Mister, Mister* in Cologne, and Heiner Müller's *The Scab*

in East Berlin. Peter Zadek makes German directing debut in Cologne with Jean Vauthier's *Captain Bada*.

1959 Gründgens stages premiere of Brecht's *St. Joan of the Stock-yards* in Hamburg. Grass's *Ten Minutes to Buffalo* premieres in Bochum. In Berlin, Marianne Hoppe plays Alexandra del Lago in Williams's *Sweet Bird of Youth*. Teo Otto is appointed professor of stage design at Düsseldorf Art Academy.

1960 Bruno Ganz debuts in Bremen.

1961 Premiere of Helmut Baierl's *Frau Flinz* at Berliner Ensemble. East German regime seals off West Berlin with concrete wall surrounding the city. DeKowa awarded Federal Service Cross. Dieter Dorn begins directing career in Hannover. Eberhard Esche begins career at Deutsches Theater. Frisch's *Andorra* premieres in Zurich and Grass's *The Wicked Cooks* in Berlin. Horowitz stages premiere of Dürrenmatt's *The Physicists* in Zurich. Premiere of Müller's *The Settler, or Life on the Land* results in his expulsion from the East German Writers' Union.

1962 Engel premieres Brecht's *Schweik in the Second World War* at Berliner Ensemble. Piscator becomes intendant of the Free Volksbühne in West Berlin. Schaubühne am Halleschen Ufer founded in West Berlin.

1963 Berliner Theatertreffen ("theater gathering") founded with intention to invite "the most notable productions in the German-speaking theater" to Berlin for a citywide festival in May of each year. August Everding named Munich Kammerspiele's intendant. Hansgünther Heyme becomes principal director of Hessian State Theater in Wiesbaden. Piscator premieres Rolf Hochhuth's *The Deputy* at West Berlin Free Volksbühne.

1964 Ruth Berghaus establishes career as stage combat choreographer in Berliner Ensemble production of *Coriolanus*. Dorn named full-time director at Hannover State Theater. Peter Weiss's *Marat/Sade* premieres at Berlin Schiller Theater and is subsequently invited to Berlin Theatertreffen. Barlog premieres Edward Albee's *Who's Afraid of Virginia Woolf?* at Berlin Schiller Theater.

1965 Heyme's Wiesbaden production of *Marat/Sade* invited to Theatertreffen. Piscator premieres Weiss's *The Investigation* at the Berlin

Freie Volksbühne. Otto Sander debuts in Düsseldorf, and Peter Stein begins work with Kortner in Munich.

1966 Premiere of Grass's *The Plebians Rehearse the Uprising* at Berlin Schiller Theater. Schweikart premieres Harold Pinter's *The Homecoming* at Berlin Schlosspark Theater, and Heinrich Koch premieres Albee's *Tiny Alice* at Hamburg Deutsches Schauspielhaus. Berliner Ensemble makes first appearance at Theatertreffen, with Brecht's adaptation of *Coriolanus*. Premiere of Peter Handke's *Insulting the Audience* in Graz.

1967 Stein attracts national attention with his premiere of Edward Bond's *Saved* at Munich Kammerspiele. Frankfurt am Main production of John Osborne's *Look Back in Anger* invited to Theatertreffen.

1968 Dorn begins work at Burgtheater. Peter Palitzsch premieres Tankred Dorst's *Toller* in Stuttgart, and Claus Peymann premieres Handke's *Kaspar* in Frankfurt am Main. Jürgen Flimm begins working with Kortner in Munich, and Dimiter Gottschef begins working in East Berlin. Premiere of Wolfgang Bauer's *Magic Afternoon* in Hannover. Heyme becomes director of Cologne City Theaters. Katharina Thalbach makes debut with Berliner Ensemble. Beckett's staging of his *Endgame* invited to Theatertreffen; Berliner Ensemble makes second, and last, appearance at Theatertreffen, with Brecht's *The Bread Shop*.

1969 Besson awarded directorship of Berlin Volksbühne. Grass's *Max, a Play* premieres at Berlin Schiller Theater. Klaus-Michael Grüber makes directorial debut in Bremen with *The Tempest*. Stein's production of *The Changeling* at the Zurich Schauspielhaus prompts Berlin Senate to offer him the Schaubühne am Halleschen Ufer. Peymann's production of *Kaspar* and Palitzsch's premiere of Dorst's *Toller* are invited to Theatertreffen.

1970 Stein, Peymann, and Dieter Sturm agree to reorganize Berlin's Schaubühne am Halleschen Ufer, with Botho Strauss as dramaturg and Ganz, Jutta Lampe, and Michael König as core of acting company. East German regime bans Achim Freyer's production of Goethe's *Clavigo*. Peymann premieres Handke's *The Anxiety of the Goalie at the Penalty Kick*. Müller granted position of dramaturg at Berliner Ensemble. George Tabori's *The Cannibals* premieres at Berlin Schiller Theater. Beckett's staging of his *Krapp's Last Tape* invited to Theatertreffen.

1971 Peymann premieres Handke's *The Ride across Lake Constance* at Schaubühne, in which Barbara Sukowa makes her debut. Dorn premieres Christopher Hampton's *The Misanthrope* at Munich Kammerspiele. Berghaus given directorship of Berliner Ensemble. Cornelia Froboess joins Munich Kammerspiele company, Edith Clever the Berlin Schaubühne. Peymann premieres Strauss's *The Hypochondriac* at Hamburg Deutsches Schauspielhaus.

1972 Peymann premieres Thomas Bernhard's *The Ignoramus and the Madman* at Salzburg Festival. Peter Zadek premieres Dorst's adaptation of Hans Fallada's *Little Man, What Now?* in Bochum. Thalbach joins East Berlin Volksbühne company. Zuckmayer awarded Heinrich Heine Prize.

1973 Pina Bausch founds Dance Theater of Wuppertal. Luc Bondy begins directing career in Munich, and Flimm begins his at Mannheim National Theater. Handke awarded Georg Büchner Prize. Franz Xaver Kroetz's *Barnyard* premieres at Munich Kammerspiele.

1974 Bondy's premiere of Bond's *The Sea* attracts national attention; the production is invited to Theatertreffen. Müller's *Cement* premieres in East Berlin. Peymann becomes intendant of Württembergsiches Staatstheater in Stuttgart. Stein stages Strauss's adaptation of Maxim Gorky's *Summer Folk* at Schaubühne to national acclaim. Wolfgang Engel granted directorship of Radebeul Regional Theaters in East German Saxony.

1975 Flickenschildt awarded Federal Distinguished Cross for Service to the Arts. Niels-Peter Rudolph premieres Strauss's *Familiar Faces, Mixed Feelings* in Stuttgart. Müller makes first appearance at Theatertreffen, in Frank-Patrock Steckel's Schaubühne production of *The Scab*.

1976 Baierl awarded National Prize of the GDR. Müller's *The Peasants* premieres at East Berlin Volksbühne. Grüber stages Hölderlin's *Empedocles* at Schaubühne. Dozens of East German theater artists are put on "indefinite leave" for their vocal support of banned singer Wolf Biermann.

1977 Manfred Wekwerth becomes director of Berliner Ensemble, and Dorn is named principal director at Munich Kammerspiele. Stein premieres Strauss's *Trilogy of Repeated Meetings* at Schaubühne. Thalbach leaves East Germany and joins Schiller Theater troupe in West Berlin.

1978 East German authorities ban Jürgen Gosch's production of Büchner's *Leonce und Lena* at East Berlin Volksbühne. Elfriede Jelinek awarded Roswitha of Gandersheim Memorial Medal. Stein stages *Shakespeare's Memory* at Schaubühne.

1979 Premiere of Müller's *Hamlet Machine* in Essen. Paul Dahlke awarded Federal Service Cross. Flimm becomes intendant of Cologne City Theaters. East German authorities force Gottschef to return to Bulgaria. Armin Müller-Stahl leaves East Germany and establishes a career in West Germany and United States. Peymann and Rudolph become intendants of Bochum Schauspielhaus and Hamburg Deutsches Schauspielhaus, respectively. At Schaubühne, Robert Wilson premieres his *Death, Destruction, and Detroit* and Stein premieres Strauss's *Big and Small*.

1980 Bausch gets first invitation to Theatertreffen with her staging of *Arien*. Boy Gobert becomes director of Hamburg Thalia Theater. Peymann premieres Bernhard's *On the Eve of Retirement* in Bochum. Stein stages *The Oresteian Trilogy* at Schaubühne.

1981 Berlin Senate provides Stein with new theater, the Schaubühne am Lehniner Platz, built to his specifications. Bausch's *Bandoneon* is invited to Theatertreffen. Everding is named intendant of Bavarian State Theaters in Munich.

1982 Gosch receives first invitation to Theatertreffen with staging of Gorky's *The Lower Depths*. Jossi Wieler attracts national attention with his staging of Kleist's *Amphytrion* in Bonn. Frank Baumbauer becomes principal director at Bavarian State Theater in Munich.

1983 Andrea Breth makes breakthrough as "directress of the year" with her staging of *House of Bernarda Alba* in Freiburg. Bondy premieres Strauss's *Kaldewey Farce* at Schaubühne; Wilson premieres his *The Golden Window* at Munich Kammerspiele and is invited to Theatertreffen. *Theater Heute* names Sukowa "actress of the year" for her performance of Hilde Wrangel in Zadek's *The Master Builder*.

1984 *My Fair Lady* begins a 10-year run in Munich. Reinhild Hoffmann premieres her *Callas* at Dance Theater of Bremen; the production is later invited to Theatertreffen. Wilson, in collaboration with Müller, stages his *CIVIL warS* in Cologne, which is also invited to Theatertreffen. Gosch begins work as director at Hamburg Thalia Theater.

1985 Gottschef begins work in Cologne, staging Müller's *Quartett*. Müller is awarded East Germany's National Prize, First Class but is forbidden to rejoin East German Writers' Union. Günther Rühle is named intendant of Frankfurt City Theaters. Stein departs Schaubühne and embarks on a freelance career. Russian director Yuri Liubimov stages his adaptation of Fyodor Dostoyevsky's *Crime and Punishment* at Burgtheater.

1986 Peymann assumes directorship of Vienna Burgtheater. Herbert Achternbusch premieres his *Gust* at Munich Kammerspiele, and Hoffmann premieres her *Föhn* (*Hot Wind*) at Bremen Dance Theater, which is later invited to Theatertreffen. Bausch awarded Federal Service Cross.

1987 Baumbauer named intendant of Theater Basel. Breth awarded Kortner Prize. Wilson stages *Hamlet Machine* at Hamburg Thalia Theater and is invited to Theatertreffen.

1988 Peymann's premiere of Bernhard's *Heroes' Square* at Burgtheater sparks an uproar throughout Austria. Freyer stages his adaptation of Ovid's *Metamorphoses* at Burgtheater. Tabori premieres his *Mein Kampf* at Vienna Akademie Theater.

1989 GDR collapses; hundreds of former East German theater artists seek work in West Germany. Stein stages his "text-true" production of Anton Chekhov's *The Three Sisters* at Moscow Art Theater to wide acclaim. Thalbach makes her directing debut in West Germany with *Macbeth* at Berlin Schiller Theater.

1990 Germany is officially reunited. Thalbach stages Brecht's *A Man's a Man* at Hamburg Thalia Theater to wide acclaim. Frank Castorf is named principal director at Berlin Deutsches Theater, and Heyme becomes director of Ruhr Festival. Wilson stages his adaptation of *Lear*, with Marianne Hoppe in the title role, at Frankfurt City Theater. Christian Stückl stages first revised Oberammergau Passion Play.

1991 Elmar Goerden begins directing career at Schaubühne, and Stein is named director of Salzburg Festival. *Theater Heute* names Gottschef "director of the year." Müller stages his *Hamlet Machine* at Berlin Deutsches Theater. Anna Viebrock becomes principal designer at Theater Basel.

1992 Müller becomes director of Berliner Ensemble, Breth of Schaubühne, and Thalheimer at Chemnitz City Theater. Castorf is named

intendant of Berlin Volksbühne. Berghaus stages Brecht's *In the Jungle of Cities* at Hamburg Thalia Theater and is invited to Theatertreffen. Tabori awarded Büchner Prize.

1993 Baumbauer named intendant of Hamburg Deutsches Schauspielhaus; he hires Marthaler and Wieler as principal directors and Viebrock as principal designer. Strauss awarded Berlin Theater Prize.

1994 Tabori premieres his *Requiem for a Spy* at Vienna Akademie Theater, and Wieler premieres Jelinek's *At Home in the Clouds* in Hamburg. Karin Beier makes directorial debut with award-winning production of *Romeo and Juliet* in Düsseldorf.

1995 Wolfgang Engel becomes director of Leipzig City Theater. Kroetz's *Mr. Paul* premieres at Berlin Deutsches Theater and Wilson's *The Black Rider* in Dortmund. Goerden is appointed principal director at Stuttgart State Theater. Grüber receives Kortner Prize.

1996 Lars-Ole Wallburg becomes dramaturg and Marthaler premieres his *Zero Hour* at Hamburg Deutsches Schauspielhaus. Beier stages her *Midsummer Night's Dream: A European Shakespeare* in Düsseldorf.

1997 Breth is appointed principal director at Vienna Burgtheater. Sasha Waltz stages her *Way of the Cosmonauts* at the Berlin Sophia Halls; it is later invited to Theatertreffen. Castorf's production of Zuckmayer's *The Devil's General* attracts wide attention and is also invited to Theatertreffen. Thirza Brucknen premieres Jelinek's *Stecken, Stab, und Staml* in Hamburg.

1998 Bachmann is named director of Theater Basel. Thomas Ostermeier premieres Ravenhill's *Shopping and Fucking* at Berlin Deutsches Theater, Marthaler his *Unanswered Question* at Theater Basel, and Einar Schleef, Jelinek's *A Sports Play* at Vienna Burgtheater.

1999 Premiere of Strauss's *The Kiss of Forgetfulness* at Zurich Schauspielhaus. Bausch is awarded European Theater Prize. Berliner Ensemble company dissolves; Theater am Schiffbauerdamm retains name and Peymann assumes directorship. Grass is awarded Nobel Prize for literature. Ostermeier becomes director of Berliner Schaubühne and names Mayenburg his dramaturg. *Theater Heute* awards Marius von Mayenburg its "best young playwright" citation after premiere of his *Fireface* in Munich.

2000 Clever tours her one-woman show featuring Goethe's female characters. Grüber awarded Konrad Wolf Prize. Luk Perceval stages his collection of battle scenes from Shakespeare's history plays (titled *SCHLACHTEN!*) at Hamburg Deutsches Schauspielhaus and is invited to Theatertreffen. Peymann premieres Kroetz's *End of the Coupling* at new Berliner Ensemble; Mayenburg's *Parasites* premieres at Hamburg Deutsches Schauspielhaus. Wieler named director of Hannover State Theater.

2001 Baumbauer named intendant of Munich Kammerspiele. Castorf stages his adaptation of Williams's *Streetcar Named Desire* as *Destination: America* at Berlin Volksbühne. Goerden is appointed principal director at Bavarian State Theater in Munich. Thalheimer becomes first director to have productions staged in two different theaters invited to Theatertreffen. Viebrock is appointed principal designer at Zurich Schauspielhaus. Martin Kušej's staging of Karl Schönherr's *Faith and Homeland* attracts international attention and invitation to Theatertreffen.

2002 Thalheimer receives both the Nestroy Prize and the Friedrich Luft Prize. Michael Maertens awarded Gertrud Eysoldt Ring. Flimm appointed head of Salzburg Festival. Stückl becomes intendant of Munich Volkstheater.

2003 Bausch awarded knighthood in French Legion of Honor. Breth awarded Nestroy Prize. Wallburg becomes principal director at Theater Basel.

2004 Jelinek awarded Nobel Prize for literature; his *The Work* premieres at Vienna Akademie Theater under Michael Steman. Theatertreffen is dominated by coproductions of conceptual pieces originating in opera houses, film studios, and dance theaters and among "free groups" such as the Rimini Protocol and Styrian Autumn.

2005 Bernd Wilms reappointed intendant of Deutsches Theater in wake of Berlin municipal bankruptcy. Flimm is appointed director of Ruhr Triennale and Goerden intendant of Bochum Schauspielhaus. Dozens of new Schiller productions mounted throughout German-speaking theater in honor of the 200th "Schiller Year."

Reader's Note

The dictionary section that comprises the heart of this volume contains many entries for people, places, groups, plays, and other important topics relating to the German theater. In the entries for individuals, the name—listed surname first—is followed by the individual's dates and the principal occupation(s) of the individual in the exercise of his or her profession in the German theater. For example:

WOTRUBA, FRITZ (1907–1975). Designer.

If the individual used a pseudonym, the original name will follow in parentheses, as in:

DUMONT, LOUISE (Louise Maria Hubertine Heynen, 1862–1932). Actress, teacher.

Entries for plays appear in bold italics, alphabetized by the first substantive word. The German title is followed if necessary by the English translation in parentheses, the name of the playwright, and usually the year in which the play premiered. If the title's translation into English is well known, it too will appear in bold italics as part of the entry header. For example:

BIBERPELZ, DER (THE BEAVER COAT) by **Gerhart Hauptmann**. Premiered 1893.

If the translation is not well known, it will not appear in bold; for example:

DEUTSCHEN KLEINSTÄDTER, DIE (*The Small-Town Germans*) by **August von Kotzebue**. Premiered 1802.

If the play title in German is the same or nearly the same as in English, it appears without parentheses; examples include *Agnes Bernauer* and *David und Goliath*.

Names, play titles, theaters, cities, and other topics that have their own entries in the dictionary are cross-referenced when they appear in another entry. The item will appear in bold print on its initial mention. This approach allows readers to find additional related information in the entries for items that have associations with one another. For example, the name **Ernst Deutsch** appears in bold within the **EXPRESSIONISM** entry, because Deutsch, an outstanding exemplar of Expressionist acting, has his own entry.

This dictionary attempts to avoid abbreviations, insofar as that is feasible. Some abbreviations, however, are unavoidable, such as the GDR for the former German Democratic Republic (East Germany) and SS for the Nazi Schutzstaffel (Hitler's personal guard force).

Translations of most German phrases, titles, and usages, especially those unfamiliar to most English-speaking readers, follow parenthetically the phrase in question, for example, *königliche preussische allergnädigste generalpriviligierte National-Schauspieler* (Royal Prussian and All-Graciously Granted Holders of the National Concession for Acting). More familiar usages or terms, such as *Komödie* (comedy) or *Schauspielhaus* (theater), are usually left to stand alone.

Introduction

The German-language theater is one of the most vibrant anywhere in the world. It boasts long and honored traditions that include world-renowned plays, playwrights, actors, directors, and designers, and several German theater artists have had an enormous impact on theater practice around the globe. Students continue to study German plays in dozens of languages, and every year scores of German plays are produced in a wide variety of non-German venues. In German-speaking Europe itself, more than 400 professional theaters continue to attract literally millions of audience members each year.

The German-language audience is certainly among the most remarkable components of the German theater, for it has a legacy of supporting and maintaining traditions that became firmly established more than 250 years ago. Thus the German theater is a relative newcomer to European stage, and influences from English and French traditions are particularly copious, though the impact of Danish and Italian practices were also present. From these and other influences have developed a uniquely German set of characteristics, chief among them the idea of theater as a "moral institution." But "German theater" also means an extraordinarily broad set of other criteria; they include a wide range of acting styles down through the years. Most non-German speaking audiences are familiar (usually through film) with the acting of Peter Lorre, Elisabeth Bergner, Gert Fröbe, or perhaps Armin Müller-Stahl. But who knew that the first actor ever to win the Best Actor Award from the American Academy of Motion Picture Arts and Sciences was the German actor Emil Jannings?

In a similar way, many non-German-speaking students of theater have heard of, and may even be familiar with, Johann Wolfgang Goethe or Bertolt Brecht. Few, however, realize that August Kotzebue was among the most frequently performed playwrights throughout the United States

from 1800 to 1840. Goethe is much better known, and probably for good reason: his *Faust* is an acknowledged masterpiece of Western Civilization. Scholars and critics have consistently ranked Goethe with other great national poets like Dante, Calderon, Molière, and even Shakespeare. Brecht was also a writer of national significance, but his global influence is most clearly in evidence in the actual practice of theater. Brecht's numerous treatises on and advocacy of modernism in the theater—along with his plays that incorporated the political causes he championed—made him one of the 20th century's most identifiable voices demanding accommodation to and acceptance of new patterns of perception. Few productions anywhere during the latter half of the 20th century could avoid being "Brechtian," since the acceptance and implementation of Brecht's methods and ideas were nearly universal.

ORIGINS THROUGH THE 17TH CENTURY

German theater practice was not always well known, of course, although evidence of theatrical performance in Germanic idioms by the 14th century is abundant. There are even reliable reports of performances with a theatrical nature among the pre-Christian Germanic tribes. Pagan worship usually included dance and song, while minstrels, troubadours, and bards entertained tribal gatherings of various magnitudes. Julius Caesar listed at least 11 of the Germanic tribes he encountered in the Gallic Wars, and Tacitus in his *Germania* described eight others. Such peoples, whose numbers far exceeded those in extant Roman accounts, ranged from the Baltic coast and the Jutland Peninsula to the Alps, from the Rhine in the west to the Vistula in the east.

Caesar defeated a large band of Germanic Suevians in 70 B.C., and the Roman Empire continued its efforts to expand into German territory until A.D. 9, when Hermann (known in Latin as Arminius) defeated a Roman army in the Battle of the Teutoberg Forest. Roman influence on the Germanic tribes was by that time already substantial, though Christianity became the most significant of its influences. The work of a cloistered nun named Hroswitha in 970–980 bears witness to those influences. Hroswitha wrote six plays in Latin, based on the precedents of Terence but interlarded with Christian history. By the early 13th century, religious plays began to appear in Middle High German, the earli-

est of which was *The Easter Play of Mary*; in the meantime, German towns were the sites of an increasing numbers of guild cycles, likewise performed in Middle High German.

The first performances in Early New High German took place at the beginning of the 14th century; they were *Vasnachtspile*, or Shrovetide (Carnival season) plays, staged in or around Lübeck, Hessia near the Rhine, Sterzing in the Tyrol (present-day Italy), Swabia, and Eger (in the present-day Czech Republic). In Nuremberg, artisans and their apprentices began to perform Shrovetide plays in the 15th century, and the first author of them by name appeared mid-century. He was Hans Schnepper (c. 1400–c. 1470), an apprentice who took the name Hans Rosenplüt. Hans Folz (c. 1450–c. 1515) also authored some of the plays, though Hans Sachs is the best known of the Nuremberg authors. Actors in Sachs's tragedies, comedies, and Shrovetide plays probably came from the ranks of the Meistersingers, but the two groups (the actors and the singers) had little formal connection. The plays took place in a variety of locales, most often in the nave of St. Martha's Church, the refectory of a cloister, banquet halls, or outdoor locations. Little is really known about the stage arrangements. Some have called them "transformation" stage, allowing for the change of scenes called for in the plays. Others have contended that only platform stages were in use, in which actors appeared and then exited as others came on. There is no evidence of a house curtain.

There has been significant scholarly conjecture about the growth German theater might have achieved were it not for the Thirty Years' War from 1618 to 1648. After the success of the English Comedians and their influence on the formation of autochthonous German troupes by 1604, there is reason to believe that the work of Sachs and others could have provided a complementary development that might have resulted in the establishment of resident troupes in the early 17th century. By 1618, however, armies were already on the march through German territories; the fighting continued on a horrific scale for the next three decades, resulting in the utter destruction of most German roads and bridges and several German cities. By the time of the 1648 Peace of Westphalia, the German population was half what it had been in 1618. More than 200 independent German principalities vied with each other for what was left; the strongest to emerge were Austria, Brandenburg, Bavaria, and Saxony. Only by the mid-1650s were all non-German

troops withdrawn. Under such conditions, theater troupes were barely able to mount plays anywhere, much less find regular paying audiences.

Carl Andreas Paulsen (?–1685) was among the first theater managers to emerge in the cataclysmic wreckage left in the wake of the Thirty Years' War; he staged plays adapted from the English Comedians but also from Molière. Johannes Velten became his son-in-law and soon began running the troupe. In 1678 Velten and his wife (Paulsen's daughter Catharina Elisabeth) left the troupe to reside at the Saxon Court in Dresden, then took his own troupe on various successful tours to Copenhagen, Sweden, Riga, and central Germany. They played in courts and in cities where traders were gradually beginning to convene and restore business connections, write contracts, and form partnerships. When Velten died in 1697, his widow continued touring. The *Wandertruppe*, or touring troupe, had by 1700 become the standard German ensemble, despite the remaining economic and logistical obstacles all had to confront. Among the many arduous tasks of a *Prinzipal* (the troupe's entrepreneurial manager and usually its leading actor) in those days was to seek and receive a *Privileg*, or license, to perform in a court or city. The troupe then needed to remain in such a venue long enough to accumulate operating capital with which it could obtain a license for the next engagement. It is no exaggeration to say the troupes lived from engagement to engagement, and in some cases from hand to mouth.

Most troupes traveled with a dozen performers; they included women, following the example of the French, Italians, and Dutch since the middle of the 17th century. Velten always cast women in female parts, and his widow continued the tradition. Women in trouser roles were especially praised, however, according to diaries and annals kept by observers who saw them. Some diary accounts described the lamentable quality most troupes possessed; costumes were ragged and often filthy, settings consisted of a backdrop or two, "the boards" of the stage floor wobbled, the audience rarely stopped talking long enough to listen attentively to the actors, and the entire enterprise was frequently forlorn beyond redemption. Actresses in many instances were little more than prostitutes; during performances, actors sold medicine, pulled teeth, and did juggling acts for coins that audiences might have handy on market day. Goethe's novel *Wilhelm Meisters Lehrjahre* (*Wilhelm Meister's Apprenticeship*, 1795) is a romanticized depiction of the German actor's brutal existence during this period.

THE 18TH CENTURY

Friederike Caroline Weisenborn Neuber was determined to improve the actor's lot when she became *Prinzipalin* of a troupe she and her husband Johann Neuber managed in the late 1720s. Johann Christoph Gottsched, a Leipzig professor who was especially fond of actresses in trouser roles, particularly liked Neuber in trousers. What aroused his professional interest, however, was her reformist convictions. He saw her troupe initially at a Leipzig fair in 1727, and in her work he realized the possibility of someone who might share his advocacy for a French paradigm he sought to implement. French dramaturgical practice offered Gottsched what he considered the best model for a "national" theater among the Germans, one which he and others found deserving of public subsidy. Gottsched, however, wanted a national drama for a nation that did not politically exist. With Neuber, he shared a desire to raise the social status of German actors, and the two appealed for laws to protect them. The call for a national theater as a permanent, state-subsidized institution with high professional standards was first proposed by Christian Furchtegott Gellert (1715–1769); prior to Gellert, Gottsched promoted reform through a cleansing of the German theater's repertoire. With Neuber, he sought ways to impress upon a burgeoning mercantile public in Leipzig, Hamburg, Frankfurt am Main, and other commercial centers that theater was no longer a vulgar, unruly, amoral, and impudent exercise. It was to be a moral force within the community, where audiences recognized themselves onstage and took to heart the examples they saw before them.

The ceremonial banning in 1737 of the Teutonic Harlequin "Hanswurst" was among the numerous Gottsched-Neuber endeavors toward wholesale reform. Hanswurst had been a stock comic type in many German troupes since the 16th century; his often vulgar commentary between scenes—and often within them—was to Gottsched an abomination. So were the many *Haupt- und Staatsaktion* ("main and state action") plays in the repertoires of many troupes. Such plays involved a case of court intrigue, but in language that was as uncultivated as it was ludicrous.

The collaboration between Gottsched and Neuber did not last long, but it did attract the attention of other troupes; Gottsched had challenged troupes to do plays in costumes with greater authenticity, playing the title

role in his *The Dying Cato* in what was then considered "ancient Roman" courtly apparel. Many troupes sought partially to adopt the Gottsched-Neuber reforms, and the result was a gradual improvement in the quality of both repertoire and personnel among troupes. Neuber insisted that all performers be literate; she also forbade liaisons between actresses and local admirers. The result was a wider acceptance of theater among the emergent middle class in Germany, whose financial backing became a necessary component of a growing trend toward the realization of a truly "national" German theater culture. Theaters were fitted up in middle-class ballrooms in Altenburg in 1727, in Klagenfurth and Vienna in 1741, and in Wolfenbüttel, Kiel, Salzburg, and Erfurt in 1764. Being able to play in an adequate space such as a ballroom was a distinct advantage, since many troupes in the early 18th century still had to make do with any space they could find, which often included outdoor gardens, the ruins of ancient structures, coffeehouses, meeting halls, and stock- or grain-exchange floors.

Among other significant results of the Gottsched-Neuber collaboration was the enlistment of several influential thinkers and writers in the cause of reform. Christlob Mylius (1722–1754) called for public subsidies for theater, Johann Elias Schlegel (1719–1749) championed the theater's role as a beneficial force in German society, and Johann Friedrich Löwen (1729–1771) defended the theater's moral value while demanding the actor's full social standing. The most significant, and by far the most gifted of them all was Gotthold Ephraim Lessing, who ironically differed with Gottsched on several important points. Most important among his differences was the rejection of anything paradigmatically French; while he concurred with Gottsched on the importance of something "national" in the German theater, Lessing perceived an inherent affinity among the Germans for the English, particularly Shakespeare.

Lessing did not deny the moral improvement theater could achieve, but he saw moral improvement effected through the Aristotelian propensity of empathic response to characters. In Lessing's view, the German spectators' attempt to understand Shakespeare's characters was the first step toward understanding their own surroundings, thereby widening a knowledge of the world outside themselves. Lessing also felt that the English "domestic tragedy" was a superb teaching device, one he implemented directly in such plays as *Miss Sara Sampson* and *Emilia Galotti*.

These plays were enormously popular among German audiences, thereby vindicating Lessing's ideas; his plays also served to promote the status of German acting troupes, with whom Lessing had collaborated and for whom he often wrote. His closest association was with the troupe of Konrad Ernst Ackermann, who strongly influenced his thinking in essays published under the title *Hamburg Dramaturgy*. Lessing's essays proved to be as influential as his plays. Among those most influenced was Johann Wolfgang Goethe, in whose first play *Götz von Berlichingen* the result of Shakespeare advocacy is readily apparent.

Goethe became the German theater's first personality of global significance. Many argue that he remains the German theater's most auspicious figure. His leadership of the *Sturm und Drang* (Storm and Stress) movement among young playwrights in the 1770s was a major impetus toward the German theater's rise to significance. After Goethe, German theater joined the front ranks of European cultural consciousness, alongside and equal to the French and English.

In 1775 Goethe was invited to become an official at the Weimar court. There Goethe directed plays and became director of a professional troupe established in 1791. He remained the theater's director for nearly three decades, staging scores of productions. Most critics and scholars agree that Goethe's most significant effort in Weimar was his collaboration with Friedrich Schiller, even though the premieres he presented of Schiller's plays from 1799 to 1804 were of comparatively poor quality. The close relationship between Goethe and Schiller, however, established the Weimar Court Theater as the country's most celebrated—and its most often imitated. Court theaters vied with each other to replicate the "Weimar ideal," which included the firm conviction that aristocratic governments had cultural obligations toward all their people.

Schiller's influence, like Goethe's, was wide-ranging and enormously consequential for German theater as a whole. Schiller had (unlike Goethe) never been a director. His influence derived not from his playwriting but, like Lessing, from his theoretical musings. He adumbrated the role of German theater as a "moral institution," echoing in some ways the advocacy of Gottsched. But the moral institution Schiller had in mind differed in many respects from Gottsched's, because it was conditioned by *The Critique of Judgement* of philosopher Immanuel Kant (1724–1804). Like Kant, Schiller believed in an inherent moral sense that guided men in their daily affairs; drama at its best

cultivated that inherent sense and provided the human mind with a focus on moral sensibility. Theater was, among all art forms, the only one capable of accomplishing that task, according to Schiller. It was this moral institution he described, requiring state support. The work of Goethe and Schiller together complemented in many ways the work Gottsched and Lessing had done separately: both Goethe and Schiller had been elevated to the aristocracy; the Weimar Court Theater had achieved European renown; and middle-class theaters wanted to emulate its standards and duplicate its attempts to improve the lives of its audience members.

Courts had invited troupes into their midst since Velten had arrived in Dresden. The Neuber troupe had spawned several others of distinction, led by Ackermann, Johann Friedrich Schönemann, Abel Seyeler, Heinrich Gottfried Koch, Carl Theophil Döbbelin, and Konrad Ekhof. Distinguished and well-accomplished though these troupes may have been, their principal purpose at courts (where many were installed on a more or less residential basis) was ceremonial. The efforts of middle-class venues, on the other hand, had been of necessity directed toward compensability.

The early troupes suffered for decades, but they ended up raising the German theater to a much higher level of quality and status, especially when associated with outstanding playwrights. That was most obviously true in the case of Ackermann at his private theater in Königsberg, but also of his stepson Friedrich Ludwig Schröder at the private Hamburg Komödienhaus. As Ackermann had premiered Lessing, Schröder premiered several Storm and Stress playwrights. Actor-managers began to persuade courtiers and even rulers themselves that a professional troupe was advantageous to a court's reputation, particularly if new plays were in the repertoire. Some rulers built playhouses for their "resident" troupes, or theater troupes were absorbed into existing court opera or ballet companies. Such was the case in Gotha, which invited Ekhof and his troupe into residence to become the first permanent residential professional theater. By the end of the 18th century, most touring troupes with lineage tracing back to Neuber, Ackermann, Koch, or Abel Seyler had established permanent residence somewhere, either at an aristocratic court or in a major urban center. Döbbelin, for example, moved up in status by 1786 when he was granted sole use of the Französiches Komödienhaus (French Theater) in Berlin and his troupe

was designated the *königliche preussische allergnädigste generalpriviligierte National-Schauspieler* (Royal Prussian and All-Graciously Granted Holders of the National Concession for Acting). August Wilhelm Iffland (who had begun with Ekhof in Gotha) took over that court residence a decade later, creating Schiller productions far more elaborate than the ones Goethe had staged in Weimar, while premiering his own works with a comparable attention to detail and extravagance.

THE 19TH CENTURY TO 1871

By 1800 the Germans could boast a theater culture unimaginable a century earlier. Not only were troupes in residence at courts throughout the country, but important new plays were premiered on a regular basis. Actors developed national and international reputations. Substantial new theater structures arose wherever German was spoken. Many observers agreed that the German theater was achieving a kind of national unity, the very goal Gottsched had articulated. It all came to a crashing halt, however, with the Napoleonic wars of conquest against both Austria and later the northern German states. Napoleon's 1806 victory at the Battle of Jena (only a dozen miles from Weimar) forced Prussia, the strongest of the North German states, to cede half its territory to Napoleon. The emperor then used that territory to create the Kingdom of Westphalia as a buffer state; he also compelled Prussia to reduce the size of its army by half and to allow French forces to occupy Berlin. They removed Iffland from the Royal Theater and installed the *Société dramatique et lyrique Allemande* in his place.

French occupation lasted only three years, but the experience traumatized the Prussians enough to enact reforms intended to "modernize," or at least "de-feudalize" the way theater was henceforth to operate. Other German states, in the wake of French retreats after 1812, followed Prussian initiatives, but Napoleon's final defeat at Waterloo in 1815 and ultimately the Carlsbad Decrees of 1819 (ironically instigated in response to the murder of Kotzebue the same year) had a more pronounced effect on German theater practice than any single event of the previous century; indeed, many of the effects of the Carlsbad Decrees did not disappear until the defeat of Germany and Austria in 1918, ending World War I.

By 1819 German rulers realized that theater was not merely a source of edification or amusement. It had the dangerous potential to become a tool in the hands of revolutionaries. It had become an opinion-forming institution, and thus, like publishing, it required government oversight and police supervision. New laws stipulated that "theater operators" required special permission of the highest police authorities in all locales where such operators wished to attract a public. Other laws gave the authorities power to determine restrictions on genre, length of run, and admission prices. Behind the passage of all such regulations lay legal precedents from various German-language jurisdictions; the Hapsburgs in Vienna, the Wittelsbachs in Munich, and the various elector princes of the now defunct Holy Roman Empire had long made pronouncements about guaranteeing the validity of theater by keeping vulgarity at a genteel remove from the public stage. The effect of the Carlsbad Decrees, however, was to cast a pallor of heavy censorship over the German theater for decades.

The results, nevertheless, were surprisingly positive. In 1815 Prussian royal chancellor Karl August von Hardenburg told Count Carl Brühl to "create the best theater in Germany and afterwards tell me what it costs."[1] Aristocrats in Dresden, Munich, Vienna, Stuttgart, and Hannover said much the same. Several outstanding actors emerged during the 19th century, often in roles written by Schiller, Goethe, and Shakespeare. Shakespeare in particular became a remarkable foundation for the German theater's vitality, due largely to the translations of Schlegel and Ludwig Tieck. Their efforts toward creating a stageworthy idiom for actors made Shakespeare more than just the ideal model to be emulated as Lessing had insisted—in the 19th century, Shakespeare became a German playwright. William Shakespeare posed little threat to political authorities, many of whom wanted theater to "preserve tranquility by excluding whatsoever may excite doubt, discontent, discussion, or comparison."[2] Some historians have quoted Prussian leaders as advocating theater as a "sugar-coated pill which the people may swallow as their mouths open in laughter at what they witness on the stage."[3] Shakespeare seemed harmless to men like Schwerin; so did plays by Kotzebue, whose plots and characters pleased and politically anaesthetized audiences. Charlotte Birch-Pfeiffer's adaptations of English novels, along with her numerous original plays, also found wide favor among audiences and acceptance among censors.

Censorship and police regulation hindered neither audience growth nor further development of theater construction. The Königstädtisches Theater am Alexanderplatz in Berlin opened for business in 1824 as a venue dedicated almost exclusively to popular entertainment. Similar enterprises opened in Vienna and other cities, many of them in imitation of houses on the Boulevard du Temple in Paris. In Berlin, Joseph Kroll (1798–1848) built his "Kroll'sche Etablissement" initially as a beer garden; he soon began to offer entertainments featuring "couplets," operetta-like musical numbers with recognizable Berlin types as characters. Prussian king Friedrich Wilhelm IV was a frequent Kroll patron, and the public's interest in the Kroll product increased accordingly.

In 1845 the Prussian House of Deputies passed amendments to laws based on the Carlsbad Decrees, easing restrictions on producers like Kroll and others if they met specific legal criteria and declared all income from their efforts taxable; the law demonstrated theater's growing importance as a source of revenue for governments. The 1845 law also dispensed with requirements for stating a specific time and location of performances, while also easing somewhat the traditional restrictions on genre. Playwrights were now permitted to inject into vaudeville sketches portions of dialogue, while producers were permitted to produce many different kinds of contemporary comedies. Similar laws went into effect throughout the German Confederation. The first Berlin theater to open after the passage of the 1845 law was the Schwarzer Adler (Black Eagle) in Schöneberg, where comedian and playwright David Kalisch made his debut. Soon thereafter a second theater opened in Schöneberg: Callenbach's Theater, featuring comedian and singer Karl Helmerding. Both the Schwarzer Adler and Callenbach's prospered until the spring of 1848, when revolutionary unrest prompted Prussian authorities to close them.

The revolutionary fervor sweeping through Berlin and Vienna in March 1848 led initially to a generous loosening of censorship. In Berlin there were even promises of constitutions, legally elected parliaments, universal male suffrage, and press freedom. Those promises went largely unfulfilled, however, since any attempt to loosen censorship or encourage individual rights was anathema to Prussian and Austrian ruling elites. There were also attempts to create a German republic based on democratic principles at the Frankfurt National Assembly in 1848–1849, but Austro-Prussian rivalries led to more unfulfilled promises and the dissolution of the assembly itself.

Theater returned to its accustomed practices, and in 1851 a system of even tighter censorship enforcement went into effect. The man responsible for the changes in Berlin was Carl von Hinckeldey, the chief of police. Hinckeldey's system of spies, identity checks, press seizures, and deportations became notorious in the 1850s. Theatrical entrepreneurs were undaunted, however; they continued to open new establishments and accommodate themselves to police supervision. Some of them ultimately became Berlin's most significant venues. Deichmann's "Kasino in der Schumann Strasse" became the Deutsches Theater, where the official German premieres of Jacques Offenbach operettas regularly took place. Wallner's theater in Blumenstrasse consistently premiered dozens of plays by Roderich Benedix, Louis Angely, and Ernst Raupach.

Meanwhile in Vienna, Carl Carl leased and owned several theaters, premiering most of Johann Nepomuk Nestroy's plays. The Burgtheater in Vienna from 1849 to 1867 under Heinrich Laube (a former revolutionary who had done prison time) maintained what had become the best acting ensemble anywhere in the German-speaking theater. The Prussian Royal Theater in Berlin (the Burg's closest competitor for status) had a more entrepreneurial orientation, featuring far more boulevard comedies than did the Burg. Though productions of Schiller, Shakespeare, and Lessing outnumbered all others, the plays of Raupach, Benedix, and Emil Brachvogel were not far behind.

Among the most significant figures in the theater culture of Vienna was Nestroy, an opera singer who began acting in 1827 and by 1831 was a star performer at the Leopoldstadt Theater. There he began writing plays that, on the surface, seemed frivolous and jocund. They employed predictable plot structures, and their conventions were nearly transparent. But Nestroy's characters were unique by virtue of the dialogue he wrote for them. Nestroy used language more effectively than did his predecessors, employing shadings of dialect to rank social, economic, and cultural class; his plays featured a wide spectrum of Viennese inhabitants, all of whom spoke in the patois of their social and economic circumstances. Nestroy used language to heighten social and political irony; he would portray a pair of lovers, for example, who at the moment of high emotional ardor burst into rapturous bureaucratic jargon.

In 1869 the Prussian House of Deputies passed a law that transformed theater practice in Berlin and all other Prussian cities; when the newly unified German Reich came into being two years later, the 1869

law became the legal order of business for all theaters. The new law removed all genre restrictions and fostered unlimited free-market competition among theater managers. As a result, speculative preoccupation quickly took over. In the first year after the new law's passage, 90 new theaters were built, and in the following decade 173 more theater structures arose within the new Reich. Of those new theaters, only 78 went to individuals of a professional theater background. The others, in the picturesque phrase of one observer, were run by "fishmongers, shoemakers, upholsterers, and locksmiths."[4] Qualified or not, such new managers served new audiences, with the result that "theater" came to mean "a whole host of entertainment possibilities, from the opera to the race track to vaudeville to the bordello and everything in between. It was a kind of . . . emporium, in which you could get almost any kind of diversion if you had money to pay for it."[5] New audiences included men whose principal motivation for attendance was to find and keep an actress, ballerina, or operetta diva as a mistress. Such men now jostled for tickets alongside university students, families of professors, and civil servants, citizens striving after education and artistic edification. "That was formerly the basic audience for theater [in Berlin]. That audience had been shoved aside."

THE WILHELMINE PERIOD (1871–1918)

Theater as a business in the Wilhelmine period triumphed over Schiller's concept of theater as a moral institution. Managers sought to cast their entertainment nets wide, hoping to land the biggest possible audiences possessing the most disposable income. Most managers were themselves bourgeois in taste and aesthetic persuasion. Their preferences often reflected the patrons whom they sought to attract at the box office; managers likewise knew that the middle class of Wilhelmine society by 1871 (when the Reich came into existence) formed the largest contingent of ticket buyers. Managers throughout Germany—which at that time consisted of Alsace and Lorraine to the west, the vast Silesian and Prussian territories to the east, and in between what constitutes present-day Germany—were dependent upon middle-class commerce for their professional survival. That was true whether they managed a modest touring troupe in the hinterlands of Pomerania, a city theater

like the one in Bremen, or the exquisite archducal court theater in Darmstadt.

There were four major kinds of theater operations in the Wilhelmine Reich, with administrative and financial variations on each. Sometimes a court theater (*Hoftheater*) functioned exactly the way a city theater (*Stadttheater*) did; sometimes a city theater closely resembled a commercial theater (*Privattheater*); and sometimes court theaters were private enterprises in everything but name. In most cases, however, managers who ran court theaters served at the pleasure of the noble family who owned the property; managers, such as Count Botho von Hülsen at the Prussian Royal Court Theater in Berlin or his successor Count Bolko von Hochberg, might themselves be aristocrats. Other aristocrats were like Baroness Ida von Zedlitz, who leased her Residenz Theater in Berlin to the thoroughly bourgeois Sigmund Lautenberg and shared box-office income with him.

Most lessors of municipal theaters were like Richard Jeffe in Chemnitz; city officials found his offer to them the most attractive of several they had received, and they entered into a leasing agreement with Jeffe that ran, as most others did, for five years. City governments, and in some cases regional or even "royal" governments (the Wilhelmine Reich incorporated four separate kingdoms into its domain), leased their facilities to such entrepreneurs. Entrepreneurship was especially prevalent when a theater was located on the grounds of a spa. Spa theaters usually fell to the oversight of a consortium of individuals with medical backgrounds. They in turn leased the facility to a manager, normally during the summer months. City theaters were often not city theaters at all but actually privately owned and operated facilities whose owner had simply adopted the name "city theater" hoping to gain additional publicity.

Theater could turn handsome profits, as it did for a most remarkable group of managers. They owned the theaters they managed, where they often directed plays they themselves had written. Maximilian Harden was one critic who lamented profitability among theater managers, especially in Berlin. To him and many other vocal critics, Wilhelmine theater seemed almost unreformable. "No bourgeois audience," said critic Siegfried Jacobsohn, "can have a theater because it is first of all bourgeois and an audience thereafter."[6] Berlin's theaters usually bowed at the feet of the social strata who comprised their clientele; as a result,

theater had become "show business" in a constant search for hit plays. They staged farces, intrigues, parodies, cavalcades, variety shows, and a host of flimsy constructions that were comedic in their depictions of manners, situations, and characters. The performance run any show achieved was important to theater operators. Ads and posters always stated, "For the 100th [or 200th or 300th] performance . . ." Such numbers served managers, agents, and playwrights because high performance counts attracted bookings in provincial theaters, and provincial theaters paid royalties under newly enacted copyright laws.

Berlin's status as the high citadel of commercial theater made the Court Theater of Meiningen an attractive alternative to many Berlin critics. "The Meininger," as the company came to be known, seemed a throwback to the days when theater was an art form first and foremost. Yet the Meininger were by no means immune to the lure of Berlin and its commercial possibilities. They used lengthy Berlin residences to pay for the substantial production expenses required of their beautifully realized stagings. Otto Brahm's Freie Bühne was founded to subvert police censorship, but Brahm also devoted himself to bridging the enormous chasm between the predominantly commercial theaters and his own ideas of what commercial theater could accomplish. He was in some ways the conscience of the Wilhelmine theater. Brahm viewed the German economy's exponential expansion and the materialism that accompanied it (financed initially with billions in gold from the French in reparations payments after the Franco-Prussian War) with increasing alarm, but he also realized that the wealth it generated afforded the possibility of a commercial theater as a moral institution. His premieres of plays by Gerhart Hauptmann and Arthur Schnitzler were antidotes, he hoped, against Gustav von Moser, Oskar Blumenthal, Franz von Schönthan, and Hermann Sudermann.

Brahm's successor (and subsequently his chief competitor) Max Reinhardt was likewise in the business of offering alternatives to mainstream theatrical fare. Like Brahm, Reinhardt regularly battled police censors, but unlike Brahm, Reinhardt sought to build an audience uninterested in social or political problems. Reinhardt's audiences, said actress Tilla Durieux, did not come to solve riddles. They came instead to see stars in nicely designed costumes on nicely decorated stages; Reinhardt gave them plenty of both.[7] Reinhardt's was a modernist sensibility, while Brahm's remained in the certainties of the Wilhelmine age.

Reinhardt's premieres of Frank Wedekind and Carl Sternheim, his stunning new interpretations of Shakespeare, and, most significantly, his casting marked him as a man of the 20th century. Several new theaters were founded in imitation of Reinhardt, including the Neues Theater in Frankfurt am Main, the Kammerspiele in Munich, the Schauspielhaus in Düsseldorf, the Albert Theater in Dresden, and the Altes Theater in Leipzig. All of these were private undertakings, dependent solely on box office traffic to support their work. They took the lead in premiering many of the Expressionist plays and were later condemned for unleashing, in the last decade of the Second Reich, a volley of mortal blows against Wilhelmine culture.

THE WEIMAR PERIOD, 1919–1933

Not only did Kaiser Wilhelm II abdicate but all other hereditary rulers also lost their positions of titular leadership when the Weimar Republic came into being in 1918. The republic took its name from the city of Weimar because delegates met in the theater there to write the new republic's constitution. Among the many consequences of transforming an empire to a republic was the conversion of court theaters into state theaters. By 1920, the newly formed Reichstag had ended theater censorship, terminated the policy of leasing theaters to the highest bidder, and essentially socialized theater in the idealistic hope that all German theaters would present dramatic fare of uplift and education. Yet the national government had placed the onus of such expenditures on local governments, and nearly all local governments were virtually bankrupt. In order to finance their operations, many provincial theaters turned to Expressionist plays that had been censored or suppressed before or during the war. Herbert Ihering observed that the war's end allowed plays and productions to "come sizzling out like a cloud of steam when the valve was opened."[8] Fritz Kortner's acting was allowed, in the actor's own words, simply to "burst forth lava-like from inner volcanoes."[9]

The most explosive figure in German theater immediately after the Wilhelmine collapse was Leopold Jessner, who took over the newly rechristened Berlin State Theater and made it a showcase for classics, with arbitrary tempos, abstract sets and lighting, discordant speech, and an utter disregard for the "traditional." Jessner employed many of the

Expressionist techniques Reinhardt had developed, and the results were highly controversial productions of *Richard III*, *Macbeth*, *The Robbers*, and other bellwethers of the German stage. Other theaters attempted to do likewise, hoping that curiosity, if nothing else, would attract an audience, but few theaters had Jessner's resources at hand, and most quickly returned to Wilhelmine-style practices and repertoire. A notable exception was the Frankfurt am Main City Theater, where both Gustav Hartung and Richard Weichert attempted to emulate Jessner. Weichert's discovery of Bertolt Brecht led Ihering to award the 1922 Kleist Prize to Brecht, but only upon the commercial success of *The Threepenny Opera* in 1928 was Brecht's reputation established. Erwin Piscator likewise attempted to emulate Jessner (in Königsberg, where Jessner had begun his career), but failed. Carl Zuckmayer attempted to write in the Expressionist style, and Jessner premiered his *Crossroads* in 1920 at the State Theater, but it flopped miserably. More failure awaited Zuckmayer in Kiel, where he got a job as a dramaturg; he was fired after six months on the job, when his version of *The Eunuch* by Terence created a scandal.

By 1924 most theaters were doing sex farces, contemporary comedies of manners, detective mysteries, and pseudo-historical dramas merely to survive. Commercial trivialities in many cases became the German theater's lifeblood. When Zuckmayer's folksy comedy *The Merry Vineyard* premiered in 1925, Ihering said, "Expressionism was blown off the stage in a gale of laughter."[10] Critic Alfred Kerr, who rarely agreed with fellow critic Ihering about anything, echoed the same sentiments: "*Sic transit gloria expressionismi.*"[11]

The German theater had entered a period that came to called *neue Sachlichkeit*, or "new matter-of-factness." It was actually a reconfrontation with the facts known since Gottsched's days: audiences usually go to see theater they like, not the theater they *ought* to like. Police authorities reinvolved themselves with theater, too: Brecht was summoned to a Prussian state prosecutor's office to explain passages in his plays that one police official found objectionable. Piscator was incarcerated for indebtedness. Playwright Georg Kaiser was imprisoned on the ostensible charge of "suspicion of theft," although his real crime seems to have been asserting in court the rights of an artist in a "free society."

As the 1920s progressed, theater in the Weimar Republic became less

and less free. Concomitant with growing resistance to artistic freedom in that decade was the rise of National Socialism, which promised to "cleanse" the German theater of its "decadent" and "un-German" elements. As early as 1926 Joseph Goebbels attacked Zuckmayer's *The Merry Vineyard* as "unbelievable swinery" and "a mockery of German morals and German women." Kortner was a favorite Goebbels target because he frequently played the "great" roles in German classics in "Jewified" interpretations. Nazi attacks on Kortner and other Jews (such as Jessner, who was forced to resign from the State Theater in 1930) multiplied. Adolf Hitler promised to "settle scores," as he phrased it, with "our criminals in the world of culture." Nazi pundit Alfred Rosenberg's preferred term for such individuals was "cultural bolsheviks." In Rosenberg's view, cultural bolshevism was "the essence . . . of modern drama [and] modern theater"; both emanated "a stink of corpses" rotting in "Paris, Vienna, Moscow, and New York, where . . . bastards are 'heroes' of the times," while "whores and naked dance revues dominate the Weimar cultural scene."[12]

With one election victory after another, the National Socialist numbers and influence grew in the Reichstag during the early 1930s. Attacks on theater artists who in the Nazi opinion were considered degenerate, subversive, Jewish, Marxist, or otherwise un-German increased. The Nazis also supplanted in the minds of many audiences an entire theatrical style: in the Nazi lexicon, *neue Sachlichkeit* became *heroische Sachlichkeit* ("heroic matter-of-factness").

THE THIRD REICH, 1933–1945

The play that ushered in the era of National Socialist theatrical taste (and simultaneously sounded the Weimar theater's death knell) premiered on Hitler's birthday, 20 April, in 1933. It was *Schlageter* by Hanns Johst, who dedicated it to the new chancellor "in loving veneration and unshakable faithfulness." It was based on a real-life figure (Albert Leo Schlageter, 1894–1923), but presented him in the Nazi "heroic" mold. The premiere performance at the Prussian State Theater (now under the patronage of Hermann Goering) had such an impact on the opening night audience that at the final curtain there was stunned silence. Then the audience together rose to sing the German national an-

them, followed by a verse of "The Horst Wessel Song," the semiofficial Nazi Party anthem favored by storm troopers at torchlight rallies. Playwright Johst was a signal figure in the "new Germany." He had written several Expressionist plays in the 1920s, but like many others had turned to the "new matter-of-factness" by the mid-1920s. In 1927 his *Thomas Paine* premiered, and the Nazis proclaimed Paine "the American Horst Wessel." Hitler met Johst and requested him to work on the Schlageter material; as a reward, Johst was named dramaturg of the Prussian State Theater and president of the new Reich Chamber of Writers, and he received the first Party Prize for Art and Science. He never wrote another play.

Johst instead became a clerk in the Nazi cultural bureaucracy, which Goebbels had created as part of his all-encompassing Ministry of Propaganda. Under its auspices, the German theater became for the first time in its history a completely subsidized organ of the state, which provided high salaries, status, and subsidies and placed high expectations for production values. It also banned plays by Jews or anybody else deemed objectionable. Productions of Shakespeare were encouraged, and a yearly Shakespeare festival invited stagings from across the country, over which Goebbels himself presided. Goebbels engaged in an unusually productive competition with Goering in Berlin; as Prussian prime minister, Goering lavished unprecedented resources on theaters in his jurisdiction. Goebbels meanwhile, through the Propaganda Ministry, controlled and supported most other formerly private theaters in Berlin, including the Deutsches, the Volksbühne, the Belle-Alliance, the Lessing, the Schiffbauerdamm, and at least a dozen others. When the Third Reich expanded to include Austria in 1938, the Propaganda Ministry extended its control over all theaters in the "Greater German Reich." Heinz Hilpert was assigned to administer the former Reinhardt properties there, though as in Berlin he was saddled with Goebbels's dictates. The Propaganda Ministry later administered theaters in the annexed and conquered territories of Czechoslovakia, Poland, and France, but the "ProMi," as it was called, was far more than just an administrative agency dealing with cultural affairs and aesthetic judgments: it was an apparatus of "popular enlightenment," a bureaucracy created for centralized control. It supervised not only theater but also radio, the press, film, music, advertising, painting, sculpture, and literature. Yet its top-down management structure soon "dissolved into a polyocracy of com-

peting domains."[13] Goering competed with Goebbels at the highest level; regional mandarins fought for supremacy beneath them, and local functionaries did likewise on a still lower level. Theater artists prospered mightily. Never had so many performers been employed; at no time in German history had so many theater buildings been refurbished and renovated.

Among the most spectacular and significant productions in the Third Reich were Jürgen Fehling's, whom Gustaf Gründgens hired in 1934 and who remained at the Prussian State Theater for a decade. Both Fehling and Gründgens served at Goering's pleasure and were immune to Goebbels's whims, and they enjoyed the most privileged and protected positions in the entire theater profession during the Nazi period. Fehling's best production was *Richard III* in 1937; it mocked Goebbels in particular, as Werner Krauss played Gloucester with a clubfoot and a broadsword six feet long. At the Deutsches Theater, Hilpert could take no such chances, yet he was nevertheless a constant thorn in Goebbels's side, largely because he simply would not "align himself with the regime" (according to Goebbels).

A few other performers enjoyed relative safety by virtue of their stardom or close association with the party hierarchy; instances of resistance were present, but always on an individual basis. Scores of actors and actresses were murdered in Nazi death camps. About 4,000 people who had worked regularly in the German theater in the 1920s fled Nazi Germany. By the time Goebbels closed all German theaters on 1 August 1944, completing regular performances had in most cities become a practical impossibility due to daily and nightly Allied bombing raids. The Lessing Theater was completely destroyed in a 1943 raid, and very few other theater buildings escaped damage in the big cities.

THE COLD WAR PERIOD, 1945–1989

When the Third Reich collapsed, the German theater had lost not only most of the physical structures in which performances had taken place but also 89 surviving facilities due to new border arrangements. Within the new German borders, makeshift venues (called *Zimmertheater*, or "room theaters" that could accommodate actors and audiences) proliferated in the many locations where theater buildings no longer stood. The occupa-

tion powers strictly administered all theater activities, and every theater production needed approval from the occupying forces under whose jurisdiction the production was to be staged. The American forces, for example, delayed the German premiere of Zuckmayer's *The Devil's General* until 1948, even though it had opened in Zurich two years earlier.

There were long debates over what kind of fare was appropriate for German audiences in the immediate postwar period. There were no debates about *The Rape of the Sabine Women*, which was staged at the Berlin Renaissance Theater on 25 May 1945, only three weeks after German capitulation; the beloved old Schönthan farce was one of the few things all four Allied powers could agree on. Later in the summer of 1945, they also agreed that Lessing's *Nathan the Wise* was appropriate. The occupying powers had everyone who had worked in the theater during the Third Reich undergo some kind of "de-Nazification" program. Gründgens spent nine months in Russian custody and went through four different hearings before he was released; Heinrich George died in Russian custody.

Many theater artists went to occupation zones where they thought they had the best chance of working; for example, German translations of Thornton Wilder's *Our Town* and *The Skin of Our Teeth* proved to be enormously popular in the American zone, with Tennessee Williams's *The Glass Menagerie* a close third. In the British zone, T. S. Eliot and J. B. Priestley were popular, while in the French zone Jean Anouilh was the most frequently performed. In the Russian zone, anti-American plays such as *The Russian Question* by Konstantin Simonof were favored, and Yevgeny Schwartz's *The Shadow* was likewise popular. Anything by Maxim Gorky was approved. Among German plays, Wolfgang Borchert's *The Outsider* was perhaps the most frequently performed of all.

There was healthy competition among theaters in the Western zones, as there was in Vienna. In the 1940s there had been 17 active theaters in Vienna. During the 1945–1946 season there were 48 ensembles in operation, many of them with several venues for performance. Vienna was divided among the four victorious powers, as was Berlin, and the Russians controlled the central city, which contained most of the theaters. Yet because Austria was seen as a conquered country, rather than as a country that had collaborated with Hitler, restrictions of performance were not so severe. Egon Hilbert (1899–1974) became Austria's leading cultural politician, working tirelessly to restore the theaters in

Vienna and the Salzburg Festival.

The loss of Berlin as both political and cultural capital of Germany, and later the official division of the country into two separate states, brought new focus to what were formerly "provincial" stages. Gründgens in Düsseldorf and later in Hamburg established a "feasible (*anwendbares*) theater style." In Darmstadt, Rudolf Sellner developed a reputation for distinctive, though derivative, production values. In Frankfurt am Main, Harry Buckwitz became the foremost advocate of Brecht in West Germany during the 1950s, when the Brecht boycotts were most active and effective. Heinrich Koch advocated a Brechtian anti-illusionism in Hamburg during the 1950s, staging many plays on the "Koch-Platte," a round platform placed onstage at various angles in order to present characters at various angles for the purpose of considering their political/social stance within a drama. Hans Schalla took over the Bochum theater from Saladin Schmitt in 1947 and established it as a major theater from 1949 to 1972. The "Bochum style" came to mean wide-open spaces with distinctive lighting effects. In Munich, Hans Schweikart reestablished the Kammerspiele in 1947 amidst the ruins of the Residenztheater, then called the Theater im Brunnenhof; Schweikart had been a much-favored director and playwright under Goebbels, but his reputation survived. Hilpert established himself in Göttingen, renaming the City Theater there the "Deutsches Theater" in the hope of maintaining the Brahm and Reinhardt tradition as he had done in the Third Reich.

The most significant personality in German theater during the postwar period was Brecht, who returned to find the German theater languishing in what he considered a state of utter depravity. National Socialism had corrupted production values and especially acting so extensively, he said, that the German theater would have to start from the ground up in order to "reorient" both actors and audiences. Kortner essentially agreed with him, deriding the "Reich Chancellery style" of acting he witnessed upon his return. Schweikart, Hilpert, Gründgens, and others who had remained in the Third Reich seemed, to Brecht, merely to be recapitulating the work they had done under Goering and Goebbels. Actors such as Carl Raddatz, Elisabeth Flickenschildt, Will Quadflieg, Marianne Hoppe, and Paula Wessely were being allowed to get away with the same old routines that had been exalted in the Nazi years. Brecht's influence in the postwar period was at first far more substantial than was

Kortner's because Brecht had the resources of the German Democratic Republic behind him. He also had the benefit of numerous collaborators, chief among whom were Helene Weigel, Erich Engel, and Caspar Neher, along with composers Hanns Eisler (1898–1962) and Paul Dessau (1894–1979). Kortner's legacy was realized much later, largely through his assistants Peter Stein, August Everding, and Jürgen Flimm.

By the mid-1950s, several theaters had been rebuilt, and the system National Socialism had put in place remained largely intact. Local and regional governments provided generous subsidies, and numerous new structures reopened yearly; 1966 topped the list with an even dozen. Most were concrete monoliths in the guise of modernist architectural minimalism; nothing about their cost was minimal, however, and the cubic space they enveloped was equally enormous. Through the end of the 1960s, several cities competed to outdo each other both in expenditures and in cubic space. Dortmund spent DM37 million for an auditorium seating 1,160, Düsseldorf spent DM39 million for 125,000 cubic meters of concrete, and in 1972 Darmstadt briefly held the record, paying DM75 million for 210,000 cubic meters. Theater architects in Germany who designed these structures accepted Brecht's anti-illusionism without question, so stage aprons were largely absent. The result was mostly overhead lighting, or at least a lighting capacity severely reduced. Acoustical considerations were largely ignored until productions were under way and audiences realized they could not hear anything precisely. Acoustical engineers were then deployed to hang drapes, often in futile attempts to keep unintended echo and unwanted reverberation to a minimum. Many technical innovations took place in older houses, such as the Festspielhaus in Bayreuth, the Berlin Schlosspark Theater (a former movie theater), or the Orangerie in Darmstadt. Meantime smaller "lab theaters" of the bigger houses took precedence; among them were the Schiller Theater Werkstatt (beginning in 1959) and the Werkraum of the Munich Kammerspiele, begun in 1961.

In East Germany, emphasis was on maintaining the distinctive Soviet-style system against criticism or Western influence. While West German theaters used concrete to solidify ideas that Germany had made economic recovery from the ruins of the Third Reich, East German theaters attempted to cement their theaters within Soviet traditions and rules of appropriateness. Throughout the 1950s, however, East German artists regularly made their way westward, most never to return. Even

fewer made the journey from the West to permanent settlement in the East. After the construction of the Berlin Wall in 1961, the steady flow of artists to the West was temporarily slowed, and some prominent artists who could have left, for example, Walter Felsenstein and Erich Engel, chose to remain. Meanwhile East German productions regularly came up short of actors, many of whom continued to move to West Berlin; fewer and fewer new productions were staged in the East. At the same time, the West prospered due to the ongoing influx of new talent.

The most profound influence on German theater from the 1950s onward was German television. By 1975, 95 percent of all German households had at least one television set, and the average viewing time in each household was two hours and five minutes. Nearly everyone recognized that television posed a different kind of threat to the theater than had movies or radio in decades previous. In the years leading up to World War I, German theater producers had attempted to enlist theater artists in a boycott of all film production work. The attempt failed, and when radio and sound film appeared, similar attempts to stifle competition likewise miscarried. When television came on the scene, theater managers instead tried to incorporate the new medium fully within its ranks. Television presenters in the meantime swore to uphold and support live theater performance in any way possible. The union was hardly symbiotic, however; complicating the picture in the 1950s was the well-established German practice of government subventions for both theater and television. Many saw television as parasitical, taking subvention resources away from theater. Others complained that television was "stealing" playwrights of promise away from the theater and offering them regular wages to write scripts for TV shows. Actors likewise found TV money attractive and often discovered in television a lucrative sideline.

By far the largest impact of television on theater was the wholesale replacement by television of the situation comedy in the theater. Far fewer boulevard comedies were premiered or performed in German theaters after the 1950s than had been the case in previous decades, with the possible exception of some French or American imports. The growing generosity of subventions for the German theater furthermore prompted many critics to call for only "serious" plays in the theater, since comedies could be found on television anyway. The outcome was a growing sense of entitlement and elitism within the German theater,

fed by an overemphasis on directing at the expense of acting. The most vocal opponent of a "director's theater" was Rudolf Noelte, a disciple of Fehling, who insisted on fidelity to the text. By the 1960s the *auteur* theory of filmmaking made headway among film circles, and theater directors began to imitate their filmic counterparts, compounding the problems of elitism and theater as an "insider culture." In the large cities, there was demand for televising theater performances, and in some instances it stimulated theater attendance; in the smaller locales, however, television served to diminish theatergoing. What was on television could never be matched in small provincial theaters, would-be theatergoers reported. The strain to reach perfection in theater performances resulted in ever-longer rehearsal periods, even while productions became less and less accessible or even comprehensible to the average audience.

Between 1962 and 1972 West German theater attendance shrank by 13 percent, yet public funding to theaters increased by 215 percent over the same period. In most theaters, between 80 and 90 percent of all costs were covered by subsidies. Still, the West German economy was so productive that outlays for cultural activities accounted for only 1 percent of all government spending. In an effort to stimulate public opinion of and interest in live theater, the Berliner Theatertreffen (literally "theater meeting") was established during the 1963–1964 season to invite what a jury regarded as the most "remarkable" (*bemerkenswerte*) productions of that season to the former capital and showcase them during the month of May. The Berliner Theatertreffen proved to be extraordinarily successful, at least in terms of keeping theater in the public consciousness and helping theaters maintain their subsidies.

In the late 1960s, social and political unrest in the wake of student revolts and protests about U.S. involvement in Vietnam led to an upheaval of sorts in the German theater. There were calls for *Mitbestimmung* ("co-determination") of artistic goals, "transparency of the working process," and restructuring of the hierarchical administrative principles that had guided the German theater for generations. It was essentially a call for collectivism, though for the most part it was a long-delayed confrontation with recent German history. A generation that had come of age in the postwar period now began to question the conduct of its elders during the Nazi era, and the result in many cases was a bizarre and ironic embrace of Marxist ideals. There were at-

tempts at participatory repertoire selection, unified wage and salary levels, cooperative play direction, communal theater administration, joint decisions in casting, and open discussion of everything. Little of it worked, with the possible exception of the Schaubühne in Berlin, where a collective spirit prevailed until about 1985. In most other theaters, the traditional methods of authoritarian decision making reappeared. The search for increased democratization during the late 1960s, however, resulted in some interesting attempts to make theater more accessible to a wider group of audiences. Theaters in some cities attempted to put on plays in nontraditional venues such as sports stadiums, convention halls, and film studios.

The confrontation with Austrian Nazism reached the boiling point in 1988, the 50th anniversary of the *Anschluss* (Annexation) of Austria into the Greater German Reich, coinciding with the 100th anniversary of the new Burgtheater's construction. For that occasion, Claus Peymann commissioned Thomas Bernhard to write *Heldenplatz* (*Heroes' Square*), which treated the fate of a mythical Jewish family in 1988 Vienna. The main character, Professor Josef Schuster, discovers a contemporary anti-Semitism in Vienna more virulent than the kind he endured in Austria a half-century earlier. He commits suicide by jumping out of his apartment window onto the historic Heldenplatz before the play begins—even though there are no apartments in the buildings facing Heroes' Square in Vienna. His wife Hedwig (played by Marianne Hoppe) since their return to Vienna has suffered constant auditory seizures, in which she hears cheering masses as they applaud Hitler's triumphant 1938 speech on the square below their apartment. By the end of the play, repeated shouts of "Sieg Heil! Sieg Heil!" cause her to collapse face down into her bowl of soup and drown. Bernhard intended somehow to portray in these scenes Austria's willing destruction of its Jews and its enthusiastic acceptance of native son Hitler as its Führer.

THE REUNIFICATION PERIOD, 1989 TO THE PRESENT

The collapse of the German Democratic Republic and subsequent German reunification was initially a cause of celebration; soon thereafter came the realization that costs for reunification would ultimately run into public expenditures in the billions, and the former outlays for cul-

ture—including those for theater—would be seriously curtailed. Berlin felt the cutbacks first, since theater in the formerly divided city had been so lavishly subsidized on both sides of the Berlin Wall. Both West and East Berlin had been symbols of the competing systems, and both had enjoyed generous support from governments for their respective theaters. Reunification brought about a forced confrontation with the way theater was to operate in a "new" Germany, one unified but saddled with enormous debt.

Perhaps because the German theater had, in the 18th century, been instrumental in articulating what the German "nation" was to become, political leaders in the 1990s and the early part of the 21st century again turned to the theater for what "Germany" actually constituted. All three presidents of the newly expanded Federal Republic of Germany (Roman Herzog, Johannes Rau, and Horst Köhler) made numerous public pronouncements about the theater's importance, and Rau called into existence panels whose major task was to provide possible guidelines for the future of the German theater. At the Bellevue Palace in Berlin (the presidential residence), there were several acknowledgments of the obligation all German governments have to preserve the theater as, in the words of one panel, "a forum of public discourse and public self-understanding." The city and state theaters were places where "commonly held values" and "an orientation toward our mutual life together" were the major themes. Everyone agreed that no screen or media image can do what the theater inherently does—namely, create direct communication between artists and audiences. Most of the discussions on these panels made frequent note of the theater's decline in numerous locales; between 1992 and 2002, there had been a 12 percent loss of all theater jobs. Attendance continued to fall, and attendance at spoken drama fell at twice the rate of other types of live performance for which the state provided subsidies. Several theaters ceased operation altogether, most notably the Berlin Schiller Theater and its subsidiaries.

Berlin's theaters had been hardest hit by the reunification of the country. Because so many new outlays had to be made there, city coffers were inadequate to maintain previously magnificent levels of subsidy. Many theater artists and administrators simply could not understand how the reestablishment of Berlin as the German capital could serve to diminish accustomed subventions (often running at more than 90 percent of total expenses for the city's most well-known theaters); others

recalled the 1950s, when the West German state built new structures as an act of political will. Peymann felt that his theater, the Berliner Ensemble, was as crucial to a metropolis like Berlin as was any new train station or government building.

Carl Hegemann, dramaturg of the Berlin Volksbühne, noted that a problem theaters in Germany faced was a matter of where German "theater history" was headed. He noted that "theater history" was formerly a discipline that focused on the theater's history. Theater history now, he said, includes the history of society in the belief that theater, along with just about everything else, has become a "performative turn." The conviction among many went far beyond what Shakespeare said about the world *as* a stage. Many people now believe the world *is* a stage. The theater in former times simulated the world; the world in a media-dominated age now simulated the theater, giving theater artists altogether new tasks and responsibilities. If the city of Berlin is a theater, Hegemann said, the question is not that too much building is going on at the theater's expense, it is rather that theater designers should be remaking the city in theater's image.

Hegemann's scenario seemed highly unlikely. Politicians were ready to close many more theaters in Berlin and elsewhere, with some even suggesting the termination of the Berliner Theatertreffen. The Theatertreffen had begun in the 1960s as a means to rescue Berlin from its status as an island and to involve it somehow in the theater life of other theaters in West Germany, Austria, and Switzerland. Now that Berlin was no longer an island, was the Theatertreffen, which had enabled so many careers to prosper, really necessary? There have likewise been calls for "consolidation" of theater life in Berlin, returning to the days when Berlin had only one state theater. Combining the operations of the Berliner Ensemble, the Deutsches Theater, and perhaps the Volksbühne into one major operation would retain state obligations to the theater, while making those obligations for the Berlin Senate at least achievable.

The 200th anniversary of Schiller's death in Weimar gave many Germans a needed occasion to reconsider state obligations to theater, particularly in terms of Schiller's demand that the German theater become and remain a moral institution. The occasion also recalled Schiller's predecessors, such as Gottsched, Gellert, Mylius, and other 18th-century thinkers who insisted that the German theater needed public financial support if it is indeed to be "German" at all. The fact that attendance

at private theaters in Germany from 1992 to 2002 had actually increased by 18 percent fueled advocacy for more free-market activity in the theater. After all, Otto Brahm and Max Reinhardt never received subsidies. In a strange yet open embrace of elitism, many in the German theater have stated that they do not consider such private theaters "really" German—and anyway, most politicians were fully prepared to continue using tax revenues to subsidize theaters in their local constituencies. There has been no debate in Bochum, for example, about reducing that city's theater budget.

The "Schiller Year" of 2005 did, however, provide President Köhler the opportunity to weigh in on artistic matters as well as the obvious economic ones. In a speech at the Berliner Ensemble commemorating Schiller, Köhler recalled his readings of Schiller as a schoolboy and his youthful experiences of attendance at several Schiller productions. He then contrasted those experiences with the kinds of experiences to which many contemporary audiences are subjected, as directors feel obliged to present fragments of Schiller's plays in frequently misguided attempts to attract attention to themselves. If one to goes to a museum in Berlin, he stated, one does not expect to see paintings by Caspar David Friedrich covered in such a way as to view only part of the painting. Likewise, if one attends a Beethoven concert expecting to hear the Sixth Symphony, one does not expect to hear parts of the symphony played by a flute quartet and the rest of the symphony played backwards. Yet analogous things are taking place at theater performances. If the German theater has a national function—and as president of the republic, Köhler is convinced that it does—how does one inculcate that idea within German young people, who will be expected in the near future to support German theaters with their taxes?

Critics responded with a predictable fury to Köhler's suggestions "The theater is not a museum!" said one. "Theater is not a form of grave robbery," said another. Such discussions Schiller would certainly have recognized. That they will continue with heated debate seems certain.

NOTES

1. Quoted in Knut Lennartz, *Theater, Künstler und die Politik* (Berlin: Henschel, 1996), 14.

2. Peter Evan Turnbull, *Austria* (London: Murray, 1840), 263.

3. Eugen Schöndienst and Herbert Hohenemser, *Geschichte des deutschen Bühnenvereins* (Frankfurt/Main: Propyläen, 1979) 17.

4. Max Hochdorf, *Die deutsche Bühnengenossenschaft* (Potsdam: Kiepenheuer, 1921), 117.

5. Max Martersteig, *Das deutsche Theater im neunzehnten Jahrhundert* (Leipzig: Breitkopf und Härtel, 1924), 525.

6. Siegfried Jacobsohn, *Das Theater der Reichshauptstadt* (Munich: Langen, 1904), 12.

7. Heinz Kindermann, *Theatergeschichte Europas* (Salzburg: Müller, 1968), 8:306.

8. Herbert Ihering, *Berliner Dramaturgie* (Berlin: Aufbau, 1948), 60.

9. Fritz Kortner, *Aller Tage Abend* (Munich: Kindler, 1969), 306.

10. Ihering, *Berliner Dramaturgie*, 135.

11. Quoted in Günther Rühle, ed., *Theater für die Republik* (Frankfurt: Fischer, 1967), 671.

12. Alfred Rosenberg, *Der Mythus des 20. Jahrhunderts* (Munich: Hoheneichen, 1935), 274.

13. Detlev J. K. Peukert, *Inside Nazi Germany*, trans. Richard Deveson (London: Batsford, 1987), 43.

The Dictionary

ACHTERNBUSCH, HERBERT (1938–). Playwright. Achternbusch was perhaps the most idiosyncratic regional talent working in the German theater during the 1990s, staging his own plays and sometimes acting in them. He had little training in any of the disciplines he pursued (which included painting, fiction, poetry, and filmmaking), and the result was an anarchic mix of the autobiographical with the surreal. He nevertheless was invited to stage his plays at both the Bavarian State Theater and the Kammerspiele in **Munich**—and in 1986 his *Gust* was invited to the Berliner **Theatertreffen**. His plays, like his films, were subjective and anecdotal to the point of incomprehensibility—though at times they were oddly funny.

ACKERMANN, KONRAD ERNST (1712–1771). Actor, manager. One of the founders of professional German theater practice, Ackermann was a superb comic actor who specialized in Molière and Holberg characters. Ackermann began with **Johann Friedrich Schönemann**'s troupe and later led his own company throughout Europe for three decades. The Prussian government in 1753 awarded him the unprecedented concession of building his own 800-seat facility in Königsberg, the first private playhouse in Germany. He premiered **Gotthold Ephraim Lessing**'s *Miss Sara Sampson* in 1755 and thereafter worked in close collaboration with the playwright, creating the role of Major Tellheim in *Minna von Barnhelm* and staging other Lessing premieres. In **Hamburg** he opened the Komödienhaus, where Lessing served as **dramaturg** (though not for Ackermann) and for which he wrote his *Hamburgische Dramaturgie* (*Hamburg Dramaturgy*) in 1767. Ackermann continued to tour for the rest of his life,

attracting many of Germany's finest actors to his troupe. Among them were his daughters, Dorothea Ackermann (1752–1821), known for the title role in Lessing's *Minna von Barnhelm* and as Countess Orsina in *Emilia Galotti*, and his younger daughter Charlotte Ackermann (1757–1775), best known for the title role in *Emilia Galotti*.

ADALBERT, MAX (1874–1933). Actor. A comic actor originally in the Wilhelmine vaudeville mold of Max Pallenberg and **Guido Thielscher**, Adalbert achieved notoriety in the Weimar period for his work with **Max Reinhardt**. He replaced **Werner Krauss** in the title role of **Carl Zuckmayer**'s *Der Hauptmann von Köpenick* (*The Captain of Köpenick*) in the summer of 1931, which several critics found more "empathic" than the original casting.

ADAMBERGER, ANTONIE (1790–1867). Actress. Among the finest actresses of the early 19th century at **Vienna**'s **Burgtheater**, Adamberger was regularly featured as Klärchen in **Johann Wolfgang Goethe**'s *Egmont*. She played several other leading tragic roles by Goethe and **Friedrich Schiller** at the Burg and from 1810 to 1817 was regarded as the Burg's premiere tragedienne. Adamberger left the Burg in the 1830s to assume the much less rigorous duties of lady-in-waiting, becoming a reader for the imperial Habsburg court.

AGNES BERNAUER by **Friedrich Hebbel**. Premiered 1852. In some ways, *Agnes Bernauer* emulates the precedent of class conflict in **Gotthold Ephraim Lessing**'s *Emilia Galotti* and **Friedrich Schiller**'s *Kabale und Liebe* (*Intrigue and Love*), since the title character is the daughter of the court barber. Her incomparable beauty predictably attracts numerous aristocratic suitors, chief among them Albrecht, heir to the Wittelsbach dynasty in Bavaria. Albrecht, however, is no licentious duke who preys on young women. He sincerely loves her, and she accepts his offer of marriage as an act of God's will. Albrecht's father, Duke Ernst, accepts the situation and allows his son to marry Agnes, but disinherits his son in order to protect the dynasty. He names nephew Adolf as his heir, but when Adolf is killed in a tournament, the duke realizes he must take drastic action. That action is to drown the beautiful and completely innocent Agnes in the Danube River. Agnes's distraught husband Albrecht then launches a

revolt against his father and nearly succeeds in killing him; an imperial order conveniently arrives to preserve the duke's life, but it also excommunicates him and bans him from succession to the Bavarian throne. The duke acknowledges his action was wrong from a moral standpoint but insists it was right for "reasons of state." He raises Agnes posthumously to the nobility, then abdicates, leaving Albrecht next in line for royal succession. Hebbel based the play on an actual event in Bavarian history, which took place in the second decade of the 15th century. It benefits from strong characters, especially that of Agnes for a well-accomplished and beautiful actress. It has remained one of Hebbel's most frequently performed plays.

ALBERS, HANS (1891–1960). Actor. Albers was an extraordinarily popular performer whose breakthrough as a "legitimate" theater actor came in 1928 with **Heinz Hilpert**'s production of **Ferdinand Bruckner**'s *The Criminals*. Albers's career began in 1911, playing in provincial theaters and short silent films. His stunning blue eyes helped him get villain roles in German silents, which were shot on orthographic film stock; the film made his eyes print white, giving him a horrifying aspect. Albers made more than 100 silent films between 1917 and 1929, almost every one of them a failure. He worked in several **Berlin** theaters prior to 1928, specializing in comedies as the young lover. Soon after *The Criminals* premiered, Albers appeared in one of Germany's first sound movies, *Die Nacht gehört uns* (*The Night Belongs to Us*) and critics raved about his ability to "quatsch," to improvise naturally as if he were saying his lines for the first time. Critics and audiences alike found themselves attracted to what seemed like an experience of eavesdropping on personal conversations. "He appeared on film the way he appeared in life: simple, impudent, cynical, and humane: at that moment, Hans Albers became a film star" (Geza von Cziffra, *Kauf dir einen bunten Luftballon* [Berlin: Herbig, 1975], 161). The last significant theater production in which Albers appeared before he devoted himself almost entirely to films was Maxwell Anderson and Laurence Stallings's *What Price Glory?* (1929) with **Fritz Kortner**. Albers's first movie to win him international recognition was *Der blaue Engel* (*The Blue Angel*, 1931), with Marlene Dietrich and **Emil Jannings**. In the Third Reich, Albers became Germany's highest-paid actor, second only to actress Zarah Leander.

Albers had problems with the Nazis from the beginning of their takeover in 1933, as his lifelong relationship with Jewish actress Hansi Burg consistently brought him into conflict with the authorities. So did his refusal to fill out "Aryan" certification forms, as well as his insistence that his name always appear over the title of any film in which he appeared. Because of his well-documented antipathy toward the Nazi regime, his career resumed in the immediate postwar period with little delay.

ALEXANDER, GEORG (Werner Louis Georg Lüddeckens, 1888–1945). Actor. Arriving in **Berlin** in 1914 after initial work in Hannover, Alexander remained based in Berlin to the end of his career. Usually cast as a dandy or leading man in light comedies, he also played the dapper gentleman in movies, beginning in 1915. His career came to a halt in 1935 when he refused to divorce his second wife, a Jew. In 1938 he received a special license from the Propaganda Ministry to work, but only in private theaters—where he had always worked anyway. He continued working as a film actor in the Third Reich, though his directing career after 1935 was finished.

ALEXANDER, RICHARD (1852–1923). Actor. Alexander became one of the most popular and highly paid comic actors of the Wilhelmine period, mostly at the Residenz Theater in **Berlin**. He specialized in boulevard comedies, usually playing the comic adulterer in vehicles like Alexandre Bisson's *The Sleeping Car Porter*, Georges Feydeau's *The Girl from Maxim's*, and *Dr. Klaus* by **Adolph L'Arronge**. Alexander summed up his career with the following statistics: he kissed a woman 5,480 times in his career on the stage, committed adultery 4,736 times, discovered the actress playing his wife with another man 3,647 times, and was himself discovered *en flagrante* by the actress playing his wife 2,895 times. In his humorous and readable autobiography (*Meine Streichen beim Theater* [Berlin: Scherl, 1922]), he claimed that after every performance he redeemed himself when he came home to his spouse in real life with, "Thank God, I can now be with a woman whose blouse is buttoned up" (142).

ALPENKÖNIG UND DER MENSCHENFEIND, DER (THE ALPINE KING AND THE MISANTHROPE) by **Ferdinand Raimund**. Premiered 1828. Raimund's *Zauberstück* features several songs and comic turns typical of the genre, but its real theme is the possibility of improving humankind's basic nature. One of humankind's most miserable specimens is Rappelkopf, the misanthrope of the title. He mistreats everybody with whom he has contact, especially women; his servants regard him as an absolute tyrant. Rappelkopf suspects everybody of conspiring against him. The Alpine king Astralagus comes to the rescue by transforming Rappelkopf into his brother-in-law, allowing him to witness the inner workings of his household and discover that his relatives and servants are actually not so bad after all. Then Astralagus transforms himself into Rappelkopf, and the real Rappelkopf witnesses what a wretch he has been to the people around him. Rappelkopf is cured of his misanthropy and returns to his original form, assumes a loving posture toward his relatives and servants. They are amazed, and for the first time in his life Rappelkopf learns how to be happy.

AMPHYTRION by **Heinrich von Kleist**. Premiered 1899. Kleist completed his "comedy based on Molière" in 1807, and it was published that year; the delay before its premiere at the Neues Theater in **Berlin** nine decades later is due in part to the fact that Kleist's blank-verse treatment of the Amphytrion material has little resemblance to Molière's and indeed is not a comedy as Kleist claimed. It is instead a brilliant extrapolation on the comic device of mistaken identity.

Kleist follows the Amphytrion legend, in which Zeus seduced and impregnated Amphytrion's wife Alcmene while her husband was on a military campaign. Zeus disguised himself as Amphytrion, and Alcmene gave birth to twin sons: one was Hercules, the son of Zeus; the other was Amphytrion's legitimate issue Iphicles. Alcmene's failure to recognize Zeus's ploy has comic potential, but Kleist does not exploit it. Zeus's failure to seduce her on his own terms, i.e., as the ruler of the gods, is likewise theatrically effective but not comic. The truly comic is present in the confusion that engulfs Amphytrion's sergeant-at-arms Sosias when he finds himself the servant of two masters, and then he must confront the disguised Mercury as himself.

Kleist's "comedy" led to several treatments subsequent to the 1899 premiere; the most well known is Jean Giraudoux's *Amphytrion 38*, which the French playwright claimed was the 38th dramatic version of the material. American Samuel Nathan Behrman (1893–1973) also wrote a comedy on the material, and so did German playwright Peter Hacks, whose blank-verse version enjoyed some popularity after its 1968 premiere in Göttingen. The best treatment of them all is the 1986 Off-Broadway musical *Olympus on My Mind*, with book and lyrics based on Kleist's play by Barry Harman and music by Grant Sturiale.

ANDREE, INGRID (1931–). Actress. Andree began her career in film and television, playing leading roles in several comedies, but establishing herself as a serious actress in the German version of John Osborne's *Look Back in Anger* (as Alison) in 1958. In the 1960s she began working extensively in theater, beginning in **Munich** with **Fritz Kortner** in his 1967 production of *Miss Julie*. During the 1970s she was a member of the **Hamburg** Thalia Theater company under **Boy Gobert**, playing several leading roles in plays by **Friedrich Schiller**, Henrik Ibsen, **Frank Wedekind**, and Harold Pinter. In the 1980s she worked extensively with **Jürgen Flimm** and Robert Wilson in **Cologne**. For more than three decades she also worked in the dubbing market, speaking the translated lines of numerous actresses in American, French, and Swedish films.

ANGELY, LOUIS (1788–1835). Playwright. Angely's comedies enjoyed singular popularity in **Berlin** during the 1820s and 1830s. They were essentially transformations from their French vaudeville prototypes into treatments situated within the distinctive linguistic, social, and geographical milieu of Berlin. In addition to writing more than 100 plays, Angely was also a well-known Berlin restaurateur, often premiering his plays at his culinary establishments. They included *Sieben Mädchen in Uniform* (*Seven Girls in Uniform*, 1825), *Das Fest der Handwerker* (*The Workmens' Festival*, 1828), and *Die Reise auf gemeinschaftlichen Kosten* (*The Trip on Shared Expenses*, 1834).

ANSCHÜTZ, HEINRICH (1785–1865). Actor. Anschütz had more than 250 roles in his repertoire at the **Burgtheater** in **Vienna** in the

mid-1800s, as one of that institution's most versatile performers. **Heinrich Laube** considered him a worthy successor to **Friedrich Ludwig Schröder** and **August Wilhelm Iffland**, though that estimation is no doubt somewhat exaggerated. His vocal work was extraordinarily resonant, and many considered his Lear and Falstaff among the best of his generation.

ANZENGRUBER, LUDWIG (1839–1889). Playwright. Known best for his *Bauernstücke*—plays in rural settings written in local dialect—Anzengruber had ample opportunity to observe rural life in his native Austria as an orphaned child and as a young man with no prospects. After a series of menial jobs, he tried acting and was engaged by a miserable touring troupe that barely earned enough to pay the expenses of its personnel. Anzengruber began writing plays for the troupe, but none of them was successful. He gave up acting and returned to **Vienna**, where he got a job working as a police clerk. That position, however, afforded him time in 1870 to write his first play in rural dialect, titled *Der Pfarrer von Kirchfeld* (*The Priest of Kirchfeld*), which was produced at the Theater an der Wien. The play was an immediate hit with Viennese audiences, making Anzengruber's name well known throughout the city almost overnight and affording him unaccustomed material comfort and security. He completed several more dialect plays in succession, including *Der Meineidbauer* (*The Farmer Forsworn*, 1871), *Die Kreuzelschreiber* (*The Cross Makers*, 1872), and *Der G'wissenswurm* (*A Bad Conscience*, 1874). They became enormously popular in the new German Reich as well, with hundreds of performances each year. His *Das vierte Gebot* (*The Fourth Commandment*, 1878) dealt not with peasants but with civic corruption in Vienna, but it proved to be almost as popular as his earlier plays written in dialect.

APPEN, KARL VON (1900–1981). Designer. Best known for his work with the **Berliner Ensemble**, of which he became principal designer in 1954. Appen began his career in Frankfurt am Main working for private theaters. His designs for **Bertolt Brecht** resembled those of **Caspar Neher** and **Teo Otto** in the 1950s, emphasizing an abstract practicality.

ARNOLD, FRANZ (1878–1960). Playwright, actor. Arnold was among the most commercially successful playwrights in the Weimar Republic. He began his career as an actor in 1897 and worked for a decade in a series of provincial venues before his **Berlin** debut in 1907 as Giesecke in **Oskar Blumenthal** and **Gustav Kadelburg**'s *Im weiss'n Rössl* (*The White Horse Inn*). In 1909 he made his debut at the Lustspielhaus, a theater wholly devoted to comedy production. There he met **Ernst Bach**, under whose direction he acted and with whom he frequently performed. Their first triumph written together was *Die spanische Fliege* (*The Spanish Fly*, 1913), in which Arnold played the central character Klinke, while Bach played his imaginary son Gerlach. Their collaboration was interrupted by the war's outbreak, and Arnold subsequently acted and directed in an army theater on the Western Front. After the war he returned to Berlin and again began writing plays with Bach, directing them himself. They became known as "the firm of Arnold and Bach," turning out hit plays season after season. In every season except 1923–1924, their plays were among those most often performed during the Weimar Republic. The partnership ended with Bach's death in 1929.

ASLAN, RAOUL (1890–1958). Director, actor. Aslan was born in Greece but received his education in **Vienna**, where as a teenager he studied with **Adolf Sonnenthal**. He worked regularly in **Hamburg**, **Berlin**, and Stuttgart, while appearing in several films. Many critics praised his Oedipus as comparable to that of **Werner Krauss**. Aslan became an outstanding character actor in classical roles during the Third Reich, though he won the highest praise for his role as the debonair Bolingbroke in the **Burgtheater**'s production of Eugène Scribe's *A Glass of Water*. He was nominated for the honorary title *Staatsschauspieler* (state actor), an indication of the favor he found among leading National Socialists. After World War II he remained in Vienna, where for three years he was director of the **Burgtheater**.

AUFRICHT, ERNST JOSEF (1898–1971). Manager, actor. Aufricht is best known as the producer of **Bertolt Brecht** and Kurt Weill's *Die Dreigroschenoper* (*The Threepenny Opera*) and *Happy End* at the **Theater am Schiffbauerdamm** in **Berlin**. He took private acting lessons in Berlin after his release from the German army in 1918 and

played minor roles in Dresden's newly renamed Saxon State Theater from 1920 to 1923. He then moved to Berlin, where he worked with **Berthold Viertel** for three years, after which he became a directing assistant at the Wallner Theater. He leased the Schiffbauerdamm from 1928 to 1931 with a mind to present leftist-oriented alternative fare to Berlin audiences. In addition to the better known Brecht/Weill collaborations (directed by **Erich Engel** and designed by **Caspar Neher**), he produced Peter-Martin Lampel's *Poison Gas over Berlin* in 1929, Marieluise Fleisser's *Pioneers in Ingolstadt* in 1929, and **Ernst Toller**'s *Bank the Fires* and **Ödön von Horváth**'s *Italian Night*, both in 1931. In 1932 he took over management of the Admiralspalast Theater in Berlin, but in 1933 the National Socialists forced him to leave Germany.

AYRER, JAKOB (1543–1605). Playwright. Ayrer wrote more than 100 plays, most for the performances in Nuremberg during Shrovetide. He wrote all of them in verse and was thought to have been acquainted with some plays by **Shakespeare** by virtue of having witnessed performances by the **Englische Komödianten** (English Comedians). He represents a continuation of the **Hans Sachs** tradition of popular performance in Nuremberg.

– B –

BAAL by **Bertolt Brecht**. Premiered 1923. In this series of 22 scenes, Brecht depicts the dissolute life of a poet who has named himself for the heathen god of the Old Testament. The Israelites fell periodically into the worship of Baal, though Baal in the play serves as a metaphor for Brecht's youthful contempt of conformity. The play's stunning poetic idiom presents an early indication of Brecht's precocity. It also manifests distinct **Expressionist** tendencies, with discontinuity of plot combined with fragmented characterizations and often inchoate character motivations.

BAB, JULIUS (1881–1955). Critic, **dramaturg**. Bab was active as a **Berlin** theater critic from 1900 to 1935. He wrote reviews for the Berlin newspapers *Die Welt am Montag* and *Berliner Volkszeitung*,

while contributing lengthy essays to **Siegfried Jacobsohn**'s journal *Die Schaubühne*. Bab began his career as **Leopold Jessner**'s dramaturg in Königsberg and later worked in a similar capacity for the Berlin Volksbühne. He was a thoughtful critic, one committed to the "new" drama of the 20th century. His reviews often took an anti-establishment tone, praising what he considered innovative departures from standard practice. His early praise of **Georg Kaiser** and **Bertolt Brecht** marked him as a forward-looking observer, though he was criticized for his nostalgic longing for the "old days" when actors had significant influence. Bab often provided his readers with an unusual understanding of the actor's work, as his biographies of **Agnes Sorma**, **Albert Bassermann**, **Adalbert Matkowsky**, and the **Devrients** bear witness. He worked with the Jewish Cultural League for two years in Berlin after the Nazis came to power and emigrated to the United States in 1935.

BACH, ERNST (1876–1929). Playwright, director. Bach was a native **Viennese** who became best known for his work in **Berlin** as half of the "firm of Arnold and Bach," though he was already an established director when he first encountered **Franz Arnold** in 1909. The phenomenal success of their playwriting partnership enabled Bach to run the Volkstheater in **Munich** throughout the Weimar years. Bach began acting in Vienna's Raimund Theater, and his Berlin career began in 1903 at the Residenz Theater under Sigmund Lautenberg. In 1905 Bach began directing at the Lustspielhaus; in 1908 he became principal director there, and a year later he began working with Arnold. Bach's career with Arnold began in 1913 with *Die spanische Fliege* (*The Spanish Fly*) and resumed in 1918, after both men had completed army service, with the military comedy *Zwangseinquartierung* (*Forced Emergency Housing*). Among other—and almost always stupendously successful—comedies Bach and Arnold wrote were *Der keusche Lebemann* (*The Reluctant Playboy*, 1921), *Der kühne Schwimmer* (*The Intrepid Swimmer*, 1922), *Die vertagte Nacht* (*The Night of the Following Day*, 1923), *Der wahre Jakob* (*The Genuine Jacob*, 1924), *Stöpsel* (1926), *Hurra—ein Junge!* (*Hurray—It's a Boy!*, 1927), *Unter Geschäftsaussicht* (*Business Looks Good*, 1928), and *Week-end im Paradies* (*Weekend in Paradise*, 1929). Most of these shows starred **Guido Thielscher** in their premiere produc-

tions; his antics often were a trademark of products from the firm of Arnold and Bach.

BACHMANN, STEFAN (1966–). Director. Bachmann studied litera-ture and worked at the Schauspielhaus in his native Zurich until 1988, when he began working as an assistant to **Luc Bondy** at the Schaubühne in **Berlin**. There, he completed studies in theater history and formed a student troupe, members of which later formed the The-ater Affekt. Their productions, most notably of **Heinrich von Kleist**'s *Penthisilea*, won the 1995 Friedrich Luft Award, while Bach-mann's productions in Kassel, in **Hamburg**, and at the Berlin Volks-bühne continued to attract wide critical praise. He became director the Theater Basel in 1998, and a year later critics in a poll taken by *Theater Heute* designated Theater Basel as "theater of the year."

BAHR, HERMANN (1863–1934). Playwright, critic. Bahr is best known as the author of light comedies, but he was initially a cham-pion of **Naturalism**; he later condemned it, however, in favor of a modernism associated with nationalism. As a freelance essayist in **Vi-enna** from 1892 to 1906, Bahr wrote extensively about plays he thought should be produced and what kind of actors should appear in them; few managers paid him any regard, so he left Vienna for **Berlin** in 1906 to work for **Max Reinhardt**, working as a **dramaturg** and publicity agent. Bahr's first playwriting success came in 1909 with the premiere of ***Das Konzert*** (*The Concert*), a conventional situation comedy that proved to be both enormously popular and commercially lucrative. Bahr's other plays were far less successful, but neverthe-less provided important glimpses into the world of both the Austrian and German theater. His best plays, besides *The Concert*, were *Josephine* (1898), *Der Franzl* (*Little Franz*, 1900), *Der Meister* (*The Master*, 1904), *Sanna* (1905), *Die Andere* (*The Other*, 1906), *Der arme Narr* (*The Poor Fool*, 1907), and *Der Faun* (*The Fawn*, 1907). His collected works total 120 volumes, including 40 plays, 10 nov-els, 5 collections of novellas, 9 published volumes of diaries, 8 vol-umes of theater criticism, and 48 compilations of essays.

BAIERL, HELMUT (1926–). Playwright. Baierl was active with **Bertolt Brecht** and **Helene Weigel** at the **Berliner Ensemble** in the

1950s, writing *Frau Flinz* for Weigel. She premiered it in 1961 with herself in the title role, a kind of modern-day Mother Courage. Baierl was an active member of the Socialist Unity party, which ran the East German regime. He succeeded **Elisabeth Hauptmann** as party secretary for the Berliner Ensemble in the 1960s, a position which granted him substantial power and influence in repertoire selection and casting. After the collapse of the East German regime, Baierl maintained his loyalty to the enterprise of which he was a part, while recognizing (as he once said) that the party was essentially a criminal organization. It had awarded him the National Prize of the German Democratic Republic in 1976 and, shortly before the regime's dissolution, the Patriotic Service Order, along with the 1985 Johannes R. Becher Medallion.

BALSER, EWALD (1898–1978). Actor. Balser was trained as a construction tradesman, but upon his release from military duty at age 20 he decided to start auditioning for acting jobs. By 1920 he was working regularly in Basel. He successfully auditioned for **Louise Dumont** in Düsseldorf both to work for her and to study under her tutelage. By 1928 Balser was a regular member of the **Burgtheater** company in **Vienna**. Until 1944 he alternated between engagements at the Burg and in **Berlin** with **Heinz Hilpert** at the **Deutsches Theater**.

In Berlin, critics praised Balser's Teutonic Petruchio, and **Joseph Goebbels** liked his Tellheim in the 1940 film *Das Fräulein von Barnhelm* (*The Barnhelm Girl*, adapted from **Gotthold Ephraim Lessing**'s 1762 comedy *Minna von Barnhelm*). Balser won a great deal of unspoken admiration while playing Marquis Posa in **Friedrich Schiller**'s *Don Carlos* in 1940 when from the stage of the Deutsches Theater he looked directly at Goebbels (sitting in a nearby box seat) and punctuated the line "Geben Sie Gedankenfreiheit!" (Grant freedom of thought!), provoking a cascade of applause from the audience.

In Vienna, Balser played a wide range of roles, from Hamlet to Sir Toby Belch in *Twelfth Night*, from Wallenstein to Egmont in classical roles. In modern plays, his Hellmer in Henrik Ibsen's *A Doll's House* was widely praised, as was his General Harras in **Carl Zuckmayer**'s *Des Teufels General* (*The Devil's General*) in 1948. Though he was born in the Rhineland, Balser became a confirmed Viennese by the

1930s and the city, as well as Austria, showered him with official honors. Among them was the Ring of Honor from the city of Vienna, along with its Kainz Medallion; Austria made him a member of its Grand Service Order for his artistic contributions to the republic.

BARLACH, ERNST (1870–1938). Playwright, sculptor. Barlach is best known in the German theater as a playwright associated with the **Expressionist** movement in the early 1920s. His plays were often mystical, usually featuring tortured characters with intense longings left unfulfilled. **Jürgen Fehling** was the director most closely associated with Barlach, largely because both men shared what they perceived to be a North German sensibility; Fehling directed most Barlach premieres, usually at the Berlin State Theater. **Joseph Goebbels** admired Barlach's sculptures and had a substantial collection until Hitler condemned them. The Nazi regime did not ban Barlach's plays outright, but they were not produced during the Third Reich. A "Barlach revival" took place in **Berlin** during the late 1950s, with several productions staged at the Schiller Theater.

BARLOG, BOLESLAW (1906–1999). Director, **intendant**. Best known as intendant of the **Berlin** city theaters in the 1950s and 1960s, Barlog established his directing career with several films in the Nazi era. He began directing in Berlin immediately after the war at the Schlosspark Theater and in 1951 assumed managership of the Schiller. There he assembled a group of outstanding actors who had made names for themselves in the Nazi era but who in the Cold War era became closely identified, as did Barlog, with attempts to revive West Berlin's theater culture.

BARNAY, LUDWIG (1842–1924). Actor. Barnay was one of the few Jewish actors to enter the upper social echelons of Wilhelmine society, ultimately gaining official recognition from Kaiser Wilhelm II himself. Born in Budapest, he joined a German-language touring troupe when he was 18 under the name Ludwig Lacroix. He worked with several other touring troupes in the Habsburg Empire and began using his real name in 1864 when he got his first engagement at the **Burgtheater** in **Vienna**. There he caught the attention of several critics in heroic parts, for example, as Marc Antony in *Julius Caesar* and

Rochester in Birch-Pfeiffer's adaptation of *Jane Eyre*, titled *Die Waise von Lowood* (*The Orphan of Lowood*). He was much in demand as a guest artist throughout the remainder of the decade, though he appeared in Leipzig and Frankfurt am Main on a regular basis as the eponymous actor-hero in his own play, *Kean*. His fame rose to new heights as a member of the Meininger troupe in the 1870s, though he often violated the company's policy of not accepting applause after famous speeches. London critics in particular noted his long bows as Antony over the body of Caesar during the Meininger tours to Great Britain in 1881. Barnay was instrumental in founding the Genossenschaft deutscher Bühnen-Angehörigier, the German actors' benevolent association, whose goal was to counter the influence of the Deutscher Bühneverein (German League of Theaters), founded in 1846 to promote the interests of managers, producers, and owners.

Barnay tried his hand at co-managing a theater in 1883 when he agreed to join fellow actors **Fredrich Haase**, **Ernst Possart**, **August Förster**, **Siegwart Friedmann**, and playwright **Adolph L'Arronge** at **Berlin**'s Friedrich-Wilhelmstädtisches Theater in 1883. The leader of that venture was L'Arronge, who changed the theater's name to **Deutsches Theater**, intending to imitate French management styles by featuring *sociétaires* in leading roles. Barnay was a *sociétaire*, but he departed after only one year. He became a manager in his own right when he leased the Walhalla Theater (for many years associated with operetta productions) in 1888 and renamed it the Berliner Theater. Barnay's goal was to do classics, with himself in the leading roles, at low prices to attract a less affluent clientele. He had some success with his venture, but gave it up in 1893. Barnay ran the Wiesbaden City Theater until 1906, though he was frequently on tour. His American tours were particularly lucrative. At the Germania Theater in New York, he played leading roles in *Hamlet*, *King Lear*, **Friedrich Schiller**'s *Wallenstein's Death*, **Karl Gutzkow**'s *Uriel Acosta*, and his own *Kean*. In 1906 Barnay was named principal director at the Royal Theater in Berlin, and in 1908 he was appointed director of the Royal Theater in Hannover, where he remained until his retirement in 1911.

BARNOWSKY, VIKTOR (Isidor Abrahamowsky, 1875–1952). Director, manager. Barnowsky became an important producer in **Berlin**

during the 1920s. He was sometimes considered an alternative to **Max Reinhardt** because of his emphasis on modern plays. What made Barnowsky unique was his cultivation of an audience for both serious modernism along with an appreciation of the boulevard comedy. He began his career as an actor, playing bon vivant types in French comedies at the Residenz Theater in 1893. In 1905 he took over from Reinhardt the lease on the Kleines Theater, and there he established himself as a director and manager, doing not only popular fare but also staging plays by George Bernard Shaw. From 1913 to 1924 he ran the Lessing Theater, where his production of August Strindberg's *To Damascus* was much praised, and his staging of **Georg Kaiser**'s *From Morn to Midnight* in 1921 was hailed by several critics as the best Kaiser production Berlin had yet seen. In addition to traditionally profitable comedies at the Lessing, Barnowsky staged *As You Like It* with **Elisabeth Bergner**, and **Fritz Kortner** in Strindberg's *Playing with Fire*. Barnowsky was also adept at discovering new talent. Among his most important discoveries were **Max Adalbert**, **Curt Goetz**, and **Käthe Dorsch**, whose careers blossomed under his tutelage. In 1933 he emigrated to New York, where he wrote screenplays and became a teacher of theater.

BASSERMANN, ALBERT (1867–1952) Actor. Bassermann became one of the most acclaimed actors of his generation by 1911, having by that time worked and starred in numerous outstanding productions with the Meininger troupe, then with **Otto Brahm** and **Ludwig Barnay**, and later with **Max Reinhardt**. His career began in his native Mannheim; he worked thereafter in a succession of provincial theaters that included Heidelberg, Nauheim, Lüneburg, and Bern in dozens of roles and a wide variety of character types. Bassermann was one of the few German actors who, when he reached his maturity, remained unrestrained by type casting, for he continued to play a variety of heroic and character parts, classical roles, robust comic turns, and preposterous farce characters.

Bassermann's career with the Meininger began with impetuous heroes like the Marquis Posa in **Friedrich Schiller**'s *Don Carlos*, Franz von Moor in *Die Räuber* (*The Robbers*), Iago, and Prince Hal. When he came to **Berlin** to work with Barnay, he played Oswald in *Ghosts*, Nikita in Leo Tolstoy's *The Power of Darkness*, Hjalmar in *The Wild*

Duck, and several others in the "pre-modernist, pre-**Alexander Moissi**" style. His acting was perhaps the last remnant of the **Adalbert Matkowsky** mold, though his work for Brahm in **Gerhart Hauptmann** and Henrik Ibsen plays at the Lessing Theater broke new ground for realistic portrayals. Brahm, however, cast Bassermann in farce roles as well, realizing that Bassermann in such roles helped increase his box office sales. One year before Brahm's death, **Friedrich Haase** awarded Bassermann the **Iffland Ring**, designating him the finest of German actors. When he began working with Reinhardt, Bassermann created several roles for **Carl Sternheim** premieres, most significantly *Die Kassette* (*The Strongbox*, 1911) and *Der Snob* (*The Snob*, 1914). In the 1920s Bassermann continued with Reinhardt, playing Mephisto, Shylock, Wallenstein, Lear, and other roles of historical proportions. He also went on tour frequently and made more than 30 silent films.

Bassermann left Germany with his wife Else Schiff when the Nazis came to power and then worked in Switzerland and Austria before emigrating to the United States. In Hollywood he subsequently made several successful films, and he is perhaps the only former Berlin star to have appeared in one with Ronald Reagan, namely, *Knute Rockne, All-American* (1940). That year also saw Bassermann's Oscar nomination for his work in Alfred Hitchcock's *Foreign Correspondent*. In 1945 Bassermann appeared in the Hollywood adaptation of **Carl Zuckmayer**'s *Der Hauptmann von Köpenick* (*The Captain of Köpenick*), titled *I Was a Criminal*. When he returned to Germany in 1946, he concentrated on older character parts in several theater productions to the acclaim of thousands.

BAUDISSIN, WOLF (1789–1878). Translator. A Danish diplomat with a passion for German theater, Baudissin, with Dorothea Tieck, translated 13 **Shakespeare** plays into German, helping to complete the standard **Schlegel-Tieck** translations of Shakespeare for the stage. Baudissin also translated four volumes of Molière's works into stage German, along with several Gozzi and Goldoni comedies.

BAUER, WOLFGANG (1941–). Playwright. Bauer was a **Viennese** playwright whose hilarious depictions of "swinging Vienna" in the late 1960s enjoyed enormous popularity and then quickly faded into

obscurity. They included *Magic Afternoon*, which many observers at the time considered the seminal play of the "68ers"—students in both Germany and Austria who began clamoring for a confrontation with the Nazi past. *Magic Afternoon* had nothing whatsoever to do with Nazis, however. Its subjects were sex, drugs, rock and roll, violence, and boredom on one afternoon in Vienna. His subsequent efforts included *Change* (1969), *Party for Six* (1969), and *Gespenster* (*Ghosts*, 1974), none of which were as popular as *Magic Afternoon*. Yet they established him as a popular playwright, with his hand temporarily on the pulse of the postwar generation.

BAUER ALS MILLIONÄR, DER, ODER DAS MÄDCHEN AUS DER FEENWELT (THE PEASANT AS MILLIONAIRE, OR THE GIRL FROM THE FAIRY WORLD) by Ferdinand Raimund. Premiered 1826. In this comedy of the *Zauberstück* variety by Raimund, a girl from the fairy world (she is actually only part fairy, since she lives with her father; her mother, however, was a complete fairy) has fallen in love with a fisherman. Her father, thanks to certain fairies of his acquaintance, has found a fortune in gold and is reluctant to allow his daughter to marry the fisherman. Fairies come to the girl's aid and make the father's castle and all his gold disappear. Evil spirits then tempt the father with additional gold, urging him to send the girl away from her boyfriend. The father sees the error of his ways and opts for the happiness of his daughter, whom he gladly gives in marriage to her fisherman.

BÄUERLE, ADOLF (Otto Horn, 1786–1859). Playwright, journalist. Bäuerle was originally an Austrian civil servant who became a **Viennese** theater critic and in 1806 the editor of *Wiener Allgemeine Theaterzeitung* (*Theater Daily of Vienna*); he edited that daily newspaper until his death. Bäuerle began writing plays in 1813 and is widely credited with creating the stock Viennese character type named Staberl, whom several playwrights subsequently imitated. Bäuerle's popular comedy *Staberls Hochzeit* (*The Marriage of Staberl*) initiated a long series of Staberl plays at the Theater in der Leopoldstadt, where nearly all his plays were premiered. They often featured songs by Wenzel Müller (1767–1835) and portrayed other Viennese types in familiar Viennese locales. Bäuerle was unusually prolific, writing

on average about four plays per year until 1848, when his antirevolutionary sentiment turned audiences against him. He continued newspaper work, but concurrently began writing a string of successful novels.

BAUERNFELD, EDUARD VON (1802–1890). Playwright. Bauernfeld was a **Viennese** lawyer who, like **Franz Grillparzer**, was a state civil servant. He began writing comedies of manners based on his experiences as a man-about-town in the late 1820s, and **Joseph Schreyvogel** premiered many of them at the **Burgtheater**. His most successful of these was *Bürgerlich und Romantisch* (*Bourgeois and Romantic*), which the Burg premiered in 1835. Bauernfeld wrote several other comedies until his forced retirement from the civil service in 1849, after which he attempted to write comedies of social criticism. Among the best of the latter was *Der kategorische Imperativ* (*The Categorical Imperative*, 1851). His comedies were successful in nearly all German-language theaters, earning him a place in several Viennese literary societies and honorary degrees from universities. The city proclaimed his 70th birthday an official occasion of celebration, and when he turned 80, the celebrations were even more elaborate and extensive.

BAUMBAUER, FRANK (1945–). **Intendant**. Baumbauer gained considerable notoriety in the 1990s for his businesslike approach to running theaters, notably in Basel and **Hamburg** (he had previously run the **Munich** Residenz Theater). Baumbauer had begun his career as an assistant in Düsseldorf and began directing his own productions at the Bavarian State Theater in his native Munich. In 1983 he became chief director at that theater, and in 1987, intendant of Theater Basel. There, he established his career as a theater administrator, using a much less confrontational approach with city politicians and union leaders than had been the case in most cities. The result was that his theater continued to run efficiently, and often far more successfully, with fewer subsidies. Among many in the German theater profession, however, Baumbauer's approach was close to heresy. His operations at the **Deutsches Schauspielhaus** in Hamburg, for example, accepted less subvention every year as a percentage of annual operating expenses; by 1999 subsidies covered "only" 72 percent of

his expenses, among the lowest subvention rates of any major theater in Germany. Among other controversial measures Baumbauer initiated with city officials a specific annual subsidy for every year over the course of his contract as intendant, thereby giving himself some budgetary predictability. His opponents said that such tactics provide officials the opportunity to base government support on the personality of a theater's administration—that is, subsidies predicated on the intendant's success, rather than on "community needs" and the centuries-old and nearly sacred German tradition of state obligation to theater and the arts generally.

Baumbauer certainly did not lack artistic success in Hamburg; he hired **Christoph Marthaler**, who went on to become *Theater Heute*'s "director of the year" twice. He fostered **Jossi Wieler** in Basel and likewise hired him to work in Hamburg, where in 1994 he staged the premiere of Nobel Prize–winning playwright **Elfriede Jelinek**'s *Wolken.Heim* (*At Home in the Clouds*); it was invited to the Berliner **Theatertreffen** and named "production of the year." The Deutsches Schauspielhaus was itself awarded "theater of the year" three times under Baumbauer's tenure. Attendance rates at the Schauspielhaus were also among the highest of any in Germany, even though it has the largest seating capacity (1,397) of any dramatic theater in the country. Yet Baumbauer is not an iconoclast; he refuses even to consider the commercial practices of a length-of-run contract for actors, common in the English-speaking theater; he also rejects out of hand any departure from the rotating repertory theater model, which some politicians have noted is economically unfeasible compared with the "long run" of a successful production. He also rejected the idea of "merging" theaters in close geographical proximity.

There was extensive controversy when Baumbauer left Hamburg to assume leadership of the Munich Kammerspiele in 2001. City officials that year had fired **Dieter Dorn**, who had worked at the Kammerspiele since 1977. Complicating Baumbauer's assumption of Dorn's job was the fact Dorn was thereafter hired to run the Bavarian State Theaters in Munich, and with him went many of the Kammerspiele's audience. Baumbauer found such a development inevitable, given the long presence of Dorn in Munich. He meanwhile recognized that the Kammerspiele's audience needed changing, as do most of the city-subsidized theaters in Germany. A worthwhile goal for

German municipal theaters, he has stated, is to change the identities of those theaters and make them more closely resemble festival theaters, in which non-German directors are invited to stage productions and where new German plays are more frequently staged than elsewhere.

BAUSCH, PINA (1940–). Choreographer, director. Bausch began traditional dance studies at the Folkwang School in Essen when she was 15 years old. She then studied dance at the Juilliard School in New York, later getting engagements with the New American Ballet company and the Metropolitan Opera. Bausch returned to work in Essen in 1962 and began choreographing in 1968. In 1973 she founded the Dance Theater of Wuppertal. In the 1980s three of her productions were invited to the Berliner **Theatertreffen**.

Bausch has been awarded dozens of international prizes and citations, firmly planting her within the firmament of the European and German cultural establishment. Among her awards are the Federal Service Cross (1986), the European Theater Prize (1999), and a knighthood in the French Legion of Honor (2003). Her work is furthermore the subject of several books, articles, and scholarly inquiry, although her dance theater pieces initially provoked widespread condemnation among critics due to the violent nature of her **Naturalistic** choreography. In many of her works, seemingly brutal encounters take place on a habitual basis: men slam women into walls, women kick men in the groin, and everybody gets involved in a kind of kinetic spectacle. Bausch has also been accused of using choreography to espouse a deeply cynical view of human relations. In one instance, a couple is tightly curled into an erotic embrace, when suddenly a second man appears to reposition them; every time he does so, the woman falls violently, and repeatedly, to the floor. Bausch's performers must be trained dancers, though they also at times speak abbreviated dialogue.

BAYREUTH FESTSPIELHAUS. The Festival Theater of Bayreuth in Bavaria is a testament to **Richard Wagner**'s ideas about illusionism. The structure had profound influence on both theater architecture and technical practice in the years subsequent to its construction, which was completed in 1876. Wagner demanded stage space and machin-

ery at a "mystical remove" from audience members sitting in the auditorium, which resulted in a duplicate proscenium wall; he also called for an orchestra pit out of sight from the audience, which resulted in a stage apron far longer in extension than was the normal practice. The stage apron indeed covered the orchestra pit almost entirely and allowed more stage area for performers. A series of pipes mid-stage fitted with steam vents created a "steam curtain" for mist and fog effects, effectively masking scene changes. Most significant was Wagner's insistence on a "democratic" form of audience seating, which necessitated a fan-shaped auditorium, no center aisle, and good sight lines from every seat in the house. Many theaters in Germany during the 1880s and 1890s underwent renovations to accommodate Wagner's operas, resulting in improved facilities for performances of spoken drama as well.

BECHER, JOHANNES R. (1891–1958). Playwright. One of the few **Expressionist** playwrights who ultimately achieved the political power he sought in his youth, Becher became minister of culture in the East German state in 1954. During the National Socialist period, he had lived in the Soviet Union, where he became an advocate of Socialist Realism. In that style, he wrote his most frequently performed play, *Winterschlacht* (*Winter Battle*, premiered 1952 in Prague); it became a staple of the repertoires in most theaters located within Eastern Bloc countries during the later 1950s.

BEIDEN LEONOREN, DIE (**THE TWO LEONORES**) by **Paul Lindau**. Premiered 1888. In this comedy, Otto Kaiser is a local judge with a wife named Leonore who is 20 years his junior. She is a fun-loving woman who takes nothing very seriously, frequently embarrassing her stern and often inflexible husband at social gatherings. When a young man of her husband's acquaintance named Hermann Wieberg propositions her, she does little to discourage him. Meanwhile her husband's uncle Christian warns Otto about the conduct of his wife, and Otto is appropriately concerned. The second Leonore of the title arrives in the person of Leonore's daughter, who has been attending boarding school in Switzerland. Like her mother, she is affable, gregarious, and beautiful. Hermann falls madly in love with her, in the process abandoning any thought of an affair with her mother.

What happens next is unexpected: the daughter falls in love with Hermann, and the elder Leonore recognizes a change in her formerly flirtatious suitor. She agrees that a marriage between her daughter and Hermann would be best for all concerned and even her husband Otto agrees. Lindau's comedy was the kind **Otto Brahm** and other critics of **Berlin**'s boulevard theater culture despised; its enormous popularity with audiences throughout Germany in the late 1880s did little to assuage Lindau's vociferous critics.

BEIER, KARIN (1965–). Director. Beier has the distinction of directing several **Shakespeare** productions during the 1990s in their original English-language versions, attracting large audiences to them and winning wide critical acclaim in the process. For her production of *Romeo and Juliet* in Düsseldorf in 1994, she received the "young director of the year" award from numerous publications. After completing studies in English literature at the University of Cologne, she formed a theater group called Countercheck Quarrelsome, devoted to producing both Shakespeare and contemporary English-language plays in Bochum, **Munich**, **Vienna**, **Cologne**, and her principal base of operations, Düsseldorf. She has also regularly directed German-language productions at the **Deutsches Schauspielhaus** in **Hamburg**, along with highly praised German-language productions in Bonn and Bremen.

BELLE-ALLIANCE THEATER. The Belle-Alliance Theater in **Berlin** got its name from nearby Belle-Alliance Square; it began as a beer garden and dance pavilion whose initial audience consisted of soldiers stationed in three nearby regimental barracks, along with artisans in the immediate neighborhood. The business reform law of 1869 allowed owner August Wolf to rebuild his establishment and offer plays by **Johann Wolfgang Goethe**, **Friedrich Schiller**, and **William Shakespeare**—usually at ticket prices far lower than what patrons were paying at the Court Theater. Wilhelmine Berlin offered the Belle-Alliance and theaters like it an ever-expanding audience due to the city's explosive population growth. Wolf attempted unsuccessfully to enlarge his audience with the German-language premieres of Henrik Ibsen's *The Pillars of Society* in 1878 and *Love's Comedy* in 1896. His primary fare was the *Posse mit Gesang*, featuring farcical plots and memorable

melodies. The most frequently performed playwrights under Wolf were Carl August Görner (1806–1884), Heinrich Wilken (1836–1880), and Leon Treptow (1853–1916). Seating capacity for the Belle-Alliance was about 1,600; the theater was razed in 1913.

BENEDIX, RODERICH (1811–1873). Playwright, actor. Benedix enjoyed extraordinary popularity as a comic playwright during the 1840s with plays such as *Das bemooste Haupt* (*The Man with Moss Growing on His Head*, 1841). Benedix began his career as an actor in his native Leipzig soon after graduating from school, spending a decade performing in several small provincial theaters. He gave up acting in favor of playwriting, though he continued working in theaters as a technical director, and he was much in demand as a public lecturer. By 1855 he became general director of the Frankfurt am Main City Theater, and he later held similar posts in **Cologne** and Leipzig. Benedix wrote more than 100 comedies, many of which remained in the repertoires of theaters throughout the 19th century. Among the most popular of them were *Dr. Wespe* (1843), *Das Gefängnis* (*The Jail*, 1859), *Aschenbrödel* (*Cinderella*, 1868), and perhaps funniest of them all, *Die zärtlichen Verwandten* (*The Tenderhearted Relatives*, 1866).

BERGHAUS, RUTH (1927–1996). Director, **intendant**. Berghaus began her career as a choreographer, having studied dance in Dresden. She moved to **Berlin** in the late 1940s to study at the Academy of the Arts there, which had been reconstituted in the aftermath of Germany's defeat and Berlin's destruction. There, she encountered **Bertolt Brecht** and began to work for him as a choreographer with the **Berliner Ensemble**. She worked in a similar capacity at the **Deutsches Theater** and with the East German State Opera, located in the **Karl Friedrich Schinkel**–designed house on Unter den Linden. For that institution, she collaborated with Brecht on the staging of Paul Dessau's *The Sentencing of Lucullus* in 1951, the first of several collaborations she completed with Dessau (whom she married in 1954). Berghaus garnered substantial attention for her stage combat choreography in the 1964 Berliner Ensemble production of *Coriolanus*, and thereafter she worked regularly with the company in numerous capacities. That work culminated in her assuming the duties

of intendant when **Helene Weigel** died in 1971. Berghaus remained in that post until 1977, after which she began directing operas in Frankfurt am Main, Dresden, Prague, Brussels, **Vienna**, **Hamburg**, and shortly before her death, Leipzig.

BERGNER, ELISABETH (Elisabeth Ettel Czinner, 1897–1986). Actress. Bergner became one of the most sought-after actresses in the Weimar Republic, and when she was forced to leave Germany in 1933 she established herself as a film actress in Great Britain and the United States. Bergner began acting studies at the age of 15 in Zurich, where at 19 she made her debut as Rosalind in *As You Like It*. In Zurich she later played Ophelia to **Alexander Moissi**'s Hamlet, and on his recommendation she found work in **Munich**, **Vienna**, and by 1922 **Berlin**. In the capital, she played a number of trouser roles because her legs were so shapely; in the title role of Strindberg's *Queen Christina* at the Lessing Theater, she made a lasting impression on critics and audiences. She then worked for **Max Reinhardt** at the **Deutsches Theater** and for **Leopold Jessner** at the State Theater; critics hailed her portrayals of **Shakespearean** heroines, as they did her Nora in *A Doll's House*, Nina in the German-language premiere of Eugene O'Neill's *Strange Interlude*, and the title role in George Bernard Shaw's *St. Joan*. Bergner's film career commenced in Berlin as well; beginning in 1923 with *Der Evangelimann*, she made more than 30 films, receiving an Oscar nomination for *Escape Me Never* in 1935. In 1936 she reprised Rosalind in the film version of *As You Like It* with Laurence Olivier as Orlando.

Bergner's stage work in both London and New York continued well into the 1930s and 1940s. She did four productions in New York, including the Margaret Kennedy play *Escape Me Never* on which the film was based; *The Two Mrs. Carrolls* by Martin Vale ran for two years on Broadway (1943–1945). The producer of nearly all these efforts, both on stage and in film, was her husband Paul Czinner (1890–1972), whom she had married in 1933.

They returned to Germany in 1954 and she resumed working, mostly in television. She was awarded the Ernst Lubitsch Prize in 1979 and the Eleonora Duse Prize in 1982. In 1987, a park in the Steglitz district of Berlin was named in her honor.

BERLIN. Berlin was the undisputed center of theater activity in Germany by 1871, surpassing **Vienna** as the German-speaking theater's preeminent city. The city's prominence grew through succeeding decades until the post–World War II period; in the early 1970s, it began to regain that distinction, and since 1989 the process has accelerated.

Berlin came into existence with the union of two villages in 1307. It was unimportant until 1489, when it became the seat of the Brandenburg electors (*Kurfürsten*). **Englische Komödianten** (English Comedians) arrived in Berlin sometime in the early 17th century to play before the Brandenburg court, but whatever influence they may have had on Berlin vanished during the Thirty Years' War, which devastated the city. Frederick William the Great Elector (1620–1688) rebuilt the city, and German troupes began to visit it regularly. In 1701 Berlin became the Prussian capital, and Prussian courts were generous in granting performance licenses to troupes. They played mostly in the Theater im Marstall and the Theater in der Poststrasse, though both of these facilities were temporary.

In 1742 the Prussian court built the Royal Opera House on Unter den Linden, but it was reserved for Italian opera. Touring troupes utilized the Theater im Donnerschen Haus, the Theater am Monjoubiplatz, and the Theater in der Behrenstrasse. **Carl Theophil Döbbelin** bought the Theater am Monjoubiplatz for his own troupe but also rented it to others; **Heinrich Gottfried Koch** did the same when he bought the Theater in der Behrenstrasse in 1771. The court constructed the Französiches Komödienhaus (French Comedy Theater) in 1776, but only French troupes played there until the court granted Döbbelin a license to stage plays in German. It became the Königliches Nationaltheater (Royal National Theater) in 1787 and in 1796 **August Wilhelm Iffland** was named its **intendant**. Court officials closed the building in 1801 and moved Iffland's troupe to the Langhans-Bau am Gendarmenmarkt, but Iffland was able to retain the name Royal National Theater.

Courtiers continued to run the troupe after Iffland's death, many of them maintaining its high quality with outstanding performers. In 1820 the **Karl Friedrich Schinkel**–designed Königliches Schauspielhaus (Royal Theater) was completed and the royal troupe moved in. In 1824 a group of private businessmen built the Königstädtisches

Theater am Alexanderplatz, financed on the basis of a royal license allowing performances the royal troupe declined to produce. In the 1840s a series of private garden theaters appeared, some of them prospering enough financially to establish themselves on a permanent basis. Owners added pavilions, then roofs, then panoplies of stage machinery; **Wilhelm Friedrich Deichmann**'s Wilhelm-Städtisches Theater was one such that grew by accretion into one of Berlin's best-known entertainment venues.

By 1869 there were 11 full-time private theaters in Berlin, and in that year the Prussian court issued a decree removing all genre restraints on theaters and abolished the Royal Theater's patent. When the German Reich was declared in 1871 with Berlin as its capital, entrepreneurs built dozens of theater structures on the speculation that Berlin's growing population could support an increasing number of theater enterprises. **Adolph L'Arronge** purchased the Wilhelm-Städtisches and refurbished it as the **Deutsches Theater**, which has been closely identified with Berlin's theater life ever since. **Otto Brahm** leased the theater from L'Arronge in 1894 and ran it until 1904; **Max Reinhardt** bought it from L'Arronge in 1906. Theater owners like L'Arronge, **Oskar Blumenthal**, and others leased their buildings to directors or ran the buildings themselves, a pattern that remained largely intact until 1935. The high point of theater enterprise in Berlin was between 1900 and 1914, when approximately 40 theaters operated profitably in the city. The most notable of them was Reinhardt's, who ushered in a new era of modernist theater practice.

By the time the city expanded its limits to become Greater Berlin in 1920, it had become the nation's largest city and indeed the fifth largest city in the world. Because it was also Germany's financial, political, commercial, and industrial center, Berlin bore immediate witness to the upheavals to befall both Germany and the German-speaking theater in the 20th century. Not all new trends or new plays began in Berlin, but nearly all theater artists wanted to establish careers there, knowing that success in Berlin usually meant success elsewhere. Compared to Berlin, most other theater centers in the German-speaking world (with perhaps the exception of Vienna) qualified only as provincial stages.

Theater performances continued through the Spartacist uprising in Berlin in the winter of 1918–1919, largely because the decades-old

police **censorship** had ended. Though civil war raged in the streets and scores of people were killed on a daily basis, new plays dominated repertoires, and new trends in acting and design came bursting out "lava-like" (as **Fritz Kortner** described it) onto Berlin's theater scene. **Leopold Jessner** took over the renamed Berlin State Theater and outraged traditionalists with "Jewified" treatments of **William Shakespeare** and **Friedrich Schiller**. Reinhardt continued to dazzle audiences at the Deutsches and even expanded his empire to include several other facilities in the city.

The devastating monetary inflation in 1923 sent many theaters into bankruptcy, but when economic stabilization returned in 1924, Berlin's theater life resumed a throbbing vitality. New directors, actors, and designers matched and even exceeded the innovations of the early 1920s; playwrights such as **Bertolt Brecht**, **Carl Zuckmayer**, and **Georg Kaiser** found complementary directorial talents in **Erich Engel**, **Heinz Hilpert**, and **Jürgen Fehling**. Producers continued to make substantial profits on a booming boulevard theater culture that thrived on plays by **Franz Arnold** and **Ernst Bach**, **Toni Impekoven** and **Carl Mathern**, and **Curt Goetz**.

The Wall Street crash of 1929 initiated a downward economic spiral for theaters in Berlin, and as the economic crisis worsened, politics began to affect theater practice. **Joseph Goebbels** had called Berlin "the reddest city west of Moscow," and by 1930 Nazi sympathizers were openly threatening Jewish-owned facilities and disrupting performances of plays they considered politically offensive.

The National Socialist takeover in 1933 marked a profound change in Berlin's theater life, as it did on the rest of Germany. For the first time, a German national government set up an elaborate apparatus to subsidize and promote theater throughout the country; Goebbels's Ministry of Propaganda and Popular Enlightenment assured artists of steady incomes, health insurance, and generous old-age pensions. Outwardly the German theater thrived on the regime's cultural policies; those policies, however, imposed control over all aspects of theater work. They also specified the exclusion of Jews, "cultural Bolsheviks," and others deemed undesirable. The result was an unprecedented emphasis on extravagance in design and acting, along with a burst of playwriting that accorded with the regime's philosophy. The regime refurbished most of the theaters in Berlin, many of

which the Propaganda Ministry had expropriated and turned into "state theaters." Hermann Goering appointed **Gustaf Gründgens** to run the State Theater, while Goebbels countered with Hilpert at the Deutsches; **Heinrich George** ran the Schiller Theater, and **Eugen Klöpfer** the Volksbühne on the renamed Horst-Wessel-Platz. In August 1944 the regime closed all theaters in Germany and Austria to direct resources toward the failing war effort; theaters did not open again until May 1945, when the Renaissance Theater in Berlin staged *Der Raub der Sabinerinnen* (*The Rape of the Sabine Women*).

The postwar period in Berlin saw the repair of many theater buildings damaged in the war, including the Deutsches, the **Theater am Schiffbauerdamm**, and the Volksbühne; others, including the Lessing and the State Theaters, had been damaged beyond rescue. Allied occupation forces fostered a desire among many Berliners to rehabilitate the city's theater life, though the city remained divided. The Soviet zone contained most of the older theaters, and there Brecht located his **Berliner Ensemble**. The Western zones in many instances witnessed new construction, such as the Schiller Theater. Many artists formerly identified with Berlin's theater life, however, left and settled elsewhere. When East German officials sealed off the eastern sector of Berlin in 1961, two distinct Berlin theater cultures arose, both enjoying lavish subsidies as showpieces for opposing regimes.

The establishment in 1964 of the Berliner **Theatertreffen**, or "theater gathering," was a recognition that West Berlin had become an island and that Berlin itself was no longer the epicenter of German theater life; the gathering invited to Berlin outstanding productions from provincial stages which in many cases were producing work far more substantial than Berlin's anyway. **Erwin Piscator** had returned to West Berlin, but Gründgens was in **Hamburg**, Hilpert in Göttingen, and Kortner in **Munich**. In East Berlin, the Berliner Ensemble was rapidly becoming a Brecht museum, while the Deutsches, the Volksbühne, and other East Berlin theaters remained content to serve what amounted to captive audiences. From a material standpoint, Berlin's theater in the Cold War period ironically reproduced National Socialism's subvention extravagance while serving primarily a propagandistic function.

In 1968, a new generation of theater artists began working in West Berlin, and a theatrical renaissance began to take place. At the

Schaubühne am Halleschen Ufer, **Peter Stein**'s productions were often the most stunning anywhere, spawning a host of imitators. By the 1970s his company was probably the most distinguished in the German-speaking world, and in 1981 the city provided Stein's troupe with a new facility, the Schaubühne am Lehniner Platz.

When the Soviet Union collapsed and Berlin was reunited, opportunities for former East German artists in Berlin improved—though public funding began to shrink markedly throughout the 1990s. Several theaters (including all of the Berlin city theaters) closed, and debates intensified about Berlin's enormous public subsidies for its theaters; many struggled to maintain relations with influential members of the Berlin Senate who could enable them to continue receiving subventions. Some private theaters remained, but Berlin's theater landscape could never return to its original, pre–National Socialist contours, when most theaters could stay in business on their own.

BERLINER ENSEMBLE. The company founded by and for **Bertolt Brecht** attained international renown in 1954 and 1955 for its prize-winning productions at the "Theater of the Nations" festival in Paris; by the mid-1970s the company was moribund, essentially calcified in its status as a Brecht museum and icon of the East German state. Brecht had the establishment of his own company in mind when he accepted an invitation from Soviet officials and the Kulturbund zur demokratischen Erneuerung Deutschlands (Cultural League for the Democratic Renewal of Germany) to visit East Berlin in 1948. Authorities of the Socialist Unity party (formed in a 1946 merger between the Communist Party of Germany and eastern caucuses of the Social Democratic Party) had experienced a revelation with Wolfgang Langhoff's production of Brecht's *Fear and Misery in the Third Reich* staged in 1948 at the **Deutsches Theater**; they found in the play valuable political attributes and offered Brecht the resources to restage *Mutter Courage und ihre Kinder* (*Mother Courage and Her Children*), which had premiered during World War II in Zurich. Given the opportunity of casting his wife in the title role and codirecting the play with former colleague **Erich Engel**, Brecht accepted the offer, and the production opened late in that year. The production proved to be such an enormous hit that it was still playing to sold-out houses in October 1949 when the German Democratic Republic was proclaimed into existence.

Four weeks later, officials of the new republic's Ministry of Popular Education authorized Brecht and **Helene Weigel** to found the Berliner Ensemble. It became a lavishly subsidized operation, though utterly dependent on "the first peasant and workers' state on German soil," as the GDR grandiloquently described itself. The republic was financially strapped but nevertheless provided money that allowed Brecht extravagantly long periods to rehearse his plays and to mount very few new productions per year. The company was in residence at the Deutsches Theater when in June 1953 street riots broke out in Berlin; after Soviet troops quelled the revolt, Brecht publicly and enthusiastically supported the regime. As a reward for his loyalty, Brecht and the Berliner Ensemble were given a permanent home in 1954 at the **Theater am Schiffbauerdamm**, where the premiere of Brecht and Kurt Weill's *Die Dreigroschenoper* (*The Threepenny Opera*) had taken place in 1928.

Though Brecht was in agreement with the regime's political goals, he opposed with equal fervor its embrace of illusionism and Stanislavskian realism. As a result, he often ran afoul of party dictates and faced accusations of "formalism," accusing him of greater interest in theatrical form than in didactic content. Yet Brecht attracted some of the best talent available throughout the German-speaking world, who recognized in the company a determination to supplant ideas and methods that had held sway in the German theater since **Gotthold Ephraim Lessing**'s day. There was little doubt in the German theater profession that the Berliner Ensemble was among the most innovative anywhere. The influence of the company throughout Europe and the United States was likewise substantial, as artists and scholars began to study Brecht's methods in the numerous *Modellbücher* the company published. These were profusely illustrated, folio-sized books documenting company productions, presenting in the smallest detail how the company employed Brecht's methods. Party disenchantment persisted, however, until Brecht's death two years later.

Weigel continued to work along the lines Brecht had stipulated; she had officially been the company's leader anyway, with Brecht merely an artistic adviser. More than half the company's repertoire consisted of Brecht plays and Brecht adaptations, with **Gerhart Hauptmann**, **Heinrich von Kleist**, Molière, and Maxim Gorky comprising most of the rest. The company often toured Europe and the

Soviet Union and did residencies in London on two occasions: in 1956 at the Palace Theater and in 1965 at the National.

When Weigel died in 1971, **Ruth Berghaus** assumed leadership of the company, but its slow decline into predictability seemed inevitable. **Manfred Wekwerth** replaced her in 1977, but increasingly the company relied on old productions, staging new ones ever less frequently. New actors joined the troupe, but often merely as replications of established performers who had for one reason or another departed.

When the GDR dissolved in the collapse of the Soviet Union, there was intense discussion about ways to preserve Brecht's legacy and ultimately the Berliner Ensemble itself in a newly reunified Germany. At one point there were five directors of the company, each of them vying for a claim ultimately to lead it. **Heiner Müller** prevailed in 1992 and ran the company until his death in 1995. The company officially dissolved in 1999 but continued under **Claus Peymann**'s directorship as one of Berlin's major cultural centers, the recipient of generous subsidies.

BERNAUER, RUDOLF (1880–1953). Playwright, manager, actor. Bernauer became one of the most successful theater businessmen of the Weimar period, though his goal always was to emulate the artistic achievements of **Max Reinhardt**. Bernauer began his career as an apprentice under **Otto Brahm** at the **Deutsches Theater** while still a student at the University of **Berlin**. He subsequently worked as a full-time actor for Brahm, performing alongside Reinhardt. Bernauer was among the first actors Reinhardt hired in 1903 at the Neues Theater in Berlin, and later Bernauer became Reinhardt's personal assistant at the Deutsches Theater. With Carl Meinhard (1886–1949), Bernauer wrote a series of parodies of then-current Berlin theatrical triumphs, which they called the *Bösen-Buben-Bälle* ("Bad Boys' Balls"), presenting them at the Berliner Theater. They soon bought that facility, and in 1911 they added the Theater in der Königgrätzerstrasse to their list of properties. They bought the Komödienhaus two years later and eventually became owners of the Theater am Nollendorfplatz as well.

After he became a wealthy theatrical entrepreneur, Bernauer continued to write. In the waning years of the Weimar Republic, he formed a partnership with Rudolf Österreicher, and together they

completed some of the most successful comedies of that period. Their *Der Garten Eden* (*The Garden of Eden*, 1926), *Geld auf der Strasse* (*Money in the Streets*, 1928), and *Konto X* (*The X Account*, 1930) were performed hundreds of times in scores of productions.

In 1931 Bernauer premiered the German version of Lewis Milestone's film *All Quiet on the Western Front* at the Theater am Nollendorfplatz, and **Joseph Goebbels** ordered white mice released throughout the theater to disrupt the film's running. When the National Socialists came to power, they immediately arrested Bernauer and later forced him to auction his Berlin properties at a considerable loss. He emigrated to London in 1934.

BERNHARD, THOMAS (1931–1989). Playwright. Bernhard was born in Holland but grew up in Austria. Most of his plays in the 1970s and 1980s were scathing critiques of Austrian history, particularly of Austrian comportment during the Nazi era. In his play *Histrionics* (1984), he defined Austria as "the pus-filled boil of Europe." The implication, however, was that he had the moral authority to lance the infection so that healing, one day in the far distant future, might ultimately take place. In the meantime, however, he felt compelled to remind Austrians of their appalling conduct after 1938, when they invited native son Adolf Hitler to rule over them, carried out his orders, and afterward tried to convince the world they were "Hitler's first victims."

Bernhard came to prominence in 1972 with **Claus Peymann**'s production of *Der Ignorant und der Wahnsinnige* (*The Ignoramus and the Madman*) with **Bruno Ganz** at the Salzburg Festival. It set a precedent for his long collaboration with the director and an uncompromising vituperation toward his countrymen. Bernhard's plays often consisted of long, rambling monologues that attempted through literary devices to puncture and deflate his country's comfortable view of itself. His work was rarely performed outside the German-speaking world because in translation many audiences find it nearly incomprehensible. The "characters" in his plays, such as they are, speak in the idiom of practiced banality, somewhat in the manner of **Ödön von Horváth**.

Bernhard's *Vor dem Ruhestand* (*Eve of Retirement*, 1979) differed somewhat from his earlier works, first because its topic was German

history instead of Austrian and second because the characters were less fragmented. It featured a prominent jurist who was a Nazi judge and Heinrich Himmler protégé, now in line for a prestigious post in the West German government. In secret, however, he celebrates Himmler's birthday every year, occasions for which he dons his old SS uniform and has sex with his sister. Bernhard's best play was *Heldenplatz* (*Heroes' Square*, 1988), which Peymann (by then **intendant** of the **Burgtheater**) commissioned for the centenary of the Burg's reconstruction in 1888. The year 1988 also marked the unfortunate 50th anniversary of Austrian native Hitler's triumphal march into Vienna, where he received a hero's welcome. Bernhard's play is a vitriolic attack on the "unheroic" embrace accorded Hitler when he came to Heroes' Square and declared an *Anschluss* (annexation) of Austria into the Reich. The play set off waves of ideological denunciation and—literally—piles of manure on the Burgtheater's ornate entryway steps the evening of the play's premiere. The performance itself generated a likewise generous amount of applause and standing ovations, which competed with an equally vociferous chorus of hoots and catcalls.

BERSTL, JULIUS (Gordon Mitchell, pseud., 1893–1975). Playwright, **dramaturg**. Berstl began working as a dramaturg in the Wilhelmine period, first at the Kleines Theater in **Berlin** (1909–1913), then at the Lessing. After military service, Berstl worked for **Viktor Barnowsky** beginning in 1919. Berstl's successes as a playwright included *Dover-Calais* (1926), *Scribbys Suppen sind die Besten* (*Scribby's Soups Are the Best*, 1929), *Napi* (1930), and *Penelope* (1930). Alongside his theater activities, he worked extensively in the dramatic publishing business at the Drei Masken Verlag and later became part-owner of the Gustav Kiepenheuer publishing firm. Berstl emigrated to London in 1936 and wrote radio drama in English for the BBC under the name Gordon Mitchell.

BESSON, BENNO (1922–). Director. Besson was closely associated with **Bertolt Brecht**, beginning as an assistant with the **Berliner Ensemble** in 1949. Because he was Swiss, Besson was able to work freely outside the East German state, and because he was Brecht's most gifted protégé, he was in demand within it. Thus he moved

throughout the German-speaking theater world with unusual freedom. Besson staged plays in West Germany, his native Switzerland, and Austria, returning on a regular basis to East Berlin and Rostock throughout the 1960s. Many of his productions had Brecht or **Helene Weigel**'s direct blessing and imprimatur, among them *Don Juan* (Rostock Volkstheater, 1952), *Der Prozess der Jeanne d'Arc du Rouen* (*The Trial of Joan of Arc in Rouen*, **Deutsches Theater**, 1952), *Der gute Mensch von Sezuan* (*The Good Person of Setzuan*, Rostock, 1956, and **Berliner Ensemble**, 1957), *Pauken und Tompeten* (*Trumpets and Drums*, Berliner Ensemble 1955), *Die Tage der Kommune* (*Days of the Commune*, Karl-Marx-Stadt City Theater, 1956), *Mann ist Mann* (Rostock, 1958), and *Turandot* (Zurich Schauspielhaus, 1969). In 1969 Besson became director of the Berlin Volksbühne, helping it to regain some of the luster it had lost in comparison to its titular competitor in West Berlin, the Freie (Free) Volksbühne. Besson is the father of **Katharina Thalbach**.

***BIBERPELZ, DER* (*THE BEAVER COAT*)** by **Gerhart Hauptmann**. Premiered 1893. Considered among Hauptmann's finest plays and certainly his best comedy, the playwright subtitled it *A Thieves' Comedy* because it focused not on the stolen object of the title but on the thief who stole it. She was Mother Wolff, whose simple charm and wit are matched only by her dishonest cunning and kleptocentric materialism. She is a wolf in sheep's clothing, but nobody in the pathetic little **Berlin** suburb where she resides seems to recognize her beneath the clever disguise. Most ignorant of all is the preposterous local magistrate Wehrhahn, who represents Wilhelmine bureaucracy in all its preening, narcissistic complacency. Hauptmann's strategy was to present his characters preying on each other, since he saw in Wilhelmine society a ruinous kind of Darwinian struggle for supremacy. The merciless ingenuity of the Wolffs easily outmatches the strutting smugness of the Wehrhahns (German for "rooster"), with resulting losses for everybody around them. Hauptmann's dialogue is a masterful patois of Berlinese, legalistic cant, and political sloganeering. The comedy is also notable for a near absence of comic devices; **Naturalists** praised Hauptmann for the play's "authentic" and "untheatrical" milieu. It has remained enormously popular in most German repertoires since its premiere, with thousands of performances in

each decade since. The characters of Mother Wolff and Wehrhahn have likewise afforded actors and actresses opportunities to develop "signature performances" with historical resonance—though the originals (**Else Lehmann** and **Emmanuel Reicher**, respectively) have tended to remain the standards against whom all subsequent Mother Wolffs and Wehrhahns are compared.

BILLINGER, RICHARD (1893–1965). Playwright. Billinger was one of the most frequently performed of the playwrights whom the National Socialists favored as a proponent of their "blood and soil" ethos. His most ironic success came in 1932 when he won the Kleist Prize, an accolade the Nazis had consistently condemned and immediately terminated when they came to power. Billinger's plays sometimes became the basis of films which the Nazi party supported and promoted; notable among them were *Die Hexe von Passau* (*The Witch of Passau*) and *Die goldene Stadt* (*The Golden City*), the latter based on Billinger's play *The Giant*.

BIRCH-PFEIFFER, CHARLOTTE (1800–1868). Playwright, actress, manager. Charlotte Pfeiffer married Christian Birch, a Danish physician with literary aspirations, in 1825. Thereafter her career blossomed into one of the most considerable of the 19th century. Her plays were more frequently performed than any others from the 1840s until her death, she played leading roles (especially in her own plays) for two decades in **Berlin**, and she successfully ran the Zurich city theater from 1837 to 1843. Birch-Pfeiffer wrote 74 plays, all of them at one time or another in the repertoires of nearly every German-speaking theater in Europe and America. Her best plays were adaptations of novels, most notable among them *Dorf und Stadt* (*Village and Town*, based on Berthold Auerbach's *Die Professorin*), *Der Glöckner von Notre Dame* (based on Victor Hugo's novel *The Hunchback of Notre Dame*), *Die Waise von Lowood* (Charlotte Brontë's *Jane Eyre*), and *Die Grille* (Georges Sand's *La Petite Fadette*). The plays adapted from other sources were similar to, though more popular than, her original works, but everything she wrote featured outstanding roles for actors. **Hedwig Niemann-Raabe**'s performance as Lorle in *Dorf und Stadt* was a triumph the actress never equaled. The same is true of Friederike Grossmann's in

Die Grille and, in *Die Waise von Lowood*, the performances of **Ludwig Barnay** as Rochester and Josephine Wessely as Jane Eyre, all of whom achieved "a kind of immortality" (Friedrich Kant, "Charlotte Birch-Pfeiffer," *Neuer Theater-Almanac*, 11:55). Birch-Pfeiffer, according to **Eduard Devrient**, was able to create characters that "allowed the performer to put himself in the most advantageous theatrical light possible. As a result, every actor in Germany aspired to shine forth in a role by Charlotte Birch-Pfeiffer" (*Geschichte der deutschen Schauspielkunst* [Leipzig: Weber, 1874], 273).

Birch-Pfeiffer's father had been a schoolmate of **Friedrich Schiller**'s and was convinced of his daughter's rhetorical skills at a very early age. When she was 12, he arranged for her to audition at the Bavarian Royal Court Theater in **Munich**; the theater's director was likewise impressed and arranged for her to study with Franz Anton Zuccarini, one of that theater's leading character actors. She debuted in Munich one week before turning 13 in a melodrama titled *Mosis Errettung* (*Mosi's Rescue*). Charlotte's idol was Sophie Schröder, and she aspired to play the big heroine parts like Medea, Maria Stuart, and Joan of Arc. She did so in touring companies during the early 1820s. She generally got good reviews, though some mentioned that her figure was "a bit too full" for effective heroine parts, and her voice "altogether too rough for Gretchen or Juliet." The year of her marriage to Birch, she became a permanent member of the Munich Royal Court Theater Ensemble.

Her first play was an 1828 melodrama titled *Herma, oder die Söhne der Rache* (*Herma, or the Sons of Revenge*), which premiered in **Vienna**. There soon followed a dozen others within the next four years, nearly all of them drawing sizable houses. Her tenure as manager of the Zurich City Theater also marked the beginning of her career as an opera librettist, particularly for composer Giacomo Meyerbeer (Jakob Liebmann Beer, 1791–1864). In 1844 she became a member of the Royal Court Theater in Berlin, and there she remained established almost to the end of her life as a performer specializing in character parts.

There was always a debate about her superiority in roles she had written or in roles written by others. Many fellow playwrights hated her plays, and poet Heinrich Heine was particularly incensed by her commercial success; he said she "served up dried peas and sow

beans, both of which are inedible," yet knew secret recipes that some-how "softened the audience's resistance to them" (quoted in Kant, "Charlotte Birch-Pfeiffer," 59). Most critics reluctantly agreed that Birch-Pfeiffer was an extremely skilled artisan, though few acknowl-edged that her skill at audience manipulation derived from the fact that she was her own most insightful audience member. She also pos-sessed an extraordinary business sense. Acting as her own agent in convincing managers to produce her plays, she often presented to managers a "package" deal that granted performance rights to her most popular plays in exchange for producing the less successful ones. **Heinrich Laube** conceded that she was manipulative, but noted that her audiences were not so easily fooled. She gave them what they wanted within the prevailing confines of **censorship** prac-tices, and they appreciated it. Her main interest was in any case the acting, Laube noted, "which is a good thing—indeed it is a necessary thing for the theater's development. Masterpieces for the stage come along so seldom that acting would simply shrivel up were it not for plays such as Birch-Pfeiffer's" (Kant 60).

BLEIBTREU, HEDWIG (1868–1958). Actress. Bleibtreu made her acting debut at age 4 in a **Ferdinand Raimund** production in which both her parents (Sigmund and Amalie Bleibtreu) were performing. She attended acting classes at a **Vienna** conservatory and made her professional debut in Augsburg at age 17. She had engagements in numerous theaters until her breakthrough as Klärchen in **Johann Wolfgang Goethe**'s *Egmont* at the **Burgtheater** in Vienna—again with her parents in the cast. Bleibtreu remained at the Burg for sev-eral years, playing heroine roles opposite **Friedrich Mitterwurzer** and later **Josef Kainz**. She spent 60 years as a permanent member of the Burg company, while also appearing in several films. Among the most memorable of her many films roles was Anna Sacher, the cigar-smoking wife of the hotelier who invented the Sacher torte, and the Landlady with Orson Welles and Joseph Cotten in *The Third Man*. In the 1950s she received several awards and citations for her work and contributions to Austrian theatrical art.

BLUMENTHAL, OSKAR (1852–1917). Playwright. Blumenthal was among the most successful playwrights of the Wilhelmine era, but he

was equally successful as a theater critic and manager. At age 20 he earned a doctorate in German literature at the University of Leipzig, and within two years he became *Feuilleton* (an "arts and leisure" section) editor of the *Berliner Tageblatt*. There he became a widely read critic, known and feared within theater circles as "Bloody Oskar." Blumenthal directed many of his most severe reviews at Henrik Ibsen, whose plays he dismissed as "psychological steeple chasing " (*Theatralische Eindrücke* [Berlin: Hofmann, 1909], 112).

Blumenthal began his own playwriting career in the early 1880s under the pen name Otto Guhl, and by 1883 he enjoyed impressive success with *Der Probepfeil* (*The Trial Balloon*), which premiered at **Adolph L'Arronge's Deutsches Theater**. It and his other plays usually bespoke the dramatic qualities he had advocated as a critic, earning him the enmity of other critics. That enmity grew proportionally with his continued achievements, as few other playwrights in the 1880s and 1890s could match Blumenthal's total of hit plays. When he became a producer in 1888 by building his own superbly equipped and tastefully constructed theater near the new Reichstag building in **Berlin**, he had likewise few peers in making enormous sums of money.

After *The Trial Balloon*, which became the second most frequently performed comedy throughout Germany during the 1883–1884 season, Blumenthal subsequently wrote or cowrote a dozen hit comedies. Some of them were so successful that they often competed with each other in several theaters in the same German city. His most successful season came in 1897–1898, when three of his plays were among the top five most frequently produced on German stages. One of them, *Im weiss'n Rössl* (*The White Horse Inn*), remained one of the German theater's most frequently performed comedies for years after it initially premiered. When songwriter Ralph Benatzky transformed it into a musical in 1930, it was so popular that it ran for another decade, not only in Germany but in New York as well. Another of his comedies, adapted by David Belasco in 1900 as *Is Marriage a Failure?*, ran for 366 performances during the 1909–1910 season on Broadway.

Blumenthal's playwriting success was based on supremely well-crafted superficiality, formulaic plots, and a whole-hearted embrace

of aphorism and badinage. His characters lacked gravity and, as **Siegfried Jacobsohn** noted, were little more than "husks full of effective witticisms" ("Hülsen wirkungsvoller Bonmots," *Die Schaubühne*, 13:415). Jokes "came out of the character's mouth and did not emanate from the character's inner dramatic being, while the characters themselves had only a loose connection to the plot," complained Rudolph Lothar (*Das deutsche Drama der Gegenwart* [Munich: Müller, 1905], 282). One could have anticipated such playwriting, however, having read Blumenthal's theater reviews. Blumenthal had always prized facile exchanges over internal development. He realized that most audience members in Berlin during the 1890s did not understand internal development in characters, and if they did understand it, they did not care about the niceties of a character's "inner dramatic being."

Oskar Blumenthal personified what **Max Martersteig** claimed was a collusion among the Berlin press, its commercial interests, and its middlebrow literary circles. Blumenthal's beginnings as a newspaper theater critic led him to write the "new German *Gesellschaftsstück*," a middlebrow society play he felt was an antidote to the "social play" of Ibsen. In the process, Blumenthal attracted substantial attention from theater professionals in Berlin, who like most theater professionals were afraid to confess the fact that literary plays dealing with social problems rarely attract audiences for an entire season. Blumenthal had no such fear, agreeing with fellow critic and successful playwright **Paul Lindau** that "in modern [theater] art, reality seems to begin where soap leaves off" (Max Martersteig, *Das deutsche Theater im neunzehnten Jahrhundert* [Leipzig: Breitkopf und Härtel, 1924], 640).

Yet Blumenthal is important for writing plays that captured the ethical consciousness of his day. *The Trial Balloon, Die grosse Glocke (The Big Bell)*, and *Ein Tropfen Gift (A Drop of Poison)* were far less pretentious than the flimsy comedies of predecessors such as Hugo Lubliner, **Gustav von Moser**, L'Arronge, and Lindau. Like them, Blumenthal was convinced that people went to the theater to be entertained and to avoid thinking about the world outside. Unlike them, he wanted theater to provide not just an evening's entertainment but rather an entire experience based on accessibility and what he later called the "theater of the living."

BLUNCK, HANS (1888–1961). Playwright. Blunck was a Nazi functionary in the Propaganda Ministry, though he had experienced some minor success as a playwright in the Weimar period while employed as an administrative official at the University of **Hamburg**. He became a strong supporter of the Nazi movement in the later 1920s, and in the Third Reich wrote two comedies that were often in theater repertoires during the mid-1930s: *Die Lügenwette* (*The Wager of Lies*, 1933) and *Der Sprung ins Bürgerliche* (*The Leap into Prosperity*, 1934). In 1938 the regime awarded him the Goethe Medallion for his "exemplary artistic endeavors."

BOIS, CURT (1901–1991). Actor. Bois is best known to English-speaking audiences as the pickpocket in the opening scenes of the 1942 Warner Bros. feature film *Casablanca*. His career, however, covered nearly eight decades in more than 100 movies and stage productions, both in English and in German. Bois began performing professionally at age 6 in cabaret acts and movies. During World War I, he worked as a dancer and comedian in cabarets and clubs throughout Germany, Austria, Hungary, and Switzerland. Beginning in 1924 he began doing operetta at the Theater am Kurfürstendamm in **Berlin**, and from 1925 to 1933 he worked steadily with **Max Reinhardt**, both in Berlin and in **Vienna**. Bois emigrated to Vienna in 1933 and in 1934 he left for New York, where he appeared in three Broadway shows. In 1937 Bois arrived in Hollywood, appearing in more than 40 films by 1950, when he returned to East Berlin to work for **Bertolt Brecht** at the **Deutsches Theater**. There he played Puntila in the 1950 production of *Herr Puntila und sein Knecht Matti* (*Mr. Puntila and His Servant Matti*) under Brecht's direction. Bois left East Berlin in 1953 to begin working in West Berlin, though his association with Brecht had damaged his career prospects. By 1959, however, he was working steadily at the Schiller and Schlosspark Theaters in West Berlin and directed a feature film, *Ein Polterabend*. In the last decade of his life, Bois gave two of his most interesting film performances, first in *Das Boot ist voll* (*The Boat Is Full*, 1981) and later in *Der Himmel über Berlin* (*Wings of Desire*, 1987) with **Bruno Ganz** and **Otto Sander**.

BONDY, LUC (1948–). Director. Through the 1970s and 1980s Bondy was among the most celebrated of free-lance directors in the German

theater. A string of invitations to the **Berliner Theatertreffen**, beginning with his 1974 Bavarian State Theater production of Edward Bond's *The Sea*, led to several others, among them his 1976 Frankfurt am Main production of Marivaux's *The Game of Love and Chance* and later Pierre Carlet de Chamblain de Marivaux's *The Triumph of Love* (Berlin Schaubühne, 1986). Bondy's 1978 **Hamburg Deutsches Schauspielhaus** production of Ibsen's *Ghosts*, two 1981 productions in **Cologne** (Samuel Beckett's *Happy Days* and Witold Gombrowicz's *Yvonne, Princess of Burgundy*), and **William Shakespeare**'s *The Winter's Tale* in 1990 at the Berlin Schaubühne were also invited.

Bondy studied acting with Jacques LeCoq in Paris before beginning work in Germany as a directing assistant at the Thalia Theater in Hamburg. He got his first directing job in **Munich** in 1973. He has also worked extensively in the French theater, most notably directing new translations of plays by **Arthur Schnitzler** in Nanterre and by Ibsen in Lausanne. In the 1990s Bondy began directing operas in several European opera houses.

BONN, FERDINAND (1861–1933). Playwright, manager. Bonn is best known as the first Sherlock Holmes in German theater and the popularizer of other fiction by Sir Arthur Conan Doyle (1859–1930) for the German stage. His first acting job was at the Deutsches Theater in Moscow in 1885; thereafter he worked at the **Munich** Court Theater, the **Burgtheater** in **Vienna**, and for **Oskar Blumenthal** at the Lessing Theater in **Berlin**. In 1905 he opened "Ferdinand Bonn's Berliner Theater" on Charlottenstrasse, where he presented an entire repertoire of plays he had written himself. Most critics found Bonn's acting skills tolerable but attacked his playwriting talents with vituperative ferocity. After his theater went bankrupt, Bonn went on tour, though he returned to Berlin and staged a performance of *Richard III* on horseback for the Busch Circus; critics responded with nearly universal condemnation. His luck changed in 1907 when Kaiser Wilhelm himself came to see Bonn's German-language premiere of *Hund der Baskerville* (*The Hound of the Baskervilles*); Wilhelm's son, Crown Prince Wilhelm, who had seen the show six times already, had encouraged his father to attend. The kaiser met Bonn after the performance and praised him for his perseverance and his

courage, knowing "the struggle you have had to make." Bonn felt emboldened at that moment to inform the kaiser that he had written a trilogy about the Hohenzollern dynasty. He gave Wilhelm II a copy, but never heard from him again. Bonn contented himself with playing Holmes in other productions of his Conan Doyle adaptations to wide audience acceptance, though general opprobrium from critics rarely abated.

BORCHERT, WOLFGANG (1921–1947). Playwright. Borchert is best known for *Draussen vor der Tür* (*The Outsider*), which was originally performed on radio in early 1947. He was briefly an actor before being drafted into the German army at age 19; he later survived wounds in battle and endured frequent clashes with officers on charges of insubordination. Borchert was imprisoned for "defeatist comments" in 1942 and sent to the Eastern Front, where he contracted hepatitis. After confinement to a field hospital, he was released from the army in 1943. Returning to **Berlin**, Borchert worked up a cabaret act in which he parodied **Joseph Goebbels**. For that offense, he was sentenced to prison in Moabit and later reassigned to infantry duty on the Western Front. In 1944 he was captured by the French but later released because his illnesses had worsened. He went to **Hamburg** and began working as a director's assistant at the Kammerspiele. Borchert then wrote *The Outsider*, which was perhaps the most frequently performed German play of the postwar period. The stage premiere took place at the Hamburg Kammerspiele one day after he died, 19 November 1947. It became an international hit, with thousands of performances around the world in more than 20 languages.

BRACHVOGEL, EMIL (1824–1878). Playwright. Brachvogel was a trained sculptor who became a playwright by attending scores of plays in **Berlin** and witnessing the success of **Charlotte Birch-Pfeiffer** and others who adapted novels for the stage. His first success was *Narziss* (*Narcissus*, 1857), based on a novel by Denis Diderot (1713–1784) titled *Rameau's Nephew*; it proved to be Brachvogel's most successful dramatic effort and was performed hundreds of times in scores of theaters in the second half of the 19th century.

BRAHM, OTTO (Otto Abrahamsohn, 1856–1912). Director, critic. Brahm was among the first important **Berlin** critics to dispute prevailing Wilhelmine practices of repertory selection. He insisted on a "theater of modern life" as an alternative to Berlin's vibrant boulevard theater culture, and he was among the first newspaper critics to become a professional director in Berlin when he assumed leadership of the Freie Bühne organization. Brahm and like-minded individuals founded the Freie Bühne to subvert police **censorship** and present controversial plays that dealt with social problems. Brahm and his backers objected to most contemporary German plays because "they offered absolutely no way out of the problems in our contemporary world." Brahm dismissed such popular plays as "freshly baked goods that go stale almost as soon as they hit the shelves" (*Theater, Dramatiker, Schauspieler* [Berlin: Henschel, 1961], 257). On the afternoon of 29 September 1889, Brahm staged Henrik Ibsen's *Ghosts,* and subsequent afternoons saw the premieres of **Gerhart Hauptmann**'s *Vor Sonnenaufgang (Before Sunrise),* the Goncourt brothers' *Henrietta Marechal,* Leo Tolstoy's *The Power of Darkness,* **Ludwig Anzengruber**'s *Das vierte Gebot (The Fourth Commandment),* August Strindberg's *The Father,* Zola's *Therese Raquin,* and Arno Holz and Johannes Schlaf's *Die Familie Selicke (The Selicke Family).* The German theater was not, Brahm said, "a moral institution but rather one of taste cultivation." Brahm's premieres of controversial plays sought to accomplish such cultivation and bring such plays into the German mainstream.

Brahm himself entered the German theatrical mainstream in 1894 when he took out a 10-year lease on the **Deutsches Theater** in Berlin and ran it successfully as a literary showplace. Between 1894 and 1904 he premiered a Hauptmann play every season, the most successful of which was *Die Weber (The Weavers).* Brahm had presented that play with the Freie Bühne, but his attempt to present it for public performance met with strong police resistance. Brahm and his attorneys successfully got a court order to overturn the police ban—in the process outraging Kaiser Wilhelm II, who judged the play "dangerous socialistic propaganda." *Die Weber* remained in the Deutsches Theater repertoire all 10 seasons, and in sum total, Brahm performed Hauptmann 1,169 times, more than a third of Brahm's total 3,000

performances at the Deutsches. One major reason he did so many of them was Hauptmann's grant to Brahm of exclusive performance rights to his plays in Berlin.

As a critic, Brahm had adumbrated the stage director's two most important abilities as "the art of staging and the art of literary discovery." Since assistants Cord Hachmann and Emil Lessing did most of his stagings, Brahm concentrated on the latter. His greatest discoveries were Hauptmann, Max Dreyer, and Otto Erich Hartleben, but he did not abandon the task of staging altogether. Though he seldom spoke to actors during rehearsals, he wrote them brief notes, sent to them while they were onstage. Brahm paid higher salaries to actors than did anyone else in the 1890s, resulting in an outstanding ensemble that compared favorably with the Meininger troupe in the 1870s. Brahm turned the Deutsches Theater into the German home of stage realism, but his productions were larely monochromatic.

Brahm lost the lease on the Deutsches in 1904 but soon secured a lease on the Blumenthal's Lessing Theater, where he continued to present **Naturalistic** plays in largely the same manner. He refused to do plays by **Frank Wedekind**, **Carl Sternheim**, or others he considered too "modern." He likewise rejected most modernist design ideas. His planned collaboration with Gordon Craig ended with Brahm's conclusion that Craig was "a crackpot with unrealizable ideas," while Craig found Brahm "impossibly 19th century in his outlook" (Craig, *Towards a New Theatre* [London: Dent, 1913], 30). When Brahm died in 1912 during emergency surgery, the German theater lost a director steeped in the tradition of absolute fidelity to the playwright's text, but also one of its first directors devoted to the modern theater as an advocate of sociopolitical engagement.

BRANDAUER, KLAUS MARIA (Klaus Steng, 1944–). Actor, director. Brandauer is best known internationally for his film work, but his acting career began in Tübingen in 1963; by 1968 he had returned to his native **Vienna** as a member of the Theater in der Josephstadt company. In that venue, Brandauer appeared in **Fritz Kortner**'s last production, **Gotthold Ephraim Lessing**'s *Emilia Galotti*. Brandauer became a member of the **Burgtheater** company in 1972, playing dozens of major roles in classics of the German repertoire through the next two decades. He attracted international attention in 1981 when

he played the title role in István Szabo's film *Mephisto*, based on Klaus Mann's novel of the same name. Since the central character was loosely based on **Gustav Gründgens**, comparisons between Brandauer and Gründgens were inevitable; Braundauer said he welcomed the comparisons and was indeed flattered by them. Four years later, Brandauer won an Academy Award for best supporting actor in *Out of Africa*, playing opposite Meryl Streep (who won the Best Actress Award for her work in the film). Brandauer has since won several awards for his work as both an actor and director, both in Austria and in Germany (where he works mostly in **Munich**). In 1995 he was named professor at the Max Reinhardt Seminar in Munich.

BRAUT VON MESSINA, DIE (*The Bride of Messina*) by **Friedrich Schiller**. Premiered 1803. Schiller's overriding concern with this blank-verse tragedy was the chorus. For the program of **Johann Wolfgang Goethe**'s premiere staging in Weimar, he published a lengthy essay on the role of a chorus and the performance of choral verse in tragedy. Schiller borrowed plot devices from Sophocles and Dante, featuring a child fatally cursed (she later becomes the bride of the title) and two brothers in love with her. He set the play in medieval Messina on the island of Sicily, where two princelings are at odds over the title of their recently deceased father. The bride, Beatrice, as an infant was left exposed to die on a hillside, the result of a dream that she would bring disaster to her family. Beatrice found protection as an infant from Isabella, the mother of the two aforementioned brothers. Isabella's attempts to reconcile her sons at first succeed, then they fall apart on the realization that they have both fallen in love with Beatrice. One brother kills the other, then himself. The chorus observes, reports on, and participates in the action.

BRECHT, BERTOLT (Eugen Berthold Friedrich Brecht, 1898–1956). Playwright, director, theorist. Brecht was among the most influential playwrights, and arguably the most accomplished, in 20th-century German theater. After his death, his influence gained such force that by the late 1970s most scholars and critics considered his plays indispensable to any repertoire or curriculum. His life and work betokened abundant contradictions. Though a devoted Marxist, he frequently ran afoul of the East German authorities whom he loyally

served. Though feminist critics subsequently found his ideas helpful to their cause of discrediting male hegemony in theater research and criticism, he was an unrepentant philanderer and exploiter of female collaborators. While a modernist critic of Aristotelian formal tradition, his ideas were firmly rooted in 19th-century dialectical materialism and in anti-illusionism, largely a reaction to the influence of **Richard Wagner**. Through Brecht's career, however, there runs a remarkable thread of consistency.

Brecht began conceiving of "his" theater in the mid-1920s, and he continued to develop a consonant set of positions to undergird it for the next quarter-century. By the time he published his *Kleines Organon für das Theater* (*Small Organum for the Theater*) in 1948, those ideas had matured into a fully realized philosophy, one that guided his efforts as a director until his death. In addition to his work as a theorist, he developed acutely polished playwriting skills and concomitantly became one of Germany's greatest modern poets. In many ways, Brecht followed the precedent **Johann Wolfgang Goethe** had established, beginning as a playwright and ultimately becoming a cultural figure with global significance.

Brecht's gifts as a playwright came officially into public view when **Herbert Ihering** awarded him the **Kleist Prize** in 1922. Ihering was an early Brecht champion, recognizing in him a unique and powerful talent. He claimed that Brecht had changed the literary countenance of Germany—a claim many found exaggerated at the time. His earliest plays were derivative and inchoate; most regarded him as a provincial iconoclast whose early efforts, e.g., *Trommeln in der Nacht* (*Drums in the Night*) and *Im Dickicht der Städte* (*In the Jungle of Cities*) were inconsequential imitations of **Frank Wedekind** or **Georg Büchner**.

Brecht arrived in **Berlin** in 1924 with **Carl Zuckmayer** to work for **Max Reinhardt**, but devoted most of his time there to an informal study of Marxism, seeking thereafter to apply Marxist concepts to what he considered a "non-Aristotelian" dramaturgy. The initial result was his 1926 *Mann ist Mann* (*A Man's a Man*) in Darmstadt, which featured a diffident stevedore named Galy Gay as a "character-as-construction," amenable to subsequent "deconstruction" since social forces had originally "assembled" him. In 1928 Brecht enjoyed his first Berlin hit with ***Die Dreigroschenoper*** (*The Threepenny Opera*, an adaptation based on John Gay's *The Beggar's Opera* of

two centuries earlier); it featured Kurt Weill's stunningly innovative music, but Brecht claimed credit for most of *Threepenny*'s success — though his collaborator **Elisabeth Hauptmann** had done most of the work on the libretto. Brecht's attempt to repeat the commercial success of *Threepenny* with *Happy End* in 1929 (again with Weill's music and Hauptmann's libretto, in the same theater under the same producer, with the same director and many of the same cast members) was a resounding flop. His 1930 attempt at opera with Weill, *Aufstieg und Fall der Stadt Mahagonny* (*The Rise and Fall of the City of Mahagonny*) likewise failed. His numerous *Lehrstücke*, or didactic playlets, in the late 1920s manifested most directly his devotion to Marxist dogma. Of them the best is *Die Massnahme* (*The Measures Taken*, 1930), which infuriated orthodox Communist Party members because it portrayed party agitators as murderers.

By the early 1930s, Brecht had also earned the vituperative enmity of the National Socialist Party. Nazi attacks on him and his wife **Helene Weigel** (whom he had married in 1928) accelerated as the financial crisis in Germany deepened. His 1931 production of *Mann ist Mann* in Berlin was more successful than its 1926 premiere, but it earned him little money. Brecht briefly went to Switzerland when the Nazis took power, but then settled in Denmark until 1939. During this period he traveled extensively, with trips to New York, London, Paris, and Moscow in hopes of promoting his stage works. His returns to Denmark, however, provided him the most fruitful period in his playwriting career. At one point he was working on a dozen projects, many of which became his greatest plays. His repeated attempts to get them produced met with little success, however; *Die Rundköpfe und Spitzköpfe* (*Roundheads and Peakheads*) premiered in Copenhagen, and two years later his series of scenes about life in Nazi Germany titled *Furcht und Elend des Dritten Reiches* (*Fear and Misery in the Third Reich*) ran briefly in Paris.

When Germany initiated hostilities in 1939, Brecht found a brief refuge in Sweden and later in Finland, but by 1940 he wrote desperate pleas to friends and German exiles in the United States asking for help getting him and his family to America by way of the Soviet Union. He made it to Santa Monica, California, in 1941, where he rewrote several works. In that year the Zurich Schauspielhaus premiered his ***Mutter Courage und ihre Kinder*** (*Mother Courage and*

Her Children); Zurich premieres of *Das Leben des Galilei* (*The Life of Galileo*) and **Der gute Mensch von Sezuan** (*The Good Person of Setzuan*) followed in 1943.

After the war, Brecht left the United States in the wake of anti-communist hearings in Washington, where in 1947 he had testified as an "unfriendly witness" before the House Un-American Activities committee. He continued to revise plays and imagine new productions for them after returning to the Soviet-occupied sector of Berlin, where he actively pursued the possibilities of establishing working conditions he had long desired. In February 1948 he staged his adaptation of *Antigone* in Chur, Switzerland; in June of that year, he premiered *Herr Puntila und sein Knecht Matti* (*Mr. Puntila and His Servant Matti*) in Zurich; and the same year, **Der kaukasische Kreidekreis** (*The Caucasian Chalk Circle*) premiered in Minnesota. None of these productions generated the notoriety he sought. A reworked version of *Fear and Misery in the Third Reich*, retitled *The Private Life of the Master Race*, opened in New York, but its impact was minimal. Brecht and actor Charles Laughton attempted to rework *Galileo* for American audiences, and Laughton premiered the play in Hollywood and later in New York. But critics could not understand it, and audiences did not respond to it.

A 1949 *Mother Courage* production in Berlin, however, finally provided Brecht with what amounted to a triumphal return. It was the first time he had had a hit in 20 years. When Brecht finally got the working situation he wanted in East Berlin, his success was absolute, resounding, and a complete vindication of the failures and frustrations he had experienced since 1928. *Mother Courage*, which premiered at the **Deutsches Theater** on 11 January 1949, made an enormous impact, despite the songs that "interrupted" the traditional narrative flow of the action, the projections which stayed in view throughout a scene, and the emphasis on "pastness" in the play that constantly reminded audiences they were watching a reflection of reality in a theater, not reality itself. The acting (particularly that of Weigel in the title role) furthermore lacked all bombast; indeed, it recalled the Meininger attention to detail. Brecht's ideas about acting had developed while he was in the United States, where the Stanislavsky "Method" was becoming extremely influential, but in Germany, bombast and declamation still held sway. Brecht rejected

both approaches and sought a third style of acting—one that was "realistic" but at the same time not **Naturalistic**.

Brecht's rejection of the Stanislavsky Method was tantamount to heresy, since Stanislavsky was the "approved" orthodoxy in the Soviet sphere of influence. Brecht was a Marxist who agreed in principle with the East German party's agenda, but he had an artistic agenda of his own. He wanted a theater that was "epic," meaning it concentrated on thought, employing narrative devices at the expense of plot, and the "plot" of a Brecht play was merely a series of often disconnected scenes. Brecht consciously sought to tie events together so that, he said, "the knots are strikingly noticeable." Unsubtle, obvious scene connections were necessary "illusion breakers," jarring the spectators out of their empathy and forcing them to contemplate what they had just seen on the stage. Instead of implicating spectators in the action, Brecht wanted to turn them into critical observers. Many such "epic" conventions manifested Brecht's rejection of Wagner's concept of the *Gesamtkunstwerk*, or unified work of art. Brecht was convinced that "fusing" disparate production elements produced a kind of passivity in the spectators, diminishing their capacity for action once outside the theater. Sympathy for or identification with a character was a process Brecht dismissed as a form of hypnosis, representing outdated effects the bourgeois theater had used for years. Brecht's productions subjected incidents and characters to the process of *Verfremdung*, usually translated as "alienation."

Such viewpoints contravened those of the East German leadership, who echoed Soviet demands for "socialist realism." Many in the leadership could not understand why Mother Courage did not see the error of her ways and reject her life as a camp follower to become more politically engaged at the play's conclusion. Had she learned nothing from her sufferings? Brecht answered that if Mother Courage herself had learned nothing, surely the public could learn something by watching her. While the East German regime sought to establish the Soviet model of realism based on melodrama, Brecht sought a new, far more modernist theater practice. He believed historical processes, social dynamics, or even full personalities could be realized only in the abstract. Socialist realism wanted audiences to identify with characters and sought to prevent critical detachment; Brecht considered socialist realism "un-Marxist and reactionary" (Martin

Esslin, *Brecht: A Choice of Evils*, 4th ed. [London: Methuen, 1984], 189). The party continued its generous patronage of Brecht and his **Berliner Ensemble**, but as the 1950s progressed, it endeavored to limit the number of new productions the company presented. In 1949 the company premiered 14 new productions and in 1950 there were 16; this declined to 11 in 1951, 7 in 1952, and just 5 in 1953.

In June 1953, workers revolted against the East German state in Berlin; Soviet tanks crushed the uprising, but Brecht publicly shared the party's conviction that "outside agitators" had influenced the workers and that "unrepentant Nazi sympathizers" had started it. On 17 June 1953, one of many dates that would mark the GDR's penchant for violent repression of its own citizens, Brecht sent a letter of support to Walter Ulbricht, reiterating his agreement with party goals.

In 1954 Brecht's status rose within the East German state enormously and unexpectedly: *Mother Courage* made guest appearances in Bruges, Amsterdam, and Paris, where *Mother Courage* won first prize for the best play at an international theater competition; Brecht and **Erich Engel** won first prize for directing. When the East German authorities later that same year placed the **Theater am Schiffbauerdamm** at Brecht's exclusive disposal, he seemed well on his way to realizing his goal of transforming the German theater, removing all vestiges of illusionism, and implementing altogether new criteria for acting and stage design. He died only two years later, but many of his anti-illusionistic ideas had already taken firm root in German theater consciousness.

Brecht had several affinities with **Friedrich Schiller**'s conception of theater as a moral institution. The mission of "his" epic theater was entirely moral and didactic, yet dedicated to the "discovery" of means to eliminate causes of oppression. That was the basis of the *Verfremdungseffekt*, because only through the "effect of distancing" could anyone—artist, spectator, or performer—discover the means by which such elimination of oppression could take place. That approach prompted critics in the East to accuse him of "formalism " and "cosmopolitanism." In West Germany, there were several organized boycotts of theaters attempting to produce his plays. Ultimately Brecht triumphed over his many foes, though he did not live to see and enjoy the full effects of his triumph. *See also BAAL.*

BREMEN. Bremen achieved substantial prestige as a theater city in the latter part of the 20th century with the presence of **Bruno Ganz, Hangünther Heyme, Peter Stein, Peter Zadek**, and other notables regularly in its midst. It had enjoyed a similar prestige at the beginning of the 18th century as a venue for touring troupes. When the Velthen troupe was performing outdoors in 1739, however, a lightning bolt struck a nearby gunpowder storage facility, causing an enormous explosion that killed dozens of people. City fathers took the event as a sign of Heaven's displeasure; they banned theater troupes until 1765, when **Konrad Ernst Ackermann** and **Konrad Ekhof** successfully petitioned the Bremen city council for a license. Even then, performances were relegated to available barns or other shabby facilities. In 1792 business leaders erected a theater building and troupes performed there until 1824, when it became the Bremen City Theater with its own troupe. The city regularly hosted sojourns by the Meininger troupe in the 1870s and later by troupes of visiting virtuosi. The theater was destroyed in World War II and rebuilt in 1950.

BRETH, ANDREA (1952–). Director. While studying literature at Heidelberg, Breth worked concomitantly at the Heidelberg City Theater as a director's assistant. In 1975, as a director in her own right, she staged a popular production of Yevgeni Schwartz's *The Enchanted Brothers*. After several stagings in **Hamburg**, Wiesbaden, and Bochum, she was about to make her breakthrough in 1981 at the **Berlin** Volksbühne with *Emilia Galotti* by **Gotthold Ephraim Lessing**—but critics panned it and audiences avoided it. The Freiburg City Theater subsequently hired her in 1983 to stage Federico García Lorca's *House of Bernarda Alba*, which proved to be Breth's career resurrection, and *Theater Heute* named her "directress of the year" as a result. In 1985 Breth began a remarkable string of triumphs: nine of her productions were invited to the Berliner **Theatertreffen**. She directed at several important regional theaters, winning the 1987 Kortner Prize, and in 1992 she was appointed artistic director of the Schaubühne am Lehniner Platz. In 1997 Breth was named house director of the **Burgtheater** in **Vienna**. She was awarded the Nestroy Prize in 2003.

BRONNEN, ARNOLT (1895–1959). Playwright. Bronnen had short-lived success with "extreme **Expressionism**" in plays such as *Vatermord* (*Patricide*, 1922), *Die Geburt der Jugend* (*The Birth of Youth*, 1922), and *Die Exzesse* (*The Excesses*, 1923). *Vatermord* got attention after **Max Reinhardt** premiered it in **Berlin**, largely because of its overweening Oedipal conflict: the leading character commits incest with his mother and later murders his father. Bronnen then attempted to attract the attention of right-wing nationalists with plays glorifying the German war effort or the resistance to the 1923 French occupation of the Rhineland; he again got widespread, but brief, attention. When the Nazis came to power, Bronnen attempted to curry their favor with public denunciations of Reinhardt, and they gave him a minor post in a regional broadcasting studio. After the war, he attempted a playwriting comeback in East Germany, but it failed.

BRUCKNER, FERDINAND (Theodor Tagger, 1891–1958). Playwright. Bruckner enjoyed an astonishing run of popularity with three plays in the later years of the Weimar Republic. They were *Krankheit der Jugend* (*The Illness of Youth*, 1926), *Die Verbrecher* (*The Criminals*, 1928), and *Elisabeth von England* in 1930. **Heinz Hilpert** premiered that latter two; he even staged *Elisabeth* in England in 1931. Bruckner had been an active playwright in his native Austria since 1911, and his first **Berlin** premiere took place in 1922 at the facility he had leased that year, the Renaissance Theater. None of his three major plays, ironically, premiered there. Bruckner was forced to emigrate in 1933 and worked briefly for the Paramount film studio in Hollywood. He returned to Europe in the 1950s and worked as a "dramaturgical assistant" at the Schiller Theater in Berlin.

BRUDERZWIST IN HABSBURG, EIN (*Fraternal Guile within the House of Habsburg*) by **Franz Grillparzer**. Premiered 1872. Grillparzer's blank-verse tragedy covers nearly four tumultuous decades within the Habsburg dynasty. Emperor Rudolf II attempts to resist the ambitions of his brother Matthias for the Habsburg throne, but religious conflicts and political intrigues thwart his attempts. A third Habsburg brother, Max, along with a Habsburg nephew named Ferdinand (who rules the Austrian duchy of Styria), throws his support behind Matthias. As they gather other supporters to their cause, the

only Habsburg remaining loyal to Emperor Rudolf is Leopold, but his troops suffer defeat against the troops of Matthias in a battle near Prague. Rudolf holes up in Prague's ancient Hradschin Castle for his own safety, where Max and Ferdinand, former loyalists to Matthias, arrive to tell Rudolf they were mistaken in supporting the usurper. But they come too late: Rudolf has abdicated, and in doing so has signed an alliance with the Protestant Duke of Braunschweig, Heinrich Julius. It seems clear that a religious war is now inevitable, as Catholic leaders led by the new Emperor Matthias prepare for battle with Protestants from the north.

Grillparzer based his play on events that took place from 1581 up to the outbreak of the Thirty Years' War in 1618, with the implication that such strife among the Habsburg relatives brought on the disastrous conflict that lasted until 1648. Though Grillparzer finished writing the play in 1850, it did not premiere until **Heinrich Laube**'s staging in 1872 at the City Theater; a competing production at the **Burgtheater** followed soon thereafter.

BRÜGGMANN, WALTER (1884–1945). Director. Brüggmann was well known for his leftist sympathies in the Weimar Republic, but remained for a time in the Third Reich as director of the Bavarian State Theater. In 1935 he won approval of the Propaganda Ministry to begin directing at **Max Reinhardt**'s former Grosses Schauspielhaus, which the Nazis renamed Theater des Volkes (Theater of the People). His most significant production there was *The Taming of the Shrew* with an aging Gerda Müller as Katherine. Brüggmann was fired in 1936 for making anti-Nazi comments and for "moral degradation," presumably homosexual activities. Jailed for nine months in 1937, he subsequently emigrated to Switzerland, where he worked steadily in Bern. In 1942 the Propaganda Ministry invited him to return to **Berlin**, but he turned down the offer and remained in Bern for the rest of his career.

BÜCHNER, GEORG (1813–1837). Playwright. Büchner's three plays remained unperformed during his lifetime and were not premiered until decades after his untimely death of typhoid in Zurich. His first was ***Dantons Tod*** (*Danton's Death*, 1835), which he wrote in the aftermath of the failed 1830 revolution and his own disillusionment

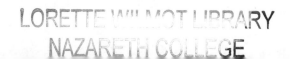

with attempts to establish greater freedoms in his native Hessia. He wrote the comedy *Leonce und Lena* sometime in 1836, and it became the first of his plays to be premiered (in 1895). His best-known play, *Woyzeck*, is not a play at all but a fragment of scenes on which he had been working shortly before his death. It premiered in **Munich** during the 1913–1914 season and became emblematic of "primordial modernism" because it was so inchoate, but also because several critics perceived in the random suffering of its nearly inarticulate hero a personification of powerless victimhood in the merciless grip of authoritarian forces. Alban Berg (1885–1935) composed an opera he titled *Wozzeck* based on the play; it premiered in 1925. Werner Herzog (Werner Stipetic, 1942–) directed a popular film version in 1979 starring **Klaus Kinski** as Woyzeck.

BÜCHSE DER PANDORA, DIE (*PANDORA'S BOX*) by **Benjamin Franklin Wedekind**. Premiered 1903. In some ways, *Pandora's Box* is a repudiation of the play it succeeds, *Erdgeist* (*Earth Spirit*). It features Lulu and many of the same characters reaping the whirlwind sown in the earlier play. Countess Geschwitz has arranged for Lulu's transfer to a hospital, as Lulu has contracted cholera in prison. Lulu has spent several years there for the murder of Dr. Schön. With Alwa, Lulu escapes from the hospital, and the two flee to France. In the following act, Lulu and Alwa have married, but the pimp Casti-Piani wants to set up Lulu in his business; if she does not agree, he says he will turn her over to the police. Lulu urges the murder of Casti-Piani, realizing that only Countess Geschwitz loves her unconditionally. Alwa, Lulu, and Countess Geschwitz escape shortly before the French police arrive. In the brutal third act, Lulu has become a degraded whore in a London flophouse who services men so that Alwa can go through their coat pockets in an adjacent hallway. Countess Geschwitz appears with a picture of Lulu in her youthful prime, and one of Lulu's clients beats Alwa to death. Lulu goes looking for new customers and returns with a particularly shady one whose name is Jack. Countess Geschwitz attempts suicide as Lulu takes Jack into her room, because Countess Geschwitz realizes that the man is Jack the Ripper. Her suicide attempt fails and Jack finishes her off by disemboweling her. He then kills Lulu in the same manner.

The box which "Pandora" opened in *Earth Spirit* fills the stage of *Pandora's Box* with all manner of pestilence, of which cholera is per-

haps the mildest. Wedekind's Lulu is no longer an animated Earth Spirit but a decrepit Typhoid Annie—yet not a shameful figure, according to Wedekind in his prologue to the play. He states (as "the shamefaced author") that he has obeyed his muse and done her bidding, inferring that if Lulu is no longer a force of nature, she is still an instrument of fate. The work premiered at the Intimes Theater in Nuremberg.

BUCKWITZ, HARRY (1904–1987). Director. Buckwitz was best known as "**Bertolt Brecht**'s director" in West Germany during the boycotts against Brecht in the early 1950s. Buckwitz had been captured by the British in East Africa and repatriated during the war. He worked incognito in Lodz, Poland, as a hotel clerk until 1945, whereupon he returned to his native **Munich**. He remained there until 1951, when he became director of the Frankfurt City Theaters, and there he staged a series of widely admired Brecht productions, often with designs by **Teo Otto**.

BURCKHARD, MAX (1854–1912). **Intendant**. Burckhard was a talented lawyer and imperial administrator who became one of the most important managers in the long history of the **Burgtheater** in **Vienna**. Under his administration there (1890–1898), he opened the Burg's repertoire to the work of several playwrights the Burg had neglected or shunned, including Henrik Ibsen, **Gerhart Hauptmann**, **Arthur Schnitzler**, and **Hugo von Hofmannsthal**; Frank Wedekind and **Carl Sternheim**, however, remained largely unperformed. Burckhard was also responsible for luring some of the best Austrian performers of the era back to Austria after they had been working for lengthy periods elsewhere, including **Josef Kainz**, **Hedwig Bleibtreu**, **Adele Sandrock**, and **Friedrich Mitterwurzer**. Schnitzler based the likable character of Dr. Winckler in *Professor Bernhardi* largely on Burckhard.

BURG. *See* BURGTHEATER (VIENNA).

BÜRGER SCHIPPEL (*Citizen Schippel*) by **Carl Sternheim**. Premiered 1913. Sternheim's comedy is ostensibly about an amateur singing contest, but its true subject matter is class distinctions and prejudice. Three respectable members of the middle class need a

tenor for their quartet to help them win first prize again in a local competition. They grudgingly recruit a local masonry helper (Schippel) because of his superb singing talent. The quartet wins the prize, and one of the original three offers his sister to Schippel as a token of his gratitude; Schippel feels insulted, because the sister is "damaged goods," having recently slept with a local aristocrat. Yet one of the other original three singers agrees to marry the sister and challenges Schippel to a duel from a misplaced desire to preserve her honor. Schippel agrees to the duel and slightly wounds his challenger. Everything ends happily, and Schippel becomes a fellow snob with his acceptance into "good society."

BURGTHEATER (VIENNA). In 1741 the Habsburg empress Maria Theresa (1717–1780) leased a reception hall next to the royal and imperial palace, the Hofburg, to Karl Josef Selliers (1702–1755) for the purposes of presenting plays to her court. Selliers was at the time director of the Kärntnertortheater in **Vienna**, where he presented mostly operas and ballets. Maria Theresa's son and successor Joseph II (1741–1790) decreed the structure a "Teutsches Nationaltheater" (German National Theater) in 1776 and ran it himself, presenting plays by **Gotthold Ephraim Lessing**, **Johann Wolfgang Goethe**, and **William Shakespeare**; in 1778 he presented Wolfgang Amadeus Mozart's comic opera *Die Entführung aus dem Serail* (*The Abduction from the Seraglio*). Because of Joseph's personal involvement, the place developed a reputation for high production values and superb performances through the 1780s—including **Friedrich Ludwig Schröder**'s from 1781 to 1785. Joseph appointed Johann Franz Brockmann (1745–1812) the theater's first director in 1789. In 1794, the former reception hall became the "Royal and Imperial Court Theater Next to the Burg," or "Burgtheater"—often later shortened still further to "the Burg"—one of the most illustrious theaters in the German-speaking world.

From 1814 to 1832 **Joseph Schreyvogel** ran the theater, concentrating on classics and producing several **Franz Grillparzer** premieres. Schreyvogel's were among the first almost completely unabridged **Shakespeare** productions in the German theater. He was also responsible for the world premiere of **Heinrich von Kleist**'s *Prince Friedrich of Homburg* and several others by Grillparzer. Un-

der **Heinrich Laube** from 1849 to 1867, the repertoire became more modern, with numerous productions of plays by **Karl Gutzkow**, **Friedrich Hebbel**, and especially **Charlotte Birch-Pfeiffer**; as a result, Laube was among the first German directors to employ the box set consistently. His acting ensemble remained first rate, with several of the German theater's outstanding talents, including **Bogumil Dawison**, **Adolf Sonnenthal**, and **Charlotte Wolter**, under contract.

Franz Dingelstedt's administration (1870–1881) featured numerous lavish productions and the first Shakespearean cycle of history plays on a German stage. During the Dingelstedt period, plans for the construction of a new Burgtheater on Vienna's Ring Strasse began to take shape. After 14 years of construction the new facility, designed by Gottfried Semper and Karl Haenauer, opened in October 1888. It was among the first theaters in Austria to be completely electrified, though its acoustical problems were not solved until a decade later. That occurred under **Max Burckhard**'s administration (1890–1898), which saw an analogously electrifying new openness to the plays of Henrik Ibsen, **Gerhart Hauptmann**, August Strindberg, and **Arthur Schnitzler**. Burckhard's successor was **Paul Schlenther**, a co-founder of the Freie Bühne in **Berlin**; his administration (1898–1910) continued the trend Burckhard had started.

The collapse of the Habsburg Empire in 1918 made the Burg a state theater, and as such it began to lose its status a premiere citadel of German theater culture. Private theaters such as **Max Reinhardt**'s attracted more attention from the public, largely because they could boast artistic talent more audiences wanted to see. Through the 20th century, the Burg had several capable administrators, along with numerous outstanding actors and actresses. In 1945 the structure was severely damaged in an Allied bombing raid, and repair of the damage required an entire decade before the building could reopen to the public.

Among the numerous directors to run the Burgtheater in the postwar period, **Claus Peymann** remained longest in office, from 1986 to 1999. His premieres of plays by **Thomas Bernhard**, **Elfriede Jelinek**, **Peter Handke**, Peter Turrini, and **George Tabori** went a long way toward attracting much wider media attention to the Burg, although the media attention and controversy the premieres attracted could not make up for the generally poor quality of the plays themselves. Under Peymann's administration, however, the Burg emerged

as one of the leading theaters in a newly conceived and unified Europe. The Burgtheater was no longer just a German-language institution; it was a cultural bulwark known throughout an entire continent.

BUSCH, ERNST (1900–1980). Actor. Busch began his career as an actor with the **Kiel** City Theater in 1921. He moved to **Berlin** in 1923 searching for work, but found little on offer until 1927, when the Volksbühne offered him several roles. By that time, however, he had established himself as a cabaret singer in numerous Berlin venues. In 1928 **Erich Engel** and **Bertolt Brecht** cast him in *Die Dreigroschenoper* (*The Threepenny Opera*), and he appeared in Georg Wilhelm Pabst's 1931 film version. In the late 1920s, Busch had begun recording songs extolling class consciousness and the German Communist Party, many of which were part of his cabaret act. Up to the National Socialist election victories and their ultimate takeover of government in 1933, he had the image of a genuine working-class hero instead of an actor.

Busch fled to Amsterdam in March 1933 and later to London; in 1934 he presented his cabaret act in Zurich and Paris, and in 1936 he toured the Soviet Union. In 1937 Busch fought against Franco's forces in the Spanish Civil War, but with the Nationalist victory in Spain, he escaped again to Amsterdam. Busch was in France when the Germans conquered that country, and he was arrested and interned in various camps. In 1943 the Gestapo in Paris sent him to Berlin, where he was tried for high treason and sentenced to death. There is substantial evidence that **Gustaf Gründgens** intervened on his behalf and got his sentence reduced to four years at hard labor. At any rate, he was still alive in the Moabit prison when Soviet troops conquered Berlin in April 1945.

Busch began working steadily at the **Deutsches Theater** in 1945, and in 1946 he was instrumental in helping Gründgens gain his release from Soviet custody, since Busch's credentials as a Communist Party member were impeccable. He worked with Brecht beginning in 1949, appearing in several **Berliner Ensemble** productions, most notably playing Azdak in *Der kaukasische Kreidekreis* (*The Caucasian Chalk Circle*) in 1954. In 1957 he played the title role in Engel's Berliner Ensemble production of *Leben des Galilei* (*The Life of Galileo*) at the **Theater am Schiffbauerdamm**.

Busch's career as an actor flourished until late 1960, when he had a serious falling out with the leadership of the Socialist Unity party that ruled East Germany. There were reports that he had slapped the face of Erich Honecker, the rising star of the party who was later to become its boss. The contretemps with Honecker did little to advance Busch's work as an actor, and most observers at the time felt that Busch's retirement "for health reasons" (he lived another two decades) lent credence to reports that he had become persona non grata with the regime. Still, the shooting for the film version of *Mutter Courage und ihre Kinder* (*Mother Courage and Her Children*), with **Helene Weigel** reprising her stage work in the title role, was already complete, and the film's release in 1961 was allowed to proceed despite Busch's prominent presence in it (he played the cook).

Busch's recording career continued unhindered through the 1960s and 1970s. He was considered, even by party stalwarts, to be the interpreter of Hanns Eisler's (1898–1962) music nonpareil, and Eisler himself described Busch as "the singing heart of the German working class."

– C –

CARL, CARL (Carl von Bernbrunn, 1787–1854). Manager, actor. Carl began his career as an actor at **Vienna**'s Theater in der Josephstadt under the name Carl Meier. He left Vienna soon thereafter when he got engagements in numerous **Munich** theaters, among them the Ducal Garden Theater and the Isartortheater; he ultimately became director of the latter. In that position, he began to stage his own comedies, featuring himself as "Staberl," a variation on the **Hanswurst** character. Carl opened an acting school in Munich and in the 1820s emerged as that city's most significant theater artist. During summers, he leased theaters in Vienna to showcase his playwriting and acting talents; in 1826 he leased the Theater an der Wien, and the following year he leased the Theater in der Joephstadt, making his departure from Munich permanent. At the Theater in der Josephstadt, Carl attracted several outstanding talents to work with him, most notable among them **Johann Nepomuk Nestroy** and **Wenzel Scholz**. In 1838 he bought the Theater in der Leopoldstadt, establishing that theater as Vienna's most important venue for comedy by premiering

more than 30 Nestroy comedies. Carl had the Theater in der Leopold-stadt leveled in 1847 and rebuilt it as the Carl Theater, where he continued to premiere Nestroy's work. When Carl died, Nestroy assumed the theater's directorship.

CASPAR, HORST (1913–1952). Actor. After studies with **Lucie Höflich** in **Berlin**, Caspar made his debut in 1933 and ultimately became a member of **Heinrich George**'s company at the Schiller Theater in Berlin. There he established himself in heroic parts such as Don Carlos, Tasso, and Hamlet. Caspar had a film career of sorts during the Third Reich, playing both a leading role in a 1940 version of *Die Räuber* (*The Robbers*) and **Friedrich Schiller** in a 1940 film titled *Friedrich Schiller: Triumph of Genius*; in a wig and costume characteristic of the late 18th century, Caspar looked a lot like Schiller. His appearance as a "German heroic type" enamored him of many in the Nazi hierarchy. After World War II, Caspar became a member of **Gustaf Gründgens**'s company in Düsseldorf, playing more mature roles such as Faust—not always an enviable task if Gründgens was playing Mephisto.

CASTORF, FRANK (1951–). Director, **intendant**. Castorf is, in the minds of many, the best director (certainly among the most decorated) born after World War II currently working in the German theater. The influential monthly *Theater Heute* has named him Germany's "director of the year" five times; he has also received the Schiller Prize, the Nestroy Prize, the Kortner Prize, and the Friedrich Luft Prize, in addition to numerous other citations for his work. Those include a dozen invitations to the Berliner **Theatertreffen** between 1991 and 2005.

Castorf completed theater history studies at Humboldt University in East **Berlin** in 1976 and soon thereafter began directing plays in a series of tiny provincial East German theaters. The regime forbade him from working in East Berlin due to the tenor of his productions and his frequent attempts to stage plays that the regime had forbidden. However, when East Germany disintegrated along with other Warsaw Pact countries in 1989, Castorf found himself in demand throughout former West Germany, perhaps in part because of his well-publicized (in the Western media, at any rate) jousting with the

East German authorities during the 1980s. He accepted invitations to direct plays in the West, but concentrated on staging formerly "problematic" plays in the former East Germany, almost as if he were testing the historical reality of the Berlin Wall's collapse.

Castorf became established in Berlin—in the former eastern sector—as principal director of the **Deutsches Theater** from 1990 to 1992. In 1992 he accepted the position of intendant of the Volksbühne, which likewise is located in what was East Berlin. In that position, he is scheduled to remain at least until 2007. Among his numerous stagings invited to the Berliner Theatertreffen was his 2001 adaptation of Tennessee Williams's *A Streetcar Named Desire*, which he retitled *Destination America* (a variation on the German title of *Streetcar*, which is *Endstation: Sehnsucht*, literally "Destination: Longing").

CENSORSHIP. The **Gottsched-Neuber** reforms of the 1730s had firmly established in both the public and the aristocratic consciousness that theater was a moral institution with responsibilities for *Bildung* (a term meaning cultural education and refinement). **Friedrich Schiller**'s subsequent deliberations on the role of theater as a moral institution added weight to the argument that theater had a special function in German society. The Napoleonic wars of the late 18th and early 19th centuries, however, prompted a reappraisal of such notions, and the Carlsbad Decrees of 1819 were the result. These decrees were drafted at a conference of German states in Carlsbad (now in the Czech Republic) and later enacted into law as a means of counteracting revolutionary sympathies. Their numerous provisions provided for uniform press censorship and strict governmental supervision of both rehearsals and performances.

In March 1820 the Prussian government set a precedent for most German states and principalities by codifying censorship as a matter of police enforcement. The 1820 codification was in many ways an extension of 18th-century reform movements, since censorship perpetuated the fiction of the ruler's role as "trustee for his people," assuring them of good taste and appropriateness in theatrical fare. Most courts throughout Germany and Austria made frequent pronouncements about guaranteeing the "validity" of theater by keeping "vulgarity and disrespectful expressions at a genteel remove from the

stage," but those pronouncements "rang hollow . . . in light of the sovereign's disregard of the theater in every other respect except censorship" (Hans Knudsen, *Deutsche Theatergeschichte* [Stuttgart: Kröner, 1970], 319).

Court theaters were exempt from official censorship, since they came under the exclusive jurisdiction of the local ruler, but local rulers were loath to present themselves as nonconforming to the larger, more powerful courts (such as Prussia), under which they operated even in the 19th century as feudal vassals. The police theater censor made his official debut in Prussia on 16 March 1820, after a decree by Prince Karl von Hardenburg (1750–1822) granting the royal police minister responsibility for theater performances. Censorship took place thereafter in **Berlin** under the jurisdiction of a "royal presidium [established] for all theaters, those crown administered excepted . . . whose jurisdiction shall extend to all published and nonpublished tragedies, dramas, comedies, and/or musical plays, which, without expressed permission of the royal presidia or those persons assigned authority to grant said permission, may not be performed" (H. H. Houben, *Polizei und Zensur* [Berlin: Gersbach, 1926], 102). In other words, court theaters were expected to censor themselves (which they nearly always did) but private theaters were to be strictly supervised.

In 1848 censorship protocols appeared to change substantially in the aftermath of street riots and calls for a republican parliament among most of the German states. A "Cabinet Order" by Prussian king Friedrich Wilhelm IV liberalized the 1820 decree, stating that theater censorship was "incompatible" with the "basic legal provisions of free speech." The order called for the elimination of theater censorship. On 31 January 1850, a new Prussian constitution went into effect; Article 27 granted "every Prussian" the "right through word, print, writing, and visual means to express his opinion," but the Berlin police began immediately to look for ways to extend their jurisdiction over theater, since "presentation" (*Darstellung*) was not officially spelled out in Article 27. In February 1850 the Royal Police Presidium issued regulations that required officers to file official reports on theater performances "if the content of the play offers anything suspicious" (Houben, 104). In December 1850 Berlin police chief Karl Friedrich von Hinckeldey (1805–1856) issued a police di-

rective that successfully excluded theater from the freedoms of Article 27. In **Vienna**, the Habsburg court was no less flexible. **Johann Nepomuk Nestroy** lampooned his problem with Austrian censors in his *Freiheit in Krähwinkel*:

> A censor is a pencil who has taken human form, or a human being who has become a pencil, an eraser become flesh hovering over the human imagination, a crocodile who lingers along the banks as the river of ideas flows by, easing into the water to bite off the heads of writers.

That line was cut by Viennese censors and not allowed to be performed.

The unification of the German Reich in 1871 left intact the essentially unrestricted power of police to censor the stage, largely because the vast majority of theater producers, managers, agents, and actors liked the system as it was. The idea of theater as a moral institution usually implied state support of one kind or another, even if that meant restrictions on subject matter. The highly publicized Ladenburg-Kugler Plan (proposed by an official in the Prussian Culture Ministry named Adalbert von Ladenburg and an art history professor named Franz Kugler) encouraged state control of theater so long as the state subsidized it. The plan called for raising the artistic standards of provincial stages, cultivating participation in those theaters among provincial governments, rationalizing the system of taxation on box office sales, implementing qualifications for managers of theaters, creating real training institutes for young theater artists, regulating royalty payments to playwrights and composers, developing a pension plan for performers, and finally establishing a set of regulations by which all legal questions regarding theater performance could be settled. There was great hope that such measures might be implemented; in the end, none of them was. It remained for private organizations such as the Deutsche Bühnenverein (German Producers' League), Genossenschaft deutscher Bühnenangehöriger (Society of German Theater Artists), Pensionanstalt für Theaterschaffende (Theater Artists' Pension and Retirement System), and Vereinigung künstlerischer Bühnenvorstände (Organization of Theater Boards of Directors) gradually to realize the points of the Ladenburg-Kugler Plan over the next half-century.

Cracks in the censorship façade began to appear as well, as talented lawyers such as Richard Grelling (1853–1929) successfully appealed

police decisions in Prussian courts, allowing **Oskar Blumenthal,
Otto Brahm, Max Reinhardt, Viktor Barnowsky**, and others to
present plays by **Frank Wedekind, Gerhart Hauptmann, Carl
Sternheim**, and **Arthur Schnitzler** to the general public. Police cen-
sors usually used language of moral outrage when banning a play or
calling for changes in a script. They found the use of the "inherited
disease theory" [in Henrik Ibsen's *Ghosts*] causing brain damage, for
example, inappropriate for a "family drama." When Sigmund Lauten-
berg attempted to do **Max Halbe**'s *Der Amerikafahrer* (*The Traveler
to America*), censors demanded that a male cast member not touch an
actress's bloomers but "rather her back or at most the hem of her
skirt." Censors banned the use of German words or words in lan-
guages the audience might understand that could cause offense: they
forbade *Weiber* (wenches) and *Roué* in *Der kleine Schwerenöter* by
Leon Gandillot and *Mieder* (corset) in *Marquise* by Victorien Sardou
and disallowed an actor from undoing his suspenders in *Dr. Jojo* by
Albert Carré. Grelling usually got permission for managers to present
plays in question if certain offensive portions of the script were omit-
ted; Reinhardt got permission from the police to do *Frühlings
Erwachen* (*Spring's Awakening*) by arguing that the high ticket prices
and the small capacity of the Kammerspiele would attract a wealthy
clientele unlikely to stir up trouble.

With the collapse of the Second Reich in 1918, most censorship
protocols collapsed with it. For about six years, the German theater
experienced unprecedented freedom from governmental interven-
tion. After the death of President Friedrich Ebert (1871–1925), how-
ever, local jurisdictions began to ban plays, often using the same ar-
guments frequently heard in the Wilhelmine period; in many cases,
courts upheld their decisions.

Under the Nazi dictatorship, censorship did not officially exist.
Theaters were supposedly independent entities and remained theoret-
ically autonomous, allowing artistic freedom fancifully to flourish.
But **Joseph Goebbels**, in his capacity as propaganda minister, held
complete executive authority over all professional theater activity in
Germany and ultimately its annexed territories. Theater directors had
to submit all plays for approval to the Propaganda Ministry, whose
officials merely wanted to examine plays "to insure that the German
Volk and its ethnic sensibilities would not be injured" (Hildegarde

Brenner, *Die Kunstpolitik des Nationalsozialismus* [Hamburg: Rowohlt, 1963], 16).

The German Democratic Republic employed a similar procedure to assure conformity with state goals for the theater. The regime regarded theater in particular as "one of the most important facets of domestic policy, [assuming] artistic production . . . as a socially formative force" (H. G. Huettich, *Theater in the Planned Society* [Chapel Hill: University of North Carolina Press, 1978], 2). The "official" artistic policy was one of "socialist realism," which assumed that only "positive" portrayals of communist societies were feasible because such societies had achieved their major goals and were no longer subject to criticism.

> All preoccupation with art for its own sake, as well as with dilettantism, form, myth, and mysticism of any kind, had to be negated. Art had simply to be functional, and as such, supportive of the Party while accessible to the intellects and feelings of the majority of the people. [Theater] was assigned a central role in the social system as a planned, organized, and well integrated part of a cultural policy aimed at solidifying the people behind the Party. (Huettich, 11)

In West Germany, numerous localities sought to ban **Bertolt Brecht**'s plays in the 1950s, and in some instances those bans were effective. By the 1960s, however, Brecht's and most other plays, along with a myriad of performance styles, appeared with increasing frequency, a trend that continued beyond the collapse of the GDR and into the 21st century.

CHRONEGK, LUDWIG (1837–1891). Director, actor. Chronegk is best known as the director who staged most of the Meininger productions, but he began his career as a comedian in small provincial theaters. He signed his first contract with the Meiningen Court Theater in 1866, doing mostly **Shakespearean** roles. By 1871 he had become a director at the theater, and under his direction the company began its ascent to worldwide renown. Duke **Georg II** of Saxony-Meiningen named him director of the entire company in 1877 and subsequently bestowed upon him numerous honors. In addition to Chronegk's superb staging abilities, he was effective in forging an "ensemble" outlook among the company's actors. He was skillful in

dealing with actors' temperaments, convincing them they were part of a whole rather than simply supporting the work of a star. He was also instrumental in arranging the company's profitable tours throughout Europe between 1874 and 1890. The tours established the company as Europe's finest, and its influence continued well into the 20th century.

CLAVIGO by **Johann Wolfgang Goethe**. Premiered 1774. Goethe based this revenge tragedy on an episode from the memoirs of French playwright Pierre Augustin Caron de Beaumarchais (1732–1799), detailing the seduction and betrayal of his sister at the hands of a Spanish scoundrel named Clavijo. In Goethe's play, Clavigo indeed seduces and abandons Marie Beaumarchais and then departs for Madrid. There Beaumarchais finds him and forces him to write a letter of reconciliation to his sister. Clavigo, led astray by his companion Carlos, subsequently abandons Marie again, and she dies of shock. Beaumarchais then kills Clavigo.

Many critics condemned the play as an overdone sketch; when Beaumarchais saw himself portrayed on the stage in a 1779 Augsburg production, he said the play had incidents absent in the original event, revealing Goethe's "empty-headedness" and paucity of talent. *Clavigo* was nevertheless enormously popular with audiences throughout Germany, largely because of its perceived contemporaneousness.

CLEVER, EDITH (1940–). Actress. Clever is best known for her work with the Schaubühne am Halleschen Ufer. She grew up in the Rhineland but attended the Otto Falckenberg School in **Munich**; she thereafter had engagements through the 1960s in Kassel, Bremen, Zurich, and Munich. In Munich she met and worked with **Peter Stein**, whom she subsequently joined at the Schaubühne. Thereafter she achieved her most well-known work, remaining as a member of the theater's ensemble until 1979—though she returned periodically for individual productions. In the 1970s, her roles included Warwara in Maxim Gorky's *Summer Folk*, Ruth in **Botho Strauss**'s *Trilogie des Wiedersehens*, and Clytemnestra in Aeschylus's *The Oresteian Trilogy*. Clever became for audiences in Berlin the representative personality of the Schaubühne, as her stage presence struck many as riveting. It consisted of an intense psychic dislocation combined with

primordial power, though in her performances her power seemed to have turned self-destructively inward. Beginning in the mid-1990s Clever began directing plays and acting in one-woman shows. Numerous critics described her solo performance of **Johann Wolfgang Goethe**'s female figures, a collage of scenes she had assembled in 2000, as "the final chord of the Schaubühne era."

COLOGNE. Cologne (Köln) has for centuries been one of the most important cities in Europe—though it has rarely had any theatrical significance. It began as a Roman colony (*colonia* in Latin, from which Cologne takes its name) and military outpost in 38 B.C., and the present layout of the inner city retains the original Roman street design. In A.D. 50 it became Colonia Agrippinensis, named for the general whose troops set up the initial settlement, and since then it has remained an important juncture of commerce due first of all to its location on the Rhine, and because of the way trade routes developed over the centuries. It was home to hundreds of businesses operating in the Middle Ages, profiting from the commerce between England, Northern Europe, and Venice. Cologne by the 13th century had important links with major European commercial and banking centers, a university (the first German university, in fact, founded by a city council), and the seat of an influential Roman Catholic archbishopric.

Cologne lacked a theater history to match its stature as a major metropolitan center. Few individuals are associated with the foundation of a theater tradition there in the same way one thinks of **Gotthold Ephraim Lessing** with **Hamburg**, **Wolfgang Heribert von Dalberg** with Mannheim, **Karl Lebrecht Immermann** with Düsseldorf, or **Caroline Neuber** with Leipzig. Jacques Offenbach was a native of Cologne and its Rhenish environs, but Paris made his career possible. Several factors contributed to Cologne's comparative dwarfishness as a theater center, chief among them the occupation of the city by the French in 1794, which lasted until 1815. During that period Cologne's businessmen had little interest in developing theater as a means to maintain its German identity, nor did they concern themselves with promoting theater as a worthy trademark of the city the way their counterparts in other German commercial centers had begun to do. Cologne furthermore never benefited from the presence of a court in its midst that might have fostered theater as an object of

aristocratic pride. The leading lights of Cologne instead concentrated upon reorganizing the Carnival festival, along with completing the construction of the massive cathedral (construction of which had begun in 1248). They neglected the theater, and the result was a reputation for "one of the worst theater cultures in all of Germany," according to a lexicon published in 1841.

Theater culture suffered at the hands of city leaders, whose indifference down through the centuries mark Cologne as an exception to the general rule of most major German metropolitan centers. Touring companies nearly always encountered difficulties attempting to get permission for performances, even though Cologne's large and wealthy population and its numerous market squares would have made it a desirable destination for many troupes. The first professional troupe in Cologne was an English one in 1592, and in 1648 another English troupe performed *The History of the Royal Virgin and the Martyrdom of St. Ursula* in the municipal ball house in Apostel Strasse. The saint of the title was the local patron, and city fathers warmed to the totally fictitious connection in the play between Queen Elizabeth I and a Catholic martyr; they granted the English troupe a lengthy residence. Troupes from Holland, France, Poland, and Italy, along with numerous German troupes, followed during the remainder of the 17th century, most performing in the city's Haymarket Square. When such troupes attempted to extend residency permits, however, city officials almost always denied their requests.

Attempts to build permanent theater buildings likewise met with unusual impediments. Bankers were reluctant to grant loans to local entrepreneurs, though in 1784 a theater made of brick arose in what came to be known as Komödien Strasse. The city council declined to approve concessions granting monopolies to such undertakings, which would perhaps have ensured some degree of success. Performances in the Komödien Strasse facility often met with devastating reviews published in local newspapers. Critics complained about the inconvenient location of the theater building, the narrowness of the street on which the building was located, and the difficulty carriages had in arriving at the building.

In 1827 a City Theater arose, but it burned to the ground 20 years later. Its replacement likewise burned down in 1859, followed by the destruction of yet another replacement in 1869. The numerous at-

tempts to create permanent companies during the 19th century likewise ended mostly in failure. Cologne's population, while wealthy and conscious of the status accruing from a permanent theater company in its midst, lacked an intellectual middle class sufficiently influential to promote theater as a "moral institution," the Schillerian motto so successfully employed in other German cities to build audiences among the middle class. The University of Cologne had been closed during the French occupation, and it remained defunct until 1919.

By the turn of the 20th century, establishments with names like "Pleasure Palace of Greater Cologne" and "Great Hall of the Reich" were enjoying a profitable business. Another City Theater had been built, this time by the city government itself, which in turn leased it to a local producer. The most successful of producers who leased the Cologne City Theater was **Max Martersteig**, whose productions of **Johann Wolfgang Goethe** and **Friedrich Hebbel** between 1904 and 1911 were thought exceptional.

The "theater revolution" of the 1920s largely passed by Cologne unnoticed. The innovative **Gustav Hartung**, who had made a name for himself directing **Expressionist** productions in Frankfurt, came to Cologne in 1924 and lasted only one year. He had the support of then mayor Konrad Adenauer (1876–1967), but Hartung's productions of **Georg Kaiser**, **Fritz von Unruh**, and Eugene O'Neill never found much acceptance among Cologne audiences. An attempt was made in 1930 at the municipal theater to present **Bertolt Brecht** and Kurt Weill's *Die Dreigroschenoper* (*The Threepenny Opera*), but Adenauer felt compelled to weigh in against any play by Brecht; an abridged version was later allowed to run. That same year a production of *'Tis a Pity She's a Whore* was attempted, but the producer was advised that the title had to be changed; even the benign title *Giovanni und Isabella* could not quiet public outrage regarding the plays's subject matter.

Only after World War II did Cologne attempt to build a theater reputation. The attempt was largely successful, as a dozen productions staged in Cologne were invited to the Berliner **Theatertreffen** between 1967 and 2000; 1981 was a particular high point, when three Cologne productions were invited. **Jürgen Flimm**, **Hansgünther Heyme**, **Luc Bondy**, and **Jürgen Gosch** have chosen to work on a regular basis in Cologne, an indication that the city's reputation has improved.

Perhaps Cologne's most significant contribution to the German theater is its Theater Archives and Museum, located in the nearby town of Porz-Wahn. Founded by Prof. Carl Niessen in 1929, it presently houses Germany's largest theater collection, administered by Prof. Elmar Buck of the University of Cologne's Institute for Theater, Film, and Television Research.

– D –

DAHLKE, PAUL (1904–1984). Actor. Dahlke studied theater history at Humboldt University in **Berlin** before taking acting lessons at **Max Reinhardt**'s school, beginning in 1927. He then began performing in boulevard comedies in Berlin, becoming an audience favorite as the young man frequently falling in and out of love. **Heinz Hilpert** began casting him in serious parts at the Volksbühne and later at the **Deutsches Theater**, and throughout the Third Reich, he remained with Hilpert, becoming one of the director's favorite young character actors. After the war, Dahlke worked for three years with **Erich Engel** in **Munich** at the Kammerspiele, and in the early 1950s he became one of Germany's most familiar German generals, playing the title role in numerous productions of **Carl Zuckmayer**'s *Des Teufels General* (*The Devil's General*). In the late 1970s, Dahlke began receiving numerous awards for his work, culminating in the Federal Service Cross in 1979.

DALBERG, WOLFGANG HERIBERT VON (1750–1806). Director, manager. Dalberg was among the most significant managers of the late 18th century, training such artists as **August Wilhelm Iffland** and **Friedrich Schiller** and creating what came to be an auspicious theatrical enterprise in Mannheim. As a court minister in the duchy of Würrtemberg, he received his appointment as "honorary director" of the Mannheim theater as a kind of hobby. He invited the Gotha company to reside in Mannheim in 1778, and one year later the Mannheim National Theater came into existence. From 1779 to 1796 (when the theater was temporarily closed due to the Napoleonic wars), Dalberg engaged numerous outstanding performers as part of his ensemble; many of them (like Iffland and **Ferdinand Fleck**) es-

tablished their careers under Dalberg, while others (like **Abel Seyler**) saw their careers rescued and even extended. Dalberg not only premiered Schiller's *Die Räuber* (*The Robbers*), *Fiesko*, and *Kabale und Liebe* (*Intrigue and Love*) but even named Schiller his theater's resident playwright. Dalberg also staged several new translations of **William Shakespeare**'s works. The best of them was *Julius Caesar*, which he premiered in 1785; *Timon of Athens* in 1789 was not so successful. Dalberg's own plays were even less successful, though several troupes continued to perform them periodically throughout the 18th century.

DANTONS TOD (*DANTON'S DEATH*) by **Georg Büchner**. Premiered 1902. Büchner completed his play about the French revolutionary icon Georges Danton (1759–1794) in 1835; the delay between its completion as a script and its premiere on the stage was due to many factors, including Büchner's premature death, the play's perceived stance in favor of revolution, and its large cast requiring at least a dozen outstanding actors. In it, the title character is counterpoised against Robespierre and St. Just, much as Danton was in historical accounts of the French Revolution. The play gives predominant focus to the subjective experience of Danton, his conscience-ridden revulsion against the crimes to which he was party, and ultimately his admirable courage. Danton rejects flight from France to spare himself the guillotine, and his thunderous denunciation of his opponents in the climactic third act seals his fate. Büchner adds a gripping final scene to the proceedings, as the wife of Danton's colleague Camille Desmoulins cries out to the bloodthirsty crowd "Long live the King!" assuring her own public decapitation.

DAVID UND GOLIATH by **Georg Kaiser**. Premiered 1922. Kaiser's "David" of the title is a small bank clerk named Möller and "Goliath" is a brewery owner named Magnussen. The play takes place in Denmark, where David is the embodiment of petty bourgeois honesty and unpretentiousness. Magnussen has helped Möller buy a lottery ticket, which later comes up a winner. Magnussen meanwhile has gone broke and employs all manner of ruses to get what he considers "his" share of the winnings. Möller resists him at every turn, even when Magnussen offers Möller his daughter in exchange for cash. They are

already in love, but Möller is appalled by the offer. When he discovers that the girl is actually poor, Möller accepts her and comes to her father's aid, his distaste for him notwithstanding.

DAWISON, BOGUMIL (1818–1872). Actor. Dawison was among the most celebrated of the virtuosi in the mid-1800s and the first Jewish actor to play Shylock in the German theater. Dawison was born in Warsaw, Poland, and worked for many years there as a newspaper clerk, teaching himself German and French. He made his first stage appearance in 1837 at a small Warsaw theater, where a touring troupe of German actors saw his performances and convinced him to study acting in **Berlin**. Dawison made his German-language debut in 1841 and by 1846 had been hired as an actor at the Breslau City Theater. Critics and audiences both praised his work in Breslau, where he got his first leading roles. From Breslau he went to the **Hamburg** Thalia Theater and later to the **Burgtheater** in **Vienna**. At the Burg in 1849, his breakthrough to stardom came in Otto Ludwig's *The Hereditary Forester*. He then went to the Dresden Court Theater and competed directly with **Emil Devrient**, whose restrained style was in stark contrast to Dawison's. Dawison's national reputation had reached its peak by 1865, and thereafter he mostly toured. His most successful tours were in America, where he did lengthy runs in New York. His performances in bilingual productions with Edwin Booth attracted unprecedented publicity in the English-language press of New York and got Dawison several offers to remain in America for months, earning him more money than any German performer before him. His emotion-laden, unpredictable renderings of **Shakespearean** characters were perhaps his most popular attribute, making him similar in many ways to **Ludwig Devrient**.

DEICHMANN, FRIEDRICH WILHELM (1821–1879). Manager. Deichmann built the Friedrich-Wilhelmstädtisches Theater in **Berlin**, the venue that subsequently became the **Deutsches Theater**. As a reward for his diplomatic services in Paris during the 1840s, the Prussian royal court granted Deichmann a performance license in 1848, permitting him to run an outdoor theater in Berlin's Schumann Strasse. Deichmann later enclosed the space and sought to imitate the vaudeville theaters he had seen in Paris. He began to feature *Lokalpos-*

sen, comedies which dealt farcically with local themes and characters, featuring a liberal admixture of local references and topical allusions. The "local comedy" at Deichmann's theater became what Gottfried Keller called "an anti-elitist dramatic form," contradicting the "experts" who at the time maintained that there was no lasting worth in treating the daily activities of ordinary people on the stage. Such fare became so successful for Deichmann that he renamed his theater for himself and in 1858 purchased the German-language rights to Jacques Offenbach's operettas. The operettas made Deichmann wealthy, and in 1872 he sold the Friedrich-Wilhelmstädtisches Theater for the then unheard-of sum of RM1.6 million. From the proceeds, he bought himself a large estate in Swinemünde and lived out his days taking walks along the Baltic seacoast.

DEKOWA, VIKTOR (Viktor Kowalczyk, 1904–1973). Actor. DeKowa was one of the most popular actors in the Third Reich. He was a member of **Gustaf Gründgens**'s company at the Prussian State Theater from 1935 to 1943, starring in several of that theater's most popular productions. As Lord Goring in *An Ideal Husband*, DeKowa "combined the talents of a cabaret conférèncier and a classical dramatic actor . . . speaking every line like an aphorism" (**Herbert Ihering**, "*Ein idealer Gatte* im Staatstheater," *Berliner Börsen-Courier*, 9 December 1935). DeKowa played opposite **Marianne Hoppe** in the State Theater's world premiere of Charlotte Rissmann's *Promise Me Nothing*, which ran longer in the theater's repertoire than any other contemporary play during the 1936–1937 season. In 1939, Gründgens teamed him with **Käthe Gold** in the sentimental romantic comedy *Karl III and Anna of Austria*. DeKowa appeared in more than a dozen movies during the Nazi period as well, usually in roles that required a young leading man and his love interest.

After the war, DeKowa began appearing in films again in 1947, but his most significant role in the postwar period was as the SS officer Schmidt-Lausitz in **Carl Zuckmayer**'s *Des Teufels General* (*The Devil's General*). That role marked his "graduation" to parts in the 1950s requiring more maturity. He was awarded numerous citations for his work in the postwar period, a demonstration perhaps of how successful he had become in putting memories of his reputation as a "Nazi heartthrob" behind him. In 1961 he received the Federal Service Cross,

in 1962 the Ernst Reuter Medallion from the city of **Berlin**, in 1963 the Mérit Civique from the French government, and shortly before his death the Great Service Cross of the Federal Republic from Chancellor Willy Brandt.

DEUTSCH, ERNST (1890–1969). Actor. Deutsch is most closely identified with his roles in **Expressionist** plays, and indeed many consider the precedents he set in such plays as **Walter Hasenclever**'s *Der Sohn* (*The Son*) to be the model that subsequent "expressionist acting" followed. His interest in acting began in his native Prague, where along with future authors Franz Kafka and Franz Werfels he regularly attended productions at the city's Deutsches Theater. In 1914 Deutsch made his stage debut at the **Vienna** Volksbühne, and in 1916 he enjoyed his first taste of national acclaim for his perform-ance in Dresden as the title character of the aforementioned *Der Sohn*. Soon after that Dresden premiere, Deutsch became a regular member of **Max Reinhardt**'s company at the **Deutsches Theater** in **Berlin**, where he remained until 1933. There he appeared in Expres-sionist plays such as **Georg Kaiser**'s *Von Morgens bis Mitternachts* (*From Morn to Midnight*), but also in popular realistic American plays such as George Manker Hopkins and Arthur Watters's *Bur-lesque*, Maxwell Anderson and Laurence Stallings's *What Price Glory?*, and Eugene O'Neill's *Strange Interlude*.

Throughout the 1920s, Deutsch's angular facial features, thin frame, and abrupt, seemingly painful movement style placed him in demand as a silent film actor. Many of the films in which he appeared capitalized on his Expressionist tendencies toward the bizarre and even the freakish. Those films included *Vom Schicksal erdrosselt* (*Strangled by Fate*), *Die Tochter des Henkers* (*Daughter of the Hang-man*), *Die Frau im Käfig* (*The Woman in a Cage*), and *Der Golem* (*The Golem*). He later appeared in film versions of *Burlesque* and *From Morn to Midnight*.

Deutsch was forced to flee Berlin in 1933. He returned to his na-tive Prague and later went to Vienna, but by 1938 he had settled in Hollywood, finding work under the name Ernest Dorian in films playing Nazis, German spies, or Wehrmacht officers. His most well-known English-language role, however, came in 1949 as Baron Kurtz in *The Third Man* with Orson Welles and Joseph Cotten. In the 1950s

he played the title role in **Gotthold Ephraim Lessing**'s *Nathan der Weise* (*Nathan the Wise*) more than 2,000 times in tours throughout the German-speaking world. In 1973 the founders of the Junges Theater in **Hamburg** renamed the theater (founded in 1951) the Ernst Deutsch Theater.

DEUTSCHEN KLEINSTÄDTER, DIE (*The Small-Town Germans*) by **August von Kotzebue**. Premiered 1802. A merciless satire on German (and especially Prussian) provincialism, Kotzebue's action focuses on the mayor of Krähwinkel and his family. The town is fictional, but it serves as a humorous metaphor for a German stereotype: stubbornness, parochial thinking, and an overweening concern for titles after one's name. Kotzebue's central target is the mayor's wife, Frau Stahr, who finds her prospective son-in-law insufficient. She prefers Herr Sperling, whose titles include building and street inspector. The daughter's preference turns out to be the nephew of a nobleman with a list of titles of which Frau Stahr could only dream. The marriage is, after overcoming several minor bureaucratic hurdles, allowed to proceed.

The play has been performed thousands of times and has spun off several imitations and adaptations in several languages. **Johann Nepomuk Nestroy**'s *Freiheit in Krähwinkel* employed many of Kotzebue's assumptions about German provincialism.

DEUTSCHES SCHAUSPIELHAUS (HAMBURG). The "Hanseatic Republican Court Theater" was built as a manifestation of civic pride, a monument to **Hamburg**'s long-standing tradition of bourgeois support of the theater and a direct challenge to aristocratic pretension. A public stock corporation whose stated goal was the construction of a theater as "a bulwark against the hegemony of bad taste" offered shares to wealthy patrons and average citizens alike in the late 1890s, and the superb structure, in imitation of the **Viennese** baroque style, was completed in 1900. From that year until 1909, its director was Alfred von Berger (1853–1912), followed by a series of directors through World War II, all quite conservative; Berger, for example, rejected **Naturalism** out of hand. **Erich Ziegel** was perhaps an exception to the conservative rule, but he lasted only two years (1926–1928).

After the war, Arthur Hellmer (1880–1961) was the theater's **intendant,** preparing the way for its most famous and influential personality, **Gustaf Gründgens**, who was intendant from 1955 to 1963. Under his leadership, the theater enjoyed its greatest international renown, premiering several new plays (including **Carl Zuckmayer**'s *The Cold Light*, **Bertolt Brecht**'s *St. Joan of the Stockyards*, and the German-language premiere of John Osborne's *The Entertainer*). Its seating capacity of more than 1,100 makes the Deutsches Schauspielhaus one of the largest theaters in Germany. It was completely renovated between 1980 and 1984 and remains one of the premiere theaters in the German-speaking world, where significant directors and actors want to work.

DEUTSCHES THEATER (BERLIN). The Deutsches Theater remains one of the premiere venues in German theater history by virtue of **Otto Brahm**'s work there during his 10-year lease of the structure from 1894 to 1904, followed by **Max Reinhardt**'s ownership of it from 1906 until 1934; facing expropriation at the hands of the Nazis, Reinhardt in that year bequeathed it to the German nation. The structure had its beginnings in 1850 as the Friedrich-Wilhelmstädtisches Theater under its founder and builder **Friedrich Wilhelm Deichmann**. He sold it in 1872, after which it went through a series of owners until **Adolph L'Arronge** bought it and renamed it the Deutsches Theater. L'Arronge ran it himself until leasing it to Brahm in 1894, then selling it to Reinhardt. Reinhardt purchased an adjoining dance hall and named it the Kammerspiele (Chamber Theater, with 456 seats) and made it easily accessible to the main house.

During the Nazi era, **Heinz Hilpert** attempted to maintain the theater's illustrious history, since it had been the site of several important world premieres, where dozens of the German theater's most celebrated theater artists had established their careers or had done significant and influential work. The National Socialists maintained the structure admirably, and afterward the Communist regime of the German Democratic Republic did an even better job, given the damage the building sustained in World War II. The Deutsches Theater reopened in October 1945 with **Gotthold Ephraim Lessing**'s *Nathan der Weise* (*Nathan the Wise*).

In 1949 the Deutsches Theater became home to **Bertolt Brecht** and the **Berliner Ensemble**. It was named "State Theater of the German

Democratic Republic" that same year, and during the ensuing 40-year Cold War period, the Deutsches Theater had some of the best acting and directing talent of which the East German regime could boast. When the GDR collapsed in 1989, the theater entered a period of uncertainty. With the arrival of Bernd Wilms, its future stabilized, and with Wilms's reappointment as **intendant** in 2005 in the wake of serious infighting among **Berlin**'s governmental and cultural elites, the signal seemed clear that the Deutsches Theater would maintain its status as an important and dynamic landmark on the German cultural landscape.

DEVRIENT, CARL AUGUST (1797–1872). Actor. After serving in the Napoleonic wars as a cavalry officer, Devrient used the influence of his uncle **Ludwig Devrient** to get an audition with **August Ernst Klingemann** in Braunschweig, where he made his debut. In 1821 he was engaged for heroic roles at the Dresden Court Theater, where he remained until 1835. In Hannover three years later, Devrient began to play character parts; his Lear and William Tell were especially praised. **Ludwig Tieck** found him effective in mature roles, having witnessed his earlier work. His career was unfortunately blemished by frequent quarrels with his brother **Emil Devrient**. Carl Devrient was also the brother of **Eduard Devrient** and was the father of **Friedrich Devrient** and **Max Devrient**.

DEVRIENT, EDUARD (1801–1877). Actor, historian. With a career as an orchestra bassist well established by 1820, Devrient's parents hoped their son could avoid the acting trade, which they felt had plagued their family since the rise of uncle **Ludwig Devrient** to stardom in **Berlin**. To their shock and horror, Eduard abandoned instrumental music at age 43 and began acting in Dresden. By 1852 he had become director of the Karlsruhe Court Theater. Devrient's true success, however, lay in his probity as a theater historian. His five-volume *Geschichte der deutschen Schauspielkunst* (*History of German Dramatic Art*), published between 1848 and 1874, was the first of its kind: a detailed account of the German theater's history, often recounted from the standpoint of the actor. Eduard Devrient was the brother of **Carl Devrient** and **Emil Devrient** and the father of **Otto Devrient**.

DEVRIENT, EMIL (1803–1872). Actor. Emil Devrient's was perhaps the most versatile of all the talent among the Devrient family, playing

lengthy heroic parts such as Hamlet, the Marquis Posa, Toquato Tasso, and Prince Hal while singing bass roles in numerous operas. His career as both actor and basso began in Bremen; he continued in both professions when he went to Leipzig in 1828 and in **Hamburg**, where critics hailed his Hamlet as among the best of his generation. Devrient moved to Dresden in 1831, where he remained for the remainder of his career at the Court Theater with a concentration on spoken drama; from there he launched a company concomitant with his acting work in Dresden that toured England, among the first of its kind to play London in German. Emil Devrient was the brother of **Carl Devrient** and **Eduard Devrient** and the nephew of **Ludwig Devrient**.

DEVRIENT, FRIEDRICH (1825–1871). Actor. The son of **Carl Devrient**, Friedrich made his debut at the Court Theater of Detmold in 1845. He had a substantial career as an actor, and at one time appeared with his father at the Hannover Royal Theater in the same productions. Devrient never achieved the renown of his father or his uncles **Emil Devrient** and **Eduard Devrient**, nor did he work extensively in the same exalted venues as they. After his Hannover engagements, he appeared at the **Hamburg** City Theater, then went to Wiesbaden and from there to St. Petersburg in Russia, where he completed his career.

DEVRIENT, HANS (1868–1927). Actor, historian. The son of **Otto Devrient** and grandson of **Eduard Devrient**, Hans began his career as an actor in Weimar. He subsequently worked in a series of venues that included the Mannheim National Theater, the Frankfurt am Main City Theater, and the city theaters of Jena and Oldenburg before settling in **Berlin** to complete his doctoral studies. Devrient was then appointed professor of theater history in Weimar, where he wrote and edited several publications. Most notable among them was a history of **Johann Friedrich Schönemann**'s troupe, a drama survey of the 18th century, and a history of the Oberammergau passion play.

DEVRIENT, LUDWIG (1784–1832). Actor. Among the first German actors to earn the sobriquet "demonic," Devrient was an emblem of **Romanticism** on the German stage. He began his career in 1804 as "Ludwig Herzberg," whom audiences found utterly unconvincing.

When he began to play character roles and comedy in Breslau by 1807, however, he discovered his métier. In 1814 he joined the **Berlin** Royal Theater, and there he achieved his greatest renown. Many described him on stage as a riveting presence; his facial features were distinctively attractive, with eyes that could often transfix the onlooker. Devrient's chronic alcoholism contributed to his reputation as wild and unpredictable. As a character actor, he likewise baffled audiences when he played more than one character in the same play. As a guest artist in 1828 at the **Burgtheater** in **Vienna**, Devrient created a sensation as Shylock, as critics recognized in him "the manifestation of primeval Nature." He had abandoned completely any attempt at rhetorical delivery, concentrating instead on the bizarre, the extraordinary, and at times the repulsive. He became close friends with E. T. A. Hoffmann, who influenced Devrient's work substantially.

Devrient was "demonic" in the sense that he made an artistic virtue of being possessed, rather than having all his faculties under full control. Composer **Richard Wagner** was one audience member who came under Devrient's spell; after the performance Wagner said nobody would dare even whisper or make any movement because everyone was held by "a magic force no one had the power to withstand." Devrient is the subject of Hoffmann's 1817 essay "Strange Sorrows of a Theater Director" and was the main figure in Karl von Holtei's 1852 novel *Die Vagabunden* (*The Vagabonds*). Ludwig Devrient was the uncle of **Carl Devrient**, **Eduard Devrient**, and **Emil Devrient**.

DEVRIENT, MAX (1857–1929). Actor. The son of **Carl Devrient** by his second marriage, Max differed from his cousins by taking acting lessons from a teacher other than one of his relatives. He made his debut in Dresden during the 1878–1879 season. By 1882 he had established himself at the **Burgtheater** in **Vienna**, playing well-known character parts, even though he was only in his mid-20s at the time. Among his notable successes in the 1880s and 1890s were Gessler in *Wilhelm Tell* (*William Tell*), Mephisto in *Faust*, Brakenburg in *Egmont*, the devious Zawisch von Rosenberg in **Franz Grillparzer**'s *König Ottokars Glück und Ende* (*King Ottokar's Rise and Fall*), and Gloucester in **Shakespeare**'s *Richard III*. Devrient remained at the Burg for the remainder of his career and in 1920 became its chief director.

DEVRIENT, OTTO (1838–1894). Actor. The son of **Eduard Devrient** and trained for the stage by his father, Otto made his debut as a teenager in Karlsruhe while his father was that theater's director. Like his uncle **Emil Devrient**, he both acted in theater productions and sang opera. Devrient worked in a variety of leading venues during the 1860s, and by 1873 had become chief director at the Weimar Court Theater. In that auspicious locale he became nationally known for his portrayal of Mephisto in **Johann Wolfgang Goethe**'s *Faust*. In 1884 he became director of the Oldenburg Court Theater and, under Count Botho von Hülsen, director of the Berlin Royal Theater; there he remained until his retirement. Otto Devrient was the father of **Hans Devrient**.

DINGELSTEDT, FRANZ (1814–1881). Director, **intendant**. Dingelstedt is best known as a **Shakespearean** director both in **Munich** and in **Vienna**, though he began his career as a journalist and man of letters. He lost several editorial positions at newspapers due to frequent clashes with political authorities, but by 1846 he had become **dramaturg** at the Stuttgart Court Theater. In 1851 he was named intendant of the Munich Court Theaters and soon thereafter the king of Bavaria raised him to the aristocracy. In 1854 Dingelstedt attempted to create elaborate productions of Shakespeare's chronicle plays in Munich, casting the best actors then working. The results were a failure, but by 1857 he became intendant of the Weimar Court Theaters. In 1864 Dingelstedt staged a widely acclaimed cycle of Shakespeare's plays and helped to found the German Shakespeare Society. He became director of the **Burgtheater** in 1871.

DÖBBELIN, CARL THEOPHIL (1727–1793). Actor, manager. Döbbelin had a substantial career with **Caroline Neuber** and her troupe, playing the title role in the premiere of **Johann Christof Gottsched**'s ill-fated *The Dying Cato*. Döbbelin thereafter formed his own troupe, with which he toured until 1769 when he purchased the Theater am Monjoubiplatz in **Berlin**. He bought the Theater in der Behrend Strasse in 1775 and in that venue both staged and played the title role in the 1783 premiere of **Gotthold Ephraim Lessing**'s *Nathan der Weise* (*Nathan the Wise*). Döbbelin's became the first troupe to establish itself permanently in Berlin under a royal conces-

sion from the Prussian king in 1786, when the crown designated Döbbelin's troupe the *königliche preussische allergnädigste general-priviligierte National-Schauspieler* (Royal Prussian and All-Graciously Granted Holders of the National Concession for Acting) and permitted them to perform under court sponsorship at the Französiches Komödienhaus (French Comedy Theater) in Berlin on Gendarme Square.

DON CARLOS by **Friedrich Schiller**. Premiered 1787. Schiller's verse tragedy has enjoyed an extensive stage history, with productions every year since its premiere in **Hamburg** under **Friedrich Ludwig Schröder**. Its political subject matter is a familiar one in German drama, namely, the Spanish oppression of liberty during their occupation of the Low Countries from 1519 to 1581. Schiller's treatment is the most unwieldy, due to its numerous plot twists, yet it contains the best verse of any, along with some great speeches for actors. Critics for decades have vied with each other to identify the "greatest" Carlos, though most agree that among the best have been **Adalbert Matkowsky**, **Josef Kainz**, **Friedrich Kayssler**, **Fritz Kortner**, and **Klaus Kinski** under Kortner's direction in 1950 at the **Munich** Kammerspiele. Among the great Posas have been **Pius Alexander Wolff** and **Albert Bassermann**, though there is little doubt that the greatest King Philipp was its original, Schröder himself.

In the play, Prince Carlos loves his stepmother Elisabeth, to whom he was once in fact betrothed; his father King Philipp stole her from him. His confidant, the Marquis Posa, arranges a meeting between Don Carlos and Queen Elisabeth, to whom the prince confesses his abiding passion. Elisabeth does not reciprocate, but she convinces Don Carlos to agitate against the Spanish occupation of the Low Countries. Carlos requests permission from his father to go to the Low Countries as viceroy, but Philipp refuses and appoints the brutal Duke of Alba instead. Carlos, in despair, receives word that Elisabeth wants to meet him for a romantic rendezvous; he leaps at the bait, only to discover that Princess Eboli has come in Elisabeth's stead. The princess has a grudge against Elisabeth and reports an affair between her and Carlos to Alba and Philipp's priest-confessor, the evil Domingo. Philipp soon receives reports of the son's affair with his queen, but he distrusts Alba and Domingo. The king then appoints

Posa instead as viceroy to the Low Countries. The marquis pleads for the Netherlands with the king in a famous and oft-quoted speech ending with "Geben Sie Gedankenfreiheit!" (Grant freedom of thought!). When an emissary of King Philipp shoots and kills Posa, Don Carlos demands to be appointed in his stead to the Low Countries. In a final and heartbreaking meeting between Elisabeth and Carlos, Philipp has his son arrested and turned over to the Inquisition for torture and ultimately death.

There have been few English-language productions of the play, despite its enormous popularity as a basis for opera, including the famous version by Giuseppe Verdi. Richard Mansfield directed and starred in a 1906 version on Broadway. A popular production adapted by Mike Poulton under the direction of Michael Grandage transferred from its 2004 origin in Sheffield to London in 2005 with Richard Coyle as Don Carlos, Elliot Cowan as the Marquis Posa, Ian Hogg as the Duke of Alba, and Derek Jacobi in a stunning portrayal of King Philipp.

DÖRING, THEODOR (Theodor Häring, 1801–1878). Actor. Döring was a warehouse clerk in **Berlin** before he began working with the Urania theater club and later joined a troupe of strolling players in the early 1820s. By 1825 he was working regularly at a theater in Bamberg, where he used the name Döring for the first time. The next year saw him in Breslau, and from there he had successive engagements as a young character actor in Mainz, Mannheim, **Hamburg**, Stuttgart, and Hannover. In 1846, Berlin Royal Theater director Karl Theodor Küstner saw Döring's performances and hired him to a lifetime contract. Döring remained in Berlin for the rest of his career, praised for his remarkably supple movement, versatile voice, and gift for comic portrayals. He was Berlin's greatest Falstaff in the 1850s and 1860s, though he also played Orgon in *Tartuffe*, as well as numerous comic parts in plays by **Roderich Benedix**, **Louis Angely**, and **Eduard von Bauernfeld**. In 1872 Döring received the **Iffland Ring**, and three years later he became the first German actor to be awarded the Order of the Red Eagle from the German emperor.

DORN, DIETER (1935–). Director. Dorn is closely associated with theater work in **Munich**, where he worked for nearly a quarter-century leading the city's Kammerspiele. The city and the state of Bavaria

have honored him with several orders of citation. Dorn began theater studies in Leipzig but left the German Democratic Republic in 1956 to study in West **Berlin.** He remained there and began an acting career until the Staatstheater Hannover offered him a job as an assistant director in 1961, while working on radio broadcasts of plays in **Cologne** with the NDR (Norddeutscher Rundfunk) network. In 1964 he began directing plays full-time at the Hannover Landesbühne, and in 1968 he left for Essen and **Vienna**'s **Burgtheater.** In 1971 Dorn began working regularly in **Hamburg,** where he staged the German-language premiere of Christopher Hampton's *The Philanthropist*; it was subsequently invited to the Berliner **Theatertreffen** and helped establish Dorn's national reputation as a director.

In 1977 Dorn began work as the *Oberspielleiter* (chief director) of the Munich Kammerspiele, where he began his fruitful collaborations with actress **Cornelia Froboess.** His staging of **Gotthold Ephraim Lessing**'s *Minna von Barnhelm* with Froboess in the title role won him another Theatertreffen invitation, as did productions of **Botho Strauss**'s *Gross und Klein* (Big and Small) and **Frank Wedekind**'s Lulu plays, all of which prominently featured Froboess. His most monumental Kammerspiele production was a bizarre rendition of **Johann Wolfgang Goethe**'s *Faust, Part 1*, with **Helmut Griem** in the title role; Froboess played Martha in that production. Other Theatertreffen invitations included **Shakespeare**'s *Troilus and Cressida* and the Botho Strauss world premiere of *Schlusschor* (*Final Chorus*).

Dorn had several successes in Munich, and in the latter half of the 20th century he provided the city with a justifiable pride in its long-standing theater traditions. The city government nevertheless fired him from his Kammerspiele post in 2001. The next year, state government officials named him **intendant** of the Bavarian State Theaters, where he is scheduled to remain through the first decade of the 21st century.

DORSCH, KÄTHE (1890–1957). Actress. Dorsch began her career as an operetta soubrette at age 18 in the mold of Marie Geistinger and Josephine Gallmeyer, working initially in Mainz and soon thereafter in **Berlin.** There she performed regularly in the Admiralspalast Theater, becoming one of that theater's most appealing sopranos. In 1927 she decided on a career change and began accepting serious roles at

the **Volkstheater** in **Vienna**, and later at the **Burgtheater**. The change served to extend her career as a performer, and by the 1930s she was hired for several roles in plays by **Gerhart Hauptmann**, George Bernard Shaw, and Henrik Ibsen, culminating in her much-praised portrayal of Queen Elizabeth I in **Friedrich Schiller**'s *Maria Stuart*. She even convinced **Heinz Hilpert** and **Carl Zuckmayer** in 1931 to adapt Ernest Hemingway's novel *A Farewell to Arms* so she could play the sentimentally tragic Catherine Barkley, doomed to die in childbirth. During the Third Reich, Dorsch played several doomed heroines, none more ill-fated than Marguerite Gautier in **Gustaf Gründgens**'s popular 1937 production of *Camille*. Through her suffering, she seemed to attain a magisterial dignity, a quality on full display in the 1941 film *Komödianten* (*The Comedians*), a biography of the legendary **Caroline Neuber**.

Dorsch exploited her friendship with Hermann Goering during the 1940s to save dozens of lives. She had once been engaged to marry Goering when he was an air force lieutenant during World War I; he retained a sentimental attachment to her, of which she took full advantage for the sake of many former colleagues in prison or in concentration camps. She arranged for the escape of several Jewish families, whom she sometimes supported abroad from her own funds. Nazi authorities referred to her as "the Jewish mother" in the early years of the regime, but as the terror against Jews worsened, her tactics became more brazen. Dorsch came ever more fully to rely on the quixotic protection of Goering. Hers was a career like that of Gründgens—one fully immersed in political intrigue—yet her courage was based on inner conviction and a sublimity that often seemed to radiate from her on stage in performance.

Her postwar career included summer tours throughout West Germany and revivals of *Maria Stuart*. On the occasion of her retirement in 1953, she received numerous awards, including the Art Prize of the City of Berlin.

DORST, TANKRED (1925–). Playwright. Dorst is one of the few German playwrights whose first plays were written for the puppet theater. By the early 1960s he was writing for life-size actors, beginning with *Die Kurve* (*The Curve*, 1960). In 1968 he wrote *Toller*, a biographical treatment of **Ernst Toller**, a playwright with Marxist

revolutionary sympathies, largely because Dorst had by that time so strongly identified with Toller as a politically engaged idealist. In *Eiszeit* (*The Ice Age*, 1973), Dorst identified with Norwegian writer and playwright Knut Hamsun (1859–1952), who had supported Adolf Hitler and the German occupation of his native Norway. Dorst's best-known efforts were adaptations from other sources, particularly *Kleiner Mann, was nun?* (*Little Man, What Now?*), based on the novel by Hans Fallada (Rudolf Ditzen, 1893–1947) with **Peter Zadek** in 1972.

DRAMATURG. The office of dramaturg within a German theater's administration is closely bound to the idea of a theater with responsibilities for moral uplift and literary presentation. Few commercial theaters have had dramaturgs, but most subsidized institutions have had at least one on the payroll. Some have described the dramaturg's role as "in-house critic," but in most contemporary German theaters the role of dramaturg enjoys a status much higher than that. He may indeed function periodically as a critical observer, but his tasks also include responsibilities for helping to select repertoires, casting productions, translating or adapting plays, directing, serving as liaison with the media, editing programs, representing the institution to the public at large or to legislators who provide subsidies, dealing with agents, and perhaps a dozen other duties, either assigned to him directly by the artistic director or **intendant** or spelled out specifically in his contract.

Most observers agree that **Gotthold Ephraim Lessing** was the first dramaturg, though Johann Elias Schlegel (1719–1749) adumbrated the dramaturg's role in his 1747 treatise *Schreiben von Errichtung eines Theaters in Kopenhagen* (*Notes on the Establishment of a Theater in Copenhagen*). **Joseph Schreyvogel**'s role as dramaturg at the **Burgtheater** in **Vienna** ultimately permitted him to become the company's artistic director. **Ludwig Tieck** was certainly the most important dramaturg the Dresden Court Theater ever had, though his successor Karl Gutzkow became likewise well known. Some directors, such as **Otto Brahm** and **Bertolt Brecht**, have actively engaged in dramaturgical work while running their own theaters; other dramaturgs, such as **Botho Strauss**, have used the position as a springboard to successful playwriting careers. The most notorious misuse

of the term and office of dramaturg was **Josef Goebbels**'s appointment of Rainer Schlösser as "Reich dramaturg" during the Nazi dictatorship. Goebbels permitted Schlösser to strike terror among artists, since Schlösser was the Propaganda Ministry's chief enforcer of Nazi artistic doctrine in German theaters.

DREIGROSCHENOPER, DIE (THE THREEPENNY OPERA) by **Bertolt Brecht**; music by Kurt Weill. Premiered 1928. Brecht, greatly assisted by **Elisabeth Hauptmann**, created this musical by adapting the John Gay classic *The Beggar's Opera*, which had premiered exactly 200 years earlier. The Brecht-Hauptmann version attempted to place the action within a **Berlin** context, though none too successfully. Their attempt succeeded largely due to the efforts of Weill, whose music included 19 songs and orchestrations that were precedent-setting in their originality. The Berlin musical theater had experienced few opening nights comparable to 31 October 1928, when the show opened at the **Theater am Schiffbauerdamm** under **Erich Engel**'s direction. The action follows the Gay precedent almost entirely, though Brecht and Hauptmann gave events a Victorian background. The characters were Gay familiars, and Macheath was now called Mackie Messer, or "Mack the Knife."

In the first act, rumors reach the "Beggar King" Peachum that his daughter plans to marry Mackie, a possibility which fills both Peachum and his wife with trepidation. Women who marry Mackie have a tendency to turn up dead, so father and mother attempt to find their daughter and dissuade her from any matrimonial intentions. The next scene demonstrates the futility of their efforts, as Mackie and Polly Peachum relax in an empty livery stable, receiving wedding gifts and solicitations from friends and admirers, most of them partners in crime with Polly's father. Among the well-wishers is the sheriff of London, Tiger Brown, a friend of Mackie's from their days in the military. Back in Peachum's residence, Polly informs her parents that she is indeed Mackie's wife; they respond with threats to reveal her new husband's murderous background to the authorities. Polly swears loyalty to Mackie.

In the next act, Polly begs Mackie to flee London for his own safety, and Sheriff Brown tells Mackie he can no longer protect him. In a nearby whorehouse, Mackie makes his usual Thursday night

visit—where the police are waiting for him, tipped off by the Peachums. In prison, Mackie receives visitors, among them Lucy, the daughter of Sheriff Brown. Mackie has promised to marry Lucy, but she finds out he is already married. Mackie convinces her of his enduring love for her, and she promises to help him. Polly then appears for an unpleasant confrontation with her rival, but Mrs. Peachum gets Polly to leave—just as Lucy helps Mackie to escape from his cell.

In the final act, Peachum demands of Sheriff Brown the capture of Mackie, threatening to send all his beggars into the London streets to disrupt the upcoming coronation unless Mackie is found. In the final scene, Mackie is in prison, awaiting his date with the gallows. Just as he is about to face the hangman, the king's courier arrives with a pardon, along with the advice that injustice should not be taken too seriously. And besides, the courier notes, we all need a happy ending sometimes.

DREI ZWILLINGE, DIE (*The Three Twins*) by **Anton "Toni" Impekoven** and **Carl Mathern**. Premiered 1920. Among the most popular comedies of the early 1920s, Impekoven and Mathern take mistaken identity to nostalgic extremes in *The Three Twins*; the playwrights set the play in the idyllic days before aristocrats were forced to give up their seigneurial assets in the aftermath of the kaiser's 1918 abdication. It concerns the Falkensteins, a distinctly minor branch of German aristocrats who, through a mixup at birth, discover they must admit a new member to their family. That new member is the third twin of the title. Eberhard von Falkenstein, elder twin brother and heir to the Falkenstein estate on the Rhine, has been reared by his father Count Oktavio von Falkenstein according to the strict customs of their illustrious family. Eberhard is supposedly a few minutes older than his brother Krafft (they look nothing at all alike), although no one really knows for sure; the hospital in which they were born burned to the ground soon after their birth and all records were lost. The nurses had supposedly tied a red ribbon on the older twin's ankle, but in the confusion that ribbon was lost.

A wine merchant named Knäblein from nearby Bonn arrives to take orders for Count Oktavio's favorite beverage, the sweet Rhenish white wine of the region. Knäblein is a charming bumbler, but servants notice a stunning similarity between him and the younger twin

Krafft (stage directions call for the same actor playing Krafft to play Knäblein). When the servants introduce Knäblein to Oktavio, the count in dazed agreement says the merchant looks enough like Krafft to be his twin brother. Knäblein reveals that he was born in the same hospital as the Falkenstein twins. "Look," he says, "I've still got the red ribbon that was tied onto my leg when I was a baby!" Everyone now realizes that Knäblein is in fact the third twin of the Falkenstein family. The Falkensteins go into emergency session; they decide that Krafft must become heir and that Eberhard will have to settle for a lesser title. They swear among themselves to reveal nothing to Knäblein. But the affable Knäblein finds out anyway, and he is delighted at the prospect of owning a castle; even the dispossessed Eberhard is won over, observing that being bourgeois will be easier than being an aristocrat: no more getting up at 6:00 A.M. to ride the horses and inspect the estate, no more sitting through hours of lessons in noble behavior with his father—and he'll earn 60,000 marks a year as a wine merchant, far more than he ever would have had as Count von Falkenstein.

DREWS, BERTA (1901–1987). Actress. Drews had three distinct phases to her career: the Weimar period, in which she regularly played leading roles in some of the most popular plays in the German contemporary repertoire; the Third Reich, when she worked extensively with her husband **Heinrich George**; and the postwar period, playing mature parts while appearing in movies and television. Drews studied at **Max Reinhardt**'s acting school in **Berlin** and began working in Stuttgart. With **Otto Falckenberg** in **Munich**, she played Liza Doolittle in *Pygmalion*, Pirate Jenny in *Die Dreigroschenoper* (*The Threepenny Opera*), and Lulu and Countess Geschwitz in **Frank Wedekind**'s Lulu plays, along with many other roles by **Carl Zuckmayer**, **Bertolt Brecht**, and **Ferdinand Bruckner**. Drews returned to her native Berlin to join the Volksbühne company and married George in 1932. They worked together at the Schiller Theater in Berlin and in films until 1944. Soviet troops arrested both of them in 1945 and placed them in detention. Drews resumed performing in 1948, first at the Hebbel Theater in Berlin. Among the best of the mature character parts of this period was her Dr. Mathilde von Zahnd in **Friedrich Dürrenmatt**'s *Die Physiker*

(*The Physicists*). The best-known film in which she appeared was *Die Blechtrommel* (*The Tin Drum*), which won the Academy Award for best foreign-language film in 1980.

DUMONT, LOUISE (Louise Maria Hubertine Heynen, 1862–1932). Actress, teacher. Dumont became one of the most prominent theater artists and teachers of the 20th century, though she had established her acting career in the later decades of the 19th century. Her career as a theater manager began in 1904 when she and Gustav Lindemann founded the Düsseldorf Schauspielhaus, but she had already begun her unique contributions to German theater culture in 1902 when she established an actress's costume supply center called the "Zentralstelle für die weiblichen Bühnenangehörigen Deutschlands" (Clearinghouse for Female German Theater Artists). In an age when actresses were still expected to supply their own costumes, Dumont collected clothing from wealthy women and inventoried them for cost-free use. By 1906 she had launched an acting school in Düsseldorf alongside the Schauspielhaus, and students in the school began working in the theater alongside professionals as part of their curriculum. Dumont and Lindemann financed their operation on an entirely private basis, and the theater attracted positive critical notices from the beginning. In diametric opposition to many theater managers of the Wilhelmine era, Dumont believed the pursuit of profit was theater's ruin; she described her philosophy and her theater's work in a journal her theater published titled *Die Masken* (*The Masks*). With the Düsseldorf Schauspielhaus and *Die Masken*, Dumont began a trend in the German theater that was followed by Arthur Hellmer, who cofounded the Neues Theater in Frankfurt am Main; **Erich Ziegel**, who founded the **Munich** Kammerspiele; Ziegel and Miriam Horwitz, in **Hamburg** and later in Dresden; and Alwin Kronacher, who founded the Altes Theater in Leipzig. All of these were private undertakings, depending on box office traffic and wealthy benefactors to support their work.

Among Dumont's most outstanding students was **Gustaf Gründgens**, who claimed that Dumont and Lindemann taught him "respect for our profession and the fact that art can only prosper in the soil of truth and reality" (Heinrich Goertz, *Gustaf Gründgens* [Reinbek: Rowohlt, 1982], 15). One of the school's primary aims was "the complete education of the body as an obligatory field of study." Students

were required to take lessons in fencing, juggling, and circus techniques, along with various kinds of dance and movement classes. It was a curriculum unmatched among German acting schools at the time, and Gründgens credited Dumont and Lindemann with training that kept him flexible and supple for the rest of his career.

Sybille Schmitz was another Dumont student of note: she auditioned for Dumont as a teenager, over the strenuous objections of her parents and also those of Dumont's colleagues, who claimed Schmitz would be nearly impossible to cast. Dumont insisted on admitting Schmitz and awarded her a half-scholarship. Three months later, Schmitz was working regularly in Berlin.

Dumont became a well-established public personality in the 1920s; her friendships with politicians such as Foreign Minister Walther Rathenau (1867–1922) attracted public attention, as did her growing reputation as a widely published writer of cookbooks. During the 1920s Dumont's principal professional focus became the acting school, as she and Lindemann were forced to close the Schauspielhaus in the wake of the devastating financial crisis of 1923–1924. A street bears her name today in Düsseldorf.

DURIEUX, TILLA (Ottilie Godefroy, 1880–1971). Actress. Durieux was among the most provocative actresses on the German stage in the initial years of the 20th century. **Viennese** by birth, Durieux began her acting career in Olmütz and Breslau before coming to **Berlin** in 1903 to work with **Max Reinhardt**. He found her stunning beauty and irresistible magnetism invaluable for his **Frank Wedekind**, **Carl Sternheim**, and Oscar Wilde productions. She created sensations in the title role of Wilde's *Salomé* and later in Wedekind's Lulu plays, flaunting the characters' lascivious allure in a galvanizingly unwonted manner. Durieux also assisted Reinhardt with police **censors**; she "entertained" them on numerous occasions and often succeeded in getting performance bans lifted. Further, Durieux was instrumental in helping secure funding for Reinhardt and later in the 1920s for **Erwin Piscator**.

Durieux's first husband, Paul Cassirer (1871–1926), was a publisher and important art patron who assisted Reinhardt. Her second, the wealthy brewer Ludwig Katzenellenbogen (1877–1943), enabled Piscator in the late 1920s to lease the Theater am Nollendorfplatz. In

the early 1920s she worked with **Leopold Jessner** at the State Theater; critics hailed her performance as Countess Werdenfels in Wedekind's *The Marquis of Keith* for its "whorish hardness," combined with an intellectual depth that constantly flickered with wide-awake eroticism. Her films with **Fritz Kortner** during the 1920s, such as *Haschisch, das Paradies der Hölle* (*Hashish, the Paradise of Hell*), initiated her film career.

Durieux was the subject of several portrait paintings, most notably by Fanz von Stuck, Emil Orlik, and Pierre-Auguste Renoir. The Renoir painting now hangs in New York's Metropolitan Museum, showing her in the costume for Reinhardt's 1914 production of George Bernard Shaw's *Pygmalion*. In 1933 she escaped arrest (Katzenellenbogen was murdered in a concentration camp) and ultimately found sanctuary in the Croatian capital Zagreb, where she worked as a seamstress. She lived in Zagreb until 1955, when she returned to West Berlin and began a new career as a television actress. In 2004 the city of Berlin opened Tilla Durieux Park near Potsdamer Platz in her honor.

DÜRRENMATT, FRIEDRICH (1921–1990). Playwright. Swiss native and pastor's son Dürrenmatt became a leading playwright in the postwar period, primarily because his concerns with guilt, personal responsibility, and the exploitation of power found wide resonance in both Europe and the United States. His plays were sometimes compared with **Bertolt Brecht**'s; Dürrenmatt admired Brecht's dialectical approach and the theatricality Brecht employed, but Dürrenmatt was far less didactic in his approach. His characters, like Brecht's, often border on the grotesque—but unlike Brecht's they remain more accessible to audiences because Dürrenmatt never sermonizes. The actions of his characters—bizarre and grotesque as they often seem—are more connected to their motivations and seem less foreordained by the playwright.

Dürrenmatt established his reputation with the comedy *Romulus der Grosse* (*Romulus the Great*, 1949) and the absurdist *Die Ehe des Herrn Mississippi* (*The Marriage of Mr. Mississippi*, 1952); both proved to be popular, but his *Der Besuch der alten Dame* (*The Visit*, 1956) became a hit of international proportions. The latter is Dürrenmatt's best play, which he described as "a tragic comedy"; in it, he

calls into question the dueling ideas of collective guilt and retributive justice. It premiered at the Zurich Schauspielhaus under **Oskar Wäl-terlin** with **Therese Giehse** (Brecht's original Mother Courage) in the title role. Giehse was only 58 at the time, but she was highly effective as Claire Zachanassian (the "old lady" who makes "the visit"), who arrives in her poverty-stricken home town of Güllen to share her enormous wealth with the townspeople if they will murder Alfred Ill (played by **Gustav Knuth** in the premiere production), who long ago seduced, impregnated, and abandoned her. After much soul searching and deliberation, the townspeople do her bidding. The New York production of *The Visit* featured Lynne Fontanne and Alfred Lunt in the roles of Claire and Alfred Ill (named "Anton Schill" in New York) under Peter Brook's direction, with the same designer as for the Zurich world premiere, **Teo Otto**. Critic Brooks Atkinson called the play "a bold, grisly drama of negativism" (*New York Times*, 6 May 1958).

Dürrenmatt's "comedy" *Die Physiker* (*The Physicists*, 1961) is likewise a compelling duel, this time between insanity and sanity. A physicist named Möbius pretends to be insane in order to protect the world from his research discoveries. In the same institution (administered with ruthless efficiency by its chief psychiatrist, Dr. Mathilde von Zahnd) with Möbius are inmates who pretend to be Einstein and Newton; they turn out to be secret agents, and Dr. von Zahnd has also disguised her true identity. Or perhaps she is the one who is really mad, while the three inmates of her asylum are sane. The play owes a great deal to Pirandello in its conclusion, but Dürrenmatt's use of what he called the "functional grotesque" makes *Die Physiker* a wide-ranging examination of the limits to human reasoning and its power to resolve or even understand human dilemmas.

– E –

EGG, LOIS (1913–1999). Designer. Egg studied under **Emil Pirchan** in **Vienna** and brought much of his interest in abstraction, initially found in **Leopold Jessner**'s productions, to designs in Innsbruck (where she began her career). She later worked in Koblenz and in Prague (at the city's Deutsches Theater) during the Nazi dictatorship.

After the war, she worked extensively with **Heinz Hilpert** and at the **Burgtheater** in Vienna.

EGMONT by **Johann Wolfgang Goethe**. Premiered 1791. *Egmont* marks **Goethe**'s distinct departure from the emotional excesses of the **Sturm und Drang** (Storm and Stress) movement, though the play remains a hagiographic treatment of a hero's struggle. The hero is the title character, based on a historical Flemish figure executed during the Spanish occupation of the Low Countries. Egmont appears as an aristocratic man of the people, irresistibly charming and manly, yet impulsive to the point of impracticality. His love interest is Klärchen, whose infatuation with him produces swoons of desire that end in suicide. Egmont also has a magnetic effect on Margaret of Parma, sister of King Philipp and regent of the Low Countries until the arrival of the tyrannous Duke of Alba. Egmont can only forestall the inevitable after Margaret's departure; his desire for his country's liberation is impractical, especially when contrasted with that of his fellow conspirator William of Orange. Both William and Egmont are summoned before Alba; William wisely escapes, but Egmont foolishly complies—though it requires 50 armed men to carry him off to his waiting prison cell. In the play's concluding act, Egmont awaits his execution; Alba's son Ferdinand visits him in admiration, an implausible counterpoint to his father's oppression. The crowning touch of apotheosis comes at the play's conclusion, when a vision of Klärchen pervades the prison cell: she is the Spirit of Liberty, infusing Egmont with the courage he needs to face his execution as the sacrificial offering for the emancipation of his people.

EHRE, DIE (*Honor*) by Hermann Sudermann. Premiered 1889. Sudermann's play enjoyed abundant popularity through the Wilhelmine period, during some seasons being performed hundreds of times in theaters throughout Germany and Austria. It is a treatment of the class conflict between two families, one rich and one poor, featuring a voluble and attractive *raisonneur* named Count Trast. The role afforded numerous actors of the period opportunities for **Naturalistic** acting that rivaled those in plays by **Gerhart Hauptmann** and George Bernard Shaw. In *Die Ehre*, Count Trast enriches a young man who had sought an "affair of honor"—that is, a duel—with the wealthy

capitalist who had seduced his sister. The seducer had laughed off the young man's challenge because he did not possess the income to make him a social equal. Complicating the picture is the love of the wealthy daughter for the now enriched brother. The play was at the time considered Naturalist because it dealt, albeit superficially, with social distinctions; its reliance on well-made play techniques, along with Trast's declamations borrowed from Shaw, prevented it from consistent inclusion in repertoires into the 1920s. Like other Sudermann plays, it is today a mere curiosity.

EINEN JUX WILL ER SICH MACHEN (*Out on a Lark*) by **Johann Nepomuk Nestroy**. Premiered 1842. One of the funniest plays ever written in German, Nestroy based his farce on an 1835 English one-act titled *A Day Well Spent*. Thornton Wilder (1897–1975) adapted Nestroy's treatment in 1938 as *The Merchant of Yonkers*, and it subsequently became the basis of the Broadway musical *Hello, Dolly!* Tom Stoppard created an enormously successful adaptation titled *On the Razzle* in 1981. Nestroy treats the rise and fall, and rise again, of dry goods clerk Weinberl. Promoted to partner in a suburban Viennese spice emporium, Weinberl seeks a little spice in his own life with an evening of fun before he assumes the responsibilities recently awarded him. He and his companion Christopherl go through a series of mishaps that threaten the careers of both when they embark on unwonted adventures in riotous living. They soon get far more adventures than they had imagined possible, and Nestroy's masterful touch is apparent in every minor upheaval Weinberl and Christopherl confront, which include abundant mistaken identities, misunderstandings, calamities, confusion, and finally reconciliation. In the end, Weinberl proposes to a young widow—and to his astonishment she accepts. The play ends with the prospect of three weddings, with nobody the worse for wear.

EKHOF, KONRAD (1720–1778). Actor, manager. Ekhof directed the first full-time subsidized court theater with a repertoire in German, beginning in 1774 at the court in Gotha. Prior to that achievement, Ekhof had toured for decades, having begun his career with the **Konrad Ernst Ackermann**–Sophie Schröder troupe. Ekhof continued the effort with remnants of that troupe under the leadership of **Jo-**

hann Friedrich Schönemann, helping to establish theater in the German language as a respectable enterprise. Ekhof continued in the **Caroline Neuber** reformist tradition, distancing acting in particular from its dubious associations with prostitution, tooth pulling, and improvisation. He insisted that actors be literate, have good memorization skills, overcome the impulse toward self-aggrandizement, and continue to learn new roles throughout their careers. He applied those dictates to himself, which led in large measure to his success in roles by **Gotthold Ephraim Lessing**. His Tellheim in *Minna von Barnhelm* and Odoardo in *Emilia Galotti* helped to solidify Lessing's stature as a playwright, though Ekhof unfortunately continued to play these leading-man roles even into his fifties, somewhat tarnishing his earlier reputation. In 1764 he joined Ackermann's permanent troupe in Hannover, and later went with the troupe for its ill-fated attempt to found a theater in **Hamburg**. Ekhof was physically unimpressive, but he was blessed with a sonorous voice. He concentrated on acting in a subdued, unmannered style, convincing fellow actors to forgo grand gestures and vocal bombast in favor of a more measured performance that resembled everyday comportment. Lessing praised him extensively, holding him up in his *Hamburg Dramaturgy* as a model for all German actors to emulate. At the time of his death, several critics referred to Ekhof as "the father of German acting," though he had for the most part continued traditions that Neuber had already established.

EMILIA GALOTTI by **Gotthold Ephraim Lessing**. Premiered 1772. Lessing's tragedy has class conflict at the core of its action, and as such it had a strong influence on **Friedrich Schiller**'s *Kabale und Liebe* (*Intrigue and Love*), which treats a similar situation. In Lessing's tragedy, Prince Gonzaga lusts for the beautiful and middle-class Emilia, who is already betrothed to Count Appiani. Gonzaga commissions his servant Marinelli to disrupt the marriage festivities. Marinelli plans a holdup of the wedding coach, but in the process Appiani is killed. The perpetrators "rescue" Emilia and carry her off to Gonzaga's palace under "protective custody," since Marinelli has denounced Appiani as a traitor and implicates Emilia in the conspiracy. Gonzaga wants to bring Emilia to the estate of his chancellor, Grimaldi, for questioning. Emilia's father Oduardo is permitted a brief visit with his daughter, who pleads with her

father to spare her the inevitable disgrace that awaits her. She insists that he kill her with his dagger, and after anguished deliberation he does her bidding.

ENGEL, ERICH (1891–1966). Director. Engel was the ultimate "Brecht insider," working with **Bertolt Brecht** at a level that matched the influence of **Helene Weigel**, **Elisabeth Hauptmann**, and **Caspar Neher**. Altogether, Engel staged or closely collaborated with Brecht in the direction of eight significant productions or world premieres of Brecht's plays: *Im Dickicht der Städte* (*In the Jungle of Cities*, **Munich**, 1923), *Mann ist Mann* (**Berlin**, 1928), *Die Dreigroschenoper* (*The Threepenny Opera*, Berlin, 1928), *Happy End* (Berlin, 1929), *Mutter Courage und ihre Kinder* (*Mother Courage and Her Children*, Berlin, 1949), *Das Leben des Galilei* (*The Life of Galileo*, Berlin, 1957), *Herr Puntila und sein Knecht Matti* (*Mr. Puntila and His Servant Matti*, Berlin, 1949), and *Schweyk im Zweiten Weltkrieg* (*Schweik in the Second World War*, Berlin, 1962).

Engel had substantial actor training, but he began directing professionally at the **Hamburg** Kammerspiele after his release from the German army as a medical orderly in 1918. He encountered Brecht and Neher for the first time when he was working as a director at the newly renamed State Theater in Munich. Despite his extensive experience with Brecht, Engel worked steadily under the Third Reich. He was a gifted director of **Shakespeare**'s plays, and **Heinz Hilpert** hired him to direct Shakespeare almost exclusively at the **Deutsches Theater**. Engel worked extensively in movies in the 1930s, directing a high-profile version of *Pygmalion* in 1935 with **Gustaf Gründgens** as Henry Higgins. In 1945 he became director of the Munich Kammerspiele, and in 1949 he renewed his collaboration with Brecht, with the results noted above.

ENGEL, FRITZ (1867–1935). Critic. Fritz Engel was among the most conservative of the **Berlin** critics in the Wilhelmine and Weimar Republic periods. His criteria of judgment remained the axiomatic ideals of **Johann Wolfgang Goethe**, and stylistic departures such as **Naturalism**, **Expressionism**, and the more radical excrescences of the 1920s usually met with his disapproval. Engel wrote for the *Berliner Tageblatt*, and between 1910 and 1916 he was that newspa-

per's chief theater critic. His motto was "Theater criticism is not a guillotine; it is a scale of measurement."

ENGEL, WOLFGANG (1943–). Director, actor. Engel's theatrical career began in 1962 as a stagehand in the German Democratic Republic. In 1965 he passed the regime's standardized test for actors and began working in Schwerin as both an actor and an assistant director. In 1974 he was named director of the Saxony-Radebeul Regional Theaters. Through the 1980s he worked steadily as an actor and resident director at the Dresden State Theater, where his production of **Friedrich Hebbel**'s *Die Nibelungen* (*The Nibelungs*) won national attention and toured to **Munich**, Zurich, and **Vienna**. That production also won him a valuable contract to begin directing in West Germany, at the State Theater of the Saarland. He began working extensively in the West after the collapse of the GDR, but he returned to what was formerly East Germany in 1995 when he was named director of the Leipzig City Theater.

ENGLISCHE KOMÖDIANTEN (English Comedians). This name accrued to several English theater troupes that journeyed from London to Germany. The first arrived in Dresden about 1586 and sought protection and endorsement from the Saxon court. Other troupes from England followed, petitioning rulers in Kassel, Braunschweig, and Halle. They also toured the countryside, doing plays by Elizabethan playwrights, including **William Shakespeare** and Christopher Marlowe. By 1592 some English troupes began to recruit German performers, following the practice of casting boys in female roles. By about 1604 many of the troupes began to perform in German-language adaptations of Elizabethan plays. Rival German troupes began to form in competition with the originals, expanding the repertoire to include adaptations of French and Italian plays. Many scholars date their formation as the beginning of German professional theater.

ERDGEIST (*Earth Spirit*) by **Benjamin Franklin Wedekind**. Premiered 1898. The first installment of Wedekind's testament to female power, against which nothing can prevail. The playwright shaped the play to resemble a boulevard intrigue, but the audacity he invested in

the character Lulu, whom Wedekind portrays with the primal power of the Earth itself, terminates any further parallels to popular entertainment. Lulu is by no means a social climber as she might appear, nor is she an erotic tease; she is instead a force that consistently succeeds in overpowering male desire and dismantling it.

In a brief prologue, Lulu appears as a serpent in a small-time circus act, Wedekind's way of establishing biblical precedents for the action to follow. In the opening scenes, Lulu is married to Dr. Goll, who kills himself when he discovers Lulu with a painter who finds her irresistible. In the next act, Lulu has married the painter, but Lulu finds him boring. She is excited by Alwa Schön, a homosexual theater producer; Alwa's father, the rich Dr. Schön, becomes her lover, but he prepares to marry a more socially acceptable young lady. The painter discovers the Lulu–Schön relationship and kills himself. In the next act, Lulu has become a theater showgirl, pursued by aristocrats. Dr. Schön begs Lulu to behave herself; he cannot tear himself away from her, but he also lacks the courage to break off his engagement. Lulu says he should marry his fiancée anyway and takes delight in his weakness. She then sits him down and dictates a letter to the fiancée that he will sign, breaking off the engagement. In the final act, Lulu has married Dr. Schön but has also initiated a lesbian affair with Countess Geschwitz. Schön is in despair, realizing he has no power whatsoever over Lulu. She next seduces his son Alwa, and there is a touching father–son reconciliation. Meantime Lulu "entertains" schoolboys in the next room—but the Schöns, father and son, return with a pistol. The father demands that Lulu shoot herself. There is a struggle, and Lulu pumps several shots into him. Lulu pleads with Alwa to tell police that she shot only in self-defense. As the police pound at the door, a schoolboy emerges from the bedroom and laments, "They'll kick me out of school for this!"

While the events of the play are sensational, Wedekind's remarkable dialogue keeps the play riveted to his original intention. The characters do not speak to each other, nor do they listen to each other. They instead "speak past one another," a form of dialogue some have termed *Aneinandervorbeireden*, incorporating a conspicuous absence of intimacy. The character of Lulu has predictably sparked enormous controversy since the play's premiere (in which Wedekind himself at a late point in the production's run played Dr. Schön). Lulu has been

depicted as the personification of female sexuality, the female Don Juan, an erotic Angel of Death, an anarchic femme fatale, the projection of male wish fulfillment, and a host of other representations. Lulu in Wedekind's creation is, however, a force of Nature who transcends—or at least frustrates—most attempts at literary analysis. *See also BÜCHSE DER PANDORA, DIE.*

ERFOLG, EIN (*A Success*) by **Paul Lindau**. Premiered 1874. In this sentimental comedy, a journalist named Fritz Marlow has written a play titled *Ein Erfolg*, which is scheduled for production at the Court Theater. The director of the Court Theater, Herr Fallbein, has promised Fritz that the play will be an enormous success. Fritz's publisher Dr. Klaus, along with his wife Gertrud, agrees with Herr Fallbein, although they secretly are convinced that Klaus's unfinished comedy *Aristocracy and Industry* would have been a much better choice. They regard Fritz as a dilettante; after all, his book of poetry titled *Impending Darkness* sold only 11 copies! In the course of the play, Fritz learns that those 11 copies were all bought by a single patron, a young lady named Eva Drossen, and he sets out to meet this obviously insightful person. However, he has a rival in Baron Fabro, who is courting Eva as well. Fabro knows, as Fritz does not, that Eva is a rich heiress. On the night of *Ein Erfolg*'s premiere, Baron Fabro attempts to sabotage the production by stealing the second act of the prompter's copy. Fritz paces back and forth in the lobby, undone by anxiety. Eva encourages him and tells him not to worry; as the curtain comes down on the second act to thunderous applause inside the theater, they realize they are in love. But Baron Fabro is not finished with his schemes; he attempts to slander Fritz through the wife of a government minister and have his play suppressed. It turns out, though, that the minister's wife is a good friend of Eva's mother, both of whom see through the Baron's schemes.

ERNST, ADOLF (1846–1927). Manager, actor. Ernst was one of the most successful and prosperous theater managers in the Wilhelmine period. He began his career as an actor playing the "refined clown" in such comedies as **Paul Lindau**'s *Ein Erfolg* (*A Success*), **Gustav von Moser**'s *Der Veilchenfresser* (*The Violet Eater*), and Julius Rosen's *O diese Männer!* (*Ah, These Men!*). In 1879 Ernst rented the

Louisenstädtisches Theater in **Berlin**, and in 1888 he bought the place, renaming it after himself. He continued to offer popular comedies there, though he also did an extended run of Wilhelm Mannstaedt and Julius Freund's *Eine tolle Nacht (One Crazy Night)*, featuring circus performers in elaborate clownery, dance numbers, gymnastic movement, and singing. Ernst's most significant acting "discovery" was **Guido Thielscher**, whom Ernst cast in the title role of the German-language premiere of Brandon Thomas's *Charley's Aunt*. It proved to be so popular that Kaiser Wilhelm II ordered a performance of it at his private theater in Potsdam.

ESCHE, EBERHARD (1933–). Actor. Esche was one of the outstanding actors of the German Democratic Republic, whose vocal resonance and commanding presence on stage brought him several classical roles at the **Deutsches Theater** in **Berlin**, where he worked from 1961 onward. Esche began his career in Meiningen, Erfurt, and other East German regional theaters in the mid-1950s. Among his most significant roles at the Deutsches was Wallenstein, which he played beginning in 1979. Esche also appeared in several East German films, including the highly respected and controversial *Spur der Steine (The Trace of Stones)* in 1966.

ESSLAIR, FERDINAND (1772–1840). Actor, director. Esslair became one of the German theater's most renowned **Romantic** actors, despite his unusual height and lack of "heroic" good looks. "I cannot imagine a hero whose lady love comes up to his navel," said **Johann Wolfgang Goethe** of Esslair, though others were kinder in their estimation. Contemporary engravings reveal him as a distinctively handsome man, fully believable in heroic roles for which he became famous: Tell, Wallenstein, Lear, Claudius, and even Götz von Berlichingen. Esslair was a member of several provincial ensembles before he joined the **Munich** Court Theater in 1820 both as an actor and director. He had what many termed an "overpowering" voice. His acting style resembled **Ludwig Devrient**'s to a degree, though Esslair was perhaps more dependable for grandiloquence in gesture.

EVERDING, AUGUST (1928–1999). Director, **intendant**. Everding's work is closely associated with **Munich**, where he attended univer-

sity and studied under **Fritz Kortner** at the Kammerspiele. In 1955 he directed his first production there, and for the next eight years directed numerous Kammerspiele productions. In 1963 Everding was named the Kammerspiele's intendant, a post he retained for 10 years before briefly leaving Munich to become intendant of the **Hamburg State Opera**. In 1977 Everding returned to Munich as intendant of the Bavarian State Opera, and in 1982 he assumed responsibility for all of Munich's subsidized theaters.

EXPRESSIONISM. The term *Expressionism* as it applies both to German theater and to drama was a manifestation of modernism by about 1910, though the rejection of illusionism on which Expressionism was primarily based had set in a decade earlier. As an artistic movement, it began as a rejection of **Naturalism**, fed by Sigmund Freud's (1856–1939) ideas of the subconscious. As a dramatic style, it embraced self-referentiality, meaning that a play constitutes a self-enclosed world. An Expressionist play, therefore, is simply what it is; just as an Expressionist painting did not claim to represent something external to itself, Expressionist plays were worlds that existed in and for themselves. Some of the original Expressionist playwrights were in fact painters, for example, **Oskar Kokoschka** and Vassily Kandinsky (1866–1944), whose conception of character had little to do with motivation or dramatic action in the Aristotelian sense but rather as functions of a subjective experience. Other Expressionist playwrights shared Naturalism's partiality for social change, but most were concerned with innovations in dramatic structure. Many admired August Strindberg's later plays, which **Max Reinhardt** and others staged with unusual frequency after about 1912. They admired the self-conscious distortions Strindberg employed, creating characters who often existed largely in a self-enclosed environment.

Many well-known Expressionist plays were written prior to World War I, though most remained unperformed or unpublished until after 1918. Nearly all employed discontinuity, combined with a penchant for the fragmented, the fractured, and the discordant—all modernist signals to official Wilhelmine culture, which preferred the harmonious and the complete. The paucity of Expressionist plays on German stages before 1918 was due to police **censorship**, which during the war intensified. Reinhardt nevertheless succeeded in presenting

the world premiere of Reinhard Johannes Sorge's *Der Bettler* (*The Beggar*, subtitled *A Dramatic Mission*) in 1917, largely because Sorge had been awarded the Kleist Prize for it in 1912 and had died of wounds suffered in action on the Western Front in 1916. Most critics consider *The Beggar* the first Expressionist play of any significance in the German theater: it employed distortion at nearly every turn, featuring characters with only generic identities, speaking dialogue that was abrupt and condensed. The drab existence of the everyday disappeared in the swelling ecstasy of "essential experience," such as when the central character (known only as "the Poet") murders both his parents. Having done so, the Poet sloughs off all responsibility to society and is free to experience further ecstasies of his wholly personal and subjective "mission," per the play's subtitle. Playwrights subsequent to Sorge—chief among them **Walter Hasenclever**, **Georg Kaiser**, **Ernst Barlach**, **Arnolt Bronnen**, and **Ernst Toller**—employed similar devices and strategies, with uneven degrees of success. Kaiser was the most widely produced after World War I, *Von Morgens bis Mitternachts* (*From Morn to Midnight*) and *Die Koralle* (*The Coral*) the best known among them.

In performance, Expressionism required acting that renounced realistic portrayals or psychological nuances that informed motivation. **Ernst Deutsch** was regarded in the early 1920s as the "high priest" of Expressionist acting, though **Fritz Kortner**, **Werner Krauss**, **Agnes Straub**, and **Heinrich George** were at the time likewise regarded as experts in the technique. Expressionist acting sometimes required actors to alternate shrieking and whispering their lines, to move across the stage rhythmically or mechanically, and sometimes to gesticulate in a nightmarish fashion. Deutsch was thought particularly adept at rolling his eyeballs, for example; Kortner had an admirable ability to "telegraph" speeches when required or to make obscene passages sound poetic. **Jürgen Fehling** was particularly gifted as a director of actors in the Expressionist style; he also fashioned innovative ways of employing "body speech" when moving large numbers of actors in crowd scenes.

Expressionism in stage design and lighting influenced the work of directors such as **Leopold Jessner** in their productions of **William Shakespeare**, **Heinrich von Kleist**, or **Friedrich Schiller**. In the early 1920s, Jessner frequently outraged traditionalists who expected to hear

familiar passages delivered in a familiar way, only to hear Kort-
ner or Straub say things that were largely unintelligible. Scene design
reflected the premium on distortion. Window frames and doorways
narrowed upward, trees turned into skeletons, and shadows were
painted on walls. Lighting was perhaps the most obvious use of the
subjective viewpoint in Expressionism; spotlights often isolated char-
acters in the throes of torment or transports of revelation. Lighting also
served to provide abstract "stations" in plays which required them,
such as Kaiser's *From Morn to Midnight*. The most intriguing use of
Expressionist lighting took place in Jessner's 1919 production of
Richard III; the blood-red light focused on Gloucester at the height of
his power faded to a warm white glow by the time of his defeat at the
Battle of Bosworth Field at the hands of Richmond.

EYSOLDT, GERTRUD (1870–1950). Actress. Eysoldt was best
known for her androgynous portrayals of Puck in *A Midsummer
Night's Dream* and Lulu in **Erdgeist** (*Earth Spirit*), both under **Max
Reinhardt**'s direction. In them she was the abandoned yet resource-
ful waif, "the kind of child-like actress who fascinated Reinhardt his
entire career" (Edward Braun, *The Director and the Stage* [New
York: Holmes and Meier, 1982], 96). **Julius Bab** described her as
"sexless and gaunt, with the pointedly moving body of a boy and the
volatile, menacing mien of a cat" (*Die Frau als Schauspielerin*
[Berlin: Oesterhold, 1915], 76). For Reinhardt, she also played fe-
male roles in which she left no estrogenic doubt whatsoever, includ-
ing Oscar Wilde's Salome, August Strindberg's Miss Julie, and the ti-
tle role in his world premiere of **Hugo von Hofmannsthal**'s *Elektra*.
In those roles, she played diametrically opposite the traditional co-
quette of Jenny Gross or the soubrette of Marie Geistinger. Eysoldt
realized that the difference between herself and her predecessors lay
in "exaggerated stylization," which "reminded men of their impo-
tence, exploiting their lack of will power, [and] making [her charac-
ters] naïvely dangerous" (Gottfied Reinhard, *Der Liebhaber* [Mu-
nich: Knaur, 1973], 132).

Eysoldt began studies in music at the Royal Music School in **Munich**
and debuted at the Munich Court Theater in 1890. When she played
Hedda Gabler in a 1907 Reinhardt production opposite **Friedrich
Kayssler** as Lovborg, the atmosphere was charged with her complete

domination of Kayssler, making his gruesome suicide in a whorehouse seem foreordained. Eysoldt remained a member of the Reinhardt company while concomitantly performing Hedda, Salome, Lulu, Elektra, and Miss Julie in Dresden, Stuttgart, and her native Munich until 1920. In that year she became manager of the Kleines Theater in **Berlin** and its principal director, while continuing to teach at Reinhardt's acting school in the **Deutsches Theater**.

In 1986 the city of Bensheim, along with the Deutsche Akademie der Darstellenden Künste (German Academy of Performing Arts, located in Bensheim), began yearly to award the Gertud Eysoldt Ring to an actor or actress who, in the opinion of a jury, had created the most outstanding performance in a German theater of that season. Recent winners have been Ulrich Matthes in 2004 for his portrayal of George in Edward Albee's *Who's Afraid of Virginia Woolf?* at the Deutsches Theater Berlin; Dörte Lyssewski for her portrayals in 2003 of Charlotte in **Johann Wolfgang Goethe**'s *Clavigo* and the title role in *Hedda Gabler* at the Schauspielhaus Bochum; and Michael Maertens in 2002 for the title role in **Arthur Schnitzler**'s *Anatol* at the Akademie Theater in **Vienna**. The prize carries with it a 10,000-euro emolument.

– F –

FAHRENDE SCHÜLER IM PARADIES, DER (*The Wandering Scholar from Paradise*) by **Hans Sachs**. Premiered about 1550. In this play, a peasant wife laments the passing of her late husband when a "scholar" (i.e., a student on semester break) appears at her doorway and asks for money. The scholar says he has left Paris not three days ago, but she misunderstands him to have said "Paradise" and not "Paris." She asks if he saw her husband there, and the student says he did indeed—and he needed boots, a good pair of trousers, and money. The wife provides her guest with a bundle of clothing and a pouch with 12 gulden. The scholar accepts both but says he needs money as well for his trip. She gives him more money and he departs. Her present husband then enters and asks her why she's singing so joyfully. She tells of her chance meeting with a scholar from Paradise and how she gave him money and clothing for her late husband. The husband

immediately departs to find the scholar, vowing to beat him soundly. When he returns, he will beat his wife as well.

A curtain is pulled across the space, and the student stands before it, noticing a man on horseback coming his way. He hides the bundle behind the curtain as the peasant comes onstage, asking the scholar if he has seen a man burdened down with pack and guilt. The scholar says he has seen such a man, who ran directly into yonder bog. The peasant gives the scholar some coins and asks him to watch his horse as he departs into the bog looking for the miscreant. "Fair Fortune many thanks, and ease to ye, my weary shanks!" says the student, departing for the peasant's horse, which he intends to ride to a nearby inn called Paradise.

The curtain is then pulled back to reveal the peasant woman worrying about her husband, who has not returned for some time. The peasant enters from the side, and the wife asks if he found the "scholar from Paradise." He did, he says, and to speed him on his journey gave him his horse. The wife hugs her husband and praises him for his generosity and kindness.

FALCKENBERG, OTTO (1873–1947). Director, teacher. Falckenberg began his directing career when **Erich Ziegel** hired him in 1913 at the **Munich** Kammerspiele. He directed the world premiere there of August Strindberg's *The Ghost Sonata* in 1915, a precedent-setting production which had a momentous impact on German directors **Jürgen Fehling**, **Richard Weichert**, and **Gustav Hartung**, who in the next few years emulated Falckenberg's use of abstraction and fragmentation. When Ziegel left the Kammerspiele in 1916, Falckenberg became its director in 1917, the same year he staged the world premiere of **Georg Kaiser**'s *Von Morgens bis Mitternachts* (*From Morn to Midnight*). Falckenberg continued to direct numerous world premieres, the most significant of which was his 1922 staging of **Bertolt Brecht**'s *Drums in the Night*, which created a nationwide sensation and resulted in Brecht winning the Kleist Prize that year. Several actors studied under Falckenberg as his reputation as a teacher as well as a director blossomed in the 1920s; among them were **Marianne Hoppe**, Heinz Rühmann, **Ewald Balser**, **Elisabeth Flickenschildt**, and **Käthe Gold**. He remained head of the Kammerspiele until 1945. In 1947 the Otto Falckenberg School was founded

to carry on his teaching legacy, and it remains one of the foremost theater conservatories in Germany.

FAUST by **Johann Wolfgang Goethe**. *Faust, Part 1* premiered in 1819 at a private theater in **Berlin**, and its first complete professional performance took place in 1829 in Braunschweig. *Faust, Part 2* premiered in **Hamburg** in 1854, and the first staging of both parts together on the same program was in 1875 in Weimar. Taken together, both parts comprise an elaborate and stageworthy dramatic poem. *Faust, Part 1*, however, succeeds on its own as a superb play for actors; it may indeed be the greatest play ever written in German. Goethe invested in it a lifetime of interest and accomplishment; it is superbly well written, with verse variants among several forms. Its characters, however, mark it as a theater piece with few equals; the roles of Faust, Margarete, and especially Mephistopheles are riveting. They have become vehicles for several German actors on the path to stardom.

A prelude featuring a director, a poet, and an actor sets the tone— but the action begins with the prologue, set in Heaven with God (referred to as "the Lord"), his archangels, and Mephistopheles (known henceforth as "Mephisto"). Mephisto secures permission from the Lord to tempt Faust, but so long as Faust "strives" for betterment, the Lord declares, Mephisto has no claim upon him.

In the prologue, it becomes clear that Mephisto, not Faust, is the play's central character. Rarely has any playwright invested so much irresistible charm and aphoristic magnetism in one character. He is Goethe's masterpiece. Faust, meantime, Goethe depicts as a weary but insatiable intellect, having earned several doctoral degrees. He unfortunately finds himself no more enlightened than he was when he began his studies as an undergraduate. Mephisto leads him through several adventures, but only when Faust encounters the incomparably innocent Margarete (known as "Gretchen," the German diminutive for "Margaret") does Mephisto find a means by which he may complete the temptation of Faust and convince him to cease his striving.

There are numerous scenes with arresting characterizations; they include one with Faust's research assistant, one in his study where Mephisto initially appears as a poodle, and another with his students in a local pub. When Faust meets Gretchen, his lust for her cannot

subside. He tries to stay away from her, but she represents everything to him that a life of learning has denied: sensuality, intimacy, and raw sexual pleasure. His desires get the better of him, and he succeeds in impregnating her. Faust encounters Gretchen's brother and kills him in a street brawl, but Mephisto transports Faust to the Harz Mountains, where a Witches' Sabbath is under way. Faust has ample opportunity among the witches to fulfill every earthly desire, but he cannot take his mind off the beautiful, and now bereaved, Gretchen. He returns to her and discovers her in prison, where she is confined and awaits execution for killing their infant child. Faust offers her the opportunity of escape, but she refuses it. As Faust and Mephisto make their getaway, a voice from Heaven announces, "She is saved!"

Faust, Part 2 takes on dimensions larger than those of *Part 1*, featuring Faust and Mephisto in episodes that move back and forth across time and space, into a noumenal realm of abstract preoccupations. There is little of the traditional character motivation from *Part 1*, as Faust conjures up figures from history, gods from ancient mythology, and events of metaphysical magnitude. At one point, Faust and Mephisto invent paper currency; at another, Faust beds and impregnates Helen of Troy. By the play's conclusion, Faust has dammed rivers, reclaimed land from the sea, and populated it with settlers. At age 100, he feels his work on Earth is finished and falls dead into his grave. Mephisto claims his soul, but thanks to Gretchen's intercessory efforts, Faust's soul glides its way Heavenward, to the singing of a celestial chorus.

The "Faust material" Goethe employed for his plays derived from legends and chapbooks popular in the 16th century. The most widely distributed among them was *Historia von Doctor J. Faustus* attributed to a Johann Spies, published in 1587. The most important treatment prior to Goethe's was probably that of Christopher Marlowe (1564–1593), whose *Tragical History of Dr. Faustus* is thought to have premiered in 1589; it was published in 1604. Several German treatments appeared in the 17th century, but Marlowe's treatment became the basis for numerous German puppet shows, some of which Goethe witnessed as a boy in Frankfurt am Main. **Gotthold Ephraim Lessing** began work on a Faust play shortly before his death in 1781, and the opera titled *Faust* by Ludwig Spohr (1784–1859) premiered in 1816. Goethe's treatment has been by far the most influential in

other genres and languages, though not all subsequent treatments directly imitate it. **Christian Dietrich Grabbe**'s *Don Juan und Faust* (1829) premiered in Detmold. Nikolaus Lenau (1802–1850) wrote an epic poem he titled *Faust*, published two years after he had emigrated to the United States in 1833; many of the verses contained in Lenau's epic were set to music by Felix Mendelssohn, Robert Schumann, Richard Strauss, and other significant composers. **Richard Wagner** wrote a "Faust Overture" in 1844. Berlioz's *The Damnation of Faust* (1846) is a kind of oratorio, while the opera by Charles Gounod (1818–1893) is a fully realized and accessible stage work, still widely performed to this day.

An 1868 opera by Arrigo Boito (1842–1918) titled *Mefistofele* began a trend that shifted dramatic emphasis from Faust to Mephistopheles, a trend that accelerated in the 20th century. At the conclusion of the Boito opera, Mefistofele surrounds an elderly Faust with gorgeous sirens who offer all manner of fleshly pleasures; Faust resists, but an antichorus of equally gorgeous angels repulse Mefistofele by dropping a cascade of roses on him. Ferrucio Busoni (1866–1924) put a particularly 20th-century twist on the proceedings by having Mephisto remind Faust that his creditors are in hot pursuit, and so is the brother of some girl whom Faust has previously seduced. In the Busoni treatment, Faust seems mired in quotidian concerns, and Mephisto offers him a temporary way to avoid confronting his problems. In Thomas Mann's *Doktor Faustus* (1947) the title character (named Leverkühn) contracts syphilis and the Devil appears to him in a kind of hallucination; the Faust character later collapses into imbecility.

In the latter part of the 20th century, the name Mephisto began to appear in an increasingly bizarre set of venues: as a feline character in the Andre Lloyd Webber musical *Cats*, a mad scientist in the U.S. animated television series *South Park*, in the *Diablo* series of video games, and in a wide range of shoe styles manufactured in France.

FECHTER, PAUL (1880–1958). Critic. Fechter began his career in 1906 as a theater critic in Dresden, and by the time he arrived in **Berlin** in 1911 to write for the *Vossische Zeitung*, he was convinced that theater criticism should have a political tendency. His politics were liberal and national, which meant he supported the German war

effort from 1914 to 1918 while remaining critical of the kaiser and inherited privilege. After serving in the German army in World War I, he became chief critic for the Berlin *Deutsche Allgemeine Zeitung*, an appointment that complemented his political and theatrical interests. Among the playwrights he promoted was **Carl Zuckmayer**, awarding him the Kleist Prize in 1925. In the Third Reich, he remained active as a theater critic, writing "informative correspondence" for the *Berliner Tageblatt* and for the National Socialist literary organ *Das Reich*.

FEHLING, JÜRGEN (1885–1968). Director. Fehling was among the most innovative German theater directors in the 20th century, producing significant work from the beginning of the Weimar Republic to the end of the Nazi era. Fehling himself claimed that his most important achievement was continuing the **Berlin** theater tradition, which he said **Otto Brahm** had almost single-handedly initiated. Fehling was, however, by no means a follower in Brahm's **Naturalist** footsteps. Fehling's first productions in Berlin were of **Expressionist** plays, which he described as "reflections between the playwright's text and the consciousness of the director." Those reflections, he said, were to guide a director in projecting a "theatrical resonance" of reality in performance. His concept of "reality," however, was far more subjective and calculated than that of his contemporaries. The concepts that ended up in performance were furthermore rarely premeditated because he never used a *Regiebuch*. He allowed actors to exercise substantial freedom in rehearsal, which he thereupon shaped into final form. Fehling did dozens of productions during the Weimar period for a variety of Berlin theaters, including premieres of works by **Ernst Barlach**, **Ernst Toller**, Else Lasker-Schüler, and **Bertolt Brecht**, while also staging stunning productions of Greek classics and **William Shakespeare**. **Leopold Jessner** hired Fehling in 1922 as a regular staff director at the State Theater, where he remained through the Third Reich under **Gustaf Gründgens**. There he did the most extraordinary Shakespeare productions of his career, some of which earned him death threats from Hermann Goering. Yet he also was most often the director of choice for Nazi playwrights **Hanns Johst**, Hermann Burte, Friedrich Griese, **Hanns Friedrich Blunck**, and Hans Rehberg.

FLACHSMANN ALS ERZIEHER (*Flachsmann as Educator*) by Otto Ernst. Premiered 1900. Ernst's parody of the German school system was among the most frequently performed comedies in the German theater for three decades after its premiere. It concentrated on school headmaster Flachsmann and his self-designated nemesis Flemming, though several types of school denizens people the play, from teachers to students and their parents to janitors and school board officials. Most of the teachers seem willing to put up with Flachsmann's idiosyncrasies as long as they can drink tea and play cards in peace. Parents remain content as long as there is discipline in the classrooms.

Flachsmann's efforts toward ridding himself of Herr Flemming, a young and unprepossessing teacher in the school, comprise the play's first two acts. What makes the play funny is the characterization of Flachsmann, a stereotypical martinet whose principal goal is keeping his job. Equally important to Flachsmann is keeping the knowledge of his forged teaching certificates hidden from the teachers he supervises. Flachsmann finds several allies, implying that they too have credentials somewhat less than impressive. Flachsmann's ability to manipulate his underlings comprises a series of humorous episodes, which makes Flemming stand out in contrast to his colleagues by virtue of his refusal to capitulate to Flachsmann's demands.

The unexpected arrival of school inspector Prell complicates matters, for at a hearing Flachsmann accuses Flemming of insubordination, incompetence, and general inadequacy. The accusations cause a change in Flemming, and he suddenly finds the courage to make public counteraccusations against his boss. Prell investigates all the accusations and discovers Flachsmann's forgery; he turns the school over to Flemming's leadership, but the inference is that Flemming will not succeed as a school principal because he lacks the proper authoritarian frame of mind.

The play belongs to a series of thinly veiled attacks on the German school system during the Wilhelmine era, including **Frank Wedekind**'s *Frühlings Erwachen* (*Spring's Awakening*) and the Heinrich Mann novel *Professor Unrat*, on which Josef von Sternberg's 1931 film *Der blaue Engel* (*The Blue Angel*) was based.

FLECK, FERDINAND (1757–1801). Actor. Fleck was the prototype of the "**Romantic** actor" in Germany, a performer whose work was thor-

oughly unpredictable but alternately inspired by the workings of a gigantic and mysterious, unfathomable talent. He became one of **August Wilhelm Iffland**'s most important collaborators as a character actor, though he began his career as a comic singer and juvenile. He worked with **Friedrich Ludwig Schröder** in **Hamburg** during the 1779–1780 season, and in 1783 he began working with **Carl Theophil Döbbelin** in **Berlin**. Iffland hired him in 1786 for the Mannheim Nationaltheater, where in 1790 Fleck began directing plays, remaining there until he departed with Iffland for Berlin in 1796.

Fleck won critical and popular acclaim as Odoardo in *Emilia Galotti* by **Gotthold Ephraim Lessing** and Karl von Moor in **Friedrich Schiller**'s *Die Räuber* (*The Robbers*), but it was in the title role of Schiller's *Wallenstein* (for the Berlin premiere, which Iffland staged) that he created a sensation. Fleck was so convincing as the doomed, superstitious Bohemian general that many mistakenly assumed Schiller had written the part specifically for him. Fleck continued to receive fulsome praise for his good looks, abundant acting talent, and "superb organ," his voice. **Ludwig Tieck** in particular was extravagant in his praise of Fleck; he said the actor had a voice that "rang with the clarity of a bell" and a "soft" fire in his eyes. But when he appeared in **Shakespearean** roles, he stood "in an unearthly light, which seemed to follow him about the stage, as every utterance and every look went through our hearts" (Gross, *Johann Friedrich Ferdinand Fleck* [Berlin: Selbstverlag der Gesellschaft für Theatergeschichte, 1914], 4). Such a powerful stage presence marked Fleck as an authentic representative of the heroic tradition, a genius whose lack of discipline relied for veracity upon the spontaneous arousal of passion. He often played Shylock, for example, with an aristocratic air, but as the play progressed he became a man possessed of a mania for revenge. As a result, Fleck did not do well in contemporary plays. When he did appear in plays by Iffland, he too often relied on predictable mannerisms and vocal patterns.

FLICKENSCHILDT, ELISABETH (1905–1977). Actress. Flickenschildt became closely identified with **Gustaf Gründgens**'s productions in **Hamburg** during the 1950s, but she began her career in 1933 and was well established in **Berlin** by 1937 under **Heinz Hilpert** at the **Deutsches Theater**. In 1939 she began working extensively with

Jürgen Fehling at the Berlin Staatstheater and continued there until 1944; she also made a dozen films during this period, notably the **Emil Jannings** productions of **Heinrich von Kleist**'s *The Broken Jug* and *Ohm Krüger* (with Gründgens and **Lucie Höflich**). After World War II, Flickenschildt began working intensively with Gründgens in Düsseldorf and later in Hamburg. She credited him during the 1950s with making her one of the most distinctive actresses in classical roles; her performances as Clytemnestra, Phedra, Volumnia, and Maria Stuart won wide praise. Flickenschildt's performances in modern plays were less distinctive though no less effective. With thick red hair and standing nearly six feet tall, her presence onstage could be imposing. She received the Federal Distinguished Cross for Service to the Arts in 1975.

FLIMM, JÜRGEN (1941–). Director. Flimm in the 1980s became reminiscent of the theater artist in the early 20th century who gained bourgeois respectability, with work widely recognized and praised within the German theater establishment. In the latter part of the 20th century, his was one of the most recognizable cultural profiles anywhere in German-speaking Europe. Soon after completion of his theater history studies at the University of **Cologne** in 1968, Flimm began working as an assistant to **Fritz Kortner** at the **Munich** Kammerspiele. In 1973 he began working as a full-time director at the Mannheim National Theater, and in 1979 he returned to Cologne as **intendant** of the Schauspiel Köln. His reputation largely rests, however, on his extraordinary 15-year tenure as intendant of the Thalia Theater **Hamburg**, maintaining and in some instances restoring that institution's reputation as one of Germany's leading showplaces. Flimm began directing operas in 1978 with Luigi Nono's *Al gran sole carico d'amore* in Frankfurt am Main; he has since staged dozens of operas throughout Europe and the United States, most notably **Richard Wagner**'s Ring Cycle in Bayreuth in 2000. In 2002 Flimm became director of the Salzburg Festival, and in 2005 he assumed directorship of the Ruhr Triennale. Flimm also has the distinction of an academic career, teaching regularly at universities and writing books, alongside his professional activity. He has held guest professorships at Harvard and at New York University in the United States and is professor of theater at the University of Hamburg. The recipient of the

Konrad Wolf Prize from **Berlin**'s Academy of the Arts and the Federal Service Cross from the German government, Flimm has also received honorary degrees from several universities in Germany.

FLORATH, ALBERT (1888–1957). Actor. Florath began his career with touring troupes in 1908 and had a brief career as a politician after 1918, when he was elected to the Bavarian state legislature. In 1920 he returned to acting and became one of **Berlin**'s best-known character actors, appearing in several **Jürgen Fehling** productions of **Ernst Barlach** premieres. During the Third Reich, Florath was a "reliable rustic," playing comic parts in the State Theater's **Shakespeare** productions, such as Dogberry in *Much Ado about Nothing*, Touchstone in *As You Like It*, and Grumio in *The Taming of the Shrew*, in which he appeared as "a Germanic Sancho Panza," in the words of one reviewer (Bernhard Eck, "Ein komödiantsiches Spiel," *Völkischer Beobachter*, 16 October 1942, 5). In the postwar period, there was considerable demand for Florath as a film actor, and from 1946 to 1956 he appeared in more than 50 movies.

FÖRSTER, AUGUST (1828–1889). Actor, manager. Förster is one of the few actors in German theater history with an earned doctorate— or at least one whose doctoral studies preceded his acting career. Soon after completing his dissertation in 1851 at the University of Jena, Förster joined a touring troupe and played leading-man parts with them for two years. In 1853 he was engaged to play comic tenor roles in Posen. He then returned to spoken drama in Stettin and later Danzig, where he also directed plays. In 1858 **Heinrich Laube** hired Förster at the **Burgtheater** in **Vienna**, and he remained there until 1875, when he assumed directorship of the Leipzig City Theater. He joined **Adolph L'Arronge**'s ill-fated partnership in **Berlin** to run the **Deutsches Theater** and remained with L'Arronge until 1888, when he left Berlin to become Burgtheater director. There he encountered difficulty at first, and only when he took over the roles **Heinrich Anschütz** had played was he able to establish credibility in his short tenure with the Burg company.

FORSTER, RUDOLF (1889–1968). Actor. Though Forster's acting career began well before World War I (with several traveling troupes

in his native Austria), he seemed to burst on the scene in 1920 in a series of spectacular performances for both **Max Reinhardt** and **Leopold Jessner**. At the Berlin State Theater, with **Fritz Kortner** in the title roles of *Richard III*, *Othello*, and *Macbeth*, Forster brought to the roles of Buckingham, Cassio, and Banquo, respectively, a style which **Herbert Ihering** termed "altogether new: sharp, cynical, polished, and vulgar" (*Berliner Börsen-Courier*, 16 February 1925). Throughout the 1920s, Forster played classics, revivals, and premieres with a riveting modernist sensibility, emphasizing the fragmentation of characters; his specialty was exploring the "conflicted" inner nature of roles such as the Grand Inquisitor in **Friedrich Schiller**'s *Don Carlos*, even though most audiences and critics had rarely before imagined such inner conflicts existed. He became best known internationally in the film version of *Die Dreigroschenoper* (*The Threepenny Opera*), in which he played Mackie Messer. Forster attempted an American career in the late 1930s, but he returned to **Berlin** in 1940 to work with **Heinz Hilpert**. In the postwar period, Forster worked steadily in a number of theaters throughout West Germany in mature character parts; he also became more active in film and television in the 1950s and 1960s, appearing in more than 40 productions.

FRAU OHNE GEIST, DIE (*The Woman without Intellect*) by Hugo Lubliner. Premiered 1878. This comedy by Lubliner (also known as Hugo Bürger) treats the rise of the Wilhelmine nouveau riche in the person of the play's title character, Stephana Kopsch, the daughter of the wealthy parvenu August Kopsch. His ill breeding is evident in nearly every uncouth remark that comes out of his mouth. He is a typical product of the *Gründerjahre* (the "Foundation Years" of the 1870s), standing in stark contrast to men whose wealth was inherited. The action takes place in the prosperous and tradition-rich publishing firm of Westermann, where Hedwig Westermann and her cousin Adrienne live in a tastefully furnished apartment above the business. Adrienne is in love with the rich and handsome Werner, and to win him over, Hedwig introduces him to the somewhat unsophisticated Stephana; she is unassuming and much less "vivacious" than Adrienne. The scheme backfires when Werner finds Stephana preferable to Adrienne. Upon the announcement of Werner's engagement to

Stephana, Adrienne tells Stephana that Werner was a victim of a scheme that went awry, and that in his heart he still prefers her. But Werner and Stephana get married anyway, much to the chagrin of the entire Westermann family, not to mention the heartbroken but still vivacious Adrienne.

FREYER, ACHIM (1934–). Designer, director. Freyer is one of the few outstanding designer-directors working in the German theater. He began his career in the German Democratic Republic in the 1950s, designing **Benno Besson**'s productions of **Bertolt Brecht**. He came under a cloud in 1970, when a production of **Johann Wolfgang Goethe**'s *Clavigo* he had designed was banned; he thereafter began working steadily in West German opera. In the mid-1970s his association with **Claus Peymann** in Stuttgart started, and his directing debut took place at the Schlosspark Theater in **Berlin**. By the late 1970s he was both directing and designing operas. His most notable success came in 1988 when he worked with Robert Wilson (1941–) on *Einstein on the Beach*, which led to subsequent directing/design projects exclusively for spoken drama at the **Burgtheater** in **Vienna**. His adaptation of Ovid's *Metamorphoses* at the Burg was invited to the 1988 Berliner **Theatertreffen**.

FRIEDMANN, SIEGWART (1842–1916). Actor. Friedmann studied intensively with **Bogumil Dawison**, who took a fatherly interest in Friedmann and arranged for him to live with the Dawison family during his training in Dresden. Friedmann's first professional engagement was in Breslau for the 1863–1864 season, playing Ferdinand in **Johann Wolfgang Goethe**'s *Egmont*. He joined Dawison in **Berlin** the next year at the Royal Theater; there and at the Mecklenburg Court Theater in Schwerin, he established his reputation in a wide variety of roles that included Franz von Moor, Hamlet, Richard III, Clavigo, and several others in the "classic" repertoire. He also became highly adept in leading roles by **Paul Lindau**, Hugo Lubliner, and **Gustav von Moser**. **Heinrich Laube** hired him in 1872 as a member of the **Vienna** City Theater company, and there he established himself as a star performer with lucrative appeal. He embarked on several profitable tours in the mid-1880s, but joined **Adolph L'Arronge**'s consortium to run the **Deutsches Theater** in 1883. He

remained longer with L'Arronge in Berlin than anyone else in the partnership. When he finally left in 1890, L'Arronge claimed Friedmann's departure was the most difficult of all because he and Friedmann had become good friends, and theirs was "a friendship that endured the travails of the partnership" (L'Arronge, *Deutsches Theater und Deutsche Schauspielkunst* [Berlin: Concordia, 1896], 77). Friedmann went on tour in 1890 and retired from the stage in 1896.

FRISCH, MAX (1911–1991). Playwright. Frisch began his writing career as a journalist in his native Zurich, but he did not begin writing plays until he had established himself as a licensed architect in the 1940s. He continued to practice architecture while on a yearlong Rockefeller grant in the United States in 1951, but finally felt confident enough about his playwriting in 1955 to give up his architecture practice. His early plays included *Nun singen sie wieder* (*Now They Sing Again*, 1946), *Die chinesische Mauer* (*The Wall of China*, 1947), *Santa Cruz* (1947), *Als der Krieg zu Ende war* (*When the War Was Over*, 1949), *Graf Öderland* (*Count Oederland*, 1951), and *Don Juan, oder die Liebe zu Geometrie* (*Don Juan, or the Love of Geometry*, 1953). These plays established Frisch in many German-speaking theaters, though few produced them elsewhere.

Frisch's best plays, however, were yet to come—and they were the ones that established his international reputation. They were *Biedermann und die Brandstifter* (*The Firebugs*, 1958) and *Andorra* (1961). The former acknowledged its debt to **Bertolt Brecht** (whom Frisch had met in 1949) in its subtitle, *ein Lehrstück ohne Lehre* (*A Didactic Play without Didacticism*); it was based on a radio play Frisch had written in 1955. *Biedermann und die Brandstifter* was in many ways an allegorical condemnation of Germany, represented by the title character, whose name implies "Mr. Comfortable." Biedermann permits two arsonists to move into his house, even though he knows of several recent arson cases in his city. In his complacency, he even allows the arsonists to store gasoline in his attic, and when his house goes up in flames, he and his wife perish. In an epilogue Frisch wrote especially for performances in Germany, he portrayed Herr and Frau Biedermann in Hell, complacent as ever, unrepentant, refusing to take responsibility for the destruction in their midst they had somehow rationalized to themselves.

Andorra takes place in a courtroom, and it too indicts complacency and the lack of civil courage, this time among citizens of a mythical "Andorra." A series of individuals enter a witness stand to deny any responsibility for the death of a man mistaken as a Jew who falls victim to a dictatorship of "the Blacks." It turns out that the man was not a Jew, but in their testimonies his fellow citizens acknowledge that none of them had come to his aid.

Both *Biedermann* and *Andorra* premiered at the Zurich Schauspielhaus and stirred substantial controversy, initially in Switzerland where Frisch had become increasingly vocal about Switzerland's complicity with Germany in World War II. *Andorra* was a flop on Broadway in 1963 (in a translation by **George Tabori**), running for only two weeks. *The Firebugs*, however, enjoyed a more successful international reputation, and it continues to appear in the repertoires of many theaters around the world.

FRÖBE, GERT (1913–1988). Actor. Fröbe, as Gert Frobe, became the best known German actor of the 1960s by virtue of his performance in the title role of the 1964 James Bond thriller *Goldfinger*. Prior to that award-winning performance, he had worked extensively as a stage actor in numerous theaters, including **Vienna**'s **Burgtheater**; his theater career actually began when he was a designer in Dresden, where **Erich Ponto** discovered his acting talent. In the late 1940s, Fröbe worked with **Erich Engel** in **Munich** at the Kammerspiele, and in Munich during those years he established himself as a cabaret comedian. In that capacity he began to get film roles in several German films, and from 1948 to 1964 he appeared in more than 70 of them. After *Goldfinger*, Fröbe appeared in 30 more films, including *Is Paris Burning?* (1967) as Col. Dietrich von Choltitz, with Kirk Douglas and Glenn Ford; and *Chitty Chitty Bang Bang* (1968) with Dick van Dyke. His crowning achievement as a stage actor came in 1973 when he played the charlatan theater director Immanuel Striese in **Franz von Schönthan**'s preposterous farce *Der Raub der Sabinerinnen* (*The Rape of the Sabine Women*) at the Munich Deutsches Theater; he reprised the role a decade later in a video production, which aired on the ARD network.

FROBOESS, CORNELIA (1943–). Actress. Froboess has the remarkable distinction of remaining a highly successful "provincial"

actress, one who has remained in **Munich** for her entire career—a career that began when she was just five. As a child star in the 1950s, Froboess became a much-loved favorite on radio and television shows. In the late 1950s she became a bona fide teen idol with several hits to her credit on the German pop music charts, with songs by Paul Anka particularly successful in her renditions of them. Along with her singing career came several film roles, and between 1958 and 1963 she made more than 20 movies. By 1964 she had begun a serious study of theater in private lessons; in 1971 she became a full-time member of the Munich Kammerspiele company, and there she established herself in numerous productions, many of which were invited to the Berliner **Theatertreffen**. Her most notable performances came in productions by **Dieter Dorn**, who cast her as the leads for *Erdgeist* (*Earth Spirit*) and *Büchse der Pandora* (*Pandora's Box*) by **Frank Wedekind**, *Minna von Barnhelm* by **Gotthold Ephraim Lessing**, *Gross und Klein* (*Big and Small*) by **Botho Strauss**, among many others. Froboess also combined her acting and singing talents in Lerner and Loewe's musical *My Fair Lady* in Munich, which ran for 10 years at Munich's Gärtnerplatz Theater.

FRÖHLICH, GUSTAV (1902–1987). Actor. Fröhlich is best known among international audiences as the tortured Freder Fredersen, son of the capitalist exploiter of workers in Fritz Lang's *Metropolis* (1927), although he had a remarkable career in the German theater as well. Sometimes called "the Don Juan of German films," Fröhlich played leading men in dozens of movies and continued playing them concomitantly on the stage throughout the Weimar period, the Third Reich, and well into the postwar years. He was originally a newspaper editor and author of cheap novels, but he began acting in the 1920s. Fröhlich is one of the few German actors to have served on active duty with the German army in both world wars, and he is doubtlessly the only actor to have confronted **Joseph Goebbels** about his affair with actress Lida Baarova. Fröhlich was living with Baarova at the time of her liaison with Goebbels, and accounts vary as to the severity of the altercation between the two. During the Weimar period and the Third Reich, Fröhlich worked primarily on the stage under **Heinz Hilpert**'s direction, most notably in 1931 as Frederic Henry in the Hilpert–**Carl Zuckmayer** adaptation of Ernest

Hemingway's *A Farewell to Arms*. In the postwar period, he appeared in several productions in regional theaters.

FRÖHLICHE WEINBERG, DER (*The Merry Vineyard*) by **Carl Zuckmayer**. Premiered 1925. Zuckmayer's earthy comedy features a vintner from the Rhineland who insists that his daughter first become pregnant before marrying the man of her choice. Since the daughter's dowry includes half of his prosperous vineyard, she has no shortage of potential suitors. The play occasioned numerous protests after its premiere, many of them near Zuckmayer's native Rhenish countryside, where many residents felt themselves libelously portrayed. In most other locales, however, the comedy was enormously popular, and it remained a staple in most repertoires until 1933 when the National Socialists banned it, claiming Zuckmayer had made "a mockery of the Christian viewpoint, of German morals, [and] of German women" (quoted in **Günther Rühle**, *Theater für die Republik* [Frankfurt: Fischer, 1967], 667). The vintner himself copulates with a local girl 45 years his junior in a neighboring barn during the play, so the sense of moral indignation felt by some communities was perhaps understandable. The comedy also included debates about the preferred size of the male sex organ, a comparison of fertility rates between women and brood sows, and an unapologetic assertion that wine consumption fostered male potency.

FRÜHLINGS ERWACHEN (*Spring's Awakening*) by **Benjamin Franklin Wedekind**. Premiered 1906. Wedekind's play about adolescent sexuality was considered unperformably obscene for years after he wrote it in 1890–1891, yet it became one of **Max Reinhardt**'s biggest hits of the 1906–1907 season when the director premiered it at the **Deutsches Theater**. Indeed it was performed more often during that season than any other play in the Deutsches repertoire. It features on-stage masturbation and sadomasochism, discussions of copulation, and the death of the leading female character by abortion. Its principal character is 15-year-old Melchior Gabor, whose relationships with fellow students end in catastrophe. His attempts to enlighten his friend Moritz Stiefel about the biological facts of human reproduction end in Moritz's suicide—though Moritz comes back in the play's final scene with his severe, self-inflicted head wound on

full display. Melchior impregnates the 14-year-old Wendla Bergmann, much to the shame of her hysterical mother; the mother arranges for a doctor to perform an abortion on Wendla, but she dies in the process. Another schoolgirl becomes a prostitute, and a schoolboy finds onanistic pleasure in reading Shakespeare's *Othello* aloud. In the aforementioned final scene, Wedekind abandons the heretofore realistic depiction of the action and opts for caricature: Moritz confronts Melchior in a village cemetery and tries to convince his friend to join him in suicide; then a mysterious "Man in the Mask" (often played by Wedekind himself in productions of the play after Reinhardt's premiere) appears to persuade Melchior, successfully as it turns out, to choose life.

FUHRMANN HENSCHEL (*TEAMSTER HENSCHEL*) by Gerhart Hauptmann. Premiered 1899. Hauptmann wrote this play originally in the distinct German dialect of his native Silesia as part of his attempt to make the play a **Naturalist** emblem. Henschel's costume is accordingly soiled with the dust of the roads and the manure of his horses even as he attends to his dying wife and their newborn daughter. At death's door, his wife notices Henschel's attraction for the housemaid Hanne Schäl; her dying wish, extracted from Henschel, is that Hanne leave the household. Yet the wife's death occasions hardship for Henschel and he marries Hanne anyway, in the hope that she will manage his house and children for him. She does so at first, but soon takes up with a local lout as her lover. Henschel begins an inevitable physical and psychic decay, combined with remorse and guilt. His downward spiral ends in suicide.

– G –

GANZ, BRUNO (1941–). Actor. Zurich-born Ganz emerged as the German-speaking theater's most celebrated actor when he was awarded the **Iffland Ring** in 1996. He had begun his training in 1960 as a teenager with the Zurich Stage Studio and soon thereafter began performing professionally in Bremen. In 1970 Ganz joined **Peter Stein** at **Berlin**'s Theater am Halleschen Ufer and soon became a stalwart of the company, appearing in several Schaubühne produc-

tions, most notably the much-praised *Summer Folk* in 1975. By that time, Ganz had worked with several outstanding German directors in noteworthy productions, such as **Claus Peymann**'s 1972 world premiere of **Thomas Bernhard**'s *Der Ignorant und der Wahnsinnige* (*The Ignoramus and the Madman*) at the Salzburg Festival. Ganz had also established himself as a film actor of some repute. In 1976 he appeared in Wim Wenders's *The American Friend* (with Dennis Hopper) and Eric Rohmer's *Die Marquise von O* (with Schaubühne colleague **Edith Clever**); dozens of film roles followed, consolidating his reputation as an international star. His films included *The Boys from Brazil* (1978) with Laurence Olivier and Gregory Peck, *Der Himmel über Berlin* (*Wings of Desire*, 1987) with Peter Falk, and Jonathan Demme's 2004 remake of *The Manchurian Candidate* with Denzel Washington and Meryl Streep. His portrayal of Adolf Hitler in Oliver Hirschbiegel's *Der Untergang* (*The Downfall*, also in 2004), won him widespread praise from critics and audiences internationally.

GAS I AND GAS II by **Georg Kaiser**. *Gas I*, which premiered in 1918, and *Gas II* (1920) were the final installments of Kaiser's "Gas Trilogy," inaugurated by *Die Koralle* (*The Coral*). In *Gas I*, the Billionaire's Son carries on the work of his deceased father, but he does so in the hope of bettering mankind. The enormous gas factory he oversees is run on a profit-sharing basis, with workers enjoying unprecedented benefits and humane treatment. For some inexplicable reason, however, the gas factory explodes. The Billionaire's Son takes the explosion as a signal of fate and refuses to rebuild the factory, but the workers revolt and demand the factory's reconstruction. When the Billionaire's Son refuses to comply with their demands, the state dispatches military forces to oversee reconstruction, and the Billionaire's Son shoots himself. His sister (the Daughter) appears and promises to rebuild the gasworks.

Gas II begins with the factory rebuilt, but the workers function robotically in preparation for war. The central figure in this last installment of the trilogy is the Billionaire Worker, who pleads for peace and brotherhood among all mankind, yet the workers continue as the automatons they have become in predetermined movements to make ready for the Day of Judgment that will destroy everything.

The workers launch a missile filled with poison gas as the play ends in mass self-extermination.

GEBÜHR, OTTO (1877–1954). Actor. Gebühr enjoyed a career that spanned more than half a century, working almost until the day he died. He remains best remembered for his portrayals of King Friedrich II (Frederick the Great of Prussia) in a series of films. Along with his film work, Gebühr worked steadily in the theater of the Wilhelmine, Weimar, and National Socialist periods, beginning in 1898 at the Dresden Court Theater. He worked for two years (1907–1909) in New York under Heinrich Conried at the Irving Place Theater, returning to **Berlin** in 1909 to work for **Otto Brahm** at the Lessing Theater. Gebühr appeared in scores of theater productions during the Weimar Republic and the National Socialist period. The Nazis named him a *Staatsschauspieler* (state actor) in 1937 for his body of work, most notably in such comic roles as Wibbel in *Schneider Wibbel* (*Wibbel the Tailor*), the theater director Striese in *Der Raub der Sabinerinnen* (*The Rape of the Sabine Women*), and Dr. Jura in *Das Konzert* (*The Concert*). His Frederick the Great series began with *Fridericus Rex* (1922), in which he played Frederick as Prussia's tormented crown prince. That film led to a series of Fridericus films, with the Potsdam palace Sans Souci as a backdrop, including *Die Mühle von Sans Souci* (*The Mill at Sans Souci*, 1928); *Der alte Fritz* (*Old Fritz*, 1928); *Das Flötenkonzert von Sans Souci* (*The Flute Concert at Sans Souci*, 1930); *Die Tänzerin von Sans Souci* (*The Dancer from Sans Souci*,1932); *Der Choral von Leuthen* (*The Chorale at Leuthen*, 1933); *Fridericus* (1936); and *Der grosse König* (*The Great King*, 1942).

GEORG II, DUKE OF SAXONY-MEININGEN (1826–1914). Director, designer. Georg II was among the first aristocrats in 19th-century Germany who sought to raise fundamentally the standards of production values that were commonplace in the German theater at the time. He had extensive exposure to high-quality theater productions in England and on the Continent before succeeding his father as duke in 1866, recognizing that quality productions of **William Shakespeare**, **Friedrich Schiller**, and **Johann Wolfgang Goethe** in most German duchies were few. By the time his company, known as "the Meininger,"

had finished touring in 1890, Georg had widely influenced the German theater with his acute attention to pictorial detail, historical accuracy, and ensemble acting. Many scholars recognize Georg II as the first director, a personality whose absolute authority gives a production its final form and shapes it as a work of theatrical art. The duke, however, was most interested in an accurate representation of the playwright's script, with emphasis on the milieu called for in the script. He supplied actors with all costumes required for the production, forbidding them from changing them in any way; provided materials for costumes, settings, properties, and accessories that were valid for the play's time period; required long rehearsal periods (sometimes lasting months) so that actors became accustomed to the milieu he had created; and demanded that they "act" from the first rehearsal to opening night.

The result was an unprecedented level of illusionism—a level few audiences had ever before witnessed. The company's first performances in **Berlin** created a sensation, as audiences beheld settings individually styled for each play in the repertoire. The floor was part of the stage design and settings were asymmetrical because Georg found symmetry both unnatural and predictable. Crowd scenes involved every actor in the company and required the absorption of each performer. Georg in effect had created the "unified production"—one in which all aspects of the performance contribute to a total illusionistic effect.

Georg II had numerous collaborators in this achievement, chief among them **Ludwig Chronegk**, whose tour management and staging of the productions put Georg's ideas into effect. Georg's wife Ellen Franz (1839–1923), whom he married in 1873, was instrumental in assisting him with casting and repertoire selection. Between 1874 and 1890 the Meiningen company put on more than 2,500 performances during 81 guest tours to 36 German cities. *Julius Caesar* was their most frequently performed play, followed by *A Winter's Tale* and Schiller's **Wilhelm Tell** (*William Tell*). The duke also introduced some contemporary playwrights to German audiences, most notably **Ernst von Wildenbruch**. The Wildenbruch premieres led to enormously profitable runs, allowing the company occasionally to premiere far less popular fare, such as some works by Henrik Ibsen. In late 1886 Georg II premiered Ibsen's *Ghosts* in the presence of the playwright, though most of his regular subscribers in Meiningen

found the play indecent and boycotted the production; when the company attempted to perform it in Berlin the next spring, police **censors** banned the play.

The Meininger company boasted some of the best acting talent available at the time, though Georg actively dampened any virtuoso display. Since he commissioned costumes for specific actors, actors often individualized characters they played. And because the settings were likewise constructed for individual productions, actors leaned toward conforming their speech and movement to their surroundings. As a consequence, Georg created a new standard of value for realistic acting on the German stage—one based on ensemble interaction and detailed patterns of stage activity.

GEORGE, HEINRICH (Georg August Hermann Schulz, 1893–1946). Actor, **intendant**. George was among the most celebrated actor-managers of the Third Reich. **Joseph Goebbels** named him to head the Schiller Theater in **Berlin**, and in 1937 Adolf Hitler personally named him *Staatsschauspieler* (state actor).

George began his career as a violinist in 1912 at the Kolberg Municipal Theater, where he was later hired as a bit player. In 1917 he began acting for the Frankfurt am Main City Theater, doing productions of **Walter Hasenclever**'s *Antigone* and **Fritz von Unruh**'s *Platz (Place)*. In Frankfurt, George developed a reputation as "an uncomplicated, primitive, and modern actor . . . [contributing] to the overthrow of **Naturalism** in German acting through ecstasy in word and gesture. He caught everyone's attention . . . with his volcanic outbursts, throwing words out like huge granite blocks" (**Herbert Ihering**, *Von Josef Kainz bis Paula Wessely* [Berlin: Hüthing, 1942], 159). **Max Reinhardt** put George under contract in 1922, casting him in numerous productions, the most noteworthy of which was **Bertolt Brecht**'s *Drums in the Night*. George subsequently played leads in several other Brecht plays, including Galy Gay for the world premiere of *Mann ist Mann*. He also worked with **Erwin Piscator**, further establishing credentials for himself as a theater artist with left-wing sympathies. By the mid-1920s, George was openly associating with leading Jews in the Weimar Republic, even signing a petition "For the Freedom of Art" in protest against judicial persecution of artists.

George began film work in Berlin during the 1920s, appearing in Fritz Lang's *Metropolis*, a film establishing him in critical opinion as one of the industry's most consequential actors. Nazi commentators did not agree with that assessment, and in 1930 George seriously antagonized Goebbels when he re-created on film his stage role as Émile Zola in *Die Affäre Dreyfus* by Hans-José Rehfisch; Goebbels assailed both the play and the movie as a "Jewish-inspired election maneuver against National Socialism."

When the Nazis came to power, George changed his political stripes and publicly declared his allegiance to the new regime. He ingratiated himself with Goebbels by starring in the 1933 pro-Nazi film *Hitlerjunge Quex*. For Goebbels, George was the embodiment of that quality much prized among National Socialists—*Volkstümlichkeit*; he was an "*urwüchsiger Kraftkerl* [primitive strongman-type], an earthy species of Teuton with both feet on the ground, a German craftsman in the mold of **Hans Sachs**, a great portrayer of the people, one who wore his heart on his sleeve" (Ihering, 161)." Goebbels immediately recognized the propagandistic potential of George's physical attributes; they were not superficial "bourgeois coziness nor unsophisticated gullibility; they represented instead genuine power, elementary humor, gallantry, manliness, restraint, and certainty of instinct" (Ihering, 161).

For George, favor with the Nazi regime meant financial and artistic opportunity. He appeared in 31 films between 1933 and 1945, all of them in featured or starring roles. They were among the era's most important propagandistic efforts, beginning with *Heimat*, costarring Zarah Leander; the execrable *Jud Süss*; *Wien 1910* (based on the life of anti-Semitic **Viennese** mayor Karl Lueger), *Friedrich Schiller*, and *Andreas Schlüter*, all nationalist biopics; and *Kolberg*, filmed in the last days of the war. He also starred in several comedy films based on popular stage works: *Wenn der Hahn Kräht* (*When the Rooster Crows*), *Versprich mir nichts* (*Promise Me Nothing*), and *Der Biberpelz* (*The Beaver Coat*).

George gave what proved to be his farewell performance (though no one knew it at the time) as the village judge Adam in a 1944 production of **Heinrich von Kleist**'s *Der zerbrochene Krug* (*The Broken Jug*); it created a sensation, largely because it came at a time when British and American bombing raids regularly interrupted performances. It had the

desired propagandistic effect of instilling within audiences the idea that tribulations borne for the sake of German culture were worth the sacrifice. Who else but a German audience, for example, could truly appreciate a German artist like Heinrich George in a German masterpiece like *The Broken Jug* while the enemies of German culture were literally dropping bombs in an attempt to destroy it? The entire production was "built around George's overt vitality," said one observer.

> Guilt crawls crab-like across his face in moments of intensity, to the extent that one barely hears the dialogue. . . . This is no clever peasant knave but a helpless, awkward bungler, sweating with anxiety, anticipating the next catastrophe that awaits him. (Theo Fürstenau, "*Der zerbrochene Krug* im Schillertheater," *Das Reich*, 22 June 1944, 6)

Audiences who risked seeing his performance could identify with the catastrophes befalling him, but they also drew sustenance from George's bluff vigor. The actor's performance

> focused entirely on the sensory, as a Breughel-like panorama unfolds before us in a picture-perfect rendering. . . . It is worth the price of admission just to see Heinrich George, whose vitality fills the entire stage space from wall to wall. George's Adam frequently crosses the line into farce, but you still have to love this big, overgrown child, who is hardly aware of his own foibles. He is replete with comic imagination, which he applies with practiced dexterity—yet the moments which seem off the cuff are the funniest. (Florian Kienzl, "Mit seiner ganzen Vitalität," *Frankfurter Zeitung*, 24 June 1944, 17)

In the face of inevitable catastrophe, this production said that life, especially German life, still offered opportunities to laugh. George's performance allowed audiences to draw sustenance from that experience, fed by George's enormous reserve of organic, *volkstümlich* vitality, strengthening them to make additional forced sacrifices "for Führer and Fatherland."

GERRON, KURT (Kurt Gerson, 1897–1944). Actor. Gerron was a popular actor who worked steadily through the Weimar Republic and was later murdered in a Nazi concentration camp. He appeared in dozens of **Berlin** productions and made more than 50 films before his breakthrough in 1928 as Tiger Brown in the world premiere of **Bertolt Brecht** and Kurt Weill's *Die Dreigroschenoper* (*The Three-*

penny Opera) at the **Theater am Schiffbauerdamm** in Berlin. His most significant silent film was *Tagebuch einer Verlorenen* (*Diary of a Lost Girl*, 1929) with Luise Brooks, in which he played Dr. Vitalis. His most important sound film was *Der blaue Engel* (*The Blue Angel*, 1931) with Marlene Dietrich, in which he played Kiepert the Magician. Later in 1930 he played Dr. Kalmus in the musical comedy film *Drei von der Tankstelle* (*Three Friends from the Gas Station*) with Lillian Harvey and Heinz Rühmann. After the National Socialists came to power, he left Germany for tours in Czechoslovakia and Austria, went to Paris to make a movie, and ended up in Holland. When German troops invaded and occupied Holland, he was arrested and sent to the Westerbork camp. In 1944 he was transported to Auschwitz, where he died in a gas chamber.

GIEHSE, THERESE (Therese Gift, 1898–1975). Actress. Giehse rose to the top ranks of German actresses without career triumphs in **Berlin**; she indeed came fully into prominence while in exile. Giehse began her career with a fruitless search for work in Berlin and later brief engagements in Siegen, Gleiwicz, and Landshut before she began playing small roles at the Bavarian State Theater in her native **Munich**. At the Lobe Theater in Breslau, she began to play bigger roles, attracting the attention of **Otto Falckenberg**, then head of the Munich Kammerspiele. Giehse returned to Munich to work with Falckenberg, and from 1925 to 1933 she did a series of outstanding performances for Falckenberg, among the best of which was Mother Wolff in Falckenberg's production of *Der Biberpelz* (*The Beaver Coat*). On the side, with Erika and Klaus Mann, she formed a cabaret act in Munich called *Die Pfeffermühle* (*The Pepper Mill*).

After the National Socialist takeover in 1933, Giehse could no longer work in Munich because she was Jewish. She therefore emigrated to Zurich, where she and the Manns played their cabaret act steadily at the Hotel Hirsch and on tour in The Netherlands, Belgium, Czechoslovakia, and briefly the United States. In 1937 Giehse returned to Zurich as a regular member of the Schauspielhaus company, and in 1941 she played the title role in the production that established her career for the rest of her life: the world premiere of **Bertolt Brecht**'s *Mutter Courage und ihre Kinder* (*Mother Courage*

and Her Children). She also appeared in the Schauspielhaus premieres of **Der gute Mensch von Sezuan** (*The Good Person of Setzuan*) in 1943 and of *Herr Puntila und sein Knecht Matti* (*Mr. Puntila and His Servant Matti*) in 1948.

In 1949 Giehse returned to Munich, but she also spent time with Brecht's **Berliner Ensemble**, playing the title role in their 1949 production of *Vassa Zhelesnova* and in 1952 directing **Heinrich von Kleist**'s *Der zerbrochene Krug* (*The Broken Jug*) in Berlin. For the most part, however, she remained in Munich or Zurich for the rest of her career. She had two enormous successes in Zurich, and many observers have held that her performances in them matched her 1941 work as Mother Courage: In early 1956 Giehse played Claire Zachanassian (the title role) in the world premiere of **Friedrich Dürrenmatt**'s *Der Besuch der alten Dame* (*The Visit*) at the Schauspielhaus, and in 1962 she played villainous Dr. Mathilde von Zahnd in the world premiere of *Die Physiker* (*The Physicists*).

Few other actresses matched the heights Giehse attained or created the leading roles in plays that later became famous worldwide. Her career is some ways resembles that of **Fritz Kortner**, as both experienced the losses of exile and the triumphs of contributing in major ways to the renascence of the German theater after the havoc of National Socialism.

GLAUBE LIEBE HOFFNUNG (*Faith, Hope, and Charity*) by **Ödön von Horváth**. Premiered 1932. In this relentlessly gloomy play, neither faith, hope, nor charity is anywhere in evidence. A young woman named Elisabeth appears at the door of an "anatomical institute"—a mortuary—in an unamed Bavarian city. She tells a policeman named Alfons of her hope to sell her own corpse; she has heard that she can get 150 marks for it while still alive. Elisabeth needs the money in order to pay a fine of 150 marks the authorities have levied against her for selling corsets and ladies' underwear door-to-door without a license. An assistant mortician dissuades her, since it is not the institute's policy to purchase corpses. The assistant's boss, the chief mortician, then appears with a baron whose wife has just been killed in an auto accident. He tells the Baron he sees people like Elisabeth every day who hope to make a little money by selling their bodies. It's a sign of the times in which we live, he says. The mortician then

takes temporary pity upon her and loans her the money. Elisabeth attempts to collect welfare payments from the state but is denied. "Dummheit und Stolz wachsen auf einem Holz" (Stupidity and pride grow on the same branch), jeers a clerk in the welfare office.

All the characters seem to know each other from previous encounters. When Elisabeth makes friends with Maria, for example, she meets up with the old baron whose wife the mortician was embalming in the first scene. But the baron has reported to the police that Maria stole his cufflinks, and now she too she is arrested. Her arrest sets up the renewed acquaintance between Elisabeth and the policeman Alfons; soon they are lovers.

On the morning following a night of lovemaking, Elisabeth makes coffee for Alfons in a scene of homey domesticity. Police then burst into the room with a warrant for Elisabeth's arrest, as she has failed to pay the fine of 150 marks. Her relationship with Alfons threatens his career, so he sorrowfully breaks it off. The final scene takes place in the police station where Alfons works. Into the station staggers the mortician from the first scene, drunk. Then bystanders bring in a listless Elisabeth; she has jumped from the bridge outside the station into the river flowing beneath it and has nearly drowned. A valiant young man in a tuxedo jumped in to save her, and he attempts artificial respiration on her. As she regains consciousness, he immediately calls his mother and tells her his picture will be in the newspaper tomorrow and everyone says he's a hero. "So—now I get the motorcycle you promised me, right?" After a pause on the phone, he exclaims, "But you promised!" Hanging up the phone, he says to her, "You old dromedary!" He was too quick to claim heroism, however, for in the commotion Elisabeth dies. "I want to confess to her murder," says the mortician; his initial pity for her probably led to her downfall. "An eye for an eye, tooth for a tooth. Quick, hang me for it!"

GLEICH, JOSEPH ALOIS (1772–1841). Playwright. Gleich is thought to have written more than 200 works for the stage, nearly all intended as fare for **Viennese** popular theaters. He was assistant director of the Theater in der Josephstadt from 1814 to 1816, but thereafter concentrated on playwriting while working full time as a court bureaucrat. Among his better known and popular works were *Die Musikanten am Hohen Markt* (*The Musicians on Market Day*, 1816),

Herr Dr. Kramperl (1820), *Ydor, der Wanderer aus dem Wasserreiche* (*Ydor, the Traveler from Watery Realms*, 1820), and *Die weissen Hüte* (*The White Caps*, 1822).

GLIESE, ROCHUS (1891–1976). Designer. Gliese was among the most accomplished of stage designers in the **Expressionist** style during the Weimar Republic period, creating several distinctive designs for **Jürgen Fehling** at the **Berlin** State Theater in the 1920s. He also designed more than a dozen silent films, working as assistant director on *Das Kabinett des Dr. Caligari* (*The Cabinet of Dr. Caligari*, 1920). His most distinctive stage designs were for Fehling's **Ernst Barlach** productions in the mid-1920s, employing unprecedented abstraction. He followed F. W. Murnau to Hollywood in the late 1920s, designing *The Main Event* and *Sunrise* for him; the latter earned Gliese an Academy Award nomination. His stage design work blossomed under the Third Reich, as he created several astonishing settings for **Gustaf Gründgens** at the Berlin State Theater. For *King Lear*, he mixed neo-Baroque extravagance with minimalist abstraction; for *Egmont*, he created a neo-**Romantic** replication of central Brussels, including live horses on the stage. His *Der Raub der Sabinerinnen* (*The Rape of the Sabine Women*) employed a Biedermeier coziness. He continued film design work in the 1930s, though with less frequency. Most distinctive among his film art direction in the 1930s was *Tanz auf dem Vulkan* (*Dance on the Volcano*) with Gründgens. Gliese continued working as a guest designer for several theaters during the 1950s and 1960s, most notably for the **Burgtheater** in **Vienna** and the **Munich** Opera.

GOBERT, BOY (Christian Klee Gobert, 1925–1986). Director, **intendant**. Gobert was best known for his work as a director in his native **Hamburg**, but he began as an actor shortly after World War II. From 1947 to 1950 he appeared frequently at the city's Deutsches Schauspielhaus, and in the 1950s worked regularly in several regional theaters. From 1960 to 1969 he was a member of **Vienna**'s **Burgtheater** company. In the 1970s his film acting career took precedence over his theater work, but in 1980 he was named intendant of Hamburg's Thalia Theater, where he remained until 1985. Shortly before his death, he became intendant of **Berlin**'s municipally subsidized theaters.

GOEBBELS, JOSEPH (1897–1945). Reich minister for propaganda and popular enlightenment. As the first propaganda minister in a German government, Goebbels had pervasive influence on all areas of artistic activity within his portfolio; theater was no exception. Goebbels was like most Nazi officials in his attachment to and fascination with the celebrity of famous and attractive theater personalities; however, he differed from most others among the Nazi elite by virtue of his earned doctorate (from Heidelberg in 1921), his polished skill at inventing and employing political jargon, his expertise in manipulating public opinion, and his boundless energy. He created the "ProMi," as the Propaganda Ministry came to be called, as a tool to exploit the possibilities of entertainment to champion Nazi political endeavors. Goebbels made little distinction between politics and art, frequently noting that both he and Adolf Hitler were "artistic individuals" and as such had dedicated themselves to a "rebirth" of German theater. Goebbels had begun to write party position papers on the theater in 1926, when Hitler appointed him the Nazi party's propaganda director for **Berlin**. One such paper declared that German theater and drama in the future should be "heroic," "steely romantic," "factual without sentimentality," and "national with great pathos." Upon Hitler's appointment to lead the government in 1933, Goebbels drafted Reich Cultural Chamber legislation, which Hitler's cabinet subsequently passed into law as the *Reichskulturkammergesetz* (Reich Cultural Chamber Act).

In May 1933 Goebbels gathered around him more than 300 theater directors and managers to inform them, in phrases similar to those above, that theater was henceforth to function as a tool for furthering the state's goals, with full subvention by the state. Goebbels proceeded to rule theater and other art forms by decree. For example, in May 1936 he forbade "night criticism," banning critics from writing their reviews overnight if the review was to appear in the next morning's papers. In November of that year, Goebbels banished theater criticism altogether, replacing it with "cultural reporting" and "cultural consideration." In 1937 Goebbels began to bestow cash prizes and medals in compensation for the Swedish Royal Academy's refusal to award any German national a Nobel Prize; Carl von Ossietzky had been awarded a Nobel, but Nazi authorities refused to release him from the concentration camp where he was being held to accept the award. Actors were frequent recipients of ProMi cash emoluments, in

addition to the honorific "state actor" or "state actress" (*Staatsschaus-pieler/in*), and Goebbels usually appointed actors to manage major theaters. He became increasingly concerned after 1937 about the reputation of the Nazi regime abroad and sent several troupes abroad on public relations tours.

As the war progressed after 1939, Goebbels increasingly used the damage or destruction of theater buildings during Allied air raids as pretexts to motivate additional sacrifices among the public for the sake of the regime. He insisted that performances in Berlin continue, even if raids interrupted them on an almost nightly basis. "Is it not interesting," he once rhetorically asked,

> that the English have destroyed dozens of German theaters, while England itself does not have even a single serious theater? And the Americans are not even worth mentioning. They lay waste to Europe's cities and cultural landmarks, since there is nothing to compare them with in Chicago or San Francisco. (Goebbels, "Unsterbliche deutsche Kultur . . . ," *Der steile Aufstieg* [Munich: Zentralverlag der NSDAP, 1944], 340)

By 1944, however, Goebbels recognized that theater performance could no longer continue in Germany, Austria, or their occupied territories. In August of that year, he decreed the closure of all facilities for the duration of the war.

GOERDEN, ELMAR (1963–). Director. Goerden is one of the few German directors to have earned an American graduate degree before beginning his career. His first professional engagement was in **Berlin** as an assistant director at the Schaubühne am Lehniner Platz from 1991 to 1994. In 1995 he began the most significant work of his career to date, in Stuttgart. Two of his productions there were invited to the Berliner **Theatertreffen**, and he was awarded the Gertrud Eysoldt Prize as one of the German theater's outstanding young directors. Goerden was named chief director of the Bavarian State Theaters in 2001, and beginning in 2005 he became **intendant** of the prestigious Bochum Schauspielhaus.

GOETHE, JOHANN WOLFGANG (1749–1832). Playwright, director. Goethe bestrides the German theater like a colossus, not only because his plays possess a high dramatic quality, remain frequently

produced, and are the subject of intense, ongoing scholarly inquiry but also because his work as a director marks Goethe as an extraordinary figure in German culture as a whole. His long life, the enormous variety of his activities and interests, the magnitude of his artistic output, and the poetic record of his numerous tempestuous affairs with notable women have all contributed to his near-legendary status.

Goethe was born in Frankfurt am Main to a wealthy family who educated him at home. He attended the universities of Leipzig and Strasbourg, earning a law degree at the latter institution. His interests in the theater began as a child, attending performances with his parents. His first success as a playwright came with *Götz von Berlichingen*, published in 1773 and first performed in 1774. It established his playwriting career and his leadership of the **Sturm und Drang** (Storm and Stress) movement among young playwrights who wanted to both imitate **Shakespeare** and rid the German theater of French neoclassical vestiges.

The quality of Goethe's subsequent plays was uneven, with only *Clavigo* (1774) and *Stella* (1776) enjoying much success. Goethe subtitled *Stella* "*A Drama for Lovers*," and its characters manifest proclivities for intense passion similar to those in *Clavigo*. The plays' passionate characters probably explain their popularity among German audiences in the 1770s and 1780s. At the same time, Goethe's novel *The Sorrows of Young Werther* (1774) was an unambiguous success throughout Europe in many translations. It solidified his reputation as Germany's most extraordinary writer. Goethe continued writing plays, but he often let them "digest" in his mind for years after he started work on them. A good example is *Egmont*, which he began in 1775 and worked on intermittently for the next dozen years. It finally premiered in 1791.

Many of his works remain fragmentary, perhaps because in 1775 he accepted an invitation from the 18-year-old Duke Karl-August of Saxony-Weimar to become an official at the Weimar court. Goethe directed amateur theatricals at the Weimar ducal theater (and even appeared as an actor on occasion), but his most important assignment was to serve as the duke's chief courtier. Karl-August raised him to the aristocracy in 1782, allowing him to add "von" to his name.

Only when he departed for a two-year sojourn to Italy in 1786 was Goethe able to concentrate fully on playwriting. The results were reworkings of *Iphigenie auf Tauris* and several other plays.

When Goethe returned to Weimar in 1788, however, he had changed his outlook from Sturm und Drang to a conviction that embraced a kind of "classicism" based on restraint, harmony, and balance. He attempted to put that classical viewpoint into action when he became director of a professional troupe Duke Karl-August had established at what became the Weimar Court Theater in 1791. Goethe remained the theater's director for the next 26 years, though his most significant efforts there were his stagings of **Friedrich Schiller**'s late plays in their world premieres. Goethe and Schiller had known each other previously when Schiller had briefly lived in Weimar from 1788 to 1789. Schiller had then moved to the nearby university town of Jena, where with Goethe's help he was appointed to an adjunct professorship in history. By 1794 Goethe and Schiller had established a close friendship, and in 1799 Schiller moved back to Weimar. Between 1799 and Schiller's death in 1805, Goethe turned the Weimar Court Theater into one of the country's most celebrated.

The "classicism" Goethe favored as a theater director had little to do with classical Greek drama and even less with the staging of works by ancient Greek playwrights. Instead he was concerned with a clarity in performance that enabled audiences to see more distinctly the implications of significant patterns of action taking place on the stage. "The actor must realize that he should not only imitate Nature," he wrote in *Rules for Actors*, but also "present it in an idealized form, thereby uniting the true with the beautiful in his performance." Goethe also laid down other rules for actors aimed at eliminating discrepancies in proper enunciation, regionalisms in pronunciation, and idiosyncrasies in movement. Most humorously, in "Avoiding Bad Habits," he wrote: "The actor should never allow his handkerchief to be seen on stage, still less should he blow his nose in it, still less spit in it. It is disgusting for audiences to be reminded of such bodily functions in a work of art." He insisted on disciplined rehearsals, especially for his Schiller stagings, beginning in 1798 with Schiller's **Wallenstein Trilogy**.

With his concern for clarity, Goethe moved vigorously against contemporary currents in staging for the German theater—currents he had helped set in motion. At the same time, Goethe realized that the kinds of plays he favored, and the stagings for them he preferred, would at-

tract few paying customers to Weimar, his fame and Schiller's notwithstanding. He therefore did several stagings of popular fare by **August von Kotzebue** and **August Wilhelm Iffland**, along with musical offerings of operas, operettas, and *Singspiele*. Kotzebue was by far the most frequently performed playwright in Weimar under Goethe. Goethe's acquiescence to popular taste had its limits, however: he resigned his post when a touring company was scheduled to perform an adaptation of a French melodrama that featured a talented dog in the leading role. Goethe felt that a dog onstage—especially in a leading role—was a violation of everything he stood for.

Goethe used the additional time he then enjoyed to complete what many consider his masterpiece, *Faust*. The first performance of sections of *Faust, Part 1* took place in 1819 at an aristocrat's private theater in **Berlin**, and its first complete performance was staged by **August Ernst Klingemann** in Braunschweig in 1829. That production toured to several cities to widespread acclaim. Goethe staged a version of it himself in Weimar in 1829 on the occasion of his 80th birthday. He completed *Faust, Part 2* in 1831, but forbade its performance until after his death; its first complete performance had to wait until 1854 in **Hamburg**. The first complete performance of both parts of *Faust* together did not take place until 1875, in Weimar.

Goethe worked on the two parts of *Faust* intermittently for a period of 60 years, and it was a culmination of all the ideas that had intrigued or occupied him during those six decades. The play has since gained an exalted status as one of the great works of Western civilization, in many ways the ultimate expression of anything possible in the theater. It has natural and supernatural characters, episodes from the Trojan War, interplanetary travel, in vitro fertilization, and locations that range from Faust's study to the throne of Heaven. Several German actors have reached the pinnacle of their careers by placing their individual stamp on the role of Mephisto. The most famous performances of Mephisto in the 19th century were by **Karl Seydelmann** and later by **Bogumil Dawison**. The most riveting Mephisto of the 20th century was **Gustaf Gründgens**, who began performing it in 1932 and continued playing the role until his death 31 years later.

GOETZ, CURT (Kurt Götz, 1888–1960). Playwright, actor. In the 1920s Goetz became known as "the German Noël Coward" by virtue

of his translations and subsequent imitations of the English boulevardier. He got his first acting job in Rostock, and in 1910 **Viktor Barnowsky** hired Goetz for roles in plays by George Bernard Shaw at **Berlin**'s Lessing Theater. In that venue, Goetz's success with Shaw roles led him to begin writing his own plays. His first effort, *Ingeborg* (1921), proved to be a hit for Barnowsky, as did *Der Lampenschirm* (*The Lamp Shade*, 1923). When Barnowsky moved to the Theater in der Königgrätzer Strasse in 1925, Goetz went with him, and his career flourished throughout the Weimar Republic; his biggest hit in those years was *Hokuspokus*, which ultimately had more than 2,000 performances. During the Third Reich, Goetz enjoyed an even loftier status than he had in the Republic, with 236 different productions of his plays from 1933 to 1944. Even when he left Europe in 1939 and sailed for New York, Nazi authorities did not interpret his departure as defection; productions of his plays by the score remained in the repertoires of most theaters. In New York, Goetz staged *Das Haus in Montevideo* (*The House in Montevideo*)—a comedy about a German professor with 12 children who inherits a brothel in Paraguay—on Broadway under the title *It's a Gift*. After World War II, he returned to Europe and resumed work in Germany, maintaining an unrivaled popularity and appeal, directing and starring in productions of his own plays on tour and making two films that were among the most popular of the 1950s.

GOLD, KÄTHE (1902–1997). Actress. Gold was a child star in several theater productions before she left her native **Vienna** in 1926 for her first adult engagement, in Bern. She had a remarkable ability to play young women with mature sensibilities, or older character types while retaining a juvenile insouciance. After Bern she worked in Breslau and **Munich**, arriving in **Berlin** in 1932. Two years later **Gustaf Gründgens** made Gold a permanent member of his ensemble at the State Theater, where she played significant roles in some of the most celebrated productions of the Third Reich; they included Ophelia in *Hamlet*, Gretchen in *Faust*, Nora in *A Doll's House*, and Pippa in *Und Pippa tanzt!* (*And Pippa Dances!*).

Gold was the subject of a rare dispute between a fan club and the Propaganda Ministry during the Nazi dictatorship. She had greatly impressed **Richard Billinger**, who had written the play *Rauhnacht*

(*The Twelfth Night*), in which Gold had performed in 1932; Billinger won the Kleist Prize for the play that year, and he later wrote the role of Anna in *Der Gigant* (*The Giant*) for her in 1937. Anna was a farmer's daughter who abandoned the simple life of her country village to experience the excitement of living in the "golden city" of Prague. Gold's many fans in Berlin were outraged when Swedish actress Kristina Söderbaum (1912–2001) was selected to play Anna in the 1942 film version (titled *Die Goldene Stadt* [*The Golden City*]); several wrote the Propaganda Ministry vociferous letters of protest. However, since Söderbaum was married to the film's director, Veit Harlan (1899–1964), the protests had little effect.

After World War II, Gold returned to Vienna, where she became a leading member of the **Burgtheater** company and one of the very few actresses anywhere to play both Laura Wingfield in Tennessee Williams's *The Glass Menagerie* and Blanche Dubois in his *A Streetcar Named Desire* during the same season (1948).

GOSCH, JÜRGEN (1943–). Director. Gosch became one of the German theater's leading directors in the 1980s, with numerous productions invited to the Berliner **Theatertreffen**. He began his career in East Germany, where he completed studies as an actor in **Berlin**. His first engagement was in Mecklenburg, but in 1967 he began working in Potsdam as both an actor and a director. He attracted attention in East and West Germany with his "breakthrough" 1978 staging of **Georg Büchner**'s *Leonce und Lena* at the Berlin Volksbühne, which the East German regime strongly criticized and soon banned. Soon thereafter Gosch escaped to the West, where he began working in Hannover and Bremen. His most significant directing work emerged initially in **Cologne**, where his productions of Maxim Gorky's *The Lower Depths* and Molière's *The Misanthrope* were widely praised. Beginning in 1984 Gosch worked steadily under **Jürgen Flimm** at the Thalia Theater in **Hamburg**, and his production of *Oedipus Tyrannus* by Sophocles appeared at the 1986 Theatertreffen. In the 1990s he assumed a similar position under Thomas Langhoff at the **Deutsches Theater** in Berlin. Gosch's 2005 staging of Edward Albee's *Who's Afraid of Virginia Woolf?* was widely praised and attracted nationwide attention, including another Theatertreffen invitation.

GOTTSCHED, JOHANN CHRISTOPH (1700–1766). Scholar, playwright. Gottsched was a pastor's son who, as a professor at the University of Leipzig, had a missionary zeal to reform the German theater; with **Caroline Neuber** in the mid-18th century, he realized his missionary goals. Gottsched viewed theater as the ideal instrument to establish both spoken and written German as a literary language, but based on French models. In 1732 he convinced Neuber to begin performing his *Der sterbende Cato* (*The Dying Cato*), and he supported her attempts to make theater performances more professional by improving the diction of actors, correcting their comportment offstage, augmenting production values, and banning the presence of the low comic type **Hanswurst** from the stage. Nearly all German troupes in the first half of the 18th century were presenting fare that was vulgar, sloppy, and poorly produced. Between performances actors augmented their incomes by selling quack medicine, pulling teeth, or giving astrological advice; actresses in many cases provided sexual favors to anyone with money to pay for them. Gottsched wanted to cultivate in German audiences the taste for an alternative "national" drama, cleansed of obscene gimmicks, indecent innuendo, and juvenile humor—all of which Hanswurst personified. Gottsched envisioned a German theater whose principal task was public edification, and his quest for reform complemented Neuber's of raising the social status of actors and actresses. Their shared efforts were a driving force behind the German theater's transformation from a *Schaubude* (show booth) to a *Schaubühne* (theatrical showplace).

Gottsched's attempts to raise the status of the German language was successful, though his attempts to write neoclassical tragedy in German based on French precedents were not. He published six volumes of plays imitating Jean Racine and Pierre Corneille between 1740 and 1745, but their inadequacies as stageworthy vehicles led to a break with the Neuber troupe. Gottsched was among the first German theorists to propose a "systematic" discussion of comic theory, and in it he echoed earlier German views on drama's need to parallel life as closely as possible to achieve its moral ends. "The moral force of a play is dependent on its degree of realism, for the spectators must be able to recognize themselves and their environment in order to take to heart the examples they see on the stage," he wrote. Gottsched

described comedy as "an imitation of a depraved action, which through its essential ridiculousness the spectator is both amused and morally renewed." Both "depraved action" (*lasterhafte Handlung*) and "essential ridiculousness" (*lächerliches Wesen*) must coexist in performance, however, if the spectator's renewal is to take place (*Versuch einer critischen Dichtkunst* [Darmstadt: Wissenschaftliche Buchgesellschaft, 1962], 643).

GOTTSCHEF, DIMITER (1943–). Director. Gottschef began working in East **Berlin** in 1968, attracting little attention until his support for singer/songwriter Wolf Biermann caused his forced repatriation to his native Bulgaria. In 1985 he returned to Germany at the invitation of the **Cologne** theaters to stage **Heiner Müller**'s *Quartett*, and thereafter he reestablished his directorial credentials in the unified Germany during the 1990s. In 1991 he was named "director of the year" by *Theater Heute* magazine, and in 1992 his Cologne production of August Strindberg's *Miss Julie* in Cologne was invited to the Berliner **Theatertreffen**. From 1993 to 1996 Gottschef was house director at the Düsseldorf Theater, and from 1996 to 2000 he worked under **Leander Haussmann** in Bochum. Thereafter he worked in **Vienna**, Frankfurt am Main, **Hamburg**, and Berlin. His 2004 Berlin Volksbühne production of *Black Battles with Dogs* by Bernard-Marie Koltès (1948–1989) garnered a **Theatertreffen** invitation.

GÖTZ VON BERLICHINGEN by **Johann Wolfgang Goethe**. Premiered 1774. Goethe based this play on a Franconian knight who lost his hand in a 1504 battle and thereafter used an iron prosthesis (hence the play's subtitle, *With the Iron Hand*). Götz von Berlichingen became known to most Germans through the publication of his autobiography in 1731, and Goethe based much of his play on that publication. In the play, Goethe portrays Götz as a swashbuckling freedom fighter frequently at odds with establishment figures like bishops and dukes. Götz reluctantly joins his friend Franz von Sickingen on the side of the peasants in the Peasants' Revolt of 1524–1525; he is eventually captured and dies in prison, "Freedom! Freedom!" his final utterance. *Götz von Berlichingen* was Goethe's first stage hit, and it helped to inaugurate the **Sturm und Drang** (Storm and Stress) movement in German drama.

GRABBE, CHRISTIAN DIETRICH (1801–1836). Playwright. Grabbe's plays seldom found audience favor during his lifetime, but the 20th century was kinder to him. He studied law in Leipzig while endeavoring unsuccessfully in Dresden to become an actor or do theater work in some capacity. In **Berlin** during the 1820s, he wrote several plays, most notable among them *Scherz, Ironie, und tiefere Bedeutung* (*Jest, Irony, and Deeper Significance*, 1822). It was not produced until 1907, however, largely because his contemporaries found the play an unstageable, disconnected series of gloomy scenes in which most of the characters seemed incomprehensible. Grabbe returned from Berlin in 1824 with a law degree to his native Detmold, where he worked in a military judge advocate's office from 1826 to 1834. That period of regular employment afforded him the time and resources to complete several other plays, including *Don Juan und Faust* and *Napoleon, oder die Hundert Tage* (*Napoleon, or the Hundred Days*). The former was successfully premiered at the Detmold Court Theater, but the latter did not premiere until 1895. The modest success of *Don Juan und Faust*, however, encouraged him to quit his job and move to Düsseldorf as **Karl Lebrecht Immermann**'s **dramaturg**. When the Düsseldorf enterprise began to crumble, Grabbe quarreled with Immermann and returned to Detmold. He died soon thereafter of tuberculosis in his boyhood home, a jailhouse of which his father had been warden.

A literary society in Detmold now bears Grabbe's name and has its headquarters in that home, which houses an archive and a small experimental theater. A spectacular production of *Napoleon* staged by **Leopold Jessner** at the Berlin State Theater in 1922 was to date the most significantly attended of any Grabbe play. Grabbe's anti-Semitism found wide resonance during the Third Reich, when dozens of theaters did his plays; Nazi authorities even instituted "Grabbe Festival Weeks" in Detmold, inviting theaters with Grabbe plays in their repertoire to Detmold for special performances. *Don Juan und Faust* and *Scherz* were the most frequently performed during the Third Reich. In the 1970s a modest Grabbe revival took place among some German theaters, who staged several of his early, formerly unproduced plays.

GRANACH, ALEXANDER (Jessaja Szajko Gronach, 1890–1945). Actor. Granach was known for his fiery portrayals of conflicted char-

acter types, usually performed in the modernist style **Max Reinhardt** assiduously cultivated in performers like **Gertrud Eysoldt**, **Alexander Moissi**, and **Paul Wegener**. Granach's background gave him little in the way of formal preparation for the acting profession. He was an *Ostjude* from Galicia who was uneducated, uncultured, and unhealthy—but consumed with a passionate, uncompromising ambition to become an actor. He ran away from home at age 12, and by the time he was 19, he was working with an amateur Jewish theater group in **Berlin**. There he began study at Reinhardt's acting school, and in the next five years Granach began to get roles with Reinhardt and other managers in Berlin.

Drafted into the Austro-Hungarian army in 1914, he fought on the Italian front until his capture and spent the remainder of the war in a prisoner-of-war camp. He returned to Berlin in 1920 and soon thereafter began acting in silent films. Among the most notable were F. W. Murnau's *Nosferatu* (1922) and *Erdgeist* (*Earth Spirit*, 1923), although he made more than a dozen others. In the meantime, his work with Reinhardt continued, playing nearly every night through the 1920s in character roles at the **Deutsches Theater** or its adjoining Kammerspiele. He won his widest acclaim, however, as Shylock at the **Munich** Kammerspiele.

The election of the National Socialist government in 1933 meant an abrupt end to Granach's work in Germany. He emigrated to Poland and then to the Soviet Union, where he appeared mostly in films; in 1937 Granach barely escaped death during the first of Stalin's attempts to "cleanse" Soviet cultural activity. In 1938, with the help of Lion Feuchtwanger (1884–1958), Granach emigrated to New York. In 1939 he arrived in Hollywood in time to play a Soviet apparatchik in *Ninotchka* with Greta Garbo. That movie established him in Hollywood, allowing him to remain and work there until his death. Granach wrote an eminently readable autobiography, *Da geht ein Mensch* (English title: *There Goes an Actor*), which exquisitely captured the tragedies and triumphs of his life; it proved to be so popular after its publication in 1945 that it subsequently appeared in numerous translations.

GRASS, GÜNTER (1927–). Playwright. Grass was awarded the Nobel Prize for literature in 1999 and is best known for his novels, but

he wrote plays in the 1950s and 1960s. His short plays included *Hochwasser* (*High Water*, premiered in Frankfurt am Main, 1957); *Onkel, Onkel* (English title: *Mister, Mister*, **Cologne**, 1958) in; *Noch zehn Minuten bis Buffalo* (*Ten Minutes to Buffalo*, Bochum, 1959); and his full length, three-act *Die bösen Köche* (*The Wicked Cooks*, 1961), which premiered in the Workshop of the Schiller Theater in **Berlin**, as did *Davor* (English title: *Max, a Play*) in 1969.

By far his most frequently performed play, however, was *Die Plebejer proben den Aufstand* (*The Plebians Rehearse the Uprising*, 1966), premiered likewise at the Schiller Theater Workshop. It examined the role of **Bertolt Brecht** in the 1953 workers' uprising against the Communist regime of the German Democratic Republic. The play depicted Brecht (called "The Boss") staging a scene from his adaptation of **William Shakespeare**'s *Coriolanus* on the afternoon of 17 June, the day Russian troops killed scores of German workers in the streets of East Berlin and in the process destroyed the East German regime's credibility beyond repair. Demonstrators disrupt the rehearsal and ask Brecht to write a public declaration of his support of their uprising. Brecht declines to do so (in fact, Brecht wrote a letter of public support for the East German regime *against* the workers) and tells the demonstrators that he believes their revolt is pointless. He then dismisses the demonstrators as cowards, telling them they lack "even the courage to step on the lawn." (Brecht's private diaries reveal that he was contemptuous of workers generally, despite his declaration of loyalty to the "workers' state." See his *Arbeitsjournal*, ed. Werner Hecht [Frankfurt: Suhrkamp, 1973], 2:1010.) In the play, Brecht asks the demonstrators to remain in the theater, where unbeknownst to them, he records their responses to his provocations and insults on a tape recorder. He later plays back their responses for the purpose of using their uprising in his Shakespeare adaptation. When he learns that they have been killed in demonstrations outside, Brecht realizes his failure and supposedly plans to resign. In reality, Brecht did no such thing, of course, later accepting the Stalin Peace Prize. But Grass wanted to portray Brecht as a "typical" German intellectual who in most cases refuses to involve himself in politics. The play met with mixed reviews but was performed in numerous German theaters thereafter.

Grass has been awarded dozens of prizes and awards, among them the Büchner Prize, the Fontane Prize, the Premio Internazionale Mon-

dello (1977), the Alexander-Majakowski Medal from his native Danzig (now Gdańsk), the Antonio Feltrinelli Prize (1982), and the Grand Literature Prize of the Bavarian Academy, along with honorary doctorates from Kenyon College, Harvard University, and the universities of Gdańsk and Poznań.

GRIEM, HELMUT (1932–2004). Actor. Griem was familiar to German audiences by the time he became internationally known for his performance as Maximilian von Heune in the Bob Fosse film *Cabaret* (1972). He began his career in Lübeck in 1955, playing Starbuck in one of the first German productions of *The Rainmaker* by Richard Nash. The success of that production led to several subsequent engagements in **Cologne**, **Munich**, and **Hamburg**, culminating in a lengthy engagement with the **Burgtheater** in **Vienna** to play a number of heroic leading parts. These included **William Shakespeare**'s Richard II, **Heinrich von Kleist**'s Prince Friedrich of Homburg, Major von Tellheim in **Gotthold Ephraim Lessing**'s *Minna von Barnhelm*, and Tom Wingfield in Tennessee Williams's *The Glass Menagerie*. In Vienna, Griem began his film and television career, and by the 1980s he had established himself as a theater director as well. His Munich production of Orton's *Entertaining Mr. Sloane* was a remarkable box office success, as were his later commercially produced stagings in Vienna during the 1990s of Eugene O'Neill's *Long Day's Journey into Night*, John Millington Synge's *The Playboy of the Western World*, Arthur Miller's *Death of a Salesman*, and Ariel Dorfman's *Death and the Maiden*. Shortly before his death, Griem was awarded the Federal Service Cross for his contributions to German culture.

GRILLPARZER, FRANZ (1791–1872). Playwright. Grillparzer was perhaps the most accomplished playwright of 19th-century Austria; scholars sometimes compare his work to **Heinrich von Kleist**'s as an example of late **Romanticism**, because his characters (like Kleist's) often suffer passions of unbridled dimensions in plays that cover vast expanses of time and territory. Grillparzer was a graduate of the University of **Vienna**'s law school and served in the Habsburg bureaucracy for decades; in 1856 he received the honorary title of *Hofrat* (court counsel) for his services. As a playwright, however, he sometimes ran

afoul of the Habsburg establishment, and he never received the literary honors many thought his due. **Joseph Schreyvogel** was the first director to encourage Grillparzer; his *Die Ahnfrau* (*The Ancestress*) premiered at the Theater an der Wien in 1817 and was generally successful. Schreyvogel's 1819 premiere of Grillparzer's five-act verse tragedy *Sappho* at the **Burgtheater**, however, was sensationally popular. It earned Grillparzer both money and renown, and the Burg named him one of its *Theaterdichter* (theater poets) thereafter.

Grillparzer is one of the few German-language playwrights to have been strongly influenced by plays of the Siglo de Oro, the "golden age" of Spanish drama in the 17th century. His *Der Traum ein Leben* (*Life Is a Dream*) is perhaps the best example, since it derives in many respects from the Calderón de la Barca original. Grillparzer's *Weh dem, der lügt* (*Woe Betide the Liar*) is likewise thought to have antecedents in the work of Lope de Vega; Grillparzer set the play in medieval France, and unfortunately audiences hated it. His *Die Jüdin von Toledo* (*The Jewess of Toledo*, 1851), based directly on Lope's *The Peace of Kings and the Jews of Toledo* (1617), was more successful when it premiered after Grillparzer's death.

Grillparzer was most successful in plays that dealt with Habsburg history; his first play chronicling the Habsburg dynasty was *König Ottokars Glück und Ende* (*King Ottokar's Rise and Fall*, 1825), featuring the first Habsburg king, Rudolf I, and his successful overthrow of the Bohemian king Ottokar. Czech patriots naturally resented the portrayal of Ottokar as a morose cuckold, and the play was at first banned; only when Empress Augusta Caroline intervened on his behalf was the production allowed to proceed. That was not the last encounter with **censors** for Grillparzer, though. Many critics have argued that Grillparzer's frequent conflicts with censors led him to a despondency that negatively affected his work. That may be true to some extent, but **Heinrich Laube**'s numerous productions of Grillparzer's plays in the 1850s occasioned a revival of estimation for Grillparzer; that led to what is arguably his best play, *Ein Bruderzwist in Habsburg* (*Fraternal Guile within the House of Habsburg*), which premiered posthumously. Even before the 1850s, however, there was general recognition of Grillparzer's achievements. Habsburg chancellor Klemens von Metternich himself named Grillparzer to the Austrian Academy of Sciences in 1847; he was awarded

several honorary doctorates in the 1850s, and in 1861 Grillparzer was appointed to the newly established Upper House of the Austrian parliament. When he died, thousands lined the streets as his funeral cortege passed by; an estimated 20,000 mourners accompanied it to the Hietzinger Cemetery in Vienna.

GROSZ, GEORGE (Georg Gross, 1893–1959). Designer. Grosz is best remembered for his work with **Erwin Piscator**, especially on one production: *Die Abenteuer des braven Soldaten Schwejk* (*The Adventures of Good Soldier Schweik*) in 1928. For that production, Grosz provided dozens of his characteristic caricatures and cartoons, many of which Piscator then had enlarged and mounted for use as scenery onstage. Piscator employed the images as life-size figures whom Schweik encountered in his "adventures." Grosz had begun cartooning after his release from the army in 1916, publishing his work in weekly magazines. He was arrested and reassigned to the front in 1917, then in 1918 was arrested for desertion and placed in a military prison. His military experiences had a profound effect on his artistic perceptions, and after the war he was again arrested on several charges, first for insulting the German army and another time for "corrupting inherently German morals." He later was convicted of blasphemy and fined for portraying a crucified Christ wearing a gas mask like those worn by German troops in the trenches. His sketches were in many cases vicious renderings of severely disfigured or dying soldiers, prostitutes, obese war profiteers, or sanctimonious church officials—all of which amounted to an enormous, vituperative tapestry that indicted his fellow Germans for what he perceived as their militaristic depravity, obeisance to authority, and comfortable self-satisfaction.

GRÜBER, KLAUS-MICHAEL (1941–). Director. Grüber is most closely associated with the Schaubühne am Halleschen Ufer during the 1970s, but his many productions outside Germany since that decade have established him as a director of international consequence. The son of a pastor, Grüber began theater studies in Stuttgart after school graduation. He holds the distinction among German directors as one of the few who began a professional career by working first in Italy before returning to establish himself in Germany; he

arrived in Italy in 1964 to work under Giorgio Strehler (1921–) at his Piccolo Teatro in Milan.

Grüber's first professional engagement as a full-time director in Germany came in 1969 under Kurt Hübner in Bremen, where his most noteworthy directorial effort was **Shakespeare**'s *The Tempest*. Subsequent productions in Düsseldorf and Frankfurt am Main followed, but his most well-known efforts came under the auspices of the Schaubühne, for whom he staged *Winter Journey* in the **Berlin** Olympic Stadium. He added numerous other popular Schaubühne productions to the company's repertoire, including plays by **Ödön von Horváth**, **Bertolt Brecht**, Shakespeare, Anton Chekhov, and Eugène Labiche, though none with the sensational attraction of *Winter Journey*. His production in a Parisian church of an adapted version of **Johann Wolfgang Goethe**'s *Faust*, titled *Faust-Salpêtrière*, won widespread approval among the French in 1975. His 1982 adaptation of *Faust* for the Berlin Freie Volksbühne was not so fortunate, however; most German critics condemned it, especially those with a devotion to Goethe. Grüber returned to Paris in 1985, where a prodigiously popular production at the Comédie Française of Jean Racine's *Bérénice* gained him additional favor among French critics and audiences.

Grüber's reputation recovered in Germany during the late 1980s with outstanding productions in **Munich**, at the Salzburg Festival, in **Vienna**, and in Frankfurt am Main. His opera productions have also been widely praised, but his theater productions have earned him seven invitations to the Berliner **Theatertreffen**, and he has staged plays on a regular basis throughout Europe. Grüber was awarded the Kortner Prize in 1995, and when he was awarded the Konrad Wolf Prize in 2000, the jury praised his "thirty-year-long resistance to superficiality," while noting that in every production, "Grüber's attempts to experience anew what the theater can be."

GRÜNDGENS, GUSTAF (1899–1963). Actor, **intendant**, director. Gründgens was the most galvanizing performer since **Josef Kainz**, and many contend he was the greatest actor in 20th-century German theater. Gründgens was certainly among its most controversial, due largely to his relationship with Hermann Goering. Klaus Mann chronicled it in his *roman à clef* titled *Mephisto*, which was the basis

of a film by the same title starring **Klaus Maria Brandauer** as "Hendrik Höfgen," the spectacular yet unscrupulous *ersatz* Gründgens.

Gründgens was the superlative Mephisto of his generation and made many deals with Goering—but he was not the diabolical, obsessive schemer some imagined. Before his meteoric rise to stardom in **Berlin**, he studied at the **Louise Dumont**–Gustav Lindemann school in his native Düsseldorf. His professional career began in **Kiel** but entered its upward trajectory in **Hamburg**, where Gründgens worked steadily for **Erich Ziegel** and Mirjam Horwitz at the Kammerspiele from 1923 to 1928. He alternated his work there with cabaret acts; Gründgens was a gifted song-and-dance man, a versatility unusual in the German theater. His 1928 breakthrough in Berlin came as the sadistic Ottfrid Berlessen in **Heinz Hilpert**'s premiere of **Ferdinand Bruckner**'s *Die Verbrecher* (*The Criminals*), with **Lucie Höflich** and **Hans Albers**. Soon thereafter Gründgens became Berlin's busiest director, casting himself in several boulevard thrillers and romantic comedies, usually as a scoundrel in evening wear or a gentleman criminal.

Gründgens's film career concomitantly began to blossom, as he appeared in more than a dozen movies between 1930 and 1933. The best of his performances in those years was in Fritz Lang's *M* (1931) with **Peter Lorre**; as the merciless "prosecutor" Schränker, he represents the crime syndicate that puts Lorre on trial. Gründgens's films during the Third Reich included adaptations of George Bernard Shaw's *Pygmalion* (1935) and Oscar Wilde's *A Woman of No Importance* (1936), but the most notable was *Tanz auf dem Vulkan* (*Dance on the Volcano*), in which he put his singing abilities on full display. In this film, as in others, the impression Gründgens made was one of virtuotistic bravura; his was so riveting a presence that characters around him seem drawn irresistibly into his thaumaturgy. Gründgens began playing Mephisto in 1932, but in the Third Reich his signature role was Hamlet. Performances sold out months in advance, with crowds ringing the Berlin State Theater two and sometimes three people deep hoping somehow to snatch up any canceled reservations.

As a highly visible theater manager, Gründgens avoided direct confrontations with **Joseph Goebbels** through his protection by Goering. Gründgens's long-standing friendship with Goering's actress wife Emmy Sonnemann was invaluable, helping him to defend **Jürgen**

Fehling and his controversial **Shakespeare** productions. Gründgens also used his influence to assist many Jews and colleagues married to Jews, most notable among them **Ernst Busch**—but Gründgens was himself a target of Nazi hatred because of his homosexuality. Gründgens's marriage to **Marianne Hoppe** blunted efforts to discredit him, and his assistance to Busch ultimately saved his life when Soviet authorities arrested him in 1945 and held him in detention for nine months.

He returned to Berlin for several **Frank Wedekind** and **Carl Sternheim** roles at the **Deutsches Theater** before his departure for Düsseldorf in 1947 as intendant of that city's theaters. There he revived *Faust, Part 1*, *Hamlet*, *Wallsteins Tod* (*Wallentein's Death*), and several other productions he had staged under Goering. His performance at the 1949 Edinburgh Festival in such roles ignited a firestorm of controversy and protest in British newspapers, though most agreed that his Mephisto was astonishing. In 1955 Gründgens became intendant of the **Deutsches Schauspielhaus** in **Hamburg**, where Hilpert directed him as Archie Rice in the German-language premiere of John Osborne's *The Entertainer*. Gründgens himself premiered **Bertolt Brecht**'s *St. Joan of the Stockyards* and did several "classic" roles from the German repertoire, but his signature role remained Mephisto. Peter Gorski's 1961 film of *Faust, Part 1* coincided with Gründgens's New York appearance in the role, persuading most observers that Gründgens had entered the German theater's pantheon.

GUTE MENSCH VON SEZUAN, DER (THE GOOD PERSON OF SETZUAN) by **Bertolt Brecht**. Premiered 1943. Three gods appear in the imaginary Chinese city of Setzuan searching for a "good person." They find no one of that description until they encounter the prostitute Shen Te, who offers them shelter for the night. They give her money and extract a promise from her to "be good." The thesis **Bertolt Brecht** propounds throughout the play is that economic circumstances determine whether or not one can afford morality. Only when certain basic needs are met can "goodness" be considered. "We never mess with economics," reply the gods, inferring that religion is useless in the practical needs of people.

Shen Te buys a tobacco shop with her new wealth and is immediately beset by all manner of indigents hoping to benefit from her

good fortune. Brecht creates an alter ego for Shen Te in the form of her "cousin," Mr. Shui Ta. He drives a hard bargain, provides employment for the people, and generally brings order to social chaos. Meantime Shen Te falls in love with an unemployed pilot, who impregnates her. Witnesses note that Shui Ta is becoming plump on his accumulating wealth. The courts charge him with Shen Te's murder. When Shen Te reveals that she and Shui Ta are the same "good person," the gods intervene and forgive her for not being so good after all. They also give her permission to call upon her "cousin" whenever the need arises.

The play extends the idea Brecht first explored in *Mann ist Mann*— that of a flexible identity formed by economic, social, and political circumstances. It also exemplifies in numerous aspects the Brechtian principle of *Verfremdung*, or distancing audience response from the experience of watching it. Its setting is remote, the central character is bifurcated, and songs frequently interrupt the anticipated narrative flow. The play found abundant resonance among critics in the Cold War period who maintained that improvement of social and economic conditions was a prerequisite for improving, and even changing, human nature.

GUTZKOW, KARL (1811–1878). Playwright. Gutzkow came to prominence as a member of the "Young Germany" movement, which among younger German intellectuals voiced sympathy for the ideals of the 1830 revolution in Paris, especially those of universal male suffrage, religious tolerance, and sexual emancipation. In 1831 Gutzkow wrote *Uriel Acosta*, a five-act blank-verse tragedy about an Orthodox Jew who confronted intolerance and bigotry in his own religion; the play did not premiere until 1846, but thereafter it proved exceedingly durable as a standard feature in several theater repertoires. Gutzkow was briefly imprisoned in 1836 for his revolutionary convictions, but public sentiment ran in his favor. He edited several publications through the 1840s, during which time his playwriting thrived. His best effort from that decade was the comedy *Der Königsleutnant* (*The King's Lieutenant*), written for the **Johann Wolfgang Goethe** centenary in 1849. It remained popular through the 1880s. He worked as a **dramaturg** in Dresden, but for the most part Gutzkow concentrated on writing novels for the remainder of his life.

– H –

HAACK, KÄTHE (1897–1986). Actress. Haack became one of the most popular actresses in **Berlin**'s numerous commercial theaters during the 1920s, playing ingenue parts in dozens of boulevard comedies. She was most often seen at the Lessing Theater, though she also appeared at the Residenz Theater, the Trianon Theater, and the Theater am Kurfürstendamm, concluding her "Weimar period" with a much-praised portrayal of the mayor's wife in **Carl Zuckmayer**'s *Der Hauptmann von Köpenick* (*The Captain of Köpenick*) at **Max Reinhardt**'s **Deutsches Theater**. In 1934 **Gustaf Gründgens** hired her as a member of his company at the State Theater, where she remained until 1944. In the postwar years, she resumed her career in several Berlin commercial productions, culminating in the role of Mrs. Higgins in the Theater des Westens's extraordinarily popular production of Lerner and Loewe's *My Fair Lady*, which ran for three years in Berlin. Haack's film career was likewise resplendent, with more than 150 movie roles to her credit.

HAASE, FRIEDRICH (1825–1911). Actor. Haase was a first-rate actor by 1846 at the Court Theater of Weimar. His father was a chamberlain for Prussian king Friedrich Wilhelm II, and as one of the king's godsons, Haase grew up in the presence of actors at **Berlin**'s Royal Theater. He studied under **Ludwig Tieck**, learning a great deal about **Shakespearean** staging, and he put those lessons into practice by the time he was a theater manager in Gotha, where he patterned his 1866 production of *Hamlet* on Tieck's ideas about Elizabethan staging. He ran the Leipzig City Theater from 1870 to 1876, after which he embarked on several profitable tours throughout central Europe, Russia, and America. His presence in New York resulted in a series of sold-out houses, especially when he played Mephisto in **Johann Wolfgang Goethe**'s *Faust* on Broadway. At the Neues Stadttheater in New York, Haase starred in plays by **Karl Gutzkow** and **August von Kotzebue**. On a second tour of New York in 1881, Haase did a season at the Neues Germania Theater in plays by Karl von Holtei, **Friedrich Schiller** (as Philipp II in *Don Carlos*), Shakespeare (as Shylock in *The Merchant of Venice*), and **Gotthold Ephraim Lessing** (Marinelli in *Emilia Galotti*). He returned to Ger-

many having earned an enormous amount of money in America, hoping to form a company along the lines of the Meininger troupe.

In 1883 Haase accepted **Adolph L'Arronge**'s offer to join a consortium at the newly renamed **Deutsches Theater**, with the goal of devoting care and preparation to productions in emulation of the Meininger. The attempt foundered on the inability and/or unwillingness of Haase and other cofounders to commit enough time in Berlin to produce Meininger-like detail in production. L'Arronge maintained that Haase was so used to being a star on tour that he never did become a contributing partner. Haase earned a paltry RM2,000 as a partner; to him, "that was a sacrifice. In five months' touring during 1881 alone he earned 137,440 Reich Marks" (L'Arronge, *Deutsches Theater und deutsche Schauspielkunst* [Berlin: Concordia, 1896], 73). Haase claimed that he was interested in ensemble acting, but he was too steeped in 19th-century traditions of virtuotistic display; **Theodor Döring** had bestowed upon him the **Iffland Ring** in 1878, and his star status proved ultimately too difficult a barrier to overcome—especially when it meant playing smaller roles with younger actors in the roles for which he had once been famous.

HALBE, MAX (1865–1944). Playwright. Halbe became one of the Wilhelmine period's most successful playwrights with *Jugend* (*Youth*, 1893), though none of his other plays approached its popularity and frequency of performance. It treated family conflict and forbidden love in an imitation of **Naturalistic** fashion, but it was essentially a formulaic melodrama. Set in West Prussia in an accord with Naturalism's demands for authenticity, Halbe portrayed two young lovers (Hans and Anna) doomed by the jealousy of Anna's stepbrother—who in the end kills Anna. Halbe wrote more than 20 plays, all of which were successfully produced.

HAMBURG. Hamburg has enjoyed several illustrious periods of theater activity, the first and foremost of which was the formation there in 1765 of the first "national" theater in Germany. The attempt in that year to establish a troupe on a permanent basis, supported by the independent resources of businessmen instead of a court, initially failed. Still, **Gotthold Ephraim Lessing**'s *Hamburg Dramaturgy* testified to the importance of that effort even though it failed. **Friedrich Ludwig**

Schröder reestablished a permanent company in 1774 and led it to unprecedented heights, comparable to the renown **Johann Wolfgang Goethe** enjoyed in Weimar. In 1827 the city council built a new Hamburg City Theater, based on plans by **Karl Friedrich Schinkel**, with a troupe that included **Emil Devrient** and Christine Enghaus. In the aftermath of the Great Fire of 1842, the Thalia Theater was founded, and in 1874 the City Theater was refurbished. Several small theaters arose in the latter half of the 19th century, though none could compare with the splendid new **Deutsches Schauspielhaus** built in 1900. Designed by the firm of Fellner and Hellmer, this granite-clad structure bespoke Hamburg's rapidly expanding wealth and prominence in the German Reich. In 1912 the Thalia Theater was rebuilt.

In World War II, all of Hamburg's theaters were either destroyed or severely damaged—yet within a decade of the war's conclusion, all of them had been rebuilt and several more added to an already bustling theater culture. The appointment of **Gustaf Gründgens** as **intendant** of the Deutsches Schauspielhaus in 1955 was a significant juncture in Hamburg's renewal. His staging of *Hamlet*, with Maximilian Schell in the title role, was a high point in Hamburg's history during the 1950s, exceeded only by Gründgens himself as Archie Rice in **Heinz Hilpert**'s 1957 German premiere of John Osborne's *The Entertainer*. Gründgens presented the world premieres of **Carl Zuckmayer**'s *The Cold Light* in 1955 and **Bertolt Brecht**'s *St. Joan of the Stockyards* in 1959. Perhaps surpassing them all was Gründgens's Mephisto in his staging of *Faust, Part 1* at the Deutsches Schauspielhaus; Gründgens had actually created the production in Düsseldorf, but Hamburg gladly accepted it as a phenomenon in its midst, and thousands of Germans flocked to the city to witness what many observers regarded as the performance of a lifetime.

HANDKE, PETER (1942–). Playwright. Handke enjoyed a vogue in the 1970s for his distinctly apolitical plays; many considered him an antidote to **Bertolt Brecht**. His *Kaspar* (1968) was among the most widely performed plays anywhere in German-speaking theaters. *The Anxiety of the Goalie at the Penalty Kick* (1970) and *The Ride across Lake Constance* (1971) were not so well received, but they were in many ways precursors to subsequent postmodernist developments in the German theater. The latter in particular is an anarchic perform-

ance piece, in which actors assume bizarre personae that have nothing to do with the famous names attached to the figures they supposedly represent, such as **Emil Jannings**, Henny Porten, **Elisabeth Bergner**, and others. Handke received the Büchner Prize in 1973 and has since written numerous screenplays.

HANSWURST. A kind of Teutonic Harlequin, Hanswurst was a coarse clown with *commedia* antecedents that Josef Anton Stranitzky (1676–1726) had formulated by 1705 in **Vienna**. Stranitzky, a licensed dentist who often pulled teeth during intermissions of his performances, conceived of Hanswurst as a Salzburg peasant in yellow trousers and a red jacket. Hanswurst had made his way into several **Haupt- und Staatsaktion** plays by the 1720s, but **Caroline Neuber** ceremoniously banned him from the "proper" German stage in 1737. Hanswurst refused to disappear altogether from the German stage, however, as numerous actors revived him in various guises throughout the 18th century. Hanswurst embodies the German theater's initial vulgarity and emphasis on sexual innuendo to attract a popular audience. He became a favorite among audiences, but reformers like **Johann Christoph Gottsched** and Neuber found him altogether embarrassing and an impediment to the acceptance of theater's legitimacy.

HARTUNG, GUSTAV (1887–1946). Director. Hartung began his directing career in Bremen, but he made his most significant contributions at the Frankfurt am Main City Theater. There he staged a number of **Expressionist** productions as that theater's head director and **dramaturg** between 1914 and 1920. In Frankfurt, Hartung began working with **Carl Sternheim**, and the two developed a mutually beneficial working relationship. Hartung continued to do numerous premieres of Sternheim's work until 1933; he especially understood the "hard edge" of Sternheim's dialogue. Hartung also premiered **Fritz von Unruh**'s plays, most notably *Platz* (*Place*) and *Ein Geschlecht* (*One Generation*). He arrived in **Cologne** in 1924 with the support of its mayor, Konrad Adenauer, but remained there only one year. Audiences were not receptive to his Expressionist experiments with **Georg Kaiser**, Eugene O'Neill, and other Unruh plays.

HASEMANNS TÖCHTER (*Hasemann's Daughters*) by **Adolph L'Arronge**. Premiered 1877. L'Arronge based his play on Victorien Sardou's *La Famille Benoîton*, which had premiered in 1865 in Paris. His version is less complex than Sardou's and features fewer characters, but the theme of female frivolity and the disdain of aristocrats for self-made men remains. Frau Hasemann and Mme. Benoîton are nearly identical, while Herr Hasemann has a much clearer sense of moral uprightness than does M. Benoîton; the former is outraged that his daughter should forsake her marriage vows, while the latter is only momentarily chagrined.

Hasemann is a familiar Second Reich type—one whose wife and daughters cause him no end of grief. His relative prosperity (he had been the proprietor of a gardening business but had become rich as a stock market speculator) allows him to indulge his wife Albertine with luxuries and the promise of an ocean cruise. Their eldest daughter Emilie is married to a prosperous locksmith but as yet they have no children; that does not prevent them from quarreling over how their children should be raised, however. Albertine Hasemann complains that Emilie married beneath her station, and she has therefore given her second daughter Rosa a good education so she may meet higher-class marriage prospects. There are three such prospects in view: Baron Zinnow, a shy pharmacist named Eduard Klein, and a plain-spoken but solid 40-year-old factory owner named Körner. Rose loves none of them, but her mother prefers the Baron. Rosa realizes that the Baron is merely toying with her, however, and on impulse agrees to marry Körner.

Their marriage grants Rosa and Albertine the money to move upward in society; they host parties, buy new clothes, and indulge themselves frivolously. Baron Zinnow, however, still entertains notions of an affair with Rosa, and Körner begins to suspect something is going on between his wife and her former suitor. Körner thinks his suspicions are confirmed when he discovers a letter from Zinnow suggesting a rendezvous. Meanwhile the third and youngest Hasemann daughter, Franziska, has taken ill, and pharmacist Klein delivers medication to the household himself. There he encounters Rosa, and they both realize they should have married. Hasemann becomes exasperated with the whole pretentiousness his daughters have learned from their mother and decides to assert his paternal authority. He or-

ders the youngest daughter, Franziska, to take up knitting and cooking, in order to attract the right kind of man as her husband.

HASENCLEVER, WALTER (1890–1940). Playwright. Hasenclever began as a poet of **Expressionism**, though he is best known as a playwright of that style. His *Der Sohn* (*The Son*) premiered in 1916 at the Dresden Albert Theater and was afterward produced in several theaters. He then wrote a series of mostly forgettable Expressionist dramas, few of which were produced more than once. He turned to comedy in the mid-1920s and had success with *Ein besserer Herr* (*A Better Sort of Gentleman*, 1927) and *Ehen werden in Himmel geschlossen* (*Marriages Are Made in Heaven*, 1928).

HASSE, O. E. (OTTO EDUARD) (1903–1978). Actor. Hasse arrived in **Berlin** to study law, but after three semesters enrolled instead in **Max Reinhardt**'s acting school at the **Deutsches Theater**. Upon graduation Hasse landed parts in numerous touring troupes and tiny provincial theaters. By the early 1930s, however, he was working regularly in Breslau and **Munich**. The Tri-Ergon sound technology for film enabled Hasse to capitalize on his extraordinary vocal gifts and facilitate his "discovery" as a movie actor; he worked consistently in films throughout the Third Reich. After World War II Hasse reestablished his career by playing the title role in **Heinz Hilpert**'s German premiere production of **Carl Zuckmayer**'s *Des Teufels General* (*The Devil's General*). In the 1950s he was a member of **Boleslaw Barlog**'s company in Berlin at the Schiller Theater, appearing in several notable productions, among them Samuel Beckett's *Waiting for Godot*. Alongside Montgomery Clift, he played Otto Keller in Hitchcock's *I Confess* in 1953, and in 1956 he played the title role in the film for which he is best remembered, *Canaris*. For that performance, Hasse won the Best Actor Award at the San Sebastian Film Festival. In 1961 he played the title role in a film version of **Friedrich Dürrenmatt**'s *Die Ehe des Herrn Mississippi* (*The Marriage of Mr. Mississippi*), and in 1962 he played Dr. Schön in Rolf Thiele's film *Lulu*, based on the **Frank Wedekind** plays. His remarkable voice enabled him to work extensively in the dubbing market, speaking the translated lines of Humphrey Bogart, Spencer Tracy, Clark Gable, and others in dozens of American films banned

in the 1930s and 1940s, which Germans began to see only in the 1950s.

HAUPTMANN, ELISABETH (1897–1973). Playwright. Hauptmann is best known for her collaborations with **Bertolt Brecht**, though she was a remarkable talent on her own. She arrived in **Berlin** at age 25, having worked as a private teacher since school graduation. Unable to finance university studies, she began attending a night school for adults in Berlin while working a day job for the Kiepenheuer publishing firm. At the school, she met Brecht and soon thereafter began assisting him, most significantly by providing him with ideas for plays. She was the source for *The Beggar's Opera*, having translated the Gay original for Brecht. She wrote much of the dialogue for the subsequent adaptation they created, *Die Dreigroschenoper* (*The Threepenny Opera*). Hauptmann likewise wrote most of the dialogue for Brecht's attempt to repeat *Threepenny*'s success, *Happy End*. Brecht actually credited her for that work—though under the name "Dorothy Lane."

Because she was an active member of the German Communist party, Hauptmann fled Berlin in 1933 and ended up in St. Louis, Missouri, where she lived for a time with her sister's family (their mother was a U.S. citizen); she later taught French at a branch of the University of Missouri. Her work with Brecht continued in the United States: in 1934 she assisted him in preparing the script for *The Mother*, and when Brecht arrived in California seven years later, she resumed her work with him, moving there herself in 1946 to assist Brecht with several projects. When Brecht left the United States, Hauptmann did likewise a year later. She settled in Berlin by 1949, where she continued working with the **Berliner Ensemble**, writing and translating projects for the company.

HAUPTMANN, GERHART (1862–1946). Playwright. Hauptmann studied painting and sculpture, but acting lessons in **Berlin**—along with marriage in 1885 to a wealthy young woman—convinced him to try playwriting. His first successful play was *Vor Sonnenaufgang* (*Before Sunrise*), which the Freie Bühne organization produced in 1889, though he had written several **Naturalistic** plays before then, among them *Die Weber* (*The Weavers*, about a weavers' uprising in his native

Silesia) and the comedy *Der Biberpelz* (*The Beaver Coat*, a "thieves' comedy" set in a Berlin shantytown). **Adolph L'Arronge** premiered *The Beaver Coat* in 1883 at his **Deutsches Theater**, but it failed.

In **Munich**, a student theater had staged one-night, invited-audience-only productions of *The Weavers*, but few professional managers wanted to battle the police **censors** in an attempt to stage it. Hauptmann himself filed a complaint against the Berlin police and petitioned a court to lift the ban. Finally in 1893 a sympathetic judge overruled the police, but declared that it could appear only at the Deutsches Theater. He reasoned that theater's ticket prices were so high that the clientele were unlikely to riot afterward (H. H. Houben, *Verbotene Literatur* Vol. I [Dessau: Karl Rauch, 1925], 1:353). L'Arronge, however, declined to present it. With director **Otto Brahm**, Hauptmann renegotiated with the police over the summer of 1894 and regained permission to do *The Weavers*. When *The Weavers* did open at the Deutsches to a ticket-buying public on 25 September 1894, it was an enormous hit and ran for the rest of the season. Kaiser Wilhelm II publicly denounced the play, however, and forbade all officers of the imperial armed forces to attend any performances. He also arranged the dismissal of the judge who had overruled the Berlin police. Wilhelm then began a pattern of public utterances against modernist art after the *Weavers* debacle, realizing he could no longer rely on the Prussian judicial system to enforce his personal tastes in theatrical offerings. He twice (in 1896 and 1899) vetoed Hauptmann as winner of the prestigious Schiller Prize, after he had been selected by the awards committee whose members Wilhelm himself had appointed.

By 1894, Hauptmann had completely mastered the art of creating convincing characters speaking effective dialogue (often in dialect form) within a Naturalistic setting. Brahm's direction of nearly all Hauptmann's plays after 1894 was crucial to the playwright's success. The director had an extraordinary ear for "authenticity" in dialogue, along with substantial editorial boldness, cutting relentlessly when required. Playwright and director shared a remarkable artistic relationship, along with similar leftist political convictions, and plays such as *Fuhrmann Henschel* (*Teamster Henschel*, 1896) and *Rose Bernd* (1903) provided further testimony to their beliefs. Their relationship ended in 1912 with Brahm's death, though a year earlier they had completed one of their best collaborations, *Die Ratten* (*The Rats*).

Hauptmann also wrote several nonrealistic plays, the most successful of them being **Und Pippa tanzt!** (*And Pippa Dances!*, 1906). Its premiere production featured the waif-like **Ida Orloff** in the title role, joining several other performers who, under Brahm's direction, made names for themselves in the many distinctive roles Hauptmann created for them. Other nonrealistic plays were *Hanneles Himmelfahrt* (*The Assumption of Hannele*, 1893) and *Die versunkene Glocke* (*The Sunken Bell*, 1896).

After 1912, the year he won the Nobel Prize for literature, Hauptmann's work went into a precipitous decline, and he never recovered his former gifts. Hauptmann continued writing at his estate in Silesia until his death, completing 16 stage works. His plays found dubious favor with the Third Reich, when the Nazi government claimed him as a favored artist.

HAUPTMANN VON KÖPENICK, DER (*The Captain of Köpenick*) by **Carl Zuckmayer**. Premiered 1931. Most German audiences were familiar with the subject matter of this comedy by the time **Heinz Hilpert** premiered it at the **Deutsches Theater**, as it was based on an incident that took place in 1906. The incident was also the subject of several books and articles in the popular press, popular songs, and a best-selling novel by Wilhelm Schäfer in 1930. Zuckmayer fashioned the episode of a homeless cobbler, whose mastery of military jargon prompted every German he met to knuckle under in servile obedience, into one of the German theater's most enduring comedies. It ran to full houses immediately after its premiere, and its popularity throughout Germany until 1933 was nearly without parallel. **Joseph Goebbels** assured Zuckmayer that he would share the cobbler's fate of a lengthy prison term in **Berlin**'s Moabit Prison once the Nazis took power; the Nazi government banned the play almost immediately upon their assumption to power.

Wilhelm Voigt (1850–1922) was a cobbler who could never get a real job in the booming Wilhelmine years, so he augmented his meager earnings with minor burglaries. In the play, as in real life, his luck changed when he received a lengthy sentence to Moabit Prison, where he came under the tutelage of an eccentric prison warden whose passion was Prussian military history. Voigt gained a thorough knowledge of military jargon from the warden and upon his release

he bought a Prussian captain's uniform. One afternoon in 1906 he commandeered a platoon in Berlin and ordered them to accompany him via trolley car to Köpenick (a Berlin suburb), where he demanded from the mayor a work permit and the municipal strongbox. The mayor and other Köpenick officials immediately complied with the captain's requests because Voigt blustered with an authentic air of military bombast. Good Germans obey orders, after all, and Voigt made a clean getaway. The mysterious captain turned himself in soon after the Köpenick escapade, but by that time he had become a minor celebrity. Kaiser Wilhelm II gave Voigt an audience and a lifetime pension, noting with unconscious irony that Voigt, more than any real soldier, had demonstrated the reverence Germans felt for a uniform.

Zuckmayer's innovation was to use the uniform itself as a central character in the play; it appeared in every scene, passing from its creator (a Jewish tailor in Potsdam) through the hands of several owners and ingeniously intermingling with the cobbler's various misadventures. When Voigt and the uniform are finally united, the play became comically inevitable. It gave Germans a well-deserved chance to laugh at themselves and their pretensions to greatness as a military power. Zuckmayer's bogus captain thumbed his nose at nearly everything German nationalists represented, while illuminating the stupidity of fawning obsequiousness in the face of authority.

HAUPT- UND STAATSAKTION (Main and State Action). Plays featuring political and/or historical action that touring troupes of the late 17th and early 18th centuries presented outdoors at fairs or in market squares. In most cases the troupe's leader was the author, who often wrote the play in an effort to present a flattering image of a German duke or prince in whose jurisdiction the troupe was performing. The "action," such as it was, usually involved court intrigue. Comic scenes frequently alternated with serious ones, and often the low comic figure **Hanswurst** appeared to make rude and vulgar comment on events taking place.

HAUS LONEI, DAS (*The Lonei Household*) by **Adolph L'Arronge**. Premiered 1880. Herr Lonei has reared his children strictly, practicing a Prussian regimen that allows little exercise of personal freedom. The result is that Herr Lonei's son Kurt is still in high school at age

21, unable or unwilling to pass the school's final examinations. He instead wants to become an actor, an idea Lonei finds absolutely abhorrent. But Herr Lonei relents slightly and hires the well-known actor Reinhard to be Kurt's tutor. Reinhard is unusual because he has attended university before going on stage, and Lonei hopes his son Kurt will find in Reinhard a model to emulate. During his tutorial visits to the Lonei household, however, Reinhard becomes acquainted with Kurt's sister Marie, a lovely girl who has long admired Reinhard and who is secretly in love with him. After much effort, Kurt takes the school exams but once again fails them. In despair, he throws himself into the nearby barge canal and would have drowned had Reinhard not been conveniently passing by to rescue him. Kurt's near-death experience enables him to takes the school exam once more, and this time he passes it—barely. In gratitude, Lonei agrees that his daughter Marie and Reinhard can get married.

L'Arronge used the theater as a kind of pejorative gag, an acknowledgment of the actor's low social status in Germany. But he also parodied the inflexibility of the self-made man in Herr Lonei, whose financial success has enabled him to rise in social status though he personally remains a dislikable ignoramus.

HAUSSMANN, LEANDER (1959–). Director. Haussmann grew up in East Germany as the son of theater performers, but he initially opted for a career as a graphic artist. At age 23, however, he enrolled in East **Berlin**'s Ernst Busch Theater School to study acting. He worked with **Frank Castorf** in Gera upon his graduation and, with the collapse of the East German state, began working in Frankfurt am Main. Engagements in **Munich**, Berlin, **Hamburg**, and the Salzburg Festival followed. In 1995 Haussmann was named **intendant** of the Bochum Schauspielhaus, but in 2000 he was fired. Since then, Haussmann has worked as a freelance director and has made two films about life in divided Berlin.

HEBBEL, FRIEDRICH (1813–1863). Playwright. Hebbel was born in poverty and worked at various jobs until the editor of a **Hamburg** newspaper named Amalie Schöppen published some of his poetry. With her encouragement and under her tutelage, he moved to Hamburg and attended some university lectures. He also attended classes

at Heidelberg and **Munich,** but returned to Hamburg, where a poor seamstress named Elise Lensing supported him and bore him two illegitimate children. Supported by Lensing during the early 1840s, he completed several remarkable plays, including *Judith* (1841) and *Maria Magdalena* (1844). Both had successful runs in Hamburg and **Berlin,** and the latter is often considered a kind of forerunner to realism. At the time, critics saw it as an antidote to **Gotthold Ephraim Lessing**'s middle-class tragedy; later it was thought of as a German alternative to subsequent French models by Alexandre Dumas *fils* and others because it avoided the "typical" intrigues of seduction and the moral tone favoring the middle class.

Hebbel abandoned Lensing in 1846 and married Viennese actress Christine Enghaus; under her protection in **Vienna,** he wrote several plays for the **Burgtheater,** the most noteworthy among them *Herodes und Miramne,* which **Heinrich Laube** reluctantly premiered at the Burg in 1849; *Agnes Bernauer* (1852); and the five-act verse tragedy *Gyges und sein Ring* (*Gyges and His Ring,* 1856). His most remarkable achievement in Vienna was the three-part *Die Nibelungen* (*The Nibelungs,* 1862), for which he won the Schiller Prize.

Hebbel's plays often bespeak his preoccupation with psychological tension within an individual character. The dialogue he created, both in verse and in prose, is well crafted. The ideas of Georg Wilhelm Friedrich Hegel (1770–1831) strongly influenced Hebbel. In his preface to *Maria Magdalena,* Hebbel discussed the "terrible dialectic" in his characters, who suffered the dilemma "between expansion and introspection" resulting in "an unbearable tension." Hebbel stated that dramatic art "can no longer stand outside social concerns," but those concerns do not include impecuniousness, hunger, class conflicts, love affairs, and other "surface" dilemmas. Hebbel's was a powerful intellect, and his theoretical works such as *Mein Wort über das Drama!* (*My Word on the Drama!,* 1843) and *Über den Stil des Dramas* (*On Dramatic Style,* 1847) are remarkable for their insights. He was convinced that art and history must conjointly provide a creative atmosphere of the times by taking disparate artifacts and making them comprehensible to an audience. Hebbel's diaries, collected in four volumes, also reveal a great deal about the German theater from 1835 until his death in 1863.

HELMERDING, KARL (1822–1899). Actor. An outstanding comic actor of 19th-century **Berlin**, Helmerding began acting when as a teenager he joined a touring troupe. Thereafter he worked briefly in Erfurt and **Cologne**, but he spent the remainder of his career in various Berlin theaters, usually cast as the perplexed little Berliner at odds with the big city, with its anonymous political and economic forces, or with life itself. As he aged, he began playing journeymen or traveling salesmen without prospects who wooed a young girl with promises to take her to the exotic locales of Pomerania or even the Rhineland, and later father roles, in which he tried to protect his daughters from the same irresponsible youths he had played earlier. His most significant work was at Berlin's Wallner Theater, where he played leading roles in **David Kalisch**'s "local comedies" featuring recognizable Berlin types. Helmerding's masterpiece was Gustav Weigelt, the nearly illiterate yet prosperous parvenu in **Adolph L'Arronge**'s 1873 comedy *My Leopold*. Weigelt was a beleaguered father but proud member of the entrepreneurial Wilhelmine establishment. Helmerding was said to be Otto von Bismarck's favorite actor, largely because he claimed to be one of the "Iron Chancellor's" closest advisers. Helmerding was particularly gifted in contorting his body to fit the characters he played and was a master of several Berlin dialects—though his voice was usually hoarse and high-pitched.

HEYME, HANSGÜNTHER (1935–). Director. Heyme began his professional theater career in the mid-1950s with **Erwin Piscator** in Mannheim while still a student in nearby Heidelberg. Thereafter he worked as Piscator's assistant on several productions in numerous locales. In 1963 Heyme became chief director at the Hessian State Theater in Wiesbaden; his production there of *Marat/Sade* earned him an invitation to the Berliner **Theatertreffen** in 1965 and established him as one of West Germany's most important new directors. He had four other productions invited to the Theatertreffen, most of them originating at the Württemberg State Theater in Stuttgart (the one exception was his **Cologne** production of **Friedrich Hebbel**'s *Maria Magdalena* in 1973). From 1968 to 1979 Heyme was director of the Cologne City Theaters; he later held similar posts in Bremen, Stuttgart, and Essen. From 1990 to 2003 he was director of the Ruhr

Festival in Recklinghausen. Though largely known for productions by contemporary playwrights, Heyme worked extensively with translator and philologist Wolfgang Schadewaldt (1900–1974) on new translations of Greek tragedies, staging a series of them during the late 1970s and early 1980s.

HILPERT, HEINZ (1890–1966). Director, actor. Hilpert is considered one of the leading German directors of the 20th century for several reasons. First, he staged numerous significant world premieres during the Weimar period; the ones by **Ödön von Horváth**, **Ferdinand Bruckner**, and **Carl Zuckmayer** established Hilpert as a director with a singular aptitude for discovering plays by then-unknown playwrights, which audiences and critics subsequently found both thought-provoking and highly entertaining. Second, Hilpert's conduct during the Third Reich was remarkable, for he was an outspoken opponent of the Nazi regime even as he worked directly for **Joseph Goebbels** as head of the **Deutsches Theater** from 1934 to 1944 and indirectly when he ran **Vienna**'s Theater in der Josefstadt. Several witnesses attested to his outspoken contempt for Adolf Hitler, and Hilpert's published cynicism about the National Socialist cultural agenda is public record. A third basis for Hilpert's reputation is his work in the postwar period, staging the German premieres of Tennessee Williams's *A Streetcar Named Desire* (1949), Federico García Lorca's *Yerma* (1953), and John Osborne's *The Entertainer* (1957), along with world premieres of Zuckmayer, **Max Frisch**, and numerous others, while running the Deutsches Theater in Göttingen.

Hilpert's career began as an actor after his release from a German regiment stationed in Damascus with the Turkish army. His remarkable voice and agile movement got him jobs as soon as he returned to his native **Berlin** in 1919. He soon began directing as well, beginning with the German premiere of John Millington Synge's *The Playboy of the Western World*, Jules Romains's *Dr. Knock*, R. C. Sheriff's *Journey's End*, and Zuckmayer's *Pankraz erwacht* (*Pankraz Awakens*). Hilpert was to have staged the premiere of Zuckmayer's *Der fröhliche Weinberg* (*The Merry Vineyard*) in late 1925, but Zuckmayer's contractual obligations elsewhere forced the Berlin production to premiere one day before Hilpert's in Frankfurt am Main. *The Merry Vineyard* proved to be an enormous hit that ran for years in

scores of theaters, and Zuckmayer consistently credited Hilpert for its success. Both men felt their relationship recalled the one between **Otto Brahm** and **Gerhart Hauptmann** from 1889 to 1912, and Hilpert's subsequent premiere of Zuckmayer's *Der Hauptmann von Köpenick* (*The Captain of Köpenick*) in early 1931 testified to the vibrancy of the artistic affinity between the two men. *Köpenick* became the most frequently performed play in Germany during the 1931–1932 season and it remained in the Deutsches Theater's repertoire until the National Socialist takeover. Perhaps even more eloquent testimony to Zuckmayer's relationship with Hilpert was the director's 1947 premiere production of Zuckmayer's *Des Teufels General* (*The Devil's General*) in Zurich, which took place 10 years after the two had lost contact with each other. Hilpert's premiere stagings of Horváth's plays in Berlin were likewise remarkable, especially *Geschichten aus dem Wienerwald* (*Tales of the Vienna Woods*) in late 1931 with **Peter Lorre**.

In 1932 Hilpert became director of the Volksbühne am Bülow Platz in Berlin. That theater had been built in 1914 by the Social Democratic Party, and **Joseph Goebbels** had for years attempted to erect a Nazi alternative to it. In 1933, however, Goebbels had the power simply to expropriate it and nearly all other theaters in Berlin as he saw fit. He then pushed Hilpert to give up the Volksbühne post and instead accept the directorship of **Max Reinhardt**'s Deutsches Theater, ownership of which Reinhardt had been forced to relinquish.

Goebbels had long admired Hilpert, though the director showed signs early in the Nazi dictatorship that he would not be easy to control. In May 1933 Hilpert had staged *The Trial of Mary Duggan* by U.S. playwright Bayard Veiller (1869–1943). Though the play had premiered on Broadway in 1927 and been made into a movie starring Norma Shearer in 1929, Goebbels was unaware that the play featured a distinct anti–death penalty thesis. Goebbels closed the production after four performances.

Hilpert hesitated to become the new tenant in what was essentially stolen property, but after receiving Reinhardt's approval, Hilpert accepted Goebbels's offer. He openly stated that he would run the Deutsches Theater the way Reinhardt had and that he was merely a steward of the Brahm and Reinhardt tradition. Both Reinhardt and Brahm were Jews, and Goebbels was outraged.

Why would Goebbels have offered it to Hilpert in the first place? Zuckmayer's answer was that "after the Nazis had cleaned out the Jews and the cultural Bolsheviks, there weren't that many good directors left" (Zuckmayer, *Geheimreport* [Göttingen: Wallstein, 2002], 25–26). Goebbels regarded the Deutsches Theater as a significant institution in German culture, and he also wanted to be patron of a Berlin theater like his competitor and rival Hermann Goering at the State Theater (Michael Dillmann, *Heinz Hilpert: Leben und Werk* [Berlin: Akademie der Künste, 1990], 110). Skeptics doubted Hilpert's intentions, even after Hilpert publicly declared his wish to maintain the Deutsches Theater as Reinhardt's house, with its long-standing tradition of excellence and innovation. Nazi officials likewise greeted the appointment with suspicion. Reichsdramaturg **Rainer Schlösser** detested Hilpert because of his work with Zuckmayer, whom the regime had officially declared anathema. Others knew Hilpert had close relationships with many Jews. Hilpert apologized to nobody, denied nothing, and made few promises to anybody. Yet he realized there was little room to maneuver around Goebbels, who paid all his bills, dictated what plays he could or could not do, and had the right of final approval on any decision he made. Goebbels meantime learned that Hilpert was less than a pliant subject, one capable of defiance and "interminable foot-dragging."

Goebbels naturally demanded that Hilpert present the work of regime favorites, especially "blood-and-soil" playwrights. Hilpert usually took about two to three years to see such productions completed. In numerous diary entries, Goebbels complained that Hilpert refused to "have the right contact with the regime," or that he was "boxing himself in," or that he was simply "difficult." When Hilpert nevertheless hired **Erich Engel** as a director, **Caspar Neher** as a designer, or other artists objectionable to the regime, Goebbels backed down. Hilpert's productions were at least well attended, which helped Goebbels in his ongoing rivalry with Goering for cultural supremacy in Berlin.

Working in daily proximity with and under direct supervision of Nazis gave Hilpert ample reason to consider the overall purpose of the German theater and his role in it. He began to write and publish essays that, to many, sounded preachy. **Herbert Ihering** cynically called Hilpert the "Pastor of Köpenick," deriding both the content of

Hilpert's musings and the fact of Hilpert's proletarian roots (he actually grew up in the Prenzlauer Berg section of Berlin, not the suburb of Köpenick). In his essays, Hilpert differentiated himself from other directors, both his predecessors and his contemporaries. He maintained that the most important figure in the theater was the playwright; second was the actor, but only insofar as the actor played the role the playwright had created. Third was the director, whom Hilpert saw primarily as the servant to the playwright, guide to the actor, and explicator for the audience.

Goebbels likewise derided Hilpert's musings as sentimental, noting that a theater director was the artistic embodiment of the *Führerprinzip* (leadership principle) he had long touted in the political arena. By 1943 Goebbels found himself so frustrated with Hilpert and the director's unwillingness to conform to his definition of "leadership" that he began openly referring to the Deutsches Theater company as "a concentration camp on furlough." The inference was that sooner or later, he would replace them all with individuals more attuned to his bidding. When Goebbels closed all German theaters in August 1944, he arranged for Hilpert to work in a Telefunken factory. The factory was destroyed, but Hilpert managed to escape injury and ultimately to escape Berlin before invading Soviet troops conquered the city.

Hilpert soon began directing in Zurich, then in Frankfurt, Constance, and finally in the university town of Göttingen, where he settled for the remainder of his career. In Göttingen he gathered around him several actors and designers with whom had worked throughout the Third Reich, many of them with well-established careers in film or in Berlin. Not everyone was happy to see Hilpert working again. **Bertolt Brecht** witnessed Hilpert's German premiere of Frisch's *Santa Cruz* in 1948 and denounced Hilpert as a standard-bearer in the postwar period of "Nazi theater." The "ruined acting" he saw in *Santa Cruz* was "analogous to the ruined buildings everywhere in Germany." Brecht decided after seeing Hilpert's production that all German acting "would have to be razed to the ground and rebuilt from scratch" (Brecht, *Arbeitsjournal*, ed. Werner Hecht [Frankfurt: Suhrkamp, 1973], 2:829).

The distinction between Hilpert and Brecht is helpful in understanding the intense passions that ran through the German theater in

the late 1940s and 1950s. Brecht wanted a wholesale revision, not only of German acting but also of the entire method used to create theater in Germany. Hilpert remained mindful, as he had been in 1934, of the German theater's nonpolemical traditions. Brecht soon became a target of anticommunist boycotts in West Germany, yet Hilpert was among the first to advocate Brecht's plays in open defiance of such efforts; he himself played the cook in Göttingen's production of *Mutter Courage und ihre Kinder* (*Mother Courage and Her Children*). Hilpert's theater in Göttingen did dozens of plays by little-known playwrights, in addition to lesser-known works by Zuckmayer, such as *Barbara Blomberg* (1949), *Song in the Fiery Furnace* (1950), and *Ulla Winblad* (1952). Many of these productions featured **Brigitte Horney, Carl Raddatz, Erich Ponto, Elisabeth Flickenschildt**, and others who made Göttingen a replica of Berlin's Deutsches Theater in the Weimar period, realizing a goal Hilpert had set for himself and his company when he rechristened Göttingen's municipal theater in 1950.

HOCHHUTH, ROLF (1931–). Playwright. Hochhuth was among the first German playwrights to confront events in World War II by portraying individuals from recent history as characters in his plays. **Erwin Piscator**'s premiere of Hochhuth's *Der Stellvertreter* (*The Deputy*) created a firestorm of controversy throughout Europe and North America because it portrayed Pope Pius XII as a willing collaborator in the Nazi persecution of the Jews. The inference of Vatican complicity outraged millions of Roman Catholics, especially those who had hidden or assisted Jews. Hochhuth's second play, *Soldaten* (*Soldiers*), was an indictment of Winston Churchill (1874–1965) in which he again tried to saddle characters with fictional motivations based on his documentation of the events portrayed. Both plays are extremely long, but they contain passages of powerful dialogue.

Soldiers may have created more controversy than *The Deputy* did, at least in Great Britain. There, Hochhuth was held accountable for damages in a civil suit by one of the individuals portrayed in the play. The wider implication was that Churchill as British prime minister was responsible for the death of Polish general Wladislaw Sikorski, who was president of Poland in exile. Critics also detected in the play an inference that Churchill committed war crimes by ordering the destruction

of German cities. Other critics said Hochhuth was a sensationalizing apologist for the German war effort, equating Churchill's wartime government with the Nazi regime.

Hochhuth's subsequent attempts to employ historical precedent met with far less controversy, bad reviews, and much less success at the box office.

HÖFLICH, LUCIE (Helena Lucie von Holwede, 1883–1956). Actress, manager, teacher. "Flaxen-haired, wide-hipped, and flat-chested" (John Willett, *The Theatre of the Weimar Republic* [New York: Holmes and Meier, 1988], 163), Höflich was an ideal peasant type in **Naturalist** plays like *Rose Bernd* during the Wilhelmine period. She was a stalwart in **Max Reinhardt**'s productions, playing dozens of roles at the **Deutsches Theater**; most notable among them Gretchen in *Faust, Part 1*, Nora in *A Doll's House*, and, as she matured, a superb Mrs. Alving in Henrik Ibsen's *Ghosts*. During the Third Reich, Höflich was one of the few women directors in **Berlin**; her *Moral* (*Morality*) by **Ludwig Thoma** in 1936 earned widespread praise. She also ran a small studio in Berlin during the Nazi years, mounting small productions and training young actors. Among her most noted students was **Angelika Hurwicz**, who later became closely identified with **Bertolt Brecht** and the **Berliner Ensemble** in that company's most highly publicized productions. After the war Höflich became director of the Schwerin State Theater, which was untouched by the ravages of war. There she also revived the Ekhof Theater School.

HOFMANNSTHAL, HUGO VON (1874–1929). Playwright. Hofmannsthal is closely associated with—even, in the minds of some critics at the time, embodied—the decadent culture of **Vienna** at the turn of the 20th century, when Vienna "acutely felt the tremors of social and political disintegration" (Carl Schorske, *Fin de siècle Vienna* [New York: Knopf, 1979], xviii). Hofmannsthal's voluptuously lyrical and melancholy short plays of the period, written in some cases while still a teenager, included *Der Tor und der Tod* (*The Fool and Death*, 1893), *Der Kaiser und die Hexe* (*The Emperor and the Witch*, 1897), and *Der weisse Fächer* (*The White Fan*, 1897). They were infrequently performed, but attracted widespread attention among crit-

ics as serious literature. Hofmannsthal began adapting Greek tragedies in 1904 with *Elektra*, followed by *König Ödipus* (*King Oedipus*) in 1907, employing a more disciplined, less extravagant verse in both. His work with Greek material contributed to his work as a librettist for the operas of Richard Strauss, of which *Elektra* and *Ariadne auf Naxos* are good examples. Hofmannsthal's most popular work with Strauss, however, was *Der Rosenkavalier* of 1911; it featured a conventional plot of love intrigues and has remained an enormously popular perennial with audiences and opera companies around the world. Later in the 1920s Hofmannsthal wrote his two best comedies, **Der Schwierige** (*The Difficult Man*) and *Der Unbestechliche* (*The Incorruptible Man*).

The collapse of the Habsburg Empire in 1918 shattered Hofmannsthal's perception of Austrian culture and his place in it. Determined to help rebuild it, he was a leading figure in the founding of the Salzburg Festival in 1919. Salzburg, as Mozart's birthplace and the geographical center of Europe, seemed to Hofmannsthal, Strauss, **Max Reinhardt**, and other festival founders to be the logical place for renewal, beginning with Hofmannsthal's refurbished adaptation of the medieval morality play *Jedermann* (*Everyman*, 1920) and *Das Salzburger grosse Welttheater* (*The Great Salzburg Theater of the World*, 1922) based on Calderón de la Barca's *The Great Theater of the World*. Productions of Mozart operas followed. The Salzburg Festival remains an important venue for German-language theater and European culture to this day.

HOFMEISTER, DER, ODER DIE VORTEILE DER PRIVATER-ZIEHUNG (*The Tutor, or the Advantages of a Private Education*) by Jakob Michael Reinhold Lenz. Premiered 1778. Lenz wrote one of the few "comedies" of the **Sturm und Drang** (Storm and Stress) movement, though this play is not a recognizably humorous treatment of the harm some private tutors may inflict on the families they serve. The title character is Läuffer, whom Major von Berg has hired to tutor his son. The major's daughter, Gusti, becomes the real object of Läuffer's presence in the von Berg household, though it takes him two years to complete his conquest of her. She is in love with her cousin Fritz von Berg, and he initially represents an obstacle to the consummation of Läuffer's desires. Läuffer finally overcomes all obstacles and seduces

Gusti; she becomes pregnant. She bears his child in secret and tries to drown herself. When Läuffer receives the (false) report that Gusti has died, he repents of his wrongdoing and castrates himself. Major von Berg finds Gusti alive in a forest cottage with her child and brings her back to the family home, where she finds Fritz still in love with her and they plan to marry. Meantime the castrated Läuffer—now convinced that he has overcome his lustful desires—has fallen in love with another young girl and marries her.

HOPPE, MARIANNE (1911–2002). Actress. Best known as one of the most popular and glamorous stars of the Third Reich, Hoppe's career began in 1930 and continued for 70 years. Her work with directors as chronologically disparate as **Max Reinhardt, Gustaf Gründgens, Boleslaw Barlog**, Robert Wilson, and **Claus Peymann** was among the most remarkable of any actress in the German theater's history. She frankly admitted her knowledge of the Nazi regime's terror, doing little to dispel persistent misgivings about her even as she continued to act on stage, screen, and television for decades after 1945. Her candor extended to discussions of the ways she and her colleagues socialized with Hitler, lending some support to arguments that she allowed herself, as did many other German actresses, to be used for the sake of career advancement.

Hoppe's career entered its upward trajectory when she married Gründgens in 1936. She was at her best under Gründgens's aegis, not only because he was so powerful but also because her work accorded with popular taste. She was often featured in highly publicized premieres of new comedies or in lavish **Shakespeare** productions at the State Theater, and Hoppe's star turns in each of them reflected her appeal among audiences. It helped of course that "of all our actresses, Hoppe [embodies] the purest of North German types in her racial uniqueness: blonde, candid, and Nordic, with their dry sense of humor, caustic and genuine" (F. O., review of the film *Krach um Iolanthe*, *Berliner Börsen-Zeitung*, 20 September 1934). She was a radiant example of what the Bund deutscher Mädel (League of German Girls) had in mind when it declared that "a girl's beaming health reveals an inner harmony that is the fulfillment of our striving for beauty" (Friedemann Beyer, *Die UFA-Stars im Dritten Reich* [Munich: Heyne, 1991], 32). Hoppe projected an energetic, girlish aura in much of her work during the Third Reich.

In the immediate postwar period, Hoppe suffered a complete physical and emotional breakdown, but by the early 1950s she returned to the stage, making a speciality of playing women with difficulties similar to her own—especially American women. Her Blanche Dubois in **Berlin**'s first German-language production of Tennessee Williams's *A Streetcar Named Desire* gave a singular stamp to her comeback, and she reprised the role several times in numerous productions through the decade. Her 1959 performance as film diva Alexandra del Lago in *Sweet Bird of Youth* proved equally appealing, as did her Georgie Elgin in Clifford Odets's *The Country Girl*, Deborah Harford in Eugene O'Neill's *A Touch of the Poet*, and Agnes in Edward Albee's *A Delicate Balance*. In the 1970s and 1980s she worked extensively in new plays by then-emerging playwrights, among them Edward Bond, **Tankred Dorst**, **Heiner Müller**, and especially **Thomas Bernhard**. Hoppe appeared in three of Bernhard's world premieres, including *Die Jagdgesellschaft* (*The Hunting Party*) and the controversial *Heldenplatz* (*Heroes' Square*), under the direction of Peymann. In 1990 she played the title role in *King Lear* under the direction of Robert Wilson in Frankfurt am Main.

HÖRBIGER, ATTILA (1896–1987). Actor. Hörbiger is inextricably linked to the theater of **Vienna**, and (from 1928 to 1950) with Vienna's Theater in der Josefstadt in particular. He completed his career at the **Burgtheater**, often alongside his wife **Paula Wessely**. At both the Burg and the Theater in der Josefstadt, Hörbiger was at his best in character parts—though he excelled in plays by **Ferdinand Raimund**, **Johann Nepomuk Nestroy**, and **Franz Grillparzer**. By his retirement in 1975, Hörbiger had received almost every official accolade available to an Austrian actor (though he had been born in Budapest); his name in the view of many was nearly synonymous with Austria and its theater traditions. Some observers agreed—but in a pejorative sense, since they accused Hörbiger of conformity with National Socialist cultural goals; some (including **Elfriede Jelinek**) pointed to his participation in the 1941 film *Heimkehr* (*Homecoming*) as evidence. *See also* HÖRBIGER, PAUL.

HÖRBIGER, PAUL (1894–1981). Actor. Hörbiger began his acting career in the German-speaking theaters of Czechoslovakia, and from 1920 to 1926 he was a member of the Deutsches Theater company in

Prague. He established himself as a superb character actor in **Berlin** at the Lessing Theater, where he remained from 1926 until 1940. Hörbiger also began his extraordinarily prolific film career in Berlin—one that spanned more than 250 film productions, usually playing anonymous porters (as he did in *The Third Man* with Orson Welles and Joseph Cotten), butlers, deliverymen, and clerks. Hörbiger was forced to leave Berlin in 1940 when he publicly protested the treatment of Jewish colleagues; **Joseph Goebbels** denounced Hörbiger with insults that questioned the actor's virility. He was nevertheless allowed to work in **Vienna**, and indeed made his debut at the **Burgtheater** at age 46. He remained in Vienna through the end of the war, but barely survived it. Nazi officials arrested him in January 1945 on charges of high treason and the BBC announced his execution in April of that year. He nevertheless reemerged in early May to resume working. Such experiences caused a lengthy estrangement between Paul Hörbiger and his brother **Attila Hörbiger**, whom many in the postwar period accused of close association with the Nazis. In the postwar period Paul appeared in dozens more films and later in televison series. His television career reached its zenith when, at age 75, he starred in the series *Der alte Richter* (*The Old Judge*).

HORNEY, BRIGITTE (1911–1988). Actress. Horney was one of several talented and beautiful actresses whom **Joseph Goebbels** and others in the Nazi cultural hierarchy favored. Unlike many of the stars during the Nazi period, though, she survived the war with her career intact and unblemished. Horney also benefited, unwittingly, from the reputation of her mother, noted psychologist Karen Horney (1885–1952), who established a flourishing practice in New York by the mid-1930s. When she was 19, Horney received the Max Reinhardt Prize, awarded to young performers with promise for the stage. She disappointed few observers thereafter, working regularly in **Berlin**. Horney concentrated on theater work until 1934, when she began working extensively in movies. During the Nazi period, she made more than two dozen movies, perhaps most notably with Joachim Gottschalk (1904–1941), who committed suicide rather than divorce his Jewish wife. With **Hans Albers** in 1943, she played the tsarina Catherine the Great in *Münchhausen* (1943).

Immediately after the war, Horney worked in Basel, Zurich, and Constance with **Heinz Hilpert**, later joining him in Göttingen as a

member of his company from 1953 to 1956. There, she played the title role in Hilpert's premiere of **Carl Zuckmayer**'s *Ulla Winblad*, among several others. In the mid-1950s she moved to Boston, where her husband was the curator of Boston's Museum of Fine Arts. The final phase of her career developed in the 1960s, when she began working extensively in West German television. Among her numerous credits in that medium were Aunt Polly in the German-language series based on Mark Twain's novels *Tom Sawyer* and *Huckleberry Finn*.

HORVÁTH, ÖDÖN VON (1901–1938). Playwright. Horváth was a master of listening to the ways the German-speaking petit bourgeoisie misused language; he had grown up the illegitimate son of a Habsburg diplomat, often in locales where German was not the vernacular idiom. He thus developed an ear finely attuned to the subtleties of language, which he subsequently developed into a remarkable facility for creating dialogue that allowed language to become an instrument of exploitation and abuse. His facility did not highlight mispronunciations, solecisms, or errors in syntax, as **Johann Nepomuk Nestroy** and others had done; his was a unique talent unmatched by any other playwright during the Weimar period, endowing characters with the tendency to speak in snippets of advertising slogans, political clichés, and trend-driven phraseology. He was among the first playwrights in German to portray the abominations of mass society and the media, which had so enormous an influence over German usage. Horváth also realized that the National Socialists and the Communists were highly adept at manipulating both the German language and the media, using both for considerable political benefit to themselves. Horváth's career reached its high point in 1931 when both *Italienische Nacht* (*Italian Night*) and *Geschichten aus dem Wienerwald* (*Tales of the Vienna Woods*) premiered; Horváth received the Kleist Prize the same year. Both plays featured unsympathetic portrayals of individuals at the low end of the social ladder. Rarely in any of his 21 plays were Horváth's characters admirable, or even pitiable; Horváth held them firmly responsible for the lamentable conditions in which they found themselves. As a result, his work remained largely ignored in the postwar period until the later 1960s, when a *Volksstück* revival began to take shape.

Horváth had called his plays *Volksstücke*, but such nomenclature had ironic intentions. *Volksstücke* were historically associated with

young love, musical backgrounds, and robust humor. Horváth's plays, by contrast, portrayed lovers reduced to speaking platitudes within relationships that were as miserably dangerous as they were inescapable. *Glaube Liebe Hoffnung* (*Faith, Hope, and Charity*) became Horváth's most frequently performed play during the *Volksstück* revival. It portrays a pair of lovers, but the music Horváth recommends is Chopin's "Funeral March"; the play's humor is furthermore cadaverous (Horváth subtitled it "a little dance of death") rather than robust—the play begins in front of a mortuary where a young woman has come, hoping to sell her corpse before she dies. Many Horváth productions in the mid- to late 20th century attempted to emphasize the plays' social contexts, hoping to deflect the impact of characters who prey on each other and make them appear instead as victims of social forces. Horváth's underlying contempt for the characters he portrays, however, is difficult to disguise. As in *Tales of the Vienna Woods* (the original production of which in 1931 starred **Peter Lorre** and Carola Neher, directed by **Heinz Hilpert**), the central characters in *Faith, Hope, and Charity* seem wholly deserving of their fates.

The renewed interest in Horváth in the 1960s and 1970s also had a financial basis: many of his plays require enormous scenic investiture, sometimes featuring expensive set pieces like automobiles and Ferris wheels. Only when German theaters began to receive ever larger subsidies were they capable of staging Horváth's works.

HORWITZ, KURT (1897–1974). Actor. Horwitz was one of the most important actors in **Munich**'s theater history, though some of his most important work took place in Zurich. His work with **Otto Falckenberg** in Munich at the Kammerspiele during the 1920s found him cast in leading roles that many critics said were on a professional par with the best acting talent on offer in **Berlin**. Among Horwitz's most notable characters in Munich were Mack the Knife in **Bertolt Brecht** and Kurt Weill's *Die Dreigroschenoper* (*The Threepenny Opera*) in 1929 and the title roles in Jules Romains's *Dr. Knock* (1925) and Hans-José Rehfisch's *Affäre Dreyfus* (*The Dreyfus Affair*, 1929). The National Socialist regime forced Horwitz into Swiss exile; through 1946, he worked mostly in Zurich at the Schauspielhaus, but also in Basel at the City Theater. In that year he staged and acted in the premieres of **Max**

Frisch plays there, along with the German-language premieres of Paul Claudel, Jean-Paul Sartre, and Tennessee Williams's *The Glass Menagerie*. From 1953 to 1958 Horwitz was **intendant** of the Bavarian State Theaters in Munich; he returned to Switzerland as a freelance actor in 1958, and in 1961 he staged the world premiere of **Friedrich Dürrenmatt**'s *Die Physiker* (*The Physicists*).

HOSE, DIE (*The Underpants*) by **Carl Sternheim**. Premiered 1911. The first in a series of five plays about the Maske family that Sternheim called "From the Heroic Life of the Middle Class." Family members wear masks of manners that facilitate their rise through the ranks of German society to unprecedented levels of material comfort and financial affluence. Their rise ironically begins with the fall of Frau Maske's underpants, as she watches "the king" (Sternheim was forbidden to use the word *kaiser*) go by in a parade. Two men (named Scarron and Mandelstam) witness the incident and are stimulated to rent rooms from Herr Maske, an upstanding civil servant. Maske was initially concerned that gossip about his wife's underpants might cast a shadow upon his respectable standing in Wilhelmine society, or even cost him his job, but when he realizes that the rent from the rooms creates a small rise in the Maske living standards, he announces to his wife that they can now start a family. Frau Maske reluctantly agrees, perhaps because she knows that she may already have conceived a child by either Mandelstam or Scarron.

HULLA DI BULLA by **Franz Arnold** and **Ernst Bach**. Premiered 1929. The last of the enormously popular comedies by "the firm of Arnold and Bach," this play satirized aristocrats, ridiculed republican politicians, and mocked the German film industry. The comedy opens with a film extra named Papendieck working at Berlin's ornate City Palace, where shooting for a revolutionary epic has just begun. Word comes that the film company must vacate the premises for the arrival of the King of Hamudistan, Abdulla di Bulla. The republican government, eager to loan the king money and secure oil leases in his country, has arranged to give the king a German-style royal treatment in the kaiser's former apartments. Word of the film company's abrupt departure does not reach Papendieck in time, however, and he assumes that King Abdulla and his retinue are leading actors in the film for

which he has been hired for one day's shooting. Several comic scenes swiftly unfold, including one in which Abdulla's lieutenants plot his overthrow in favor of his cousin, the eponymous Hulla di Bulla. Convinced that the actor playing King Abdulla needs to play his part more convincingly, Papendieck reveals the plot to him. The perpetrators are arrested, and Papendieck is awarded the title Duke of Hamudistan. The next day comes word from the kingdom of Hamudistan that Hulla di Bulla has indeed effected a coup d'état and that Abdulla is in fact an ex-king. That means Papendieck is an ex-duke as well, but all ends happily as Abdulla di Bulla departs for London (where he has secretly deposited millions in gold bullion). Republican politicians are mollified, and Papendieck departs for his next assignment as a film extra.

HURWICZ, ANGELIKA (1922–1999). Actress. Hurwicz studied acting under **Lucie Höflich** in the 1940s, disguising her Jewish family background and ultimately getting jobs in the German countryside at the height of World War II with touring theater troupes. In mid-1945 she returned to **Berlin**, where she began working at the **Deutsches Theater**. There she met **Bertolt Brecht** and began working with him and **Helene Weigel** as they prepared their production of *Mutter Courage und ihre Kinder* (*Mother Courage and Her Children*) in 1949; Hurwicz played the deaf-mute daughter of Anna Fierling in that consequential production, killed in a barrage of gunfire near the end of the play. Her performance won her widespread renown, including a prize for acting from the East German government. She played the role through the 1950s and repeated it in the 1961 video version. For the company's 1954 premiere production of *Der kaukasische Kreidekreis* (*The Caucasian Chalk Circle*), Hurwicz played the pivotal role of Gruscha to widespread acclaim, solidifying her status as a genuine "Brecht actress." She left the company after Brecht's death, however, appearing in numerous theaters throughout the German-speaking world in the 1960s. In 1964 she wrote a much-discussed book on her experiences with Brecht and the **Berliner Ensemble**.

– I –

IFFLAND, AUGUST WILHELM (1759–1814). Actor, manager, playwright. Iffland became for many observers by the time of his death the

signal personality of German acting—the figure against whom were measured all subsequent actors. As a boy he showed promise as an actor, and at age 17 **Konrad Ekhof** engaged him at the Gotha Court Theater. There Ekhof trained him rigorously, impressing on Iffland the importance of concentration, mnemonic skills, and intelligent line readings. When the Gotha company disbanded in 1779 after Ekhof's death, Iffland began a lengthy and fortuitous engagement at the Mannheim Court and National Theater, where he came under the prodigious influence of **Wolfgang Heribert von Dalberg**, who reinforced the teachings of Ekhof while assigning Iffland a wide variety of leading roles in demanding plays. Among his most significant roles was Franz von Moor in the 1782 premiere of **Friedrich Schiller**'s *Die Räuber* (*The Robbers*); the nationwide success this play enjoyed, along with his portrayal of characters from **William Shakespeare** and **Gotthold Ephraim Lessing**, earned Iffland a national reputation. He took guest engagements at several major theaters through the 1780s and 1790s, and by the time he departed Mannheim for **Berlin** in 1796, he enjoyed the status of Germany's best-known actor.

Unlike most actors of his day, Iffland was highly literate and well read. He wrote extensively on the craft of acting, insisting that an actor was to assure audiences of the "wholeness" of any performance they witnessed. He said he always strived for consistency, completeness, and beauty "in the perception of the whole." Iffland also developed playwriting skills to parallel those of his performances, and he became one of the German theater's most popular playwrights. His *The Hunters* and *The Bachelors* were highly praised and often imitated *Rührstücke* ("plays that move an audience"). They remained wildly popular with German middle-class audiences long after Iffland's death. Audiences saw themselves flatteringly portrayed in such plays, confronting and overcoming challenges with surprising courage and fortitude; the plays fulfilled theater's "moral imperative," upon which both **Johann Christoph Gottsched** and Lessing had earlier insisted. Iffland additionally assigned a kind of nationalistic mission to the actor's work, stating that the "inner nobility" of a character was essentially a German trait, one totally missing among the French. The theater also had an obligation, Iffland said, to teach audiences the moral validity of "noble" comportment in daily life. **Johann Wolfgang Goethe** found Iffland's acting altogether "astonishing," praising the actor's ability to concentrate on "human peculiarities" and to gather them all together so that

they "constitute a whole character." Schiller, however, found Iffland too "conversational" in verse dramas, yet audiences thronged to see Iffland's productions of Schiller's verse plays at the Berlin Royal Theater.

When Iffland premiered the new **August Wilhelm Schlegel** translations of Shakespeare in Berlin, audiences held Iffland in reverential awe. Iffland thereafter became the first German actor to enjoy substantial wealth and to gain standing among the Prussian nobility. He moved easily within aristocratic circles, enjoying a nationwide influence no other actor before him had attained.

IFFLAND RING. A diamond-studded finger ring with the likeness of **August Wilhelm Iffland** in the center. It first graced the hand of **Ludwig Devrient**, whom colleagues wanted to designate as the German's theater's foremost actor. Devrient in 1832 bestowed the ring upon the successor he personally designated, who happened to be his nephew **Emil Devrient**; Emil wore it for the next 30 years. Successors have included **Theodor Döring**, 1872–1878; **Friedrich Haase**, 1878–1911; and **Albert Bassermann**, 1911–1952. Bassermann failed to bestow it before his death, because three men whom he had designated as recipients died soon after he had announced them as his successor. In 1954 the Austrian Educational Ministry took responsibility for and ownership of the ring, naming **Werner Krauss** the ring's bearer. Krauss likewise was reluctant to name a successor as he approached death in 1959, so the Ministry took on the additional responsibility of designating subsequent recipients. In that year the Ministry named Josef Meinrad its recipient, and in 1996 awarded it to **Bruno Ganz**.

IHERING, HERBERT (1888–1977). Critic. Along with **Alfred Kerr**, Ihering was one of the two most influential theater critics from the late Wilhelmine period through the end of the Weimar Republic. He attempted to remain active under the Third Reich, but **Joseph Goebbels** banished him in 1935 to the casting office of the Tobis film studio; later **Heinz Hilpert** hired him as a **dramaturg** at the **Deutsches Theater** in **Berlin**. After the war Ihering resumed his journalistic career and continued writing lengthy essays. He had been the first to recognize **Bertolt Brecht**, awarding him the Kleist Prize in 1922. Long before that, he recognized and wrote about the signif-

icant personalities and developments that revolutionized the German theater in the 1920s. His principal venue was the *Berliner Börsen-Courier*, a newspaper whose focus was the financial world. Ihering described theater reviewing as an analysis of artistic energy, and he therefore judged most productions according to the challenges they presented to both performers and audiences. He was one of **Max Reinhardt**'s harshest critics, and he likewise loathed the slick boulevard comedies on offer by the dozen every season in Berlin. Ihering was perhaps Berlin's finest critical thinker, given to extended examinations of plays or productions he thought offered new developments. He was rarely a theater fan in the manner of his archrival Kerr; to Ihering, theater was a serious undertaking with implications for German culture as a whole. His writing style was spare and to the point; as **Fritz Kortner** once noted, "You read [Ihering's] reviews to improve your grammar."

IMMERMANN, KARL LEBRECHT (1796–1840). Manager, playwright. Immermann studied law and was a Prussian court official when he began his theater career about 1829, working with amateurs. As the manager of the Düsseldorf Stadttheater in 1835–1837, he sought to imitate the idealized "Weimar style" by attempting to create a disciplined acting ensemble and present works of high literary value. At Düsseldorf he hired **Christian Dietrich Grabbe** as his **dramaturg**, but his directing efforts ended largely in disaster. Düsseldorf audiences rejected literary emphases in favor of popular entertainment; Immermann's admiration of **Ludwig Tieck**, however, prompted him to reexamine **Shakespeare**'s plays and to look for ways to create in Germany the kind of stage for which Shakespeare had written. The result was a precedent-setting 1840 production of *Twelfth Night*. Though it featured amateur actors, the stage had been specially built by architect Rudolf Wiegmann (1804–1865), who had published research on 16th-century building materials. Immermann's plays were largely derivative; during his lifetime, most observers considered him a dilettante.

IMPEKOVEN, ANTON "TONI" (1881–1947). Playwright, actor, director, manager. Impekoven was among the most often performed playwrights in the Weimar Republic, though he frequently wrote with

Carl Mathern. Their *Die drei Zwillinge* (*The Three Twins*) was the most frequently performed play of the 1919–1920 season, and their *Luderchen* (*The Tart*) the following season nearly equaled it. Impekoven began his career in 1900 as an actor in **Berlin**, where he worked with **Franz Arnold** and **Ernst Bach** until the outbreak of World War I. In 1914 he began working at the Frankfurt am Main City Theater. There he met Mathern, and both began to imitate the methods of Arnold and Bach. Their first success was *Junggesellendämmerung* (*Twilight of the Bachelors*) in 1918. Impekoven began directing in 1930, though his playwriting output had by then become meager. He remained in Frankfurt am Main for the rest of his life and became **intendant** of the Frankfurt am Main City Theaters shortly before his death.

IM WEISS'N RÖSSL (*THE WHITE HORSE INN*) by **Oskar Blumenthal** and **Gustav Kadelburg**. Premiered 1898. Berlin manufacturer Wilhelm Giesecke, the personification of a Wilhelmine parvenu, travels south to the Salzkammergut region in Austria with his sister Charlotte and his daughter Ottilie. He hopes for a respite from the rigors of making money in Berlin, but in the process he encounters difficulties with baggage handlers, coachmen, and hotel porters. Ultimately the family settles in at the modest and unprepossessing hotel Im weiss'n Rössl on the shores of Lake Wolfgang. The White Horse Inn is the charge of a formidable but young and attractive widow, Josepha Vogelhuber. Giesecke's real conflicts begin upon the arrival of Dr. Siedler, who is suing Giesecke in Berlin for unlawful business practice. Giesecke makes immediate plans to depart, but discovers that every other hotel in the area is booked—and anyway, his sister and daughter like the White Horse Inn. A teacher named Heinzelmann appears, and he is the mild-mannered, easygoing opposite of Giesecke; he comes to the hotel every other summer (when he can afford it) simply to enjoy himself. His daughter Klärchen is as lovable as he is, though her speech impediment causes her embarrassment. On their journey, they have met a young man named Sülzheimer, whose father is also a rich manufacturer. Giesecke determines that his daughter Ottilie will marry Sülzheimer, but the young Sülzheimer has fallen in love with Klärchen, despite or perhaps because of her speech impediment—and to Giesecke's profound consternation, Ottilie has fallen in love with Dr. Siedler. Hotel owner

Josepha had her sights set on Dr. Siedler as well, but ultimately acquiesces to the courtship of her headwaiter and agrees to marry him.

Several humorous types troupe through the play, including local villagers, letter carriers, forest rangers, yodelers, and hotel staff members. Giesecke's utterance, "Das Geschäft ist richtig" (It's a good business), became a popular phrase in Berlin during the 1900s. The play is a spoof on Austrians and on the simple, honest folk who ran vacation businesses in Austria, but Blumenthal and Kadelburg were also parodying the Berlin nouveau riche and their legal concerns. What made this play so popular is the agreeable superficiality of the characters. Leopold, the headwaiter, is a masterpiece of the frustrated male ego, while the object of his affections, Josepha, is his foil. Giesecke and Siedler are likewise antagonists, though their conflict in Berlin—the basis of their motivations, after all—is never clarified. Audiences recognized everybody in this play as a type, and as such they behaved according to expectations.

The White Horse Inn became a musical in 1930, when Ralph Benatsky (Rudolph Josef Frantisek, 1884–1957) used the script as the libretto. It has remained popular since then, performed thousands of times in German-language theaters around the world.

INTENDANT. Artistic and managing director of a German theater. The term *intendant* is of French military derivation: the *intendant français militaire* was a kind of quartermaster and administrative officer. The German use of the word in a theatrical context came into being in the late 18th century but its first appearance in print was in 1810, when a Prussian administrative order called for a theater administrator to "deal with maintaining peace and order in theaters under the surveillance of police." The term has recently come to mean an artistic administrator with several areas of responsibility at a venue (or venues) where not only spoken drama but also opera, operetta, and dance are performed. Some theaters concentrating on spoken drama have more than one venue, for which the intendant likewise has responsibility for repertoire selection, finances, casting, and general administration.

– J –

JACOBS, MONTAGUE "MONTY" (1875–1945). Critic. Jacobs was a staunch defender of **Max Reinhardt**, beginning in 1905 when he

became a drama critic for the *Berliner Tageblatt*. At the beginning of World War I, he left Germany and emigrated to England, where he became a naturalized British citizen. Jacobs returned to **Berlin** in 1920 and became editor of the *Vossische Zeitung*'s literary section; the following decade witnessed his best writing, which was intellectually insightful and in most cases dedicated to the reader's understanding of productions he had seen. He eschewed attempts to proselytize, preferring instead to evaluate unsentimentally—though he often castigated directors who tried to impose themselves on productions.

JACOBSOHN, SIEGFRIED (1881–1926). Critic. Jacobsohn began his career as principal theater critic for Berlin's *Welt am Montag* newspaper in 1901, and in that capacity became a vociferous **Max Reinhardt** supporter. Concomitant with his support for Reinhardt was his founding of the theater weekly *Die Schaubühne* on 1905, which became one of the most influential theater publications of the late Wilhelmine era. After the collapse of the Wilhelmine Reich in 1918, *Die Schaubühne* became *Die Weltbühne*, which expanded its purview to include not only theater but also German politics and culture, with a decidedly left-wing viewpoint. According to **Günther Rühle**, Jacobsohn in the capacity of editor for that publication continued the critical tradition of **Otto Brahm**, with an extraordinary gift for written German that combined "insightful passion and arduous wit" (Rühle, *Theater für die Republik* [Frankfurt: Fischer, 1967], 1169).

JAHNN, HANS HENNY (1894–1959). Playwright. Jahnn's **Expressionistic** plays in the early 1920s made sensational use of Freudian preoccupations; characters in his plays often resorted to violence, sexual perversity, or sado-masochism or in some other way failed to control their primordial urges. Among them were the title roles of *Pastor Ephraim Magnus* (1919), *Die Krönung Richard III* (*The Coronation of Richard III*, 1921), and *Der Artz, sein Weib, sein Sohn* (*The Doctor, His Mistress, His Son*, 1922). All of them featured extremes of behavior; his *Richard III* in particular was an attempt to depart from the **Romanticism** of the familiar **August Wilhelm Schlegel** translation and present Gloucester as a homicidal psychopath, though it was written, as one critic put it, "in a verse characteristic of schoolboys" (Hans Natonek, *Berliner Börsen Zeitung*, 11 February 1922). Jahnn was awarded the Kleist Prize in 1920.

JANNINGS, EMIL (1884–1950). Actor. Jannings was among the most distinctive character actors the German theater ever produced, though he is remembered in the main for his outstanding body of film work. He began acting in small restaurant theaters in Bohemia prior to World War I. From there he moved on to theaters in Bremen, Leipzig, Nuremberg, Mainz, Darmstadt, and finally **Berlin**, where **Max Reinhardt** cast him in several productions. Even as a young man, Jannings was usually cast as an *urwüchsiger Kraftkerl*, a somewhat primitive, barrel-chested type whose impetuosity usually got him in trouble; in most cases, the type was overly sensitive. Jannings's film breakthrough came in 1924 with F. W. Murnau's *Der letzte Mann* (*The Last Laugh*), which led to several Hollywood offers; the most significant of those were two Paramount films, Victor Fleming's *The Way of All Flesh* in 1927 and Josef von Sternberg's *The Last Command* in 1928. For both films, Jannings won the first Academy Award ever given to an actor. His difficulty with spoken English, however, precluded continued work in Hollywood sound films and forced him to return to Berlin, where he concentrated on film work. His international reputation solidified in 1931 with Sternberg's *Der blaue Engel* (*The Blue Angel*).

JELINEK, ELFRIEDE (1946–). Playwright. Jelinek was awarded the Nobel Prize for literature in 2004; her numerous plays have appeared from the 1970s on in several German-language theaters. They follow for the most part in the satirical traditions of **Ödön von Horváth**, **Karl Kraus**, and especially **Thomas Bernhard**. Jelinek studied music at the **Vienna** Conservatory and theater history at the University of Vienna, completing a degree in organ music in 1971. She soon thereafter began writing radio plays; her 1974 *wenn die sonne sinkt ist für manchen auch noch büroschluss* (*when the sun goes down some people think it's time to close the office*) won critical praise. Short pieces for the theater, along with novels and poetry, mostly bespoke a critical stance toward her native Austria. Jelinek's plays are extraordinarily inaccessible, since the dialogue she creates does not emanate from characters but are disembodied voices emerging randomly from psychological and historical strata of Austrian society. As a result, her work has rarely appeared anywhere outside German-speaking Europe—and when it does it is in most cases poorly attended. Jelinek's "princess dramas" tend to focus on her fixation with

female victimhood, in particular the inability of women in the West to overcome centuries of stereotypical images men have created. Jelinek has been the recipient of numerous awards, including the Roswitha of Gandersheim Memorial Medal (1978); awards from the cities of Vienna, Bochum, Bremen, **Cologne**, Düsseldorf, Darmstadt, Mainz, Mühlheim, and Wolfenbüttel; the Berlin Theater and Radio Prize; the Else Lasker Schüler Prize (for her entire dramatic work); and the Lessing Critics Award (2004).

JESSNER, LEOPOLD (1878–1945). Director. Jessner was best known for his work during the Weimar Republic, when he was appointed **intendant** of the Prussian State Theater, the tradition-bound, **Karl Friedrich Schinkel**–designed Royal Theater on Gendarme Square near the Royal Palace. Having begun his career in the private theaters of **Hamburg** and his native Königsberg, Jessner ushered in a new era of state-subsidized, modernist theater practice in **Berlin** by staging classics with elevated tempo, fragmented acting, largely abstract settings, symbolic colors, streamlined diction, and an unwonted emphasis on the fractured and discordant. His credo was "thinking a thought through to its conclusion," employing drum rolls, rhythmic shouts, and the exploitation of light to break up the stage space. His stagings often outraged his numerous adversaries and delighted his supporters in the ruling Social Democratic Party. Jessner had long been a member of that organization, which had assumed control of the Prussian Cultural Ministry in the aftermath of the kaiser's abdication. Producers dependent upon the box office, meanwhile, relied on production and dramatic styles that had a wider audience appeal— an appeal that in most cases was traditional.

There is some debate about who originated the "Jessner steps," though Jessner became identified with them in many productions; they served his directorial goals for symbolism as much as for practical stage platforming. In a 1920 production of **William Shakespeare**'s *Richard III*, the steps served as metaphors for the vaulting ambition of Gloucester (played by **Fritz Kortner**). Jessner's own ambition was to transform the State Theater from a former imperial plaything to a "showplace of the people." His production of **Friedrich Schiller**'s *Wilhelm Tell* (*William Tell*) set off a riot outside the theater, and in most other plays dear to the heart of traditionalists, Jessner de-

manded that actors no longer speak their lines in the familiar declamatory style. In his production of *Macbeth*, for example, actors alternatively shouted and whispered to each other. Costumes usually had no direct connection to the historical period and settings likewise evinced no specific architectural characteristics. Jessner most often sought compaction, reducing everything in a production to basic elements. His selection of contemporary plays at the State Theater also reflected his desire to break new ground. **Frank Wedekind**'s *Der Marquis von Keith* (*The Marquis of Keith*), *Duell am Lido* (*Duel on the Lido*) by Hans-José Rehfisch (featuring the State Theater debut of Marlene Dietrich), and world premieres of **Ernst Barlach**, **Carl Zuckmayer**, and **Georg Kaiser** flaunted trends in functional lighting and abstract scene design no less than did Jessner's productions of classics. The acting at times revealed more Freudian self-preoccupation than character motivation.

As the 1920s progressed, Jessner came under increasing fire from the National Socialists, who assailed him for "absolutely un-German" productions that betrayed his Jewishness and his "hyper-modern, bolshevistic, mollusk-like and neurasthenic aesthetics." Jessner held forth at the State Theater until 1930, despite attempts in the Prussian state legislature to remove him. He remained in Berlin and worked actively as a director in several theaters before he was forced to emigrate in 1933. He later staged Schiller's *William Tell* in Palestine and subsequently in Los Angeles.

JOHST, HANNS (1890–1978). Playwright, **dramaturg**. Johst was a significant **Expressionist** playwright, but he is best remembered as a fervent National Socialist and devotee of Adolf Hitler. His *Schlageter* was a highly effective treatment of the first Nazi "martyrs," premiering on Hitler's birthday in 1933, soon after he had been named chancellor; *Schlageter* went on to be performed hundreds of times in the 1930s. His earlier work, such as *Der junge Mensch* (*The Young Man*, 1916), *Stroh* (*Straw*, 1916), and *Der Einsame* (*The Lonely One*, with **Christian Dietrich Grabbe** as the central character, 1917), employed many of the ecstatic outbursts and fragmented scenarios characteristic of **Georg Kaiser**, **Walter Hasenclever**, and Reinhard Johannes Sorge; Johst's *Thomas Paine* (1927) was a return to realism and traditional structure. *Schlageter* was a curious combination of

both Expressionistic and melodramatic techniques; some of the lines in *Schlageter* became oft-repeated Nazi aphorisms, for example, "When I hear the word 'culture,' I unholster my Browning!" and "We stand by Schlageter, not because he is the last soldier of the world war, but because he is the first soldier of the Third Reich!"

JOURNALISTEN, DIE (*The Journalists*) by Gustav Freytag. Premiered 1852. Freytag's comedy of intrigue within the newspaper publishing business was a staple of theater repertoires for five decades after its premiere. In it, Adelheid von Runek has left her estate and has come to visit Colonel Lang in the city. She intends with her visit to call upon her childhood friend Konrad Bolz, who works as an editor for a newspaper called *The Union*. The paper's managing editor is Professor Oldendorf, who is in love with Colonel Lang's daughter Ida. An election is upcoming, and the Union Party nominates Oldendorf as its candidate. He is opposed by the *Coriolanus* newspaper, and its backers nominate Colonel Lang to run for the same office. They hope that running against his prospective father-in-law will deter Oldendorf. Oldendorf refuses to step aside, however, and in retaliation the colonel forbids Oldendorf from coming to his house. Ida and Adelheid try to restore peace between the two, but Konrad Bolz proves to be a superb campaign manager and Oldendorf wins the election by a small majority. Adelheid tries to console her friend the colonel in his loss, pointing out that the people who nominated him were merely using him against their real enemy, Oldendorf. She buys the *Union* newspaper, and Oldendorf resigns from it to become the new member of parliament. Meantime Konrad has fallen in love with Adelheid, and the colonel forgives Oldendorf.

The play is effective as a romantic comedy, but it is also an accurate reflection of how newspapers actually functioned in the days before typewriters. Freytag also shows how newspapers were more mouthpieces than sources of news, vehicles their owners used to manipulate public opinion more than anything else. *The Journalists* cannot be considered a 19th-century German precursor to *Citizen Kane*, but it is interesting nonetheless if only for its depiction of the newspaper business and the idiosyncratic characters within it.

JUNGFRAU VON ORLEANS, DIE (*The Maid of Orleans*) by **Friedrich Schiller**. Premiered 1801. Schiller subtitled his play in verse about Joan

of Arc *A Romantic Tragedy*, though it contains many of the other traits found in his historical dramas. Chief among them is the idea of a character who achieves "sublimity" in the swirl of historical forces. Here Joan is caught up in romantic feelings for her English adversary, which ultimately results in French defeat. When she returns to Reims for the coronation of the Dauphin, her passions have not yet cooled; her own father accuses her of witchcraft, which she interprets as a justifiable sign of God's wrath. She returns to battle against the English and is captured, but somehow escapes. She returns to the battle yet again and is mortally wounded. The French troops under her command recognize in her a great national heroine, and a rose-tinted hue fills the sky, presumably as her soul floats heavenward from the battlefield.

The Maid of Orleans proved extraordinarily popular in **August Wilhelm Iffland**'s production at the Royal Theater in Berlin. It remained in the repertoire for years, and the play was the most frequently performed of any by Schiller throughout the 19th century.

– K –

KABALE UND LIEBE (*Intrigue and Love*) by **Friedrich Schiller**. Premiered 1784. Like **Gotthold Ephraim Lessing**'s *Emilia Galotti*, Schiller's "middle-class tragedy" involves class distinctions, of which young love is the principal casualty. Schiller's is the more realistic portrayal, however, with dialogue that echoes usage characteristic of the 18th-century middle class. The aristocratic Ferdinand von Walter loves Luise Miller, daughter of an upstanding court musician; the elder Miller attempts to break off the relationship between his daughter and the young man, knowing what perils lie ahead for such relationships. There ensue numerous intrigues between Ferdinand's father, Prime Minister von Walter (called simply "President"), and his unappealing courtier Wurm to arrange a marriage between Ferdinand and the prince's mistress, Lady Milford. Lady Milford herself is on the side of young love and promises Ferdinand her assistance. Ferdinand pleads with Luise to run away with him, but she refuses to "overturn the order of society." Meanwhile, the President and Wurm convince Luise to write a letter to Ferdinand, falsely confessing infidelity. She then plans to commit suicide, but her father convinces her instead to run away with him, thereby putting effective distance between his

daughter and such intrigues typical of the court. When Ferdinand confronts her with the letter of confession, she maintains that she does not love him. Ferdinand then poisons her drink and in her dying gasps, she confesses her true feelings for him and discloses what his father and Wurm forced her to do. Ferdinand finishes the drink and, as he too dies, accuses his father of murdering them both. In the end, the President and his henchman Wurm give themselves up to justice.

KADELBURG, GUSTAV (1851–1925). Playwright, actor. Kadelburg was a native Hungarian who began his acting career in Leipzig but by age 20 was engaged at the Wallner Theater in **Berlin** to play bon vivant roles. He then worked in **Hamburg** for a decade before returning to Berlin at the **Deutsches Theater** in 1884 under **Adolph L'Arronge**, for whom he began directing plays. At the Deutsches, Kadelburg met **Oskar Blumenthal**, who was then a theater critic but was also writing comedies under a pen name. They began a collaboration that resulted in some of the most popular fare to appear on Wilhelmine stages, including *Das zweite Gesicht* (*Two-Faced*, 1890), *Die Grossstadtluft* (*Big City Airs*, 1891), *Die Orientreise* (*A Trip to the Orient*, 1892), and most popular of all, *Im weiss'n Rössl* (*The White Horse Inn*, 1898). Kadelburg brought to the comedies they wrote a sure sense of comic structure and effective timing. Kadelburg's collaboration with **Franz von Schönthan** was less extensive but no less successful; their *Die Goldfische* (*The Goldfish*) remained one of the most frequently performed comedies through the Wilhelmine years.

KAINZ, JOSEF (1858–1910). Actor. Kainz was perhaps the most idolized actor of his day. Many saw in him the embodiment of a completely new departure for acting on the German stage. **Otto Brahm** recognized in Kainz a performer who broke the grip of **Johann Wolfgang Goethe**'s idealism, inaugurating a new age of realism. Others saw Kainz as more "impressionistic" than realistic, bringing an introspective, psychological detail to characters he portrayed. But nearly everyone agreed that he eschewed the traditional contrivances of a virtuoso, even though his acting remained thoroughly virtuotistic.

Kainz began his career in Leipzig, but his education as an actor took place under the tutelage of **Georg II** and his Meiningen court troupe beginning in 1877. For the next three years, Kainz played a

wide range of characters, developing skills that often enabled him to discover contradictory traits within a character. Kainz was slight of build and delicate of feature, but he had a graceful athleticism that provided him an agility and physical control on the stage far beyond that of his contemporaries. He was a natural "heroic type," but his ability to speak verse without mannerism, presenting himself almost as a contemporary to his audiences, won him unprecedented critical regard and popular acclaim.

Kainz's numerous appearances in leading and supporting roles with the Meininger troupe led to the engagement in **Munich** between 1880 and 1883 (when he played leading roles only) that solidified his reputation. When **Adolph L'Arronge** hired him as his marquee performer at the **Deutsches Theater** in 1883, Kainz became the dominant actor in **Berlin**. He then worked briefly for **Ludwig Barnay** in Berlin, but a contract dispute between the two men led Kainz to take an extensive tour of the United States. He returned to L'Arronge in 1892, reprising such roles as Romeo, Richard II, Prince Friedrich of Homburg, Hamlet, Don Carlos, Egmont, and others with which he had conquered Berlin. Kainz joined Brahm's troupe at the Deutsches in 1894, but Brahm miscast him; he furthermore expected him to play classics in the **Naturalist** manner. Such mistakes revealed the fact that Kainz was best when playing roles close to his own personality; when he played villain parts, as he did in Brahm's first production, **Friedrich Schiller**'s *Kabale und Liebe* (*Intrigue and Love*), the results were unusual and often disappointing.

In 1899 Kainz returned to his native Austria, where he joined the **Burgtheater** company in **Vienna**. With the Burg, Kainz achieved perhaps his greatest renown as an artist, prompting some critics there to describe his acting as "Nietzschean." As Goethe's Torquato Tasso, Kainz eclipsed the normal expectations of that character's visionary idealism and sent Tasso into another realm entirely, one best described as a world of "divine suffering." Few actors had convincingly played the role of Tasso before Kainz; even fewer since Kainz have left audiences, as he did, with a similar sense of shattering, sublime despair. When Kainz died, there was a general consensus in the German theater that a unique presence had departed. **Hugo von Hoffmansthal** was one of many writers and poets to eulogize Kainz, noting that his acting "had measured the abyss of life and death with the

eye of a poetic messenger. O thou messenger of all messengers, a spirit! Thou spirit!"

KAISER, GEORG (1878–1945). Playwright. Kaiser's life changed considerably when he married a wealthy woman in 1908. Prior to that time, he had held several jobs, including merchant seaman, but he began writing plays about the time he returned home with malaria from a sea voyage. After his fortunate marriage, he wrote in excess of 70 plays, many in the **Expressionist** vein. Between 1915 and 1933, more than 40 of them premiered; during that period, there was a premiere of at least one new Kaiser play every year but two (1916 and 1932). Kaiser was a fixture in the repertoires of nearly every German-speaking theater in the Weimar Republic, but his plays were performed elsewhere in Europe as well; even theaters in Tokyo, New York, and Sydney did them.

Kaiser wrote his best plays between about 1915 and 1920. Among them were *Die Bürger von Calais* (*The Burghers of Calais*); ***Von Morgens bis Mitternacht*** (*From Morn to Midnight*); ***Die Koralle*** (*The Coral*); *Hölle, Weg, Erde* (*Hell, Road, Earth*); and ***Gas I*** and ***Gas II.*** Most of them premiered outside **Berlin**; seven premieres took place in Frankfurt am Main, three in Düsseldorf, and two in **Munich**. His comedies, on the other hand, mostly reworked material from the early 1920s, usually premiered in Berlin. Maria Magdalena von Losch, later known as Marlene Dietrich, made her Berlin debut in a musical revue Kaiser wrote titled *Es liegt in der Luft* (*It's in the Air*). His musical collaboration with Kurt Weill *Der Silbersee* (*The Silver Lake*) had its premiere in Erfurt, Leipzig, and Magdeburg simultaneously on 18 February 1933. The Magdeburg premiere in particular was remarkable, since protestors from several National Socialist organizations demonstrated noisily outside the theater against the production. Kaiser remained in Germany until 1938 and signed an oath of allegiance to the Third Reich, though Nazi officials banned his plays. He then emigrated to Switzerland and remained there until his death.

KALISCH, DAVID (1820–1872). Playwright. Kalisch is best known as the founder and editor of the satirical weekly *Kladderadatsch*, though his comedies in **Berlin** from the 1850s to the late 1860s were among the most popular theatrical fare anywhere on the German

stage. He was closely associated with **Franz Wallner** during those two decades, while continuing to publish *Kladderadatsch*; at one point, Kalisch spent time in prison when the weekly's satire angered Prussian authorities. Kalisch made his debut in the 1840s as a performer of "couplets" at the Schwarzer Adler in Berlin, a bistro that featured vaudeville-style entertainments. He began writing material for comic actors in Berlin, which led to his relationship with Wallner. Wallner had booked actor Philipp Grobecker (1815–1883) in a comedy titled *Münchhausen*, for which Kalisch had written some dialogue. The comedy's success encouraged Kalisch to write full-length comedies for Wallner, including *Der Aktienbudiker* (*The Stock Market Hero*), *Ein gebildeter Hausknecht* (*An Educated Houseboy*), *Berlin bei Nacht* (*Berlin by Night*), and several others. Their success in Berlin and throughout the German-speaking world (though their subject matter was nearly always Berlin and its denizens) made Kalisch one of the first comic playwrights in the German theater to attain substantial wealth.

KASIMIR UND KAROLINE by **Ödön von Horváth**. Premiered 1932. Horváth's extravagant but brutal satire on the petit bourgeoisie in Munich has 110 scenes, takes place at an amusement park, and requires a large Mercedes convertible onstage to be driven off and then wrecked, a Ferris wheel, and a huge cast of nonspeaking extras. Kasimir has just lost his job as a chauffeur, so to cheer him up his girlfriend Karoline suggests they go to the Oktoberfest grounds in Munich for a few beers to help him forget his troubles. Accompanying them are his friend Merkl Franz, a lowlife hoodlum just out of jail, and his girlfriend Erna. Kasimir shows off his strength at the "Hit the Lukas" game; he hits the plate with a sledgehammer and rings the bell. Merkl Franz constantly threatens to knock out Erna's teeth, to which she replies, "You'd have every right." Kasimir and Karoline decide to break up, but they run into each other in the amusement park throughout the play. He alternately begs her to forgive him, calls her a slut, or bitterly bemoans his unemployment. Merkl Franz becomes aggressively drunk. "Women are like shit!" he screams at Erna, to which she replies, "Don't be so crude. What'd I ever do to you?" "You're a woman. That's enough!" Two wealthy businessmen in their 60s make suggestive comments to Karoline and Erna, and

one of them supplies Karoline with beer until she agrees to go to bed with him if he pays her enough money. Suddenly the play is interrupted by the overflight of a large zeppelin, and fights break out on the park grounds. Karoline agrees to leave with the man and gets into his Mercedes; they drive off but the car is wrecked offstage because the man passed out. The other older man reappears, having been beaten up by a gang of teenagers. The Munich police take away Merkl Franz for having instigated the fights. Karoline at last accepts Kasimir's offer to go home with him, agreeing that "as long as we don't hang ourselves, we'll be all right." They exit singing "The Last Rose of Summer."

KAUKASISCHE KREIDEKREIS, DER (*THE CAUCASIAN CHALK CIRCLE*) by **Bertolt Brecht**. English language premiere 1948; German premiere 1954. This play employs an ancient narrative convention, namely, establishing the "true" stewardship of a precious resource. In the initial scene of the play the resource is disputed land; as the play-within-the-play convention unfolds, the resource is a child whose maternity is in dispute. The story's basis is a Chinese parable from the 13th century that **Klabund** had adapted in 1925. Brecht employed it to promote a collectivist thesis: that resources should be allocated to those best suited for their stewardship.

The play's action revolves around a revolt somewhere in the Caucasus, during which an aristocratic mother abandons her small son, and a serving maid named Gruscha saves the tiny princeling from certain death. Later the biological mother reappears to demand the return of her son; Gruscha has in the meantime endured horrific hardship in her efforts to save the boy. In a humorous trial scene, a drunk named Azdak is assigned to adjudicate the case. He places the child in a circle drawn with chalk and orders the women to wrest the boy from each other. Gruscha gives up the match for fear of harming the child, so Azdak awards the boy to her (much as King Solomon had done in a similar biblical case, 1 Kings 3:16–28). The metaphor then returns to the initial scene of a land dispute, concluding that resources should go to those best able to serve the entire community.

The play has several arresting scenes, all based on Brecht's eschewal of anything illusionistic; in one, for example, Gruscha with the child clinging to her crosses a steep mountain pass by clambering

between two chairs or ladders on stage. Brecht also employed two distinct plots (featuring Gruscha and Azdak separately) and united them only in the trial scene. As in his other major plays, Brecht used songs to interrupt the action and make critical commentary on the ideas under discussion. Most convincing are the characterizations of Gruscha and Azdak; both are abstractions of ideas and neither is motivationally coherent—nor did Brecht intend them to be.

KAYSSLER, FRIEDRICH (1874–1945). Actor, director. Kayssler began acting with a university student group in **Munich**, where **Otto Brahm** saw him in 1895 and put him under contract at the **Deutsches Theater**. There, while still a young man, he performed a series of leading roles in the classics—Hamlet, Don Carlos, Götz von Berlichingen, Karl von Moor, and several others. He made a brief sojourn to Breslau in the late 1890s, but returned to **Berlin** in 1900 where he remained active for the rest of his life. While still working for Brahm, Kayssler joined **Max Reinhardt** and Martin Zickel in forming the *Schall und Rauch* (*Noise and Smoke*) cabaret in 1901, doing turns in Pierrot costumes from **Friedrich Schiller**'s *Don Carlos*, interlarding it with references from **Gerhart Hauptmann**'s plays. Later they parodied symbolism, doing a skit called "Carleas et Elisande" by a certain "Isidor Mysterlinck."

By that time, Kayssler had become in the public's mind an embodiment of the Schiller hero, a type he continued to play when Reinhardt took over the Deutsches Theater and throughout the remainder of the Wilhelmine period. In the Weimar Republic, he participated in several left-wing theatrical exercises, including the management of the Berlin Volksbühne. He hired **Erwin Piscator** to stage a series of inflammatory productions, and in 1925 he presented the German premiere of Soviet culture minister Anatoly Lunascharsky's *The Unchained Don Quixote* and the world premiere of *Brest-Litovsk* by Hans-José Rehfisch in 1930. His film work in the 1920s was politically neutral, though it included Gustav Ucicky's glorification of Frederick the Great with **Otto Gebühr**, titled *Das Flötenkonzert von Sans Souci* (*The Flute Concert at Sans Souci*).

Kayssler's work in the Third Reich was prejudiced by his acceptance of the title *Staatsschauspieler* (state actor), implying his consent to regime cultural policies. Such films as *Friesenot* (1935)

and *Unternehmen Michael* (1937) exalted Nazi viewpoints and received praise from the Propaganda Ministry. His work in the theater tended toward the classics, though his 1937 portrayal of Armand Duval's father in *Camille* was probably his most popular role.

KERR, ALFRED (Alfred Kempner, 1867–1948). Critic. Kerr was among the most influential and innovative of theater critics during the late Wilhelmine and Weimar Republic periods. He felt that theater criticism was an art form unto itself, and over a career spanning three decades, he sought to convince everyone that he was its consummation. The certitude with which Kerr held his opinions, along with an enormous ego, fostered self-aggrandizement in nearly all his reviews. His numerous visits abroad, especially to London and New York, made him among the most cosmopolitan of the **Berlin** critics.

Kerr's 1909 arrival in Berlin allowed him to develop fully his powers of observation begun as a critic in his native Breslau, then in Königsberg and Frankfurt am Main. Even as a beginner, he championed **Otto Brahm**, **Gerhart Hauptmann**, and Henrik Ibsen. His left-of-center political tendencies were apparent in his dismissal of Sudermann, though he was skeptical of both **Max Reinhardt** and **Expressionism**. **Bertolt Brecht** likewise failed to win his favor, describing *Mann ist Mann* as "nonsense from a small talent." When Kerr found an actress he liked, **Fritz Kortner** claimed, he "didn't write a review of her performance. He wrote her a love letter." Kerr's wit was legendary, recalling one play as "the hapless laughing at the helpless." He was prophetic in his many observations about the disaster waiting to befall the German theater under National Socialism, and he was among the first writers whom **Joseph Goebbels** stripped of German citizenship after the Nazis took power.

Kerr was essentially a modernist, recognizing the novel perceptions of **Frank Wedekind**, **Carl Sternheim**, and **Georg Kaiser** as they consciously applied a fragmented and distorted German for the purposes of stage dialogue. Kerr shared their inventive tendencies in his reviews, eschewing traditional "reportage" narrative in favor of sentence fragments, puns, parenthetical asides, slang, and jargon grouped somewhat randomly under Roman numerals. **Curt Goetz**'s parody of Kerr in the comedy *Hokuspokus* is a good example: "Roman numeral four. Poetry? A flop? A hit? A flop! All things consid-

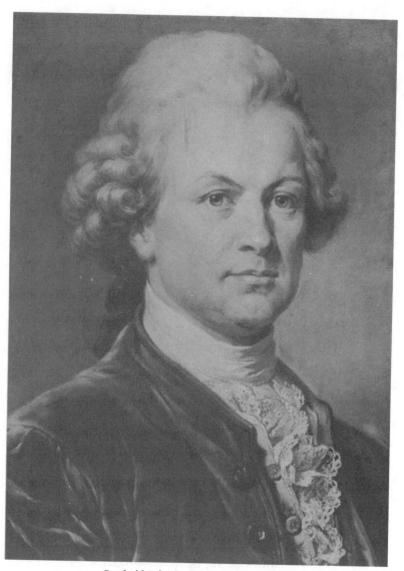

Gotthold Ephraim Lessing (1729–1781)

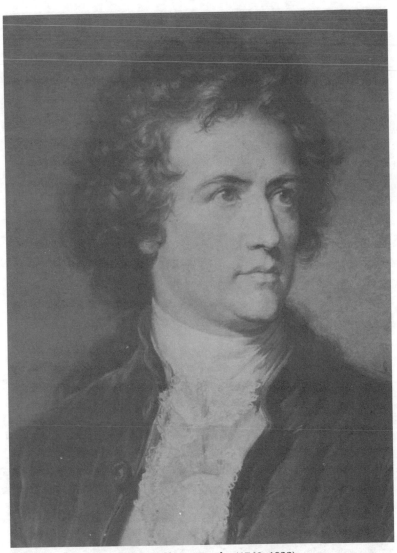

Johann Wolfgang Goethe (1749–1832)

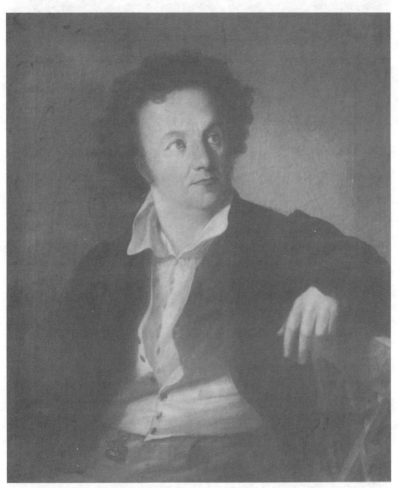

August Wilhelm Iffland (1759–1814)

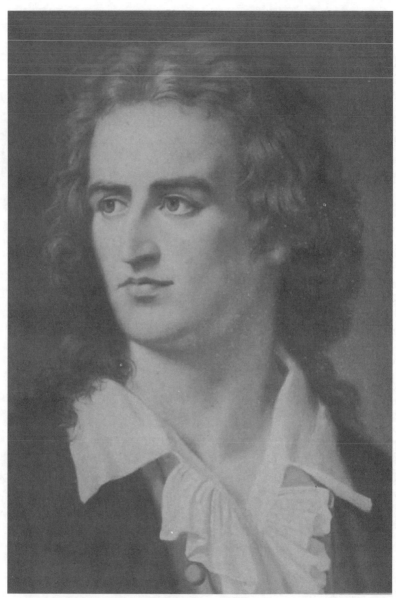

Friedrich Schiller (1759–1805)

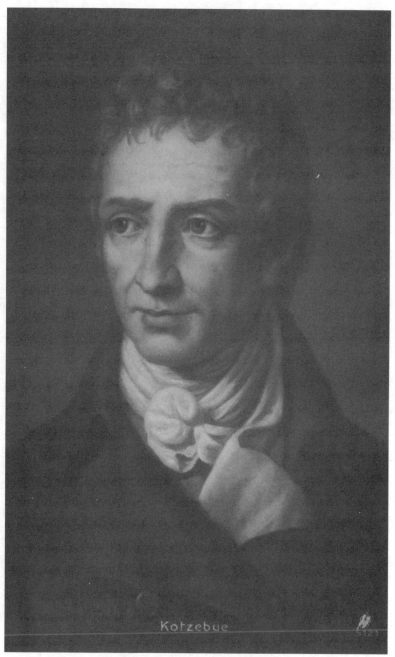

August von Kotzebue (1761–1819)

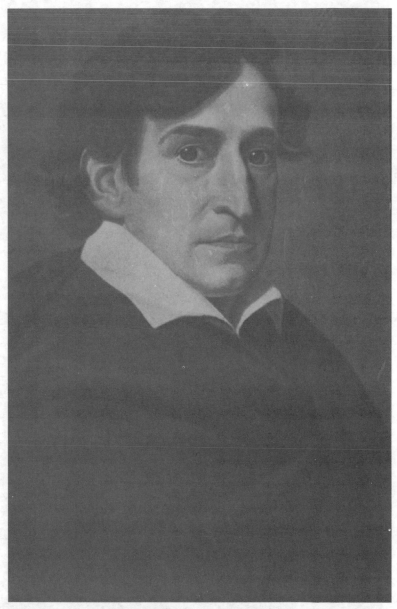

Ludwig Devrient (1784–1832)

Charlotte Birch-Pfeiffer (1800–1868)

Max Martersteig (1853–1926)

Louise Dumont (1862–1932)

Max Reinhardt (1873–1943)

Heinz Hilpert (1890–1966)

Fritz Kortner (1892–1970)

Bertolt Brecht (1898–1956)

Therese Giehse (1898–1975)

Gustaf Gründgens (1899–1963)

Bruno Ganz (1941–)

ered: the eyes glaze over. It's a flop! Roman numeral five. But what a flop! Long live kitsch!"

KESSLER, COUNT HARRY (1868–1937). Diplomat, critic. Kessler occupies a unique place in the German theater, for he was never a theatrical professional but nevertheless was closely involved in the nation's cultural life, especially the theater, from the Wilhelmine period through the Weimar Republic.

By the turn of the 20th century, the work of Edward Gordon Craig had intrigued Kessler to the point that he wanted German managers to employ him in any way possible. He brought Craig to Germany with a promise of staging an outdoor masque in Weimar during the spring of 1904, but Craig backed out of the deal because "weather changes were less susceptible to his absolute control" (L. M. Newman, "Reinhardt and Craig?" in *Max Reinhardt: The Oxford Symposium*, ed. Margaret Jacobs and John Warren [Oxford: Oxford Polytechnic Press, 1986], 6). Kessler brought **Hugo von Hofmannsthal** and Craig together, and he later persuaded **Otto Brahm** to commission Craig to design scenery and costumes for the world premiere of Hofmannsthal's adaptation of Thomas Otway's *Venice Preserv'd* at the Lessing Theater in **Berlin**. "Brahm found Craig a crackpot with unrealizable ideas, but he accepted two designs for the scenery and used them for two of the play's five acts. The overall results were dismal, and Hofmannsthal refused thereafter even to speak with Craig. Brahm did likewise" (Newman, 6). Kessler also attempted to interest **Max Reinhardt** in a Craig production, and negotiations got under way. They ended when Reinhardt concluded that Craig was both unstable and greedy.

Kessler is often quoted in histories of the Weimar Republic for his witty, often sardonic, eyewitness accounts. He had access to the corridors of power and to personalities at the center of the action; his descriptions were flavored with the "old school" manner for which he has become justifiably admired. After looters ransacked the City Palace in Berlin, for example, Kessler noted in his diary that the

> furniture, objects, remaining mementos, and art objects of the Kaiser and Kaiserin are so abstemiously petty bourgeois and tasteless that you feel no need to bring charges against the vandals, only astonishment that the poor, terrified, unimaginative creatures who had once vegetated among

these artifacts in the costly ambience of the palace, surrounded by lack-
eys and scheming toadies, could have had such an effect on world his-
tory. The world war emanated from this underworld, or at least, what
guilt the Kaiser bore for the war: from this kitschy, confined sham-world
of conspicuously false values issued his judgements, plans, combina-
tions, and decisions. A sick judgment, a pathological agitation connected
to an all-too-well-lubricated machinery of state! Now that dismal men-
tality lies strewn about like so much junk. I have no sense of compassion,
but rather one of horror and guilt that this world was not destroyed long
ago. (*Tagebücher, 1918–1937*, ed. Wolfgang Pfeiffer-Belli [Frankfurt am
Main: Insel, 1982], 84)

KIEL. The port city of Kiel, capital of Schleswig-Holstein, has a
recorded history of theater performances dating to 1638, when an
English troupe played the city. Thereafter Dutch, Danish, and addi-
tional English troupes followed, performing in the city hall. In 1677
the city's municipal auditorium was converted into a opera house,
and in 1738 **Caroline Neuber** and her troupe played there. Kiel be-
came a destination for most of the major troupes after the Neuberin's
successful sojourn, even after the city came under Danish rule in
1773. **Abel Seyler** opened a German-language court theater in 1787,
but it closed in 1806 and German theater in Kiel then became a rar-
ity. The opera house was razed in 1840 and in its place the Kiel city
theater arose under the leadership of Count Carl Friedrich von Hahn-
Neuhaus. Its staple fare was opera, though a season of German-lan-
guage theater was annually on offer. In 1907 the city built a com-
pletely new and modern facility, and in 1919 Kiel offered **Carl
Zuckmayer** his first job after World War I. He staged a particularly
bawdy production of Terence's *The Eunuch*, featuring abundant fe-
male nudity. He was fired soon thereafter, prompting him to pursue a
career as a playwright rather than a director. The theater was de-
stroyed in World War II, but citizens erected a new one in 1953, and
it still stands.

KINSKI, KLAUS (Nikolaus Nakzynski, 1926–1991). Actor. Kinski's
became a recognizable cinematic countenance comparable to **Peter
Lorre**'s of a generation earlier. He began his career as a theater actor
with no training (as Lorre had done), appearing in Tübingen and later
Baden-Baden. There **Boleslaw Barlog** hired him to work in **Berlin**,

beginning in 1946. In Berlin he established himself at both the Schlosspark Theater and the **Deutsches Theater**, and by 1950 Kinski had caught the attention of **Fritz Kortner**, who hired him for a production of *Don Carlos* in 1950 at the **Munich** Kammerspiele. Kinski in fact resembled a young Kortner, and like Kortner in his 20s, Kinski's acting style was often frenetic and untraditional. Kinski began to concentrate on film acting by the mid-1950s and subsequently appeared in more than 100 films, the vast majority of which failed to exploit his enormous talent. Few good actors have made more bad movies than did Kinski. The exceptions were usually those by Werner Herzog (though Kinski appeared briefly in *Dr. Zhivago* under David Lean's direction). For Herzog, Kinski played a series of profoundly "conflicted" characters, beginning in *Aguirre, der Zorn Gottes* (*Aguirre, the Wrath of God*, 1972), *Nosferatu* (1979), **Woyzeck** (1979), and concluding with *Fitzcarraldo* (1982).

KLABUND (Alfred Henschke, 1890–1928). Playwright. Klabund is best known for his novels, but his dramatic adaptation from the Chinese of *Der Kreidekreis* (*The Chalk Circle*, 1925) was the basis of **Bertolt Brecht**'s *Der kaukasische Kreidekreis* (*The Caucasian Chalk Circle*). In 1918 Klabund had begun translating poetry from Chinese and Japanese into German; *The Chalk Circle* was extremely popular after its premiere in Meissen. It was a fairy tale in dramatic form written for **Elisabeth Bergner**, though it contains some representation of a corrupt officialdom that Brecht likewise employed. Klabund wrote several other plays, none of them successful.

KLEIST, BERND HEINRICH WILHELM VON (1777–1811). Playwright. Kleist was a master of German verse, in both comedy and tragedy. During his own lifetime, however, his work found little favor among managers due to the French occupation of most German territories. Kleist's most important plays were the tragedy *Die Familie Schroffenstein* (*The Schroffenstein Family*, 1803), the comedy *Der zerbrochene Krug* (*The Broken Jug*, 1806), a tragedy about Amazons titled *Penthesilea* (1808), the romantic drama *Käthchen von Heilbronn* (*Kathy of Heilbronn*, 1810), and the psychological study with patriotic Prussian overtones *Prinz Friedrich von Homburg* (*The Prince of Homburg*, 1811). A production of *The Schroffenstein Family* took place in

Graz, Austria, during the 1803–1804 season without his knowledge, but it soon folded. In Weimar, an 1808 production of *The Broken Jug* attracted little attention, as was the case for an 1811 staged reading of *Penthesilea* in **Berlin**. *Kathy of Heilbronn*, however, proved to be somewhat popular after its premiere at **Vienna**'s **Burgtheater** in 1810. Productions of *Kathy* followed in Graz, Karlsruhe, Bamberg, and Würzburg. By that time, unfortunately, Kleist had committed suicide in Berlin, despairing ever of having success as a playwright. He had persistently tried to convince **August Wilhelm Iffland** to produce his plays, but Iffland rebuffed him with equal persistence.

Only when Count Brühl assumed directorship of the Royal Theater did Kleist's work begin to gain popularity in Berlin. **August Ernst Klingemann** had staged Kleist's plays in Braunschweig in the early 1820s, but only after Brühl staged *Kathy of Heilbronn* in 1824 with Luise von Holtei (1800–1825) in the title role did critics begin to take serious notice of Kleist. By that time, **Ludwig Tieck** had published Kleist's plays and thereafter began a recognition of Kleist's eminence as a playwright. Not only was Kleist a master of verse, as Tieck had insisted but he was also gifted in the creation of characters whose inner conflicts are compelling. Kleist's mastery in a wide range of dramatic achievement is similarly remarkable: *Kathy of Heilbronn* remains one of the best of German dramas about "romantic knighthood"; *The Broken Jug*, among the very best German comedies ever written, features a leading character with distinct Falstaffian dimensions; and *The Prince of Homburg* deserves the esteemed position it shares alongside the works of **Johann Wolfgang Goethe** and **Friedrich Schiller** as a classic of the German stage. *See also* KLEIST PRIZE.

KLEIST PRIZE. The principal impetus for this prize came from **Berlin** theater critic **Fritz Engel** in 1911. Engel felt that, on the 100th anniversary of **Heinrich von Kleist**'s suicide (13 November 1811), never again should a young playwright writing in German die from lack of attention. Engel put together the Kleist Foundation, whose board consisted of several notables, among them **Ludwig Barnay**, **Otto Brahm**, **Hugo von Hofmannsthal**, Ludwig Fulda, **Max Reinhardt**, and **Arthur Schnitzler**. The foundation itself was made up almost entirely of actors, directors, critics, playwrights, and publishers.

All had "progressive" political and artistic agendas in mind when agreeing to membership. The foundation's mission was to provide financial support to struggling male and female playwrights of the German language—though the actual emolument remained relatively small compared to other such prizes.

Three women won the prize: Anna Seghers, Else Lasker-Schüler, and Agnes Miegel. **Carl Zuckmayer** won the prize in 1925, but he dismissed its value because it often signaled to producers and audiences a predilection for left-wing causes. He nevertheless accepted the prize, and the play for which he received it (*Der fröhliche Weinberg* [*The Merry Vineyard*]) went on to earn him thousands of marks. Most often recipients of the prize were supposed to be controversial, or at least unusual. Thus the foundation took the singular step of naming someone to award the prize, rather than awarding it on the basis of a jury vote. For example, **Paul Fechter** awarded Zuckmayer his prize; **Herbert Ihering** awarded **Bertolt Brecht** his; and in 1931 Zuckmayer in turn awarded **Ödön von Horváth** the Kleist Prize.

The National Socialists disbanded the foundation in 1933, calling attention to "all the Jews and half-Jews on the Foundation's board" and the "decadent writing" the foundation had supported.

KLINGEMANN, AUGUST ERNST (1777–1831). Manager, director. Klingemann sought to imitate **Johann Wolfgang Goethe** by becoming a theater manager with intellectual aspirations. He studied at Jena under Friedrich von Schlegel and other esteemed professors, working periodically in his native Braunschweig as a teacher and **dramaturg**. When he became manager of the Braunschweig National Theater in 1818 Klingemann began building an outstanding ensemble, which by 1821 included **Emil Devrient**. Klingemann's interest in and productions of **Heinrich von Kleist** marked him as a unique manager in the 1820s, though his enterprise went bankrupt in 1826. When the Braunschweig theater was reconstituted in 1828, he was hired to direct, and in 1829 he staged the first production of Goethe's *Faust, Part 1* in its entirety.

KLÖPFER, EUGEN (1886–1950). Actor, manager. Klöpfer had an active and successful career as a performer. He began acting at age 23

in **Munich** and then worked in provincial stages until 1918, when he came to **Berlin** as a character actor engaged to play *Kraftkerle*, the earthy species of Teuton associated with **Heinrich George** and **Emil Jannings**. He gained notoriety in roles befitting his physical type—Götz von Berlichingen, Florian Geyer, Falstaff, Woyzeck, and the like. Such roles became his métier in the 1920s.

In 1930 Klöpfer became an active member in the National Socialist Party, and in 1934 the new regime promptly bestowed upon him the honorific *Staatsschauspieler* (state actor). **Joseph Goebbels** saw personally to the 1936 appointment of Klöpfer as head of the Volksbühne—which the Nazis had expropriated in 1934 after they came to power—but by 1938 the actor's alcoholism had began to cloud both his talent and his judgment, especially in his relations with women. Philandering ultimately brought Goebbels's wrath down upon Klöpfer—although Goebbels condemned Klöpfer not for the number of extramarital affairs he conducted but rather for his "tasteless" way of conducting them and his proclivity to go "out of control" with them. "The theater is not a free range for seduction," Goebbels wrote in his diary about Klöpfer. "I am not a moralist, but you can't keep your eyes closed all the time" (Goebbels, *Die Tagebücher*, ed. Elke Fröhlich, entry for 4 March 1937 [Munich: Saur, 1987], 3:66).

By 1943 Klöpfer had produced more "authentically German" plays favored by the regime than had his directing colleagues **Heinz Hilpert** at the **Deutsches Theater** and **Gustaf Gründgens** at the Prussian State Theater combined. He went in and out of favor far more often than did the others, too—yet his "unfortunate vices" and "questionable tendencies" notwithstanding, Goebbels never considered getting rid of Klöpfer altogether. Later Goebbels did remove the Theater am Nollendorfplatz from Klöpfer's portfolio, awarding it to **Harald Paulsen** instead. In 1948 Allied occupation forces rehabilitated Klöpfer, and he resumed his acting career, though he never regained his former prominence.

KNUTH, GUSTAV (1901–1987). Actor. Knuth is closely associated with the theaters of **Hamburg** and Zurich, though he worked for **Gustaf Gründgens** at the **Berlin** State Theater from 1937 to 1944. Knuth began his career as a teenager (with very little training) in Heidelberg, and from there worked primarily in Hamburg-area theaters

until he departed for Berlin. He established himself as a "natural" actor in leading roles of the German repertoire, bringing an earthy humor even to such roles as Iago, Woyzeck, and the Grand Inquisitor in **Friedrich Schiller**'s *Don Carlos*. For Gründgens, Knuth continued in such roles, though his work after the war at the Zurich Schauspielhaus was perhaps his most important. He was the first General Harras in **Carl Zuckmayer**'s *Des Teufels General* (*The Devil's General*, under **Heinz Hilpert** in 1946), and later the first Matti in **Bertolt Brecht**'s *Herr Puntila und sein Knecht Matti* (*Mr. Puntila and His Servant Matti*) under Brecht's direction in 1948. Knuth subsequently played leading roles in most of the **Friedrich Dürrenmatt** world premieres in Zurich, most notably as Ill in *Der Besuch der alten Dame* (*The Visit*, 1956) and Sir Isaac Newton in *Die Physiker* (*The Physicists*, 1962). Knuth earned fulsome praise among many observers in the postwar period for bringing a homely, unaffected dimension to his acting, perhaps as an antidote to some of the *völkisch* acting that had taken place during the Third Reich. Knuth was perceived as something "down-to-earth," but completely without the bitter aftertaste of nationalistic philistinism. Knuth also had leading roles in dozens of films, including the enormously popular *Grosse Freiheit Nr. 7* (*Port of Freedom*) with **Hans Albers** in 1944 and *Sissi, the Young Empress* (with Romy Schneider in the title role) in 1956.

KOCH, HEINRICH GOTTFRIED (1703–1775). Actor, designer, manager. Koch was a reformer strongly influenced by **Caroline Neuber**; many consider him a forerunner of **August Wilhelm Iffland**. He was one of the most versatile German performers in the 18th century, with talents in several areas and a strong desire to transform the German theater into an art form—a sometimes formidable task even after the reforms of the 1730s were in place. Koch began acting in 1728 with the Neuber troupe, and with them he began playwriting and designing costumes. Indeed, much of his contribution to reform the German theater came from his determination to design and build costumes suitable for the individual plays the actors performed; before Koch, Neuber's and most other troupes had employed stock costumes of French style and derivation. Koch also designed and built scenery for Neuber, and he was reported to have been her best actor in the title role of Molière's *The Miser*. Koch formed his own troupe

in 1749, and with this troupe he did several **Gotthold Ephraim Lessing** productions in the later 1750s that Lessing himself praised. He dissolved the troupe in the early 1760s and joined **Konrad Ekhof** with the remnants of the **Johann Friedrich Schönemann** troupe in **Hamburg**; when Ekhof departed, Koch assumed leadership of the troupe and took it to Leipzig, where he opened the new Schauspielhaus with Johann Elias Schlegel's patriotic play about the Teutons, *Hermann*. **Johann Wolfgang Goethe** saw the production when Koch was on tour with it and praised the artistry Koch devoted to it, "despite his advanced years." Koch spent his remaining time in **Berlin**, where he purchased the Theater in der Behrenstrasse in 1771; there he continued his efforts to mount detailed productions, which many Berliners recalled 25 years later when Iffland was in his Berlin heyday. Koch's last production at the Theater in der Behrenstrasse was Goethe's *Götz von Berlichingen*.

KOKOSCHKA, OSKAR (1886–1980). Playwright. Kokoschka was best known as a successful painter but, like several modernists prior to World War I, he also tried his hand at playwriting. Kokoschka's *Murderer, the Hope of Women* was testimony to his deep distrust of "official" precepts of taste and his interest in Freudian perceptions of sexuality. The play also manifested Kokoschka's recognition of violence in the rapid cultural changes taking place before World War I. The play's dialogue consists of shouts, shrieks, and other fragmented utterances characteristic of early **Expressionism**, but what made the play most unusual was Kokoschka's violent graphic displays that accompanied the dialogue when it was first published. Productions of Kokoschka's plays, which included *Hiob* (*Job*) and *Der brennende Dornbusch* (*The Burning Bush*) were rare and ran only briefly. National Socialists included Kokoschka's paintings in the infamous 1937 exhibition of *Entartete Kunst*, sometimes called "degenerate art." He spent the war years in Great Britain and returned to Vienna in the 1950s to execute several stage designs.

KOLPORTAGE (*Pulp Fiction*) by **Georg Kaiser**. Premiered 1924. Kaiser satirically dedicated this comedy "to the welfare of children and to the contemporary theater" because its ostensible subject matter was a child caught in a custody dispute during a divorce. The action

takes place in Sweden, where a wealthy, aristocratic couple's unhappy marriage has produced a son, Erik. Both parents want custody of the child as divorce proceedings ensue. The mother "buys" the infant son of beggar woman Antje Appelblom with the guarantee of a monthly pension; she then sends the child outdoors in the care of a nanny and, as expected, the father's agents soon kidnap the baby. The mother then departs with her real son for a farm in Kansas, where her relatives have assured her that the boy will grow up with and be protected by cowboys. The main action takes up 20 years later on the eve of the birthday of the young man whom everyone assumes is Erik, heir to the large Swedish estate where he was raised after being abducted from his nanny. This Erik has fallen in love with a young noblewoman. Soon the mother arrives and announces that hers is the real son and is now ready to assume his inheritance. The old beggar woman tells the false Erik that his real name is Acke Appelblom. The aristocrats are outraged, but realize there is nothing they can do about it.

The play features numerous ironic protestations about the inherent superiority of the nobility, but it turns out that Acke, the beggar woman's son, possesses an inborn nobility; he tells his fiancée he will understand if she must break off their engagement now that he is penniless. But she agrees to go off to America with him, where he will seek his fortune "legitimately." The play's appeal lies in showing the predictable decadence of the privileged leisure class, the benefits of an American upbringing, the beggar woman who had triumphed over poverty, and the sudden reversals of fortune. It was indeed a melodramatic and "trashy" story—hence the title of the play—and one German audiences liked immensely. It was one of Kaiser's most popular plays, with scores of productions throughout the 1920s.

KONZERT, DAS (*The Concert*) by **Hermann Bahr**. Premiered 1909. Bahr's most popular and successful play makes dual use of the word *concert* in its title. The first is a rendezvous the pianist Gustav Heink makes with a female admirer in a secluded mountain cottage; the second describes what happens when Heink's wife and the admirer's husband discover their spouses in the cottage. The dialogue Bahr creates for the foursome is analogous to a string quartet: there is a predictable amount of dissonance at first, but everything ends harmoniously. At one point, the pianist's wife appears ready to leave with

the cuckolded husband. She discovers, however, that, like her husband the pianist, the other man is a 48-year-old child. Men simply never grow up, she observes, "and that is why a woman must get wiser every year." The pianist realizes he cannot live without such wisdom from his wife, and the aggrieved husband forgives his wife; she did not really betray him, he realizes, but was simply "overcome" with the pianist's celebrity and star status.

KOPP, MILA (1904–1973). Actress. Kopp began acting in her native **Vienna** during the 1920s and worked in several provincial theaters before becoming a regular member of the Schiller Theater company during the Third Reich under **Heinrich George**. She was most effective in the 1950s playing character women under **Heinz Hilpert**'s direction in Göttingen. Among the best of her portrayals were Mrs. Antrobus in Thornton Wilder's *The Skin of Our Teeth*, Lady Britomart in George Bernard Shaw's *Major Barbara*, Gina Ekdal in Henrik Ibsen's *The Wild Duck*, the Maid in Federico García Lorca's *House of Bernarda Alba*, and Mother Wolff in **Gerhart Hauptmann**'s *Der Biberpelz* (*The Beaver Coat*). She also did several films in the 1950s and television productions in the 1960s.

KOPPENHÖFER, MARIE (1901–1948). Actress. Koppenhöfer began her career in Stuttgart, but by the early 1920s she was working regularly at the **Munich** Kammerspiele and the **Cologne** City Theater, where even as a young actress she developed a reputation for performances in tragic roles by **Johann Wolfgang Goethe**, **Friedrich Schiller**, and **Heinrich von Kleist**. In 1923, however, she appeared as Marie in the world premiere of **Bertolt Brecht**'s *Im Dickicht der Städte* (*In the Jungle of Cities*) and a year later in his adaptation of *Edward II*. In 1925 Koppenhöfer moved to **Berlin**, where she remained for the next 19 years, working either at the **Deutsches Theater** or at the State Theater with **Gustaf Gründgens** and **Jürgen Fehling**. The regime awarded her the title of state actress in 1943. After the war, she returned to Munich, where she appeared in several German premieres of previously banned plays.

KORALLE, DIE (*The Coral*) by **Georg Kaiser**. Premiered 1917. *The Coral* is the first play in Kaiser's **Gas** Trilogy, in which The Billion-

aire establishes his fortune during the heady days of the Wilhelmine empire. The Billionaire has risen from rags to riches, but his son rejects the life of a capitalist and works as a stoker in a steam plant. Stunned by his son's life, the Billionaire is determined to make amends. Yet the Son rejects any suggestion of a reconciliation between the two, so the Billionaire sets out to reject his former life and transform himself in the process. In a barely plausible plot twist, Kaiser has the Billionaire switch identities with his chief administrator (the Secretary), who differentiates himself from his boss by the piece of coral adorning his gold watch chain. The Billionaire then murders the Secretary, and in the hope of assuming his identity, attaches the piece of coral to his own watch chain. But his plans go awry when he is arrested for the murder of the man police believe is the Billionaire. As he is led off to the gallows, the Billionaire exits with a clean conscience, knowing he has transformed himself.

KÖRNER, HERMINE (1878–1960). Actress, manager. Körner showed early in childhood an extraordinary talent for the piano and studied with promising composer Max Reger (1873–1916) to attempt a career as a concert pianist. In 1898 she changed her mind, however, and without having studied acting or even having been in a play, she auditioned for the **Burgtheater** in **Vienna**. She was cast in the title role of Oscar Wilde's *Salomé*, much to her own surprise as well as nearly everyone else's. In 1904 Körner began working at the **Berlin** Residenz Theater, where she became one of director Sigmund Lautenberg's major attractions in French boulevard comedies.

Realizing she needed more training as an actress (critics complained of her "brittle organ," meaning that her voice was weak), Körner moved to Düsseldorf in 1909 to both study under and work with Dumont. The training was highly effective, for she soon received an offer of permanent company membership in the Dresden Court Theater. She remained in Dresden until 1915, but then, to the shock of the German theater establishment, relinquished that lifetime sinecure to work with **Max Reinhardt** in Berlin instead. Körner remained in Berlin until 1919, and then began a new career in the 1920s as theater manager and director. She ran the **Munich** Schauspielhaus until 1925 and the Albert Theater in Dresden until 1929, before returning to Berlin in 1931 to concentrate on acting. She was a member of **Gustaf**

Gründgens's company at the State Theater from 1933 to 1944, becoming a favorite of the National Socialists in the process and receiving their ultimate honorific *Staatsschauspielerin*, or state actress. After the war, she resumed her managerial career in Stuttgart, but her greatest triumph in the postwar years was the title role in Jean Giraudoux's *The Madwoman of Chaillot* in 1950.

Körner had an astonishingly wide range as an actress, though most agreed her greatest work came in character parts, along with numerous roles in Greek tragedies. She received several awards and prizes in the postwar period, and in her will she even instituted one of her own: the Hermine Körner Ring, given to a German actress displaying "serious striving" toward excellence in her art.

KORNFELD, PAUL (1889–c. 1943). Playwright. Kornfeld was an influential **Expressionist** playwright, with two plays in that vein to his credit: *Die Verführung* (*The Seduction*, 1917) and *Himmel und Hölle* (*Heaven and Hell*, 1919). He later wrote comedies, which were more frequently performed than his straight plays, but his subsequent influence derived from an insightful essay on Expressionist acting published as an afterword to *The Seduction* in 1921. In it, he called for the actor to acknowledge the fact that he was acting, and that what was taking place on stage was not reality; the actor was instead an embodiment "of thought, feeling, or fate!" Kornfeld said the closest analogy to Expressionist acting was an opera singer who hits a high C in the midst of his death throes. There is more truth about life and death "in the sweetness of that note than if he were **naturalistically** to crawl and writhe on the stage floor" ("Nachwort an den Schauspieler," in *Die Verführung* [Berlin: Fischer, 1921], 166). Kornfeld's essay has been widely translated and published. Kornfeld himself perished in a Nazi extermination camp sometime between 1942 and 1944.

KORTNER, FRITZ (Nathan Kohn, 1892–1970). Actor, director. Kortner was among the most gifted actors in the Weimar Republic and was instrumental in revitalizing the German theater in the post–World War II period. He received training at the **Burgtheater** in his native **Vienna** and began his career in Mannheim in 1910. The following year he was working for **Max Reinhardt** in **Berlin**, but his career did not blossom until 1919 when he began work with **Leopold Jessner**. At

the newly renamed State Theater, he played a series of classics in controversial productions, bringing an abrupt, strongly arbitrary style to great characters such as Hamlet, Gessler, Macbeth, Danton, and especially Shylock. Later, under Reinhardt, he brought a similar intensity to plays by **Frank Wedekind** and **Bertolt Brecht**. His most commercially successful production in the Weimar period was Maxwell Anderson and Laurence Stallings's *What Price Glory?* (under the title *Rivalen*, in a translation by **Carl Zuckmayer**) with **Hans Albers**.

In the 1920s, Kortner worked steadily in films, completing more than two per year during that decade. Among the most memorable were *Die Büchse der Pandora* (*Pandora's Box*) with Louise Brooks and *Die Frau, nach der man sich sehnt* (The Woman You Long For) with Marlene Dietrich. The former was in some ways a recapitulation of the stage production **Erich Engel** directed at the State Theater, amalgamating *Erdgeist* (*Earth Spirit*) and *Pandora's Box* together for one evening's performance. Kortner played Dr. Schön in the first play and Jack the Ripper in the second. "Lulu shot me as Dr. Schön, but I avenged him as Jack the Ripper [when I] cut open her belly. We thought that was poetical in the sense of Wedekind" (Kortner, *Aller Tage Abend* [Munich: Kindler, 1969], 254). Kortner's film acting differed significantly from his stage performances; for the screen, he was often subtle and compliant with film's commercial demands, while on stage his "strength of expression," as he described it, was to many observers "obvious exaggeration" (274).

Kortner was on a Scandinavian tour when the National Socialists came to power and he immediately emigrated to England, where he appeared in a few films. Later he settled in Vienna to work at the Burgtheater, but in 1938 he was forced to move again, this time going to Hollywood. There Kortner met often with Reinhardt, Thomas Mann, **Berthold Viertel**, and numerous other German exiles. Meeting with Brecht was always difficult, because Brecht would talk about the "inability of the Germans to revolt" because they were Hitler's "willing subjects." "We differed on that," Kortner recalled. "I was at that time an excessive enthusiast for the so-called 'good German.' Years later, after my return, I learned to restrain that enthusiasm" (320).

Returning to **Munich** in 1949, Kortner began directing at the Kammerspiele. He was intent on reforming German acting as he found it upon his return. It was "pompous, puffed up, and ponderous," he said,

though he gave credit to directors who had worked under the Nazis such as Engel, **Jürgen Fehling**, and **Gustaf Gründgens** for "coming back from the dead [in the 1950s] and wanting to create an 'anti-Hitler acting style'" (305). Kortner observed that the Nazis approached "style" completely in terms of externals, which—despite such modernist tendencies as spare stage decoration, abstract lighting, and symbolic use of color—had nothing to do with what was "really modern" in the theater, which he described as "an intellectual procedure and only in the narrowest sense a fact of decor" (306). He insisted that "Nazi theater" may have *looked* modern, but it was essentially a throwback to the old heroic affectation of the court theaters.

Kortner directed a series of outstanding productions in the postwar years. His 1954 *Waiting for Godot* with Heinz Rühmann was one of the first significant "absurdist" productions in the German theater. Among Kortner's acting "discoveries" was **Klaus Kinski**, who played the title role for Kortner in a Berlin production of **Friedrich Schiller**'s *Don Carlos* and later Prince Hal in **William Shakespeare**'s *Henry IV, Part 1* at the Kammerspiele. In the last production he ever directed, Kortner cast a young **Klaus Maria Brandauer** as Prince Hettore Gonzaga in **Gotthold Ephraim Lessing**'s *Emilia Galotti*. Among Kortner's directorial assistants in Munich were **Peter Stein** and **Jürgen Flimm**, who subsequently employed Kortner's techniques and ideas. Their work is perhaps Kortner's greatest legacy to the German theater.

Kortner's two books of memoirs are among the best any German actor ever wrote. On nearly every page of both books, one senses Kortner's passion for acting; what emerges is a man stupendously talented and extremely unfortunate, yet one who never gave up on anything. He is unapologetic for what he termed "the Jewishness brought to art," both as an actor and later as director. He was likewise proud of his talent and took credit at times for developments where no credit was due. For Jessner's innovative departures in Shakespeare's *Richard III* of 1920, for example, Kortner claimed he had a dream of the famous "Jessner steps" and had sketched out the steps along with the entire design of *Richard III* for Jessner. He also claimed credit for giving Zuckmayer the idea for *Der Hauptmann von Köpenick* (*The Captain of Köpenick*) and said he could never forgive Zuckmayer for "stealing" it: "I was the initiator of the play with the original idea and

the outline of the action. Zuckmayer always had a contradictory attitude towards this fact. Before and after Hitler he denigrated my contribution and when Hitler came [to power] Zuckmayer cursed me." Beyond the questionable veracity of such assertions remains the fact that Kortner's postwar career would have been impossible elsewhere in Europe or in the United States. He would probably have resorted to teaching somewhere in his later years because he was simply too irascible and too noncommercial to continue directing and acting. But the generously subsidized German theater was hungry for a new identity of itself in the 1950s and 1960s, and Kortner was one who helped provide it.

KOTZEBUE, AUGUST (1761–1819). Playwright. Kotzebue's dramatic output was prodigious, thought to have exceeded 220 plays. Many of them have been performed thousands of times. His life as a diplomat, theater director, editor, and spy, and his death by assassination, were the stuff of legend throughout the 19th century. Critics in most cases dismissed his work as superficial and formulaic. **Johann Wolfgang Goethe** staged 87 different Kotzebue plays in Weimar, and Kotzebue's plays were on the bill more than 600 times under Goethe's management in Weimar alone. Other court and municipal theaters, especially in **Berlin**, Mannheim, **Vienna**, and **Munich**, featured Kotzebue productions in their repertoires for decades. Most German theaters outside Europe performed Kotzebue more often than any other playwright; for the first play performance ever in Chicago, for example, Kotzebue shared the bill with **Shakespeare**.

Kotzebue was born in Weimar and studied law in nearby Jena. He earned a law degree in Duisburg and thereafter worked for the Prussian foreign service, serving first in St. Petersburg. In 1785 he became president of the Prussian judicial council in the province of Estonia and was raised to the nobility, adding "von" to his name. In the same year, he began writing plays. The most successful of his initial playwriting efforts was *Menschenhass und Reue* (*Misanthropy and Repentance*), which premiered in 1789. In the 1790s he concentrated his efforts on playwriting instead of diplomacy, even as Europe was in the midst of the Napoleonic wars. He returned to Russia in 1800 but was promptly arrested and sent to a Siberian prison camp; his friend and patron Tsar Paul I (1754–1810) saw to his release from the prison

camp and named him director of the Deutsches Theater in St. Petersburg. Unfortunately, the tsar was assassinated the following year, which forced Kotzebue to leave St. Petersburg immediately and return to Berlin. With the occupation of Berlin by Napoleon's troops in 1806, Kotzebue returned to his estate in Estonia (inherited from his Russian wife, who had died in 1790) and remained there until 1813. In 1817 he accepted espionage assignments from Tsar Alexander I, whose foreign office sent him to Germany. Two years later, Kotzebue was assassinated in Mannheim by a university student with nationalist passions.

Throughout his travels, Kotzebue had continued to write plays, for he had developed an often infallible sense for plots and characters that pleased and entertained audiences. To this day, few scholars or critics dispute his status as the "Father of Trivial Dramatic Literature," but few likewise grant him approbation as a significant contributor to German theater. That his plays provided employment throughout the 19th century to thousands of actors, scenic artists, and even playwrights who imitated him seems today of little consequence; among his non-German imitators were Richard Brinsley Sheridan (1751–1816) and William Dunlap (1766–1839). Kotzebue is accused of strengthening the public's taste for sensationalism, since many of his plays (e.g., *Die Spanier im Peru* [*The Spaniards in Peru*, 1797]) call for elaborate scenic investiture. **Johann Wolfgang Goethe** stated that if Kotzebue had devoted himself to developing his enormous playwriting talent with the same energy he used merely to churn out plays, he would have been in the front rank of German playwrights. Friedrich Nietzsche, on the other hand, said he was already in the front rank, and indeed claimed that Kotzebue's was the only "real" talent among the Germans.

KRAUSS, WERNER (1884–1959). Actor. Krauss joined **Albert Bassermann**, **Fritz Kortner**, and **Gustaf Gründgens** as one of the greatest acting talents in the 20th-century German theater. His was the widest range of character portrayals, from Oedipus to Dr. Caligari to the Captain of Köpenick and Jack the Ripper, even to Jüd Süss in the propaganda film of the same name. Krauss played nearly every major character in nearly all of **Shakespeare**'s plays; he played both Faust and Mephisto to ringing acclaim, and his roles in plays by **Friedrich**

Schiller were equally extensive. His voice was unusually expressive, and though he was relatively short in stature and had little grace in his movement, witnesses almost uniformly report that he was riveting every time he appeared on a stage. His intensity captured the attention of audiences everywhere he performed, as he was able to direct their attention to his own absorption within the character. Few actors before or since Krauss possessed his uncanny chameleon-like ability to transform himself so completely into the character he was playing.

Krauss grew up the son of a pastor and attended teachers' college before volunteering as an extra at the Lobe Theater in Breslau. He then joined a touring company with no theater training whatsoever, touring the countryside in miserable productions of farces and melodramas. His first engagement at a permanent theater came in 1908 at Guben; he thereafter held jobs in Bromberg, Aachen, Nuremberg, and finally in **Berlin**, where **Max Reinhardt** hired him for small roles at the **Deutsches Theater** in 1913. At the Deutsches, Krauss began to attract attention to his ability at metamorphosis when Reinhardt cast him in larger roles by **Frank Wedekind**. His first major roles in Berlin were the title characters in Wedekind's *Der Kammersänger* (*The Court Soloist*) and *Der Marquis von Keith* (*The Marquis of Keith*). Into those parts, as he did with Bottom in *A Midsummer Night's Dream* and dozens of other minor characters, he seemed simply to disappear.

When Reinhardt revamped the Busch Circus around the corner from the Deutsches Theater and reopened it in 1919 as the Grosses Schauspielhaus, Krauss played Agamemnon in a production of Aeschylus's *The Oresteian Trilogy* that stunned every member among nightly audiences of 3,700 individuals who saw it. Indeed, one critic said "a deep shudder" passed through everyone in the new house who witnessed Krauss's performance (Stefan Grossmann, *Vossische Zeitung*, 30 December 1919). At the same time, Krauss was alternating his performances as Agamemnon before huge crowds with a performance before perhaps 300 people at a time in August Strindberg's three-character *Advent*.

Soon thereafter Krauss left Reinhardt and went to work for **Leopold Jessner** at the newly named Staatliches Schauspielhaus (State Theater) on Gendarme Square in Berlin. There Krauss seemed to explode onto an altogether new theater landscape, even as he buried himself deeper

into the German theater's greatest roles. As Shakespeare's Julius Caesar, he filled **Karl Friedrich Schinkel**'s enormous space with a presence "that seemed to leap off an old Roman coin" (Hans Flemming, *Berliner Tageblatt*, 29 May 1920). Even after he was dead at the hands of assassins, the presence of Caesar remained as "the very personification of Imperator, the prototype [that engendered] a long line of Roman Caesars" (Norbert Falk, *BZ am Mittag*, 29 May 1920). Krauss followed up his death as Caesar with his death as Old Hilse in **Gerhart Hauptmann**'s *Die Weber* (*The Weavers*) at the State Theater, and when he died in the play's final scene, no one in the audience moved a muscle, even after the actors proceeded onstage for a curtain call. Only gradually, as they realized Krauss had left his chair onstage and was actually alive and ready to take his bow, did they begin clapping. In *Die Räuber* (*The Robbers*), Krauss again died—but this time a well-deserved death of the villainous Franz von Moor. The grotesque sight of Krauss, his knees knocking together as he proclaimed, "I am an outcast of Hell, the misbegotten depravity of passion," eradicated all thought of him as the majestic Caesar or the hubris-ridden Agamemnon—but by 1921, when the production opened, most audiences had come to expect such protean efforts from Krauss.

His reputation throughout the country had grown exponentially after the release of *The Cabinet of Dr. Caligari*, in which he played the title character who supposedly carries a mystical somnambulist around in his "cabinet" for display at county fairs. The fact that Dr. Caligari is the figment of a mental patient's imagination made Krauss's portrayal of him no less imposing, and his performance in the 1919 film has remained, in the opinion of many, one of the most frightening ever recorded. Krauss had made several films before *Caligari*, but this one solidified his standing in the minds of most Germans that he was indeed among the most magnificent performers in their midst. Some critics said they already knew Krauss had defined "**Expressionist**" acting, citing his performance as Robespierre in Reinhardt's 1920 world premiere of Romain Roland's *Danton*. In it, Krauss was the "dandy of the Reign of Terror" (Paul Wiegler, *BZ am Mittag*, 16 February 1920), an angular abstraction whose words cut more sharply than the guillotine. Through the 1920s his film acting added to his reputation, while his theater work did likewise. Two performances mark his artistry at the beginning of the 1930s: first as the

unemployed shoemaker Wilhelm Voigt in **Heinz Hilpert**'s world pre-
miere of **Carl Zuckmayer**'s *Der Hauptmann von Köpenick* (*The
Captain of Köpenick*), and later a role that could not be more different
from Zuckmayer's sympathetic ne'er-do-well: Iago to **Heinrich
George**'s Othello. Yet both are representative of Krauss's incompara-
ble versatility in an almost endless series of completely different roles.

A role that permanently besmirched him, however, emerged after
1933: that of Nazi sympathizer. There have been numerous attempts
to explain Krauss's allegiance to the National Socialists; some attrib-
uted it to his naïveté. Zuckmayer said Krauss always had a childlike
gullibility, but ultimately he felt that Krauss was like many other Ger-
man actors in the Third Reich: most concerned with their own self-
interest. Krauss was involved from the beginning of governmental
regulation and subsidy of theater activity during the Nazi era. When
the new Reich Ministry for Popular Enlightenment and Propaganda
was created, **Joseph Goebbels** appointed a former Reinhardt actor
named Otto Laubinger as president of the Reich Theater Chamber;
Laubinger's "representative to the profession" was Werner Krauss.
Krauss was implicated with Nazi manipulation of the theater from the
outset of the Hitler dictatorship; he was also a frequent recipient of
numerous prizes and awards from the regime, including the Goethe
Medallion for Art and Science and the honorific "state actor."

Given his affinity for the Nazis, it is difficult to explain Krauss's
starring role in the most important anti-Nazi performance that took
place in the Third Reich: **Jürgen Fehling**'s production of Shake-
speare's *Richard III*, in which Krauss hobbled around with a club foot
in obvious parody of Goebbels's handicap; the enormous, six-foot-long
sword Krauss carried with him reduced his actions to that of a petulant
child—again in mockery of Goebbels. Since Krauss was dwarfed by
his enormous weapon (designed by Traugott Müller), the result de-
picted Richard as a cruel child with dangerous means at his disposal.
The parallel to Goebbels was unmistakable. Krauss was furthermore
no devil in royal purple but rather the dangerous comedian, stroking his
sword, carrying it with him all the time, dropping it only once—when
his mother curses him. The sword became a costar with him; it became
a representative of his thoughts, describing his thoughts when his lips
were closed. When the final confrontation came in Act V, there was no
final battle. Fehling cut the battle and allowed **Bernhard Minetti** and

Krauss to stand alone, facing each other on that enormous stage. Richmond raised his sword and as soon as Richard shouted, "A horse! My kingdom for a horse!" he sank to the floor in death.

Krauss had died thousands of times onstage in his career, but his career never recovered its former vitality after World War II. He was forbidden to perform until 1950. The final decade of his life was spent in Austria, which awarded him the **Iffland Ring** in 1954.

KROETZ, FRANZ XAVER (1946–). Playwright. Kroetz attempted to make a career of acting with little formal training, but found himself drawn to the plays of Marieluise Fleisser and **Ödön von Horváth**. He attempted to write the way they did, often in the dialect of his native lower Bavaria. His success was so phenomenal that by the mid-1970s, he was second only to **Bertolt Brecht** as the most frequently performed playwright in the German theater. During that decade, he was an active member of the German Communist Party, a fact which largely informed his creation of what were termed "critical *Volksstücke*" that concentrated on the dialectical relationship between characters and establishment power. His characters were usually inarticulate, unemployed, uneducated laborers who suffered from a variety of social dysfunctionality in settings that were often primitive and rural.

Kroetz's breakthrough came in 1971 with the premieres of two one-acts, *Heimarbeit* (*Work at Home*) and *Hartnäckig* (*Stubborn*) at the **Munich** Kammerspiele. Both plays featured implied criticism of the Bavarian state's social services and policies. *Stallerhof* (*Barnyard*) and *Mensch Meier* (an almost untranslatable phrase, meaning in some sense "Everyman" and at the same time "Oh, what the hell!") were among his most frequently performed plays. *Stallerhof* concentrated on a mentally impaired couple who attempt unsuccessfully to care for their baby, whom the mother eventually kills. It, like *Wunschkonzert* (*Hit Parade*) and others in the Kroetz oeuvre, featured scenes of onstage defecation, which prompted consternation among most audiences. In *Wunschkonzert*, a typist spends the evening in her cramped apartment listening to a string of songs; she experiences painful constipation as the radio plays hit songs of the past. Then she commits suicide. Characters in his plays often seem tightly bound to basic bodily functions and instincts—situations Kroetz implies can

never be improved without state assistance. In *Mensch Meier*, a family consisting of father, mother, and son wrestle with the seeming pointlessness of everyday life, all of them taking turns hammering at each other in verbal attacks.

Kroetz's career went into a downward trajectory in the mid-1980s from which it never fully recovered. In 2000 **Claus Peymann** staged the premiere of his *Das Ende der Paarung* (*The Breakup*) as a highlight of his first season at the **Berliner Ensemble**; it treated the last days of the Green Party politicians Gert Bastian and Petra Kelly in 1992, when Bastian shot and killed Kelly, then committed suicide. Most critics greeted the play with condemnation.

KRONES, THERESE (1801–1831). Actress. Krones is best remembered for her work with **Ferdinand Raimund** in **Vienna**. She began acting at age five with her father's touring troupe and as a teenager played numerous soubrette roles in Austrian provincial theaters. She was engaged at the Theater in der Leopoldstadt in 1821 and soon became one of Vienna's favorite actresses in roles by **Joseph Alois Gleich**, Karl Meisl, **Adolf Bäuerle**, and other identifiably Viennese playwrights. Krones's work with Raimund began with *Der Diamant des Geisterkönigs* (*The Fairy King's Diamond*) in 1824, followed by *Das Mädchen aus der Feenwelt* (*The Girl from the Fairy World*) in 1827, which Raimund wrote for her. His *Die gefesselte Phantasie* (*The Imagination Enchained*) and *Der Alpenkönig und der Menschenfeind* (*The Alpine King and the Misanthrope*) followed in 1829. Her premature death at age 29 was an occasion of mourning throughout Vienna.

– L –

LAMPE, JUTTA (1937–). Actress. Lampe was associated with the Schaubühne am Halleschen Ufer in **Berlin** at the height of its renown from the 1970s through the mid-1980s, appearing in numerous productions directed by **Peter Stein**, **Luc Bondy**, and **Klaus-Michael Grüber**. She differed from **Edith Clever**, the Schaubühne's other grand dame, in that her despair had more pathos. As Solveig in *Peer Gynt*, she seemed a saint who had been totally secularized, and as the goddess Athena at the conclusion of *The Oresteian Trilogy*, she beamed

benediction as she transformed the Furies into protective spirits. Other important productions in which she had leading roles included Maxim Gorky's *Summer Folk*, Anton Chekhov's *The Three Sisters*, and Pierre Marivaux's *The Triumph of Love*.

L'ARRONGE, ADOLPH (Adolf Aronsohn, 1838–1908). Playwright, manager. L'Arronge had a spectacular career as a playwright and theater owner in **Berlin**, but he had conservatory training in music and a successful career as an orchestra conductor before he tried his hand at playwriting. His playwriting career was so lucrative that it enabled his unintended career as a theater manager to take shape and endure for more than 30 years. His conducting career began in 1860 at the **Cologne** Opera House after graduating from the Leipzig Conservatory; from there, he conducted orchestras in Stuttgart, Budapest, and Berlin before beginning to write plays in 1866. Most of his early efforts were failures, but with *Mein Leopold* in 1873 he established himself as one of the most capable playwrights in the new German Reich.

L'Arronge's father, Eberhard Theodor L'Arronge (1812–1878), had been a popular actor in Lübeck, **Bremen**, and **Hamburg**, and as a teenager L'Arronge had witnessed his father's transformation from a tragic actor to a character actor specializing in comedy. The senior L'Arronge also began running theaters in the 1860s, initiating the first "Offenbach craze" in Cologne, which permitted him to pay for his son's conservatory training. From his father's experiences, Adolf learned that substantial money could be made in the theater business, particularly if one had audience-pleasing material at hand. *Mein Leopold* was the first step toward his status as one of the German theater's wealthiest men.

L'Arronge followed *Mein Leopold* with a series of blockbuster hits: *Hasemanns Töchter* (*Hasemann's Daughters*, 1877), *Doktor Klaus* (1878), *Wohltätige Frauen* (*The Lady Benefactors*, 1879), *Der Kompagnon* (*The Business Partner*, 1880), *Haus Lonei* (*The Lonei Household*, 1880), and *Die Sorglose* (*The Carefree Woman*, 1882). Their success enabled him to purchase **Friedrich Wilhelm Deichmann**'s Friedrich-Wilhelmstädtisches Theater (where his father had frequently performed in the 1850s) for RM900,000 in cash, renaming it the **Deutsches Theater**. L'Arronge originally planned to organize the Deutsches Theater along partnership lines in the French manner;

those plans went awry, but L'Arronge proceeded with his playwriting career, premiering his own and other popular works (particularly those of **Oskar Blumenthal**) at what was then his own facility. As a playwright, L'Arronge copied formulas of his own and others that had proved successful, though adding elements of Berlin local color and personality. His use of romantic entanglement was particularly effective because he avoided the unpleasant implications of adultery so characteristic of the French boulevard comedies he imitated. L'Arronge was skillful in the portrayals of the self-made man's downfall, supported in many cases by a true-hearted and wise wife or a naïve but loyal daughter. He was circumspect in his portrayal of social and economic conditions and how they affected his characters, but there was little ambiguity. The "German scrupulousness" that **Max Martersteig** said was so characteristic of L'Arronge characters became a source of warm, nonsatirical humor. L'Arronge's stupendous success with such formulas marked the victory of superficiality in the German theater. "Behind it, all originality, all concerns for social problems, and anything significant had to wait in line" (Martersteig, *Das deutsche Theater im neunzehnten Jahrhundert* [Leipzig: Breitkopf und Härtel, 1924], 637).

LAUBE, HEINRICH (Heinrich Rudolf Constanz, 1806–1884). Playwright, director. Laube was the dominant figure in **Vienna**'s theater life from about 1850 to 1880, though he arrived at that exalted status by a circuitous route. Laube was a prime mover in the *Junges Deutschland* literary movement, which had a radical political outlook advocating democracy and universal suffrage. He spent time in prison for his literary and journalistic activities in the 1830s, but by the 1840s his political ardor had cooled to the point where he became a moderately successful playwright. His *Karlschüler*, about **Friedrich Schiller**'s travails as a student in Stuttgart, was his most popular effort in the late 1840s, and his 1848 play *Prinz Friedrich*, about the young Frederick the Great and his homosexual love for Lieutenant Katte, likewise became popular. Based on the success of those plays, Laube was elected to the first democratic German Parliament in Frankfurt, but he resigned in 1849 to become director of Vienna's **Burgtheater**.

Though his selection as the Burg's director was astonishing in view of his revolutionary past, Laube remained in that position until

1867. In the view of many observers, he reestablished that institution as the German language's premiere theater. He staged his own popular *Count Essex* there in 1856 and championed the work of **Franz Grillparzer**, whose work the Burg had hitherto neglected. Laube had substantial literary gifts as a director; he recognized, with one notable exception, what was both stageworthy and effective as literature in a theater's repertoire. The exception was **Friedrich Hebbel**, the worth of whose plays Laube failed to recognize. In most cases, however, Laube staged new plays as if he had written them himself; never before had the Burg presented so many new plays. His advocacy of **Charlotte Birch-Pfeiffer** and his attachment to **William Shakespeare** are good examples of his devotion to what he considered the best that German-language theater had to offer.

Laube left the Burg in 1869 for Leipzig, remaining there until 1871. He then returned to Vienna and founded the City Theater, where he staged operettas and imitations of French plays about "women with a past" by **Paul Lindau** and Hugo Bürger. Laube staged the premiere of Lindau's *Marion Delorme*, perhaps Germany's first successful imitation of French *Unsittendrama* about women desirous of breaking into "good society." Laube also premiered Bürger's *Der Frauenadvocat* (*The Women's Lawyer*), a play with tendencies similar to Lindau's.

LAUTENSCHLÄGER, KARL (1843–1906). Stage technician. Lautenschläger is best known for his adaptation of Japanese designs for the *Drehbühne*, a stage revolve mechanism, for the **Munich** Residence Theater in 1896. The stage revolve he developed was a turntable 16 meters (52.5 feet) in diameter, installed on an even plane with the floor surface of the stage and driven by a gearing device beneath the stage floor under electric power. His design was used in dozens of other German theaters; **Max Reinhardt**'s production at the **Deutsches Theater** of *A Midsummer Night's Dream* was among the first fully to exploit Lautenschläger's technology, though several other directors and designers, both at the Deutsches and elsewhere throughout the German theater, made wide use of it thereafter.

LEBRUN, THEODOR (Theodor Leineweber, 1822–1895). Manager, actor. Lebrun was among the most talented managers of a commercial theater in **Berlin**, especially in the seasons between 1865 and 1887

when he ran the Wallner Theater. He began his career to doing amateur theatricals for the Urania club in Berlin and then became a professional character actor in provincial venues such as Dessau, Stettin, Danzig, Breslau, Wiesbaden, and Riga. He began directing in Breslau in 1857 and leased the Wallner Theater from its owner **Franz Wallner** seven years later. Lebrun's initial repertoire featured comedies by **Roderich Benedix** and **Gustav von Moser**, but his premieres of **Adolph L'Arronge** provided successes that assured Lebrun a lengthy and profitable tenure in Berlin. The first of the L'Arronge hits was *Mein Leopold*, which continued in the Wallner repertoire for a decade after its premiere in 1873. Lebrun himself created the title role in *Doktor Klaus*, a comedy whose success equaled that of its predecessor and created a precedent for other L'Arronge comedies that dominated many repertoires, running thousands of times in scores of productions throughout the German-speaking world.

By the early 1880s, Lebrun realized that his establishment could not prosper indefinitely on the triumphs of one playwright, and he premiered a modest comedy written by one of his former actors and his brother. The play was *Der Raub der Sabinerinnen* (*The Rape of the Sabine Women*) and the playwrights were Paul and **Franz von Schönthan**. The popularity of that play exceeded that of anything L'Arronge had written, and Lebrun later premiered several more Schönthan comedies, many of which became staples of profit-making production for scores of theaters. Lebrun's tactic of developing new plays among actors he had under contract proved a unique resource. **Gustav Kadelburg** had been one of the first actors Lebrun hired when he took over the Wallner, and by the 1890s Kadelburg and his collaborators, especially **Oskar Blumenthal**, had written several popular plays for Berlin's ever-expanding comedy market. Lebrun entered semiretirement in 1887 and concentrated on acting character parts at the Thalia Theater in **Hamburg** for two years. In 1889 he retired permanently to East Prussia.

LEHMANN, ELSE (1866–1940). Actress. Lehmann was best known for her **Naturalistic** acting, particularly in the premieres of **Gerhart Hauptmann**, but she began her career as a comic soubrette at **Berlin**'s Wallner Theater. After her highly praised performance as Helene Krause in the 1889 Freie Bühne premiere of Hauptmann's *Vor Sonnenaufgang*

(*Before Sunrise*), L'Arronge hired her to work at his **Deutsches Theater** in three Hauptmann premieres: *Einsame Menschen* (*Lonely Lives*), *Kollege Krampton* (*Colleague Krampton*), and **Der Biberpelz** (*The Beaver Coat*). In the latter, Lehmann played the leading role of the middle-aged yet crafty Mother Wolff, even though Lehmann herself was only 27 at the time. When **Otto Brahm** took over the Deutsches in 1894, he retained her services for all the Hauptmann productions he planned to present, regarding Lehmann even then as Germany's finest actress in the Naturalstic style. She became the prime female attraction of his entire operation, both at the Deutsches and later at the Lessing Theater in Berlin, as her appearances usually prompted sellouts. For Brahm, she attracted audiences not only to Hauptmann performances but also to numerous revivals of Henrik Ibsen; she subsequently went on tour in those productions, also including in her repertoire the plays of Hermann Sudermann and **Arthur Schnitzler** in hundreds of performances throughout Europe. She remained so closely identified with Hauptmann, however, that when **Max Reinhardt** revived *Der Biberpelz* in 1916, he cast Lehmann again as Mother Wolff, this time at the more appropriate age of 50. Brahm claimed that over two decades as Berlin's foremost Naturalistic actress, Lehmann had transformed the German theater; her ability to project a completely natural and unaffected character on the stage created a precedent hundreds of actresses were to follow. Her admiration for Brahm was mutual; indeed, it was so substantial that when he died in 1912 she went into retirement, emerging from it only infrequently and with reluctance.

LENYA, LOTTE (Karoline Blamauer, 1900–1981). Actress. Best known for her association with **Bertolt Brecht** and Kurt Weill, Lenya appeared in the world premieres of *Aufstieg und Fall der Stadt Mahagonny* (*The Rise and Fall of the City of Mahagonny*), *Pioniere in Ingolstadt* (*Pioneers in Ingolstadt*), and **Die Dreigroschenoper** (*The Threepenny Opera*). Her New York career was nearly as remarkable, largely because on Broadway she reprised the career she had established in **Berlin**—a feat no other German theater artist except Weill has ever replicated; she was also married to Weill twice, once in Germany and again in the United States. Lenya's Broadway debut took place in 1937 under **Max Reinhardt**'s direction, but her first real success there was the premiere of *The Threepenny Opera*, which opened in 1955 and

ran for 2,600 performances. She won a Tony Award for her performance as Jenny, the same role she played in Berlin at the **Theater am Schiffbauerdamm** and in the 1931 film version. In *Cabaret* (1966), however, she not only reprised her work in Berlin but revivified it in a show that was an ingenious epigone of the Brecht-Weill oeuvre, in the process receiving another Tony Award. Lenya's work in film was less substantial, with one notable exception: in the James Bond thriller *From Russia with Love* (1963), she played the murderous Rosa Klebb, a former KGB agent who wore poison-tipped shoes.

LEONCE UND LENA by **Georg Büchner**. Premiered 1895. Büchner's only comedy is a satire on the scores of small duchies and the princelings who ruled them in the German Confederation of his day. The young aristocratic couple of the title are engaged to be married to prospective partners they have never met nor even seen. They both run away from home, meet each other by chance, and fall in love. Officials from their parents' respective courts return them back home for the appointed marriage ceremonies, yet both Leonce and Lena remain ignorant of each others' true identities. Masked during the wedding ceremony, they discover only at the end that they have married each other. Amid general rejoicing, Leonce determines to rule his duchy as a kind of fantasy empire where true love can flourish.

LESSING, GOTTHOLD EPHRAIM (1729–1781). Playwright, **dramaturg**, theorist. Lessing was a pastor's son who became the German theater's most accomplished playwright and critic during the mid-18th century. His influence and accomplishments were so substantial that he almost single-handedly raised German drama and criticism from its previously insular and parochial status to one of European distinction. Lessing's plays were instrumental in establishing the cultural legitimacy of troupes for which he wrote, especially **Konrad Ernst Ackermann**'s. Ackermann premiered Lessing's first big hit, *Miss Sara Sampson* in 1755; other successful vehicles for German troupes followed, most notably *Minna von Barnhelm* in 1762 and *Emilia Galotti* in 1772. These three plays, along with the dramatic poem *Nathan der Weise* (*Nathan the Wise*, 1779), have remained among the most frequently performed in German repertoires since the 18th century.

Lessing first attracted attention as an Enlightenment thinker when he began working for a **Berlin** newspaper in 1748 and in the process made Voltaire's acquaintance in Potsdam at the court of Frederick the Great. Lessing was then formulating ideas about rejecting French influence on German theatrical activity, however; instrumental in that formulation was a rereading of Aristotle and a rediscovery of English theater, particularly its applicability to the needs of the Germans. While Lessing agreed with **Johann Christoph Gottsched** about the need for a "national" theater, Lessing felt that English development of the "domestic tragedy," for example, Lillo's *The London Merchant*, was most suitable for German audiences. His treatment of the *Medea* plot and character material, transforming it into the domestic tragedy that became *Miss Sara Sampson*, was a new departure for the German theater. It was not only enormously popular with audiences throughout German-speaking Europe but also provided career-shaping roles for actors and actresses. *Miss Sara Sampson* initiated Lessing's involvement with the Ackermann troupe, one that continued through the foundation of the **Hamburg** National Theater in 1767.

In Hamburg, Lessing served as the first dramaturg, writing a series of essays that eventually became the *Hamburgische Dramaturgie* (*Hamburg Dramaturgy*). In it, Lessing poses a number of questions about what kind of theater the Germans should be developing—and in the process made a complete break with Voltaire. He concludes that **Shakespeare**'s "play-world" was more authentic than anything the neoclassical strictures could provide. Acknowledging that reason tells us that ghosts do not exist, Shakespeare carefully re-creates all the conditions in which we normally expect ghosts to appear. In Shakespeare's world, the spectator furthermore experiences the inner worlds of characters, thus expanding the spectator's understanding of the world outside himself. Rejecting the neoclassical unity of time, he stated that time's passage is irrelevant to a character's actions: even in "small" actions, he noted, character can be revealed—and that is the real test of great drama, he says. The names of princes and kings lend majesty to a play, he notes, but if we pity kings, we pity them as human beings. Though their positions make their troubles more important, their social or political status does not make them more interesting. Whole states and nations may be involved, but "state" or "nation" is far too abstract to "touch our feelings." On the unity of

place, Lessing felt it was all a matter of geographical literacy on the part of the audience. "Discrepancies can only be observed by those who know the distance of the locality . . . [but] not everybody knows geographical distances . . . [while] everybody knows if the distances just don't feel right" (Lessing, *Kritik und Dramaturgie* [Stuttgart: Reclam, 1967], 63). In these and similar deliberations, Lessing was obviously addressing his concerns to a specifically German audience and its capacity to discern significance in dramatic performance.

Lessing had a remarkable intellect, capable of complex theoretical musings such as the above, found also in *Laokoön* (1766), a discussion of "the limits of painting and poetry." As such, *Laokoön* was among the first large-scale explorations of aesthetics in German. His *Nathan the Wise* was the first play in German to use iambic pentameter; it was a plea for religious tolerance that was published posthumously.

LIEBESGESCHICHTEN UND HEIRATSSACHEN (*Love Affairs and Wedding Bells*) by **Johann Nepomuk Nestroy**. Premiered 1843. Nestroy plots the course of three love affairs in this comedy, each of which must overcome the hurdles of class distinctions and prejudice—though from the standpoint of a preposterous arriviste butcher named Fett (German for "fat"). A marquis falls in love with Fett's niece, but Fett turns him down. Meanwhile Fett's daughter Fanny has fallen in love with a man named Bucher; his business fortunes having recently declined, Fett attempts to call off the marriage plans he once approved between the two. Into the mix comes Fett's sister-in-law, whose suitor is an impecunious valet passing himself off as a count. In a hilarious sequence of mistaken identities, chance encounters, and overheard conversations, the marquis is allowed to marry the niece, Fanny Fett marries Bucher, and the valet is exposed as an impostor.

LINDAU, PAUL (1839–1919). Playwright, **intendant**. Lindau was a pastor's son who began a journalistic career after completing a dissertation on Molière at the Sorbonne in Paris. He edited newspapers in Düsseldorf, Leipzig, and **Berlin**, becoming concomitantly well known for his witty, well-structured essays on theater and his comedies such as *Ein Erfolg* (*A Success*) and *Die beiden Leonoren* (*The Two Leonores*). In 1895 Lindau became intendant of the Meiningen Court Theater; four years later he assumed leadership of the Berliner

Theater, and in 1904 he was named director of the **Deutsches Theater**. In 1909 Lindau became chief **dramaturg** of the Berlin Royal Theater, at which post he remained for the rest of his long and productive life.

LINDEMANN, GUSTAV. *See* DUMONT, LOUISE.

LINGEN, THEO (Franz Theodor Schmitz, 1903–1975). Actor. Lingen was one of the most popular and accomplished comic character actors of which the 20th-century German theater could boast. Unlike Max Pallenberg or **Max Adalbert**, Lingen was not a comedian—he was a master in comic parts, and he brought a vitality even to serious parts that most of his contemporaries envied and few could match. A principal source of his comic gifts was his appearance: he stood over six feet tall, rarely in his career weighed more than 160 pounds, and had an extremely long nose and set of ears; he combined a loose-jointed frame with an unusual ability to twist his face in innumerable directions at the same time. His "look" was distinctly reminiscent of **Johann Nepomuk Nestroy**, as several observers noted. Beyond his looks, however, was a masterful sense of timing and attention to detail. In boiling an egg on stage, for example, audiences imagined him and the egg having a conversation, much to their delight.

Lingen began his career while still in school in his native Hannover; from there, he worked throughout the Weimar period in regional stages until he got a two-year contract with the **Berlin** State Theater in 1929. His most significant work prior to the National Socialist takeover was in **Bertolt Brecht**'s *Mann ist Mann* (1931). Lingen remained in Berlin throughout the Nazi dictatorship, usually at the State Theater under **Jürgen Fehling**'s or **Gustaf Gründgens**'s direction. He was at his best as Malvolio in *Twelfth Night*, Wehrhahn in **Gerhart Hauptmann**'s *Der Biberpelz* (*The Beaver Coat*), and the semidisreputable fop Riccaut de la Marlinère in **Gotthold Ephraim Lessing**'s *Minna von Barnhelm*. Lingen began acting in films in 1930 and was at his funniest in *Das Testament des Dr. Mabuse* (*The Testament of Dr. Mabuse*, 1933), which, though it was not a comic film nor was his role as a criminal supposed to be humorous, was nevertheless a comic masterpiece. Lingen made more than 80 films during the Third Reich, the best of which was *Tanz auf dem Vulkan* (*Dance on the Volcano*)

with Gründgens in 1938. After the war, Lingen became a permanent member of the **Burgtheater** company in **Vienna**, while continuing film and television work to the end of his career.

LISELOTTE VON DER PFALZ (*Liselotte of the Palatinate*) by **Anton Impekoven** and **Carl Mathern**. Premiered 1919. The eponymous heroine of this pseudohistorical comedy, one of the most popular on German stages in the early 1920s, is the historical Elisabeth Charlotte, daughter of the Elector Palatinate in Heidelberg. Liselotte is married off to the Duke of Orleans, brother of the French king Louis XIV, and in Louis's court Liselotte is the embodiment of German honesty, forthrightness, earthiness, and candor. She stands in stark contrast to the decadence of Versailles, mildly rebuking court ladies for their wan expressions and ennui. German girls are healthy, robust, and vivacious, she says, terms which also describe Liselotte herself. The play projects a historical atmosphere, and by the final act Liselotte is a matron, France has gone to war with Germany, and French armies have taken her childhood friends prisoner. King Louis agrees to release them if Liselotte will agree to a marriage between her son and his bastard daughter. The confrontation between Liselotte and the girl's mother (Louis's mistress) reveals Liselotte's wisdom in accepting that both young people must make the best of a regrettable situation they have inherited—a plea with contemporary analogies for common sense between France and Germany in the postwar period.

LORRE, PETER (Laszlo Loewenstein, 1904–1964). Actor. Lorre achieved his greatest fame as a film actor in the United States, but he had established superb credentials in **Berlin** before he fled to Hollywood. "Germany isn't big enough for two murderers like Hitler and me," he is reported to have said in 1933. With no formal training as an actor, he began with a **Vienna** improvisational troupe in 1923; while assuming scores of roles in that endeavor, he chose "Lorre," a variation on the word *role*, as his stage name. Lorre's first theater engagement was in Breslau, and he subsequently worked in Zurich and again in Vienna before making his debut in Berlin in 1929 in Marieluise Fleisser's *Pioniere in Ingolstadt* (*Pioneers in Ingolstadt*) at the **Theater am Schiffbauerdamm**. **Bertolt Brecht** claimed he had never seen an actor quite like Lorre, ironically agreeing with a Nazi critic

who said Lorre seemed always on the edge between the tragic and comic, "the hysterical and the phlegmatic. If he can play other characters this well, we have an actor of the first order" (Biedryzynski, *Deutsche Zeitung*, 2 April 1929). Lorre became an overnight sensation in the play, which led to his engagement at the Volksbühne in **Georg Büchner**'s *Dantons Tod* (*Danton's Death*) with **Lotte Lenya** and in **Georg Kaiser**'s *Nebeneinander* (*Next Door*) at the **Deutsches Theater**. Lorre's most significant work in Berlin, however, came in 1931 when he played Galy Gay in Brecht's production at the Prussian State Theater of his *Mann ist Mann* and Alfred in **Heinz Hilpert**'s resplendent production of **Ödön von Horváth**'s *Geschichten aus dem Wienerwald* (*Tales of the Vienna Woods*) in its world premiere. The former was a confirmation of Lorre's genius; the latter revealed its astonishing development.

With those two productions, Lorre became heir to **Alexander Moissi**'s mantle as the German theater's greatest exponent of modernist performance. He meanwhile had begun a remarkable film career, culminating likewise in 1931. As a serial child murderer in Fritz Lang's *M*, his performance ranked with that in *Tales of the Vienna Woods* as both chilling and fascinating. When the National Socialist government assumed power in 1933, Lorre left Germany almost immediately and soon found work in London with Alfred Hitchcock (1899–1980) as Abbott in *The Man Who Knew Too Much* (1934). His subsequent work in American films had its basis in the career he established in Germany, though he initially played the familiar murderer type for Columbia Pictures, which had offered him $1,000 per week and a seaside villa in Santa Monica. He realized, he later said, that standing five foot, three inches tall effectively removed him from consideration of parts Clark Gable played, but when 20th Century–Fox offered him a series of films as a Japanese detective named Mr. Moto, he gladly accepted the offer. When that series ended, Lorre worked as a freelance actor in Hollywood rather than signing with one particular studio. He appeared in several outstanding films, among them *Strange Cargo* with Gable (1940); *The Maltese Falcon* with Humphrey Bogart (1941); *Casablanca*, again with Bogart (1942); and *Arsenic and Old Lace* with Cary Grant (1944). Lorre returned to Germany in 1950 and filmed *Der Verlorene* (*The Lost Man*), for which he received the first Federal Film Prize ever awarded. He

then returned to the United States and worked in another 20 movies, among them *Around the World in Eighty Days* with David Niven (1956), *The Big Circus* with Vincent Price (1959), and *Muscle Beach Party* with Frankie Avalon and Annette Funicello (1964).

– M –

MARIA STUART by **Friedrich Schiller**. Premiered 1800. Schiller's five-act blank-verse tragedy about the conflict between the heroine of the title and Queen Elizabeth I features a fictional confrontation between the two that is pure bravura for the actress playing the title role. Schiller took substantial liberties with the historical events surrounding the historical Mary Stuart and Elizabeth Tudor, but the play has enjoyed enormous popularity since its premiere, appearing hundreds of times during the 19th century in the **Berlin** Royal Theater's repertoire alone. **August Wilhelm Iffland** presented it there in 1801, serving to popularize it throughout the German-speaking theater. **Käthe Dorsch**, **Elisabeth Flickenschildt**, **Adele Sandrock**, and **Paula Wessely** are only a few of the 20th century's actresses to have played Maria Stuart successfully. Maria's death scene is a prime example of Schiller's genius with verse, and his play depicts Elizabeth as a broken woman in the face of Maria's courage and true nobility. **Leopold Jessner** directed a silent film version of the play in 1927; Gaetano Donizetti's opera *Maria Stuarda*, based on the play, premiered in 1835.

MARTERSTEIG, MAX (1853–1926). Actor, director, manager, historian. Martersteig has the distinction, shared with few others, of success as both a German theater artist and a chronicler of German theater history. He was an actor in Rostock, Weimar, Aachen, and Frankfurt an der Oder; a director in Mainz, Aachen, and Kassel; and a manager in Mannheim, **Cologne**, and Düsseldorf. Martersteig's books on **Pius Alexander Wolff** and **Johann Wolfgang Goethe**'s acting theory, and especially his monumental study of the German theater's development during the 19th century, mark him as a singular and insightful observer. His writing is furthermore unlike most other historical accounts at the time, since his use of extended metaphors makes for engrossing and informative reading.

His acting career began in 1873, and critics praised his Hamlet in Rostock. Informed subsequently that he was "too ugly for romantic roles, and too stupid to play character parts," Martersteig began to work as a director, staging several productions in Kassel before assuming management of the Mannheim National Theater from 1885 to 1890. For the next six years, he ran the Deutsches Theater in Riga, then worked as a freelance director in **Berlin** until 1905, when he became **intendant** of the Cologne City Theaters. Martersteig finished his career in Leipzig, as intendant there from 1912 to 1918. As a manager, Martersteig was an advocate of Henrik Ibsen and **Friedrich Hebbel**, though his productions of **Shakespeare** were his most noteworthy.

Martersteig's contribution to scholarship concomitant with active theater production is perhaps his greatest achievement. His *Das deutsche Theater im 19. Jahrhundert* (*The German Theater in the 19th Century*) was among the first comprehensive and methodical approaches to theater's place within German social culture. He regarded theater as "a completely social product," taking into account the vagaries of numerous political movements, legislation, warfare, and social trends that shaped the German theater over 10 decades. With the unification of Germany, he said, there was a general consensus that the "German Nation" had a mission: "to help fulfill the awakening and transmission of a humane Germanic culture to the rest of the world" (*Das deutsche Theater*, 517). His was also a masterful account of economic factors that persistently bedeviled court, city, and commercial theaters, while recounting the maneuvers both actors and playwrights undertook in efforts to make their work remunerative. Martersteig was a shrewd drama critic as well, exploring important but now forgotten playwrights such as Wilhelm Hackländler, Karl Töpfer, **Eduard von Bauernfeld**, **Ernst Raupach**, **Roderich Benedix**, **David Kalisch**, and the formidably successful **Charlotte Birch-Pfeiffer**. His work is also valuable for describing the careers of significant 19th-century actresses who "were prepared to go the limits in perfecting their travesty of sex and woman as an instrument of pleasure, with a seductive clarity on the boards of the stage" (506).

MARTHALER, CHRISTOPH (1951–). Director. Marthaler began his career as a musician, playing incidental music in several German-language theaters, including those in his native Switzerland. He be-

gan directing plays in Basel and in 1993 became a house director under **Frank Baumbauer** in **Hamburg**; he later held a similar position under **Frank Castorf** at the **Berlin** Volksbühne. Marthaler was awarded several citations in the 1990s for his work, including the Europe Prize in 1998 and *Theater Heute*'s "director of the year" in 1997 and 1999. Through the 1990s his productions were consistently invited to the Berliner **Theatertreffen**; he has 10 invitations to his credit. In 2001 Marthaler became **intendant** of the Schauspielhaus in his native Zurich; he was fired from the position in 2004, but has remained much in demand as a director since.

MARTIN, KARL-HEINZ (1888–1948). Director. Martin was best known in the 1920s as a director who specialized in the **Expressionist** style, staging several plays by **Georg Kaiser**, **Fritz von Unruh**, and **Ernst Toller**. In 1918, he even wrote a book about staging Expressionism. Martin briefly worked for **Max Reinhardt** in the early 1920s, but by the mid-1920s he had begun directing popular plays for commercial theaters. In the Third Reich he began directing films, and after the war he was director of the Hebbel Theater in **Berlin**.

MASSARY, FRITZI (Friederike Masaryck, 1882–1969). Actress. Massary was best known as a musical star, though **Fritz Kortner** said her acting talent was so substantial that every theater director in Germany wanted to cast her in straight plays, and every opera director in Europe wanted her for roles like Carmen. Massary established her career in her native **Vienna** in operettas and was said to be the best Merry Widow of her generation. She appeared in most of Franz Lehár's other works, along with those of Jacques Offenbach and Leo Fall, but by 1929 she had begun to appear exclusively in spoken dramas, the most notable of which was Bruno Frank's *Nina*, which he wrote especially for her.

MATHERN, CARL (1887–1960). Playwright. Mathern was a newspaper staff writer in Frankfurt am Main in 1914 when he met actor **Toni Impekoven**. They began collaborating on comic skits and one-act comedies, and in 1918 they completed their first full-length comedy. By 1920 they had become a playwriting duo second in popularity only to **Franz Arnold** and **Ernst Bach**. Mathern gave up regular

journalistic employment in 1930 and lived on his abundant royalties, remaining in Frankfurt am Main through the Third Reich and continuing to write for the next 30 years, though he never again achieved the success he had enjoyed with Impekoven.

MATKOWSKY, ADALBERT (1858–1909). Actor. Matkowsky was in many ways a throwback to the acting of earlier days in the German theater, in particular to the time of **Ludwig Devrient**, with whom he was frequently compared. Matkowsky began his career at the Court Theater of Dresden at age 19, and his stunning good looks, deeply resonant voice, and athleticism marked him as a Dresden audience favorite in several heroic roles. He became a kind of celebrity in Dresden, playing Sigismund in Calderón de la Barca's *Life Is a Dream*, the title roles in **Friedrich Schiller**'s *Don Carlos* and **Heinrich von Kleist**'s *Prinz Friedrich von Homburg* (*The Prince of Homburg*), and **William Shakespeare**'s Romeo and Prince Hal, among many others. Critics usually hailed Matkowsky's superb physique in such roles, while others found his flamboyance irresistible. His fiery presence in tradition-laden Dresden had by the mid-1880s become an irritation to the theater's aristocratic managers, however, and they fired him in 1886.

Matkowsky soon found work in **Hamburg** and remained there for two years, but his greatest acclaim awaited him in **Berlin**, where the Royal Theater hired him in 1889. For the next two decades, Matkowsky maintained near-iconic status as Macbeth, Othello, Karl von Moor, Marc Antony, Coriolanus, and other "mature" heroic roles. Matkowsky's acting ran counter to the demands—becoming insistent by the end of the 19th century—for more "**naturalistic**" acting, but he was not a neo-**Romantic**. As he grew older, his physique became more stout and solid, counteracting his former reliance on depicting a hero's "suffering." He instead sought to reveal traits that redeemed the character; when playing Macbeth, for example, he emphasized the Scottish lord's bravery in battle. When playing Karl von Moor, he emphasized the "gruesome calm" of that "magnificent scoundrel."

At no time did Matkowsky depart from preplanned patterns of artificiality in his performances, but his riveting stage presence conveyed to many audience members a kind of solitary force ready to take on the entire world. He seemed at times, in the great classical roles, ready to

emerge victorious over the forces of fate and destiny. That kind of un-predictability, characteristic of his Berlin years, made his performances appear somehow improvised, yet they were carefully calculated to evoke a considerable empathic response. Most witnesses agreed that his effect on audiences was peculiarly stirring, like "a Vesuvius, on whose body flow downwards the blood-stained tears of Christ" (Carl Hage-mann, *Deutsche Bühnenkünstler um die Jahrhundertwende* [Frankfurt am Main: Kramer, 1940], 119). Matkowsky's enormous popularity in Berlin, especially among Royal Theater audiences, was due in large part to his success at personifying the Wilhelmine ideal of manliness and valor; in many ways, he depicted a truly heroic and resolute nature, un-sullied by modernist distractions like self-doubt or neurotic preoccupa-tions. When he died at age 51 in Berlin, many lamented his passing, echoing, "Here was a Caesar—when comes such another?"

MAYENBURG, MARIUS VON (1972–). Playwright. Mayenburg completed studies in playwriting at **Berlin**'s University of the Arts in 1998 and the following year his *Feuergesicht* (*Fireface*) was selected for the Berliner **Theatertreffen**. *Fireface* had premiered at the **Munich** Kammerspiele in 1999, the same year *Theater Heute* named him Germany's "best young playwright"; he also became **dramaturg** of Berlin's Schaubühne am Lehniner Platz that year. *Fireface* had its English-language premiere the following year at the Royal Court Theater in London. Mayenburg's *Parasiten* (*Parasites*) premiered in 2000 at the **Deutsches Schauspielhaus** in **Hamburg**. In these plays, as in his first play *Haarmann* (written while still a student), Mayen-burg concentrated on title characters who are violent psychopaths; they murder people, set fire to churches and schools, and otherwise abuse everyone around them. *Haarmann* was based on an actual criminal case in the 1920s, when a police informer of that name went on a killing rampage by luring more than 20 young men to his apart-ment in Hannover and murdering them by biting through their throats and later eating parts of their bodies. Such characters (including Kurt in *Fireface* and Ringo in *Parasites*) interest Mayenburg because of the intense conflict within themselves; outside influences have little impact on them, since they feel imprisoned within their own selves. Such figures are obsessed with cruelty, against others and ultimately against themselves. Mayenburg has been awarded several prizes and

awards for his playwriting, including the Kleist Award from the Frankfurt Playwrights' Foundation.

MEININGER. *See* GEORG II, DUKE OF SAXONY-MEININGEN.

MEIN LEOPOLD by **Adolph L'Arronge**. Premiered 1873. *Mein Leopold* is a satire on the moral climate pervading the *Gründerjahre*, or "foundation years," of the Second Reich. L'Arronge's central character is Gustav Weigelt, a nearly illiterate yet prosperous parvenu, a proud member of the "new" establishment. He is also a beleaguered father. Weigelt had been a cobbler until the explosion of real estate prices in Berlin allowed him to convert his property into an apartment building. His success made him oblivious to the profligacy of his beloved son Leopold, who in many ways embodied the "new" Germany based on materialism, luxury, and pretentiousness. Weigelt embodies the Wilhelmine self-made man, curiously emblematic of newly rich entrepreneurs, men of commerce who retained characteristics of a Berlin stereotype. He owns a leather-bound collection of **Friedrich Schiller** and **Johann Wolfgang Goethe** ("the former in cowhide and the latter in pigskin") but can barely read a sales contract. Add to this functional illiteracy some deft touches of brutishness and greed, along with a full helping of overindulgence toward his son. In one instance, Weigelt evicts a poor family from the shanty in his courtyard in order to install a stable so that Leopold can keep a horse and impress everyone as a gentleman of leisure.

By the play's final act, Weigelt is a sadder, poorer, but wiser man. Forced to liquidate all his assets in order to pay off his son's debts, he works alone at his cobbler's bench. He becomes reconciled with his other children, whom he has neglected in favor of the wastrel son. The son, who had (in addition to pauperizing his father) offended the honor of a young lady and run off to America, had seen his business ventures there fail, so he is coming back to Germany a fully repentant prodigal for a reunion with his father.

MENSCHENHASS UND REUE (*Misanthropy and Repentance*) by **August von Kotzebue**. Premiered 1789. One of Kotzebue's first plays, this was also one of his most popular, his most often adapted and plagiarized, and certainly among his most frequently performed.

It concerns an estranged aristocratic couple, embodying the two human characteristics of the title. Baron Meinau is a misanthrope, though he saves a stranger's life by rescuing him from drowning. His wife had an adulterous affair and she repents of her folly—though at first the Baron rejects her repentance completely. The man whom the Baron saved from drowning was once in love with the Baroness, and he becomes the agent for their reconciliation. In several English-language translations, the play's title became *The Stranger*.

MINNA VON BARNHELM by **Gotthold Ephraim Lessing**. Premiered 1768. Said to be the first "national comedy" in German because it seemed less plagued than its contemporaries by French influences, this comedy is also "national" in the sense that it calls for a Prussian-Saxon reconciliation. The title character is a lively young Saxon princess in love with a duty-bound Prussian major named Tellheim. Prussian military authorities have discharged Tellheim due to financial irregularities for which he was responsible, and he feels he is no longer worthy of Minna's devotion. Their planned marriage is out of the question. He holes up in a small inn, where she finds him disconsolate, yet she convinces him that she has lost her fortune—and since both are now penniless they should start life anew. The character of Minna is one of the finest of all female roles in the German repertoire, largely because it consists of a focused determination, though humorous and often playful, to get Tellheim to fall in love with her again. When King Frederick the Great removes all charges against Tellheim and restores him to the rank of officer, Tellheim realizes that her love for him is more valuable than rank or station—a realization that for a Prussian constitutes a powerful catharsis. The play also benefits from singularly effective comic characters, Minna's maid Franziska and Tellheim's orderly Just.

MINETTI, BERNHARD (1905–1998). Actor. Minetti was born to a family of Italian immigrants, and he intended initially to study theater history in **Munich**. He became one of **Berlin**'s most outstanding actors by age 25, however, beginning at the State Theater and remaining there until 1944. He appeared in many of **Jürgen Fehling**'s productions at the State Theater, most notably with **Werner Krauss** and **Gustaf Gründgens** in plays by **William Shakespeare**. Because

of those associations, Minetti was often accused of being a Nazi sympathizer—accusations he was not always able to refute. In the postwar period, he returned to his native **Kiel** and proceeded to work in numerous locales until he returned to Berlin in the early 1960s. At the Schiller Theater in Berlin, he remained a member of the company until the theater closed 30 years later for financial reasons after reunification. In the meantime, he worked with several of the emerging new directors in the 1970s, and in 1975 **Thomas Bernhard** wrote a play especially for and about him, titled (appropriately enough) *Minetti*. In the 1980s Minetti was the recipient of numerous prizes and citations. He received *Theater Heute*'s "actor of the year" award seven times.

MISS SARA SAMPSON by **Gotthold Ephraim Lessing**. Premiered 1755. A reversal of the *Medea* plot, Sara represents Creon's innocent daughter Creusa, while the adventurous Mellefont is Jason. Lessing refigured the play's classical antecedents in the disguise of a "domestic tragedy," borrowed from the English dramas he greatly admired. Sara and Mellefont have arrived in an English inn before their intended departure for elopement in France. Sir William Sampson also arrives in the hope of seeing the two before they depart. Mellefont is pursued by the evil Marwood, by whom Mellefont has conceived a child. Sara remains chaste and forgiving throughout, and in the end Marwood poisons her. In her dying breath, Sara asks her father to forgive Mellefont and to love his child. Marwood departs for Dover, where she claims she will commit suicide. Sir William intends to raise the illegitimate daughter as his own, as a legacy to his now departed daughter. The play seems overwrought and melodramatic by contemporary standards, but it was a precedent-setting and successful undertaking at the time of its premiere and for many years afterward.

MITTERWURZER, FRIEDRICH (1844–1897). Actor. Mitterwurzer was among the most idiosyncratic of German actors in the 19th century, usually eschewing grand gestures and grandiloquence of speech while concentrating on a character's "inner life." He appeared in many of the German-speaking world's best theaters, becoming most widely known at **Vienna**'s **Burgtheater**. But unlike most other great stars, Mitterwurzer made a name for himself in smaller roles, in which he invested an unusual amount of individuation. Mitterwurzer

played **Shakespeare**'s Julius Caesar, for example, without the impe-
riousness common among actors of his generation; Mitterwurzer's
Caesar was a man "deeply unsure of himself, crippled by superstition
and paranoia" (Simon Williams, *German Actors of the 18th and 19th
Centuries* [Westport, CT: Greenwood, 1985], 134). Mitterwurzer's
first Burgtheater engagement came in 1867 as a guest performer. In
1871 **Franz von Dingelstedt** made him a member of the company.
There he remained for nine years, specializing in plays by **Adolf
Wilbrandt**, Karl Töpfer, Salomon Mosenthal, and **Charlotte Birch-
Pfeiffer**. He left the Burg in 1880 but remained in Vienna, working
in various commercial venues. In 1886 Mitterwurzer began his nu-
merous tours throughout Germany and in the United States, where in
New York he alternated "great" roles (Richard III, Franz von Moor,
Hamlet, and Faust) with lesser-known roles in farces. His most suc-
cessful of the latter was the preposterous theater director Immanuel
Striese in **Franz von Schönthan**'s *Der Raub der Sabinerinnen* (*The
Rape of the Sabine Women*), which played to standing-room-only au-
diences on Broadway for three consecutive weeks.

MOISSI, ALEXANDER (Aleksandër Moisiu, 1879–1935). Actor.
Moissi was among the German-speaking theater's first modernist ac-
tors. Unlike most of his illustrious predecessors on the German stage,
Moissi was not a native German speaker. He was born in Albania and
grew up speaking Greek and Italian. His 40-year career in German
earned him millions of dollars and wide acclaim, but at no time did
Moissi lose his Mediterranean inflection. Nevertheless, that did not
diminish his appeal; indeed, it seemed to enhance it.

Moissi was **Max Reinhardt**'s most frequently cast star in **Berlin**,
where he became known for superbly effective death scenes. He ex-
pired hundreds of times as Romeo, Hamlet, Danton, and the suicidal
Fedya in Leo Tolstoy's *The Living Corpse*. Reinhardt initiated
Moissi's transformation from a provincial café singer to an interna-
tional star by insisting that Moissi retain his foreign accent. Reinhardt
often cast foreigners because he sought an alternative to "high Ger-
man" stage speech. Moissi became Reinhardt's most emblematic per-
former in provocative premieres of Maxim Gorky's *The Lower
Depths* (the first play Moissi did for Reinhardt), **Hugo von Hof-
mannsthal**'s *Elektra*, **Georg Büchner**'s *Dantons Tod* (*Danton's*

Death), and **Frank Wedekind**'s *Frühlings Erwachen* (*Spring's Awakening*). In those and other plays, Moissi put himself on display as much as he created a character. He thus became the first German actor of a 20th-century type, a man who exhibits his own existence as a work of art, "a soul in the process of decomposition" (Rüdiger Schaper, *Moissi* [Berlin: Argon, 2000], 62). Several observers proclaimed Moissi as the "new" **Josef Kainz**, but unlike Kainz, Moissi embodied the young, decadent, depravity-seeking 20th century. Moissi's onstage sufferings and deaths became objects of morbid fascination. When Moissi played Oswald in Henrik Ibsen's *Ghosts*, his death throes started early in the play's second act and staggered on to the play's final scene, as he floundered into the lap of Agnes Sorma (as Mrs. Oswald) and gurgled, "May I sit near you mother? . . . I am the living dead!"

Moissi volunteered for the German air force in 1914 and qualified as a fighter pilot. In 1915 his plane was shot down over England because he had mistakenly wandered into British airspace. The British sent him to a prisoner-of-war camp in France, and in French custody he performed as a singer at various French outposts along the Western Front. In Switzerland he reprised many of his prewar roles with a Reinhardt tour. In a 1917 prisoner-of-war exchange, Moissi gained his release, but his Berlin career never fully recovered its prewar glory. In his native Albania, King Zogu accorded Moissi state citizenship and asked him to be "master of ceremonies" at his court. Moissi declined the offer and elected to continue the profitable but exhausting business of touring. In New York, critics hailed him as "Europe's greatest living actor," "the man with the golden voice," and "the John Barrymore of the Old World." Moissi died in 1935 while on tour aboard a train that had just departed **Vienna**, where Moissi had expired on stage for what turned out to be the last time.

MÖLLER, EBERHARD-WOLFGANG (1906–1972). Playwright. Möller's professional debut came in 1929 with *Douamont*, which was widely successful because it portrayed heroic conduct among German soldiers on the Western Front. Less successful was *Kalifornische Tragödie* (*California Tragedy*) in 1929, set in California during the Gold Rush days. Its main character is Johann Jacob Sutter, whose life is turned upside down when gold is discovered on his property and the government is too weak to help him. Möller joined

the Nazi Party in 1931 and was named **dramaturg** at the Königsberg Theater in 1933. In 1934 **Joseph Goebbels** assigned him a job in the Propaganda Ministry to **censor** plays and commissioned him to write an outdoor spectacle titled *The Frankenburg Dice Game*. It was premiered at the 1936 Olympic Games in Berlin under the direction of **Matthias Wiemann**. In 1940 Möller became a "battle reporter" with the SS and remained in that position until 1945. He was arrested by the Allies and spent three years in prison.

MORAL (*Morality*) by **Ludwig Thoma**. Premiered 1908. As the title implies, Thoma's enormously popular comedy is about morals, or at least about moralistic attitudes in public life. It opens with a speech by a political candidate who leads an organization to fight prostitution, pornography, and other forms of public vice—but his speech is interrupted by news that police have arrested a local madam whom both candidate and his supporters know very well. She has kept a record of her customers, and at the police station she proves a match for her interlocutors. The aforementioned candidate tries to convince the police to drop charges against her on the pretext that "too many of the better people in the town might become involved." The chief is mystified, since he assumed the candidate would congratulate him and press for Mme. de Hauteville's prosecution. In a moment when the police chief is distracted by a telephone call, the candidate steals the madam's account ledger from the office. The phone call, however, was from the prime minister, who says that a prominent aristocrat was hiding in the whorehouse closet when police arrived. If the lady goes to trial, she threatens to reveal everything she knows. The police chief offers an abject apology to the prime minister for the efficiency of his department in fighting vice and promises to raise hush money to keep the whole affair quiet. The action returns to the candidate's house in the final act, where he has found his name on every other page of the ledger. He additionally fears he will be arrested for theft of evidence. When the police show up, he nearly has a heart attack, but they inform him of their need to raise hush money and to refurbish the whorehouse as the madam has requested. The candidate promises the cooperation of his antivice society in the interest of family values and preserving social order. The police chief assures him that the prime minister will award him a medal for his efforts in fighting vice.

MOSER, GUSTAV VON (1825–1903). Playwright. Moser was the author or coauthor of many successful "military comedies" in the Wilhemine period, largely because Moser was himself a former army officer. His prodigious output of such fare earned him the unofficial rank of "five-star general of comedy." Moser was most accomplished when writing with fellow former officers, notably **Franz von Schönthan** and Wilhelm von Trotha. Moser lived in an area called Lauban, which was served by theaters in Görlitz, Posen, Zittau, and Bad Warmbrunn. These four theaters became his workshops to try out new plays, rewrite them based on audience response, and then grant them a **Berlin** premiere—usually at the Wallner Theater. If they were successful there, they made their way through scores of German provincial theaters. Most provincial houses did at least one Moser play every year, and many did three or four a year. **Otto Brahm** claimed that both German playwrights and German actors were "ruined" in the process, calling the plays "Moserades" (Otto Brahm, "Moser," *Die Nation* 6 [1888–1889]: 89). Female audience members in particular were drawn to Moser's comedies depicting young lieutenants in love with local girls. The German theater did little otherwise to attract young female audience members, but Moser's plays set a precedent for later hits employing similar motifs. Moser's *Der Veilchenfresser* (*The Violet Eater*) is like many a Moser comedy, portraying an excessively gallant Hussar lieutenant who sends bouquets of violets to his female acquaintances.

His collaboration with Schönthan titled *Krieg im Frieden* (*War in Peace*, 1880) features a middle-class home as its battlefield, with the major combatants being a mother and daughter competing for the attentions of a young lieutenant. It had predictable features of the genre, including unswerving deference to senior officers, military trumpet fanfares interrupting courtship antics, colorful costumes, and a military-style of speech among the soldiers that curiously omitted the definite article—but it differed from most in that women conspire to win the lieutenant. In the funny opening sequence of *The Violet Eater*, the young lieutenant comes downstairs for breakfast, attaching his monocle. He looks at mother and daughter and says, "By Jove, a beautiful young girl. In fact, two of them." He is a caricature, as he is in most such comedies, putting on airs and too much after-shave lotion.

MOSHEIM, GRETE (1905–1986). Actress. Mosheim was the kind of Jewish actress, according to critic Joachim Kaiser, of which the German theater at one time could boast a full supply, "small in body but with an unmatched fullness of experience. In Mosheim one sensed a mixture of Jewish self-confidence, Potsdam, cultural worldliness, plus a melange of näiveté and realism all mixed in together" (Kaiser, *Süddeutsche Zeitung* [Munich], 31 December 1986). Mosheim made her debut with **Max Reinhardt** in 1928 as an ingenue, a type she continued to play as Gretchen in **Johann Wolfgang Goethe**'s *Faust* and George Bernard Shaw's *Pygmalion* until forced to leave Germany in 1933. She emigrated first to Switzerland, then to London, and finally settled in New York with her husband. Mosheim returned to **Berlin** triumphantly in 1952 in John van Druten's *I Am a Camera* at the Schlosspark Theater. She remained based in New York for the rest of her career, though she usually appeared in one German production a year. Among her biggest roles were Mary Tyrone in Eugene O'Neill's *Long Day's Journey into Night* (1956); Winnie in Samuel Beckett's *Happy Days* (1961); Claire Zachanassian in **Friedrich Dürrenmatt**'s *Der Besuch der alten Dame* (*The Visit*, 1962); Hannah in Tennessee Williams's *Night of the Iguana* (1962); Aunt Abby in several German, Swiss, and Austrian productions of Joseph Kesselring's *Arsenic and Old Lace*; and the Widow in Edward Albee's *All Over* (1972).

MÜLLER, HEINER (1929–1995). Playwright. Müller was considered the leading playwright of the German Democratic Republic, and in many ways his life and career echo that regime's bleakest idiosyncrasies. His career in East German theater began in 1957, when his first plays were published and he began working at the Maxim Gorky Theater in East **Berlin**. His plays were structurally indebted to **Bertolt Brecht**'s one-act politicized didactic pieces called *Lehrstücke*. Müller called his plays *Brigadestücke*; these "brigade plays" portrayed platoons of workers and their tribulations within a totalitarian state that claimed always to have their best interests in mind. Although Müller was awarded the regime's Heinrich Mann Prize, many of his plays, including *Der Lohndrücker* (*The Scab*, 1958) and *Die Umsiedlerin, oder Das Leben auf dem Land* (*The Settler, or Life on the Land*, 1961), met with official disapproval, which led to his expulsion from the East

German Writers' Union. *The Scab* was based on a real character named Hans Garbe, an energetic and ambitious bricklayer who ran afoul of other workers in the immediate postwar years, when the GDR was attempting to repair war-ravaged structures. *Der Bau (The Construction Site)* borrowed material from the novel *Spur der Steine (The Trace of Stones)* by Erik Neutsch (1931–), which became a 1966 movie likewise suppressed because it featured the unflattering portrayal of a Communist Party functionary.

Müller turned his attention to adaptations of Greek classics in the mid-1960s, though in them Müller seemed to reject the didactic purposes he had formerly espoused. In the 1970s he took on the abstract style with which he later became identified, notably in *Zement (Cement*, 1974), which was based on a Russian novel of the same title by Feodor Gladkov (1883–1958). Western critics noted that *The Scab*, *The Construction Site*, and *Cement* prominently featured building materials; the inference was that Müller's viewpoint in such plays was not directly unfavorable toward the regime. He nevertheless focused on discrepancies present in construction efforts, many of them seemingly inevitable in planned societies like those of East Germany and the Soviet Union.

Müller's lack of optimism and accusations of "formalism" (lack of accessibility) were reminiscent of similar problems the East German regime had encountered with Brecht, because "official" art was supposed to be both avant-garde and accessible; experimentation was unnecessary because it was superfluous. Yet perhaps because so many observers in the West were comparing Müller to Brecht, the regime permitted Müller to become **dramaturg** of the **Berliner Ensemble** in 1970. In that capacity, Müller continued adapting or reworking classic material, such as *Philoctetes, Heracles, Prometheus, Oedipus, Medea, Hamlet*, and *Macbeth*. These and other reworkings, however, likewise lacked a positive affirmation of what the regime termed "socialism as it existed in reality." His *Hamletmaschine (Hamlet Machine*, 1977) was particularly pessimistic, but when it premiered in Essen in 1979, the regime began to realize it had a valuable celebrity on its hands. In both *Hamletmachine* and *Quartett* (1980), Müller moved even further away from the ideal of accessibility, embracing instead a collage-oriented dramaturgical aesthetic; such approaches won him numerous admirers in the West and even grudging respect in the East.

Despite profound misgivings among many in what was termed the *Kulturapparat* (cultural apparatus) of the East German regime, Müller was permitted to travel to the West in the mid-1970s (venturing as far away from Berlin as Austin, Texas); his fundamental loyalty to the Soviet-style system was rewarded with extensive travel permissions and ultimately with the GDR's National Prize, First Class in 1985. In 1988 he was finally permitted to rejoin the East German Writers' Union—but it was too late: Müller had already been awarded the Büchner Prize from the city of Darmstadt and was earning substantial sums in hard currency because his plays, banned in the GDR, were being performed throughout Europe and in the United States. He had essentially become independent of the East German regime.

When the regime collapsed in 1989, Müller remarked laconically on the privilege he had experienced of living through the downfall of three German regimes. "I foresee little hope in the downfall of the Federal Republic, however." In the wake of the GDR's dissolution, Müller briefly assumed leadership of the Berliner Ensemble, and in 1993 he staged **Richard Wagner**'s *Tristan und Isolde* at the **Bayreuth Festspielhaus**. Müller's last staging was Brecht's *Der aufhaltsame Aufstieg des Arturo Ui* (*The Resistible Rise of Arturo Ui*) in 1995; it ironically became the company's most popular staging in years. After Müller's death, the company performed it on tour in cities throughout Germany, and later included cities in France, Russia, Turkey, Brazil, Belgium, the United States, Argentina, and Portugal.

MÜLLER, TRAUGOTT (1895–1944). Designer. Müller was an extraordinarily talented and busy designer in the Weimar period. He then began directing films in the Third Reich. Müller's designs for **Erwin Piscator** in **Berlin** were exceptional, because they marked Müller as one of the first German constructivists. His designs for Piscator of *Die Räuber* (*The Robbers*) in 1926 at the Schiller Theater, *Storm over Gothland* at the Volkbühne, *Hurrah, We Live!* and *Rasputin* at the Theater am Nollendorfplatz (all in 1927), however, left Müller completely exhausted. He began working at the Berlin State Theater in 1932, and his productions there with **Jürgen Fehling** in the late 1930s surpassed all his previous efforts. They may indeed be the best design work he ever created. His designs for *Richard III* (1937, with **Werner Krauss** in the title role) and *Richard II* (1939,

with **Gustaf Gründgens**) were among many he designed for Fehling and Gründgens; they were the most stunning of any theatrical designs in 20th-century German theater. Müller's 1939 production design for the Gründgens-directed film adaptation of the Theodor Fontane novel *Effi Briest* called *Der Schritt vom Wege* (*The False Step*) provided him with the opportunity to direct Gründgens in the title role of the highly popular *Friedemann Bach* (1940).

MÜLLER-STAHL, ARMIN (1930–). Actor. Müller-Stahl is a film actor with an international reputation, but he began studies in the former German Democratic Republic in music and painting. In 1952 he decided to become an actor, and after brief studies for his new profession, he debuted that year with the **Berliner Ensemble** at the **Theater am Schiffbauerdamm**. The following year he became a member of the Volksbühne company and by the early 1960s his was a well-known face on East German television and in East German films. In 1976 the GDR banned him from all performance work because he had signed a petition protesting the treatment of singer Wolf Biermann, and for three years he struggled to survive. He escaped the GDR in 1979 and has since established himself both in German films and in Hollywood.

MUNICH. Munich (München) is the capital of Bavaria, an area the Romans originally conquered in the first century B.C. The beneficially situated village of Munich came under Carolingian dynastic rule in the 10th century and received its city charter in 1158. The Wittelsbach ruling house made Munich its residence in 1255, and Munich came under the influence of the court. Guilds also had a strong cultural impact on the city's life, staging cycle plays in the mid-14th century and attracting touring troupes throughout the 15th century. By 1500 guild cycles reached their zenith in Munich in number and ostentation, owing to the support of both the Church bishops and the Wittelsbach princes. The 16th century is noteworthy for the expansion of the Jesuit presence in Munich; the 1568 marriage of William V and Renate of Lorraine was a particular occasion of unprecedented theatrical display throughout the city.

Jesuit schools continued to stage performances in a lavish fashion, but not until 1653 was the first theater built in Munich. It was in-

stalled in the royal residence and became known as the Residenz Theater. Four years later the Wittelsbachs built an opera house near the residence and for decades it remained Munich's primary performance venue, mostly for Italian opera. In 1751 the Wittelsbach prince Max III Joseph commissioned architect François de Cuvilliés (1695–1768) to build what became the most costly theater structure anywhere in German-speaking Europe; the Cuvilliés Theater opened in 1753 and became a showplace of aristocratic grandeur.

In 1765 the court made plans to institute a dramatic theater dedicated solely to spoken drama; soon thereafter a brewery was refurbished and christened the National Schaubühne. When Bavaria became an independent kingdom in 1808, the place was renamed the Court and National Theater. In 1811 a lavish new structure housing both opera and dramatic productions arose, but it burned to the ground in 1823. It reopened in 1830 and a series of aristocrats ran the place until 1919. **Friedrich Hebbel**'s *Agnes Bernauer* premiered there in 1852, and beginning in the mid-1860s, several private theaters began to appear on the Munich theater scene, including the Gärtnerplatz Theater, the Deutsches Theater, the Schauspielhaus, the Volkstheater, and the Prince Regent's Theater.

By 1900 Munich's population had experienced a fivefold increase over the previous 50 years, to more than half a million; many of the new theaters carved out niches for themselves to serve a variety of tastes among the growing population. In the early 1900s Munich was the site of numerous world premieres, attesting to the city's growing reputation as a more amenable, or at least a less intensely urbanized, city than the Reich capital **Berlin**. In 1907 Georg Fuchs (1868–1949) founded the Munich Artists' Theater, dedicated to reforming the actor–audience relationship by eschewing illusionism, dispensing with the stage apron, and cultivating the ideal of "transorchestral unity." The result was a "relief stage," in which actors had little room to move on an extremely shallow stage space; they thus assumed statuary poses. The Kammerspiele was founded in late 1912, and early in 1913 **Erich Ziegel** assumed its leadership; **Otto Falckenberg** became its director in 1917 and under him the Kammerspiele developed as one of the premiere theaters in Germany.

At the Munich Volkstheater, the "firm" of **Franz Arnold** and **Ernst Bach** held sway in the 1920s, while Falckenberg attracted nu-

merous outstanding actors and directors to Munich for the next two decades. Falckenberg had directed the world premiere of August Strindberg's *The Ghost Sonata* in 1915, and in 1922 he staged the world premiere of **Bertolt Brecht**'s *Trommeln in der Nacht* (*Drums in the Night*) at the Kammerspiele. **Erich Engel** became the Kammerspiele's director immediately after World War II, followed by **Hans Schweikart** from 1947 to 1963. Under Schweikart and his successor **August Everding**, **Fritz Kortner** conducted his most significant work during the postwar period. His 1954 *Waiting for Godot* was a high-water mark for Munich's theater in the 1950s, and the training Kortner gave to **Peter Stein** and **Jürgen Flimm** in the 1960s at the Kammerspiele had an impact felt well into the 1990s. **Dieter Dorn**'s work at the Kammerspiele began in the 1970s, and his is the work most closely associated with Munich itself since that decade.

MUTTER COURAGE UND IHRE KINDER (*Mother Courage and Her Children*) by **Bertolt Brecht**. Premiered 1941. The "mother" of the title is Anna Fierling, a camp follower during the Thirty Years' War. Her three children accompany her as she sells liquor and provisions to soldiers. One by one, all three of her children are killed in various situations, and her wagon likewise disintegrates as the play progresses. But Anna courageously muddles on to the end of the play, not fully realizing that she has provided the occasions of her children's misfortunes. Her boast at the end, as she pulls the wagon by herself off the stage, is that she engaged in the business of camp following to provide for her children. Brecht's intention was to show how political systems force people like Fierling into war profiteering and in effect prolong wars. He did his best to "alienate" audiences from the character of Mother Courage in correspondence to his theory of the *Verfremdungseffekt*, but she nonetheless wins empathy of most spectators by virtue of her remarkable tenacity and wit. Most critics agree that *Mother Courage* probably fails according to Brecht's theory; the play succeeds remarkably well on its own.

– N –

NATHAN DER WEISE (*Nathan the Wise*) by **Gotthold Ephraim Lessing**. Premiered 1783. One of Lessing's most frequently per-

formed plays in the post–World War II period, due largely to its humanitarian subject matter and the sympathetic rendering of its title character. Nathan is a Jew living in Jerusalem during the Crusades, and Lessing's plot has devices similar to those found in Voltaire, especially when Nathan's adoptive daughter Recha falls in love with a young Templar knight. But *Nathan the Wise* is by no means a neoclassical tragedy; it is rather a "dramatic poem" with debts to Giovanni Boccacio's *Decameron*. From it Lessing borrowed the parable of the rings, which are metaphors for the three religions tracing their beginnings to Abraham: Judaism, Christianity, and Islam. When Nathan recites the parable to Saladin, sultan of Jerusalem, Saladin realizes that the Templar knight is actually his nephew and thus the brother of Nathan's daughter Recha. The play is static, but it contains some of Lessing's finest verse, written in iambic pentameter. **Ernst Deutsch**, **Albert Bassermann**, and **Paul Wegener** were among the actors returning from exile in the late 1940s and early 1950s who played Nathan to wide public acclaim and critical praise.

NATURALISM. The Naturalist strain of theater production and playwriting in Germany was essentially a reaction to well-made play conventions and a call for a more authentic environment on stage, as the term *artistic* came to mean "unnatural." German Naturalists, such as Arno Holz (1863–1929) and Wilhelm Bölsche (1861–1939), followed French precedents in calling for a new dramatic art to replace the unnatural or "fabricated" variety, which had been based on such structural techniques as exposition, cause-to-effect arrangement of incidents, complications, building scenes to a climax, reversals, use of withheld information to keep plots believable, and rational resolutions of conflicts. Such devices were the "factor X" in the minds of Naturalists, which had to be removed from plays if they were to be truly "art" and not just "artistic." Holz came up with a formula playwrights were to use in creating such plays, which he reduced to

$$Art = Nature - X.$$

Naturalist acting made its putative appearance in 1885, in a **Berlin** production of *Théodora* by—of all playwrights—Victorien Sardou (1831–1908), against whom French Naturalists had begun to rail for his enormously popular fabrications for the stage. *Théodora* was such

a one—an elaborate spectacle for which Sardou became justifiably renowned. It treats a love affair between the Byzantine empress Theodora and one of her many lovers, as a consequence of which Théodora is ceremonially executed at the end of the play. In the Residenz Theater production, **Emmanuel Reicher** played Emperor Justinian as a lazy coward, because by 1885 Reicher had decided to become a "presenter of human nature" (*Menschendarsteller*) rather than an actor. The novelty of Reicher's approach caught the attention of both critics and audiences, and the production proved to be unusually popular. Reicher told the press that it was more important for him to play a man who happened to be an emperor rather than somebody's preconceived notion of an emperor, and he employed an astonishing technique to overcome "superficial bravura" and invest the character he was playing with a "naturalness" that kept him and the German actors who imitated him from being simply German-speaking duplicates of their French counterparts. Reicher went on to star in several **Gerhart Hauptmann** productions, as did his many emulators.

In 1887 Naturalism in Germany benefited as well from the visit of Andre Antoine's Théâter Libre in 1887, which contributed to the founding of the Freie Bühne in 1889. Andre Antoine (1858–1943) had championed the works and ideas of Émile Zola (1840–1902), whose *Naturalism in the Theater* (1881) had condemned Sardou and the *pièce bien fait* (well-made play) as inimical to theater art. The German Naturalists, especially **Otto Brahm** and his supporters who founded the Freie Bühne, sought Naturalism as a means to usher in a sense of "modernity"—based, however, on concepts of social justice. They premiered Arno Holz and Johannes Schlaf's *Die Familie Selicke* (*The Selicke Family*) because the play's principal premise was that a brutal and oppressive environment (the setting was a disease-ridden Berlin tenement) had caused the family's destruction.

Brahm also premiered Hauptmann's *Vor Sonnenaufgang* (*Before Sunrise*) for many of the same reasons, though the emphasis was on heredity rather than environment. A Darwinian doctrine prevailed either way, though there remained a stylistic emphasis on the "authentic" in dialogue, performance, stage design, and costume. Hauptmann was particularly skillful in using dialects, and several "Naturalist actors" got good notices for dampening virtuosity in favor of behavioral mannerisms in performance. Naturalism came into sharpest focus

with Hauptmann's *Die Weber* (*The Weavers*), which added class con-
flict to the mix of social evils and provided an abundance of authen-
ticity. Hauptmann actually wrote two versions of the play, one in
Silesian dialect and another in standard stage German. An added hall-
mark of *The Weavers* is Hauptmann's use of a chorus (the Silesian
weavers) as the play's protagonist.

Naturalism briefly captured the public's imagination, but its vogue
soon faded. Playwrights such as Hermann Sudermann and **Max
Halbe** began to write commercially successful plays based on social
or domestic conflicts. As early as 1891 **Hermann Bahr** published a
widely read essay condemning Naturalism and its inherent limita-
tions, even though he had been an early supporter of it. By about
1900 Naturalism as a novel direction in the German drama had run
its course.

NEHER, CASPAR (1897–1962). Designer. Neher is best remembered
as a member of **Bertolt Brecht**'s "inner circle," a close collaborator
who participated in several of the triumphs and disappointments in
the Brecht portfolio. Neher and Brecht almost literally grew up to-
gether, attending the same school in Augsburg. They corresponded
throughout World War I, when Neher was in the trenches with an in-
fantry division; he was severely wounded and nearly killed in 1917,
but later was commissioned an officer and awarded the Iron Cross for
bravery. By the time Neher designed *Im Dickicht der Städte* (*In the
Jungle of Cities*) for Brecht at the **Munich** Residenz Theater in 1923,
he had already established himself in **Berlin** with **Jürgen Fehling**'s
production of **Heinrich von Kleist**'s *Käthchen von Heilbronn* (*Kathy
of Heilbronn*) at the Berlin State Theater.

In early 1924 Neher returned to Munich to design Brecht's *Edward
II* at the Kammerspiele, which Brecht himself directed. Later the
same year **Max Reinhardt** hired Neher as a resident designer at the
Deutsches Theater and at the same time hired both Brecht and **Carl
Zuckmayer** as **dramaturg**s. In 1925 Neher designed sets and cos-
tumes for **Erich Engel**'s production of Brecht's *Coriolanus* at the
Lessing Theater. In 1926 he designed the world premiere of *Mann ist
Mann* (*A Man's a Man*) in Darmstadt, followed by three other pro-
ductions of the play, the most important of which took place at the
Berlin State Theater with **Peter Lorre** in 1931. The most significant

design he executed for Brecht before the Nazi takeover was for *Die Dreigroschenoper* (*The Threepenny Opera*) in 1928, followed by *Happy End* the following year. Neher both directed and designed *Aufstieg und Fall der Stadt Mahagonny* (*The Rise and Fall of the City of Mahagonny*) for its Berlin premiere in 1931.

During the Third Reich, Neher worked in Frankfurt am Main with Walter Felsenstein and in Berlin with **Heinz Hilpert**, a collaboration which had begun at the Volksbühne in 1932. From 1933 to 1944 Neher designed several Hilpert productions, mostly **William Shakespeare** and Kleist, both in Berlin and in **Vienna** at the Theater in der Josephstadt. His most significant design for Hilpert, however, came after the war with the world premiere of Zuckmayer's *Des Teufels General* (*The Devil's General*) at the Zurich Schauspielhaus.

Neher resumed designing Brecht's works in the postwar period with *The Threepenny Opera* in 1948 at the Munich Kammerspiele. Subsequent designs with Brecht included *Herr Puntila und sein Knecht Matti* (*Mr. Puntila and His Servant Matti*, 1949), *Die Mutter* (*The Mother*, 1950), *Der Hofmeister* (*The Tutor*, 1950), and *Die Verurteilung des Lukullus* (*The Trial of Lucullus*, 1951). Neher quit working in East Berlin in 1952, largely due to political forces beyond his control. Late in 1952 Neher asked Brecht for his understanding, but communications between the long-time friends stopped. In the following years, Neher worked in West Berlin, at the Salzburg Festival, and in England, even while the **Berliner Ensemble** did a residence at the Palace Theater in London, absent any of Neher's design work in the productions staged there.

After Brecht's death in 1956 there was a scramble for royalties on several collaborative efforts, but Neher in most cases was excluded from financial considerations. A November production of *Die Tage der Kommune* (*Days of the Commune*), staged by **Benno Besson**, used Neher's designs without his permission. In 1957, Engel staged *Das Leben des Galilei* (*The Life of Galileo*) with Neher's designs and participation, but Neher by that time remained focused on activities in Salzburg and at the Metropolitan Opera in New York, where he designed Alban Berg's *Wozzeck* and Giuseppe Verdi's *Macbeth*. In 1959, **Gustaf Gründgens** premiered Brecht's *Die Heilige Johanna der Schlachthöfe* (*St. Joan of the Stockyards*) at the **Hamburg** Deutsches Schauspielhaus with Neher's design, 30 years after Neher and Brecht had originally discussed and planned the project.

Neher had a significant impact on design in the postwar period. He embraced a self-referentiality in design that supplanted illusionism. He had an ability, cultivated in his collaborations with Brecht, to see a playwright's text in concrete terms, "then use his controlled sensitivity to line and color [and] set them down . . . as supplements to the words in the script" (John Willett, *Caspar Neher: Brecht's Designer* [London: Methuen, 1986], 31). Yet Neher was never so rational in his designs as to make spectacle didactic. Though he employed realistic touches, his emphasis was on the theatrical and the exploitation of scenic stratagems. Frequently the screens, lighting, or abstract details he provided were functional, but they also provided the proper mood or atmosphere required in the scene.

NEIDHARDTSPIEL, DAS (*The Play of Sir Neidhardt*). The earliest manuscript of the anonymous *Neidhardtspiel* dates from about 1350. Thought to be the among the oldest surviving medieval farces, it was discovered in the St. Paul monastery in Austrian Carinthia. Its ostensible use was for a springtime festival. In its 58 lines, the knight Neidhardt and a noblewoman wager that if he can find the season's first violets, she will accept his poem. He proceeds to find said flowers, places his cap over them, and returns to her. In his absence, peasants find the cap, uproot the flowers, and leave a "repulsive substance" (i.e., fecal matter) under the cap. Neidhardt returns with the lady to present her with his discovery—to which she is justifiably outraged, as the peasants enjoy themselves. **Hans Sachs** revised and somewhat cleansed the play for public presentation in Nuremberg during the Shrovetide season. In his version the "repulsive substance" (*ein überaus ekelhafter Gegenstand*) became a "human product" (*menschliches Produkt*).

NESTROY, JOHANN NEPOMUK (1801–1862). Playwright, actor. Nestroy ranks among the most successful and noteworthy of the German-language theater's comic playwrights. His plays when premiered were extremely popular; upon his death they were generally forgotten, but in the 1880s a series of revivals in his native **Vienna** (where he had staged the plays initially) led to a reappraisal and subsequent revivals in German theaters elsewhere—including New York, Chicago, and Milwaukee, where Nestroy was a staple in German-American repertoires. In the 1890s his works were collected and published, making

nearly his entire oeuvre available to any theater desirous of doing them. In the 1920s Nestroy enjoyed another rebirth, as critics, directors, and audiences alike found a new appreciation of Nestroy's comic authenticity, along with his profoundly effective satirical gifts. His works continue to be performed throughout the German-speaking theaters to this day and remain the subject of ongoing scholarly inquiry.

Nestroy began his career as a basso at the Court Opera in Vienna; his vocal gifts were such that he was in demand at opera houses throughout Europe and in the mid-1820s was a permanent member of the Amsterdam opera company. By the late 1820s he tired of opera and began performing comic roles in regional theaters throughout the Habsburg territories. In 1826 he was arrested in Graz for improvisational byplay in which he criticized Habsburg ruling practices—not the last time Nestroy would run afoul of **censorship** authorities in his career. In 1829 he returned to Vienna to work regularly at the Theater in der Josephstadt; two years later **Carl Carl** placed him under lengthy contract to become a permanent member of his company. There Nestroy began writing plays (usually featuring himself in the leading role).

Nestroy's first hit for Carl was *Der böse Geist Lumpazivagabundus* (*The Evil Spirit Lumpazivagabundus*) in 1833. It was a parody of **Ferdinand Raimund**'s popular *Zauberstück* (magical play) formula. The title character is the patron saint of drunken street bums, but he is a distinctly minor figure in the play, appearing only at the beginning. The main action is wholly lifelike, set in contemporary Vienna and featuring three recognizable types: a tailor, a cobbler, and a carpenter—all of them shiftless wastrels. One night in a typically Viennese flophouse, by the grace of their patron Lumpazivagabundus, they dream of the same lottery number; they buy a lottery ticket together the next day and indeed become instantly wealthy. The carpenter and the tailor quickly go through their money in dissolute fashion, but the cobbler (played by Nestroy) marries his sweetheart and reforms himself. The play had many of the characteristics that distinguished Nestroy from his predecessors: the dialogue was realistic, the dilemmas were believable, the setting was contemporary, sentimentality was noticeably absent, and the roles were splendid performance vehicles for Nestroy and his colleagues.

In many subsequent plays (he wrote more than 80), Nestroy created roles for **Wenzel Scholz** and himself; Scholz was as compact,

corpulent, and diminutive as Nestroy was tall, lean, and angular. Often their mere appearance on the stage together evoked peals of laughter. Nestroy wrote more than 30 plays for them both; among the best are *Der Talisman* (*The Talisman*, 1840) and **Einen Jux will er sich machen** (*Out on a Lark*, 1842). The latter is better known because it is the basis of the Broadway musical *Hello, Dolly!*, but the former is a comic masterpiece featuring Nestroy as a red-haired outcast who climbs the Viennese social ladder by wearing a wig. Other plays bearing mention are *Zu ebener Erde und im ersten Stock* (*Upstairs, Downstairs*, 1835); *Eine Wohnung ist zu vermieten* (*An Apartment for Rent*, 1837); *Das Haus der Temperamente* (*The House of Temperaments*, 1837), *Glück, Missbrauch, and Rückkehr* (*Fortune, Extravagance, and Return*, 1838), *Das Mädl aus der Vorstadt* (*The Girl from the Suburbs*, 1841), **Liebesgeschichten und Heiratssachen** (*Love Affairs and Wedding Bells*, 1843), and *Der Zerissene* (*A Preoccupied Mind*, 1844).

In these and many others, Nestroy's social satire and oblique political criticism caused him frequent problems not only with the authorities but also with Viennese newspaper critics; the latter preferred the older, less pointed and more sentimental approach Nestroy eschewed. Nestroy's lack of sympathy for the misfortune of his characters was a distinctive feature for which critics frequently called him to account. Yet Nestroy was not interested in ridiculing the Habsburg establishment with the goal in mind of overturning it; when the 1848 revolution in Vienna briefly lifted police censorship, Nestroy immediately satirized the "new order" with *Freiheit in Krähwinkel* (*Freedom Comes to Krähwinkel*), implying that revolutions are as preposterous as empires. In the play, a journalist helps foment a revolution in the town of Krähwinkel, which stands for every form of narrow-mindedness Nestroy sought always to satirize. In this play, however, as in nearly all his works, Nestroy does not resort to cynicism; his satire of institutions, officiousness, prejudice, and tradition usually remains optimistic.

Nestroy's optimism dimmed with the death of Scholz, after which he reluctantly agreed to take over administration of the Carl Theater. That responsibility ultimately led to his premature death, and his passing was an occasion of mourning throughout the city of Vienna. As they had during his lifetime and as members of his audience, the

Viennese showered Nestroy with public expressions of devotion and admiration. They stopped attending productions of his plays, however; many felt that without him in the roles he had written for himself, the appeal of a Nestroy play was sorely diminished. Only when the generation that had personally witnessed Nestroy had likewise passed from the scene were Viennese actors able to revisit and revive the plays, often with fortuitous results.

In the 20th century, Nestroy's reputation continued to grow, and his influence spread. The playwright most scholars and critics cite as Nestroy's 20th-century heir is **Ödön von Horváth**, though his plays often feature a violence and despair completely alien to Nestroy. Few actors have been compared to Nestroy, even though abundant pictorial evidence of Nestroy in performance exists. The actor most similar to Nestroy in type was probably **Theo Lingen**; Lingen's abundant comic gifts likewise resemble Nestroy's, but his record of performance in Nestroy's plays is somewhat meager.

NEUBER, CAROLINE (Friederike Caroline Weisenborn, 1697–1760). Actress, manager. "Die Neuberin," as Neuber came to be celebrated even in her own lifetime, was most significant as a theater reformer in the 18th century. Many scholars and critics, including **Johann Wolfgang Goethe**, have credited her with changing the course of German theater history, largely because she established standards of respectability and esteem among both middle-class and aristocratic audiences. Prior to die Neuberin, most troupes performing in German endured reprobation as boorish vulgarians; by the mid-1720s she was the leader of Germany's preeminent troupe, concentrating on a repertoire that excluded the low **Hanswurst** comedy type and the excesses of improvisation. By 1730 she and her husband Johann Neuber (1697–1756) had built Germany's most literate and cultivated troupe, demanding memorized texts among performers and circumspect behavior off the stage. In a letter to **Johann Christoph Gottsched** she stated that her artistic goals included the betterment of society, especially by "seizing any opportunity to do something useful and worthwhile." Her collaboration with Gottsched in the 1730s expanded her company's repertoire, though she still did **Haupt- und Staatsaktion** plays along with adaptations of English sentimental comedies and the French *comédies larmoyantes*. She premiered **Gotthold Ephraim**

Lessing's *Der junge Gelehrter* (*The Young Scholar*) in 1748. Neuber was a superb actress in her own right, and she trained numerous actors who subsequently formed their own troupes, borrowing many of the techniques she had employed. Neuber was also gifted as a playwright of "afterpieces," short play scenarios performed after the main offering. Goethe memorialized her as Madame Nelly in his four-volume novel about touring theater troupes, *Wilhelm Meisters Lehrjahre* (1795). She is the subject of the 1941 film *Komödianten* (*The Comedians*), directed by G. W. Pabst (1885–1967) and starring **Käthe Dorsch** as die Neuberin.

***NIBELUNGEN, DIE* (*THE NIBELUNGS*)** by **Friedrich Hebbel**. Premiered 1861. Based on the medieval saga, written in Middle High German in Austria sometime around the early 13th century. Hebbel turned what he considered a "national epic" into a stageworthy trilogy by concentrating on the blood lust and seething hatred between two women, Brunhild and Kriemhild. Against them, even the superhuman strength and courage of Siegfried cannot prevail. The play consists of a prologue followed by two five-act tragedies: *Siegfrieds Tod* (*Siegfried's Death*) and *Kriemhilds Rache* (*Kriemhild's Revenge*). Hebbel carefully charted the growing animosity between Brunhild and Kriemhild beginning with Siegfried's assistance to Günther, king of the Burgundians, in the latter's conquest of Brunhild on her wedding night. Kriemhild subsequently humiliates Brunhild by publicly disclosing the tactics Siegfried used. When Günther's courtier Hagen kills Siegfried using likewise unfair tactics during a bear hunt, Kriemhild swears revenge against Hagen and all the Burgundians by marrying Etzel, king of the Huns, and fomenting war against the Burgundians. The trilogy is a magnificent blank-verse treatment (it took Hebbel seven years to complete it) of tribal enmity that is ultimately resolved not through incarnadine violence but through acceptance of mercy "in the name of Him who was crucified!" The play is markedly different from the Nibelungen saga **Richard Wagner** employed when composing his Ring Cycle of operas.

NIEMANN-RAABE, HEDWIG (1844–1905). Actress. Niemann-Raabe was one of the finest performers in 19th-century German theater, and if such witnesses as **Otto Brahm** and colleague **Ludwig**

Barnay are to be believed, she had the ability to transcend the normal limits of performance in almost any role she attempted. Niemann-Raabe enjoyed a career far lengthier than did most actresses of her day, beginning in childhood as Carla Eugenia in **Friedrich Schiller**'s *Don Carlos*. She worked steadily for the next five decades as a member of German companies in venues as disparate as Amsterdam in the west, Moscow in the east, **Vienna** in the south, and **Hamburg** in the north. She toured throughout Europe on numerous occasions. Niemann-Raabe began as an ingenue and in her 40s began doing character parts; Brahm said her Frankziska in **Gotthold Ephraim Lessing**'s *Minna von Barnhelm* was the finest he had ever seen, largely because she eschewed the "artificial drollery" attempted by most of her contemporaries in the role. In some ways, Niemann-Raabe presaged the **Naturalist** emphasis in female roles by **Gerhart Hauptmann**, for example, Mother Wolff in *Der Biberpelz* (*The Beaver Coat*) and Frau Wermelskirch in *Fuhrmann Henschel* (*Teamster Henschel*). In her 50s and 60s, she played the *Salondame* with such humor and self-parody that Barnay wished he could enroll every young actress then just beginning in the profession to witness this "great artist" at work. Niemann-Raabe's artistry did not, however, extend to the plays of Henrik Ibsen. Brahm's admiration of her and his concomitant advocacy of the Norwegian playwright notwithstanding, her refusal to play the ending of *A Doll's House* as written caused a furor in Berlin, where she was scheduled to appear as Nora at the **Deutsches Theater**. Ibsen initially refused to alter the play, so she told him and **Adolph L'Arronge** she would change the ending of the play on her own and remain in the house with Torvald and the children. Ibsen relented, albeit reluctantly, and wrote the "German ending" for her. She in turn relented soon thereafter and agreed to play Nora as written.

NINA by Bruno Frank. Premiered 1931. This comedy satirized the German film industry, but its real subject was the overt manipulation of identity. Popular film actress Nina has decided to retire from films in order to spend more time with her devoted husband, a shy inventor. She proposes to the producer of her films that her replacement be Trude Mielitz, who looks and sounds so much like Nina that she could easily become the studio's next diva (the play is written so that

the same actress plays both Nina and Trude). The producer agrees to become Trude's Pygmalion, and the former stand-in rises from obscurity into full-blown, petulant stardom. Trude and the producer travel to Hollywood, and there she learns definitive lessons in flamboyant superficiality from German film moguls already in residence. She returns to Berlin in the final act with an aura of tawdry glitz and irresistible banality.

Frank cleverly combined exits and entrances for Nina/Trude, while his pacing allowed the contrasting personalities of both to emerge. Frank created the roles for his mother-in-law **Fritzi Massary**, who played them in the premiere production. Many other actresses played the roles successfully until the Nazi takeover, when the play was banned. As he had in his earlier successes (particularly *Sturm im Wasserglas* [*Tempest in a Teacup*]), Frank combined political observation with appealing entertainment value. *Nina* was about the creation of an image, and Frank used the analogy of Nina with Adolf Hitler, whose success in manipulating the media by exploiting recent technological innovations in the creation of his own image as Germany's savior was unprecedented.

NOELTE, RUDOLF (1921–2002). Director. Noelte returned from military service in World War II to work as a directorial assistant with **Jürgen Fehling**, **Karl-Heinz Martin**, **Erich Engel**, and Walter Felsenstein in **Berlin**. His directorial breakthrough came in 1948 with the first Berlin production of **Wolfgang Borchert**'s *Draussen vor der Tür* (*The Outsider*). In many ways he remained a Fehling disciple his entire career, staging dozens of productions in the 1950s and 1960s in the Fehling manner. That meant staying faithful to the playwright's text but embracing abstraction as a means of illuminating it. Noelte also cultivated a reputation for exactitude, and many actors in the 1980s described him as a "fearsome" figure, a "difficult" colleague with whom to work; as a result, he was seen as a figure from the "old school" of directors in the 1920s. He nevertheless won widespread praise for his work, earning nine invitations to the Berliner **Theatertreffen** between 1965 and 1984. Noelte worked consistently as a freelance director in dozens of venues, most notable among them the Thalia and the **Deutsches Schauspielhaus** in **Hamburg**; the Kammerspiele and the Bavarian State Theater in **Munich**; and the

Renaissance Theater and the Freie Volksbühne in his native Berlin. Noelte staged nearly every play in the German dramatic canon, but was known particularly for his work with **Carl Sternheim**'s comedies. He was also a gifted director of plays for television.

– O –

O DIESE MÄNNER! (*Ah, These Men!*) by Julius Rosen. Premiered 1876. In this flimsy but widely popular comedy, the Morland family (parents and two daughters) have arrived at a fashionable south German spa and want merely to relax. Interrupting their leisure is the wife of a government minister, Frau Schraube, who has brought her three daughters to the spa in search of eligible husbands. She has a system in place for her search, but little luck to go with it. Thus she often proclaims the play's title, "Oh, these men!" to the chagrin of other guests. But the search for men is not the main plot complication. That comes in the form of a bet between the spa's director Dr. Sauber and Herr Morland. The two have known each other since their school days, and Dr. Sauber notices that Morland is completely under the thumb of his wife Olga. Herr Morland defends himself, so Sauber dares Morland to kiss the first woman who says "Guten Morgen" to him the next day. Sauber then sees to it that the first woman to do so on the morrow is none other that Frau Schraube. Morland's kiss creates a scandal in the spa, and Frau Schraube takes her leave of the place with her daughters. Meanwhile, Frau Morland takes pity on her husband, who has fallen victim not only to his friend's practical joke but also to the foul temper of Frau Schraube. The comedy was considered an accurate, if harmless, satire of Wilhelmine mores and manners during the 1876–1877 season, when it became one of the most frequently performed plays of that season throughout the new Reich.

ORLOFF, IDA (Ida Margaretha Weissbeck, 1889–1945). Actress. Orloff began her career in 1905 playing a small role in *Die Büchse der Pandora* (*Pandora's Box*), in which **Adele Sandrock** and playwright **Frank Wedekind** himself were performing. **Otto Brahm** saw the production and immediately engaged Orloff as a member of his company at the Lessing Theater in **Berlin**, where she played a series

OTTO, TEO (1904–1968). Designer. Otto was among the most prolific stage designers the German theater ever produced. He became chief designer for the Prussian State Theater in 1930, and in a career that remained active until his death, he completed designs for more than 800 productions. He emigrated to Switzerland in 1933, becoming resident designer for the Zurich Schauspielhaus. Immediately after the war, Otto began a long-standing collaboration with **Harry Buckwitz**, but he worked extensively as well at the **Burgtheater** in **Vienna** at the Salzburg Festival. He also worked with numerous directors in several other non-German venues, including New York, London, Paris, and Milan. Otto is perhaps best known for the numerous **Bertolt Brecht** designs he completed for Buckwitz in Frankfurt am Main in the 1950s; he was named professor of stage design at the Art Academy of Düsseldorf in 1959, a post he held until his death.

– P –

PAULSEN, HARALD (1895–1954). Actor. Paulsen is best known as the original Mack the Knife in the world premiere of **Bertolt Brecht** and Kurt Weill's *Die Dreigroschenoper* (*The Threepenny Opera*). As a teenager Paulsen worked as an apprentice at the Thalia Theater in **Hamburg** and took acting lessons there from **Leopold Jessner**. Before his career could get started, however, he was drafted into the German army and served on the Western Front. Soon after his release from military duty, **Max Reinhardt** hired Paulsen, and by 1922 he had made a name for himself as a comedian. His vocal gifts were so substantial that he sang in some **Berlin** opera productions during the 1920s, but he also worked in operettas, musical revues, and roles for the debonair man-about-town. His casting as Mack the Knife was therefore logical and ironic, given the goals Brecht and **Erich Engel** had for the production. They cast him again for the 1930 premiere of *Aufstieg und Fall der Stadt Mahagonny* (*The Rise and Fall of the City of Mahagonny*). Paulsen remained active in both theater and film during the Third Reich, and in 1937 he was named *Staatsschauspieler* (state actor), marking him as one of the regime's favorites. That did not harm his career after the war, though, for between 1948 and his death he appeared in more than 25 films.

PENSION SCHÖLLER (*The Schöller Boardinghouse*) by Carl Laufs and Wilhelm Jacoby. Premiered 1890. One of the German theater's most effective farces, *Pension Schöller* has remained a favorite among audiences and performers since its premiere. Its action centers on the encounter of a provincial naïf named Philipp Klapproth with several eccentric "big-city" types at the boardinghouse of the title. While Klapproth's wife is out shopping and not expected back for hours, Klapproth asks his nephew to help him "go to a kind of house I've always heard about, but never had the nerve to visit." "A brothel?" asks the nephew. "Of course not!" retorts Klapproth. The kind of house he has in mind is one of those whose residents are "mentally impaired." The nephew takes Klapproth to Pension Schöller, a boardinghouse near the city's center where a half dozen remarkable characters reside. Among them is a student actor who cannot pronounce the letter *l* except as an *n*; his favorite play, naturally, is "*Winnem Tenn* by Friedrich Schinner." There is also a big-game hunter who tries to recruit Klapproth to go with him on his next safari, a woman who is taking inventory of every man she meets in the hope of finding a suitable husband for her daughter, a retired army major with a striking resemblance to Kaiser Wilhelm II, a woman who is writing a novel but after 17 years of note-taking has yet to write a single word, and similar oddballs who make their entrances and exits through the numerous doorways in the sitting room of the boardinghouse.

The Schöller boardinghouse is intended as a cross section of the Berlin population; the result is a parody of Berlin itself, and that parody extends to Schöller and his wife, the nominal authorities in charge of the place. They are perhaps the most bizarre of all, because they assume all their residents are completely normal. At the turn of the 20th century, no list of plays that regularly sold out would be complete without *Pension Schöller*, even though many critics condemned it as "disguised theater art." It had absolutely nothing to do with art, apologized one critic years later, "and [it] had no plans to be confused with art. But it certainly sets the laugh-muscles in motion" (Peter Squence, "Hessisches Landestheater, Kleines Haus: *Pension Schöller*," *Berliner Lokal-Anzeiger*, 14 May 1937).

PEYMANN, CLAUS (1937–). Director. Peymann began his directing career at the experimental Theater am Turm in Frankfurt am Main,

where he developed his accustomed taste for provocation and contro-versy. Like many of his contemporaries who had witnessed the passing of notable directors from the 1920s and 1930s, Peymann embraced controversy for the sake of notoriety, a pattern he has continued throughout his career. His first brush with a public squabble over his work at the national level came in 1971 with the world premiere of **Pe-ter Handke**'s *Der Ritt über den Bodensee* (*The Ride across Lake Con-stance*) at the Schaubühne am Halleschen Ufer in **Berlin**. That pro-duction led to a falling out with the theater's leading director and Peymann's colleague **Peter Stein**, so Peymann departed for work as a freelance director in Stuttgart, the Salzburg Festival, the **Deutsches Schauspielhaus** in **Hamburg**, and the **Burgtheater** in **Vienna**.

Peymann became **intendant** of the Württembergiches Staatsthe-ater in Stuttgart from 1974 to 1979, then director of the Bochum Schauspielhaus, a position he held until 1986 when he took over the Burgtheater. He remained in Vienna until 1999, when he assumed leadership of the **Berliner Ensemble** at the **Theater am Schiff-bauerdamm** in Berlin. In all of these venues, Peymann's productions won praise from colleagues throughout the German theater world, and the result has been a substantial number of invitations to the Berliner **Theatertreffen**. Peymann's 20 invitations exceed those of any other director except **Peter Zadek** since the Theatertreffen's in-ception in 1963–1964. Few other directors can match Peymann's longevity, his administrative gifts, his artistic vision, his ability to work with contemporary playwrights, and his unprecedented skill at manipulating the media.

Peymann has directed a number of world premieres, among them **Thomas Bernhard**'s *Minetti, Immanuel Kant, Vor dem Ruhestand* (*Eve of Retirement*), and *Heldenplatz* (*Heroes' Square*); Gerlind Reinshagen's *Himmel und Erde* (*Heaven and Earth*); and **Franz Xaver Kroetz**'s *Das Ende der Paarung* (*The Breakup*). The Bernhard productions at the Burg stirred the greatest controversy, due in part to Bernhard's extremely unflattering remarks about Austrians, usually timed to coincide with premieres of his plays. While in Bochum, Pey-mann had nine productions selected for the Theatertreffen, among them **Friedrich Schiller**'s *Die Räuber* (*The Robbers*), **Heinrich von Kleist**'s *Kätchen von Heilbronn* (*Kathy of Heilbronn*), and **Johann Wolfgang Goethe**'s *Faust, Part 1* and *Part 2*.

In Stuttgart, however, Peymann attracted attention less for artistic reasons than for political activities; a good example is his campaign in the mid-1970s to provide dental care for members of the Baader-Meinhof gang. Such campaigns usually endeared him to some, but alienated him from elected officials who provide the enormous subsidies he requires for the theaters he operates. Peymann has faced down attempts to cut subsidies for theaters where he has worked, usually by threatening to resign amid accusations of bureaucratic insensitivity, thereby gaining favor from the media. The result has typically been a contract extension with no decrease in public funding. Since his arrival at the Theater am Schiffbauerdamm in Berlin, he has threatened to resign nearly every year if funding for his theater were to be reduced. He is the recipient of numerous prizes and awards, and most critics consider him one of the most gifted directors working in contemporary German-language theater.

PIRCHAN, EMIL (Emil Pirschan, 1884–1957). Designer. Pirchan was **Leopold Jessner**'s most accomplished designer in the 1920s at the **Berlin** State Theater. He took the name of painter Emil Pirchan (1720–1778) when he embarked on his career as a stage designer. Among his most significant designs for Jessner were *Richard III* in 1919 and *Wilhelm Tell* (*William Tell*) in 1923, both with **Fritz Kortner** in the title role. Pirchan later worked at the **Burgtheater** in **Vienna** and became a professor at the Art Academy in Vienna, where he taught numerous courses on stage design. He is also the author of several books, the best of which is a treatment of the Viennese soubrette Marie Geistinger, published in 1947.

PISCATOR, ERWIN (1893–1966). Director. Piscator's experience of frontline duty in World War I had a lifetime impact on his work. The German army drafted Piscator into infantry service when he was a student in **Munich**, and the daily experience on the Western Front of violent death, filth, and dread had profound repercussions. Though he was relieved of direct battle duties in 1917 and became a leader of a military theater troupe (often playing female characters, such as the title role in Brandon Thomas's *Charley's Aunt*), he returned to **Berlin** from the trenches determined to become a theater artist who could enlist theater as an art form in service to political and social change. In the process,

he changed the theater by creating a new sense of mass-media performance, made possible through the implementation of technology.

Piscator joined the German Communist Party in 1919 and began working with Richard Hülsenbeck (1892–1974), **Karl-Heinz Martin**, Wieland Herzfeld (1896–1988), Herzfeld's brother John Heartfield (1891–1968), and **Georg Grosz** to stage "alternative theater" under the rubric "Kunst ist Scheisse!" (Art is shit!). Later the same year, he departed for Königsberg, where he planned to establish a troupe dedicated to the presentation of "propaganda and agitation," or "agitprop" in the terminology borrowed from the Bolsheviks. His ultimate goal at the time was to employ theater in fomenting German revolution similar to the one the Bolsheviks had carried out in Russia two years earlier. He returned a year later to Berlin, where he joined the "Proletarian Theater" troupe, doing agitprop plays in union halls and on the street in working-class neighborhoods. Piscator's experiences with this troupe included the accidental invention of "epic theater," he later stated. It developed from necessity, when Heartfield failed to show up with the required scenery. Piscator substituted a large, hastily sketched map to inform the audience where the action was set. Proletarian audiences greeted the Proletarian Theater with indifference, and police frequently broke up their performances.

Piscator next tried working in Berlin's small Central Theater, which Hans-José Rehfisch (1891–1960) had leased in 1922. With Rehfisch, he directed three plays that resulted in his Berlin breakthrough: Maxim Gorky's *Philistines*, Romain Rolland's *The Time Will Come*, and Leo Tolstoy's *The Power of Darkness*. Critics praised Piscator's modest productions of them, and in 1924 **Friedrich Kayssler** hired Piscator to direct at the Berlin Volksbühne. His first production there was Alfons Paquet's *Fahnen* (*Flags*), the first that Piscator publicly labeled "epic." Paquet was not a playwright but a journalist who had assembled a kind of documentary script dramatizing the 1877 Chicago street riot, after which several anarchists were executed for their perceived complicity in the event. Piscator eschewed anything American in the production but added projections on upstage screens to establish the social context of the play. Critics found little to praise in it, but Volksbühne audiences found it riveting.

Piscator then staged two revues for the German Communist Party, but party officials insisted that no "epic" devices be used in them. He

returned to the Volksbühne to direct Eugene O'Neill's *Moon of the Caribbees*, which critics found much to their liking. His next two productions, however, enraged critics. The first was an adaptation of **Friedrich Schiller**'s *Die Räuber* (*The Robbers*); the second was Ehm Welk's *Gewitter über Gotland* (*Storm over Gothland*), featuring medieval fishermen who looked curiously like Lenin, Trotsky, and other Russian revolutionaries. He also used filmstrips of World War I sea battles, harbors, and sailors. Despite critical opprobrium, Piscator attracted widespread admiration from middle-class leftists in Berlin, who began contributing money to help Piscator lease his own theater.

With the help of **Tilla Durieux**, Piscator leased the Theater am Nollendorfplatz in 1927, renamed it the Piscator-Bühne, and opened his first season with a stunning series of productions that remain among the most remarkable in 20th-century German theater. The first was **Ernst Toller**'s *Hoppla, wir leben* (*Hurrah, We Live!*), for which Piscator presented lengthy newsreels of events taken over the 10-year period in which the play's action takes place. Actors provided a documentary "feel" to the performance by engaging in dialogue that acknowledged the presence of the film images, since the Nollendorf facility provided a technical apparatus more advanced than had the Volksbühne. Critical and audience reaction was overwhelmingly positive, allowing Piscator (and his designer **Traugott Müller**) to mount an even more elaborate production for his next offering in 1927, *Rasputin*. This production featured a globe-shaped structure situated center stage that served the dual functions of both film screen and stage unit. It contained several acting areas, and as it revolved, the different areas revealed a host of actors playing in what Piscator called "the destiny of Europe, from 1914 to 1917." Like the Toller play, *Rasputin* created a sensation and earned him enough funding to mount his most successful production yet, *Die Abenteuer des guten Soldats Schweyk* (*The Adventures of the Good Soldier Schweik*). In it, Piscator (this time with the designs of Grosz) employed projections, filmstrips, conveyor belts, cutout figures, and set pieces in a satirical caricature of Schweik, the "good soldier" of World War I who hilariously survives one disaster after another, only to die in the end. It was Piscator's greatest triumph, one he never equaled.

Piscator left Germany in 1931 for Moscow, where he hoped to make films; he met with Josef Stalin about the project and hoped to

convince him of the need for a German-style Volksbühne in Moscow. Nothing came of the discussions, however, and Piscator left in 1936 for Paris, where he hoped to finish a large-scale dramatization of Tolstoy's *War and Peace*. In 1938 he moved on to New York and accepted an invitation to set up the "Dramatic Workshop" at the New School for Social Research, where students were mostly adults who had fled Europe and had been granted asylum status. He remained in New York for the next 12 years, and his students eventually included Marlon Brando, Shelley Winters, and several other young Americans who later became well known.

In 1951 Piscator returned to West Germany with little prospect of reestablishing himself as a director. His first efforts took place in small provincial theaters and among student groups. Audiences found his work stimulating, however, despite his widely condemned background as a Communist and his perceived sympathies with Stalin. Piscator's staging of *The Robbers* in Mannheim, **Georg Kaiser**'s *Gas I* and *Gas II* in Bochum, and Arthur Miller's *Death of a Salesman* in Berlin attracted widespread attention, and in 1962 he was appointed **intendant** of the Freie Volksbühne in West Berlin (refurbished after its destruction in World War II to countervail the original Volksbühne, which was in East Berlin).

At the Freie Volksbühne, he initiated his tenure with sensational controversy and ushered in a new trend in German dramaturgy called "documentary theater." It was not really new at all, since many of his productions in the 1920s had been based on documentary evidence employed in performance, but the aftermath of World War II provided an urgency to Piscator's "documentary" efforts. The first of his productions was **Rolf Hochhuth**'s *Der Stellvertreter* (*The Deputy*), loosely based on reports about the complicity of Pope Pius XII in German war crimes. The next year, Piscator presented *In der Sache J. Robert Oppenheimer* (*In the Matter of J. Robert Oppenheimer*) by Heinar Kipphardt (1922–1982), and in 1965 **Peter Weiss**'s *Die Ermittlung* (*The Investigation*). The Weiss play was composed almost entirely of testimony about investigations into the Auschwitz extermination camp. Characters recited original testimony, identified by names of the original defendants. The Kipphardt play was likewise based on investigative

proceedings, culled from hearings that probed the loyalty of Oppenheimer both when he helped develop the atomic bomb during World War II and when he declined to work on thermonuclear weapons after the war. All three playwrights claimed to be "documenting" events in history, and Piscator insisted that the theater was a valid forum for such deliberations. Both Piscator and the playwrights failed to acknowledge the fictional quality of the undertakings, especially since all of the material employed in the performances was selective and the product of extraction for the purpose of theatrical effectiveness, if not directly or obviously for political emphasis. Political emphases, however, were never far from Piscator's intentions throughout his career as a director. Through five tumultuous decades, he retained to the end the idealistic conviction that theater could effect change in political convictions and viewpoints.

PONTO, ERICH (1888–1957). Actor, director. Ponto is best remembered for his work as Peachum in the premiere of *Die Dreigroschenoper* (*The Threepenny Opera*). The enormous popularity of the show was his breakthrough, although he had been working steadily since 1908, beginning in Passau. From there he had engagements in Düsseldorf, **Munich**, and Dresden. Ponto differed from many other actors with a **Berlin** hit in their resumes, in that he remained active in one regional theater for most of his career. He worked as an actor and director for the Dresden State Theater from 1914 to 1947, and from 1945 to 1947 he was its **intendant**. In 1947 he came under fire from Communist Party officials, so he resumed work solely as an actor in numerous West German theaters. From 1950 to 1953 he worked exclusively with **Heinz Hilpert** in Göttingen. Ponto appeared in more than 70 movies, the most notable of which was the 1938 *Schneider Wibbel* (*Wibbel the Tailor*), based on the play of the same name by Otto Ernst.

POSSART, ERNST (1841–1921). Actor, director. Possart was a pastor's son who began his acting career in 1861 with his father's malediction, "A comedian in the House of Possart! A drifter, a vagabond!" The son was later knighted and raised to the aristocracy, becoming one

of the most respected and highly paid actors in 19th-century German theater. He performed in several provincial stages before becoming a director at the **Munich** Court Theater in 1878. In 1883 he briefly joined **Adolph L'Arronge** as a founding director of the **Deutsches Theater** in **Berlin** but resigned shortly thereafter and returned to Munich. In 1887 he agreed to become **Oskar Blumenthal**'s artistic director at the new Lessing Theater in Berlin, where he played Helmer in Germany's first unabridged version of Henrik Ibsen's *A Doll's House*. He left the Lessing in 1892, again for the Munich Court Theater, where he became **intendant**. In Munich he built the new Prince Regent's Theater and established the **Wagner** and Mozart Festivals. On his numerous tours to New York and Chicago, Possart appeared with several other German stars, usually in large-cast productions of classics. He played Polonius in *Hamlet* opposite **Ludwig Barnay** as the eponymous hero; Franz von Moor in **Friedrich Schiller**'s *Die Räuber* (*The Robbers*), with Barnay as his brother Karl; and the villainous Gessler in *Wilhelm Tell* (*William Tell*). American audiences found him declamatory, though his tendency to orate found widespread approval in Munich.

POSSE. A farcical, sometimes ribald comic form, the *Posse* reached its highest popularity and definition as a legitimate dramatic genre in the mid-1840s. Several variations on the Posse developed before then, among them *Zauberposse*, *Lokalposse*, and *Posse mit Gesang*. The form usually features a young hero who suffers a series of non-threatening misfortunes on his way to a happy outcome by the play's conclusion. The Posse is historically indebted to the *commedia* for its various comic types, though it is thought to have derived its principal formal characteristics from Shrovetide plays of the 16th century.

The addition of the low-comic character **Hanswurst** to the Posse was a result of cross-breeding between commedia and Shrovetide plays in the later 16th century. Hanswurst was a regular feature of the Posse throughout the 17th century, making his most frequent appearances in **Vienna**. The Posse survived several attacks from reformers such as **Johann Christoph Gottsched**, **Caroline Neuber**, and others in the 18th century, though the reformers' efforts to get

rid of Hanswurst—at least in his most vulgar aspects—were successful. The Posse remained in the repertoires of many German troupes without Hanswurst, while others did variations on the Posse format by adding magical settings and characters. Among the most significant of these was Emanuel Schikaneder (1751–1812), who employed music by Mozart to create *Die Zauberflöte* (*The Magic Flute*), perhaps the best known of all *Zauberpossen*. **Adolf Bäuerle** created Zaberl, a distant cousin of Hanswurst, for the numerous vehicles he wrote for himself in the late 18th and early 19th centuries, which were *Possen mit Gesang* (which included several songs in the performance). They featured popular melodies as interludes in the action; Bäuerle's works resembled those of Karl Meisl (1775–1853), who wrote more than 200 of them featuring another Hanswurst cousin, this one named Kasperle. Later **Carl Carl** created Staberl, and by the second decade of the 19th century, the Posse had reached such a point of popularity with audiences that several theaters depended on it for survival. Such a market attracted and sustained the talents of **Ferdinand Raimund** and **Johann Nepomuk Nestroy**; in their hands the Posse reached unprecedented artistic levels by the mid-19th century, a level few playwrights since them have been able successfully to emulate.

PRÄSIDENT, DER (*The President*) by **Georg Kaiser**. Premiered 1928. A satirical treatment of one man's attempt to advance socially in Parisian society, Kaiser's central character is an ambitious lawyer who attempts to revive the now-defunct "International Action League against the White Slave Trade." His principal goal in the process is to meet influential members of French society and marry off his 18-year-old daughter to an aristocrat. The daughter sees through her father's machinations and realizes that she is herself on a highly sophisticated form of trading block in the white slave trade. She determines to take the fight against prostitution into her own hands and agrees to run off with a madam and a pimp, along with a suitcase full of her father's money. The two crooks plan to abandon the girl and take the money as soon as it is convenient. The lawyer discovers the plot, but too late; he loses both his daughter and his money.

– R –

RADDATZ, CARL (1912–2004). Actor. Raddatz was an outstanding actor of both theater and film who began his career in the late 1930s in his native **Berlin** with **Heinz Hilpert**. He became a well-known movie star soon after his stage appearances, playing lead roles in several films produced by the UFA studio. In the postwar period, Raddatz resumed working with Hilpert, appearing in the world premiere of **Carl Zuckmayer**'s *Barbara Blomberg* in Göttingen and thereafter in several other Zuckmayer stagings. His work in the title role of Zuckmayer's *Der Hauptmann von Köpenick* (*The Captain of Köpenick*) at the Berlin Schiller Theater in 1968, in the opinion of many critics, surpassed the performance of **Werner Krauss** as the original Captain. Raddatz's voice was an unusually supple instrument, both in musicals and in straight plays. As a voiceover specialist, he was regularly hired as the German-language voice of Robert Taylor, Humphrey Bogart, and later Lee Marvin.

RAIMUND, FERDINAND (Ferdinand Raimann, 1790–1836). Playwright, actor. Raimund is closely identified with the *Volksstück*—particularly the *Zauberstück* variety of that dramatic species—with its roots in his native **Vienna**. His career began at age 18 when he joined a small touring company; after engagements in Pressburg and Ödenburg, his breakthrough came when he was engaged by the Theater in der Josefstadt in Vienna, and in 1815 he became that theater's most popular comic actor. In 1817 Raimund began to write short pieces and interludes for the Theater in der Leopoldstadt company. His first full-length play was *Der Barometermacher auf der Zauberinsel* (*The Barometer Maker on the Magic Island*), which premiered in 1823; it established him as both the leading actor and the leading playwright of Vienna during the 1820s. Others were *Der Diamant des Geisterkönigs* (*The Fairy King's Diamond*, 1824), *Das Mädchen aus der Feenwelt* (*The Girl from the Fairy World*; better known as *Der Bauer als Millionär*, *The Peasant as Millionaire*, 1826), *Die gefesselte Fantasie* (*The Imagination Enchained*, 1828), and his best play, *Der Alpenkönig und der Menschenfeind* (*The Alpine King and the Misanthrope*, 1828); all featured Raimund in the leading role.

Raimund was named director of the Leopoldstadt Theater in 1828, but he resigned in 1830 apparently suffering from nervous exhaustion. He toured as a guest artist to perform the roles he had created for himself and won enthusiastic acclaim nearly everywhere he played; his *Der Verschwender* (*The Prodigal*) of 1834 was his last effort, and in 1836 he committed suicide in despair that he would never be taken seriously. He had little estimation as a "serious" artist, his prosperity and renown notwithstanding. The frequency of his plays in repertoires increased throughout the remainder of the 19th century, however, and by 1900 most theaters had at least one Raimund play in their repertoires. The 20th century saw successive Raimund revivals, and students regularly study them as "serious" literature for the stage, much as he had hoped. There are Raimund memorials in several Austrian towns and cities, and in Vienna a theater bears his name, along with a learned society that promotes the scholarly study of his plays and career.

RAMLO, MARIE (Marie Conrad-Ramlo, 1850–1921). Actress. Ramlo had a lengthy career at the Residenz Theater in **Munich**, where she played Nora in the first Munich production (albeit abridged) of *A Doll's House* (in 1880, under **Ernst Possart**'s direction). Ramlo was one of very few German actresses who also wrote and published dramatic criticism. She defended **Naturalism** on the grounds that it was theatrically effective, maintaining that "natural" performances were far more effective than virtuotistic displays. "What we need . . . are people of flesh and blood [who] speak, feel, and act like human beings!" (*Die Gesellschaft*, 3:593).

RAUB DER SABINERINNEN, DER (*The Rape of the Sabine Women*) by Franz and Paul von Schönthan. Premiered 1885. The sturdiest of all the great German *Schwänke*—farce-comedies—popular in the Wilhelmine period. It is actually a parody on the theater itself. Its title derives from a pathetic play that a provincial schoolmaster has written in hopes of fame and fortune as a playwright. When Immanuel Striese (the bedraggled director of a touring troupe) offers to produce it, the schoolteacher temporarily loses his hard-won middle-class respectability and agrees to let Striese proceed. Audiences never witness the production in performance, but the director comes on

periodically in costume to report the continuing catastrophe that is opening night. Brothers Paul and **Franz von Schönthan** parody the comic genre of which *Rape* is a prime example, featuring utterly coincidental occurrences, chance encounters, two-dimensional characterizations, stereotypical love interests, formulaic reconciliations, and a ridiculously unpredictable ending. All of these components add up to a whole far greater than the sum of its parts. It is little wonder that it has been produced thousands of times since its premiere and indeed was the first German play produced after the collapse of **Berlin** in 1945.

RÄUBER, DIE (*The Robbers*) by **Friedrich Schiller**. Premiered 1782. Franz von Moor launches a conspiracy against his older brother Karl, a university student. Franz convinces their father that Karl has dissipated himself beyond redemption, then forges a letter in the old man's hand that disinherits Karl. Karl takes the news of his disinheritance badly and goes on a criminal spree with fellow students, among whose number is the devious and bloodthirsty Spiegelberg. Their crimes include not only robbery but also rape and murder. Karl is disgusted when he learns of his friends' criminality, but his oath of allegiance to them forbids his departure from their company. Franz unsuccessfully attempts to win the affection of Amalia, who remains loyal to Karl; he is luckier with his father, whose distress with Karl has caused in him a kind of apoplexy. Franz seizes the opportunity to lock up his father in a tower "for his own safety." Karl appears on the scene in disguise, hoping that Amalia still loves him; when he discovers the destruction his brother's intrigues have wrought, he launches an attack on the Moor estate. Franz hangs himself rather than be captured; in the tower, Karl finds his father naked, starving, and near death. But when the old man learns that his beloved younger son has become the leader of a criminal gang, he dies. Karl hopes for a new life with Amalia, but his comrades remind him of his oath; he kills Amalia and awaits the arrival of authorities, who will render justice upon him.

 The Robbers has been a significant play in German repertoires since its premiere; the roles of both Moor brothers have offered several actors the priceless opportunity of presenting themselves as a "Schillerian hero," though Franz von Moor is hardly heroic. As Schiller's pre-

mier "outcast of Hell," he compares favorably with Iago, Gloucester, and Sir Giles Overreach as a fascinating schemer on which actors of several generations have put a personal stamp of attainment.

RAUPACH, ERNST (1784–1852). Playwright. Raupach was a pastor's son born in Silesia, but he immigrated to Russia and began a teaching career in St. Petersburg. On the side, he wrote one-act entertainments for the local German theater company. He gave up teaching in his early 40s and in 1824 devoted himself full-time to writing for the **Berlin** stage. By 1826 he had his first verifiable hit, *Die Leibeigenen* (*The Serfs*). He went on to write more than 100 popular plays, and in the 1840s many of them were a regular feature at the Berlin Royal Theater. His most popular play there was *Die Schleichhändler* (*The Smugglers*), which ran for 35 seasons. His cycle of plays about the German dynastic family *The Hohenstaufens* consisted of 16 plays. **Max Martersteig** picturesquely described Raupach's stage works as "sugar cookies, gingerbread, cream pastries, and raisin streusel. After gorging themselves on that kind of fodder, audiences did not sleep well" (Martersteig, *Das deutsche Theater im neunzehnten Jahrhundert* [Leipzig: Breitkopf und Härtel, 1924], 444).

REICHER, EMANUEL (1849–1924). Actor. Reicher spent 16 years on provincial stages playing young heroes, then bon vivants, and finally character parts before he made his **Berlin** debut in 1885 at the Residenz Theater, as Emperor Justinian in Anton Anno's staging of Victorien Sardou's *Theodora*. Anno hated Reicher's depiction of the emperor as a lazy coward, but audiences found his highly detailed antiheroism extraordinary. Before Reicher, German actors had played such roles as German-speaking duplicates of their French originals. Reicher had what many critics called the most "resplendent organ" among his contemporaries, that is, the most resonant voice, and **Oskar Blumenthal** hired him in 1892 to play realistic character parts. He remained with Blumenthal until 1894, when **Otto Brahm** hired him likewise to play character parts, mostly in **Gerhart Hauptmann**, Henrik Ibsen, and **Arthur Schnitzler** plays. Brahm had cast Reicher in the male lead in the Freie Bühne world premiere of Hauptmann's *Before Sunrise* in 1889 and thereafter Reicher became closely identified with several Hauptmann parts, most notably the preposterous

Wehrhahn in *Der Biberpelz* (*The Beaver Coat*). Reicher had a substantial career in New York from 1915 to 1920, reprising many of the hits he had enjoyed in Berlin, though in New York he performed in English and also worked as a director.

REINHARDT, MAX (Max Goldmann, 1873–1943). Director, actor, manager. Reinhardt is among the most significant figures in the entire history of the German theater. He was both the herald of a new era and a fulfillment of nearly everything that had gone before it. His work is among the most researched, documented, and studied of any in the modern theater; books, articles, symposia, entries, book chapters, and essays about him continue to proliferate. Among Reinhardt's numerous contributions was the recognition that the modernist sensibility demanded the reevaluation and reinterpretation of almost everything, coupled with an enthusiastic embrace of the technological. Reinhardt saw that modernism was a revolution in perception, not just a rejection of previous standards and practices.

Reinhardt accomplished that perception initially in acting, because he had himself begun as an actor—playing older men's parts while still in his early 20s. **Otto Brahm** discovered him in Salzburg and brought him to **Berlin** in 1894 to play the pastor in **Gerhart Hauptmann**'s *Die versunkene Glocke* (*The Sunken Bell*), Engstrand in Henrik Ibsen's *Ghosts*, and Luka in Maxim Gorky's *The Lower Depths*. Playing such older men at a young age taught Reinhardt that **Naturalism** was simply one style among many; he also learned that Brahm's devotion to Naturalism had a tendency to turn theater into a kind of flimsy pulpit. To Reinhardt, the theater was a much larger enterprise than mere literature or politics.

Reinhardt began staging some plays for Brahm that later went on tour, and in 1898 Reinhardt and others formed the Sezessionbühne, or "Secession Theater," marking a stylistic break with Brahm's approach. In 1901 he, along with other Reinhardt actors, founded the *Schall und Rauch* (Noise and Smoke) at the Kleines Theater as a cabaret, parodying much of the work they did together under Brahm. The following year Reinhardt staged full-length plays in the Kleines Theater, and in 1903 he leased the **Theater am Schiffbauerdamm** (then called the Neues Theater) and ran it concurrently with the Kleines, getting rave reviews for productions of plays by **Hugo von Hofmannsthal**, Oscar Wilde, and **Frank Wedekind**.

When Brahm gave up his lease on the **Deutsches Theater** in 1904, Reinhardt wanted to take over the lease himself. He did so in the fall of 1905, agreeing to owner **Adolph L'Arronge**'s stipulation that he give up his other theaters and dedicate himself exclusively to the Deutsches. By 1906, however, he and his brother Edmund had put together a group of "silent partners" that included Frankfurt publishers, Leipzig businessmen, Berlin physicians, some heiresses, and several others to purchases the property from L'Arronge. Reinhardt also purchased a dance hall adjoining the Deutsches Theater and converted it into a small chamber theater, which he called the Kammerspiele.

In the years that followed, the Reinhardt enterprise purchased a number of additional properties, among them the Zirkus Schumann, the Berliner Theater, the Theater in der Josefstadt in **Vienna**, and the Komödie am Kurfürstendamm in Berlin, and he leased several others. At one point, Reinhardt even ran the Berlin Volksbühne. From 1905 to 1930, Reinhardt directed 452 plays performed 23,374 times in a dozen locations, including the Salzburg Festival, which he co-founded (George E. Wellwarth and Alfred Brooks, *Max Reinhardt, 1873–1973* [Binghamton, NY: Reinhardt Archive, 1973], 10). During his lifetime, Reinhardt ran 30 different theaters and companies, establishing an international reputation for innovation and daring. In the Wilhelmine period, he alone seemed capable of bypassing police **censorship** in dozens of plays previously thought "unstageable," while providing altogether new perceptions of **Shakespeare**. He put on 2,273 Shakespeare performances in Berlin alone.

Reinhardt's strongest influence was in Berlin, where he dominated theater life until 1933. He was nearly always at the center of most experimental undertakings, attracting some of the most gifted young artists of two generations. Among the first were **Alexander Moissi**, **Ernst Deutsch**, **Alexander Granach**, and **Gertrud Eysoldt**, whom Reinhardt cast because of their distinct "otherness." Yet he cast the traditional **Albert Bassermann** numerous times as Mephisto, Lear, Wallenstein, or Shylock, and likewise in provocative plays by **Carl Sternheim**. Reinhardt had as early as 1900 arrived at the extraordinary conclusion that every play was different, each in most cases requiring a different directorial and scenic approach. That was true even of Shakespeare, as his stagings for *A Midsummer Night's Dream* repeatedly demonstrated. Reinhardt's use of the stage revolve for *Midsummer* productions (there were a dozen of them between 1905

and 1934) has been well documented; his use of the plaster skydome is less well understood, for it allowed him to deploy subtle, diffused light onto the stage floor. Light diffused over the skydome created an infinite sense of depth and space behind the pictorial elements. He dispensed with old-fashioned footlights and overhead light battens as well, replacing them with instruments in coves that divided the stage area into distinctive acting planes (J. L. Styan, *Max Reinhardt* [Cambridge: Cambridge University Press, 1982], 118); such techniques popularized a modernist lighting ethos by accentuating architectural features in the abstract. It refined, distorted, or punctuated columns, steps, arches, platforms, or other geometrical shapes to suggest "unlocalization," often resulting in self-referentiality. That was especially true when Reinhardt selected a visual motif around which he created an entire production.

Such efforts led critics to accuse Reinhardt of sumptuous stylization, using embellishments merely for the sake of decoration. Such accusations were rarely accurate, though Reinhardt's wide-ranging eclecticism prompted him often to emphasize a unifying principle in an attempt always to provide his audiences with a satisfying experience; his was never a subsidized theater, and he was keenly aware of the need for ticket sales in everything he undertook. His entrepreneurship is indeed one of his most remarkable attainments as a theater manager, and he was expert in delegating responsibility in many areas of production. Yet Reinhardt himself remained in full command of nearly every production staged at his theaters prior to 1914, creating a *Regiebuch*, or production stage book, for each. In the book was laid out in precise detail, even before any rehearsals had taken place, nearly every aspect of a planned production.

Reinhardt's influence on subsequent developments in the German theater was enormous, and not only because his "reign" as its preeminent director lasted so long. The techniques he developed had a powerful influence on the numerous directors and actors who worked under him. His "inclusiveness" of material in his repertoires from the Far East, from Arabia, and from every historical period of the Western tradition exposed audiences to aesthetic dimensions previously unimagined. His embrace of myriad styles, from the realistic to the distinctly symbolic, from the modestly intimate to the exorbitantly presentational, provided audiences with new sensations, ideas, and possibilities for theater as an art form.

RITTNER, RUDOLF (1869–1943). Actor. Rittner began his career in the German-language theaters of Bratislava and Timisoara, but by his mid-20s he was playing French comedies at **Berlin**'s Residenz Theater under Sigmund Lautenberg. He played scores of roles for Sigmund Lautenberg, most notably Hans in the world premiere of **Max Halbe**'s *Jugend* (*Youth*). **Otto Brahm** hired Rittner in 1894 to play **Naturalist** roles, mostly in plays by **Gerhart Hauptmann** and Henrik Ibsen. He created the title role of *Fuhrmann Henschel* (*Teamster Henschel*) for Brahm in 1898 and critics praised his portrayal of Oswald in Ibsen's *Ghosts* for his unprecedented "naturalness" and lack of affectation. They also praised his work as the eponymous hero in Hauptmann's *Florian Geyer* for Brahm at the Lessing in 1905, but for different reasons; he played the "black knight" caught in the intrigues of the Reformation as a melancholic idealist fighting mightily for a doomed cause. A 1906 portrait of him in the role by Lovis Corinth (1858–1925) captures much of the energy Rittner invested in the part; it hangs in the Von der Heydt Museum in Wuppertal. He enjoyed other successes in a series of Hauptmann roles, often playing opposite **Else Lehmann**, leading many critics to extol him as the German theater's foremost Naturalist actor—yet he retired at age 38 in 1907 and returned to his ancestral estate in Silesia to take up farming full-time. He returned to acting for brief periods, but in most cases for small roles in films or on radio.

ROLLENFACH. Literally, "line of business." The practice of "type-casting" performers in a play or within a production company, based upon physical and vocal characteristics, was well established in the German theater by the mid-18th century. The *Fach,* or specialty, usually determined the contract under which a performer was hired. At the time, they included—though were not always restricted to—the *Held* (hero), *Charakterdarsteller* (character actor), *Charakterkomiker* (character comedian), *Diener* (servant), *Raisonneur* (confidant), *jugendlicher Held* (juvenile), *Intrigant* (heavy man/woman, villain/villainess), *Liebhaber* (lover), *Naïf* (ingenue), *Salondame* (walking lady), *Bonvivant* (walking gentleman), *Narr* (fool), and *Soubrette* (usually a saucy maid or attractive, lower-class brunette).

ROMANTICISM. The romantic strain in German theater and drama was a multifaceted thing, with manifestations in drama, performance,

and theory. It was initially apparent in the plays of the **Sturm und Drang** (Storm and Stress) movement, which involved a conscious rejection of neoclassicism and an equally deliberate embrace of emotional excess and unrestrained lyricism. That movement was finished by the 1780s, but its effects remained in the thinking and publications of several playwrights, directors, and theorists. Most significant among the theorists were the brothers **August Wilhelm Schlegel** and Friedrich Schlegel (1772–1829). Friedrich laid out theoretical groundwork for the desired characteristics of Romantic drama in the late 1790s; August Wilhelm addressed himself specifically to German drama in his *Vienna Lectures on Dramatic Art and Literature* in 1808. In that volume, Schlegel echoed Friedrich Wilhelm von Schelling (1775–1854) in his call for an intentionally mixed tragic-comic genre.

August Wilhelm Schlegel's most significant contribution to German Romanticism was his advocacy of **William Shakespeare**—though one must also note his admiration for the irrationality he found in the work of Spanish playwright Pedro Calderón de la Barca (1600–1681). **Ludwig Tieck** was Schlegel's most well-known collaborator on the translations of Shakespeare (though Tieck was personally responsible for only one translation), but Tieck was among the most significant Romanticists in German theater practice. His *Kaiser Octavianus* (*Emperor Octavianus*, 1804) was among the first programmatic Romantic plays, with various verse forms, alternating tragic and comic episodes, and a loosely connected plot set in several European cities. It became a model for subsequent efforts by lyric poets such as Achim von Arnim (1781–1831) and Josef von Eichendorff (1788–1857) when they tried their hands at playwriting. Tieck's most successful play was the comedy *Der gestiefelte Kater* (*Puss-in-Boots*, 1797), which featured all manner of theatrical conventions in addition to varied verse forms. Actors, audience, a playwright, a stage technician, the tomcat Hinze, and even a revived **Hanswurst** take turns puncturing theatrical illusion. Tieck's *Das Leben und Tod der heiligen Genoveva* (*The Life and Death of St. Genevieve*, 1799) concentrates on the suffering of a medieval saint, though Tieck again employed a wide variety of meter and verse.

Johann Wolfgang Goethe's contributions to German Romanticism were also significant. Many critics attribute to his novel *Die Leiden des*

jungen Werthers (*The Sorrows of Young Werther*, 1795) an influence that far overshadows the worth of the novel itself. As an exercise in sentimentality, it made Goethe famous far beyond the borders of Germany. Napoleon claimed to have read the novel seven times and made a point of visiting Goethe in 1808 to discuss it with him. The success of that book led some writers to employ some features of it in dramatic form, resulting in something called the *Schicksalstragödie* ("fate tragedy"). In *Der vierundzwanzigste Februar* (*The 24th of February*), written in 1806 by Zacharias Werner (1768–1823), a curse visits members of a family in a series of unfortunate events that take place on 24 February over a period of years. Many others like it featured an individual fated to suffer; many cite **Friedrich Schiller**'s *Die Braut von Messina* (*The Bride of Messina*) as one, and **Franz Grillparzer**'s *Die Ahnfrau* (The Ancestress) is widely acknowledged as another.

Many consider **Heinrich von Kleist** the greatest of Romantic playwrights, though he eschewed any programmatic Romanticism approach in his work. His tragedies and comedies, however, manifest many Romantic benchmarks. *Prinz Friedrich von Homburg* (*The Prince of Homburg*, 1811) features a hero whose suffering is certainly obvious, though Kleist's mastery of verse allows Prince Friedrich to transcend the sentimentality of *Werther*-like preoccupations with self. Prince Friedrich is nevertheless fated to fulfill his Prussian duty. In a Romantic vein similar to Tieck's *St. Genevieve*, Kleist's *Käthchen von Heilbronn* (*Kathy of Heilbronn*, 1810) features a background of medieval splendor replete with angels, courts, castles, and emperors.

Tieck was a gifted director, but the most accomplished director of German theatrical Romanticism was probably **August Wilhelm Iffland**, who not only premiered many of the Schlegel translations of Shakespeare but also presented productions of Schiller's plays in a splendor that was as elaborate as it was unprecedented. Iffland's productions of Kleist and **August von Kotzebue** were no less splendid, often featuring enormously large casts and orchestral music he had commissioned to accompany the proceedings.

RUDOLPH, NIELS-PETER (1940–). Director, **intendant**. In the 1970s, Rudolph was a much-acclaimed director with eight invitations to the Berliner **Theatertreffen** and several important premieres to his

credit (three of them by **Botho Strauss**). In 1979 he became intendant of the **Deutsches Schauspielhaus** in **Hamburg**; by 1984, however, Rudolph resigned from that position and embarked on a freelance directing career that took him to numerous venues, including opera houses and film.

RÜHLE, GÜNTHER (1924–). Critic, **intendant**. Rühle became one of the most significant critics and scholars of the German theater with his numerous book publications in the 1960s and 1970s while serving as cultural affairs editor of the *Frankfurter Neue Presse* and lead theater critic for the *Frankfurter Allgemeine Zeitung*. In 1985 he became intendant of the Frankfurt City Theaters, a post he held until 1990 when he became cultural editor of the *Berlin Tagesspiegel*. Rühle has served as president of the German Academy of the Performing Arts and the Alfred Kerr Foundation and as a regular contributor to the magazine *Theater Heute*. He is widely acknowledged as being among the most influential critical voices in the German theater of the 20th century.

– S –

SACHS, HANS (1494–1576). Playwright. Sachs is best known as a central character in **Richard Wagner**'s opera *Die Meistersinger von Nürnberg*, but his significance in the German theater derives from his prodigious output as a playwright and adaptor of Shrovetide comedies. In 1508 he began his apprenticeship as a cobbler in his native Nuremberg; the following years as a journeyman brought him to Lübeck, **Vienna**, Frankfurt, and other prosperous locales that offered him opportunities to witness a wide variety of 16th-century performance. He returned to Nuremberg in 1517 to establish himself as a master cobbler, which he attained in 1520, about the same time he began intensive activity with the Meistersingers, a lay brotherhood descended (according to some authorities) from singers of ecclesiastical music in the Rhineland. Meistersingers were well-established citizens of the towns in which they performed, mostly guild craftsmen like Sachs. They did not sing in public, however, and the secretive nature of the organization's rules, admission policies, and prac-

tices gave rise to a predictable speculation about members' activities.

Little such speculation, however, surrounded Sachs's religious advocacy and his work with apprentices and others, performing many of his plays written in Knittelverse, which has rhyming pairs of lines with irregular numbers of stressed and unstressed syllables. Sachs employed Knittelverse to demonstrate his mastery of rhyme, writing more than 200 plays during his lifetime, almost half of them Shrovetide plays performed in the days leading up to Shrove Tuesday. Sachs took a less frolicsome or convivial view toward Shrovetide than did many of his contemporaries; his wholehearted embrace of Martin Luther's Reformation in the 1520s had caused in him a pronounced distaste for Roman Catholicism and the excessive celebrations that often accompanied Shrovetide. Sachs saw in Shrovetide an opportunity to employ theater performance for a moral purpose. To that end, he wrote and adapted material familiar to his audience, usually structuring it in ways that were at once humorous and didactic. Many of his short farces are small masterpieces.

Sachs fell into a period of neglect in the 17th century, as the Enlightenment found his plays intolerably preachy. Students of the **Sturm und Drang** (Storm and Stress) movement in the 18th century, however, rediscovered him. **Johann Wolfgang Goethe** wrote a Shrovetide play in imitation of Sachs, and thereafter a growing appreciation of his work continued into the late 19th century. Many in the Wilhelmine period came to see him as the model of the Protestant middle-class ethic, whose energy and devotion to community was worthy of emulation. The Weimar period found little in him to admire, but the Nazis embraced Sachs as a genuine representative of the *Volk* community.

SANDER, OTTO (1941–). Actor. Sander is, along with **Georg Kaiser**, one of the few personalities in the German theater to have worked as a merchant seaman before beginning an active artistic career. After completing studies at the **Otto Falckenberg** School in **Munich**, Sander began working professionally in 1965 in Düsseldorf for two years, then in Heidelberg, then **Berlin**. In the early 1970s he joined the Schaubühne company there, working with **Klaus-Michael Grüber**, **Claus Peymann**, **Luc Bondy**, **Peter Stein**, and Robert Wilson. With Stein he did several productions, though many regarded his work in

Summer Folk as being among the best performances of the 1970s. With Wilson in 1979, he got good notices as the Comedian in *Death, Destruction, and Detroit*, which led to outstanding film work that established him internationally. He was particularly effective in leading roles for Völker Schlöndorff's *Die Blechtrommel* (*The Tin Drum*, 1979), as the submarine captain in Wolfgang Petersen's *Das Boot* (*The Boat*, 1981), as the toothsome Marxist Karl Liebknecht in Margarete von Trotta's *Rosa Luxemburg* (1986), in Wim Wenders's *Himmel über Berlin* (*Wings of Desire*, 1987), and *In weiter Ferne so nah!* (*Far Away, So Close!*, 1993). Sander continued working in Schaubühne productions in the 1980s, though not as a regular member of the company. His work in that decade included performances in Bondy's production of **Botho Strauss**'s *Kalldewey Farce* (1982), Stein's much-heralded production of Anton Chekhov's *The Three Sisters* (1984), and Grüber's *Amphytrion* by **Heinrich von Kleist**.

Sander is also a gifted comedian, singer, and voiceover artist; his manic performance in the cult classic *Kondom des Grauens* (*The Condom of Cruelty*, also titled *Killer Condom*, 1996) is a good example of his comic gifts, while his narration for *Aus Liebe zu Deutschland* (*For the Love of Germany*, 2003), the German television miniseries *Das Jahrhundert des Theaters* (*The Theater's Century*, 2002), and the German version of *How the Grinch Stole Christmas* (2000) put his resonant baritone on full aural display. His performance in the 1994 Berlin staging of Ralph Benatzky's musical version of **Oskar Blumenthal**'s *Im weiss'n Rössl* (*The White Horse Inn*) was a masterpiece of comic understatement.

SANDROCK, ADELE (1863–1937). Actress. In her late 50s, Sandrock became one of the most popular and recognizable comic actresses in Germany, though her training as an actress had begun nearly a half-century earlier, taking acting lessons as a child from her mother, who had been a German actress before her marriage to a Dutch physician. Sandrock made her debut at age 15 at **Berlin**'s Urania theater club in **Charlotte Birch-Pfeiffer**'s *Mutter und Sohn* (*Mother and Son*). By 1880 she had joined the Meininger troupe, touring with that company for five years. After engagements thereafter in small **Viennese** theaters and at the Deutsches Theater of Budapest, she returned to Vienna in triumph with an 1889 production of

Alexandre Dumas *fils*'s sensational *The Clemenceau Case* at the Theater an der Wien.

Sandrock remained in Vienna for the next decade, at the end of which she worked in several **Burgtheater** productions with her sister Wilhelmine Sandrock (1862–1948). Among the major roles for which she became well known were Magda in Hermann Sudermann's *Heimat*; Rebecca West in Henrik Ibsen's *Rosmersholm*; and the title roles in **Gotthold Ephraim Lessing**'s *Emilia Galotti*, **Friedrich Schiller**'s *Maria Stuart,* and **Franz Grillparzer**'s *Sappho*. She lived what was then considered a scandalous life, conducting numerous liaisons with prominent men, and **Arthur Schnitzler** was reported to have fashioned several disreputable ladies in his plays after her. He wrote the role of Fanny Theren in *Das Märchen* (*The Fairy Tale*) for her, but it was not nearly as successful as had been her Christine in his *Liebelei* (*Loving*).

At the height of her fame in Vienna, Sandrock left to go on tour throughout Europe, but the tour ended in disaster when Sandrock attempted to play the title role in *Hamlet* and by 1904 she was bankrupt. She found work periodically in Berlin beginning in 1905, and in 1910 **Max Reinhardt** signed her to an extended contract. In the same year she began her film career, performing in several short films every year until 1920, when she began playing Lady Bracknell in Oscar Wilde's *The Importance of Being Earnest*. So wildly popular were her performances of Lady Bracknell that her career experienced an upward trajectory similar to the one in 1898, and her roles in silent films during the 1920s increased proportionally. When a new technology made sound films possible in Germany, Sandrock's rich baritone became familiar to millions who had never seen her in the theater—and her career took off again. Among her hit movies of the 1930s were *Der Kongress tanzt* (*The Dancing Congress*), *Der tolle Bomberg* (*That Crazy Bomberg*), *Morgenrot* (*Dawn*), *Die englische Heirat* (*The English Marriage*), *Flitterwochen* (*Honeymoon*), *Die grosse und die kleine Welt* (*The Big and the Little World*), and shortly before she died, *Der Favorit der Kaiserin* (*The Empress's Favorite*).

SCHILLER, JOHANN CHRISTOPH FRIEDRICH (1759–1805). Playwright, drama theorist. Schiller's plays remain among the most

widely performed in the German theater, most of them enjoying acceptance and popularity ever since their first performances. They bespeak Schiller's towering stature in the German theater, second only to that of **Johann Wolfgang Goethe**. Schiller is an altogether different personality, however, and his ideas about the nature of theater and its purpose within German social structures have had a wider influence than Goethe's.

Schiller grew up in a military family and was sent to a military school in Stuttgart. By age 20, he had become an army physician. A year later he published *Die Räuber* (*The Robbers*), a play he had written while still a school pupil; **Wolfgang Heribert von Dalberg** premiered it in Mannheim in January 1782, and it became a nationwide hit of immense proportions. *The Robbers* represented the final impassioned exclamation of the **Sturm und Drang** (Storm and Stress) movement, though Schiller at the time had no direct contact with Goethe or other Storm and Stress playwrights. *The Robbers* is, however, the best of such plays and has remained popular in German repertoires for more than two centuries. Schiller went absent without leave to attend the play's premiere and was arrested. He returned to Stuttgart and began writing *Fiesko*, but he soon left army life for good and returned to Mannheim, this time to an estate where he hid from authorities and wrote *Kabale und Liebe* (*Intrigue and Love*) and *Don Carlos*. These plays fully established Schiller as a significant figure in the German theater. *Intrigue and Love* did not gain immediate popular acceptance, but audiences soon realized it was a stunning indictment of aristocracy's misuse of inherited privilege. *Don Carlos* shares a similar historical background to Goethe's *Egmont*, namely, the Spanish occupation of the Low Countries (present-day Netherlands, Luxembourg, and Belgium). It is a verse tragedy, however, though like *Egmont* it combines personal passions and large political predicaments.

Schiller was intensely interested in European history and wrote a long narrative on the Spanish occupation, which helped him secure an adjunct professorship at the University of Jena. While in Jena, he wrote a popular history of the Thirty Years' War. In 1791 two Danish-German noblemen awarded him a generous lifetime pension, enabling him to work on lengthy theoretical treatises on the ideas of Immanuel Kant and to complete four major plays. Schiller used Kant's ideas to

explain his own writing of tragedy and in so doing proved himself a remarkable thinker. His explications are extremely elaborate, yet they reveal a startling currency in his appraisal of modern man's moral obligation to choose appropriate action. Like a precursor to existentialism, Schiller advocated an unencumbered consciousness for the realization of man's full potential. He linked concepts such as *liberty, morality, Nature, sublime, passion,* and *suffering* in a systematic way to explain what actually happens both on stage and within the audience during performance. The theater, Schiller asserted, "teaches men to bear the strokes of fortune," giving audiences momentary pain at the sight of others' predicaments; in compensation, it provides a broader understanding of courage and endurance. Like Kant, Schiller insisted that there is within the human being an inherent moral sense to which tragedy appeals. It not only appeals to this sense but flatters it and gives satisfaction to the instinct of happiness "in the accomplishment of moral laws" by providing a means for the mind to focus on its own inherent moral sense. Theater is the only art form capable of accomplishing this task, according to Schiller, and it is thus a "moral institution," deserving—indeed requiring—state support in every phase of its creation.

Such theoretical musings prepared Schiller for the last and most significant phase of his playwriting career. His late works combine philosophical complexity, fateful national conflict, and compelling blank verse to present climactic moments in a nation's history. The first of them were the **Wallenstein** plays: *Wallensteins Lager (Wallenstein's Camp)*, written in rhymed couplets and first staged in 1797; *Die Piccolomini (The Piccolominis,* 1799); and *Wallensteins Tod (Wallenstein's Death,* 1799). They depicted the catastrophic effects of the Thirty Years' War on the German nation. Though written in three separate parts and sometimes called the *Wallenstein Trilogy,* the cycle actually consists of a one-act prologue and two five-act plays. In toto, they treat the figure of Albrecht Wenzel Eusebius von Wallenstein, who had it in his power to forge German unity, but who tragically overestimated his own capacities and relied heavily upon astrological predictions, resulting in the destruction of all hopes for unity. In **Maria Stuart** (1800), Schiller presented English history at a juncture when the forces of Catholicism and Protestantism confronted each other in a fictional yet dramatic meeting between Mary

Stuart and Queen Elizabeth I. In *Die Jungfrau von Orleans* (*The Maid of Orleans*, 1801), Schiller presented French history at its turning point, when royal power became central to the emergence of a unified French state. In *Wilhelm Tell* (*William Tell*, 1804), Schiller treated the struggle for Swiss independence and the revolt of Swiss foresters against their Habsburg overlords, including Tell's assassination of a tyrannical Austrian governor.

Goethe premiered Schiller's late plays in Weimar, but **August Wilhelm Iffland** gave them their first forceful and elaborate stagings in **Berlin**. Schiller's plays have fared better than Goethe's and have been far more numerous in production to the present day. Throughout the 19th and 20th centuries, nearly every theater in the German-speaking world featured at least one Schiller play in its repertoire every season. Schiller's plays have also been more frequently adapted as operas than perhaps any other German playwright's, with Donizetti's *Maria Stuarda* and Rossini's *Guglielmo Tell*, along with Verdi's *Don Carlo* and *Luisa Miller*, among the most well-known examples.

SCHINKEL, KARL FRIEDRICH (1781–1841). Designer, theater architect. Schinkel was the most active of "classical" German stage designers in the second decade of the 19th century, but his most significant work was the architectural design for the Royal Theater in **Berlin**, which opened in 1820 on Gendarme Square. It was known popularly as the "Schinkel-Bau," or Schinkel Building. Schinkel also completed several stage designs of plays by **Friedrich Schiller**, **Johann Wolfgang Goethe**, and **William Shakespeare** for **August Wilhelm Iffland**'s successor at the Royal Theater, Count Karl Brühl (1772–1837), between 1821 and 1828.

SCHLEEF, EINAR (1944–2001). Designer, director. Schleef established his career as a designer/director with the **Berliner Ensemble** in the early 1970s. He escaped East Germany in 1976 and took up the study of film directing in 1978. In the early 1980s Schleef directed several radio plays in West Germany and concomitantly began a career writing novels that ultimately earned him several awards, most notably the Alfred Döblin Prize in 1989. From 1985 to 1990 he was a principal director at the Frankfurt am Main City Theaters, and his

staging of **Gerhart Hauptmann**'s *Vor Sonnenaufgang (Before Sunrise)* was invited to the Berliner **Theatertreffen** in 1988. In 1993 Schleef returned to the Berliner Ensemble, where his world premiere of **Rolf Hochhuth**'s *Wessis in Weimar (West Germans in Weimar)* created a sensation and was likewise invited to the Theatertreffen. He presented several other world premieres, of his own plays and one by **Elfriede Jelinek** (*Sportstück [Sporting Play]*, at the **Burgtheater** in **Vienna** in 1998), and was widely recognized with prizes and citations.

SCHLEGEL, AUGUST WILHELM (1767–1845). Scholar, critic, translator. Among the most accomplished of **Shakespearean** critics in German, Schlegel also became Shakespeare's greatest advocate and translator. He was convinced that Shakespeare was not a "pre-neoclassical primitive," as many had concluded, but instead had a vast and comprehensive dramatic insight that superseded any formal considerations. Shakespeare was neither primal nor uncivilized nor a nonrealistic playwright, according to Schlegel, but a concrete thinker in his plays. Such convictions were at wide variance with those of Schlegel's contemporaries, who often regarded Shakespeare as a gifted poet who wrote for an undeveloped theater culture. Shakespeare's anachronisms, Schlegel contended, were not weaknesses but rather a sign of confidence both in himself and in the age in which he lived. He also felt that Shakespeare knew exactly how to employ structure for maximum effect and created characters "who behave according to their own internal laws." Schlegel insisted that Shakespeare's dramatic form was extremely "compressed," and therefore the language in the plays had more functions than did normal speech in everyday life. As verse "is more concentrated in meaning than prose, it was a natural language for Shakespeare's stage." Schlegel's comprehensive knowledge of Shakespeare was due to his translations of the plays, and his influential essays established Shakespeare as a national figure in Germany.

SCHLENTHER, PAUL (1854–1916). Critic, **intendant**. Schlenther's career resembled **Otto Brahm**'s to a certain degree, beginning as a critic and concluding as a theater administrator. He also shared Brahm's enthusiasm for the plays of Henrik Ibsen and **Gerhart Hauptmann**. Schlenther and Brahm were colleagues on the **Berlin**

Vossische Zeitung, where Theodor Fontane was the chief drama critic. Schlenther succeeded Fontane in 1886, and with Brahm and others, he helped found the Freie Bühne organization to subvert police **censorship**. Schlenther left Berlin in 1898 to become director of **Vienna**'s **Burgtheater**, where he continued to present contemporary plays, many of them at in contradiction to the prevailing "royal and imperial" taste for drama.

SCHLÖSSER, RAINER (1899–1945). **Dramaturg.** Schlösser was **Joseph Goebbels**'s chief functionary in the Ministry of Propaganda as Reichsdramaturg during the Hitler dictatorship. He had responsibility for licensing performances of all plays "in fulfillment of theater's task in a National Socialist state." One of his primary tasks was to ascertain the political "reliability" and ethnic "purity" of all theater artists. Schlösser was dedicated to the National Socialist cause, helping to promote the work of playwrights whom the regime favored.

SCHMETTERLINGSSCHLACHT, DIE (*The Battle of the Butterflies*) by Hermann Sudermann. Premiered 1895. Widow Hergentheim has been left with three daughters and a small pension on which to live. They barely eke by, even though the widow takes in boarders and the daughters work in the Winkelmann dress shop as fan painters. Rosi, the youngest at 17, comes up with a design that portrays a battle of butterflies—hence the play's metaphorical title, symbolizing the battle between Rosi and her sisters for a suitable husband. The design becomes popular among Winkelmann's clientele and Rosi earns more than her sisters. The oldest sister Else at age 21 is already a widow, her husband having committed suicide in the wake of an embezzlement scandal.

Else now is in line to marry Max, the Winkelmann son. Winkelmann *père* is a shady character, having driven his wife out of the house and forced her to raise their son Max in impecunious circumstances. Max has now been forced to return and work for his father. Winkelmann oppresses everybody he can, with the exception of his best traveling salesman, the sedulous Herr Kessler. Kessler is witty and pleasant to be around—but for him the old-fashioned virtues of honor and integrity belong to the past. He once boarded with the Hergentheims, but when he became Else's lover, Frau Hergentheim

threw him out. Despite Else's engagement to Max Winkelmann, Kessler and Else maintain their illicit affair. Little sister Rosi acts as their go-between, naïvely believing that theirs is a true love. When Max discovers Else and Kessler together, they tell him that it is Rosi who is actually Kessler's girlfriend.

Kessler quits his job at Winkelmann's and everyone supposes he will now marry Rosi. But Winkelmann does not want to lose his best workers. Then Max confesses that his engagement with Else is off because he is in love with Rosi; Rosi says she loves Max, and old Winkelmann sees an opportunity. He offers his son a promotion and Rosi a fixed salary. By the play's end, it appears that the play's nicest people will be rewarded with happier lives.

This comedy fixes on the deceptiveness of appearances. It convincingly presents an unpleasant milieu, much in a Dickensian manner, and compensates "good" characters for their suffering while "bad" characters tend to reap the evil they have sown. Sudermann's sentimentality and acceptance of social conditions distinguish *The Battle of the Butterflies* from a **Gerhart Hauptmann** comedy; there is little implication that social conditions must change before the lives of good people like Rosi or Max can improve. Such characters accept social conditions as they are, unjust and exploitative though they may be. Injustice and exploitation strike bad characters equally hard, after all, and there is little inference that improved social conditions would change their behavior anyway. People like Max and Rosi must therefore make the best of a bad situation—which indeed they have already done, and their prospects are bright indeed.

SCHMITT, SALADIN (1883–1951). Director. Schmitt is closely associated with the Bochum Schauspielhaus, which he ran from 1919 to 1949 as a kind of temple dedicated to the classics. He presented various cycles of plays by **William Shakespeare**, **Johann Wolfgang Goethe**, **Friedrich Schiller**, and **Heinrich von Kleist**, usually in a format he called "Festival Weeks," which allowed audiences to see one play after another by a specific author. Schmitt's productions were usually done up in a somewhat pompous style, though they were always characterized by exactitude in delivery of dialogue. In some ways, Schmitt was a neo-Weimar Classicist, because his approach in many ways resembled Goethe's in Weimar.

of important roles, including Hannele in **Gerhart Hauptmann**'s *Hanneles Himmelfahrt* (*Hannele's Assumption*) and Hedwig in Henrik Ibsen's *The Wild Duck*. Hauptmann was so taken with her that he wrote *Und Pippa tanzt!* (*And Pippa Dances!*) for her in 1905. Orloff played the title role in the world premiere, which Brahm staged in early 1906. In 1910 she joined **Vienna**'s **Burgtheater** company and remained there until 1918. In 1933 she emigrated to England, staying until 1939, when she returned to Berlin and performed mature roles in numerous Hauptmann productions, most notably Frau Fielitz in *Der rote Hahn* (*The Red Rooster*) at the Rose Theater in Berlin.

OSTERMEIER, THOMAS (1968–). Director. After completing studies in directing at the Ernst Busch School in **Berlin**, Ostermeier embarked on his career at "The Barracks," an experimental theater workshop associated with the **Deutsches Theater**. In 1998 he staged the German-language premiere of British playwright Mark Ravenhill's controversial *Shopping and Fucking*, which won him an invitation to the Berliner **Theatertreffen**. In the same year, he followed up that controversy with the German premiere of American playwright Richard Dresser's *Below the Belt*. In September 1999, Ostermeier became director of the Schaubühne am Lehniner Platz in Berlin. He has staged several premieres of German plays at the **Deutsches Schauspielhaus** in **Hamburg**, including *Feuergesicht* (*Fireface*) and *Parasiten* (*Parasites*) by **Marius von Mayenburg**. For the Salzburg Festival, Ostermeier staged the German-language premiere of Norwegian playwright Jon Fosse's *The Name*, and in Edinburgh he staged Fosse's much-acclaimed English-language premiere of *The Girl on the Sofa*. Ostermeier has won several awards for his directing work, and in 2004 he was named an artistic associate of the Avignon Festival.

OSTERSPIEL VON MURI (*Easter Play of Mary*). Thought to be the oldest extant play written in the German language, the anonymous *Osterspiel* is in Middle High German and treats the encounters of the risen Christ with his women followers, particularly the Mary portrayed in the Gospel account of John 20:11–18. The play features a verse form considered to be characteristic of courtly poetry from about 1200 to 1240, when the play was probably written.

SCHMITZ, SYBILLE (1909–1955). Actress. Schmitz was among the most sensuous and beautiful of all the actresses in the Third Reich, though her career began at age 19 with **Max Reinhardt** after she received acting training from **Louise Dumont**. She had an altogether different "look" from other actresses, along with an obvious, raw talent that Reinhardt found appealing. Schmitz debuted for Reinhardt in early 1928 as a serving maid in Ossip Dymov's *Bronx Express*, directed by **Heinz Hilpert**. She caught the critics' eye later that year in Hilpert's production of *Die Verbrecher* (*The Criminals*). In 1929 she began working in films, most notably in *Tagebuch einer Verlorenen* (*Diary of a Lost Girl*) with Louise Brooks. Her film breakthrough came in 1932 with *F.P. 1 antwortet nicht* (*F.P. 1 Doesn't Answer*) with **Hans Albers** and **Peter Lorre**. **Herbert Ihering** said of Schmitz: "Finally a new type, finally a new tone. No outbreaks, [just] timbre in vocal expression with little obvious histrionic nuances." Her voice often registered a provocative innocence, a feature not lost on the Nazi leadership. Schmitz made 26 films during the Nazi era, though her resistance to **Joseph Goebbels'** sexual propositions led to far fewer film jobs by the 1940s.

SCHNITZLER, ARTHUR (1862–1931). Playwright. Schnitzler was a product of *fin de siècle* **Vienna**, and his artistic sensibility was in a way similar to **Hugo von Hofmannsthal**'s, though Schnitzler was much less lyrical in his plays and far more interested in the sensual. Schnitzler also had greater interest in writing plays with popular appeal. His working relationship with **Otto Brahm** was based on their mutual interest in theater production and on the deep personal friendship the two men developed at the beginning of the 20th century.

Sigmund Freud (1856–1939) recognized in Schnitzler not only a fellow Viennese physician but a man like himself who saw the connection between eroticism and morbidity. He referred to Schnitzler as a scientific colleague whom critics had likewise denounced for his "investigations [into] the underestimated and often traduced erotic" (Kurt Berge, ed., *Georg Brandes und Arthur Schnitzler: Ein Briefwechsel* [Bern: Francke, 1956], 29). Schnitzler was, like Freud, a licensed physician who cultivated an interest in psychology. By the mid-1890s, however, Schnitzler had devoted himself fully to playwriting.

His first success came with *Liebelei* (variously translated as *Light o' Love*, *Love's Adventures*, or simply *Loving*) in 1895 at the **Burg-**

theater. In it, two young gallants (one of whom Schnitzler modeled on himself as a young man) bed down with two *süsse Mädel* (lower-class girls from the Viennese suburbs). One of the girls, Christine, falls madly in love with Fritz, who is also having an affair with a married woman. The aggrieved husband of the woman challenges Fritz to a duel and kills him. Christine discovers Fritz's death in a haphazard way, days after the duel; she becomes hysterical and departs, presumably to kill herself.

Schnitzler gave Brahm exclusive rights to the performance of his plays in **Berlin** at the **Deutsches Theater**, and Brahm staged 10 Schnitzler plays, both at the Deutsches and later at the Lessing, with varying degrees of popular and critical success. Schnitzler's most successful plays among the public were his comedies, including the short *Der grüne Kakadu* (*The Green Cockatoo*, 1899), *Zwischenspiel* (*Interlude*, 1905), and *Komtesse Mitzi* (*Countess Mitzi*, 1909).

Among Schnitzler's most controversial plays was *Anatol*, again based on his own youthful adventures. Schnitzler completed it in 1893 and a Czech-language production was staged in Prague in 1895. Only in 1910, however, did the premiere of the original script take place. *Anatol* is actually seven one-act playlets, all of them featuring the title character's attempts at seduction, usually accompanied by ennui, frustration, and hypocrisy—or a combination of all three. *Der Reigen* shared a similar history of controversy with *Anatol*. Usually translated as *La Ronde*, Schnitzler completed *Der Reigen* in 1897 but it did not premiere in German until 1920 (after a 1912 Hungarian production in Budapest). Like *Anatol*, *Der Reigen* is a series of short plays, but it features an equal number of male and female characters, each of whom has sex with the other through a round of encounters (hence the title). By the final round, the original couple find themselves again in each other's presence. What made the play so disturbing was its frankness; couples matter-of-factly copulated with each other (though not in view of the audience), giving the impression of unappetizing cynicism. It lacked much of the eroticism found in Schnitzler's other works—perhaps one reason it became Schnitzler's most popular play in English translation.

Professor Bernhardi has likewise proved to be popular. It is also somewhat autobiographical, in that Schnitzler based some of it on his father. And it too was controversial—though the Berlin police allowed its premiere production for public performance at the Lessing

Theater in 1912 under Brahm's direction. Brahm correctly prophesied that a Berlin production would be easier to stage than one in Vienna, largely because "in Berlin, Jewish doctors are not persecuted, in fact they dominate the place. We will thus have fewer hurdles to jump over than in [Austria], the land of the Eucharistic Congress" (Oskar Seidlin, ed., *Der Briefwechsel Arthur Schnitzler-Otto Brahm* [Tübingen: Niemeyer, 1979], 347). Both Schnitzler and Brahm acknowledged *Professor Bernhardi* as a comedy, though it dealt with a Jewish doctor's treatment of a Catholic girl's abortion and its deadly aftermath. As she lies dying of septicemia, Bernhardi gives her enough medication to allow her to die in peace. When a Catholic priest arrives to administer last rites to the girl, Bernhardi refuses the priest admission to the girl's room. In the midst of the ensuing argument between Bernhardi and the priest, the girl expires. Bernhardi is then put on trial for "obstructing a priest," while anti-Semitic protests call for a lengthy prison term or even worse punishment. He is convicted, but only for two months. He emerges from prison refreshed and revitalized, prepared to meet his former colleagues and the public with a jovial spirit. Brahm died during the play's premiere, and Schnitzler suffered his loss profoundly.

SCHOLZ, WENZEL (1787–1857). Actor. Scholz is best known for his work with **Johann Nepomuk Nestroy** at the Carl Theater in **Vienna**. His corpulence was one of his selling points as a performer, especially in combination with Nestroy's lean angularity. In many of the comedies Nestroy wrote for himself and Scholz, there is a scene of comic byplay that emphasized their physical differences but often resulted in a kind of mutual discovery, allowing the two to proceed through various plays as devoted friends, comic antagonists, or victims of a shared fate. In some ways they were precursors to the dual acts of English vaudeville or the more well-known likes of Laurel and Hardy in American short films. Scholz began his career at the **Burgtheater** and later worked in many of the same pathetic regional theaters as did Nestroy—a fact that cemented their relationship and doubtlessly delighted them during the years of their most fruitful collaborations at the Carl. Their collaboration began with Nestroy's first hit in Vienna, *Der böse Geist Lumpazivagabundus* (*The Evil Spirit Lumpazivagabundus*) in 1833.

SCHÖNEMANN, JOHANN FRIEDRICH (1704–1782). Actor, manager. Schönemann was already an established actor when he joined the **Caroline Neuber** troupe in 1730. After working with Neuber for nine years, he formed his own troupe and continued in traditions she had established. He hired several performers she had employed, including **Konrad Ekhof**, **Konrad Ernst Ackermann**, and Sophie Schröder. By 1743 the Schönemann troupe had become so influential in its Prussian tours that the Prussian court awarded Schönemann a general concession to perform in all Prussian provinces, as well as in the major cities except **Berlin**. Schönemann published the plays his company had performed in 1748, lending credence to the German theater's growing claims as an important cultural institution. Little is directly known about Schönemann's qualities as an actor, though through his leadership of the troupe as one of its premier performers, it reached the height of its renown and profitability by the 1750s. In 1752–1753, he and Ekhof attempted to found an acting academy, but by 1754 Schönemann began to lose interest both in it and in his troupe generally. He turned his attentions instead to horse breeding, and in 1757 he surrendered full control of the troupe to Ekhof.

SCHÖNHERR, KARL (1867–1943). Playwright. Schönherr is best known for his epic depiction of Protestants expelled from their homeland in the Tyrol during the Counter-Reformation, *Glaube und Heimat* (*Faith and Homeland*). It was the most frequently performed play in German theaters for five seasons after its premiere in 1910. German nationalists in the 1920s embraced the play as a call to rescue ethnic Germans throughout Europe in the aftermath of World War I, and the National Socialists saw it as a work of prophecy.

SCHÖNTHAN, FRANZ VON (1849–1913). Playwright, actor. Schönthan was one of the most frequently performed playwrights in the Wilhelmine period; no season between 1885 and 1918 passed without several of his plays, written with collaborators or alone, in dozens of repertoires. After service as an officer in the Austrian navy, Schönthan had begun to work as an actor in provincial theaters in 1872. The **Berlin** Residenztheater hired him in 1878, and the following year **Theodor Lebrun** engaged him at the Wallner Theater. There he met **Gustav von Moser**, at that time the Wallner's leading

playwright; under Moser he polished his skills as a playwright, and in 1880 their *Der Zugvogel* (*The Migratory Bird*) premiered in **Hamburg**. Their *Krieg im Frieden* (*War in Peace*) premiered in 1880 and it too was widely popular, but their subsequent efforts proved less popular. In 1883 Schönthan became principal director at the **Vienna** City Theater. There he began collaborating with his brother Paul on a play that satirized the Wilhelmine theater itself, *Der Raub der Sabinerinnen* (*The Rape of the Sabine Women*). It premiered in 1885 and proceeded to take Wilhelmine theaters by storm; the play had thousands of performances throughout the German-speaking world, dominating repertoires for decades. Schönthan retired from acting and directing in 1886 and concentrated on playwriting until his death, working with several other collaborators successfully—but none of their efforts exceeded the success of *The Rape of the Sabine Women*.

SCHREYVOGEL, JOSEPH (1768–1832). Director. Schreyvogel is most closely associated with the **Burgtheater** in **Vienna**, of which he was de facto director from 1814 to 1832. His actual title was "**dramaturg** and court theater secretary," but under his direction the Burg company became one of the finest in the German-speaking world. Schreyvogel brought **Heinrich Anschütz** to the Burg, and his acting style served as a model for many other members of the company. Schreyvogel's productions of **William Shakespeare** and Calderón de la Barca won wide praise, but his attempts to promote **Franz Grillparzer** often met with stiff resistance from political authorities.

SCHRÖDER, FRIEDRICH LUDWIG (1744–1816). Actor, manager. Schröder's theatrical pedigree was outstanding as the son of actress Sophie Schröder and stepson of **Konrad Ernst Ackermann**. He spent his childhood with his parents touring North German towns, cities, and courts, but the troupe lost track of him in 1756 in the midst of Königsberg's evacuation when Russian armies besieged the city during the Seven Years' War. Reunited with the troupe and his parents two years later, he regularly played minor comedic parts as a singer and acrobat. Schröder remained with the company until it moved into the **Hamburg** Komödienhaus in 1767. He then joined the Austrian troupe of Felix Kurz and toured with them for two years.

Schröder took over his parents' troupe in 1771 when Ackermann died, and in 1774 he reestablished the company in Hamburg. With his mother and sisters Dorothea and Charlotte, he raised the stature of the troupe in Hamburg to unprecedented levels of competence and permanence. Schröder instituted **William Shakespeare** as a playwright fixed in the company's repertoire, though he always performed Shakespeare in bowdlerized or abridged versions. Schröder's performances as Hamlet, Lear, and Macbeth were thought to be particularly distinctive, despite his own physical limitations as a performer. His productions of the **Sturm und Drang** (Storm and Stress) playwrights were crucial to their acceptance, and his premiere of **Johann Wolfgang Goethe**'s *Götz von Berlichingen* and *Clavigo* in 1774 marked the beginning of Goethe's playwriting career. His subsequent premieres of plays by Friedrich Klinger and Jakob Lenz were likewise popular.

Schröder left Hamburg in 1778 and appeared in several German theaters as a guest artist. His reception on tour was enthusiastic almost everywhere he went, which led to an invitation in 1781 to join **Vienna**'s **Burgtheater**, where he remained for four years. Schröder returned to Hamburg in 1786 and staged numerous premieres of **August von Kotzebue**, **August Wilhelm Iffland**, English middle-class tragedies, and other popular fare that proved far more financially attractive to the theater than had Shakespeare or Goethe.

In many ways, Schröder was a precursor to the modern director, rehearsing productions and coaching actors more extensively than others had previously attempted. He insisted on disciplined rehearsals and usually approached each production as an entity unto itself rather than using the "stock" approach in casting, scenery, and costuming. The Hamburg company by 1790 had more than 120 sets in stock, far more than any other German theater. He also insisted that in performance, the actor was more important than the playwright. "The actor must overcome the playwright," he said. "Woe betide the actor if an audience leaves the theater and says, 'That play was beautifully written.' It is a literary society the audience has just left." (Schröder, *Denkwürdigkeiten des Schauspielers*, ed. Hermann Uhde [Hamburg: Mauke, 1875], 2:136).

SCHÜTTE, ERNST (1877–1948). Designer. Schütte was a gifted designer for **Max Reinhardt** and later **Heinz Hilpert**. His design for Arthur Hopkins's *Burlesque* (under the German title *Artisten*) in 1928

employed a stage revolve to capture the play's circus milieu. Schütte's use of a stage revolve was characteristic of his sense of the cinematic rather than the atmospheric; for the world premiere of **Fritz von Unruh**'s satire on the film industry, *Phea*, in 1930, he used it again to portray the hectic activity typical of film studios in **Berlin**, churning out movies on a weekly basis. Reinhardt entrusted to Schütte the designs for several other world premieres he produced late in the Weimar period with Hilpert directing: **Ferdinand Bruckner**'s *Elisabeth von England* (1930), **Carl Zuckmayer**'s *Der Hauptmann von Köpenick* (*The Captain of Köpenick*, 1931), **Ödön von Horváth**'s *Geschichten aus dem Wienerwald* (*Tales of the Vienna Woods*, 1931), and **Gerhart Hauptmann**'s *Vor Sonnenuntergang* (*Before Sunset*, 1932). Schütte was forced into exile in 1934 because he refused to divorce his Jewish wife, yet his skills were so highly prized as a designer even among the Nazis that Hilpert was able to offer him the head designer's job at the **Deutsches Theater** with full assurances from the regime that they would allow Schütte's wife and daughter to remain in **Berlin** with him unmolested.

SCHWANK. The etymological source of this form of situation comedy is the Middle High German *swanc*, meaning a prank or comic escapade; it could have meant the recitation of said prank, but by the beginning of the 19th century, **August von Kotzebue** was using *Schwank* to mean a comic play predicated on complications arising from a compounding series of situations. It developed through the 19th century as a situation comedy first and foremost, with discoveries, reversals, and mistaken identities as the basic materials of its dramatic content. The exposition is totally mechanical, much as it is in French farce, a means to set up the situation in which the comic action may develop. Characters in the Schwank have relationships with each other that go only deep enough to further the comic situation. They usually have no previous conflicts with one another, and they reveal their feelings or motivations only to the point of creating additional complications that will enable further comic situations to develop. The Schwank is most often a play with at least three acts and rarely any music. Characters do not "try" to get laughs, and actors must almost always play their lines straight. The customary situations in which characters involuntarily find themselves have been skill-

fully created to evoke pleasant, but not forceful laughter within an audience.

The Schwank enjoyed its apex of popularity between 1880 and 1930, when thousands of them were premiered—usually in **Berlin**—and subsequently in repertoires throughout the German-speaking world. Some of the most popular plays in the history of German theater have been *Schwänke*, most notable and successful among them **Franz von Schönthan**'s *Der Raub der Sabinerinnen* (*The Rape of the Sabine Women*), Carl Laufs and Wilhelm Jacoby's *Pension Schöller* (*The Schöller Boardinghouse*), and **Franz Arnold** and **Ernst Bach**'s *Die spanische Fliege* (*The Spanish Fly*).

SCHWEIKART, HANS (1895–1975). Director, **intendant**. Schweikart began his career as an actor in 1915 in his native **Berlin**, but his career is most closely identified with **Munich**, where he worked for more than half a century. Under **Otto Falckenberg**, he played a wide variety of leading roles at the Kammerspiele beginning in 1923. By 1926 he was directing there, and in 1934 he moved to the Bavarian State Theater as that institutions's chief director. Beginning in 1938 he divided his time between theater and film, directing 10 films for the Bavaria Studio in Munich. In 1947 Schweikart assumed leadership of the Kammerspiele, which he guided through the 1950s to the top ranks of German theaters, largely by fostering the productions of **Fritz Kortner** and staging the West German premieres of **Friedrich Dürrenmatt**. His productions of plays by Arthur Miller were widely praised as well, particularly his *Death of a Salesman* in 1950. After his retirement from the Kammerspiele in 1963, Schweikart staged several West German premieres of plays by Harold Pinter, Christopher Hampton, Edward Albee, and Peter Shaffer.

SCHWIERIGE, DER (*The Difficult Man*) by **Hugo von Hoffmannsthal**. Premiered 1921. Hofmannsthal demonstrated a surprising mastery of the "comedy of manners" format with this play, similar in some ways to his libretto for the enormously popular *Der Rosenkavalier*. The "difficult man" of the title is Count Bühl, who is not difficult at all. He is indeed an entirely charming gentleman, adept at pleasant conversation and gifted with an urbane wit and desirable companionability. He finds it difficult, however, to approach ladies in a superficial manner and

make small talk with them, as he is often required to do at the numerous dinner parties to which he is invited. He finds discussions of marriage altogether "indecent," even though he is an exquisitely eligible bachelor. He meets his match in Helene Altenwyl, who gently and respectfully takes the initiative, which leads to an altogether discreet engagement.

SELLNER, GUSTAV RUDOLF (1905–1990). Director, **intendant**. Sellner was best known for his stagings of Greek classics immediately after World War II, though his career as an actor, director, and intendant had begun two decades earlier. His productions applied a spare sobriety that at the time seemed novel and innovative. Unlike previous stagings of Greek classics, Sellner's eschewed grandiosity in favor of concentration on individual figures suffering the vicissitudes of fate on an unadorned stage. The approach found resonance among audiences in the immediate postwar period, largely because many in the audience had become well acquainted with suffering and grief. "Figures on the stage [in Sellner's productions] were viewed existentially, not sociologically; they did not seek to change the world but cling to what remained in a world that had changed so much" (Georg Hensel, *Frankfurter Allgemeine Zeitung*, 25 May 1990). Sellner did most of his important directing work in Darmstadt in the remains of its Court Theater. In the 1960s he became a director primarily of operas in **Berlin**.

SEYDELMANN, KARL (1793–1843). Actor. Seydelmann began his career with a troupe of court theater actors, but his first professional engagements were in Breslau, Graz, and Prague. He established himself as a serious actor in **Shakespearean** roles at the Court Theater in Kassel during the 1820s. Later he worked in Stuttgart, where he took on directorial duties and solidified his national reputation as an actor. Seydelmann was among the first actors to make a name for himself as Mephisto. His performances in that role in *Faust, Part 1* at the Royal Theater in **Berlin** confirmed Seydelmann as one of the most outstanding actors in Germany between 1838 and 1842.

SEYLER, ABEL (1730–1800). Actor, manager. Seyler was a significant 18th-century *Prinzipal*, leading his own theater troupe to resi

dencies in several courts and large cities in the 1760s. His troupe numbered more than 60 members, including a ballet corps, orchestra, and traveling designer. In the 1770s his troupe held residencies in Weimar, Gotha, Leipzig, and Dresden. Seyler became a director at the Mannheim National Theater in 1781, and from there went on to direct the Schleswig Court Theater. He remained in Schleswig until 1792, when he was awarded a lifetime pension from the ducal court of Schleswig. Seyler was instrumental in popularizing plays of the **Sturm und Drang** (Storm and Stress) movement, maintaining many of them in his repertoire for decades.

SHAKESPEARE, WILLIAM (1564–1616). Playwright. Shakespeare's significance in the German theater has been and remains unique; many have gone so far as to argue that Shakespeare is a "national" playwright whose status equals that of **Gotthold Ephraim Lessing**, **Johann Wolfgang Goethe**, or **Friedrich Schiller**. Shakespeare's popularity among German audiences and the frequency of his plays' performance in German theaters since the 18th century is undeniable. The German Shakespeare Society, founded in 1864, is the oldest surviving national professional organization created to support Shakespeare scholarship. It became the model for similar societies in England, the United States, Australia, Canada, and other English-speaking countries. In a speech before the German Shakespeare Society in 1915, **Gerhart Hauptmann** intemperately declared that Shakespeare was more German than English:

> There is no nation, not even the English, that has earned a right to Shakespeare as the German nation has. Shakespeare's characters have become a part of our world, his soul has become one with ours: and if he was born and buried in England, it is nevertheless in Germany where he truly lives.

The National Socialists made similar bombastic claims.

German audiences were likely introduced to Shakespeare's plays at some of the initial performances of the **Englische Komödianten** (English Comedians) in the late 16th century, though there is scant record of such performances; there is less likelihood that the plays were complete or authentic. The first published German record of Shakespeare's name in print came in Daniel Georg Morhof's lecture

on the origins of German literature in 1682. In 1741 Caspar Wilhelm von Borcke produced the first translation of a complete Shakespearean play (*Julius Caesar*, in French-style Alexandrine verses), and the same year saw Johann Elias Schlegel's publication of *Vergleichung Shakespears und Andreas Gryphs* (*A Comparison between Shakespeare and Andreas Gryphius*). Schlegel's essay was significant by virtue of the positive tone he took toward Shakespeare; other critics, **Johann Christoph Gottsched** most notable among them, had emphasized Shakespeare's ignorance of neoclassical rules and declared his "unworthiness" for the German stage. Lessing took issue with Gottsched on that and many other points, arguing that the German theater was far better advised to emulate the "Shakespearean model" than the French, as Gottsched advocated.

In the 1760s several new prose translations of Shakespeare's plays by Christian Martin Wieland appeared; Wieland translated one (*A Midsummer Night's Dream*) into verse. After reading Wieland's translations, Goethe declared that he "stood like one who has been blind from birth [and] was given the gift of sight by a miraculous hand." In 1771 Goethe published his "Zum Shakespeares Tag" (On Shakespeare's Name Day), in which he apotheosized Shakespeare as a godlike figure: "Natur! Natur! Nichts so Natur wie Schäkspears Menschen!" (Nature! Nature! Nothing so much like Nature as Shakespeare's characters!).

Friedrich Ludwig Schröder staged a 1776 prose translation of *Hamlet* in **Hamburg**, followed soon thereafter by *Othello*; he went on to stage several others during the ensuing decades, though they were often in abridged or truncated versions. The playwrights of the **Sturm und Drang** (Storm and Stress) movement continued in Goethe's idolizing vein, largely because emulating Shakespeare offered a complete break with neoclassicism.

New translations of the plays appeared periodically through the remainder of the 18th century, though none of them approached the magisterial heights **August Wilhelm Schlegel** reached beginning in 1798. A. W. Schlegel concentrated on what he considered Shakespeare's best plays, completing eight histories, five comedies, and three tragedies. The effort left him exhausted by 1810, and he did not finish another translation. Schlegel's publisher beseeched **Ludwig Tieck** to continue the endeavor, but Tieck was able to complete only

Pericles. Tieck likewise found the remainder of the task too daunting for him alone, and he ultimately turned to his daughter Dorothea and the Danish count **Wolf Baudissin** for help. Baudissin finished 13 of the remaining plays and Dorothea did six; Tieck eventually mentioned Baudissin's name but he never acknowledged Dorothea's work. The translations subsequently became famous as *Shakespeare's Dramatic Works, Translated by August Wilhelm von Schlegel and Ludwig Tieck* (published 1825–1833), popularly called the Schlegel-Tieck versions. They were largely the basis for Shakespeare's abundant place in the repertoires of most German theaters throughout the 19th century. Even by 1827, critic **Christian Dietrich Grabbe** complained that a "Shakespeare mania" had taken hold in Germany. By then the popularity of Shakespeare's plays had reached unprecedented proportions and few theaters had any interest in questioning its validity (as Grabbe did).

Goethe had meanwhile lost his initial enthusiasm for Shakespeare; by the mid-1790s he began to equate his former perception of "nature" in Shakespeare's plays with "formlessness." He also became distinctly troubled by the effects Shakespeare seemed to have on audiences. Goethe's sense of "classicism" in Weimar postulated an idealized unity and harmony on the stage. Shakespeare's plays had no such postulates; indeed, he concluded, the plays make few demands of any kind on audiences. "The relationship between the stage and audience in the Weimar Court Theatre paralleled the benevolent but despotic relationship between ruler and ruled in the Duchy of Weimar," Simon Williams has written. "In spirit, the teeming world of Shakespeare was far from that well structured order. Never was the unsuitability of Shakespeare to the purpose of the German court theater in the late 18th and early 19th centuries more clearly revealed" (Williams, *Shakespeare on the German Stage* [New York: Cambridge University Press, 1990], 1:92–93).

The unstructured, "teeming" state of Shakespeare's "world" was one reason so many German actors and actresses turned such characters as Hamlet, Gloucester, Othello, Prospero, Lear, Shylock, and even Dogberry (in *Much Ado about Nothing*) and Hermione (in *The Winter's Tale*) into virtuotistic star turns in the decades that followed the publication of the Schlegel-Tieck translations. Goethe's Mephisto in *Faust* and Schiller's Franz von Moor in *Die Räuber* (*The Robbers*)

offered actors a somewhat similar freedom to extrapolate, but few other German plays afforded performers such opportunities. As noted in individual entries in this volume, the careers of such 19th-century performers as **Bogumil Dawison**, **Ludwig Devrient**, **Ferdinand Fleck**, **Adalbert Matkowsky**, **Friedrich Mitterwurzer**, **Karl Seydelmann**, **Agnes Sorma**, and **Charlotte Wolter** would have been far less resplendent without the roles Shakespeare offered them. German actors and actresses of the 20th century such as **Gustaf Gründgens**, **Fritz Kortner**, **Werner Krauss**, **Agnes Straub**, and **Elisabeth Bergner** likewise benefited enormously from the chance to put a personal stamp on Shakespearean roles they played.

German directors, however, have derived the most opulent benefits from Shakespeare's status as a German playwright. In the 19th century, the productions of **Heinrich Laube**, **Georg II**, and **Josef Schreyvogel** helped them legitimize their work. In the 20th century, the career of **Max Reinhardt** is nearly unimaginable without Shakespeare. Reinhardt did five different productions of *A Midsummer Night's Dream* in **Berlin** alone. **Leopold Jessner**'s **Expressionist** productions of *Macbeth* and *Hamlet* during the 1920s at the Berlin State theater created an uproar leading to charges that he had "Jewified" the German theater. During the Third Reich, **Jürgen Fehling**'s State Theater productions of *Richard III* and *Richard II* were probably the two most significant German-language productions staged between 1933 and 1944. And in the postwar period, **Saladin Schmitt**'s Shakespearean cycles in Bochum reestablished nonpoliticized production values.

By the 1970s, however, tendentiousness and political agendas made a pronounced reemergence in the German theater, often with Shakespeare as a convenient anvil on which ambitious directors could hammer out personal obsessions. In Ulm, **Peter Zadek** staged *The Merchant of Venice* with a stereotyped, hooked-nose Shylock lusting for Gentile blood. He explored similar approaches toward other Shakespearean plays in Bochum with the stated goal of forcing German audiences to confront what he considered the particularly German malady of anti-Semitism. As new translations continued to appear throughout the 20th century, adaptations, variations, versions, and modernizations proliferated. The boundless freedom that Shakespeare afforded to not only audiences but also theater artists resulted in num-

berless new approaches that scarcely resembled the plays as pieces for theater performance. In many instances, German directors have used the plays as points of departure into flights of fancy. **George Tabori**'s 1979 *Improvisations on Shakespeare's Shylock* was staged in a former assembly room of the Munich SS and used 13 actors to play Shylock. **Peter Stein**'s *Shakespeare's Memory* (1978) was a seven-hour-long extravaganza presented on two evenings, consisting of dialogue sections from various plays by Shakespeare and attempting to replicate Elizabethan social and political conditions. **Heiner Müller**'s *Hamlet-machine* used one line and a few characters from *Hamlet* as a jumping-off place for a kind of pessimistic meditation.

Such experiments continued to proliferate into the 21st century, capturing audience and critical attention briefly, then disappearing without a trace. Nevertheless, they served as an abiding testament to Shakespeare's vital place in the German theater. That directors choose to mine Shakespeare's plays for some hoped-for discovery that might augment their own vision of what the German theater can still accomplish is a hopeful sign that Shakespeare continues to hold a unique place in the German repertoire.

SONNENTHAL, ADOLF (1834–1909). Actor. Sonnenthal made his debut at age 17 at the Deutsches Theater of Timisoara, Romania. He was born in Budapest, Hungary, and spent the early years of his career in Habsburg lands until he got an engagement in Königsberg in 1856. There, **Heinrich Laube** saw him and hired him as a member of the **Burgtheater** in **Vienna**. Sonnenthal's first role at the Burg came as the title character in William Mountfort's *Mortimer*, and it led to several subsequent star turns that included Hamlet, the Marquis Posa in **Friedrich Schiller**'s *Don Carlos*, and Lord Rochester in **Charlotte Birch-Pfeiffer**'s adaptation of *Jane Eyre* titled *Die Waise von Lowood* (*The Orphan of Lowood*). In 1859 the Burgtheater offered Sonnenthal a lifetime contract, which culminated in his being raised to the aristocracy in 1881, at which time he gave up his Hungarian citizenship.

Sonnenthal remained with the Burg until his retirement, though he frequently did guest appearances in **Berlin** and in other German cities. He ran the Burgtheater company in the late 1880s, when his career was beginning to resemble that of **Ludwig Barnay**. Like Barnay, Sonnenthal was a Jew born in Budapest and rose to become a member of

the establishment. Unlike Barnay, however, Sonnenthal could not avoid political and cultural controversy. In 1889 while performing the title role in *Wallenstein* at the Deutsches Theater in Budapest, a Hungarian nationalist set fire to the structure; his motive was to protest the appearance of Sonnenthal (by then, Adolf *von* Sonnenthal) whom some Hungarians considered a traitor and a representative of Germanic cultural imperialism. The theater was destroyed, and German-speaking troupes returned to Budapest only infrequently thereafter.

During the 1890s Sonnenthal tried his hand at **Naturalist** acting in the plays of Henrik Ibsen, with distinctly mixed results. **Otto Brahm** concluded that Sonnenthal had once been a great actor, but the advent of Naturalism meant that his acting was now out of fashion. When **Max Burckhard** took over the reins of the Burg in the 1890s and began to present the plays of Ibsen, **Gerhart Hauptmann**, and **Arthur Schnitzler**, Sonnenthal himself recognized that something had definitely changed and that his talents were insufficient to make the transition.

SORMA, AGNES (Agnes Marthe Caroline Zaremba, 1865–1927). Actress. One of the most acclaimed and accomplished actresses in the German theater, Sorma was best known for her portrayals of Henrik Ibsen heroines. She made her debut at age 15 under the name Agnes Pallatschek at the Lobe Theater in her native Breslau. She then worked in Posen and took acting lessons in Görlitz. After seeing her in Weimar, **Adolph L'Arronge** hired her for his first season at the **Deutsches Theater** in **Berlin** in 1882. She remained with L'Arronge until she joined **Ludwig Barnay**'s company in 1891 at the Walhalla Theater (which Barnay renamed the Berliner Theater) and remained there until she returned to the Deutsches Theater in 1894 to work with **Otto Brahm**.

Sorma had a tenderness onstage that was quite unusual, a direct naturalness that was disarming and always seemed completely unpretentious. **Josef Kainz**, with whom she was frequently paired in *Hamlet*, *Romeo and Juliet*, and *Don Carlos*, complained that she lacked technical skills, but in roles like Clara in **Friedrich Hebbel**'s *Maria Magdalena* and Shakespeare's Juliet, she seemed simply to "be" on the stage, never holding anything back—yet never resorting to vocal tricks, dramatic pauses, or fainting spells for effectiveness. Few actresses before her time actually looked Mediterranean in the way

Juliet might have. She was hardly a Nordic type to play Nora in *A Doll's House*, either, yet in Sorma's portrayal, Nora was herself a foreigner, or at least on foreign soil within the make-believe world of the doll's house. In other words, she was a prototype for the modernist actress, much as **Alexander Moissi** was among actors. Like Moissi, she was "agreeably" foreign, at least to most German audiences.

That was one reason **Max Reinhardt** hired her in 1904 when Brahm relinquished the Deutsches. Her dark skin, black hair, and almond-shaped eyes exuded what one contemporary called an exotic "Gypsy quality." When she fell to her knees in **Franz Grillparzer**'s *The Jewess of Toledo*, eyes glistening and bosom heaving, "no intellect, no morality could resist her" (Ferdinand Gregori, "Mit der Sorma bei Brahm," in *Agnes Sorma*, ed. Julius Bab [Heidelberg: Kampmann, 1927], 62). Ferdinand Gregori (1845–1928) played Krogstad with Sorma at the Deutsches in *A Doll's House*, and in the scene where Nora confronts the callous Krogstad, Nora is supposed to crumble under his threats of blackmail. Sorma's performance was so compelling that real tears welled up in her eyes, her body literally wracked with remorse, guilt, and fear. Gregori started crying as well and simply could not stop himself. She helped him get through the scene, but at its end he went back to his dressing room and continued bawling like a baby, so great was the impact Sorma had had on him. Reinhardt recognized that "foreignness" alone was merely an attractive novelty; Sorma combined both sensuality and modesty with it, which "was not to be confused with naïveté or ignorance" (Gregori, *Agnes Sorma*, 68). Yet she seemed to know instinctively what most men wanted from her. That knowledge, combined with her willing submission to them, often had the potential to drive many men in the audience to tears, just as it had done to Gregori.

Sorma made frequent tours throughout Europe and to the United States. In New York she played to sold-out houses in several productions at the Irving Place Theater, introducing the plays of **Gerhart Hauptmann** to audiences there. She also played many of the **Shakespearen** roles for which she had become well known with Kainz, in addition to those by Ibsen and George Bernard Shaw.

STAHL, ERNST LEOPOLD (1882–1949). Critic, **dramaturg**, scholar.

Stahl was an important "non-Berlin" critic; he frequently visited the

German theater capital but remained in **Munich** or his native Mannheim nearly all of his career. Stahl was among the first to recognize the importance of **Richard Weichert**'s work in Mannheim and later in Frankfurt am Main. He was also significant for his interest in stage design; few reviewers before him wrote much about design's role in a production, and he frequently organized museum exhibitions of stage designs. Stahl was also an insightful theater historian, writing books on **Shakespeare** in 19th-century German theater.

STEIN, PETER (1937–). Director. Stein emerged as one of the most significant directors in the 1970s, amid several others who were likewise innovative; his many detractors accused him of abandoning the whole idea of the playwright's text in favor of concentrating on himself as an artist coequal with the playwright and interlarding his stagings with Marxist ideology. Stein began working professionally in the 1960s under **Fritz Kortner** at the **Munich** Kammerspiele. His first hit production there was the German-language premiere of Edward Bond's *Saved* in 1967. The following year, he attracted even wider attention with his stagings of **Bertolt Brecht**'s *Im Dickicht der Städte* (*In the Jungle of Cities*) and Peter Weiss's *Diskurs über Vietnam* (*Vietnam Discourse*).

Many critics praised Stein's **Bremen** productions of **Friedrich Schiller**'s *Kabale und Liebe* (*Intrigue and Love*) and particularly of **Johann Wolfgang Goethe**'s *Tarquato Tasso* as the opening scenes of a new era in the German theater. In *Tasso*, Stein and **dramaturg** Dieter Sturm rearranged the play's events to reflect more accurately, they believed, a Marxist conviction of "social forces" at work on the title character and his eventual exile from the ducal court. The setting by Wilfried Minks had little to do with Goethe's original script but was intended to represent an ideological milieu in which Tasso was to subsist until called upon to perform at court. Equally innovative productions of Bond's *Early Morning*, Sean O'Casey's *Cock-a-Doodle-Dandy*, and Thomas Middleton and William Rowley's *The Changeling* at the Zurich Schauspielhaus convinced the **Berlin** Senate to offer Stein the Theater am Halleschen Ufer along with a generous subsidy to run it. He accepted their offer and moved to Berlin in 1970, taking with him fellow director **Claus Peymann**, dramaturg Sturm, and several performers with whom he had been working, in-

cluding **Bruno Ganz**, **Edith Clever**, **Jutta Lampe**, and Michael König. Among the notable productions he staged in the early 1970s at the Schaubühne (which had been founded in 1962 with neither subsidy nor full-time staff) were Brecht's *The Mother* with **Therese Giehse**, Henrik Ibsen's *Peer Gynt* (on two successive evenings), and the German premiere of Vsevolod Vishnevsky's *The Optimistic Tragedy*.

Through the 1970s Stein continued to restructure scripts as part of his political agenda, "revealing" what he considered to be their hidden ideologies in an optimistic search for relevancy. One such effort was *Shakespeare's Memory* in 1978, cobbled together from several snippets of **William Shakespeare**'s plays. Stein began to abandon an overt political approach in the 1980s when the Berlin Senate provided him with new quarters, a former movie theater remodeled to his specifications. This facility was called the Schaubühne am Lehniner Platz and there Stein staged plays like Anton Chekhov's *The Three Sisters* in a "text-true" fashion. It was so realistically detailed that it became the most popular production Stein had ever staged. When he and the company took the production to Moscow in 1989 and staged it at the Moscow Art Theater, Russian critics were so astonished by it that many claimed the production was "probably" much like the one Konstantin Stanislavsky had done for the play's world premiere in 1901. The production was a clear indication that he had retreated from his Marxist convictions.

Stein resigned as director of the Schaubühne in 1985 and turned his attention increasingly to directing opera. From 1991 to 1997 he directed the Salzburg Festival. Stein has received several awards and prizes for his body of work, including the Erasmus Prize in 1993.

STEINRÜCK, ALBERT (1872–1929). Actor. Steinrück is best recognized as a *Kraftkerl*, the soft-hearted, thickset strongman type much beloved of German audiences. His breakthrough came playing the title role of **Georg Büchner**'s *Woyzeck* in 1913 at the **Munich** Court Theater, the first professional production of that play. Steinrück had begun his career 20 years earlier and had worked steadily since the mid-1890s; he was **Max Reinhardt**'s first Dr. Schön in **Frank Wedekind**'s *Erdgeist* (*Earth Spirit*) with **Gertud Eysoldt** as Lulu at the Kleines Theater in 1902. He remained with Reinhardt until 1908,

when he began directing and acting in Munich at the Court Theater. Steinrück was also an accomplished film actor, appearing in more than 80 movies. Steinrück has the odd distinction of having one of the most lavish funeral services in the history of German theater. In fact, his was not a funeral service at all but rather a performance of Wedekind's *Marquis of Keith* to benefit Steinrück's widow and family, in which dozens of Berlin's greatest stars took part.

STELLA by **Johann Wolfgang Goethe**. Premiered 1776. The baroness of the title in this somewhat lugubrious tragedy deeply regrets the loss of her husband Fernando, who deserted her three years earlier. She shares her emotions with Cäcilie, whose husband likewise left her, though some time ago. Meanwhile in the dining room of the small hotel where the women meet, Cäcilie's daughter Lucie is charmed by a man she has met at dinner. He proves to be her long-lost father and the erstwhile husband of both Cäcilie and Stella. Fernando proposes a reconciliation with Stella, but then he prepares to depart with Cäcilie, causing enormous grief to Stella. Cäcilie suggests a *ménage à trois*, and Stella at first seems to accept it but then changes her mind and swallows poison. Fernando, in the meantime, changes his mind, too, and desires a return to Stella; when he finds her dying of the poison, he exits and an offstage pistol shot is heard. Cäcilie attempts to revive Stella, while Lucie reports that Fernando lies outside in a pool of blood. Stella, with her dying breath, begs Cäcilie and Lucie to comfort and care for Fernando.

STERBENDE CATO, DER (*The Dying Cato*) by **Johann Christoph Gottsched**. Premiered 1732. Gottsched based this verse tragedy on subject matter French neoclassical playwrights had tried to develop, as part of his efforts to reform German theater along neoclassical lines. The play's principal virtue is Gottsched's attempt to write Alexandrine verse in German. Its title character (Marcus Porcius Cato, known to history as Cato the Younger) has sought refuge in Utica, North Africa, during the civil war between the forces of Caesar and Pompey. Cato refuses the conciliatory efforts of Caesar, preferring suicide to what he realizes will be a dictatorship in Rome. The final act features Cato's lengthy deliberations on God and eternity, culminating in his realization that the way to freedom, in his case, lies only through self-inflicted death.

STERNAUX, LUDWIG (1885–1935). Critic. Sternaux wrote reviews for the **Berlin** *Lokal-Anzeiger*, often with a polished aptitude for perceiving more about the actor's work than did his contemporaries. He was particularly adept at describing an actor's performance. Sternaux disliked **Bertolt Brecht**'s plays in the 1920s, though he did not attack him with the vituperation of **Alfred Kerr** and others.

STERNHEIM, CARL (William Adolf Karl Sternheim, 1878–1942). Playwright. Sternheim came from a prosperous banking family and grew up in privileged surroundings; he attended exclusive schools in **Berlin** and several German universities. As a playwright, Sternheim satirized lower-middle-class striving to achieve the prosperity he knew and enjoyed throughout his life. In Sternheim's plays, such characters lived in a fantasy world, desirous of escape from their humdrum lives through the use of disjointed and incoherent phraseology. They ultimately achieve prosperity, but in the process become utterly pompous, a result of Sternheim's keen ear for idiomatic usage. His characters frequently spoke German "officialese" common to bureaucratic pronouncements or in small-court proceedings between litigants. The result was a vicious lampoon of Wilhelmine society in which upstanding, law-abiding citizens are often deflated by their own bombast. The language Sternheim used forced actors to discipline themselves against leisurely deliberateness in speaking; they sometimes bark at each other, using verbs that are unexpected, outdated, or weirdly inappropriate.

Sternheim considered himself the German Molière, though his true precedents lay in Berlin's culture of boulevard comedies. His uncle Hermann Sternheim (1849–1916) was director from 1887 to 1894 of the **Belle-Alliance Theater** in Berlin, where the nephew "witnessed numberless works of the lightweight muse: farces, comedies, costume pieces, along with the vitality and exuberance that . . . brought down the house with laughter I thought would never stop" (Sternheim, *Vorkriegseuropa* [Amsterdam: Querido, 1936], 74). As a nine-year-old, he witnessed theater artists at close range and learned the profession's jargon and the idiosyncrasies that enabled them to attract audiences.

Sternheim's first playwriting success was *Auf Krugdorf* (*In Krugdorf*) in 1902 at the Königliches Schauspielhaus Dresden. Its popularity in Dresden, however, did not result in demand for his other efforts

elsewhere in the country. By 1909 he secured an agreement with **Max Reinhardt** to produce an original treatment of Molière material titled *Der Riese* (*The Giant*), which he later changed to *Die Hose* (*The Underpants*)—a title rejected by police **censors**. With the help of **Tilla Durieux**'s influence on Berlin police chief Traugott von Jagow, however, Reinhardt premiered the comedy under its original title in 1911. Sternheim went on to write a series of comedies he called "Scenes from the Heroic Life of the Middle Class," which included *Die Kassette* (*The Strongbox*, 1911), *Bürger Schippel* (*Citizen Schippel*, 1913), *Der Snob* (*The Snob*, 1914), *1913* (1915), and *Tabula rasa* (1919). Some of them had interrelated characters, for example, members of the Maske family who originally appeared in *The Underpants*. The central characters in most such comedies were confidence men who sought to clamber up the social ladder by assuming the trappings of success and a thoroughgoing conformism.

When Sternheim was awarded the Fontane Prize in 1916, theaters began to mount stagings of his plays in greater number. His breakthrough as a popular and profitable playwright, however, had to wait until the 1920s and the dissolution of police censorship. Theaters in that decade did his plays repeatedly; in particular, his relationship with director **Gustav Hartung** blossomed, and Hartung's productions of Sternheim won widespread acclaim. Critics in the 1920s came to recognize Sternheim as a significant comic playwright, one whose acerbic observations of Wilhelmine manners differentiated him as both funny and merciless. The National Socialist government banned all of his plays in 1933, by which time Sternheim was living comfortably in Belgium. Upon the German invasion and occupation of Belgium in 1940, they left Sternheim unpersecuted.

STRAUB, AGNES (1890–1941). Actress. Straub was considered an outstanding actress in the **Expressionist** style immediately after World War I, but her career had begun a decade earlier in Heidelberg, playing the title role in **Franz Grillparzer**'s *Sappho*. From Heidelberg she got engagements in Bonn and Königsberg before settling in **Berlin** for the 1915–1916 season. At both the **Deutsches Theater** and later at the newly renamed State Theater in Berlin, she excelled in heavy tragic roles such as Kriemhild in **Friedrich Hebbel**'s *Die Nibelungen* (*The Nibelungs*), **William Shakespeare**'s Lady Mac-

beth, Queen Elizabeth in **Friedrich Schiller**'s *Maria Stuart*, Clytemnestra in *The Oresteian Trilogy* by Aeschylus, the title role in **Heinrich von Kleist**'s *Penthislea*, and Cäcilie in **Johann Wolfgang Goethe**'s *Stella*. In addition to those well-known roles, she played the leads in new plays by **Hans Henny Jahnn**, **Arnolt Bronnen**, **Ernst Barlach**, **Paul Kornfeld**, and **Georg Kaiser**. In 1932 Straub became the first recipient of the **Louise Dumont** Award, given to the actress considered at the time to be the best in her field. Straub's career flourished in the Third Reich, and not only as an actress. She became one of the few female director-managers during the Nazi dictatorship when she leased the Kurfürstendamm Theater in Berlin's fashionable West End and ran it as the "Agnes Straub Theater am Kurfürstendamm."

STRAUSS, BOTHO (1944–). Playwright, **dramaturg**. Strauss is among the most frequently performed contemporary playwrights in the German theater, with more productions of his plays invited to the Berliner **Theatertreffen** than anyone else's over the past 30 years. In addition, more of his plays appear throughout Europe, the United States, Australia, and Canada than of any other living playwright working in German.

Strauss was already well known in German theater circles for his work as a critic and editor at *Theater Heute* magazine in the 1960s. At **Peter Stein**'s invitation, he joined the Schaubühne am Halleschen Ufer in **Berlin** in 1970 as a dramaturg. Strauss adapted several plays for Stein, including Henrik Ibsen's *Peer Gynt* (1971), Eugène Labiche's *The Piggy Bank* (1973), and most notably Maxim Gorky's *Summer Folk* (1974). **Claus Peymann** premiered Strauss's first important original work, *Der Hypochonder* (*The Hypochondriac*), at the **Deutsches Schauspielhaus** in **Hamburg** in 1971. Four years later, **Niels-Peter Rudolph** premiered his *Bekannte Gesichter, gemischte Gefühle* (*Familiar Faces, Mixed Feelings*), a production that subsequently went to the Theatertreffen. Since then, Strauss has had 13 productions of his plays invited, including two of *Gross und Klein* (*Big and Small*) that competed against each other in 1979; Stein had premiered *Big and Small* the year before, and it remains Strauss's most frequently performed play. Other successful plays by Strauss include *Trilogie des Wiedersehens* (*Trilogy of Repeated Meetings*, 1977), *Kalldewey Farce*

(1982), *Der Park* (1984), *Die Fremdenführerin* (*The Tour Guide*, 1986), *Besucher* (*Visitors*, 1988), *Sieben Türen* (*Seven Doors*, 1988), *Die Zeit und das Zimmer* (*Time and the Room*, 1989), *Schlusschor* (*Final Chorus*, 1991), *Angelas Kleider* (*Angela's Clothes*, 1991), and *Das Gleichgewicht* (*The Balance*, 1993).

Much of Strauss's work remains accessible to audiences, though one London critic in 1989 picturesquely described it as having "the feel of Monty Python rejigged by Beckett" (*Times of London*, 20 July 2004). There is little doubt that Strauss's use of humor makes his plays appealing. Still, most of the plays remain concerned with the hopelessness of human interactions, especially relationships between men and women. As they try to get to know each other, men and women in his plays are overcome with anxiety about intimacy. "Before they know it, time has run out," said one critic (*Süddeutsche Zeitung*, 10 February 1989). Strauss has been the recipient of numerous prizes and awards, including the Büchner Prize (1989) and the Berlin Theater Prize (1993). He remains the subject of ongoing academic inquiry, with numerous master's theses written about him and at least seven doctoral dissertations in Germany alone.

STRECKER, KARL (1862–1933). Critic. Strecker was noted for his nationalistic sentiments, and as such his play reviews were important for reflecting what the ruling elites in the Wilhelmine period were thinking. He wrote for the **Berlin** *Tägliche Rundschau*, which at the turn of the 20th century had a circulation of about 30,000.

STRNAD, OSKAR (1879–1935). Designer. Strnad was an accomplished architect and teacher of design. His most important work as a stage designer took place between 1919 and 1933. Beginning in 1919, Strnad designed several productions both in **Berlin** and for the **Volkstheater** in his native **Vienna**; he came into critical prominence with his design for the Berlin Volksbühne production of **Walter Hasenclever**'s *Antigone*. In 1924 he began working intensively, and almost exclusively, with **Max Reinhardt**. At the **Deutsches Theater** in Berlin, at the Salzburg Festival, and at Vienna's Theater in der Josephstadt, Strnad completed more than 50 designs for Reinhardt, including Shaw's *St. Joan* with **Elisabeth Bergner** and **Georg Büchner**'s *Dantons Tod* (*Danton's Death*) with **Gustaf Gründgens**. Str-

nad's most famous designs for Reinhardt were for the Karl Vollmöller spectacle *Das Mirakel* (*The Miracle*), which earned Reinhardt millions of dollars on tour throughout Europe and in the United States. Though the design for *The Miracle* was spectacular in the extreme, Strnad's designs rarely emphasized the atmospheric; they tended to concentrate instead on what he called the "rhythmics" of plays. Such conceptions likewise lay behind his work as an architect in Vienna, where he continued to work as a teacher at the Kunstgewerbeschule throughout his career with Reinhardt.

STÜCKL, CHRISTIAN (1961–). Director. Stückl became well known for his direction of the Oberammergau *Passionspiele* (passion play), which he directed twice, first in 1990 and a decade later in 2000. In both productions, he was responsible for updating and revising the play; in the minds of many, he improved it as well. Prior to his work in Oberammergau, Stückl worked at the **Munich** Kammerspiele under **Dieter Dorn**, and in the early 1990s he became the theater's chief director. In 2002 he restaged **Hugo von Hofmannsthal**'s *Jedermann* (*Everyman*) for the Salzburg Festival, and since that year he has been **intendant** of the Munich Volkstheater.

STURM IM WASSERGLAS (*Tempest in a Teacup*) by Bruno Frank. Premiered 1930. A romantic comedy about civic corruption, the press, lost dogs, and the possibility of love—all of which nearly guaranteed interest among German audiences in the waning days of the Weimar Republic. Frank's superb use of familiar comic devices and romantic intrigue positioned it for lasting, and lucrative, approbation. It was the most popular comedy of the 1930–1931 season. The play's central characters were attractive members of the upper crust in republican Germany who meet an unexpected but well-deserved downfall.

In the luxurious drawing room of the city's vice mayor Herr Thoss, Viktoria Thoss welcomes a newspaper reporter who has come to interview her husband. Their conversation is interrupted by the poorly dressed, uneducated Frau Vogel, who excitedly pleads for her dog Toni, recently taken into custody. She agrees to depart when Viktoria says she will advise her husband about her dog. When Herr Thoss arrives, he is preoccupied with political matters such as the salary of the city council's doorman. Then Frau Vogel reappears to plead with Thoss to

help her, but he dismisses her claim and has her thrown out of his house. Thoss's behavior in front of a newspaper reporter sets off a chain of events leading to his downfall. The reporter writes a lead story the next day from the dog's viewpoint, and citizens call for Thoss's impeachment. Further investigations reveal that Thoss is romantically involved with the wife of the reporter's employer, the newspaper publisher. The transparent theme of the play is that politicians are jaded, while Frau Vogel and her dog, like the German people in general, are genuine and unaffected. The play's conclusion takes place at the city courthouse, where Thoss has departed for Berlin to take a job running a big company, and Frau Vogel meantime has received 20,000 marks in donations for Toni. A veterinarian testifies that Toni is a mutt with no claim to a pedigree (satirizing Nazi racial theories) and guesses his worth to be about eight marks. Viktoria appears to testify on the reporter's behalf, telling the court that despite the dog's lack of breeding, he has worth beyond monetary value because he is pure in heart.

STURM UND DRANG (Storm and Stress). A term denoting a tendency among young playwrights; as a cultural movement, its name derives from the title of Friedrich Klinger's 1777 play *Sturm und Drang*. The most significant playwright of the Storm and Stress movement was **Johann Wolfgang Goethe**, who in the 1770s rejected the restrictions of neoclassicism and attempted to write plays that adumbrated intensity, unbridled lyricism, and the exaltation of **Shakespeare** as a prototype. Goethe was the prime motivator in the tendency, and his are by far the best of the plays created during the decade, including his *Götz von Berlichingen*, *Clavigo*, and *Stella*. The playwrights who imitated him included Klinger, Jakob Lenz, **Heinrich Leopold Wagner**, and Friedrich Müller (1749–1825). Critics sometimes include **Friedrich Schiller**'s *Die Räuber* (*The Robbers*) within the Storm and Stress, but Schiller had little to do with Goethe or the others at the time, and most observers rate the play as isolated from, though somewhat similar to, the tendencies of *Götz*, Lenz's *Der Hofmeister* (*The Tutor*), or Wagner's *Die Reue nach dem Tat* (*Regret after the Deed*). Frequent preoccupations in these plays were overpowering passion, an emphasis on the power of youth and the suffering youth must at times necessarily endure, alcoholic dissipation or sexual depravity, and unrestrained extravagance in language.

STURM UND DRANG (*Storm and Stress*) by Friedrich Klinger. Premiered 1777. This is the play from which the **Sturm und Drang** cultural movement takes its name; its original title was *Der Wirrwarr* (*The Chaos*). *Sturm und Drang* is among the first of several German plays set in America—though there is hardly anything recognizably "American" in it. It is essentially a kind of revenge melodrama featuring a feud between the Bushy and Berkley families. Caroline Berkley predictably loves Karl Bushy, and because he has taken the name Wild, Caroline at first does not know he is a member of the Bushy family. There are duels between family members and their allies (including two Frenchmen named Le Feu and Blasius), deaths, and finally an attempt at reconciliation, though the original "chaos" seems destined to continue. Klinger employed an extravagant idiom in the play, with characters who often sound as if they are on the verge of hysterics.

SUKOWA, BARBARA (1950–). Actress. Sukowa has enjoyed an extraordinary career that began almost as soon as she left high school. She made her professional debut in the 1971 world premiere of **Peter Handke**'s *Der Ritt über den Bodensee* (*The Ride across Lake Constance*) under **Claus Peymann** at the Schaubühne, a production that attracted international critical attention and engendered enormous controversy. She then departed for engagements in several theaters outside **Berlin**, many of them in Frankfurt am Main and **Hamburg**. Sukowa remained in Hamburg until 1980 as a member of the Thalia Theater company, but then left to work with Rainer Werner Fassbinder in his television miniseries filming of Alfred Döblin's epic *Berlin Alexanderplatz*. In it, Sukowa played the temperamental love interest of the central character Franz Biberkopf, and her performance won her several awards along with critical acclaim. She followed up that role with a stunning portrayal of the title character in Fassbinder's film *Lola*, based on Josef von Sternberg's 1931 *Der blaue Engel* (*The Blue Angel*). In 1983 Sukowa returned to the theater for **Peter Zadek**'s 1983 production of Henrik Ibsen's *The Master Builder* at the Bavarian State Theater. That production was subsequently invited to the Berliner **Theatertreffen** as one of the best productions of the year, and *Theater Heute* awarded Sukowa its "actress of the year" commendation for her portrayal of Hilde Wrangel.

In 1986 Sukowa attained worldwide attention for her portrayal of the doomed revolutionary Rosa Luxemburg in Margarete von Trotta's (1942–) film of the same name; she won the Cannes Golden Palm award for her performance, one she has never equaled in the more than 20 movies she has made since.

– T –

TABORI, GEORGE (1914–). Playwright, director. **Bertolt Brecht** convinced Tabori to try his hand at playwriting when the two met in Hollywood, where Tabori had been working on screenplays. His *Flight into Egypt* premiered on Broadway in 1952 under the direction of Elia Kazan (1909–2003). Prior to that he worked with Brecht on the English-language version of *Das Leben des Galilei* (*The Life of Galileo*), which premiered in Los Angeles in 1947. Tabori had been a student in **Berlin** when forced into exile in 1934; he became a British subject in 1936 and began writing in English as a foreign correspondent in Bulgaria and Turkey; between 1941 and 1943 he worked as a secret agent for the British government in Palestine, returning to London in 1943 to work for the BBC. His American sojourn began in 1947, and his prolific career as a screenwriter included *I Confess* for Alfred Hitchcock in 1953. Tabori worked both in London and in New York during the 1950s, at one point becoming a member of the Actors Studio.

In 1958 Tabori's *Brou Ha Ha* premiered in London, and in 1960 his collage of Brecht material titled *Brecht on Brecht* premiered Off-Broadway. *The Cannibals* followed in 1968, *The Niggerlovers* in 1969, and *Pinkville* in 1970. He returned to live in Germany in 1971, and several plays he wrote in English were premiered in German translation during the 1970s and 1980s. They included *Clowns*, *The Demonstration*, *Sigmund's Freude* (based on material by Fritz Perls), *Talk Show*, *The 25 Hours*, *The Voyeur*, *Peepshow*, *My Mother's Courage*, and several adaptations of material for the stage by Franz Kafka. Tabori's most controversial play of the 1980s was *Mein Kampf*, subtitled *A Farce*, about the young Adolf Hitler's 1907 unsuccessful attempt to enter art school in Vienna. In the 1990s Tabori's directing career reached new heights, as seven of his productions were

invited to the Berliner **Theatertreffen**. One of them was *Oleanna* by David Mamet (1947–). In 1992 Tabori received the Büchner Prize.

THALBACH, KATHARINA (1954–). Actress, director. Thalbach began her career playing children's roles in productions by her father **Benno Besson**. She made her **Berliner Ensemble** debut in 1968 and remained with that company until 1972, when she began working with the East **Berlin** Volksbühne. Thalbach left East Berlin in 1977 to work with the Schiller Theater company in West Berlin, and after 1983 worked extensively in Zurich. She returned to the Schiller Theater in 1989 as a director, and in 1990 her **Hamburg** Thalia Theater production of *Macbeth* in 1990 was invited to the Berliner **Theatertreffen**.

THALHEIMER, MICHAEL (1965–). Director. After completing studies as an actor at the Hochschule für Musik und Theater in Bern, Switzerland, in 1989, Thalheimer embarked on an acting career that took him to Mainz, Bremerhaven, and back to Bern. In 1992 he began working as a director as well as acting at the Chemnitz City Theater, which led to directing jobs in Leipzig, Freiburg, Dresden, and Basel. In 1998 he left Chemnitz to pursue a career as a freelance director, which has led to outstanding productions that have been invited to the Berliner **Theatertreffen**. In 2001 Thalheimer became one of the few German directors in the history of the Theatertreffen to have two productions, originally staged in two different theaters, invited; as a result, he was awarded the 3sat televison network's Innovation Prize in 2001. The following year, he won the Nestroy Prize and the Friedrich Luft Prize for his directing efforts.

THEATER AM SCHIFFBAUERDAMM. Situated directly across the "Shipbuilder's Canal" (whence the theater's name derives) from the Friedrich Strasse train station, the Schiffbauerdamm Theater in **Berlin** has housed as many significant productions and important ensembles as any other in the city, with the possible exception of the **Deutsches Theater**. It was built in 1890 as the Neues Theater am Schiffbauerdamm with a seating capacity of 684 persons; at the time, many considered it the most ornately decorated house in the city. It was intended solely as a speculative real estate development, and it

remained a facility to lease for decades. Among its more well-known leaseholders were **Max Reinhardt**, the Volksbühne organization, and **Ernst Josef Aufricht**. Reinhardt staged the first of his many *A Midsummer Night's Dream* productions there, and **Carl Zuckmayer**'s *Der fröhliche Weinberg* (*The Merry Vineyard*) premiered there in late 1925. Its most famous premiere took place in 1928 under Aufricht: **Bertolt Brecht** and Kurt Weill's *Die Dreigroschenoper* (*The Threepenny Opera*). Their *Happy End* followed in 1929, though with far less success. Under National Socialism, the theater returned to its "boulevard" beginnings, as producers leased it for a year or two in the hope of attracting audiences for the worthwhile purpose of entertaining them. The structure somehow survived serious damage in World War II and reopened in 1946 under the direction of Fritz Wisten. Its years of glory began in 1954, however, when the East German government assigned the Schiffbauerdamm to Brecht and his **Berliner Ensemble**. There, Brecht took particular pleasure in presenting his plays within the ornate, even ostentatious, environment of the Schiffbauerdamm; he staged *Der kaukasische Kreidekreis* (*The Caucasian Chalk Circle*) and *Das Leben des Galilei* (*The Life of Galileo*) with **Ernst Busch** in the title role and restaged *Mutter Courage und ihre Kinder* (*Mother Courage and Her Children*). By the 1970s the company had become moribund, though the structure itself and its splendid interior remained intact. Today the building retains the name "Berliner Ensemble" atop its roof, though the company residing there operates under an organizational structure created in 1999.

THEATERTREFFEN. A combination civic forum, art festival, awards show, and mechanism for professional advancement, the Berliner Theatertreffen was founded for the purpose of inviting to **Berlin** during the month of May the most outstanding productions staged that season. A jury of individuals made the selections, and from the inaugural season (1963–1964) controversy surrounded the invitations extended, the membership of the jury, and the criteria used to extend the invitations. The most vocal complaint over the years has been the number of invitations to the same directors and/or theaters: **Vienna**'s **Burgtheater** has received 44 invitations since 1964, when its production of **Georg Büchner**'s *Woyzeck* was invited, and the Bochum

Schauspielhaus has had 28 invitations; in the same time period, all the theaters of **Cologne** have received a total of just two invitations, and the Darmstadt State Theater has been invited only once. The implication is that the **Burgtheater**'s work is more than 20 times better than Cologne's—or it may simply mean that jury members prefer a certain kind of production, especially one with the earmarks of **Claus Peymann, Peter Stein**, or **Peter Zadek**. The productions of those directors have been a regular feature of the Theatertreffen from the beginning. Meanwhile, smaller, high-quality theaters (for example, Heidelberg, Göttingen, Koblenz, or Nuremberg) have never been invited. The role of the Theatertreffen in the establishment of a director's career has likewise become singularly decisive; in many cases, an invitation to the Theatertreffen solidifies a director's work in the minds of employers (usually politicians and bureaucrats), as well as among many colleagues.

THIELSCHER, GUIDO (1859–1941) Actor. Over the course of a career that spanned nearly six decades, the popular Thielscher came to be known as *il Guido grandissimo*, one of the most popular performers in **Berlin**'s theater history. Standing five feet, six inches tall and weighing more than 250 pounds, Thielscher began as a circus clown. At age 18 he got his first acting job at Berlin's **Belle-Alliance Theater**. One of his biggest hits in the Wilhelmine era was the title role in the 1893 **Berlin** premiere of Brandon Thomas's *Charley's Aunt*. **Otto Brahm** improbably engaged him for the 1898–1899 season at the **Deutsches Theater** for **Friedrich Schiller**'s *Die Räuber* (*The Robbers*), but when Thielscher appeared in a nightshirt as the befuddled father of the feuding Moor brothers, Brahm's normally reverent and circumspect audience convulsed in laughter. Thielscher soon departed the Deutches for the familiar territory of Berlin's boulevard theaters, where he maintained his acrobatic skills well into his 60s. His most significant and popular work awaited him in the 1920s, when he often played leading roles in the comedies of **Franz Arnold** and **Ernst Bach**, many of which they wrote especially for him.

THIMIG, HELENE (1889–1974). Actress. Thimig intended to work with the **Burgtheater** in **Vienna**, where her father **Hugo Thimig** had been an established actor for decades and became its director from

1914 to 1918. Her father, however, was not impressed with her talent, and so in 1908 she left Vienna for Meiningen, where she worked for three years. In 1912 Thimig joined the Royal Theater company in **Berlin**, where she remained until 1917, at which time she joined **Max Reinhardt**'s company at the **Deutsches Theater**. When Reinhardt took over the Theater in der Josephstadt in her native Vienna, she returned there frequently to play a variety of roles, both in the modern and in the classical repertoire. Among her most noteworthy roles for Reinhardt were Ophelia in *Hamlet*, Rosalind in *As You Like It*, Luise Miller in *Kabale und Liebe* (*Intrigue and Love*), the title role in **Friedrich Schiller**'s *Die Jungfrau von Orleans* (*The Maid of Orleans*), Maria in **Johann Wolfgang Goethe**'s *Clavigo*, Glaube in **Hugo von Hoffmansthal**'s *Jedermann* (*Everyman*) at the Salzburg Festival, the title role in **Gerhart Hauptmann**'s *Dorothea Angermann*, and Klärchen in Goethe's *Egmont*.

Thimig married Reinhardt in 1932 and emigrated with him to the United States when he was forced out of Germany. After his death in 1943, she worked in more than a dozen Hollywood films; returning to Europe in 1946, she began working at the Salzburg Festival and in Vienna. As a member of the Burgtheater company, she began playing older character parts, such as in the Austrian premieres of Tennessee Williams's *The Glass Menagerie*, playing Amanda, and Federico García Lorca's *Blood Wedding*, as the Mother. Among her many awards were the Josef Kainz Medallion and the Salzburg Festival Prize.

THIMIG, HUGO (1854–1944). Actor. In a long and illustrious career closely associated with **Vienna**'s **Burgtheater**, Thimig played nearly every production the theater presented. His range was extraordinary, playing more than 200 roles in his years at the Burg and appearing in thousands of performances. Thimig began his career in Dresden and Breslau, but by age 30 he was a permanent member of the Burg company. In 1881 he was named "court actor," granting him ceremonial privileges accorded few others, and in 1897 he began directing plays at the Burg—not because he possessed any specific talent for staging plays but because his acting had become so closely identified with the "Burg style." Thimig ran the Burgtheater from 1914 to 1918. He was most popular in comic roles, especially in productions of Carlo Goldoni, **William Shakespeare**, **Johann Nepomuk Nestroy**, and

farces by **Franz von Schönthan** and Otto Ernst. His serious roles in plays by Calderón de la Barca, Henrik Ibsen, **Gerhart Hauptmann**, and **Arthur Schnitzler** were also crowd pleasers. Some critics complained that Thimig's work was out of date by the time he retired in the 1930s, but other cherished him as an embodiment of Viennese theater tradition. He was the father of **Helene Thimig**.

THOMA, LUDWIG (1867–1921). Playwright. Thoma was a **Munich** lawyer who—both as a playwright and as an editor of the weekly satirical magazine *Simplicissimus*—drew the ire of Kaiser Wilhelm II and the Prussian establishment throughout his career. He wrote novels and short stories and was particularly gifted as a writer of comedies during the first decade of the 20th century. His most popular comedy was *Moral* (*Morality*), which was an enormous hit from the evening of its premiere; it ran more than 300 times at the venue where it opened, the Kleines Theater of **Berlin**, under **Viktor Barnowsky**'s direction, and it subsequently was performed thousands of times throughout Germany and Austria. Thoma was well known in Berlin by 1908, with several satirical comedies already to his credit. His work as editor of *Simplicissimus*, however, was what made him well known among the public at large. *Simplicissimus* had debuted in 1896, aggressively pillorying the Wilhelmine establishment and Kaiser Wilhelm II in particular. *Simplicissimus* also attacked all manner of religious practice, cultural comfort, and what it considered excessive self-satisfaction. Thoma, along with his publisher Albert Langen and many of his contributors, were frequently targeted in lawsuits and prosecutions. In 1906 Thoma spent six weeks in prison for *Majestätsbeleidigung*, "insulting a person of majesty."

TIECK, LUDWIG (1773–1853). Director, playwright. Tieck was most innovative in discovering the connection between **Shakespeare** plays and Elizabethan staging, though he was also an important contributor to the German poetry of **Romanticism**. His playwriting efforts consisted mainly of dramatized fairy tales such as *Der gestiefelte Kater* (*Puss in Boots*), *Ritter Blaubart* (*Captain Bluebeard*), and *Rotkäpchen* (*Little Red Riding Hood*), though he also wrote tragedies—none of which were very successful. His contributions to and editing of the **Schlegel**-Tieck translations of Shakespeare—along with those of his

daughter Dorothea and **Wolf Baudissin**—are perhaps his greatest contribution to the recognition of Shakespeare as a "German playwright" in the 19th century. Prior to the Schlegel-Tieck translations, most theater directors (e.g., **Friedrich Ludwig Schröder** and **Johann Wolfgang Goethe**) feared that Shakespeare could not hold an audience's attention because Shakespeare was ill suited for the "realistic" stage; they feared "a breakdown of dramatic momentum" if Shakespeare were to be presented unabridged on a platform stage (Simon Williams, *Shakespeare on the German Stage* [New York: Cambridge University Press, 1990], 1:176). His work on the translations, however, allowed Tieck to discover that Shakespeare's plays functioned on a set of dynamics established primarily through character and speech, not pictorial illusion. Tieck conducted detailed research on the importance of theater architecture in the Elizabethan period, formulated the dimensions of the Fortune Theater in London, and found that successful staging in a mid-19th-century German theater was predicated on replicating the original Elizabethan environment.

As a director at the **Berlin** Royal Theater, Tieck staged several innovative productions, the most notable of which was Shakespeare's *A Midsummer Night's Dream* in 1843, for which Felix Mendelssohn (1809–1847) wrote incidental music. The production was one of the most popular ever presented in Berlin; it was given 169 times before 1885, when the **intendant** of the Royal Theater, Count Botho von Hülsen, removed it from the repertoire.

TOLLER, ERNST (1893–1939). Playwright. Toller was best known for strident, **Expressionist**-style plays that enjoyed a vogue in the early 1920s. Deeply scarred by his experiences in World War I (he suffered a nervous collapse and was released from service in 1916), he embraced Marxism as an antidote to German militarism. His participation in the Communist regime briefly established in Bavaria after the war landed him in prison, where he wrote most of his work. His *Die Wandlung* (*The Transformation*, 1919), with **Fritz Kortner** and **Heinz Hilpert** in the cast, created a sensation in **Berlin** among audiences genuinely convinced that revolution had arrived; similar plays followed, including *Masse-Mensch* (*Masses and Man*, 1922), *Die Maschinenstürmer* (*The Machine-Wreckers*, 1922), and *Der deutsche Hinkemann* (*The German Hangman*, 1923), along with a

political comedy titled *Der entfesselte Wotan* (*Wotan Unchained*, 1923), but only **Erwin Piscator**'s production of *Hoppla, wir leben!* (*Hurray, We're Alive!*, 1927) returned Toller to the public's eye. It, too, betokened the stridency characteristic of Toller's pessimistic outlook. He left Germany soon after the Nazis came to power and in 1939 hanged himself in a New York hotel room.

– U –

UND PIPPA TANZT! (*AND PIPPA DANCES!*) by **Gerhart Hauptmann**. Premiered 1906. The title character of this four-act impressionistic play is closely identified with actress **Ida Orloff**, for whom Hauptmann wrote the play. He blended **Naturalistic** scenic embellishments with symbolism, employing both prose and verse. The Naturalistic portions of the play recall his native Silesia, while the verse sections tend toward poetic preoccupation for the beautiful and fragile, yet unattainable, Pippa. Two Silesian types fall in love with Pippa, a violent lout and an idealistic poet. Pippa and the poet escape from the lout, but they must proceed through a magical forest. There they find refuge in a cottage owned by an old magician; but the lout has followed them. In his rage to possess Pippa, he knocks over a glass and breaks it; Pippa dies of shock. The lout likewise dies, while the poet goes blind. As the poet leaves the cottage to stumble along what remains of life's path, the magician remains to contemplate the meaning, or perhaps the unfathomability, of what has just transpired.

UNRUH, FRITZ VON (1885–1970). Playwright. Unruh enjoyed brief notice as an **Expressionist** playwright in the aftermath of World War I, when **Gustav Hartung** directed some of the plays he had written before and during the war. The best of them were *Ein Geschlecht* (*A Generation*, 1918), premiering in Frankfurt am Main, and *Vor der Entscheidung* (*Before the Decision*, 1914). *Platz* (*Place*) premiered in 1920. **Max Reinhardt** had earlier premiered his *Offiziere* (*Officers*, 1911), and *Louis Ferdinand, Prinz von Preussen* (*Louis Ferdinand, Prince of Prussia*, 1913) premiered in Darmstadt. Unruh was the son of a Prussian general, and he entered the Prussian officer corps himself, but later resigned his commission and became a pacifist. He emigrated

to the United States in 1932 and remained there for two decades; upon his return to postwar Germany, he attempted to revive his playwriting career, but with little success.

– V –

VEILCHENFRESSER, DER (*The Violet Eater*) by **Gustav von Moser**. Premiered 1878. A romantic military comedy typical of the species popular in the 1870s, when the glow of the German victory over the French in the Franco-Prussian War was still warm in audiences' memories. The title of Moser's comedy comes from a nickname for one of its officers, Lt. Viktor von Berndt. Viktor is a ladies' man who regularly sends large floral bouquets to women who strike his fancy. His Aunt Therese wants him to cease such juvenile behavior and settle down with Valeska, daughter of his commanding officer at the nearby fortress, Colonel von Rembach. Valeska von Rembach, however, is more interested in Viktor's friend, a promising young businessman named von Feldt. Viktor has his own interests anyway, namely, the beautiful young widow Sophie von Wildenheim. Unfortunately for him, Colonel von Rembach also has set his sights on Sophie. Furthermore, Sophie does not like Viktor, whom she considers superficial in the extreme, one of those dashing young lieutenants who fall in and out of love with unfortunate regularity.

One day Viktor exhibits behavior that seems to defy the stereotype: after he hears some of his fellow officers disparaging a young lady, he saves her honor by challenging the principal offender to a duel. It turns out that the young lady in question is Sophie's best friend, though both of them are ignorant of the gallant lieutenant's identity. At a ball in the fortress that evening Sophie treats Viktor with contempt. She then learns from his friend Feldt that after the ball Viktor must begin serving a four-week sentence in the fortress citadel for challenging a fellow officer to a duel. Thus Sophie learns of Viktor's gallantry in defense of her friend. Sophie then attempts to visit Viktor in the stockade, where she sees and attempts to avoid Colonel von Rembach, his daughter Valeska, and Viktor's Aunt Therese in a series of farcical near-misses. When the two finally get together, it is clear that Sophie and Viktor are meant for each other. After Viktor is re-

leased from confinement, Colonel von Rembach agrees to their marriage—even though he wishes he could be in Viktor's place.

VELTEN, JOHANN (1640–1697). Actor, manager. Velten was the first significant *Prinzipal* (actor-manager) among the German touring troupes, and his remarkable education enabled his troupe to perform his translations of plays from the English, French, and even Spanish repertoire long before any other troupe did. He had studied theology in Wittenberg and later received a master's degree from the University of Leipzig. It is not entirely clear how or why a man with his education should have become an actor in the 1660s as he did, but he appears as a member of Paulsen's troupe in **Hamburg** in the early part of that decade. He had married Paulsen's daughter Catharina Elisabeth sometime earlier, and with the Paulsen troupe, he toured several northern German cities as well as some Scandinavian ones, particularly in Denmark. In 1678 he and his wife left the Paulsen troupe to reside at the Saxon Court in Dresden at the invitation of Johann Georg III, king of Saxony and Imperial Elector. The troupe Velten assembled in Dresden was known officially as the "Saxon Elector's Court Comedians," and with Dresden as their base of operations, the troupe appeared in several venues, most notably Frankfurt am Main, Leipzig, Nuremberg, and eventually the Imperial Court of Emperor Leopold I in Worms. Predominant in the repertoire of Velten's troupe were adaptations from the **Englische Komödianten** (English Comedians) who had first appeared in German venues a century earlier and the comedies of Molière. Velten's troupe prospered until the death of their patron Johann Georg III in 1691; the troupe was then forced out of Dresden and its attempts to tour successfully or to find another home court proved futile.

VIEBROCK, ANNA (1951–). Designer. Viebrock studied art history at the Art Academy of Düsseldorf and did not begin stage design work until the late 1980s with **Jossi Wieler** in Basel. In 1991 she began working with **Christoph Marthaler** in Basel, and in 2001 she was named head designer at the Zurich Schauspielhaus. She held a similar position at the **Deutsches Schauspielhaus** in **Hamburg** from 1993 to 1999.

VIENNA. Vienna (Wien) was the German theater's leading city for most of the 19th century, due in large measure to the superb acting ensemble at the Königliches und Kaiserliches (Royal and Imperial) **Burgtheater**. The "Burg" dominated the city's theatrical life in a way the Royal Theater in **Berlin** did not; Vienna never possessed the speculative spirit characteristic of Berlin, either. Vienna had long been the music capital of Europe, with Franz Joseph Haydn, Wolfgang Amadeus Mozart, Ludwig van Beethoven, Johannes Brahms, and several outstanding orchestral ensembles in its midst. The Viennese love of music strongly influenced its taste in theater and differentiated it from almost all other German-language cities. Actors in Vienna were allowed to indulge in virtuosic displays to a far greater extent than elsewhere, for example; that may be one reason why Vienna never developed an independent theater movement, as Berlin did with **Otto Brahm** and the Freie Bühne. Theater as a sober examination of social problems found little resonance among the Viennese.

Vienna began as a tribal settlement along the banks of the Danube River. The Romans called it Vindobona and recognized its beneficial location as both a military outpost and a commercial center. Caesar Augustus fortified it considerably in the first century A.D. as a bulwark against the Teutonic tribes to the north; Marcus Aurelius made it one of his residences, and he died there in 180. After the Romans withdrew from Vienna in the fifth century, numerous tribes fought over it and its surrounding environs for centuries. In the ninth century, it came under Charlemagne's rule, and in 1137 it was incorporated as a city. In 1278 Vienna became the seat of the House of Habsburg, and it remained a Habsburg city until 1918.

By the 15th century, Vienna was the site of prodigious theatrical activity in the form of religious drama, especially on Good Friday and the feast of Corpus Christi. By the mid-16th century, Jesuits were staging plays on a regular basis in their schools; *commedia* troupes appeared with equal regularity throughout the city, and the **Englische Komödianten** (English Comedians) appeared around the 1590s. Theater activity in Vienna was disrupted during the 17th century not only by the disastrous Thirty Years' War but also during the second siege of the city in 1683 by the invading Turks and their allies. The Turks were driven back and finally destroyed in 1697, and shortly thereafter (in 1705) Josef Anton Stranitsky (1676–1726) felt it safe to

appear in Vienna as **Hanswurst**. Stranitsky moved into the Kärnt-nertor Theater in 1711, where he held forth for two decades.

Hanswurst had a far different experience in Vienna than he did in Leipzig or other 18th-century German theater centers. Josef Sonnen-fels (1773–1817)—not a pastor's son as **Johann Christoph Gottsched** had been, but a rabbi's son—like Gottsched attempted to reform the Viennese popular tradition and rid it of Hanswurst. Local audiences completely repudiated Sonnenfels's efforts, however, and continued to support the various manifestations of Hanswurst through the remainder of the 18th century and well into the 1800s. Sonnenfels was nevertheless raised to the aristocracy and given a professorship.

In 1741 a reception hall adjacent to the Habsburg palace was tem-porarily transformed and leased as a theater; it became the Teutsches Nationaltheater (German National Theater) in 1776; 20 years later it received the name Burgtheater. Meanwhile, the Kärntnertor Theater had been destroyed by fire; the Habsburgs rebuilt it and designated it a court theater. It was torn down in 1870. The Theater in der Josef-stadt near the royal and imperial palace began in the garden of a well-known Vienna restaurant. By 1788 it was featuring dance and vaude-ville-style acts. The Josefstadt is the only theater in present-day Vi-enna that still occupies the place on which it originated. **Max Reinhardt** bought it in 1924 and ran it until 1938, whereupon **Heinz Hilpert** took over its administration and ran it as if Reinhardt were merely in absentia.

The Raimund Theater had nothing specifically to do with **Ferdi-nand Raimund**, although the theater's owners staged Raimund's *Die gefesselte Phantasie* (*The Imagination Enchained*) for the facility's grand opening in 1893. By the 1920s the Raimund was used almost exclusively for operettas, and since then it has been identified in the Viennese public mind with musical entertainment. The Theater an der Wien (completed in 1801) likewise had a strong musical connection, with the premiere of Beethoven's *Fidelio* and later with several op-erettas by Johann Strauss, Franz von Suppé, Franz Lehár, Karl Mil-löcker, and others for whom Vienna became justifiably famous. The Theater in der Leopoldstadt also had a substantial music pedigree, since Mozart's *The Magic Flute* premiered there. **Carl Carl** bought the theater in 1838 and rebuilt it in 1847 as the Carl Theater; it had

been the site of numerous **Johann Nepomuk Nestroy** premieres and continued to be so even after Carl died and Nestroy assumed its leadership.

Following the collapse of the Third Reich (of which Austria was a part), the Viennese found several of their theaters destroyed or severely damaged—most notable among them the Carl; the Burgtheater suffered damage so severe that it did not reopen for a decade. The Akademie Theater, which the Burgtheater had annexed in 1922, was undamaged and reopened in May 1945. Some private theaters such as the Theater an der Wien and the Ronacher were intact, and in those venues performances resumed shortly after the occupation of the city. Numerous tiny "cellar theaters" arose in the late 1940s, dedicated largely to experimental or literary works. The Theater in der Josefstadt and its Kammerspiele continued to emulate the Hilpert era, as in most cases they still do up to the present time; both houses, however, receive some state subvention. With the establishment of Austria's neutrality with the Treaty of Vienna in 1955, the Burgtheater reopened; a series of talented directors helped to reestablish the theater's acting ensemble as one of the most significant in the German-speaking theater. The most controversial artistic director of the Burg was **Claus Peymann**, during whose administration (1986–1999) the premieres of plays by **Thomas Bernhard**, **Elfriede Jelinek**, **Peter Handke**, and **George Tabori** attracted substantial media attention.

VIERTEL, BERTHOLD (1885–1953). Director. Viertel was a native **Viennese** whose career began at the Vienna **Volkstheater** but later blossomed in Dresden and **Berlin**. His most significant productions in Dresden were the premieres of **Walter Hasenclever**'s *Jenseits* (*Beyond This Life*) and **Georg Kaiser**'s *Gas II*. In Berlin, Viertel's 1922 productions of **Friedrich Hebbel**'s *Judith* and **Arnolt Bronnen**'s *Vatermord* (*Patricide*) created sensations. In the wake of the German monetary collapse in 1923, Viertel founded his own company called Die Truppe ("the troupe"), which premiered Robert Musil's *Vincenz* (*Vincent*) and Kaiser's comedy *Nebeneinander* (*Next Door*) at Berlin's Lustspielhaus. Those productions marked a career turning point, as Viertel began working steadily as a freelance director, ultimately emigrating to Hollywood in 1927. He returned to Europe in 1949 and restarted his career, both in Berlin and in Vienna. At

Vienna's **Burgtheater**, he staged the Austrian premiere of Tennessee Williams's *A Streetcar Named Desire*.

VOLKSSTÜCK (Peoples' Play). In general reference to popular entertainment, the term *Volksstück* began to appear in the mid- to late 17th century as a play in dialect written for unsophisticated audiences, depicting characters from daily life who spoke the local idiom. It was the stock in trade among troupes touring Habsburg territories and what is today Bavaria, proving to be most favored in **Vienna**, where through the 19th century several theaters on a regular basis presented variations on the form. **Ferdinand Raimund** and **Johann Nepomuk Nestroy** were its most successful Viennese exponents. Its popularity in **Berlin** came later, where playwrights such as **Louis Angely** and **David Kalisch** developed audiences for it up to 1860; **Adolph L'Arronge** created its most popular Berlin manifestations and used it to satirize the initial decades of the Wilhelmine Empire.

The Volksstück became somewhat moribund with the advent of **Naturalism**, but in the 1920s **Carl Zuckmayer** and **Ödön von Horváth** initiated a revival that emphasized parody and, in the case of Horváth, a tendency toward brutal sarcasm. National Socialism promoted it as a form of *Heimatkunst* (an official "hearth-and-home" movement) that helped to preserve dialect plays in several localities; the plays of August Hinrichs are the best examples of such plays. In the early 1970s, the Volksstück experienced yet another revival, this time through the efforts of **Franz Xaver Kroetz** and Martin Sperr and the "rediscovered" plays of Marieluise Fleisser.

VOLKSTHEATER (VIENNA). The Volkstheater, completed in 1889, was built in **Vienna** idealistically to accommodate the various *Völker*, or nationalities, of the Habsburg Empire by presenting a wide variety of fare in its repertoire, featuring German-speaking playwrights from Hungary, the Balkans, and areas of the Ukraine and Poland under Habsburg jurisdiction. It was, at the time of its construction, one of the largest theaters dedicated to spoken drama; it had a seating capacity of more than 1,000. The theater reached its height of popularity in the 1920s, ironically after the Habsburg Empire ceased to exist. It was damaged during World War II and underwent extensive restoration, reopening in 1980.

VON MORGENS BIS MITTERNACHTS (*From Morn to Midnight*) by **Georg Kaiser**. Premiered 1917. In what has perhaps become the most well known of all German **Expressionist** plays, a bank cashier (identified simply as "the Cashier") attempts to realize the hopes, dreams, and fantasies denied him his entire life in the span between the morning hours and the minutes shortly before midnight. At his bank, a wealthy Italian woman makes a large deposit, and he is filled with lust for her. He steals the money, appears at her hotel, and propositions her with wholly inappropriate suggestions that they leave together. She angrily rebuffs him, and he makes his way through the snow to have lunch with his family as usual; on the way, he has a vision of death in the form of a forlorn tree. At home, he reveals his intentions to live life to the fullest, and his mother suffers a stroke. He attempts to find adventure at a bicycle racing arena and later visits a brothel. There he orders champagne and indulges himself in other pleasures; he is appalled to confront a prostitute with a wooden leg, accusing her of ruining his pleasure. He concludes his day by attending Salvation Army services, where he hears confessions to crimes like his own. He confesses his malfeasances and flings what remains of the stolen money to the crowd—and to his chagrin they greedily scramble for it. Attracted to the Salvation Army girl who offers him respite and compassion, he discovers that she has called the police to collect the reward offered for his capture. He climbs a chandelier in the vain hope of escape, but when escape appears impossible, he shoots himself. His body slumps against the curtain, on which a cross is sewn. His arms outstretched in Christ-like fashion against the cross, he mumbles something that Kaiser says should sound something like *Ecce homo*, "behold the man," from the Gospel account of Christ's crucifixion. "There must have been a short circuit," concludes a policeman.

– W –

WAGNER, HEINRICH LEOPOLD (1747–1779). Playwright. Wagner was closely associated with the **Sturm und Drang** (Storm and Stress) movement, having attended the University of Strasbourg with **Johann Wolfgang Goethe** and Jakob Lenz. He wrote two plays of note: *Die Reue nach dem Tat* (*Regret after the Deed*, 1775) and *Die*

Kindermörderin (*The Child Murderess*, 1776), both of which were epigones of Goethe and were premiered by **Friedrich Ludwig Schröder** in **Hamburg**.

WAGNER, RICHARD (1813–1883). Composer, theorist. Wagner's influence on staging and architecture was substantial, largely within the context of his vigorous opposition to nearly everything he encountered in 19th-century theater practice. His operas were in large measure "music dramas" (he called them a "dramatic poem set to music"), inferring a rejection of conventions found in Italian operas but also of realism in spoken drama. The Italian predilection for arias, separated by choral passages, separated further by recitative passages, was to Wagner an abomination. He demanded instead the use of a *leitmotif* ("leading motive") to unify the stage proceedings, because such melodic components could be used to distinguish separate features of the drama. The sound of a *leitmotif* from the orchestra, for example, could signal a character's concerns even if he were not on stage.

Wagner's analogous interest in overall unity of staging effects prompted him to reject the kind of "realism" found in much French drama at the time, which he found quotidian in the extreme. He called for a prevailing idealism on stage in its place. He insisted on seamless *Handlung* (plot line or action) that could entrance audiences, transporting them into a realm of "sublime unity" with performers, in what he termed an "artistic community." Formulas, domestic intrigues, withheld information, chance encounters, sudden recognitions, and other devices he found antithetical to the creation of sublimity. In other words, Wagner wanted all aspects of performance to work toward a common goal, under the omnipotent hand of the director, responsible for creating the *Gesamtkunstwerk*, or "total work of art." In effect, Wagner's extraordinary emphasis on illusionism required precise synchronization of music, lighting, and set changes, so the demand for a powerful director to coordinate such synchronicity was nearly ineluctable. Yet the director as consummate artist was only one of many influences Wagner had on subsequent German theater practice.

Wagner's premise of illusionism—the kind that transported audiences into the mythic, manifesting itself in his "ideal" theater structure—ultimately came into existence in the **Bayreuth Festspielhaus**. Furthermore, the popularity of his operas forced many

court and municipal theaters throughout Germany to emulate the Festspielhaus. Wagner's operas demanded such unprecedentedly elaborate technical apparatus that most theaters, in order to present them, had to renovate their facilities. That often meant tearing down the old house and replacing it with an altogether new structure. The result in most cases, since both spoken drama and opera were customarily presented in the same facility, was beneficial for spoken drama. The installation of electric lighting, hydraulic stage elevators, counterweight rigging systems, and stage revolves became fairly commonplace in many well-established court and municipal venues.

The practice of dimming houselights for Wagner's operas carried over to spoken drama, creating a convention unforeseen and even contradictory to what Wagner had envisaged. Audiences for spoken drama, instead of being transported into a mystic realm, were transformed into voyeurs by the last decade of the 19th century. Family dilemmas and social problems in plays by **Gerhart Hauptmann**, Hermann Sudermann, and Henrik Ibsen came under a kind of clinical scrutiny in performance—and such problems were the last thing Wagner wanted to present on the stage. Wagner was most interested in mood, atmosphere, and what he called a "state of spiritualized clairvoyance" within the audience, allowing them to empathize and identify totally with the character. Wagner wanted to arouse the audience's emotions, not engage its critical faculties. Wagner's goals met their principal resistance two generations after his death in the anti-illusionistic theories and practices of **Bertolt Brecht**.

In the aftermath of World War II, increased attention was paid to Wagner's virulent anti-Semitism. Wagner published numerous anti-Semitic diatribes during his career (he was a prodigious writer of essays and books, in addition to writing the lyrics for his operas). His frequent targets were Jewish musicians, who he claimed were a deleterious "foreign" influence upon German culture. Wagner's first published attack on Jews appeared in 1850, in which he claimed that the German *Volk* found the music of Giacomo Meyerbeer (Jakob Liebmann Beer, 1791–1864) and Felix Mendelssohn (1809–1847) somehow "distasteful" because it was shallow and artificial, with little connection to truly ethnic German sensibilities. What Wagner demanded was the complete assimilation of the Jews into mainstream

German culture—though the burden of that effort he placed squarely on the shoulders of Jews themselves.

In subsequent essays—the 1878 "What Is German?" for example— he accused Jews of merely imitating Germans; if the practice continued, Wagner asserted, Germans themselves would lose their identity as a distinct "race." Wagner nevertheless had several Jewish friends and colleagues, notably Hermann Levi (1839–1900), whom Wagner chose to conduct the premiere of it, although he wanted Levi to be baptized before conducting it. Wagner's widow Cosima (1837–1930) encouraged anti-Semitic interpretations of Wagner's operas, and during the National Socialist period, the Bayreuth Festival came under the jurisdiction of the English-born Winifred Wagner, widow of Wagner's son Siegfried. She was a friend and longtime supporter of Adolf Hitler, whose yearly pilgrimages to Bayreuth became well-publicized state occasions in the late 1930s. **Joseph Goebbels** frequently employed Wagner's music in radio broadcasts, desirous as he was of identifying his music with their regime. Certainly Wagner's anti-Semitism accorded with that of the Nazis, but the stature of Wagner as proto-Nazi remained questionable. Wagner had been a democrat and a strong supporter of the 1848 revolution, after all. His widely published and frequently quoted preachments against Jews, however, provided useful fodder for the Nazis and their claims as "saviors" of German culture.

WALLBURG, LARS-OLE (1965–). Director. Wallburg is one of several directors born and reared in the former German Democratic Republic who established himself after the regime's collapse in 1989. He completed studies at **Berlin**'s Free University and in 1992 with **Stefan Bachmann** and other students founded the troupe called Theater Affekt. In 1996 Wallburg entered the German theatrical mainstream when the **Deutsches Schauspielhaus** in **Hamburg** hired him as a **dramaturg** and directorial assistant. His 1999 production there of Henrik Ibsen's *An Enemy of the People* gained him his first invitation to the Berliner **Theatertreffen**, which named him "emerging director" of that year. In 2003 Wallburg succeeded Bachmann as Theater Basel's principal director.

WALLENSTEIN, EIN DRAMATISCHES GEDICHT (*Wallenstein, A Dramatic Poem*) by **Friedrich Schiller**. Premiered in toto 1799.

Schiller structured his 10-act tragedy about the flawed general of imperial armies during the Thirty Years' War as a trilogy, opening with the one-act *Wallensteins Lager* (*Wallenstein's Camp*). It briefly portrays a large number of character types, many of them disreputable, and their devotion to Wallenstein. They range from peasants to aristocrats, black marketeers to priests, cuirassiers to pikers. Few have doubts about his superb gifts as a military strategist and political infighter; a soldiers' choir sings a moving hymn that concludes this prologue.

The second part, *Die Piccolomini* (*The Piccolominis*), develops around Wallenstein's plot with his second-in-command Octavio Piccolomini to place his armies at the disposal of his adversaries the Swedes, based on astrological suppositions. A subplot involves the love affair between Wallenstein's daughter Thekla and Piccolomini's son Max. Again Schiller portrays a wide range of convincing character types to create a broad tapestry, all of whom figure panoramically in the growing counterconspiracy against Wallenstein.

In the trilogy's conclusion, *Wallensteins Tod* (*Wallenstein's Death*), Wallenstein attains tragic dimensions as he realizes his faith has been misplaced in men like Octavio Piccolomini, in other trusted lieutenants and mercenaries, and in astrology. The conclusive battle for Prague ends in disaster as his troops mutiny. Max Piccolomini is killed while leading a charge against the Swedes, and a hired assassin murders Wallenstein. Octavio surveys the utter collapse that was the hope of imperial unity and ponders the loss of his son and his estates, while realizing that he now must face accusations of disloyalty, along with accepting ultimate responsibility for Wallenstein's failure.

WALLNER, FRANZ (Franz Seraphin Leidersdorf, 1810–1876). Manager, director. Wallner became one of **Berlin**'s most significant theatrical entrepreneurs in the 1850s and 1860s, when managers were required to obtain operating concessions from the Prussian government. In 1855 he leased a facility in Blumenstrasse that became so successful Wallner bought it and named it after himself. Wallner was a native **Viennese** and had witnessed **Johann Nepomuk Nestroy** in performance at the Carl Theater. Those experiences had left an indelible mark on Wallner's own practice of theater, and by 1851 he had become director of the Freiburg Stadttheater, followed by leases

of theaters in Baden-Baden and Posen. During those residences, he assembled around him the kind of acting talent he thought best suited to the plays of Nestroy, **Ferdinand Raimund**, **Adolf Bäuerle**, and other Viennese comic masters. Berliners found Wallner's Viennese touch to their liking, largely because his productions bespoke a higher standard than ones to which they were accustomed.

Wallner's greatest playwriting discovery was **David Kalisch**, who had already established a reputation for himself as the founder of the satirical Berlin weekly *Kladderadatsch*. His first play for Wallner was *Aktienbudiker* (*The Stock Market Hero*), which Wallner premiered in 1856; it continued for 215 performances, the most of any play in Berlin's history to that time, and it was among the most frequently performed plays in Berlin during the years prior to German unification. Wallner followed it with Kalisch's *Ein gebildeter Hausknecht* (*An Educated Houseboy*) in 1858; other Kalisch plays helped the Wallner Theater become a premier venue for comedy in Berlin for the next dozen years.

Wallner's productions, many of them starring **Karl Helmerding**, made him prosperous enough to build his own new theater on Raumstrasse in 1865. It was an elaborate and far too costly building, with construction costs running three times the original estimates. The building was so impressive that city officials renamed the street facing the structure Wallner-Theater-Strasse. Political events furthermore conspired against Wallner; the Austro-Prussian War of 1866 occasioned his deportation back to Vienna. Upon his return to Berlin, Wallner leased his theater to **Theodor Lebrun**. His last production in the Wallner Theater was Kalisch's *Die Mottenburger* (*The Mottenburgers*), which closed 30 April 1868.

WÄLTERLIN, OSKAR (1895–1961). Director, manager. Wälterlin was a native Swiss who from 1938 to 1945 ran the Zurich Schauspielhaus as the most important German-speaking theater in Europe. Wälterlin had begun his career in Basel as an actor and managed the theater there until 1932. For the next five years, he directed the Frankfurt am Main Opera, and in 1938 he assumed artistic leadership of a formerly private theater called the Volkstheater am Pfauen; that year, it had become the property of a private-public consortium, which renamed it the Schauspielhaus. Wälterlin hired several expatriate German performers,

including **Therese Giehse**, **Albert Bassermann**, and Wolfgang Langhoff, presenting a repertoire that included contemporary plays by anti-Nazi playwrights. Among the most notable world premieres at the Schauspielhaus were **Bertolt Brecht**'s *Mutter Courage und ihre Kinder* (*Mother Courage and Her Children*) with Giehse in the title role. Pro-Nazi crowds in Zurich frequently but unsuccessfully attempted to shut it and other productions down, though many could continue only with protection from Zurich police officials. Wälterlin's political acumen with local officials, along with his ability to secure financial support from individuals, was instrumental in the survival of the Schauspielhaus. From the late 1940s through the 1950s, Wälterlin continued to stage world premieres, including plays by **Carl Zuckmayer**, **Max Frisch**, and **Friedrich Dürrenmatt**.

WEDEKIND, FRANK (Benjamin Franklin Wedekind, 1864–1918). Playwright, actor. Wedekind was a seminal figure in the German theater's transition to modernism. His departures, both formal and material, were radical, utilizing a cabaret sensibility to disrupt bourgeois expectations of theater performance. The dialogue in his plays was characterized by *Aneinandervorbeireden*, which characters "spoke past each other." These characters were often disquieted adolescents, murderers, confidence men, pimps, nymphomaniacs, bank presidents, or lesbians, all of them jumbled into an environment with realistic contours. Beneath the surface lurked profoundly controversial topics intended to agitate moral certitude. Wedekind's first play, *Frühlings Erwachen* (*Spring's Awakening*, 1891), scandalized audiences, critics, and producers; it and nearly all his other plays remained unperformed except for private audiences: the Lulu plays *Erdgeist* (*Earth Spirit*) premiered in 1898 and *Die Büchse der Pandora* (*Pandora's Box*) in 1903; *Der Kammersänger* (*The Court Tenor*) premiered in 1905. *Spring's Awakening* opened in 1906—and ran for 117 performances, by far the longest run of any **Max Reinhardt** production that season. Most observers had considered it pure pornography; Reinhardt had to cut the homosexual and masturbation scenes in order to get it past the police **censor**. It featured 26-year-old **Alexander Moissi** as the 15-year-old Moritz and Wedekind himself as the Man in the Mask. Throughout the Wilhelmine period, Wedekind continued to shock audiences as a playwright, cabaret per-

former, and political commentator. Many scholars have since hailed him as a forerunner to **Expressionism**, though his preoccupations with sexuality, sexual relationships, androgyny, bisexuality, and tendencies toward the scatological distinguish Wedekind most clearly as a *Bürgerschreck* ("scourge of the bourgeoisie"), determined to erode and subvert the era's moral convictions.

WEGENER, PAUL (1874–1948). Actor. Wegener made more than 60 films in a five-decade-long career, though he remains best known for *Der Golem* (*The Golem*, 1920), which he also directed and wrote. He began his career in Rostock and Nuremberg, but in 1906 **Max Reinhardt** hired him to play character roles in productions of classics at the **Deutsches Theater**. He won critical praise in several such roles, including Lear, Macbeth, Othello, and Richard III. By 1912 he began to take an active interest in film acting, and by 1913 he was appearing regularly in feature-length movies, most notably in *Der Student von Prag* (*The Student from Prague*) with **Alexander Moissi**, directed by Stellan Rye. His position as a well-known character actor solidified when the Nazis came to power; **Gustaf Gründgens** hired him at the Staatliches Schauspielhaus, where he remained until the end of the war. Wegener was among the first performers on a Berlin stage following the German defeat, appearing in **Gotthold Ephraim Lessing**'s *Nathan der Weise* (*Nathan the Wise*) at the Deutsches Theater in the summer of 1945. While performing the play in 1948, he collapsed on stage and died soon thereafter.

WEICHERT, RICHARD (1880–1961). Director, manager. Weichert became one of the most significant directors of the **Expressionist** style in the 1920s. He had studied acting with **Louise Dumont** and Gustav Lindemann in Düsseldorf before World War I, and during the war he began directing at the Mannheim National Theater. Among his most notable productions there was **Walter Hasenclever**'s *Der Sohn* (*The Son*) in 1918. Weichert embraced distortion in both lighting and set design, seeing both as a route to the central character's inner torment. He continued to promote Hasenclever's plays when he became manager of the Frankfurt am Main City Theater in 1918, a post he held until 1932. In Frankfurt he attempted to stage works by **William Shakespeare** in the Expressionist manner, but only his *Macbeth* stirred any interest. In

Frankfurt he also produced the early works of **Bertolt Brecht**, attracting national attention to Frankfurt am Main and enhancing Brecht's chances for additional productions in **Berlin**. During the Third Reich, Weichert worked regularly at the Berlin Volksbühne, directing a variety of plays that ranged from Shakespeare, **Johann Wolfgang Goethe**, and **Heinrich von Kleist** to **Franz von Schönthan**, including even Nazi favorites like Heinrich Zerkaulen. He worked periodically in **Vienna** as well. By the mid-1930s he had long forsaken the Expressionist paradigm, but after the war, he returned to Frankfurt am Main and to an Expressionism of sorts, premiering **Wolfgang Borchert**'s *Draussen vor der Tür* (*The Outsider*) in 1948.

WEIGEL, HELENE (1900–1971). Actress, manager. Weigel was best known for her marriage to **Bertolt Brecht**, though she was an outstanding performer in her own right. She began her career in Frankfurt am Main and then established herself in **Berlin** during the 1920s at the State Theater. There she appeared in several productions, winning serious critical attention in a 1926 staging of **Friedrich Hebbel**'s *Herodes und Miramne* and in 1928 at the Volksbühne production of Brecht's *Mann ist Mann* (*A Man's a Man*). The latter, along with a subsequent version of the play in 1931, set precedents for the collaboration between Brecht and her in the years to come.

With Brecht and their children, Weigel fled Germany in 1933 and ultimately settled in Santa Monica, California; they returned to East Berlin in 1948 at the invitation of Soviet Zone officials. At the **Deutsches Theater**, she played the title role in Brecht's *Mutter Courage und ihre Kinder* (*Mother Courage and Her Children*) in 1949, the role for which she is best remembered. Her performances at the 1954 Theater Festival of Nations in Paris won her world renown. Weigel became manager of the **Berliner Ensemble**, and other honors from the German Democratic Republic followed, including professorships, honorary degrees, artistic citations, and membership in the largely ceremonial House of Deputies. She continued her acting career concomitant with her managerial duties through the 1960s for the Berliner Ensemble, appearing in Brecht's adaptation of *Coriolanus*, his *Die Heilige Johanna der Schlachthöfe* (*St. Joan of the Stockyards*), and **Helmut Baierl**'s *Frau Flinz*.

WEISS, PETER (1916–1982). Playwright. Weiss is best known internationally for *Die Verfolgung und Ermordung Jean-Paul Marats dargestellt durch die Schauspielgruppe des Hospizes zu Charenton unter Anleitung des Herrn de Sade* (*The Persecution and Assassination of Jean-Paul Marat Performed by the Theater Group at the Asylum in Charenton under the Direction of the Marquis de Sade*, usually titled *Marat/Sade* in English, 1964). He made his debut as a playwright with *Nicht mit Gästen* (*Not When Guests Are Present*) at the **Berlin** Schiller Theater Werkstatt in 1963; in quick succession, there followed a number of plays, including the aforementioned *Marat/Sade* (likewise premiered at the Schiller Theater), though none of them achieved similar cult status.

The first version of *Marat/Sade* was overtly Marxist in structure, with dialectical arguments between Marat and de Sade throughout; subsequent versions downplayed Weiss's political convictions (he was a lifelong Communist Party member). Peter Brook's 1965 London production was far less Marxist than the original, featuring theatrical excrescences of Antonin Artaud; Brook's 1967 film of the production bears witness to the much depoliticized version.

Nearly all of Weiss's plays had extremely long titles, such as his *Diskurs über die Vorgeschichte und den Verlauf des lang andauernden Befreiungskrieges in Vietnam als Beispiel für die Notwendigkeit des bewaffneten Kampfes der unterdrückten gegen ihre Unterdrücker sowie über die Versuche der Vereinigten Staaten von Amerika, die Grundlagen der Revolution zu vernichten* (*Discourse on the Historical Precedents and the Length of the Ongoing War of Liberation in Viet Nam as an Example of the Necessity of Armed Struggle by the Oppressed against Their Oppressors, such as Attempts by the United States of America to Exterminate the Bases of Revolution*, usually titled *Vietnam/Discourse*, 1968).

WEKWERTH, MANFRED (1929–). Director, **intendant**. Wekwerth completed doctoral studies in 1951 and began working with **Bertolt Brecht** the same year at the **Berliner Ensemble**. His directing debut with the company came two years later with Brecht's *The Mother*, starring **Helene Weigel**. Other important Brecht productions he directed that remained in the company's repertoire through the 1960s

included *Die Tage der Kommune* (*Days of the Commune*), *Der aufhaltsame Aufstieg des Arturo Ui* (*The Resistible Rise of Arturo Ui*), **Der kaukasische Kreidekreis** (*The Caucasian Chalk Circle*), and *Coriolanus*; John Millington Synge's *The Playboy of the Western World* and Johannes R. Becher's *Winterschlacht* (*Winter Battle*) were also part of his oeuvre. Wekwerth left the Berliner Ensemble in 1969 for work in London, Zurich, the **Burgtheater** in **Vienna**, and the **Deutsches Theater** in **Berlin**. He founded the directing program at the Ernst Busch School in Berlin, and in 1977 returned to the Berliner Ensemble as its intendant, remaining in that position until the collapse of the German Democratic Republic.

WESSELY, PAULA (1907–2000). Actress. Wessely was praised for the "inner life" she created for characters she portrayed, particularly as she matured and began to play a wide variety of roles. She began her career at age 19 with the Deutsches Theater in Prague, and three years later began her work at the Theater in der Josefstadt in her native **Vienna**. She remained at that venue until 1945, when she became a member of the **Burgtheater** company. During the Third Reich, Wessely worked frequently in **Berlin**, usually at the **Deutsches Theater** under **Heinz Hilpert**'s direction.

Hilpert, above all directors, esteemed and appreciated Wessely's quiet intensity and complete absence of showiness; he recognized that her rejection of bravura was a result of focused energy. Her voice, however, manifested the character's inner torment. Such was the case early in her career with Luise Miller in **Max Reinhardt**'s production of **Friedrich Schiller**'s **Kabale und Liebe** (*Intrigue and Love*) at the Salzburg Festival in 1930. It was also present two years later, though she got more publicity for it, in the title role of **Gerhart Hauptmann**'s *Rose Bernd*. Critics praised Wessely's ability to bear up under suffering, the kind that riveted audiences in their seats. Wessely never gave in to tears or relied on outward display; at the same time, nobody in the audience sensed she was simply stoical in the face of catastrophe. She was agonizing, but she was not about to show it.

As Gretchen in *Faust*, Christine in *Liebelei* (*Loving*), or Joan of Arc in Schiller's **Die Jungfrau von Orleans** (*The Maid of Orleans*) at the 1936 Berlin Olympics, where international audiences saw her, she

created "an occasion of elementary truth. Wessely played naturalistically within a classical framework. She proceeded unflinchingly towards the inevitable, without even so much as a whimper. Everything was on the inside, accomplished by means of simplicity, yet never denying the earthiness of her temperament" (**Herbert Ihering**, *Von Josef Kainz bis Paula Wessely* [Heidelberg: Hüthig, 1942], 239).

The Nazis found this kind of acting especially useful in propaganda films during the 1940s. In *Heimkehr* (*Homecoming*, 1941), she brilliantly played the wife of a soldier killed in action; her lengthy scene about the necessity of his death and the majesty of sacrifice for Führer and Fatherland has outraged subsequent generations of Germans and Austrians, particularly **Elfriede Jelinek**. "I regard her work as comparable to the war crimes of others," Jelinek stated. "Wessely's 'naturalness' was nothing more than kitsch. She actually said in the film, 'We don't do business with Jews,' and she should have attempted to avoid it. As a highly paid star, she could have. But she did not" (*Format* Magazine, 15 May 2000).

Wessely's activities during the war had little effect on her career in Austria afterward. In fact, the mature roles she played at the Burgtheater—Nora in Eugene O'Neill's *A Touch of the Poet* (1957), the title role in Schiller's *Maria Stuart*, Ella Rentheim in Henrik Ibsen's *John Gabriel Borkmann* (1965), Amanda Wingfield in Tennessee Williams's *The Glass Menagerie* (1965), Agnes in Edward Albee's *A Delicate Balance* (1967), and Mrs. Alving in Ibsen's *Ghosts* (1969), along with several others—provided her with acting opportunities she had never before enjoyed and won her praise from many observers, who hailed Wessely as Austria's greatest actress. She was awarded dozens of citations, prizes, honorary titles, medals, rings, degrees, and honorary professorships; in the minds of most Austrians, she had achieved theatrical apotheosis.

WIELER, JOSSI (1951–). Director. Wieler is one of the few German directors to have studied theater extensively in Israel before initiating his directing career. Upon his return to Germany in 1982, Wieler directed in Düsseldorf and Heidelberg before his breakthrough production of **Heinrich von Kleist's** *Amphytrion* in Bonn, which was invited to the Berliner **Theatertreffen** in 1985. In 1988 Wieler was named principal director of Theater Basel in Switzerland, and he assumed a

similar position at the **Deutsches Schauspielhaus** in **Hamburg** under **intendant Frank Baumbauer** in 1993. The following year, he staged the production for which he is perhaps most well known, *Wolken.Heim* (*At Home in the Clouds*) by the Nobel Prize–winning playwright **Elfriede Jelinek**; it was invited to the Theatertreffen, named "production of the year," and subsequently invited to several international theater festivals. In 2000 Wieler became principal director of the Hannover State Theater, and two years he later received the Konrad Wolf Prize.

WIEMANN, MATHIAS (1902–1971). Actor. Wiemann is best known for his work with **Max Reinhardt** and **Heinz Hilpert**, but in the postwar period he became one of the German theater's best-known character actors. He made his debut in 1924 at the **Deutsches Theater** in **Berlin**, and in that venue starred with **Elisabeth Bergner** and **Rudolf Forster** in Reinhardt's much-admired production of George Bernard Shaw's *St. Joan*. Also with Bergner, he starred in the 1929 German premiere of Eugene O'Neill's *Strange Interlude*. Wiemann appeared prominently in several other Reinhardt productions of the 1920s, including **William Shakespeare**'s *Othello*, Luigi Pirandello's *Six Characters in Search of an Author*, Wolfgang Goetz's *Gneisenau*, and **Gerhart Hauptmann**'s *Michael Kramer*. Wiemann also had a substantial film career, appearing most notably in *Die ewige Maske* (*The Eternal Mask*, 1935), a Swiss production that won international awards for its frank portrayal of mental illness. The National Film Board of Review in the United States named it "best foreign film of the year" and gave Wiemann its award for best actor. After World II Wiemann began playing leading roles in German classics, and in 1968 he played pawnbroker Gregory Salomon in the German premiere of Arthur Miller's *The Price*.

WILBRANDT, ADOLF (1837–1911). Playwright. In the 1870s Wilbrandt became one of the most frequently performed playwrights at **Vienna's Burgtheater**, creating exciting roles for the company's leading performers in plays with historical subject matter. For his *Gracchus der Volkstribun* (*Gracchus, the Peoples' Tribune*), he won the 1872 Austrian Schiller Prize. In quick succession, other plays followed, notably *Arria und Messalina* (1874), *Giordano Bruno* (1874), *Nero* (1876), and *Kriemhild* (1877). He was so successful, in fact,

that he married a leading actress of the Burg and became the company's director in 1881, a post he held until 1886. By that time, King Ludwig II of Bavaria had raised him to the nobility, permitting him to add "von" to his name.

WILDENBRUCH, ERNST VON (1845–1909). Playwright. Wildenbruch was that exceptional creature in the 19th-century German theater, similar to **Gustav von Moser** and **Franz von Schönthan**: an aristocrat and former military officer who wrote extremely popular plays. He won favor from Kaiser Wilhelm II for his runaway hit *Die Quitzows* (*The Quitzows*, 1888), a glorification of the Prussian royal family, the first play in a planned trilogy. It was wildly successful and was presented thousands of times through the 1890s, winning Wildenbruch the Schiller Prize. Wildenbruch owed his playwriting breakthrough to the Meininger troupe, who usually premiered his plays. They started with *Die Karolinger* (*The Carolingians*, 1882), followed by *Väter und Söhne* (*Fathers and Sons*, 1882), *Der Menonit* (*The Mennonite*, 1882), *Christopher Marlowe* (1884), and *Das neue Gebot* (*The New Commandment*, 1885). They were verbose imitations of **Friedrich Schiller**, made to seem better in quality when the Meininger produced them. Wildenbruch was a thoroughgoing Prussian patriot, attending military schools as a boy and being commissioned an officer in the Prussian military tradition. Even when he was no longer in the military, Wildenbruch held a series of civil service jobs with the Prussian justice ministry and, when the new Reich came into being, he worked as a career diplomat in the service of the newly ordained kaiser.

Wildenbruch's companion pieces to *The Quitzows*, titled *Der Generalfeldoberst* (*The Field Commander*, 1889) and *Der neue Herr* (*The New Lord*, 1891) were not successful as sequels. In *The Field Commander*, a close relative of the Hohenzollern family is executed before a Habsburg firing squad. Even though the scene was based on an actual event that took place in 1620, Wilhelm II banned the play based on a cabinet order of 1844 which stipulated that the sovereign had to give his permission for any play in which a deceased member of the royal family was to appear. Wildenbruch begged with the kaiser in a pitiful letter to lift the ban, then in a personal audience beseeched Chancellor Otto von Bismarck to plead his case with the

kaiser. Bismarck, however, bluntly told Wildenbruch he liked his plays but thought this particular play was not worth saving. Soon thereafter, Wildenbruch got word he was to resign his position with the Foreign Ministry. He refused to do so, and in the 1890s he wrote another string of successful plays led by *Heinrich und Heinrichs Geschlecht* (*Heinrich and Heinrich's Dynasty*), premiered in 1896. In that year, Wildenbruch won his second Schiller Prize.

WILHELM TELL (*William Tell*) by **Friedrich Schiller**. Premiered 1804. Schiller's last play, written in blank verse, treats the revolt of the Swiss cantons against Austrian tyranny. Schiller employs two plots: a major line of action follows the exploits of the title character and his personal animus against the villainous Gessler, whom he ultimately murders for the sake of national liberty. Tell is not the leader of the uprising; he is rather its moral centerpiece, a man determined to maintain his individual freedom while acting under moral constraints. He is, in other words, the personification of the Schillerian ideal he termed the "sublime." Tell is therefore a combination of Robin Hood and Davy Crockett—one who fights courageously but must also tell himself, "Be sure you're right, then go ahead." There is also a curious double-plot used in the final act, when Johann Parricide is brought in during the last act to contrast with Tell; Johann has murdered his uncle, the Habsburg emperor, to satisfy his ambition. Tell has killed Gessler in an act of tyrannicide. Schiller also makes use of the "neutral playing space" convention required of many subsequent **Romantic** dramas: much of the action takes place offstage—sinking ships, earthquakes, castle fires, battles, and so forth. The characters then arrive at the "neutral space" for the "working out" part of the action.

The play is noteworthy for its numerous aphorisms that have worked their way into colloquial expression. "Durch diese hohle Gasse muss er kommen" (Through this dark alley must he go) is perhaps the best known; "es kann der Frömmste nicht in Frieden leben, wenn es dem bösen Nachbarn nicht gefällt" (Even the most pious cannot live in peace if his evil neighbor will not suffer him) is less familiar, but in performance German audiences greet it with the same familiarity as do their English-speaking counterparts hearing "Neither a borrower nor a lender be" from *Hamlet*, "pomp and circumstance" from *Othello*, or "All at one fell swoop" from *Macbeth*.

WINTERSTEIN, EDUARD VON (Eduard, Baron von Wangenheim, 1871–1961). Actor. In an extraordinarily long and distinguished career, Winterstein worked with the most significant of 20th-century German theater artists. He began performing with touring troupes, moving up to small provincial theaters, and made his **Berlin** debut in 1895 at the Schiller Theater. In 1898 **Otto Brahm** hired him for numerous **Gerhart Hauptmann** premieres, and in 1905 Winterstein began his lengthy association with **Max Reinhardt**. In the 1920s he also appeared extensively in productions at the Prussian State Theater under **Leopold Jessner**. During the Third Reich, Winterstein was a member of the Schiller Theater company, and after the war he remained in East Germany until his retirement. He appeared in several world premieres, including **Carl Zuckmayer**'s *Der fröhliche Weinberg* (*The Merry Vineyard*) and *Der Hauptmann von Köpenick* (*The Captain of Köpenick*). Winterstein also appeared in the German-language premiere of George Bernard Shaw's *The Apple Cart*, but the German-translation premiere for which he gained the widest notoriety was Eugene O'Neill's *The Hairy Ape*, in which he played the title role. Winterstein also appeared in scores of films, beginning in 1910. The most notable among them were *Der blaue Engel* (*The Blue Angel*) in 1931 with Marlene Dietrich and *Münchhausen* in 1943 with **Hans Albers**; Winterstein completed his last film shortly before he died.

WOHLBRÜCK, ADOLF (Anton Walbrook, 1896–1967). Actor. Wohlbrück was one of the few German actors in the 20th century who enjoyed a successful career in both British and German theaters and films. The descendant of a long line of circus performers, Wohlbrück completed a liberal arts education before enrolling in **Max Reinhardt**'s acting school in **Vienna**. Upon completion of his acting studies, Wohlbrück established himself as an outstanding member of the Dresden State Theater company during the 1920s before making his **Berlin** debut in 1930. Working in Berlin gave him new opportunities to work in film, and between 1931 and 1936 he appeared in more than two dozen German films. At the 1936 Berlin Olympics, he accepted an offer to work in London, and under the name Anton Walbrook, he began his English career, both in films and on the stage—particularly in West End musicals. In 1951 **Gustaf Gründgens** convinced Walbrook to return to Germany, specifically to Düsseldorf where he appeared in several popular comedies by

Curt Goetz. He continued working with Gründgens through the 1950s, and that decade also witnessed his return to German films (and to the name Adolf Wohlbrück as well). He continued working well into the 1960s, especially in German television.

WOLFF, PIUS ALEXANDER (1782–1828). Actor. Wolff is best known as the actor whom **Johann Wolfgang Goethe** personally trained in the "Weimar style," beginning when Wolff was 20 years old. Wolff learned to emphasize precise movement, gesture, and enunciation in an attempt to "unite the true with the beautiful" and capture an idealized characterization in all his subsequent characterizations. He was the first Hamlet in **August Wilhelm Schlegel**'s masterful verse translation, given at the Weimar Court Theater and later under Goethe's direct supervision in 1809. Much to Goethe's chagrin, Wolff accepted an invitation to join the **Berlin** Royal Theater in 1816, where he continued to do idealized portrayals of Hamlet, Marquis Posa in **Friedrich Schiller**'s *Don Carlos*, the title role in Goethe's *Tasso*, and other romantic leads.

WOLTER, CHARLOTTE (1834–1897). Actress. Wolter became the **Vienna Burgtheater**'s leading tragedienne in the mid-1860s, playing female leads in several plays by **Shakespeare**, **Johann Wolfgang Goethe**, **Gotthold Ephraim Lessing**, and **Franz Grillparzer**. She maintained her eminence through the 1870s, expanding her repertoire to include leading roles in French salon dramas by Eugène Scribe, Alexandre Dumas *fils*, and Victorien Sardou; critics considered her particularly effective in the title role of Scribe's *Adrienne Lecouvreur*. She enjoyed her most popular success as Jane Eyre in **Charlotte Birch-Pfeiffer**'s adaptation of the novel *Jane Eyre*, titled *Die Waise von Lowood* (*The Orphan of Lowood*). A splendid 1875 painting by Hans Makart depicting Wolter as the Roman emperor Claudius's doomed actress-wife Messalina still hangs in the Historical Museum of Vienna.

 Adolf Wilbrandt wrote *Arria und Messalina* especially for her in 1874, and it too was an audience favorite—though many critics were divided in their judgment. They accused Wolter of bringing an overburdened "natural" feel to such parts, especially when she screamed in passion. Those outbursts came to be known as *Wolterschreie* and

were a familiar trademark of her performances; audiences looked forward to them and applauded wildly when they occurred in her portrayals of Lady Macbeth, Phèdre, Sappho, and Mary Stuart. The screams were evidence of the intensity she brought to her characterizations, a tendency she learned at the Viktoria Theater in **Berlin**, where she began her career. The high point of her work there was as Hermione in Shakespeare's *The Winter's Tale*, a play curiously and inexplicably popular among the Germans in the 19th century. Her husband designed and built nearly all her costumes; she was buried in one of them, built for her when she played the title role in Goethe's *Iphegenia*.

WOMEN. The German theater has the unique distinction of having a woman as its founder. Without **Caroline Neuber**, the German theater in the 18th century would doubtless have revived somehow; there were other managers of touring troupes who by the 1730s could conceivably have reformed the German theater from its then moribund state to the heights of accomplishment as she did. Few of them, however, had her determination, ambition, competitive spirit, energy, and talent to accomplish the task. Johann Elias Schlegel and **Johann Christoph Gottsched** were eager to reform theater practice, though Gottsched wanted primarily to promote a Francophile repertoire toward that goal. His primary ambition was to imitate French drama, while his protégé Schlegel was more interested in **Shakespeare**. "Die Neuberin," however, had goals for the German theater that reached well beyond imitating another culture. She, like many others, had witnessed the miserable standards of performance prevalent among most troupes. Strolling players in other European countries were probably no worse than their German counterparts, but France, England, and Spain could boast "national" theaters by the 1730s, with audiences or courts that considered theater important enough to give it a place in the nation's cultural life. Those national theaters had produced highly accomplished playwrights, whose work solidified the importance of theater in the national consciousness.

Neuber, unlike other reformers, realized that reforming German theater involved more than simply new plays. It demanded reforming the lives of those who created theater. She placed strict limitations on the private conduct of her actresses and demanded that all performers

be literate. She established standards of enunciation and comportment that were unprecedented; only when performers adhered to specific models of decorum were they allowed to appear in public as members of her troupe. Like Gottsched, she realized that theater was a means to raise the level of social interaction among the German populace in general; unlike him, though, she understood that a specifically "German" theater was required for the task, not one based on precedents already in place or imported from somewhere else. Few women who succeeded "die Neuberin" matched her vision or influence. The practices she implemented had a wide-ranging and successful impact upon the German theater; thanks to her efforts German performers reached new heights of acceptance and affluence, and in the process she raised German audience expectations.

The woman who comes closest to Neuber in influence is perhaps **Charlotte Birch-Pfeiffer**. As a playwright, she completely dominated theater repertoires of the German Confederation, which included 39 states and four free cities. The Confederation was superseded in 1848 by the Frankfurt Assembly, which tried and failed to unite the German states under a liberal constitution, and the German Confederation was reestablished in 1851. It lasted until 1866. During those decades, Birch-Pfeiffer's plays appeared weekly in the police-regulated theater repertoires, both in the court and in municipal venues as well as their commercial counterparts. She had by the 1830s mastered the *Rührstück*, sentimental plays with strong emotional scenes and absolutely no political subject matter. Among her most frequently employed plots were treatments of the rise from poverty up the social ladder, the fulfilled longing for love, and the unexpected arrival of fortune from a long-lost relative. Birch-Pfeiffer always wrote with one goal in mind: making money. She was an actress with substantial talent, but she cultivated real genius both for writing plays the public wanted to see and for marketing them. From the receipt of her first royalty payment from the court theaters in **Vienna**, she belonged to the exclusive group of the highest earners among playwrights in the German theater. Her remarkable imagination, at work when adapting successful novels or creating her own original material, transformed her writing into a capital enterprise.

Any feminist attempt to "rediscover" Birch-Pfeiffer in the cause of reevaluating female playwrights and discovering in her characters

some disguised messengers of emancipation is questionable, because Birch-Pfeiffer's characters were, and were intended to be, tools in the service of maintaining the status quo, promoting a feeling of allegiance to authority within the audience, and stimulating ticket sales for the profit of both theater manager and herself the playwright. **Friedrich Hebbel**'s wife, the distinguished **Burgtheater** actress Christine Engelhaus-Hebbel, acted in several of Birch-Pfeiffer's plays, though Hebbel himself was not impressed with her talent as a playwright. He dismissed her as "Mother Birch."

Everybody, however, was impressed with the way Birch-Pfeiffer manipulated theater directors, who often shuddered at the prospect of negotiating with her. Her talent for negotiating was second only to that for creating theatrical effect, which she united with her ability to choose appropriate material. Birch-Pfeiffer furthermore developed the beneficial aptitude of making such characters thoroughly German in character, even though many were originally characters from English or French novels. Her work, beginning in 1828, competed with that of the "Young Germany" writers such **Heinrich Laube** and **Karl Gutzkow**, whose goal was to follow the precepts of the 1830 revolution and employ theater against the forces of Restoration policies, demanding the political, religious, and moral emancipation of the average German citizen.

Birch-Pfeiffer rejected such high-minded goals out of hand. She realized that, for heroes or heroines to be theatrically effective, they must withstand the blows of fate—not the temporary vicissitudes of politics or economics—if audiences were to appreciate them. Heroic qualities in her plays included faithfulness, good-heartedness, empathy, resoluteness, imperturbability, modesty, selflessness, charity toward mankind, love, hard work, piety, and an affinity with Nature. The pitfalls into which the hero or heroine fell seem designed specifically to test fundamental stability. That test posed an ominous, catastrophic threat that intruded upon, but at the last moment never fully succeeded in overcoming, heroic solidity. It also fell to the virtuous hero in her plays to enlighten antagonistic characters and set them on the "right path," since they are never evil but only misdirected. The hero may encounter an evildoer, but the evildoer will reveal to the hero his true self, which may be a tarnished nobility of spirit. In order to remove the tarnish, virtuous heroes often had to undergo a test

of endurance, doing the right thing at the right time, always under the rubric "Who does his duty can never fail."

Louise Dumont may well have been Birch-Pfeiffer's polar opposite in terms of how she perceived the German theater. To Dumont, using theater as a source of profit was anathema; as a result, Dumont's influence on a subsequent generation of women theater artists was fairly substantial. Among them one must include **Elisabeth Hauptmann** (1897–1973), whose contributions to 20th-century German theater have long languished in the shadows and suffered in silence; Hauptmann conducted most of her work in collaboration with **Bertolt Brecht**—in whose shadow he hoped Hauptmann would remain. Brecht had an uncanny ability to attract talented collaborators, both male and female, and then gaining credit for their efforts.

Hauptmann's work with Brecht began almost as soon as they met at a **Berlin** night school, where both were studying the works of Marx. By 1925 she had become his full-time secretary, translator (her mother was American), and companion. They began working on numerous projects together, resulting in Brecht's first major hit, *Die Dreigroschenoper* (*The Threepenny Opera*). The next year, she took the name "Dorothy Lane" to get credit for her work on the Brecht-Weill follow-up to *Threepenny*, titled *Happy End*. That year also saw Hauptmann's official enrollment as a member of the German Communist Party; she became the women's director of her party unit in the Charlottenburg section of Berlin, and when the Nazis came to power in 1933, she fled to St. Louis, Missouri, where her sister resided. She met with Brecht a year later when he came to New York for work on *The Mother*, and after his settlement in the United States as a refugee, she moved to New York. There and elsewhere they continued collaborative efforts on plays, adaptations, essays, and other activities. Among her own activities were her shortwave broadcasts to Germany to assist the Allied war effort and her work for the Council for a Democratic Germany. After the war, she returned to Europe and in 1949 took up residence in Berlin, where she continued political work as a member of the Socialist Unity Party, the successor to the Communist Party in Germany, along with intensified collaborative work with Brecht. After his death, she ran the **Berliner Ensemble** school, which concentrated on translations and adaptations for East German theaters.

Hauptmann remained silent about her work with Brecht until shortly before her death. She maintained she was his "left hand," an indication of not only their artistic but also their political affinities. Ruth Berlau, another of Brecht's numerous female collaborators and companions (Margarete Steffin, Hella Wuolijoki, and others) flatly stated that the collaboration with Elisabeth Hauptmann was the closest of the many from which Brecht clearly benefited. That he chose to withhold credit to her where credit was undoubtedly due will be a topic of debate for years to come.

As noted elsewhere in this volume, **Therese Giehse**, **Helene Weigel**, **Marianne Hoppe**, and **Elfriede Jelinek** left impressive marks on 20th-century German theater; to their names one should make special note of **Käthe Dorsch**, who at substantial risk to herself helped dozens of Jews escape Nazi Germany.

The names of several other women remain little known within the traditional annals of German theater. They include Charlotte Rissmann, whose *Promise Me Nothing* was among the most frequently performed of any comedy during the Third Reich. Marieluise Fleisser has become perhaps the best-known female playwright of the Weimar Republic, but she had competition from Ingeborg Andersen, Hartwig Bonner, Gabriele Eckehard, Sophie Klarss, Hanna Rademacher, and particularly Christa Winsloe, whose play *Gestern und Heute* (*Yesterday and Today*) became the basis for Leontine Sagan's film *Mädchen in Uniform* (*Girls in Uniform*). Sagan was herself a theater director of some note in Austria during the 1920s. Fleisser wrote *Fegefeuer in Ingolstadt* (*Purgatory in Ingolstadt*), which premiered in 1926 and enjoyed a rebirth in the early 1970s. Her second play was the far more interesting and comic *Pioniere in Ingolstadt* (*Pioneers in Ingolstadt*), which premiered in 1929 under Brecht's direction. It likewise enjoyed a revival in the early 1970s, thanks to the "new *Volksstück*" movement of that period, which rediscovered in the *Volksstück* a previously overlooked "authenticity."

The contributions of **Pina Bausch** have been less overlooked, since she has received numerous awards and citations for them. One should note, however, that Bausch has been in some ways as instrumental as was Neuber in creating a new way of looking at theater. Her "dance theater" has changed the way audiences perceive live

performance, perhaps because Bausch reconceived what theater performances could mean.

WOTRUBA, FRITZ (1907–1975). Designer. Wotruba was primarily known as a sculptor—one whom the Nazis considered *entartet*, or decadent beyond the pale of redemption. In the 1960s he began designing costumes for the **Burgtheater** in **Vienna**, and for **Gustav Sellner**'s "Sophocles Cycle," he designed a stunning catalogue of costumes for all of Sophocles' tragedies that were staged both at the Burg and at the Salzburg Festival.

WOYZECK by **Georg Büchner**. Premiered 1913. Perhaps Büchner's best-known play, *Woyzeck* was a fragmentary collection of scenes when it was discovered after his death. Its fragmentary nature made *Woyzeck* a modernist icon after its premiere in **Munich**, because many saw it as a "proto-**Expressionist**" drama that explored the mistreatment of a poor unfortunate at the hands of all-powerful institutions. It is at any rate among the first plays in German with a largely inarticulate central character, one whose sufferings define him and whose delusional criminality seems justified. Büchner based the character on medical reports he had read, and in some ways the play employs a clinical distance as a series of disjointed scenes examines Woyzeck's disintegration. Büchner was particularly gifted in creating bizarre yet fascinating secondary characters, whose fractured presence on stage make Woyzeck's disintegration seem hallucinatory yet inevitable.

– Z –

ZADEK, PETER (1926–). Director. Zadek became well known in the 1970s for his iconoclastic productions of **Shakespeare** in regional theaters, some of which provoked controversy. He is one of the few German directors (he was born in **Berlin**) to have grown up in England. He studied directing at the Old Vic School and staged English-language productions in London before working full-time in Germany. Zadek's first productions took place in London: Oscar Wilde's *Salome* and an adaptation of T. S. Eliot's *Sweeney Agonistes* in 1947.

He thereafter staged several productions in provincial Welsh and English theaters.

In 1958 Zadek got a directing job in **Cologne**, his first sojourn in Germany since emigrating with his parents in 1933. He worked throughout the 1960s in Ulm and **Bremen**, often with designer and painter Wilfried Minks as his collaborator. In Bremen he worked extensively under Kurt Hübner, who hired **Peter Stein** and **Klaus-Michael Grüber** as well to conceive new renderings of German stage "classics." Zadek was not interested in classics alone, however; he staged several Alan Ayckbourn German-language premieres, both in Bremen and in Bochum when he became **intendant** of the city's Schauspielhaus. In Bochum he also staged a series of controversial Shakespeare productions starring Ulrich Wildgruber, among them *The Merchant of Venice*. Zadek has staged five productions of *Merchant*, efforts he considers important in an effort to force Germans to confront their anti-Semitism. Zadek regards German anti-Semitism as crucial to understanding German culture; when he adapted Christopher Marlowe's *The Jew of Malta* and titled it *The Famous Tragedy of the Rich Jew from Malta*, he stated that Germans needed to acknowledge the bad side of Jews in order to fathom their antipathy toward Jews in general.

In 1999 Zadek staged *Hamlet* with Angela Winkler in the title role, though with little fanfare. His 2004 production of ***Mutter Courage und ihre Kinder*** (*Mother Courage and Her Children*) at the **Deutsches Theater** (where **Bertolt Brecht** staged his Berlin premiere production in 1949) likewise aroused little nationwide attention, unlike his Bochum and Bremen productions had once done. He remains nonetheless a significant figure in the German theater—a director with 21 productions invited to the Berliner **Theatertreffen**. Zadek has been awarded the Kortner Prize, the Piscator Prize, and the Kainz Medal.

ZERBROCHENE KRUG, DER (*The Broken Jug*) by **Heinrich von Kleist**. Premiered 1808. Kleist's verse comedy has become perhaps the most well known and certainly the most frequently performed of nearly any in German, even though the premiere **Johann Wolfgang Goethe** staged of it in Weimar was a complete disaster. It is set in a Dutch magistrate's court, where a judge named Adam presides over

a case against Eve's boyfriend, who is accused by Eve's mother of breaking her "most precious jug" upon his hasty egress from Eve's bedroom the evening previous. Adam is prepared to convict the boyfriend immediately, but the appearance of district court supervisor Walter complicates matters. Walter insists that Adam follow accepted procedure and the fine points of jurisprudence; in doing so, it becomes obvious that Adam himself was the culprit in Eve's bedroom, the one who destroyed the jug.

The character of Adam has been what the Germans call a "parade role" since the mid-1820s, when the play found its audience and became a fixture in the repertoires of most theaters. Though Adam's dilemma teeters toward the farcical on numerous occasions, the play never descends to the level of the formulaic. Adam's desperate attempts to shift blame and assign responsibility elsewhere, and ultimately his dismal failure to exculpate himself, form a masterpiece of characterization, one equaled rarely in all of German drama. The list of outstanding actors who have played Adam is a long one, and the attention scholars have paid to the play as a serious work of German theatrical art is equally extensive. One reason for both is Kleist's unprecedented expertise in the use of verse. In his hands, it becomes a fluent idiom for performance, and Kleist employs it ingeniously in the service of a comedy that is both enormously entertaining and extraordinarily effective as both entertainment and finely wrought literature.

ZIEGEL, ERICH (1876–1950). Director. Ziegel assumed leadership of the **Munich** Kammerspiele in 1913, shortly after its founding in the former Munich Comedy Theater. He began an aggressive program of premiering a new play every two weeks. One of them was Ludwig Thoma's one-act *Die Sippe* (*The Clan*), after which Munich police arrested both Ziegel and the playwright on the theater's stage. Of the more than 30 plays Ziegel presented, he directed over half of them. Ziegel left the Munich Kammerspiele in 1916 to found the **Hamburg** Kammerspiele, where he opened his administration with a week of **Frank Wedekind** plays. He continued to premiere new plays, many of them by then-unknown **Expressionists**. He briefly directed the Hamburg **Deutsches Schauspielhaus** in the mid-1920s when the Kammerspiele was torn down. After it was rebuilt in 1932, he returned there until 1934, when the Gestapo threatened him after

he staged a production of a play by **Johann Wolfgang Goethe** they felt was "insulting." He departed for Vienna, where he found little work; he then returned periodically to **Berlin** to work for **Gustaf Gründgens**.

ZIEGLER, KLARA (1844–1909). Actress. One of the last exemplars of an antiquated "heroic" acting style by the 1890s, Ziegler ironically began her career in private theaters. Her first "classical" role was Joan of Arc in **Friedrich Schiller**'s *Die Jungfrau von Orleans* (*The Maid of Orleans*) in Bamberg, but from there she worked for the private Gärtnerplatz Theater in **Munich** in soubrette roles. At the Leipzig City Theater in the late 1860s, however, she began to cultivate the orotund, declamatory style for which she became known. Her career reached its peak at the Court Theater of Munich, where she lived for the rest of her life. She amassed a sizable fortune, which she bequeathed to a foundation that opened a theater museum in 1910.

ZUCKMAYER, CARL (1896–1977). Playwright. Zuckmayer was the most popular comic playwright during the Weimar Republic, and in the seasons immediately after World War II his straight plays dominated repertoires in the Western occupation zones. During the 1950s his presence remained dominant, as most theaters in the new Federal Republic staged Zuckmayer plays in large numbers. During both the Weimar Republic and the postwar period, **Heinz Hilpert** staged nearly all the Zuckmayer premieres, recalling the artistic relationship **Otto Brahm** and **Gerhart Hauptmann** had shared.

Zuckmayer was exceptional in many ways, not least of which being his ability to write widely popular plays with literary and intellectual merit. He usually structured them after the *Volksstücke* that had enjoyed enormous popularity in the Wilhelmine period; such was the case with *Der fröhliche Weinberg* (*The Merry Vineyard*), Zuckmayer's first hit comedy, which ran for years after its premiere in late 1925. It also earned him the enmity of **Joseph Goebbels**, who accused Zuckmayer of profaning the German *Volk* in his earthy portrayal of village Rhinelanders blissfully coupling and copulating. Both Zuckmayer and Goebbels came from the Rhineland, but Zuckmayer used the Rhine as a metaphor in praise of what he considered truly "German," the mingling of peoples through the centuries. Goebbels posed

Nazi doctrine in diametric opposition to such thinking, preferring to regard the Rhine as a mystical artery of German purity.

In 1925 Zuckmayer won the Kleist Prize. Following the success of *The Merry Vineyard* came two additional hits in the 1920s: *Katherina Knie* (about circus performers) and *Schinderhannes* (the German embodiment of Robin Hood). His later efforts included the screenplay for *Der blaue Engel* (*The Blue Angel*), the translation for the German premiere of Maxwell Anderson and Laurence Stallings's *What Price Glory?*, and with Hilpert an adaptation of Ernest Hemingway's novel *A Farewell to Arms*, titled *Kat*.

Goebbels continued to attack Zuckmayer into the 1930s, particularly after the 1931 premiere of Zuckmayer's most popular comedy, **Der Hauptmann von Köpenick** (*The Captain of Köpenick*). Theaters performed it more often in 1931 and 1932 than any other play. In it, Zuckmayer again used the *Volksstück* format, this time resembling one **Adolph L'Arronge** had employed in the 1870s. It presented Germans with a humorously scathing picture of themselves, based on a familiar 1906 episode in **Berlin** when an unemployed cobbler so effectively imitated a Prussian captain that every German in sight snapped to attention and assisted him in robbing a municipal treasury. The spectacle of Germans behaving stereotypically obeisant in the presence of authority outraged most Nazis; it prompted unrestrained laughter among nearly everyone else. Zuckmayer's skepticism about authority had begun as a soldier in World War I. He had volunteered at age 17 for infantry duty, and the war had had a profound effect on him—but unlike many of his contemporaries, it was an effect that caused him to celebrate the hopeful and humorous side of human existence.

When the National Socialist government banned his work in 1933, Zuckmayer retreated to his Austrian estate and later emigrated to Switzerland. However, he periodically returned to Germany in disguise and with forged documents, which led him to begin working for the U.S. Office of Strategic Services (OSS) after he settled in Vermont during the 1940s. There he ran a farm and wrote reports for the OSS, while in the process of completing *Des Teufels General* (*The Devil's General*). Zuckmayer based that drama on the career of his friend Ernst Udet, a World War I flying ace and Goering confidant who supervised the development of fighter-bombers for the Luftwaffe. Udet had committed suicide, and Zuckmayer constructed

around his death a convincing drama about a German general's pact with the devil. Zuckmayer's depiction of *bonhomie* among the Nazi elite created a stir of controversy after Hilpert premiered it in 1946, but controversy helped the play to become one of the most frequently staged of any during the remainder of the decade.

In the 1950s Zuckmayer proceeded to finish or rewrite many of the plays he had begun in Vermont; Hilpert premiered them as usual, but in most cases the results were disappointing. Their last collaboration was *Die Uhr schlägt eins* (*The Clock Strikes One*), which met with vituperative critical derision. Zuckmayer received several awards in addition to the Kleist Prize; in 1952 the city of Frankfurt am Main awarded him its Goethe Prize, and his subsequent citations included the Greater Austrian State Prize in 1960 and the 1972 Heinrich Heine Prize for his entire body of work. Zuckmayer was a gifted essayist whose two autobiographies remain among the most readable of any that chronicle the modern German theater.

ZWANGSEINQUARTIERUNG (*Forced Emergency Housing*) by **Franz Arnold** and **Ernst Bach**. Premiered 1920. A humorous treatment from "the firm of Arnold and Bach" of the catastrophic housing shortage in Germany after the return of the defeated German army. Its focus was on Anton Schwalbe, a retired industrialist and owner of a comfortable villa within a large German city. Schwalbe's nemesis is an overzealous government housing official named Dr. Hans Hellwig, whose efforts upend the household's domestic tranquility. These two characters represent opposing mentalities in the immediate postwar period, as Schwalbe passionately desires an ordered calm within his villa, while Hellwig (like many in the republican government) seems determined to ameliorate suffering among the German population. To that end, he delivers several unfortunate homeless individuals to the villa; Schwalbe's servants then go on strike for higher wages, and Schwalbe himself is threatened with bankruptcy. In the midst of his troubles, Schwalbe gets news that he is the putative father of an illegitimate daughter. His reaction is similar to that of most Germans when contemplating the reparations payments dictated in the Versailles Treaty: stupefaction, quickly followed by outrage. When he meets the young woman who may be his daughter (a Hungarian violinist named Etélka), Schwalbe is utterly charmed, even though she

turns out not to be his daughter. This conflict, along with all the others, is peaceably resolved by the final curtain. The villa returns to normal, young lovers are united, servants return to work with a new sense of respect (in fact, the household maid turns out to be Schwalbe's daughter), and the intrusive government official is censured.

ZWEITE GESICHT, DAS (*Two-Faced*) by **Oskar Blumenthal**. Premiered 1890. The two faces of the title belong at first to Count Mengers, who appears to be a kindly gentleman but in reality is a gambler and ladies' man. He is involved in a bitter lawsuit with his young sister-in-law Charlotte, who married the Count's late elder brother and stands to inherit the entire family fortune. Count Mengers has hired an intelligent and aggressive lawyer to contest the will, but while advocating the Count's case, the lawyer falls in love with Charlotte. He, too, it turns out, has two faces. Charlotte also wears two faces; she claims to love the lawyer but is actually an unscrupulous bounder who married an old man for his money. She claims that her shabby life as a young woman made her marriage to the elderly Mengers attractive—and anyway, the old man wanted her to marry him in order to ease his advancing years. She did so at the sacrifice of her own honor. Enter a fourth party with two faces: her friend Kitty, who is actually Count Mengers's daughter just graduated from boarding school. Kitty convinces her father to settle with Charlotte because she is not really so ambitious as she seems. Furthermore, she really loves the lawyer and did indeed make her elderly husband happy in his last years. Count Mengers, satisfied with the settlement, now looks forward to his next trip to the casinos in Monte Carlo. Blumenthal's skill with dialogue turned the play into a satisfying satire on the aristocracy; it was among the most frequently performed of all comedies during the early 1890s.

Bibliography

CONTENTS

INTRODUCTION

Published material on the German theater is both extensive and, as Prof. Simon Williams, one of the great historians of the German theater, once noted, it is "dauntingly vast." No bibliography as part of a volume such as this could even approximate sufficiency; there is, however, an altogether copious and valuable stand-alone bibliography on the German theater, published by another outstanding German theater historian, Prof. Michael Patterson. Both Williams and Patterson are represented here, and readers desirous of further inquiries should without hesitation consult Patterson's *German Theatre: A Bibliography from the Beginning to 1995*.

In the meantime, there are other outstanding works available in English for anyone wishing to embark on a short course of introduction to the German theater. Among the most notable have been Marvin Carlson's

The German Stage of the 19th Century and his *Goethe and the Weimar Theatre*. To these, one should add the following: Walter Bruford's *Theatre, Drama, and Audience in Goethe's Germany*; Betsy Aikin-Sneath's *Comedy in Germany in the First Half of the Eighteenth Century*; Patterson's *The Revolution in German Theatre, 1900–1933* and *The First German Theatre*; Williams's *German Actors of the 18th and 19th Centuries*, along with his *Shakespeare on the German Stage*, vol. 1; Ann Marie Koller's *The Theater Duke: Georg II of Saxe-Meiningen*; J. L. Styan's *Max Reinhardt*; all of the books by John Willett; Glenn Cuomo's edition *National Socialist Cultural Policy*; and Glen Gadberry's edition *Theatre in the Third Reich*. Hugh Garten's *Modern German Drama* was for many years a standard text for students interested in individual German playwrights. It is still a good and valuable book, but it has become by now somewhat outdated.

Students interested in German theater developments since the end of World War II have a bit more from which to choose—at least numerically—and among these Martin Esslin's *Brecht: A Choice of Evils* ranks among the most readable and informative. John Fuegi's *Brecht and Company* and Patterson's *German Theatre Today* are extremely helpful, as are such editions as Henning Rischbieter's *German Theatre Today*, Leroy Shaw's *German Theatre Today*, and Schulze-Reimpell's booklet *Development and Structure of the Theatre in the Federal Republic of Germany*.

GENERAL STUDIES

Among the most comprehensive from the following list of general studies works are Mantzius's *A History of Theatrical Art* (in six volumes) and Kindermann's *Theatergeschichte Europas* (in 10 volumes). Both of these are standard works for theater history, yet both need updating. Rolf Kabel and Christoph Trilse revised Devrient's *Geschichte der deutschen Schauspielkunst*, and a welcome, up-to-date addition to the literature of German theater history is Peter von Becker's *Das Jahrhundert des Theaters*, based on a popular German television series. Erika Fischer-Lichte's *Kurze Geschichte des deutschen Theaters* is likewise more current, though it (like Knudsen's *Deutsche Theatergeschichte*) is not as comprehensive as one would like.

The best of many lexicons on the German theater set forth below is the *Deutsches Theater-Lexikon* begun by Wilhelm Kosch and his staff,

initially published in 1953 in two volumes, with alphabetical entries through "Max Pallenberg." Ingrid Bigler-Marshall has continued the work, beginning with volume 3 in 1992 and publishing the most recent entries in December 2004, concluding with "Hans Weisbach." Subsequent and far more compact efforts by Brauneck, Gröning, Sucher, and Trilse join the translation of *Friedrichs Theaterlexikon*, titled *The Encyclopedia of World Theatre*, as important additions to theater reference works that pay substantial attention to the German theater. Eisenberg's lexicon of the 19th century is essentially a biographical dictionary—and an idiosyncratic one at that. Henry and Mary Garland's *Oxford Companion to German Literature* provides a wealth of information on German drama, but little on the German theater, the history of performances, or theater artists. Because Goethe looms so large on the landscape of the German theater, Sharpe's *The Cambridge Companion to Goethe* is included in the following bibliographical section.

Becker, Peter von. *Das Jahrhundert des Theaters*. Düsseldorf: Dumont, 2002.

Brauneck, Manfred, and Gérard Schneilin. *Theaterlexikon: Begriffe und Epochen, Bühnen und Ensembles*. Reinbek bei Hamburg: Rowohlt, 1992.

Devrient, Eduard. *Geschichte der deutschen Schauspielkunst*. Leipzig: Weber, 1848–1874. Edited and annotated by Rolf Kabel and Christoph Trilse. Berlin: Henschel, 1967.

Drews, Wolfgang. *Die Grossen des deutschen Schauspiels*. Berlin: Deutscher, 1941.

———. *Theater: Schauspieler, Regisseure, Intendanten* Vienna: Desch, 1961.

Eisenberg, Ludwig. *Ludwig Eisenbergs grosses biographisches Lexikon der deutschen Bühne im XIX. Jahrhundert*. Leipzig: List, 1903.

Fiedler, Carl. *Das deutsche Theater: Was es war, was es ist, und was es werden muss*. Leipzig: Hartknoch, 1877.

Fischer-Lichte, Erika, ed. *Berliner Theater im 20. Jahrhundert*. Berlin: Fannei und Walz, 1998.

———. *Kurze Geschichte des deutschen Theaters*. Tübingen: Francke, 1993.

Frenzel, Herbert. *Geschichte des Theaters: Daten und Dokumente, 1470–1840*. Munich: Kiepenheuer und Witsch, 1979.

Freydank, Ruth. *Theater in Berlin*. East Berlin: Argon, 1988.

Garland, Henry, and Mary Garland. *Oxford Companion to German Literature*. Oxford: Oxford University Press, 1986.

Gregor, Joseph. *Geschichte des österreichischen Theaters von seinen Ursprüngen bis zum Ende der ersten Republik*. Vienna: Donau-Verlag, 1948.

Gröning, Karl, et al. *Friedrichs Theaterlexikon*. Velber bei Hannover: Friedrich, 1969.

Hadamowsky, Franz. *Wien: Theatergeschichte*. Vienna: Jugend und Volk, 1988.

Haxthausen, Charles, ed. *Berlin: Culture and Metropolis*. Minneapolis: University of Minnesota Press, 1990.

Hayman, Ronald, ed. *The German Theatre: A Symposium*. London: Wolff, 1975.

Herzfeld-Sander, Margaret, ed. *Essays on German Theater*. New York: Continuum, 1992.

Hinck, Walter. *Die deutsche Komödie: Vom Mittelalter bis zur Gegenwart*. Düsseldorf: Bagel, 1977.

——, ed. *Handbuch des deutschen Dramas*. Düsseldorf: Bagel, 1980.

Keil-Budischowsky, Verena. *Die Theater Wiens*. Vienna: Zsolnay, 1983.

Kindermann, Heinz. *Theatergeschichte Europas*. 10 vols. Salzburg: Müller, 1957–1971.

Knudsen, Hans. *Deutsche Theatergeschichte*. Stuttgart: Kröner, 1970.

Kosch, Wilhelm. *Das deutsche Theater und Drama seit Schillers Tod*. Leipzig: Vier Quellen, 1924.

Kosch, Wilhelm, and Ingrid Bigler-Marshall. *Deutsches Theater-Lexikon*. Klagenfurt: Kleinmayr, 1953–2004.

Mann, Otto. *Geschichte des deutschen Dramas*. Stuttgart: Kroner, 1963.

Mantzius, Karl. *A History of Theatrical Art*. New York: Peter Smith, 1937.

Michael, Friedrich, and Hans Daiber. *Geschichte des deutschen Theaters*. Frankfurt/Main: Suhrkamp, 1990.

Möhrmann, Renate, ed. *Die Schauspielerin*. Frankfurt/Main: Insel, 1989.

Patterson, Michael. *German Theatre: A Bibliography from the Beginning to 1995*. New York: G. K. Hall, 1996.

Prölss, Robert. *Geschichte der dramatischen Literatur und Kunst in Deutschland*. Leipzig: Schlicke, 1883.

Prutz, Robert. *Vorlesungen über die Geschichte des deutschen Theaters*. Berlin: Duncker & Humblot, 1847.

Robertson, Ritchie, and Edward Timms, eds. *Theatre and Performance in Austria: Mozart to Jelinek*. Edinburgh: Edinburgh University Press, 1993.

Rosenthal, Friedrich. *Unsterblichkeit des Theaters: Kulturgeschichte der deutschen Bühne*. Bonn: Klopp, 1927.

Schmid, Christian. *Chronologie des deutschen Theaters*. Berlin: Gesellschaft für Theatergeschichte, 1902.

Sharpe, Lesley. *The Cambridge Companion to Goethe*. New York: Cambridge University Press, 2002.

Simhandl, Peter. *Theatergeschichte in einem Band*. Berlin: Henschel, 1996.

Sucher, C. Bernd, et al. *Theaterlexikon 1: Autoren, Regisseure, Schauspieler, Dramaturgen, Bühnenbildner, Kritiker*. Munich: Deutscher Taschenbuch Verlag, 1999.

——. *Theaterlexikon 2: Epochen, Ensembles, Figuren, Spielformen, Begriffe, Theorien*. Munich: Deutscher Taschenbuch Verlag, 1996.

Trilse, Christoph, et al. *Theaterlexikon*. Berlin: Henschelverlag, 1977.

Weddigen, Otto. *Geschichte der Theater Deutschlands*. 2 vols. Berlin: Frensdorff, 1883.

Wiese, Benno von, ed. *Das deutsche Drama*. 2 vols. Düsseldorf: Bagel, 1958.

Williams, Simon. *Shakespeare on the German Stage*, vol. 1. New York: Cambridge University Press, 1990.

Winds, Adolf. *Geschichte der Regie*. Berlin: Deutsche Verlags-Anstalt, 1925.

Yates, W. E. *Theater in Vienna: A Critical History, 1776–1996*. Cambridge: Cambridge University Press, 1996.

ORIGINS THROUGH THE 17TH CENTURY

Among the most comprehensive studies of the German theater that covers the first part of this period is Brandt and Hogendoorn's *German and Dutch Theatre, 1600–1848*. It provides an overview of German and some Dutch theater history based on imperial edicts, municipal contracts with touring troupes, architectural descriptions, playbills, stage directions, and actors' correspondence. Catholy's examination of comedy from the Middle Ages through the baroque period is likewise valuable, though perhaps not so comprehensive. The numerous Flemming editions are commendable for the wide variety of the essays contained in them covering the baroque, while Kindermann's *Das Theaterpublikum des Mittelalters* contains intriguing examinations of medieval reception among the Germans. As such, it follows in the precedent of Walter French's rather slim volume *Mediaeval Civilization as Illustrated by the Fastnachtspiele of Hans Sachs*. Readers interested in the numerous Eastertide productions, as well as the long tradition of the less frequently staged passion plays in the German-speaking world, should consult Petersen's *Ritual und Theater*. For a discussion of staging techniques, stage structures, settings, and scenery in use during the period, Michael's *Frühformen der deutschen Bühne* is an excellent starting point.

Among the several studies of Hans Sachs and the entire Nuremberg tradition, no single volume stands out. Aylett's edition contains several essays, including one by John West about performances during Shrovetide. Catholy's volumes on the Shrovetide performances, titled *Das Fastnachtspiel des Spätmittelalters* and simply *Fastnachtspiel*, are thorough examinations of the plays; DuBruck's more recent monograph includes some analysis of audience expectations. Lenk's monograph examines

the same phenomenon, but from the standpoint of a century earlier. Petra Herrmann's study goes back even further, inquiring into the obscene "Sir Neidhart" tradition, which remained a part of the Shrovetide festivities well into the late 16th century.

Adel, Kurt. *Das Jesuitendrama in Österreich*. Vienna: Bergland, 1957.

Amstutz, Renate. *Ludus de decem virginibus: Recovery of the Sung Liturgical Core of the Thuringian Zehnjungfrauenspiel*. Toronto: Pontifical Institute of Mediaeval Studies, 2002.

Aust, Hugo. *Volksstück: Vom Hanswurstspiel zum sozialen Drama der Gegenwart*. Munich: Beck, 1989.

Aylett, Robert, ed. *Hans Sachs and Folk Theatre in the Late Middle Ages*. Lewiston, NY: Mellen, 1995.

Baeseke, Anna. *Das Schauspiele der englischen Komödianten in Deutschland*. Studien zur englischen Philologie 87. Halle: Niemeyer, 1935.

Bolte, Johannes. *Die Singspiele der englischen Komödianten und ihrer Nachfolger*. Theatergeschichtliche Forschungen 7. Hamburg: Voss, 1893.

Brandt, George W., and Wiebe Hogendoorn. *German and Dutch Theatre, 1600–1848*. Cambridge: Cambridge University Press, 1993.

Brennecke, Ernst, ed. *Shakespeare in Germany, 1590–1900*. Chicago: University of Chicago Press, 1964.

Brüning, Ida. *Le théâtre en Allemagne: Son origine et ses luttes*. Paris: Plon, 1887.

Catholy, Eckehard. *Das deutsche Lustspiel*. Stuttgart: Kohlhammer, 1969.

——. *Das Fastnachtspiel des Spätmittelalters*. Tübingen: Niemeyer, 1961.

——. *Fastnachtspiel*. Stuttgart: Metzler, 1966.

Cohn, Albert, ed. *Shakespeare in Germany in the 16th and 17th Centuries*. London: Asher, 1865.

Creizenach, Wilhelm, ed. *Die Schauspiele der englischen Komödianten*. Berlin: Speemann, 1888.

Diesch, Carl. *Inszenierung des deutschen Dramas an der Wende des 16. und 17. Jahrhunderts*. Leipzig: Voigtländer, 1905.

Dietrich, Margaret. "Der Wandel der Gebärde auf dem deutschen Theater vom 15. zum 17. Jahrhundert." Ph.D. diss., University of Vienna, 1944.

DuBruck, Edelgard E. *Aspects of 15th-Century Society in the German Carnival Comedies*. Lewiston, NY: Mellen, 1993.

Ehrstine, Glenn. *Theater, Culture, and Community in Reformation Bern, 1523–1555*. Boston: Brill, 2002.

Fischer-Lichte, Erika. *Vom "kunstlichen" zum "natürlichen" Zeichen: Theater des Barock und der Aufklärung*. Tübingen: Narr, 1983.

Flemming, Willi, ed. *Andreas Gryphius und die Bühne*. Halle: Niemeyer, 1921.

——, ed. *Das Schauspiel der Wanderbühne*. Stuttgart: Reclam, 1931.

——, ed. *Deutsche Kultur im Zeitalter des Barocks*. Constance: Athenaion, 1960.

——, ed. *Die deutsche barockkomödie*. Leipzig: Reclam, 1931.

French, Walter. *Mediaeval Civilization as Illustrated by the Fastnachtspiele of Hans Sachs*. Baltimore: Johns Hopkins University Press, 1925.

Frenzel, Herbert. *Brandenburg-preussische Schlosstheater*. Berlin: Gesellschaft für Theatergeschichte, 1959.

Geiger, Eugen. *Hans Sachs als Dichter in seinen Fastnachstspielen*. Halle: Niemeyer, 1904.

Genée, Rudolf. *Hans Sachs und seine Zeit*. Leipzig: Weber, 1894.

Hartleb, Hans. *Deutschlands erster Theaterbau*. Leipzig: De Gruyter, 1936.

Heine, Carl. *Das Schauspiel der deutschen Wanderbühne vor Gottsched*. Halle: Niemeyer, 1889.

——. *Johannes Velten*. Halle: Karras, 1887.

Herrmann, Max. *Forschungen zur deutschen Theatergeschichte des Mittelalters und der Renaissance*. Berlin: Weidmann, 1914.

Herrmann, Petra. *Karnevaleske Strukturen in der Neidhart-Tradition*. Göttingen: Kümmerle, 1984.

Hinck, Walter. *Das deutsche Lustspiel des 17. und 18. Jahrhunderts und die italienische Komödie*. Stuttgart: Metzler, 1965.

Holdschmidt, Hans C. *Der Jude auf dem Theater des deutschen Mittelalters*. Emsdetten: Lechte, 1935.

Kindermann, Heinz. *Das Theaterpublikum des Mittelalters*. Salzburg: Müller, 1980.

Könneker, Barbara. *Hans Sachs*. Stuttgart: Metzler, 1971.

Köster, Albert. *Die Meistersingerbühne des sechszehnten Jahrhunderts*. Halle: Niemeyer, 1920.

Krause, Helmut. *Die Dramen des Hans Sachs*. Berlin: Hofgarten-Verlag, 1979.

Kurtz, John. "Studies in the Staging of German Religious Drama of the Late Middle Ages." Ph.D. diss., University of Illinois, 1932.

Lenk, Werner. *Das Nürnberger Fastnachtspiel des 15. Jahrhundert*. Berlin: Akademie, 1966.

Limon. Jerzy. *Gentleman of a Company: English Players in Central and Eastern Europe, 1590–1660*. Cambridge: Cambridge University Press, 1985.

Michael, Wolfgang. *Frühformen der deutschen Bühne*. Berlin: Gesellschaft für Theatergeschichte, 1963.

Moser, Fritz. *Die Anfänge des Hof- und Gesellschaftstheater in Deutschland*. Berlin: Elsner, 1940.

Niedermeier, Cornelia. *Gedanken-Kleider: Die Allegorisierung des Körpers in Gesellschaft und Theater des 17. Jahrhunderts*. Vienna: Braumüller, 2000.

Nowé, Johan. *Et respondeat: Studien zum deutschen Theater des Mittelalters.* Louvain, Belgium: Louvain University Press, 2002.

Pascal, Roy, ed. *Shakespeare in Germany, 1740–1815.* Cambridge: Cambridge University Press, 1937.

Paul, Markus. *Reichsstadt und Schauspiel: Theatrale Kunst im Nürnberg des 17. Jahrhunderts.* Tübingen: Niemeyer, 2002.

Petersen, Christoph. *Ritual und Theater: Messallegorese, Osterfeier und Osterspiel im Mittelalter.* Tübingen: Niemeyer, 2004.

Schindler, Otto G. *Stegreifburlesken der Wanderbühne: Szenare der Schulz-Menningerschen Schauspielertruppe.* St. Ingbert: Werner J. Röhrig, 1990.

Stammler, Wolfgang. *Deutsche Classiker des Mittelalters.* Wiesbaden: N.p., 1954.

Stumpfl, Robert. *Kultspiele der Germanen.* Berlin: Junker und Dünnhaupt, 1936.

Thomke, Hellmut, ed. *Deutsche Spiele und Dramen des 15. und 16. Jahrhunderts.* Frankfurt/Main: Deutscher Klassiker, 1996.

Tittmann, Julius, ed. *Schauspiele aus dem sechzehnten Jahrhundert.* Leipzig: Brockhaus, 1868.

Tydeman, William. *The Medieval European Stage, 500–1550.* Cambridge: Cambridge University Press, 2001.

Valentin, Jean Marie. *Les Jésuites et le théâtre dans le Saint-Empire romain germanique.* Paris: Desjonquères, 2001.

Wailes, Stephen L. *The Rich Man and Lazarus on the Reformation Stage.* Selinsgrove, PA: Susquehanna University Press, 1997.

Wodick, Wilibald. *Jakob Ayrers Dramen in ihrem Verhältnis zur einheimischen Literatur und zum Schauspiel der englischen Komödianten.* Halle: Niemeyer, 1912.

THE 18TH CENTURY

Because 18th-century events were so unforeseeably decisive in shaping what became the German theater, the wealth of scholarly studies during this century is usually divided into three distinct periods. The first of them is the "reform" period, during which touring troupes struggled to establish themselves and their profession in the wake of the previous century's military and political upheavals. Among the most informative studies of this period is Aikin-Sneath's *Comedy in Germany in the First Half of the 18th Century.* It provides a superb background on the German critical disdain for popular comedy, a disdain with historical roots in German national development. After all, notes Aikin-Sneath, Gottsched wanted a national drama for a nation that did not yet exist.

Popular comedy in the first half of the 18th century was "vulgar, unruly, amoral, and impudent," and it was Gottsched's ambition to impose his taste on audiences and to establish a theater that "satisfied his moral and intellectual demands." That is an exaggeration, but Aikin-Sneath's research is first rate and makes a good case for the argument that deep divisions within 18th-century Germany denied the Germans "any cultural center." Popular theater until Lessing was "devoid of urbanity or universality." It was all "local, whether the scene is Hamburg, Leipzig, or some other town or village."

The second period begins with Lessing and his work among the successors of the Neuber tradition. Eichhorn's *Konrad Ernst Ackermann* is a superb chronicle of that collaboration; of course, the near-masterpiece of the actor's work in the 18th century is Williams's *German Actors of the 18th and 19th Centuries*, but it includes performers from the next century as well. Several other books on actors are available, and among them Bender's *Schauspielkunst im 18. Jahrhundert* is likewise exemplary. Of the volumes on Neuber herself, Oelker's *"Nichts als eine Komödiantin": Die Lebensgeschichte der Friederike Caroline Neuber* stands out.

This period is also fundamental to the rise of Shakespeare as a German playwright, as Simon Williams states in his *Shakespeare on the German Stage I, 1586–1914*. Shakespeare had led Lessing to a view of theater that altered the course of German theater history, because Lessing was convinced that Shakespeare's understanding of human nature was so comprehensive that one felt compassion even for his blackest villains. "In this way he appeared to Lessing as a typical figure of the Enlightenment." Yet as Pascal points out in his *The German Sturm und Drang*, Shakespeare seemed to have created plays "from a limitless imagination," with the result that the young Goethe and his followers found Shakespeare nearly irresistible. Shakespeare became the fundament upon which the playwrights of Sturm und Drang established their identity. For Goethe and his admirers in that movement, freedom of expression and action were overriding priorities. The idea of Shakespeare as a genius likewise made him the observed of all observers among the German Romantics—as Stahl notes in his *Shakespeare und das deutsche Theater*.

The third, and perhaps most important, phase of the German theater's development begins with the rise of Goethe and Schiller, which in turn

became the "Weimar Classical" period. Though it blossomed chronologically as a 19th-century development, Weimar Classicism appears here within 18th-century studies. Goethe and Schiller themselves represent an entire epoch in the German theater, and the number of excellent books on them and their work are legion. Among the best in English are Bruford's *Theatre, Drama, and Audience in Goethe's Germany* and Carlson's *Goethe and the Weimar Theatre.* Kindermann's *Theatergeschichte der Goethezeit* is likewise requisite, and Patterson's *The First German Theatre* is an outstanding treatment of Goethe and Schiller stagings, though the author also included in the volume discussions of stagings of plays by Kleist and Büchner.

Aikin-Sneath, Betsy. *Comedy in Germany in the First Half of the Eighteenth Century.* Oxford: Clarendon, 1936.

Alth, Minna von. *Frauen am Theater: Freche Buhlerinnen?* Basel: Herder, 1979.

Arntzen, Helmut. *Die ernste Komödie.* Munich: Nymphenburger, 1968.

Ballhausen, Günter. "Der Wandel der Gebärde auf dem deutschen Theater im 18. Jahrhundert." Ph.D. diss., University of Göttingen, 1955.

Bender, Wolfgang F. *Schauspielkunst im 18. Jahrhundert.* Stuttgart: Steiner, 1992.

Bender, Wolfgang F., Siegfried Bushuven, Michael Huesmann, et al. *Theaterperiodika des 18. Jahrhunderts.* Munich: Saur, 1994.

Brahm, Otto. *Schiller.* Berlin: Hertz, 1888.

Bruford, Walter. *Theatre, Drama, and Audience in Goethe's Germany.* London: Routledge and Kegan Paul, 1950.

Carlson, Marvin. *Goethe and the Weimar Theatre.* Ithaca, NY: Cornell University Press, 1978.

Cocalis, Susan L., and Ferrel V. Rose, eds. *Thalia's Daughters: German Women Dramatists from the Eighteenth Century to the Present.* Tübingen: Francke, 1996.

Conrad, Hans-Werner. *Einsiedels Theorie der Schauspielkunst . . . im 18. Jahrhundert.* Berlin: Ernst-Reuter-Gesellschaft, 1969.

Devrient, Hans. *Johann Friedrich Schönemann und seine Schauspielergesellschaft.* Leipzig: Voss, 1895.

Eichhorn, Herbert. *Konrad Ernst Ackermann.* Emsdetten: Lechte, 1965.

Fetting, Hugo, ed. *Konrad Ekhof, ein Schauspieler des 18. Jahrhunderts.* Berlin: Henschel, 1954.

Fleig, Anne. *Handlungs-Spiel-Räume: Dramen von Autorinnen im Theater des ausgehenden 18. Jahrhunderts.* Würzburg: Königshausen & Neumann, 1999.

Flemming, Willi. *Das Schauspiel der Wanderbühne.* Leipzig: Reclam, 1931.

———. *Goethe und das Theater seiner Zeit.* Stuttgart: Kohlhammer, 1968.

Goethe, Johann Wolfgang. *The Dramatic Works of J. W. Goethe.* Edited by Walter Scott, et al. New York: Bell, 1915.

Gottsched, Johann Christoph. *Versuch einer kritischen Dichtkunst.* 5 vols. Darmstadt: Wissenschaftliche Buchgesellschaft, 1962.

Grimm, Reinhold, and Klaus Berghahn, eds. *Schiller: Zur Theorie und Praxis der Dramen.* Darmstadt: Wissenschaftliche Buchgesellschaft, 1972.

Gross, Edgar. *Johann Friedrich Ferdinand Fleck.* Berlin: Gesellschaft für Theatergeschichte, 1914.

Hadamowsky, Franz. *Das Theater in der Wiener Leopoldstadt, 1781–1860.* Vienna: Höfel, 1934.

Haider-Pregler, Hilde. *Des sittlichen Bürgers Abendschule.* Vienna: Jugend und Volk, 1980.

Heitner, R. R. *German Tragedy in the Age of the Enlightenment, 1724–1768.* Berkeley: University of California Press, 1963.

Hoffmeier, Dieter. *Die Einbürgerung Shakespeares auf dem Theater des Sturm und Drangs.* Berlin: Henschel, 1976.

Hoffmeister, Gerhart. *A Reassessment of Weimar Classicism.* Lewiston, NY: Mellen, 1996.

Höyng, Peter. *Die Sterne, die Zensur und das Vaterland: Geschichte und Theater im späten 18. Jahrhundert.* Cologne: Böhlau, 2003.

Jenkner, Hans. *August Klingemanns Anschauung über die Funktionen des Theaters.* Clausthal-Zellerfeld: Pieper, 1929.

Kahl-Pantis, Brigitte. *Bauformen des bürgerlichen Trauerspiels.* Frankfurt/Main: Lang, 1977.

Kindermann, Heinz. *Konrad Ekhofs Schauspieler-Akademie.* Vienna: Rohrer, 1956.

———. *Theatergeschichte der Goethezeit.* Vienna: Bauer, 1948.

Klingenberg, Karl-Heinz. *Iffland und Kotzebue als Dramatiker.* Weimar: Arion Verlag, 1962.

Kosenina, Alexander. *Anthropologie und Schauspielkunst . . . im 18. Jahrhundert.* Tübingen: Niemeyer, 1995.

Krause, Markus. *Das Tirvialdrama der Goethezeit, 1780–1805.* Bonn: Bouvier, 1982.

Krebs, Roland, and Jean-Marie Valentin. *Théâtre, nation et société en Allemagne au XVIIIe siècle.* Nancy, France: University of Nancy Press, 1990.

Lamport, F. J. *German Classical Drama.* Cambridge: Cambridge University Press, 1992.

Lessing, Gotthold Ephraim. *Hamburg Dramaturgy.* New York: Dover, 1962.

———. *Werke.* Munich: Hanser, 1970–1979.

Liebscher, Otto. *Franz von Dingelstedt.* Halle: Paalzow, 1909.

Linder, Jutta. *Ästhetische Erziehung: Goethe und das Weimarer Hoftheater.* Bonn: Bouvier, 1990.

Mandel, Oscar. *August von Kotzebue: The Comedy, the Man.* University Park: Pennsylvania State University Press, 1990.

Maurer, Doris. *August von Kotzebue: Ursachen seines Erfolges.* Bonn: Bouvier, 1979.

Maurer-Schmoock, Sybille. *Deutsches Theater im 18. Jahrhundert.* Tübingen: Niemeyer, 1982.

Meyer, Wilhelm August Clemens. *Ferdinand Esslair.* Emmendingen: Dölter, 1927.

Müller-Kampel, Beatrice. *Hanswurst, Bernardon, Kasperl: Spasstheater im 18. Jahrhundert.* Paderborn: Schöningh, 2003.

Neeb-Crippen, Jerry Eugene. "Bürgerliches Lustspiel und Ritterroman: Zur Unterhaltungsliteratur im ausgehenden 18. Jahrhundert." Ph.D. diss., University of Illinois, 1994.

Neuhuber, Christian. *Das Lustspiel macht Ernst.* Berlin: Erich Schmidt, 2003.

Oberländer, Hans. *Die geistige Entwicklung der deutschen Schauspielkunst im 18. Jahrhundert.* Leipzig: Voss, 1898.

Oelker, Petra. *"Nichts als eine Komödiantin": Die Lebensgeschichte der Friederike Caroline Neuber.* Weinheim: Beltz & Gelberg, 1993.

Ohlen, Joachim. *Ferdinand Esslair.* Munich: Wölfle, 1972.

Pascal, Roy. *The German Sturm und Drang.* New York: Philosophical Library, 1953.

Patterson, Michael. *The First German Theatre.* London: Routledge, 1990.

Prudhoe, John. *The Theatre of Goethe and Schiller.* Oxford: Basil Blackwell, 1973.

Reden-Esbeck, Friedrich Johann. *Caroline Neuber und ihre Zeitgenossen.* Leipzig: Barth, 1881.

Sasse, Hannah. *Friedericke Caroline Neuber.* Endingen-Kaiserstuhl: Wild, 1937.

Schiller, Friedrich. *Dramatic Works of Friedrich Schiller: "Wallenstein" and "Wilhelm Tell."* Edited by James Churchill, et al. London: Bell, 1901.

Stahl, Ernst Leopold. *Shakespeare und das deutsche Theater.* Stuttgart: Kohlhammer, 1947.

Steiner, Gerhard. *Das Theater der Deutschen Jakobiner: Dramatik und Bühne im Zeichen der französischen Revolution.* Berlin: Henschelverlag, 1989.

Strohschänk, Johannes. *William Dunlap und August von Kotzebue: Deutsches Drama in New York um 1800.* Stuttgart: H.-D. Heinz, 1992.

Troitskii, Z. L. *Konrad Ekhof, Ludwig Schröder, August Wilhelm Iffland, Johann Friedrich Fleck, Ludwig Devrient, Karl Seydelmann: Die Anfänge der realistischen Schauspielkunst.* Berlin: Henschel, 1949.

Ulrich, Paul Stanley. *A Preliminary Bibliography of German-Language Theatre Almanacs, Yearbooks, Calendars and Journals of the 18th and 19th Centuries.* Vienna: Böhlau, 1994.

Wahle, Julius. *Das Weimarer Hoftheater unter Goethes Leitung*. Weimar: Goethe Gesellschaft, 1892.

Williams, Simon. *German Actors of the 18th and 19th Centuries*. Westport, CT: Greenwood, 1985.

Williams, Simon. *Shakespeare on the German Stage I, 1586–1914*. New York: Cambridge University Press, 1990.

Winds, Adolf. *Der Schauspieler in seiner Entwicklung* Berlin: Schuster und Loeffler, 1919.

THE 19TH CENTURY TO 1871

The German theater in the 19th century prospered to an unprecedented degree, though the Napoleonic conflicts that ushered in the new century occasioned severe disruption and helped to prolong German political disunity. That disunity, as Carlson notes in his *The German Stage of the 19th Century*, fostered a subsequently beneficial decentralized German theater practice. In a similarly paradoxical way, Fürstenthal in his *Das Preussische Civil-Recht* notes that stringent police censorship in the aftermath of the Congress of Vienna may have contributed to the liveliness of popular theater culture, especially in Vienna and Berlin. Rommel masterfully chronicles the Viennese variety of popular comedy in his *Die Alt-Wiener Volkskomödie*. Pargner has provided a similar service for popular theater culture in general with her *Charlotte Birch-Pfeiffer*, examining the reasons Birch-Pfeiffer was for 30 years the most popular of all German-language playwrights—and also one of the German theater's most successful actresses and theater managers. Meanwhile, the development of serious playwriting continued, though on a less exalted level than it had when Schiller and Goethe were active, as Martersteig confirms in his magisterial *Das deutsche Theater im neunzehnten Jahrhundert*. Martersteig does more, however, than simply survey dramatic literature, popular actors, and the socioeconomic conditions that produced them. He also provides a living portrait of the German theater over nearly the entire century.

The 19th century was nevertheless best known for its virtuoso acting, and several books are essential to an understanding of the decades prior to unification. They include Kollek's biography of Dawison, and Altman's of Ludwig Devrient. The biggest star in the German theatrical firmament during the early decades of the 19th century was Iffland, and

Kliewer's biography on him remains significant. Of course, Iffland wrote many books about himself, of which *Meine theatralische Laufbahn* remains the most important. A worthwhile examination of the German actor's social standing in those decades is Schmitt's *Schauspieler und Theaterbetrieb*, while other books on the business side of theater production include Maas's book on the Friedrich-Wilhelmstädtisches Theater in Berlin, one of the first entertainment emporia to establish a privately lucrative foothold in the city. Another such entertainment center was the Wallner Theater, though Erika Wischer's doctoral dissertation on that subject, titled "Das Wallner-Theater in Berlin," remains the only notable work concentrating on the subject.

Altman, Georg. *Heinrich Laubes Prinzip der Theaterleitung*. Dortmund: Ruhfus, 1908.

———. *Ludwig Devrient: Leben und Werke eines Schauspielers*. Berlin: Ullstein, 1926.

Anschütz, Heinrich. *Erinnerungen aus Leben und Wirken*. Vienna: Sommer, 1866.

Bauer, Roger. *La réalité royaume de Dieu: Études sur l'originalité du théâtre viennois dans la première moitié du XIXe siècle*. Munich: Hueber, 1965.

Böhmer, Günther. *Die Welt des Biedermeier*. Munich: Desch, 1968.

Brachvogel, Albert Emil. *Das alte Berliner theater-wesen bis zur ersten Blüthe des deutschen Dramas*. Berlin: Janke, 1877.

Carlson, Marvin. *The German Stage of the 19th Century*. Metuchen, NJ: Scarecrow, 1972.

Dietrich, Margaret. *Die Wiener Polizeiakten 1854–1867 als Quelle für die Theatergeschichte*. Vienna: Böhlau, 1967.

Fürstenthal, Johann August Ludwig. *Das Preussische Civil-Recht*. Vol. 1 Frankfurt/Main: Keip, 1970.

Glossy, Karl. *Josef Schreyvogel*. Vienna: Konegen, 1903.

Goldbaum, Wenzel. *Theaterrecht*. Berlin: Vahlen, 1914.

Grimm, Reinhold. *Love, Lust, and Rebellion: New Approaches to Georg Büchner*. Madison: University of Wisconsin Press, 1985.

Grimm, Reinhold, and Klaus Berghahn. *Wesen und Formen des Komischen im Drama*. Darmstadt: Wissenschaftliche Buchgesellschaft, 1975.

Grisebach, August. *Carl Friedrich Schinkel*. Leipzig: Insel, 1924.

Hebbel, Friedrich. *Hebbels Dramaturgie: Drama und Bühne betreffende Schriften*. Edited by Wilhelm von Scholz. Munich: Müller, 1907.

Hein, Jürgen. *Das Wiener Volkstheater: Raimund und Nestroy*. Darmstadt: Wissenschaftliche Buchgesellschaft, 1978.

Helbig, Gerhard, ed. *Das Wiener Volkstheater in seinen schönsten Stücken*. Bremen: Schünemann, 1960.

Hilliker, Rebecca. "The Classical-Romantic Scene Designs of Karl Friedrich Schinkel." Ph.D. diss., University of Wisconsin, 1984.

Holtei, Karl von. *Beiträge für das Königstädter Theater*. Wiesbaden: N.p., 1832.

Horch, Franz. *Das Burgtheater unter Heinrich Laube und Adolf Wilbrandt*. Vienna: Österreichischer Bundesverlag, 1925.

Iffland, August Wilhelm. *Meine theatralische Laufbahn*. Edited by Oscar Fambach. Stuttgart: Reclam, 1976.

Kindermann, Heinz. *Grillparzer und das Theater seiner Zeit*. Vienna: Müller, 1966.

Klein, Wilhelm. *Der preussische Staat und das Theater im Jahre: Ein Beitrag zur Geschichte der Nationaltheateridee*. Berlin: Selbstverlage der Gesellschaft für Theatergeschichte, 1848.

Kleist, Heinrich von. *Five Plays*. Edited by Martin Greenberg. New Haven, CT: Yale University Press, 1988.

Kliewer, Erwin. *A. W. Iffland*. Berlin: Ebering, 1937.

Klingemann, August. *Kunst und Natur*. 3 vols. Braunschweig: Meyer, 1823.

Kollek, Peter. *Bogumil Dawison*. Kastellaun: Henn, 1978.

Laube, Heinrich. *Das Burgtheater: Ein Beitrag zur deutschen Theater-Geschichte*. Leipzig: Weber, 1868.

———. *Das Wiener Stadt-Theater*. Leipzig: Weber, 1875.

———. *Schriften über das Theater*. Berlin: Henschel, 1959.

Lüdeke, Henry. *Ludwig Tieck und das alte englische Theater*. Hildesheim: Gerstenberg, 1975.

Maas, Lieselotte. *Das Friedrich-Wilhelmstädtische Theater in Berlin*. Munich: Schön, 1965.

Martersteig, Max. *Das deutsche Theater im neunzehnten Jahrhundert*. Leipzig: Breitkopf und Härtel, 1924.

May, Erich. *Wiener Volkskomödie und Vormärz*. Berlin: Henschel, 1975.

Moschner, Alfred. *Holtei als dramatiker*. Breslau: Hirt, 1911.

Müller, Eugen. *Eine glanzzeit des Zürcher stadttheaters, 1837–1843*. Zurich: Orell Füssli, 1911.

Orzechowski, Norman. *Kleists Dramen in den Bühnendekorationen des 19. und 20. Jahrhunderts*. Aachen: Shaker, 1997.

Osborn, Max. *Der bunte Spiegel*. New York: Krause, 1945.

Paldamus, Friedrich Christian. *Das deutsche Theater der Gegenwart*. 2 vols. Mainz: Kunze, 1857.

Pargner, Birgit. *Charlotte Birch-Pfeiffer*. Bielefeld: Aistheisis, 1999.

Pye, Gillian. *Approaches to Comedy in German Drama*. Lewiston, NY: Mellen, 2002.

Reeve, William C. *Kleist on Stage, 1804–1987*. Montreal: McGill-Queen's University Press, 1993.

Richel, Veronica. *The German Stage, 1797–1890: A Directory of Playwrights and Plays.* Westport, CT: Greenwood, 1988.

Ritter, Gerhard. *Staatskunst und Kriegshandwerk.* Munich: Oldenbourg, 1959.

Rommel, Otto. *Die Alt-Wiener Volkskomödie.* Vienna: Müller, 1952.

Schmitt, Peter. *Schauspieler und Theaterbetrieb: Studien zur Sozialgeschichte des Schauspielerstandes im deutschsprachigen Raum, 1700–1900.* Tübingen: Niemeyer, 1990.

Schobloch, Fritz. *Wiener Theater . . . 1806–1858.* Vienna: Verband der wissenschaftlichen Gesellschaften Österreichs, 1974.

Schöndiest, Eugen, and Herbert Hohenemser. *Geschichte des deutschen Bühnenvereins.* Frankfurt/Main: Propyläen, 1979.

Schulze-Reimpell, Werner. "Die Königlichen Schauspiele zu Berlin unter dem Generalintendanten Karl Theodor von Küstner (1842–1851)." Ph.D. diss., Free University of Berlin, 1955.

Stiehler, Arthur. *Das Ifflandische Rührstück.* Leipzig: Voss, 1898.

Townsend, Mary. *Humor als Hochverrat.* Berlin: Hentrich, 1988.

Wahnrau, Gerhard. *Berlin: Stadt der Theater.* Berlin: Henschel, 1957.

Walther, Gerhard. *Das Berliner Theater in der Berliner Tagespresse, 1848–1878.* Berlin: Colloquium, 1968.

Wischer, Erika. "Das Wallner-Theater in Berlin." Ph.D. diss., Free University of Berlin, 1967.

Zeman, Herbert. *Johann Nepomuk Nestroy.* Vienna: Holzhausen, 2001.

THE WILHELMINE PERIOD, 1871–1918

The Wilhelmine period was important for reasons more complicated than simply the unification of the German Reich under three Hohenzollern kaisers (Wilhelm I, Friedrich III, and Wilhelm II). As Epstein notes in his *Das Theater als Geschäft*, the Wilhelmine period inaugurated an explosion of economic expansion that launched the German theater as a profitable business enterprise. Such a development was roundly condemned by several critics, Julius Bab, Otto Brahm, and Paul Schlenther most prominent among them. Bab's *Das Theater der Gegenwart* provides ample evidence of his alarm. Brahm's concern went beyond economics; it included a social perspective that ultimately ushered in new aesthetic standards. Brahm's entreaty for new standards of critical judgment remains readily available in the volume under his name titled *Theater, Dramatiker, Schauspieler.* Horst Claus's biography of Brahm, *The Theater Director Otto Brahm*, is a superior chronicle of the man's commitment both to a "free theater for modern life" and also to the work of Ibsen and Hauptmann.

For a comprehensive look at the later Wilhelmine theater from the perspective of numerous critics, the Jaron volume (coedited with Renate Möhrmann and Hedwig Müller) titled *Bühnengeschichte der Reichshauptstadt im Spiegel der Kritik, 1889–1914* is indispensable. Similarly valuable, though for different reasons, is the Schöndienst and Hohenemser history of the German producers' association, titled *Geschichte des deutschen Bühnenvereins.* This book provides a stunning perspective on the so-called *Gründerjahre* (foundation years) of the Wilhelmine Reich, explaining why the *Gewerbefreiheitgesetz* (business freedom law) of 1869 led to the aforementioned expansion of business opportunities for theater managers in the 1870s and 1880s. In those decades, according to Schöndienst and Hohenemser, professional qualifications took a back seat to moral dependability (*sittliche Zuverlässigkeit*) in granting managers a theater license. Many men who became theater managers had little or no theater expertise, much less a knowledge of plays or the obligations of theater as a moral institution. Many of them, Schöndienst and Hohenemser observe, were considered "fishmongers, shoemakers, upholsterers, and locksmiths." Hence the condemnation and general hand-wringing by Brahm and others.

Brahm's successor at the Deutsches Theater, Max Reinhardt, has been the subject of numerous outstanding books. J. L. Styan's belongs to that group, joining those of Kindermann, Carter, Fiedler, and Braulich. Among the numerous playwrights whom Reinhardt premiered and continued to promote were Sternheim and Wedekind; the most comprehensive work on Wedekind remains Seehaus's *Frank Wedekind und das Theater, 1898–1959,* though Alan Best's biography is noteworthy. Of the numerous Sternheim books, Dedner's biography is perhaps the most immediately accessible.

The Wilhelmine period was also important for the Meininger, as Koller's *The Theater Duke* bears witness. Outstanding actors who had been members of the Meiningen company, such as Bassermann and Kainz, receive thorough examination in books by Richter and Kober, respectively. Other actors whose work has been the impetus for recent biographical treatment include Moissi (by Schaper) and Sandrock (by Ahlermann, titled *Ich bleibe die grosse Adele*).

Wilhelmine actors and directors whose memoirs provide authoritative —and often colorful—sources of background on the period include Alexander's *Meine Streichen beim Theater*, Blumenthal's *Allerhand*

ungezogenheiten, Bonn's *Mein Künstlerleben*, and L'Arronge's *Deutsches Theater und deutsche Schauspielkunst.*

Ahlermann, Jutta. *Ich bleibe die grosse Adele*. Düsseldorf: Droste, 1988.

Alexander, Richard. *Meine Streichen beim Theater*. Berlin: Scherl, 1922.

Allen, Ann Taylor. *Satire and Society in Wilhelmine Germany: "Kladderadatsch" and "Simplicissimus," 1890–1914*. Lexington: University of Kentucky Press, 1984.

Bab, Julius. *Albert Bassermann*. Leipzig: E. Weibezahl, 1929.

———. *Das Theater der Gegenwart*. Leipzig: Weber, 1918.

———. *Das Theater im Lichte der Soziologie*. Leipzig: Hirschfeld, 1921.

———. *Kränze der Mimen*. Emsdetten: Lechte, 1954.

———. *Schauspieler und Schauspielkunst*. Berlin: Oesterheld, 1926.

Bahr, Hermann. *Wiener Theater, 1892–1898*. Berlin: Fischer, 1899.

Balme, Christopher, ed. *Das Theater von Morgen*. Würzburg: Königshausen und Neumann, 1988.

Barnay, Ludwig. *Erinnerungen*. Berlin: Fleische, 1903.

Berstl, Julius. *25 Jahre Berliner Theater und Viktor Barnowsky*. Berlin: Kiepenheuer, 1930.

Best, Alan. *Frank Wedekind*. London: Wolff, 1975.

Blumenthal, Oskar. *Allerhand ungezogenheiten*. Berlin: Hugo Steinitz, 1898.

Bonn, Ferdinand. *Mein Künstlerleben*. Munich: Huber, 1920.

Borgfeldt, Georg. *Genies der Bühne: Charakteristiken*. Leipzig: Reclam, 1914.

Brahm, Otto. *Theater, Dramatiker, Schauspieler*. Berlin: Henschel, 1961.

Braulich, Heinrich. *Max Reinhardt: Theater zwischen Traum und Wirklichkeit*. Berlin: Henschel, 1969.

Brauneck, Manfred. *Literatur und Öffenlichkeit im ausgehenden 19. Jahrhundert*. Stuttgart: Metzler, 1974.

Buth, Werner. "Das Lessingtheater in Berlin unter der Direktion von Otto Brahm." Ph.D. diss., University of Munich, 1965.

Carter, Huntley. *The Theatre of Max Reinhardt*. New York: Blom, 1964.

Claus, Horst. *The Theater Director Otto Brahm*. Ann Arbor, MI: UMI Research Press, 1981.

Dedner, Burghard. *Carl Sternheim*. Boston: Twayne, 1982.

Doerry, Hans. *Das Rollenfach im deutschen Theater im 19. Jahrhundert*. Berlin: Selbstverlag für Theatergeschichte, 1926.

Drews, Wolfgang. *Die grossen Zauberer*. Vienna: Donau, 1953.

Eloesser, Arthur, ed. *Aus der grossen Zeit des deutschen Theaters*. Munich: E. Rentsch, 1911.

Epstein, Max. *Das Theater als Geschäft*. Berlin: Juncker, 1911.

———. *Theater und Volkswirtschaft*. Berlin: Simion, 1914.

Eulenberg, Herbert. *Der Gukkasten: Deutsche Schauspielbilder*. Stuttgart: Engelhorn, 1921.

Fetting, Hugo, ed. *Von der Freien Bühne zum Politischen Theater . . . im Spiegel der Kritik*. Leipzig: Reclam, 1987.

Fiedler, Leonhard. *Max Reinhardt*. Hamburg: Rowohlt, 1975.

Flatz, Roswitha. *Krieg im Frieden*. Frankfurt/Main: Klostermann, 1976.

Fontana, Oskar. *Wiener Schauspieler*. Vienna: Amandus, 1948.

Gajaek, Bernhard, and Wolfgang von Ungern-Sternberg. *Ludwig Fulda: Briefwechsel*. 2 vols. Bern: Lang, 1988.

Garten, H. F. *Modern German Drama*. London: Methuen, 1959.

Glaser, Hermann. *Die Kultur der wilhelminischen Zeit*. Frankfurt/Main: Fischer, 1984.

Goldbaum, Wenzel. *Theaterrecht*. Berlin: Vahlen, 1914.

Gregor, Joseph. *Das Theater der Reichshauptstadt*. Munich: Langen, 1904.

———. *Das Theater in der Wiener Josefstadt*. Vienna: Wiener Drucke, 1924.

———. *Gerhart Hauptmann, das Werk und unsere Zeit*. Vienna: Diana-Verlag, 1951.

———. *Josef Kainz*. Leipzig: Schuster und Loeffler, 1904.

———. *Max Reinhardt*. Berlin: E. Reiss, 1910.

———. *Meister deutscher Schauspielkunst*. Bremen: Schünemann, 1939.

Gregori, Ferdinand. *Der Schauspieler*. Leipzig: Teubner, 1919.

Guglia, Eugen. *Friedrich Mitterwurzer*. Vienna: Gerold, 1896.

Hagemann, Carl. *Deutsche Bühnenküünstler um die Jahrhundertwende*. Frankfurt/Main: Kramer, 1940.

Hays, Michael. *The Public and Performance*. Ann Arbor, MI: UMI Press, 1982.

Henze, Herbert. *Otto Brahm und das Deutsche Theater in Berlin*. Berlin: Verein für die Geschichte Berlins, 1930.

Herald, Heinz. *Max Reinhardt: Ein Versuch über das Wesen der modernen Regie*. Berlin: Lehmann, 1915.

Houben, H. H. *Polizei und Zensur*. Berlin: Gersbach, 1926.

Hübner, Gotthard. *Beiträge zur Geschichte des modernen Theaters*. Leipzig: Wölfert, 1877.

Jacobsohn, Siegfried. *Deutsche Bühnenkunst*. Berlin: Tagewerk, 1924.

Jährig-Ostertag, Susanne. "Das dramatische Werk: Seine küntslerische und kommerzielle Verwertung." Ph.D. diss., University of Cologne, 1971.

Jaron, Norbert, Renate Möhrmann, and Hedwig Müller, eds. *Bühnengeschichte der Reichshauptstadt im Spiegel der Kritik, 1889–1914*. Tübingen: Niemeyer, 1986.

Jelavich, Peter. *Munich and Theatrical Modernism, 1890–1914*. Cambridge, MA: Harvard University Press, 1993.

Kahane, Arthur. *Theater: Aus dem Tagebuch eines Theatermannes*. Berlin: Volksverband, 1930.

Kerr, Alfred. *Die Welt im Drama.* 4 vols. Cologne: Kiepenheuer und Witsch, 1964.

Kiefer, Sascha. *Dramatik der Gründerzeit: Deutsches Drama und Theater, 1870–1890.* St. Ingbert: Röhrig, 1997.

Kilian, Eugen. *Goethe's "Faust" auf der Bühne.* Munich: Müller, 1907.

Klotz, Volker. *Bürgerliches Lachtheater.* Munich: DTV, 1980.

Kober, Erich. *Josef Kainz: Mensch unter Masken.* Vienna: Neff, 1948.

Köberle, Georg. *Die Theater-Krisis im neuen deutschen Reiche.* Stuttgart: Neff, 1872.

Koller, Ann Marie. *The Theater Duke: Georg II of Saxe-Meiningen.* Stanford, CA: Stanford University Press, 1984.

Kutscher, Artur. *Die Ausdruckskunst der Bühne.* Leipzig: Oldenburg, 1910.

L'Arronge, Adolph. *Deutsches Theater und deutsche Schauspielkunst.* Berlin: Concordia, 1896.

Legband, Paul. *Das Deutsche Theater in Berlin.* Munich: Müller, 1909.

Lenman, Robin. "Art, Society, and Law in Wilhelmine Germany: The Lex Heinze." *Oxford Studies Review* 8 (1973): 86–113.

Liljeberg, Maria. "Otto Brahm: Versuch einer kulturhistorischen Monographie." Ph.D. diss., Humboldt University of Berlin, 1980.

Lindau, Paul. *Aus der Hauptstadt.* Dresden: Steffens, 1887.

———. *Nur Erinnerungen.* Stuttgart: Cotta, 1919.

Litzmann, Berthold. *Das deutsche Drama in den literarischen Bewegungen der Gegenwart.* Hamburg: Voss, 1894.

Löwenstein, Steven M. *Deutsch-Jüdische Geschichte der Neuzeit.* Vol. 3, *1871–1918.* Munich: Beck, 1997.

Mommsen, Wolfgang. *Bürgerliche Kultur und küntlerische Avantgarde: Kultur und Politik im deutschen Kaiserreich, 1870–1918.* Frankfurt/Main: Propyläen, 1994.

Mosse, Werner, and Arnold Paucker, eds. *Juden im wilhelminischen Deutschland, 1890–1914.* Tübingen: Mohr, 1976.

Newmark, Maxim. *Otto Brahm: The Man and the Critic.* New York: Stechert, 1938.

Pankau, Johannes G. *Sexualität und Modernität: Studien zum deutschen Drama des Fin de Siécle.* Würzburg: Königshausen & Neumann, 2005.

Paret, Peter, and Beth Irwin. "Art, Society, and Politics in Wilhelmine Germany." *Journal of Modern History* 57 (1985): 696–710.

Pfeiffer, Maximilian. *Theaterelend.* Bamberg: Kommissions-Verlag der Schmidt'schen Buchhandlung (K. Streicher), 1909.

Presber, Rudolf. *Vom Theater um die Jahrhundertwende.* Stuttgart: Greiner und Pfeiffer, 1901.

Raeck, Kurt. *Das Deutsche Theater zu Berlin unter der Direktion Adolph L'Arronge.* Berlin: Verein für die Geschichte Berlins, 1928.

Reimers, Charlotte. *Die deutschen Bühnen und . . . ihre wirtschaftliche Lage.* Leipzig: Duncker und Humblot, 1911.

Rhode, Carla. "Das Berliner-Theater von 1885–1899." Ph.D. diss., Free University of Berlin, 1966.

Richter-Haaser, Inge. *Die Schauspielkunst Albert Bassermanns.* Berlin: Colloquium, 1964.

Rickelt, Gustav. *Schauspieler und Direktoren.* Berlin: Langenscheidt, 1910.

Robert, Eugen. *Theaterabende.* Munich: Müller, 1915.

Ruppel, Karl H. *Grosses Berliner Theater.* Velber bei Hannover: Friedrich, 1962.

Sandrock, Adele. *Mein Leben.* Berlin: Blanvalet, 1940.

Sayler, Oliver, ed. *Max Reinhardt and His Theater.* New York: Blom, 1968.

Schanze, Helmut. *Drama im bürgerlichen Realismus, 1850–1890.* Frankfurt/Main: Klostermann, 1973.

Schaper, Rüdiger. *Moissi.* Berlin: Argon, 2000.

Scherl, August. *Berlin hat kein Theaterpublikum!* Berlin: Scherl, 1898.

Schlaijker, Erich. "Der Einfluß des Kapitalismus auf die moderne dramatische Kunst." *Die neue Zeit* 12/2 (1892–1894): 650.

Schlenther, Paul. *Theater im 19. Jahrhundert.* Berlin: Selbstverlag für Theatergeschichte, 1930.

Schulze, Hans Adolf. *Der Schauspieler Rudolf Rittner.* Berlin: N.p., 1961.

Sebald, W. G. *Carl Sternheim: Kritiker und Oper der Wilhelminischen Ära.* Stuttgart: Kohlhammer, 1969.

Seehaus, Günter. *Frank Wedekind und das Theater, 1898–1959.* Munich: Laokoon, 1964.

Seelig, Ludwig. *Reichstheatergesetz.* Mannheim: N.p., 1913.

Seidlin, Oskar. *Der Theaterkritiker Otto Brahm.* Bonn: Bouvier, 1978.

Sprengel, Peter. *Gerhart Hauptmann: Epoche, Werk, Wirkung.* Munich: C. H. Beck, 1984.

———. *Scheunenviertel-Theater: Jüdische Schauspieltruppen und jiddische Dramatik in Berlin, 1900–1918.* Berlin: Fannei & Walz, 1995.

Sternheim, Carl. *Vorkriegseuropa im Gleichnis meines Lebens.* Amsterdam: Querido, 1936.

Styan, J. L. *Max Reinhardt.* Cambridge: Cambridge University Press, 1982.

Thomas, Emil. *40 Jahre Schauspieler.* 2 vols. Berlin: Duncker, 1895, 1897.

Tollini, Frederick P. *The Shakespeare Productions of Max Reinhardt.* Lewiston, NY: Mellen, 2004.

Trebitsch, Siegfried. *Chronicle of a Life.* London: Heinemann, 1953.

Turszinky, Walter. *Berliner Theater.* Berlin: Seeman, 1908.

Weilen, Alexander von. *Hamlet auf der deutschen Bühne bis zur Gegenwart.* Berlin: G. Reimer, 1908.

Whitinger, Raleigh. *Johannes Schlaf and German Naturalist Drama.* Columbia, SC: Camden House, 1997.

Wilms, Bernd. "Der Schwank: Dramaturgie and Theatereffekt, Deutsches Triv-
ialtheater, 1880–1930." Ph.D. diss., Free University of Berlin, 1961.
Winterstein, Eduard von. *Mein Leben und meine Zeit.* Berlin: Arnold, 1947.

THE WEIMAR PERIOD, 1919–1933

The republic formed in the aftermath of German defeat in World War I has been a subject of endless fascination for scholars of culture; among the most informed of them was John Willett, whose five titles on the subject listed below form an invaluable collection for any student likewise interested in the German theater during the ill-fated Weimar period. Several autobiographies also offer a wealth of information on those years, none more valuable than Kortner's *Aller Tage Abend*, Kessler's *In the Twenties*, or Zuckmayer's *Als wär's ein Stück von mir* (translated in an unfortunately abridged version as *A Part of Myself*). Bernauer's *Das Theater meines Lebens*, Bois's *Zu wahr, um schön zu sein*, Aufricht's *Erzähle, damit du dein Recht erweist*, Granach's *There Goes an Actor*, and Thielscher's *Erinnerungen eines alten Komödianten* are comparable, but they do not offer the same kind of political and cultural immediacy.

The Weimar Republic was also witness to that subject of seemingly interminable cathexis among students, scholars, and readers—namely, Expressionism. As noted above, Willett's volumes on this subject are extensive. David Kuhns's *German Expressionist Theatre: The Actor and the Stage* is a thorough examination of Expressionist performance, while Schepelmann-Rieder's book on Pirchan examines the fundamentals of Expressionist stage design. Ritchie's *German Expressionist Drama* is also a study of fundamentals, but Krischke's *Horváth auf der Bühne* is valuable for its insights into another Weimar dramatic development: the reborn *Volksstück*. Of the many books about Zuckmayer and his "renewal" of the *Volkstück*, Mews's biography is the best in English. There have also been several books of Zuckmayer criticism; Wegener's *Zuckmayer Criticism: Tracing Endangered Fame* is the most readable.

Among the studies of directors closely identified with the Weimar years, the Hugo Fetting edition of Jessner's *Schriften* is impressive; Christopher Innes's *Erwin Piscator's Political Theater* is even more valuable, indeed more so than anything Piscator himself wrote. Fehling's *Die Magie des Theaters* is a kind of *Festschrift* for Fehling, comprised of essays edited by Siegfried Melchinger.

Aufricht, Ernst Josef. *Erzähle, damit du dein Recht erweist*. Munich: DTV, 1969.

Barzantny, Tamara. *Harry Graf Kessler und das Theater*. Cologne: Böhlau, 2002.

Benson, Renate. *German Expressionist Drama: Ernst Toller and Georg Kaiser*. New York: Grove, 1984.

Bernauer, Rudolf. *Das Theater meines Lebens*. Berlin: Blanvalet, 1955.

Bois, Curt. *Zu wahr, um schön zu sein*. Berlin: Henschel, 1980.

Davies, Cecil. *Theater for the People*. Austin: University of Texas Press, 1977.

Diebold, Bernahrd. *Anarchie im Drama*. Berlin: Keller, 1928.

Eroe, Geoffrey M. 1993. "The Stage Designs of Traugott Müller in Relation to the Political Theatre of Erwin Piscator and the Weimar Republic." Ph.D. diss., Stanford University, 1993.

Eser, Willibald. *Theo Lingen*. Munich: Langen Müller, 1986.

Fehling, Jürgen. *Die Magie des Theaters*. Velber bei Hannover: Friedrich, 1965.

Felsmann, Barbara, and Karl Prümm. *Kurt Gerron—gefeiert und gejagt*. Berlin: Hentrich, 1992.

Fuegi, John. *Brecht and Company*. New York: Grove Press, 2002.

Funke, Christoph, and Wolfgang Jansen. *Theater am Schiffbauerdamm*. Berlin: Links, 1992.

Gay, Peter. *Weimar Culture*. New York: Harper & Row, 1968.

Goetz, Wolfgang. *Werner Krauss*. Hamburg: Hoffmann und Kampe, 1954.

Granach, Alexander. *There Goes an Actor*. Garden City, NY: Doubleday, 1945.

Grange, William. *Comedy in the Weimar Republic*. Westport, CT: Greenwood, 1996.

———. *Partnership in the German Theater*. New York: Lang, 1991.

Haack, Käthe. *In Berlin und anderswo*. Munich: Herbig, 1971.

Hadamowsky, Franz, ed. *Caspar Nehers szenisches Werk*. Vienna: Hollinek, 1972.

Hermand, Jost, and Frank Trommler. *Die Kultur der Weimarer Republik*. Munich: Nymphenburger, 1978.

Hollaender, Felix. *Lebendiges Theater*. Berlin: Fischer, 1932.

Hortmann, Wilhelm. *Shakespeare on the German Stage*. Vol. 2. New York: Cambridge University Press, 1998.

Ihering, Herbert. *Emil Jannings*. Heidelberg: Hüthig, 1941.

———. *Käthe Dorsch*. Munich: Zinnen, 1944.

———. *Theater in Aktion*. Edited by Hugo Fetting. Berlin: Henschel, 1986.

Innes, Christopher. *Erwin Piscator's Political Theater*. Cambridge: Cambridge University Press, 1972.

Jessner, Leopold. *Schriften*. Edited by Hugo Fetting. Berlin: Henschel, 1979.

Kessler, Harry. *In the Twenties: The Diaries of Harry Kessler*. New York: Holt, Rinehart, and Winston, 1971.

———. *Tagebücher, 1918–1937*. Frankfurt/Main: Insel, 1982.

Kindermann, Heinz. *Max Reinhardts Weltwirkung*. Vienna: Böhlau, 1969.

Kortner, Fritz. *Aller Tage Abend*. Munich: Kindler, 1959.

Krell, Max, ed. *Das deutsche Theater der Gegenwart*. Munich: Rösl, 1923.

Krischke, Traugott. *Horváth auf der Bühne, 1926–1938*. Vienna: Österreichischen Staatsdruckerei, 1991.

Kuhns, David F. *German Expressionist Theatre: The Actor and the Stage*. Cambridge: Cambridge University Press, 1997.

Lacquer, Walter. *Weimar: A Cultural History*. New York: Putnam, 1974.

Maartens, Valerie von. *Das grosse Curt Goetz Album*. Stuttgart: Deutsche Verlagsanstalt, 1968.

Martersteig, Max. *Das Theater im neuen Staat*. Berlin: De Grunter, 1920.

Mews, Siegfried. *Carl Zuckmayer*. Boston: Twayne, 1981.

Overesch, Manfred, and Friedrich Wilhelm Saal. *Die Weimarer Republik*. Düsseldorf: Droste, 1982.

Patterson, Michael. *The Revolution in German Theatre, 1900–1933*. London: Routledge and Kegan Paul, 1981.

Paulsen, Wolfgang, ed. *Die deutsche Komödie im zwanzigsten Jahrhundert*. Heidelberg: Lothar Stiem, 1976.

Peukert, Detlev. *The Weimar Republic*. Trans. by Richard Deveson. New York: Hill and Wang, 1992.

Pfefferkorn, Rudolf. *César Klein*. Berlin: Rembrandt, 1962.

Piscator, Erwin. *Das politische Theater*. Reinbek bei Hamburg: Rowohlt, 1963.

———. *The Political Theatre: A History, 1914–1929*. Trans. by Hugh Rorison. New York: Avon, 1978.

Raggam, Miriam. *Walter Hasenclever*. Hildesheim: Gerstenberg, 1973.

Reinhardt, Gottfried. *The Genius*. New York: Knopf, 1979.

Richardson, Horst Fuchs. "Comedy in the Works of Curt Goetz." Ph.D. diss., University of Connecticut, 1975.

Ritchie, James MacPherson. *German Expressionist Drama*. Boston: Twayne, 1976.

Rose, Paul. *Berlins grosse Theaterzeit: Schauspieler-Porträts der 20er und 30er Jahre*. Berlin: Rembrandt, 1959.

Rühle, Günther. *Theater für die Republik*. Frankfurt/Main: Fischer, 1967.

Salten, Felix. *Schauen und Spielen*. 2 vols. Vienna: Wila, 1921.

Sarrazac, Jean-Pierre. *Actualité du théâtre expressionniste*. Louvain, Belgium: Centre d'Études Théâtrales, 1995.

Schepelmann-Rieder, Erika. *Emil Pirchan und das expressionistische Bühnenbild*. Vienna: Bergland, 1964.

Schönherr, Hans-Joachim. *Ralph Arthur Roberts*. Hildesheim: Olms, 1992.

Schürer, Ernst. *Georg Kaiser*. Boston: Twayne, 1971.

Smith, Amy. *Hermine Körner*. Berlin: Kranich, 1970.

Straub, Agnes. *Im Wirbel des neuen Jahrhunderts*. Heidelberg: Hüthig, 1942.

Theater in der Weimarer Republik. Berlin: Kunstamt Kreuzberg, 1977.

Thielscher, Guido. *Erinnerungen eines alten Komödianten*. Berlin: Langenscheidt, 1938.

Tyson, Peter K. *The Reception of Georg Kaiser*. Bern: Peter Lang, 1984.

Völker, Klaus. *Elisabeth Bergner*. Berlin: Hentrich, 1990.

Wegener, Hans. *Zuckmayer Criticism: Tracing Endangered Fame*. Columbia, SC: Camden House, 1995.

Willett, John. *Art and Politics of the Weimar Period*. London: Thames and Hudson, 1978.

———. *Expressionism*. New York: McGraw-Hill, 1970.

———. *The Theater of Erwin Piscator*. New York: Holmes and Meier, 1979.

———. *The Theatre of the Weimar Republic*. New York: Holmes and Meier, 1988.

———. *The Weimar Years: A Culture Cut Short*. London: Thames and Hudson, 1984.

Zuckmayer, Carl. *Als wär's ein Stück von mir*. Frankfurt/Main: Fischer, 1966.

THE THIRD REICH, 1933–1945

Only recently has the National Socialist period in German theater begun to attract a more balanced set of inquiries by scholars and critics. In the 1960s there were attempts to evaluate the level of work between 1933 and 1944, but many of them, perhaps understandably, got bogged down in ideological positioning. Among those works that still remain valuable are Brenner's *Die Kunstpolitik des Nationalsozialismus* and Drewniak's *Das Theater im NS-Staat*. Later, Wardetzky's *Theaterpolitik im Faschistischen Deutschland* continued in somewhat the same vein.

In the last decade of the 20th century, books with a somewhat steadier view of the Third Reich and its theater culture appeared. Daiber's *Schaufenster der Diktatur* and Reichel's *Der schöne Schein des dritten Reiches* were initial steps in that direction. Editions of essays in English (Cuomo's *National Socialist Cultural Policy*, Gadberry's *Theatre in the Third Reich*, Berghaus's *Fascism and Theatre*, and London's *Theatre under the Nazis*) contributed to this trend. Among the most valuable reference works on the Nazi years to have recently appeared is Eicher's *Theater im "Dritten Reich."* It supplements the many similar works about the Third Reich generally that have remained in print since the 1950s.

Several important books on directors active during the Third Reich also began to come out in the 1960s. Among them were Riess's *Gustaf Gründgens* and Rischbieter's *Gründgens: Schauspieler, Regisseur, Theaterleiter*.

In the 1970s several books on directors were published: Noelte's *Jürgen Fehling der Regisseur*; Badenhausen's collection of letters, essays, and speeches by Gründgens, titled *Briefe, Aufsätze, Reden*; Kühlken's *Die Klassiker-Inszenierungen von Gustaf Gründgens*; Holba's *Erich Engel*; and Engel's own *Schriften über Theater und Film*. A masterpiece of scholarship on directorial art appeared in 1990, however, with the publication of Dillmann's *Heinz Hilpert: Leben und Werk*.

Such works joined an already growing collection of worthy books on German actors and designers, such as Ball's *Heinz Rühmann*, Funke's *Hans Albers*, Jannings's autobiography *Theater, Film—das Leben, und ich*, Werner Krauss's autobiography *Das Schauspiel meines Lebens*, and Pfefferkorn's *César Klein*. Barbara Felsmann's *Kurt Gerron—gefeiert und gejagt* is the tragic account of a brilliant actor whose career began in the Weimar period and ended in Auschwitz. Even more poignant is Ulrich Liebe's *Verehrt, verfolgt, vergessen: Schauspieler als Naziopfer*; it chronicles the fates of actors such as Robert Dorsay, Joachim Gottschalk, Fritz Grünbaum, Eugen Burg, Alice Dorel, Herta Felden, and many others who were driven to suicide, "shot while attempting to escape," or murdered in concentration camps. Zuckmayer's *Geheimreport* is a fascinating account of numerous artists such as Heinrich George, Hans Reimann, and Eugen Klöpfer, who not only collaborated with the Nazis but were themselves enthusiastic National Socialist Party members.

Among the best books on a designer is Willett's *Caspar Neher: Brecht's Designer*. Of course, Neher did no designs for Brecht in the Third Reich, but he was active throughout the Nazi years. So was Brecht, though not in Germany. Lyon's *Brecht in America* is among the best books on Brecht, providing a stunningly well-crafted account of Brecht's experience in exile, "changing countries more often than shoes."

Adam, Peter. *The Art of the Third Reich*. New York: Abrams, 1992.
Aders, Egon. *Theater, wohin?* Stuttgart: Muth, 1935.
Ahleff, Eberhard, ed. *Das dritte Reich*. Hanover: Fackelträger, 1970.
Ahrens, Gerhard, ed. *Das Theater des deutschen Regisseurs Jürgen Fehling*. Berlin: Quadriga, 1987.
Albert, Claudia, ed. *Deutsche Klassiker im Nationalsozialismus*. Stuttgart: Metzler, 1994.
Albrecht, Gerd. *Nationalsozialistische Filmpolitik*. Stuttgart: Emke, 1969.
Amrein, Ursula. *"Los von Berlin!": Die Literatur- und Theaterpolitik der Schweiz und das "Dritte Reich."* Zurich: Chronos, 2004.

Arp, J. "Studien zu Problemen der nierderdeutsche Volkskomödie." Ph.D. diss., University of Kiel, 1955.

Aschheim, Steven E. *Culture and Catastrophe:* New York: New York University Press, 1996.

Asper, Helmut G., ed. *Im Rampenlicht der "dunklen Jahre.*" Berlin: Sigma, 1989.

August, Wolf-Eberhard. "Die Stellung der Schauspieler im Dritten Reich." Ph.D. diss., University of Cologne, 1973.

Ayass, Wolfgang. *"Asoziale" im NS.* Stuttgart: Klett-Cotta, 1995.

Ball, Gregor. *Heinz Rühmann.* Munich: Heyne Filmbibliothek, 1981.

Baumgarten, Michael. "Gerhart Hauptmann—Inszenierungen am Berliner Rose Theater, 1933–1944." Ph.D. diss., Free University of Berlin, 1991.

Benz, Wolfgang, et al. *Enzyklopädie des Nationalsozialismus.* Stuttgart: Klett-Cotta, 1997.

Berghaus, Günter, ed. *Fascism and Theatre.* Oxford: Berghahn, 1996.

Best, Walter. *Völkische Dramaturgie.* Würzburg: Triltsch, 1940.

Beyer, Friedemann. *Die UFA-Stars im Dritten Reich.* Munich: Heyne, 1991.

Biedrzynski, Richard. *Schauspieler, Regisseure, Intendanten.* Heidelberg: Hüthig, 1944.

Blinn, Hansjürgen. *Der deutsche Shakespeare.* Berlin: E. Schmidt, 1993.

Braun, Hanns. *Vor der Kulissen.* Munich: Heimeran, 1938.

Brenner, Hildegarde. *Die Kunstpolitik des Nationalsozialismus.* Hamburg: Rowohlt, 1963.

Bumm, Peter. *Drama und Theater der konservativen Revolution.* Munich: Verlag UNI-Druck, 1971.

Burleigh, Michael, ed. *Confronting the Nazi Past.* New York: St. Martin's, 1996.

Buschbeck, Erhard. *Raoul Aslan und das Burgtheater.* Vienna: Müller, 1946.

Cadigan, Rufus J. "Richard Billinger, Hans Johst, and Eberhard Möller." Ph.D. diss., University of Kansas, 1979.

Cerha, Ursula. *Ewald Balser.* Vienna: Böhlau, 2004.

Claussen, Horst, and Norbert Oellers, eds. *Beschädigtes Erbe.* Bonn: Bouvier, 1984.

Crew, David F. *Nazism and German Society.* London: Routledge, 1994.

Cuomo, Glenn, ed. *National Socialist Cultural Policy.* New York: St. Martin's, 1995.

Daiber, Hans. *Schaufenster der Diktatur.* Stuttgart: Neske, 1995.

Davidson, Mortimer G. *Kunst in Deutschland, 1933–1945.* Tübingen: Grabert, 1988.

Deutsches Bühnen-Jahrbuch. Genossenschaft deutscher Bühnenangehöriger, 1933–1944.

Deutsch-Schreiner, Evelyn. "Der 'vierfach männliche Blick' auf die Frau." *Zeitschrift für Literaturwissenschaft und Linguistik* 24 (1994): 91–105.

Dillmann, Michael. *Heinz Hilpert: Leben und Werk*. Berlin: Akademie der Künste, 1990.

Domarus, Max, ed. *Adolf Hitler: Reden und Proklamationen, 1932–1945*. Munich: Süddeutscher Verlag, 1965.

Drewniak, Boguslaw. *Das Theater im NS-Staat*. Düsseldorf: Droste, 1983.

Dreyer, Ernst Adolf, ed. *Deutsche Kultur im neuen Reich*. Berlin: Schlieffen, 1934.

Dürhammer, Illja, and Pia Janke. *Die "österreichische" nationalsozialistische Ästhetik*. Vienna: Böhlau, 2003.

Dussel, Konrad. *Ein neues, ein Heroisches Theater?* Bonn: Bouvier, 1988.

———. "Theatergeschichte der NS-Zeit unter sozialgeschichtlichem Aspekt." *Neue politische Literatur* 32 (1987): 233–45.

Eicher, Thomas. "Theater im 'Dritten Reich.'" Ph.D. diss., Free University of Berlin, 1992.

Eicher, Thomas, Barbara Panse, and Henning Rischbieter. *Theater im "Dritten Reich."* Seelze-Veber: Kallmeyer, 2000.

Elsner, Richard. *Die deutsche Nationalbühne*. Berlin: Heyer, 1934.

Emmel, Felix. *Theater aus deutschem Wesen*. Berlin: Stilke, 1937.

Engel, Erich. *Schriften über Theater und Film*. Berlin: Henschel, 1971.

Falkenberg, Hans-Geert. *Heinz Hilpert: Das Ende einer Epoche*. Göttingen: Vandenhoeck und Ruprecht, 1968.

Fest, Joachim C. *Das Gesicht des dritten Reiches*. Munich: Piper, 1963.

Frauenfeld, Eduard. *Der Weg zur Bühne*. Berlin: Limpert, 1941.

Frei, Norbert. "Wie modern war der NS?" *Geschichte und Gesellschaft* 19 (1993): 367–387.

Freydank, Ruth. *Theater in Berlin*. East Berlin: Argon, 1988.

Fricke, Kurt. *Spiel am Abgrund: Heinrich George*. Halle: Mitteldeutscher Verlag, 2000.

Friedländer, Saul. *Reflections of Nazism*. New York: Harper & Row, 1984.

Fritsch, Theodor, ed. *Handbuch der Judenfrage*. Leipzig: Hammer, 1944.

Funke, Christoph. *Hans Albers*. Berlin: Henschel, 1965.

Funke, Christoph, and Dieter Kranz. *Theaterstadt Berlin*. Berlin: Henschel, 1978.

Gadberry, Glen, ed. *Theatre in the Third Reich*. Westport, CT: Greenwood, 1995.

Genossenschaft deutscher Bühnenangehöriger. *Deutsches Bühnen-Jahrbuch*. Berlin: Druck- und Kommissionverlag, 1933–1944.

Gilman, Sander L. *Nationalsozialistische Literaturtheorie*. Frankfurt/Main: Athenäum, 1971.

Girshausen, Theo, and Henry Thorau, eds. *Theater als Ort der Geschichte: Festschrift für Henning Rischbieter*. Velber bei Hannover: Friedrich, 1998.

Goebbels, Joseph. *Der Kampf um Berlin*. Berlin: Eher, 1932.

———. "Rede des Propagandaministers vor den Theaterleitern, 8 May 1933." *Das Deutsche Drama in Geschichte und Gegenwart* 5.

——. *Tagebücher*. 4 vols. Edited by Elke Fröhlich. Munich: Saur, 1987.

Goertz, Heinrich. *Gustaf Gründgens*. Reinbeck: Rowohlt, 1982.

Golsan, Richard J., ed. *Fascism, Aesthetics, and Culture*. Hanover, NH: University Press of New England, 1992.

Görtz, Franz Josef, and Hans Sarkowicz. *Heinz Rühmann: Der Schauspieler und sein Jahrhundert*. Munich: Beck, 2001.

Grange, William. *Hitler Laughing: Comedy in the Third Reich*. Lanham, MD: University Press of America, 2005.

Grimm, Reinhold, and Jost Hermand, eds. *Faschismus und Avantgarde*. Königstein: Athenäum, 1980.

——, eds. *Geschichte im Gegenwartsdrama*. Stuttgart: Kohlhammer, 1976.

Grosshans, Henry. *Hitler and the Artists*. New York: Holmes and Meier, 1983.

Grunberger, Richard. *A Social History of the Third Reich*. London: Weidenfeld and Nicolson, 1971.

Gründgens, Gustaf. *Briefe, Aufsätze, Reden*. Edited by Rolf Badenhausen and Peter Gründgens-Gorski. Munich: DTV, 1970.

Gutzeit, Jutta. "Staatliches Schauspielhaus und Thalia-Theater in Hamburg, 1939–1945." Master's thesis, University of Hamburg, 1989.

Habicht, Werner. "Shakespeare in the Third Reich." In *Anglistentag*, edited by Manfred Pfister, 194–204. Giessen: Hoffmann, 1985.

Haider-Pregler, Hilde. "Das Dritte Reich und das Theater." *Maske und Kothurn* 17 (1971): 203–214.

Hammerschmidt, Ulrich. "Theaterkritik im dritten Reich." Master's thesis, University of Erlangen-Nuremberg, 1989.

Hansen, John H. "Nazi Aethetics." *Psychohistory Review* 9, no. 4 (1981): 251–281.

Haxthausen, Charles, ed. *Berlin: Culture and Metropolis*. Minneapolis: University of Minnesota Press, 1990.

Herf, Jeffrey. *Reactionary Modernism*. New York: Cambridge, 1984.

Herterich, Fritz. *Theater und Volkswirtschaft*. Munich: Duncker und Humblot, 1937.

Hewitt, Andrew. *Fascist Modernism*. Stanford, CA: Stanford University Press, 1993.

Hitler, Adolf. *Mein Kampf*. Munich: Hanser, 1939.

Holba, Herbert. *Erich Engel*. Vienna: Aktion, 1977.

Hortmann, Wilhelm. *Shakespeare on the German Stage*. Vol. 2. Cambridge: Cambridge University Press, 1998.

Hostetter, Elisabeth Schulz. *The Berlin State Theater under the Nazi Regime*. Lewiston, NY: Mellen, 2004.

Huch, Rudolf. *William Shakespeare: Eine Studie*. Hamburg: Hanseatische Verlagsanstalt, 1941.

Ihering, Herbert. *Berliner Dramaturgie*. Berlin: Aufbau, 1948.

———. *Regie*. Berlin: Hugo, 1943.

Jannings, Emil. *Theater, Film—das Leben, und ich*. Berchtesgaden: Zimmer und Herzog, 1951.

Kadner, Siegfried. *Rasse und Humor*. Munich: Lehmanns, 1936.

Kammer, Hilde, et al. *Lexikon Nationalsozialismus*. Hamburg: Rowohlt, 1999.

Kemmler, Richard S. "The National Socialist Ideology in Drama." Ph.D. diss., New York University, 1973.

Ketelsen, Uwe-Karsten. *Völkisch-nationale und nationalsozialistische Literatur in Deutschland, 1890–1945*. Stuttgart: Metzler, 1976.

———. *Von heroischem Sein und völkischem Tod*. Bonn: Bouvier, 1970.

Kirk, Tim. *The Longman Companion to Nazi Germany*. New York: Longman, 1995.

Kliesch, Hans-Joachim. "Die Film- und Theaterkritik im NS-Staat." Ph.D. diss., Humboldt University of Berlin, 1957.

Kowa, Viktor de. *Als ich noch Prinz war von Arkadien*. Nuremberg: Glock und Lutz, 1955.

Kracauer, Siegfried. "The Mass Ornament." *New German Critique* 5:67–76.

Krauss, Werner. *Das Schauspiel meines Lebens*. Edited by Hans Weigel. Stuttgart: Govert, 1958.

Kresse, Dodo, and Michael Horvath. *Nur ein Komödiant? Hans Moser in den Jahren 1938–1945*. Vienna: Österreichische Staatsdrückerei, 1994.

Kühlken, Edda. *Die Klassiker-Inszenierungen von Gustaf Gründgens*. Meisenheim: Hain, 1972.

Kuschnia, Michael, ed. *100 Jahre Deutsches Theater in Berlin, 1883–1983*. Berlin: Henschel, 1983.

Lehmann-Haupt, Helmut. *Art under a Dictatorship*. New York: Oxford, 1954.

Lennartz, Franz. *Die Dichter unserer Zeit*. Stuttgart: Kröner, 1941.

Liebe, Ulrich. *Verehrt, verfolgt, vergessen: Schauspieler als Naziopfer*. Weinheim: Beltz Quadriga, 1992.

Loewy, Ernst. *Literatur unterm Hakenkreuz*. Frankfurt/Main: Fischer-Bücherei, 1969.

London, John, ed. *Theatre under the Nazis*. Manchester: Manchester University Press, 2000.

Luft, Friedrich. *Gustaf Gründgens*. Berlin: Rembrandt, 1958.

Lukacs, John. *The Hitler of History*. New York: Knopf, 1997.

Lüth, Erich. *Hamburger Theater, 1933–1945*. Hamburg: Buekschmidt, 1962.

Lyon, James K. *Brecht in America*. Princeton, NJ: Princeton University Press, 1980.

May, Ursula. "Das Mannheimer Nationaltheater, 1933–1945." Master's thesis, Free University of Berlin, 1986.

Meier, Monika, et al. *Theater: Wissenschaft und Faschismus*. Berlin: Roessler, 1981.

Michaelis, Cassie, et al. *Die braune Kultur*. Zurich: Europaverlag, 1934.

Milfull, John, ed. *The Attractions of Fascism*. New York: Berg, 1990.

Minetti, Bernhard. *Erinnerungen eines Schauspielers*. Edited by Günther Rühle. Stuttgart: Deutsche Verlags-Anstalt, 1985.

Mohr, Albert. *Das Frankfurter Schauspiel, 1929–1944*. Frankfurt/Main: Kramer, 1974.

Mosse, George L. *Nazi Culture*. New York: Grosset and Dunlap, 1966.

Mühr, Alfred. *Mephisto ohne Maske: Gustaf Gründgens*. Munich: Langen Müller, 1981.

Naso, Eckehart. *Ich liebe das Leben*. Hamburg: Krüger, 1953.

Neocleous, Mark. *Fascism*. Minneapolis: University of Minnesota Press, 1997.

Noelte, Rudolf, ed. *Jürgen Fehling der Regisseur*. Berlin: Akademie der Künste, 1978.

Panse, Barbara. "Diese Künstler sind wie Kinder." *Theater Heute* 30, no. 9 (September 1989): 4–5.

Pilger, Else. "George Bernard Shaw in Deutschland." Ph.D. diss., University of Münster, 1940.

Poensgen, Wolfgang. *Der deutsche Bühnen-Spielplan im Weltkriege*. Berlin: Gesellschaft für Theatergeschichte, 1934.

Prinz, Michael, and Rainer Zitelmann. *Nationalsozialismus und Modernisierung*. Darmstadt: Wissenschaftliche Buchgesellschaft, 1991.

Prinzer, Helmut. *Chronik des deutschen Films, 1895–1994*. Stuttgart: Metzler, 1995.

Quaresima, Leonardo. "Der Film im dritten Reich: Moderne, Amerikanismus, Unterhaltungsfilm." *montage/av* 3, no. 2 (1994): 5–22.

Rabenalt, Arthur M. *Über die Schauspielkunst im Film*. Düsseldorf: Merkur, 1945.

Reeve, William C. *Kleist on Stage, 1804–1987*. Montreal: McGill University Press, 1993.

Reichel, Peter. *Der schöne Schein des dritten Reiches*. Munich: Carl Hanser, 1992.

Reichert, Franz. *Durch meine Brille: Theater in bewegter Zeit*. Vienna: Österreichischer Bundesverlag, 1986.

Riess, Curt. *Gustaf Gründgens*. Hamburg: Hofmann und Campe, 1965.

———. *Zürich Schauspielhaus, Sein oder Nichtsein: Der Roman eines Theaters*. Zurich: Sanssouci-Verlag, 1969.

Ritchie, James MacPherson. *German Literature under National Socialism*. Totowa, NJ: Barnes and Noble, 1983.

Rosenberg, Alfred. *Der Mythus des 20. Jahrhunderts*. Munich: Hoheneichen, 1939.

Rothe, Hans. *Der Kampf um Shakespeare*. Leipzig: List, 1936.

Rühle, Gerd. *Das dritte Reich*. Berlin: Hummel, 1934.

Rühle, Günther. *Zeit und Theater: Diktatur und Exil*. Vol. 3. Berlin: Propyläen, 1973.

Rühle, Jürgen. *Das gefesselte Theater*. Cologne: Kiepenhauer und Witsch, 1957.

Ruppel, Karl H. *Berliner Schauspiel: Dramaturgische Betrachtungen, 1936–1942*. Berlin: Neff, 1943.

Schäfer, Hans-Dieter. *Das gespaltene Bewusstsein*. Munich: Hanser, 1982.

Schlösser, Rainer. *Das Volk und seine Bühne*. Berlin: Langen/Müller, 1935.

———. *Politik und Drama*. Berlin: Zeitgeschichte, 1933.

Schnell, Ralf, ed. *Kunst und Kultur im deutschen Faschismus*. Stuttgart: Metzler, 1978.

Schoenbaum, David. *Hitler's Social Revolution*. London: Weidenfeld and Nicolson, 1967.

Schulte-Sasse, Linda. "National Socialism's Aestheticization of Genius." *Germanic Review* 66 (1991): 4–15.

Seelig, Ludwig. *Geschäftstheater oder Kulturtheater?* Berlin: Reichsverband Deutscher Bühnenangehöriger, 1935.

Seeslen, Georg. *Tanz den Adolf Hitler: Faschismus in der populären Kultur*. Berlin: Bittermann, 1994.

Silberman, Marc. "The Ideology of Re-Presenting the Classics in the Third Reich." *German Quarterly* 57, no. 4 (1984): 590–602.

Snyder, Louis L. *Encyclopedia of the Third Reich*. New York: Paragon, 1989.

Stachura, Peter D. "Who Were the Nazis?" *European Studies Review* 11 (1981): 293–324.

Stackelberg, Roderick. *Hitler's Germany*. New York: Routledge, 1999.

Stang, Walter. *Grundlagen nationalsozialistischer Kulturpflege*. Berlin: Junker und Dünnhaupt, 1935.

Staudinger, Friedrich. "Die berufsständische Idee des Bühnenkünstlers in ihrere Entwicklung." Ph.D. diss., University of Heidelberg, 1935.

Steinweis, Alan. *Art, Ideology, and Economics in Nazi Germany*. Chapel Hill: University of North Carolina Press, 1993.

Stern, Carola. *Auf das Wassern des Lebens: Gustaf Gründgens und Marianne Hoppe*. Cologne: Kipenheuer und Witsch, 2005.

Stern, Fritz. *The Politics of Cultural Despair*. Berkeley: University of California Press, 1961.

Stollmann, Rainer. *Ästhetisierung der Politik*. Stuttgart: Metzler, 1978.

———. "Fascist Politics as a Total Work of Art." *New German Critique* 14 (1978): 41–60.

Taylor, Ronald. *Literature and Society in Germany, 1918–1945*. Totowa, NJ: Barnes and Noble, 1980.

Thompson, Dorothy. "Culture under the Nazis." *Foreign Affairs* 14 (1935–1936): 407–423.

Totten-Naylor, Lyra. "The Malicious Theater: National Socialist Jewish Policy and the Theater." Master's thesis, Miami University (Ohio), 2001.

Walach, Dagmar. *Gustaf Gründgens: Eine Karriere.* Berlin: Henschel, 1999.

Wallner, Regina. "Erfolgreiche Komödien im Nationalsozialismus." Master's thesis, Free University of Berlin, 1991.

Wanderscheck, Hermann. *Deutsche Dramatik der Gegenwart.* Berlin: Bong, 1938.

Wardetzky, Jutta. *Theaterpolitik im Faschistischen Deutschland.* Berlin: Henschel, 1983.

Westecker, Wilhelm. *Kultur im Dienst der Nation.* Hamburg: Hanseatische Verlagsanstalt, 1936.

Witte, Karsten. *Lachende Erben, Toller Tag: Filmkomödie im dritten Reich.* Berlin: Vorwerk 8, 1995.

Wulf, Joseph. *Theater und Film im Dritten Reich.* Gutersloh: Mohn, 1964.

Zentner, Christina, and Friedemann Bedürftig, eds. *Das grosse Lexikon des Dritten Reiches.* Munich: Südwest, 1985.

Zuckmayer, Carl. *Geheimreport.* Göttingen: Wallstein, 2002.

THE COLD WAR PERIOD, 1945–1989

The postwar period in German theater bore the stamp of Brecht more than any other theater artist. Dozens of books on him and his work appeared with regularity, perhaps the most important of which (for English-speaking readers) was Willett's edition *Brecht on Theatre.* The "Brecht wave" peaked sometime in the mid-1980s and has since diminished considerably. Rouse's book on Brecht's influence in the West German theater is a good summation. Concomitant with the Brecht books were studies on East German theater practice, such as Huettich's *Theatre in the Planned Society* or Buhss's *DDR-Theater des Umbruchs.*

Several books attempted to find the direction in which West Germany was going in the 1960s and 1970s, but few succeeded effectively. Only when it became apparent that Peter Stein and his colleagues at the Schaubühne am Halleschen Ufer in Berlin were well on their way toward something unique, as Iden makes clear in his *Die Schaubühne am Halleschen Ufer, 1970–1979,* did the course of West German theater become more readily apparent. Müller and Schitthelm confirmed the fact in a much later publication, *40 Jahre Schaubühne Berlin.*

On what course had the West German theater embarked? Patterson's books on Stein, Erken's on Hansgünther Heyme, and Koberg's on Claus

Peymann seemed to indicate that its guiding star was the director. As Sebald notes in his edition *A Radical Stage: Theatre in Germany in the 1970s and 1980s*, West German directors had transformed the entire canon of German drama into pretexts for their own artistic endeavors. No longer did directors try to stage plays by Lessing, Schiller, Wedekind, or anybody else; they instead often used parts of plays by a playwright, or sometimes by various playwrights, to construct testaments to their own power and influence with governments who funded their enterprises. Such directorial appropriation resembled the transformations Wagner and Saxe-Meiningen had effected almost exactly 100 years earlier, as Carlson describes in his *German Stage of the 19th Century*. Both men stopped the inherited traditions of virtuoso acting and reliance on a prompter dead in their tracks. Stein, Peymann, Heyme, Bondy, and others had done something analogous, as Becker implies in *Das Jahrhundert des Theaters*.

Ahrends, Günter. *Andrea Breth: Theaterkunst als kreative Interpretation.* Frankfurt/Main: Lang, 1990.

Amstutz, Hans, and Ursula Käser-Leisibach, eds. *Schweizertheater: Drama und Bühne der Deutschschweiz bis Frisch und Dürrenmatt, 1930–1950.* Zurich: Chronos, 2000.

Bartram, Graham, and Anthony Waine, eds. *Brecht in Perspective.* London: Longman, 1982.

Becker, Peter von, ed. *Das Jahrhundert des Theaters.* Cologne: DuMont, 2002.

Braun, Hanns. *The Theatre in Germany.* Munich: Bruckmann, 1956.

Brecht, Bertolt. *Arbeitsjournal.* Vol. 2, *1942–1955.* Edited by Werner Hecht. Frankfurt/Main: Suhrkamp, 1973.

Buhss, Werner, and Harald Müller. *DDR-Theater des Umbruchs.* Frankfurt/Main: Eichborn, 1990.

Calandra, Denis. *New German Dramatists.* New York: Grove, 1983.

Clemens, Roman, and Siegfried Melchinger, eds. *Theatre on the German-Speaking Stage.* Munich: Goethe Institut, 1971.

Dace, Wallace. *National Theaters in the Larger German and Austrian Cities.* New York: Rosen, 1980.

Daiber, Hans. *Theater: Eine Bilanz.* Munich: Langen-Müller, 1965.

Domdey, Horst. *Produktivkraft Tod: Das Drama Heiner Müllers.* Cologne: Böhlau, 1998.

Eckert, Nora. *Das Bühnenbild im 20. Jahrhundert.* Berlin: Henschel, 1998.

Einem, Gottfried von, and Siegfried Melchinger, eds. *Caspar Neher.* Velber bei Hannover: Friedrich, 1966.

Erken, Günther. *Hansgünther Heyme*. Frankfurt/Main: Fischer, 1989.

Esslin, Martin. *Brecht: A Choice of Evils*. London: Methuen, 1984.

Ewen, Frederic. *Bertolt Brecht: His Life, His Art, and His Times*. New York: Citadel, 1967.

Fischer, Matthias-Johannes. *Brechts Theatertheorie*. New York: P. Lang, 1989.

Frisch, Max. *Tagebuch, 1946–1949*. Frankfurt/Main: Suhrkamp, 1950.

Funke, Christoph, ed. *Theater-Bilanz, 1945–1969 . . . in der Deutschen Demokratischen Republik*. Berlin: Henschel, 1971.

Greisenegger, Wolfgang, ed. *Lois Egg: Bühnenentwürfe, Skizzen, Aquarelle, 1930–1985*. Vienna: Jugend und Volk, 1985.

Grosse, Helmuth. *Théâtre allemand contemporain*. Geneva: Musée Rath, 1962.

Guntner, J. Lawrence, and Andrew McLean, eds. *Redefining Shakespeare . . . in the German Democratic Republic*. Newark: University of Delaware Press, 1998.

Haan, Christa. "Werner Krauss und das Burgtheater." Ph.D. diss., University of Vienna, 1970.

Herrmann, Karl-Ernst, ed. *Schaubühne am Halleschen Ufer, am Lehiner Platz, 1962–1987*. Frankfurt/Main: Propyläen, 1987.

Herzmann, Herbert. *Tradition und Subversion: Das Volksstück und das epische Theater*. Tübingen: Stauffenburg, 1997.

Hoffmann-Allenspach, Tobias. *Theaterkritik in der deutschsprachigen Schweiz seit 1945*. Zurich: Chronos, 1998.

Huettich, H. G. *Theatre in the Planned Society*. Chapel Hill: University of North Carolina Press, 1978.

Iden, Peter. *Die Schaubühne am Halleschen Ufer, 1970–1979*. Frankfurt/Main: Fischer, 1982.

Käser-Leisibach, Ursula. *Schweizertheater: Drama und Bühne der Deutschschweiz bis Frisch und Dürrenmatt, 1930–1950*. Zurich: Chronos, 2000.

Knuth, Gustav. *Mit einem Lächeln im Knopfloch*. Hamburg: Glöss, 1974.

Kreuzer, Helmut, and Karl W. Schmidt, eds. *Dramaturgie in der DDR, 1945–1990*. Heidelberg: Winter, 1998.

Lederer, Herbert. *Handbook of East German Drama, 1945–1985*. New York: P. Lang, 1991.

Lennartz, Knut. *Vom Aufbruch zur Wende: Theater in der DDR*. Seelze: Friedrich, 1992.

Luft, Friedrich. *Stimme der Kritik: Berliner Theater seit 1945*. Velber: Friedrich, 1965.

Lyon, James K., and Hans-Peter Breuer, eds. *Brecht Unbound*. Newark: University of Delaware Press, 1995.

Mainusch, Herbert, and Achim Benning, eds. *Regie und Intepretation*. Munich: Fink, 1985.

Melchinger, Siegfried. *Theater der Gegenwart*. Frankfurt/Main: Fischer, 1956.

Melchinger, Siegfried, and Rosemarie Clausen. *Schauspieler: 36 Porträts*. Frankfurt/Main: Gutenberg, 1966.

Mertz, Peter. *Das gerettete Theater: Die deutsche Bühne im Wiederaufbau*. Weinheim: Quadriga, 1990.

Mittenzwei, Werner, ed. *Theater in der Zeitenwende . . . in der Deutschen Demokratischen Republik*. 2 vols. Berlin: Henschel, 1972.

Müller, Harald, and Jürgen Schitthelm, eds. *40 Jahre Schaubühne Berlin*. Berlin: Theater der Zeit, 2002.

Neef, Sigrid. *Das Theater der Ruth Berghaus*. Frankfurt/Main: Fischer, 1989.

Patterson, Michael. *German Theatre Today*. London: Pitman, 1976.

———. *Peter Stein: Germany's Leading Theatre Director*. New York: Cambridge University Press, 1981.

Pritchard, Ilka Maria. *"Des Volkes Stimme ist auch eine Stimme": Zur Sprichwörtlichkeit in Carl Zuckmayers Dramen*. Burlington: University of Vermont Press, 2001.

Reichhardt, Hans, ed. *10 Jahre Theater in Berlin: Premieren, 1970–1980*. Berlin: Spritzing, 1980.

———, ed. *25 Jahre Theater in Berlin: Theaterpremieren, 1945–1970*. Berlin: Spritzing, 1972.

Riess, Curt. *Theaterdämmerung, oder das Klo auf der Bühne*. Hamburg: Hoffmann und Kampe, 1970.

Rischbieter, Henning, ed. *German Theatre Today*. Velber: Friedrich, 1967.

Rouse, John. *Brecht and the West German Theatre*. Ann Arbor, MI: UMI Research Press, 1989.

Rühle, Günther. *Anarchie in der Regie?* 2 vols. Frankfurt/Main: Suhrkamp, 1980, 1982.

Schirmer, Lothar. *Aus Trümmern erstanden: Theater in Deutschland nach dem Zweiten Weltkrieg*. Berlin: Gesellschaft für Theatergeschichte, 1991.

Schmidt, Dietmar, ed. *Regie: Luc Bondy*. Berlin: Alexander, 1991.

Schneider, Rolf. *Theater in einem besiegten Land: Dramaturgie der deutschen Nachkriegszeit 1945–1949*. Frankfurt/Main: Ullstein, 1989.

Schubbe, Elmar. *Dokumente zur Kunst-, Literatur-, und Kulturpolitik der S.E.D.* Stuttgart: Seewald, 1972.

Schulmeister, Karl-Heinz. *Auf dem Weg zu einer neuen Kultur*. Berlin: Dietz, 1977.

Schulze-Reimpell, Werner. *Development and Structure of the Theatre in the Federal Republic of Germany*. Cologne: Deutscher Bühnenverein, 1975.

Sebald, W. G., ed. *A Radical Stage: Theatre in Germany in the 1970s and 1980s*. New York: Berg, 1988.

Seydel, Renate, ed. *Verweile doch . . . Erinnerungen von Schauspielern des Deutschen Theaters*. Berlin: Henschel, 1984.

Shaw, Leroy, ed. *The German Theatre Today*. Austin: University of Texas Press, 1963.

Silberman, Marc. *Heiner Müller*. Amsterdam: Rodopi, 1980.

Smith, Yvette Koth. "Censorship Mechanisms in the Theatre of the German Democratic Republic, 1971–1989." Master's thesis, San Jose State University, 1999.

Stephan, Alexander. "Johannes R. Becher and the Cultural Development of the GDR." *New German Critique* 1, no. 2 (1974): 72–89.

Szondi, Peter. *Theorie des modernen Dramas*. Frankfurt/Main: Suhrkamp, 1956.

Thomson, Peter, and Glendyr Sacks. *The Cambridge Companion to Brecht*. New York: Cambridge University Press, 1994.

Vergleichende Theater-Statistik, 1949–1974. Cologne: Deutscher Bühnenverein, 1977.

Walther, Ingeborg C. *The Theater of Franz Xaver Kroetz*. New York: P. Lang, 1990.

White, John J. *Bertolt Brecht's Dramatic Theory*. Rochester, NY: Camden House, 2004.

Willett, John *Caspar Neher: Brecht's Designer*. London: Methuen, 1986.

THE REUNIFICATION PERIOD, 1989 TO THE PRESENT

The political reunification of Germany meant, among other things, an attempted reconciliation of two German theater cultures, one in the Federal Republic and the other in the Democratic Republic. Several books in the 1990s attempted to decipher what reunification would mean or had already begun to signify, though few of them offered anything beyond belabored theoretical musings. The sensational publicity that surrounded the premieres of some plays most observers accepted as the by-product of a theater culture that had become dominated by directorial mandate. Robin Detje's book on Frank Castorf is a good example of such acceptance. Balitzki's study of Castorf attempts to explore director Castorf's conviction that the postunification period is both decadent and "neo-fascist"—and why potato salad seems to make an appearance in so many Castorf productions.

The influence of Peymann has resulted in the numerous books on Thomas Bernhard. Among them, Dowden's *Understanding Thomas Bernhard* is probably the most helpful, while Honegger's is the most extensive. Fiddler's introduction to Jelinek is likewise helpful, especially as more books on the Nobel Prize–winning playwright begin to

appear. Stock's brief bibliography on Jelinek will doubtless provide additional assistance to readers interested in her.

Other studies have undertaken to reconceptualize the German theater in terms of postmodernist hypotheses and/or methodologies; a good example is Barnett's book on Heiner Müller, an attempt to understand how—or if—Müller's plays can ever be effectively staged. In some ways, the books on Müller by Fuhrmann and by Schulte and Mayer ponder the same improbabilities. Keim, on the other hand, sees Müller's later work as a "metatheatrical play" on the set pieces of Western cultural tradition, laying bare the artistic and social structures of those traditions.

Balitzki, Jürgen. *Castorf, der Eisenhändler*. Berlin: Links, 1995.

Bargna, Katya. "Der Weg ist nicht zu Ende Wenn das Ziel explodiert: Frank Castorf and the Survival of Political Theatre in the Postmodern Age." Ph.D. diss., University of Sheffield, 2000.

Barnett, David. *Literature versus Theatre: Textual Problems and Theatrical Realization in the Later Plays of Heiner Müller*. New York: P. Lang, 1998.

Bühler-Dietrich, Annette. *Auf dem Weg zum Theater: Else Lasker-Schüler, Marieluise Fleisser, Nelly Sachs, Gerlind Reinshagen, Elfriede Jelinek*. Würzburg: Königshausen & Neumann, 2003.

Detje, Robin. *Castorf: Provokation aus Prinzip*. Berlin: Henschel, 2002.

Domdey, Horst. *Produktivkraft Tod: Das Drama Heiner Müllers*. Cologne: Böhlau, 1998.

Dowden, Stephen D. *Understanding Thomas Bernhard*. Columbia: University of South Carolina Press, 1991.

Eke, Norbert Otto. *Heiner Müller*. Stuttgart: Reclam, 1999.

Fiddler, Allyson. *Rewriting Reality: An Introduction to Elfriede Jelinek*. Providence, RI: Berg, 1994.

Fischer-Lichte, Erika, et al., eds. *Ritualität und Grenze*. Tübingen: Francke, 2003.

Fischer-Lichte, Erika, and Harald Xander, eds. *Welttheater-Nationaltheater-Lokaltheater?* Tübingen: Francke, 1993

Fuhrmann, Helmut. *Warten auf "Geschichte": Der Dramatiker Heiner Müller*. Würzburg: Königshausen und Neumann, 1997.

Gleichauf, Ingeborg. *Was für ein Schauspiel! Deutschsprachige Dramatikerinnen des 20. Jahrhunderts*. Berlin: AvivA, 2003.

Haas, Birgit. *Modern German Political Drama, 1980–2000*. Rochester, NY: Camden House, 2003.

———. *Theater der Wende, Wendetheater*. Würzburg: Königshausen & Neumann, 2004.

Höller, Hans. *Thomas Bernhard*. Reinbek bei Hamburg: Rowohlt, 1993.

Honegger, Gitta. *Thomas Bernhard*. New Haven, CT: Yale University Press, 2001.

Irmer, Thomas, et al. *Zehn Jahre Volksbühne: Intendanz Frank Castorf*. Berlin: Theater der Zeit, 2003.

Jaeger, Dagmar. "Theater im Medienzeitalter: Das postdramatische Theater von Elfriede Jelinek und Heiner Müller." Ph.D. diss., University of Massachusetts, 2001.

Janke, Pia. *Die Nestbeschmützerin: Jelinek und Österreich*. Salzburg: Jung und Jung, 2002.

Janz, Marlies. *Elfriede Jelinek*. Stuttgart: Metzler, 1995.

Kalb, Jonathan. *The Theater of Heiner Müller*. New York: Cambridge University Press, 1998.

Keim, Katharina, et al., eds. *Theater ohne Grenzen*. München: Utz, 2003.

Klug, Christian. *Thomas Bernhards Theaterstücke*. Stuttgart: Metzler, 1991.

Koberg, Roland. *Claus Peymann: Aller Tage Abenteuer*. Berlin: Henschel, 1999.

Konzett, Matthias. *A Companion to the Works of Thomas Bernhard*. Rochester, NY: Camden House, 2002.

——. *The Rhetoric on National Dissent in Thomas Bernhard, Peter Handke, and Elfriede Jelinek*. Rochester, NY: Camden House, 2000.

Lehmann, Hans-Thies. *Postdramatisches Theater*. Frankfurt/Main: Verlag der Autoren, 1999.

Lennartz, Knut. *Theater, Künstler, und die Politik*. Berlin: Henschel, 1996.

Meyer-Dinkgräfe, Daniel. *Boulevard Comedy Theatre in Germany*. Newcastle upon Tyne, UK: Cambridge Scholars, 2005.

Mittermayer, Manfred. *Thomas Bernhard*. Stuttgart: Metzler, 1995.

Rigby, Catherine E. *Transgressions of the Feminine*. Heidelberg: Winter, 1996.

Rupprecht, Martin. *Bühnenbilder und Kostüme*. Edited by Lothar Schirmer. Berlin: Henschel, 2005.

Schilling, Klaus von. *Die Gegenwart der Vergangenheit auf dem Theater*. Tübingen: Narr, 2001.

Schulte, Christian, and Brigitte Maria Mayer. *Der Text ist der Coyote: Heiner Müller Bestandsaufnahme*. Frankfiurt/Main: Suhrkamp, 2004.

Schütt, Hans-Dieter, et al. *Castorfs Volksbühne*. Berlin: Schwarzkopf und Schwarzkopf, 1999.

Stock, Karl F., et al., eds. *Jelinek Bibliographien*. Graz: Stock, 2004.

About the Author

William Grange holds the rank of professor in the Johnny Carson School of Theatre and Film at the University of Nebraska in Lincoln. His interest in the German theater began when he was a college student at the University of Toledo (Ohio) and at Heidelberg University in Germany. After graduation, he went on to complete a Master of Fine Arts degree at Columbia University in New York City. While still a student at Columbia, he began working professionally as an Equity actor, appearing in several productions. He also acted with Shakespeare festivals, in summer stock, in dinner theater, and on tour with numerous companies.

Professor Grange completed doctoral studies at Indiana University, where he was awarded a dissertation fellowship from the German Academic Exchange Service to complete research in Göttingen and Berlin. He is the author of books, book chapters, scholarly articles, encyclopedic entries, published reviews, and essays. As a speaker at scholarly conclaves, he has presented papers throughout the United States, Canada, and Europe. Professor Grange has received numerous fellowships and grants for his scholarship and teaching. They include Fulbright Senior Scholar grants, the Mellon Prize from the University of Texas, senior fellowships from the German Academic Exchange Service, and several grants from the Hixson-Lied Foundation, the Nebraska Research Council, and the National Endowment for the Humanities.

Having taught and lectured at a wide variety of colleges and universities, Professor Grange teaches an equally wide variety of courses in Nebraska. They have included acting, directing, theater history, film history, and play analysis. He currently serves as chairman of the graduate committee within the Johnny Carson School.

Professor Grange has directed several plays on college campuses, including his own translations of works by Bertolt Brecht and Georg

Büchner and several plays by Shakespeare. The musicals he has directed include *Cabaret*, *Carousel*, *A Funny Thing Happened on the Way to the Forum*, *Happy End*, *Grease*, *Pippin*, *The Boy Friend*, and *Babes in Arms*. He has also performed in a number of leading musical roles, such as Captain von Trapp in Rodgers and Hammerstein's *The Sound of Music* and Prof. Henry Higgins in Lerner and Loewe's *My Fair Lady*. For the Nebraska Repertory Theatre's production of *Carnival!*, he played the carnival owner, August Wilhelm Schlegel. He most recently appeared as Caldwell B. Cladwell in Haymarket Theatre's production of the musical *Urinetown*. In their yearly awards, Professor Grange's colleagues have designated him the Johnny Carson School's Top Ranked Teacher and in other years the School's Top Ranked Scholar/Artist.